HUDSON RIVER SCHOOL VISIONS

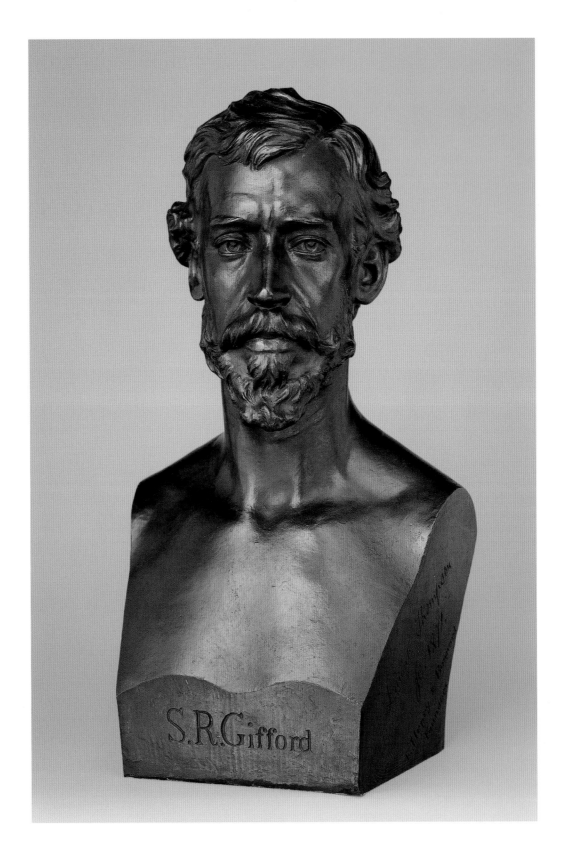

HUDSON RIVER SCHOOL VISIONS

The Landscapes of Sanford R. Gifford

Edited by Kevin J. Avery and Franklin Kelly

assisted by Claire A. Conway

with essays by Heidi Applegate and Eleanor Jones Harvey

THE METROPOLITAN MUSEUM OF ART, NEW YORK

YALE UNIVERSITY PRESS, NEW HAVEN AND LONDON

This volume has been published in conjunction with the exhibition
"Hudson River School Visions: The Landscapes of Sanford R. Gifford,"
held at The Metropolitan Museum of Art, New York, October 8, 2003–February 8, 2004;
the Amon Carter Museum, Fort Worth, March 6–May 16, 2004;
and the National Gallery of Art, Washington, D.C., September 26–June 27, 2004.

The exhibition is made possible by Deedee and Barrie Wigmore.

The exhibition was organized by The Metropolitan Museum of Art, New York,
and the National Gallery of Art, Washington.

The exhibition catalogue is made possible in part by the William Cullen Bryant
Fellows of the Metropolitan Museum.

Published by The Metropolitan Museum of Art, New York
John P. O'Neill, Editor in Chief
Ellen Shultz, Editor
Bruce Campbell, Designer
Elisa Frohlich, Production Manager
Minjee Cho, Desktop Publishing

Library of Congress Cataloging-in-Publication Data

Gifford, Sanford Robinson, 1823–1880.
Hudson River School visions : the landscapes of Sanford R. Gifford /
edited by Kevin J. Avery and Franklin Kelly; assisted by Claire A. Conway;
with essays by Heidi Applegate and Eleanor Jones Harvey.
p. cm.
Catalog of an exhibition at The Metropolitan Museum of Art, Oct. 8, 2003–Feb. 8, 2004.
Includes bibliographical references and index.
ISBN 1-58839-097-7 (hardcover)—ISBN 1-58839-098-5 (paperback)—ISBN 0-300-10184-8 (Yale)
1. Gifford, Sanford Robinson, 1823–1880—Exhibitions. 2. Hudson River school
of landscape painting—Exhibitions. I. Avery, Kevin J. II. Kelly, Franklin.
III. Metropolitan Museum of Art (New York, N.Y.) IV. Title.

ND237.G4A4 2003
759.13—dc22 2003016027

Jacket/cover: Sanford R. Gifford. *Sunset Over the Palisades on the Hudson.* See catalogue number 69

Frontispiece: Launt Thompson. *Sanford R. Gifford,* 1871. Bronze. The Metropolitan Museum of Art, New York.
Gift of Mrs. Richard Butler and her daughters, in memory of Richard Butler, 1902

PRINTED AND BOUND IN ITALY

CONTENTS

DIRECTORS' FOREWORD

The Metropolitan Museum of Art and the National Gallery of Art have always been strong advocates of the work of the Hudson River School painters. In the last quarter century, each institution has mounted what were arguably the twentieth century's premier exhibitions of nineteenth-century American landscape painting: "American Light: The Luminist Movement" was held at the National Gallery in 1980, and "American Paradise: The World of the Hudson River School," at the Metropolitan Museum in 1987. Each museum has also organized major monographic shows of the work of members of the school. The most recent of these was the 1989 retrospective at the National Gallery of the paintings of Frederic E. Church, although the initial tribute to Church was the memorial exhibition at the Metropolitan Museum in 1900, the year of his death.

Sanford R. Gifford enjoys the special distinction of having been the first artist honored at the Metropolitan Museum with an exhibition devoted solely to his work. Like Church and such Hudson River painters as John F. Kensett and Worthington Whittredge, Gifford was among fifty prominent New York artists, literati, and businessmen who convened at the Union League Club in 1869 to draft the original resolution for a municipal art institution. In 1870, Gifford joined the thirteen-member subcommittee that selected the Metropolitan Museum's first officers. When Gifford died in 1880, the Museum's first director, Luigi di Cesnola, welcomed the opportunity to honor him at the Museum's new (and present) Central Park home. As proposed by Gifford's colleagues, patrons, and friends—several of them founders and trustees of the Museum themselves—a generous representation (160) of his paintings was selected for a six-month showing. This "unique testimonial to [Mr. Gifford's] genius," as one contemporary news critic described it, generated another unprecedented undertaking: the Museum's first published catalogue raisonné, *The Memorial Catalogue of the Paintings of Sanford Robinson Gifford,*

N. A. (1881), compiled by Waldo S. Pratt, an assistant to Cesnola, and Jervis McEntee, Gifford's fellow landscape painter and close friend. In subsequent years, the Museum has expanded its mission in order to become a genuinely cosmopolitan institution with a collection representing a global range of cultures. However, it has never neglected its metropolitan base: Its nascent and intimate ties to the New York community of landscape painters have brought to its collections unequaled masterpieces by exponents of the Hudson River School—including three works by Gifford himself, two of which (cat. nos. 21, 51) are included in the present exhibition. It is especially gratifying to the Metropolitan Museum that this century's first retrospective of an American artist's work is devoted to Gifford, thus reprising its initial nineteenth-century exhibition.

Since the National Gallery of Art's inception in 1941, American art has represented an important part of our national heritage. Over the years, the Gallery has assembled a formidable group of landscapes by artists of the Hudson River School, but, until 1999, Gifford was not represented. The purchase that remedied this lacuna, *Siout, Egypt* (cat. no. 49), is without doubt one of his most masterful pictures. That acquisition, in turn, served as the impetus for an exhibition that would showcase the painter's finest works and make his exceptional artistic abilities better known to the public. Upon learning that colleagues at the Metropolitan Museum were of a similar mind, the National Gallery proposed that the two institutions collaborate on the exhibition, and the project was under way.

The tireless efforts of its two organizers have made "Hudson River School Visions: The Landscapes of Sanford R. Gifford" possible. Over the last three years, Kevin J. Avery, Associate Curator of American Paintings and Sculpture at the Metropolitan, and Franklin Kelly, Senior Curator of American and British Paintings at the Gallery, have selected the paintings and prepared a catalogue that broadens and enriches our understanding of Gifford's achieve-

ment. The exhibition—which opens at the Metropolitan Museum and closes at the National Gallery—will also travel to the Amon Carter Museum in Fort Worth.

At the Metropolitan Museum, we are grateful to Deedee and Barrie Wigmore for helping to bring "Hudson River School Visions" and its accompanying symposium to fruition. At the National Gallery, we extend our sincere gratitude to the Henry Luce Foundation for its generous support of the exhibition. To the many public institutions and private collectors whose generous loans made this exhibition a reality, we are deeply indebted.

Philippe de Montebello
Director
The Metropolitan Museum of Art,
New York

Earl A. Powell III
Director
National Gallery of Art,
Washington, D.C.

PREFACE AND ACKNOWLEDGMENTS

Sanford Robinson Gifford was one of the leading members of the Hudson River School of landscape painters. Like his contemporaries Frederic Edwin Church, Jasper F. Cropsey, Worthington Whittredge, and John F. Kensett, Gifford played a key role in establishing landscape painting as the preeminent mode of art in mid-nineteenth-century America. Acclaimed in his own time, as now, for the masterful effects of light and atmosphere in his paintings, Gifford was perhaps the most technically accomplished and sophisticated of all the Hudson River School artists, especially in his use of thin glazes to achieve subtle transitions from dark to light. Such ability, combined with a highly refined artistic sensibility, enabled Gifford to create some of the most deeply evocative and richly resonant landscapes of his era, as his contemporary Henry T. Tuckerman observed, in the *Book of the Artists*: "they do not dazzle, they win; they appeal to our calm and thoughtful appreciation; they minister to our most gentle and gracious sympathies, to our most tranquil and congenial observation."

Immediately following Gifford's death in 1880, his career was surveyed in an exhibition prepared by The Metropolitan Museum of Art, but almost a century would pass before a second show of his work would take place. In 1970, at the University of Texas in Austin, Nicolai Cikovsky, Jr., organized an exhibition of sixty-four of Gifford's pictures that traveled to the Albany Institute of History and Art, and to the Hirschl & Adler Galleries in New York—one of several modern monographic retrospectives at the time that furthered the revival of nineteenth-century American landscape painting, especially by second-generation New York artists. Those accorded such one-man exhibitions include Albert Bierstadt (1964 and 1972), Church (1966), Kensett (1968), Whittredge (1969), Martin Johnson Heade (1969), Cropsey (1970), and Asher B. Durand (1971). All but Gifford and Durand (a show of whose works is now being planned) have been given even larger monographic exhibitions since then, accompanied by substantial, well-illustrated catalogues.

Our own interests in organizing a Gifford retrospective developed separately over the last fifteen years. Gifford was prominently represented by six works in the Metropolitan Museum's exhibition "American Paradise: The World of the Hudson River School," a major survey of mid-nineteenth-century American landscape painting. While preparing the catalogue entries on Gifford's paintings, including the Museum's masterpiece *A Gorge in the Mountains* (cat. no. 21; formerly titled *Kauterskill Clove*), Kevin Avery first came up with the idea of celebrating the artist with an important museum retrospective that would reprise the Metropolitan Museum's original tribute to Gifford, the "Memorial Exhibition" of 1880. When Franklin Kelly served as Curator of Collections at the Corcoran Gallery of Art in Washington, D.C., from 1988 to 1990, he, in turn, began to plan a Gifford retrospective that would include the Corcoran's late masterpiece *Ruins of the Parthenon* (cat. no. 70); however, once he joined the staff of the National Gallery in 1990, Kelly had to put those plans on hold, in favor of a series of exhibitions devoted to the work of other American artists. The National Gallery's 1999 acquisition of the dazzling *Siout, Egypt* (cat. no. 49) inspired Kelly to revive the project. Learning of our mutual interest, we—and our respective institutions—decided to collaborate on organizing a Gifford retrospective.

The present exhibition is timely—indeed, overdue—in more ways than those just described. The publication in 1987 of Ila Weiss's *Poetic Landscape: The Art and Experience of Sanford R. Gifford* (based on her 1968 dissertation) gave scholars a thorough account of the artist's life and work, with much new information. Gifford's paintings also have been part of many exhibitions since that last retrospective, and a fuller understanding of his art in relationship to the work of his contemporaries has emerged. Thanks to the growing interest in our artistic heritage in general, in the years following the Bicentennial, and to the phenomenally active market for nineteenth-century American painting in the past quarter century, scores of new Gifford paintings of all sizes and subjects have come to light, including several of what the artist termed his "chief pictures." The "chief pictures"

included here, such as *Lake Nemi* (cat. no. 6), *Mansfield Mountain* (cat. no. 8), *Hunter Mountain, Twilight* (cat. no. 41), and *A Passing Storm in the Adirondacks* (cat. no. 44) are clearly cornerstones of the present exhibition, and represent Gifford's highest ambitions as a landscape painter. However, they alone cannot give a complete insight into his remarkable creativity without the addition of a selection of his mid-sized canvases, as well as smaller, cabinet-sized sketches, studies, and reduced versions of the major paintings. Some of these, such as *The Shawangunk Mountains* (cat. no. 36), were chosen because of their relationship to larger works that remain unlocated, while others offer clues with regard to Gifford's process of developing the major pictures. Research into Gifford's working methods has revealed that he probably prepared his studies not merely to rehearse his "chief pictures" but also to advertise them to prestigious patrons, who would request amplified versions of compositions that he showed them in his studio. Less frequently, it seems, he also fashioned reduced-scale replicas for admirers of his exhibition pictures, lavishing as much artistry and skill on these as on the large paintings. Sometimes, with certain subjects, one feels that his effects of light and air, beautifully achieved in a cabinet-sized work, could not be effectively re-created on a larger canvas. Gifford must have sensed that, too, for—unlike Church, Bierstadt, Cropsey, and even Kensett—he never painted a picture wider or taller than sixty inches; only one of his major works exceeded fifty-four inches in width. However, in his own range, Gifford was unsurpassed in the contemplative interpretation of landscape. The only difficulties encountered in making our selection are the result of his delicacy of technique, which, while effective in conveying his rare sensibility and skill at artistic expression, also has rendered many of his works vulnerable to the vicissitudes of time, environmental factors, and inept cleaning and restorations. Several well-known paintings that might be expected in a Gifford retrospective regrettably were omitted because they were deemed too compromised by their condition. Yet, we can take consolation in the fact that, of the more than 700 paintings recorded in the 1880 *Memorial Catalogue*, more than half remain undiscovered, including a substantial number of major works—undeniably, a rich incentive for further research and investigation by scholars in the future.

Weiss's thorough monograph has obviated the need for a detailed Gifford biography in the foreseeable future. In this volume, Gifford's artistic enterprise and accomplishment are summarized, assessed, and brought up to date in Kelly's essay; the three other texts address distinctive and critical aspects of the painter's career: his personal and artistic attachment to the Catskill Mountains (Avery); his closely documented travels abroad (Applegate); and his patronage (Harvey). The

essays do not seek to convey the narrative line of Gifford's life, nor to include every salient incident; much of this information is contained in the Chronology at the back of the catalogue. The variety, quality, appeal, and significance of Gifford's output warrant the discrete and extensive discussion of individual paintings or small groups of related pictures. The entries that follow are accompanied by faithful colorplates whose large size is accommodated by the format of the catalogue; these are supplemented by black-and-white illustrations of studies from the artist's surviving sketchbooks and by related works by other artists.

From the outset of this project in 1999, we have been warmly encouraged by the directors of our respective institutions, Philippe de Montebello of The Metropolitan Museum of Art and Earl A. Powell III of the National Gallery of Art. Their guidance has been deeply appreciated, and was supported, at the Metropolitan, by Doralynn Pines, Associate Director for Administration, and Mahrukh Tarapor, Associate Director for Exhibitions, and at the National Gallery, by Alan Shestack, Deputy Director, and D. Dodge Thompson, Chief of Exhibitions.

At the Metropolitan Museum, Kevin Avery is grateful to the many individuals who contributed their time and expertise toward the realization of the exhibition. In the Director's Office, Ms. Tarapor was assisted by Martha Deese, Sian Wetherill, and Alexandra Klein. Senior Vice President for External Affairs Emily Kernan Rafferty oversaw the fundraising efforts and opening-event arrangements of Chief Development Officer Nina McN. Diefenbach, Kristin M. MacDonald, Kerstin M. Larsen, and Christine Scornavacca. Secretary and General Counsel Sharon H. Cott and Rebecca Noonan refined and approved the contract between the organizing institutions. Manager for Special Exhibitions Linda M. Sylling, assisted by Jennifer D. Hinckley, lent her customary assurance and common sense in managing the budget and coordinating the contributions to the exhibition of the many Museum departments. In the Departments of American Art, Kevin Avery benefited from the guidance, support, and encouragement of Lawrence A. Fleischman Chairman Morrison H. Heckscher and the initial enthusiasm of former Chairman John K. Howat, as well as from the advice of Curator and Administrator Peter M. Kenny. He is grateful for the interest of his colleagues, Anthony W. and Lulu C. Wang Curator Alice Cooney Frelinghuysen, Alice Pratt Brown Curator H. Barbara Weinberg, Curator Carrie Rebora Barratt, Associate Curators Thayer Tolles, Amelia Peck, Frances Safford, and Beth Wees, and Research Associate Frances F. Bretter. He appreciates the unstinting aid with numerous organizational details

of Administrative Assistants Catherine Scandalis, Kathryn Sill, and Karen Zimmerman, as well as the arrangements made by Barbara Whalen and Ellin Rosenzweig for William Cullen Bryant Fellows and Friends of the American Wing events connected with the exhibition. Departmental Technicians Don Templeton, Gary Burnett, Sean Farrell, and Rob Davis deserve special recognition for their unfailing responsiveness and skill in preparing for and installing the exhibition. In other curatorial departments, Engelhard Curator of 19th-Century European Painting Gary Tinterow, Jacques and Natasha Gelman Chairman William S. Lieberman and Research Associate Ida Balboul in the Department of Modern Art, and Assistant Curator Elizabeth E. Barker and Study Room Supervisor Constance McPhee in the Department of Drawings and Prints were generous with their advice and assistance.

Metropolitan staff in numerous other departments deserve thanks and recognition for their manifold contributions: In Paintings Conservation, Dorothy Mahon monitored the condition of all paintings lent to the exhibition; in Objects Conservation, Pascale Patris did the same for their frames. In the Thomas J. Watson Library, Kenneth Soehner, Linda Seckelson, Katherine Yvinskas, and Deborah Vincelli eagerly facilitated the acquisition and referencing of materials indispensable to the author's research. In Collections Management, Jennie Choi created database reports critical to the organization of the exhibitions and catalogue. In the Registrar's Office, Aileen K. Chuk, assisted by Lisa Cain, managed the complicated loan arrangements with her usual authority and good humor. In Education, Associate Director for Education Kent Lydecker, Stella Paul, Alice Schwarz, Nancy Thompson, and Elizabeth Hammer conceived and scheduled programs and lectures to accompany the exhibition. In Archives, Jeanie James, Betsy Baldwin, and especially Barbara File facilitated our research into the role of Gifford and his patrons in the early years of the Museum. In Communications, Harold Holzer, Egle Žygas, and Diana Pitt skillfully managed publicity. In the Photograph Studio, Barbara Bridgers helpfully arranged catalogue photography that was undertaken by Mark Morosse on very short notice. In the Photograph and Slide Library, Deanna D. Cross and Carol Lekarew organized and supplied transparencies and slides of exhibition objects. The felicitous design of the exhibition was provided by Michael Langley; the graphics, by Barbara Weiss and Connie Norkin; and the lighting, by Clint Coller and Rich Lichte.

Editor in Chief and General Manager of Publications John P. O'Neill could not have been more responsive to our tastes in guiding the publication of this volume. When he could not always work directly with us, Associate General Manager of Publications Gwen Roginsky and Managing Editor Margaret Chace were expert and most accommodating. Ellen Shultz edited the text with great discrimination and sensitivity. Penny Jones took great care in compiling the bibliography. The catalogue was beautifully produced by Peter Antony, Chief Production Manager, Elisa Frohlich, Production Manager, and Jill Pratzon, Production Associate. The volume's superb design is the work of Bruce Campbell.

At the National Gallery, special thanks are due Jennifer F. Cipriano, Exhibition Officer, and Jennifer Overton, Assistant for Exhibition Administration, for their cheerful assistance with a myriad of organizational details; Susan Arensberg, Head of Exhibition Programs, for supplying interpretative materials to accompany the exhibition; Mark Leithauser, Senior Curator, Chief of Design; Gordon Anson, Deputy Chief of Design/Head of Exhibition Production; John Olson, Production Coordinator; and Jame Anderson, Architect, Design Coordinator, for insuring that the display of Gifford's works would be fittingly elegant; Faya Causey, Head of Academic Programs, for coordinating lectures and other programs connected with the exhibition; Phyllis Hecht, Web Manager, for implementing a feature devoted to Gifford on the Gallery's website; Melissa Stegeman, Assistant Registrar for Exhibitions, for expertly managing the shipping and handling of the works; Daniel Randall and Douglas Jackson, Art Services Specialists, for heading up the team that installed the exhibition; Michael Swicklick, Senior Conservator, for help with understanding Gifford's technique; Steve Wilcox, Frame Conservator, and Richard Ford, Assistant Frame Conservator, for advice about identifying original frames; Ruth Anderson Coggeshall, Chief Development Officer, Missy Muelich, Associate, Foundation Relations, Joseph Krakora, Executive Officer, External and International Affairs, Christine Myers, Chief Corporate Relations Officer, and Susan McCullough, Sponsorship Manager, for their crucial and greatly appreciated help with funding; Deborah Ziska, Press and Information Officer, for publicizing the exhibition; Genevra Higginson, Assistant to the Director for Special Events, for arranging the opening festivities with her usual flair; Pamela Jenkinson, Special Projects Officer, for her help in negotiating an especially difficult loan; and Charles Brock, Assistant Curator, and Abbie N. Sprague, Curatorial Assistant, Department of American and British Paintings, for their help with so many aspects of the project over the years.

We are especially happy to welcome the Amon Carter Museum in Fort Worth as the middle venue for the exhibition. That institution has long been an important force in the world of American art history through its exhibitions, publications, and programs, and it provides an excellent arena for making Gifford's art more

widely known to the public. It has been our pleasure to work with the following colleagues at the Amon Carter Museum: Ruth Carter Stevenson, President; Patrick Stewart, Director; Jane Myers, Chief Curator; Patricia Junker, Curator of Paintings and Sculpture; Wendy Haynes, Exhibition Manager; and Melissa Thompson, Registrar.

Innumerable colleagues in other institutions cheerfully offered their valuable time and assistance in the course of our research and extensive travels to see Gifford paintings, and we gratefully cite them in order of the libraries, museums, and universities where they welcomed us: Addison Gallery of American Art, Phillips Academy, Andover, Massachusetts, Susan Faxon, Curator; Adirondack Museum, Blue Mountain Lake, New York, Caroline Welsh, Curator; Albany Institute of History and Art, Tammis K. Groft, Director of Collections and Exhibitions, Sarah Bennett, Curatorial Administrator, Rights and Reproductions; Archives of American Art, Smithsonian Institution, Joy Wiener (New York) and Judy Throm and Elizabeth Botten (Washington, D.C.); Art Complex Museum, Duxbury, Massachusetts, Charles Weyerhauser, Director, Catherine Mayes, Senior Curator, and Maureen Wengler, Registrar; The Art Institute of Chicago, Judith A. Barter, Field-McCormick Curator of American Arts; Art of the Americas, Marian Wardle, Curator, and Susan G. Thompson, Senior Registrar; Museum of Art, Brigham Young University, Provo, Utah; Brooklyn Museum of Art, New York, Linda S. Ferber, Andrew W. Mellon Curator of American Art, and Barbara A. Gallati and Theresa Carbone, Curators, American Paintings and Sculpture; Bureau of Historic Sites, New York State Office of Parks, Recreation and Historic Preservation, Peebles Island, Waterford, New York, Anne Ricard Cassidy, Collections Manager, Joyce Zucker, Paintings Conservator, and Eric Price, Objects Conservator; The Cleveland Museum of Art, Henry Adams, former Curator, and Kathleen McKeever, Curatorial Assistant, American Art; Colby College Museum of Art, Waterville, Maine, Hugh Gourley III, Director; The Columbus Museum, Columbus, Georgia, Brigitte Foley, Assistant Curator; Corcoran Gallery of Art, Washington, D.C., Sarah Cash, Bechhoefer Curator of American Art; Currier Museum of Art, Manchester, New Hampshire, Susan E. Strickler, Director, and P. Andrew Spahr, Curator of Paintings; The Detroit Institute of Arts, Jim Tottis, Acting Curator, American Art; Everson Museum of Art, Syracuse, New York, Thomas Piché, Jr., Senior Curator, Deborah Ryan, Curator, and William Flanagan, former Registrar; The Fine Arts Museums of San Francisco, Edna Root Curator of American Art Tim Burgard, and Daniel Cornell, Assistant Curator; The Frances Lehman Loeb Art Center, Vassar College, Poughkeepsie, New York, Patricia Phagan, The Philip and Lynn Strauss Curator of Prints and Drawings, and Karen Casey Hines, Assistant Registrar; Freer Gallery of Art, Smithsonian Institution, Washington, D.C., Kenneth Myers, Curator of American Art; Georgia Museum of Art, University of Georgia, Athens, Annalies Mondi; Harvard University Art Museums, Fogg Art Museum, Cambridge, Massachusetts, Theodore E. Stebbins, Jr., Curator of American Art, Kimberly Orcutt, Assistant Curator, Kevin Moore, Henry Luce Research Associate, and Dorothy Davila, Visual Archives Administrator; High Museum of Art, Atlanta, Maureen Morrissette, Associate Registrar; Indiana University Art Museum, Bloomington, Kathleen A. Foster, former Class of '49 Curator of Western Art after 1800, Nan Brewer, Lucienne M. Glaubinger Curator, Works on Paper, and Jenny McComas, Graduate Assistant; Library of Congress, Washington, D. C., Jeffrey M. Flannery, Manuscript Reference Specialist; Lorenzo State Historic Site, New York State Office of Parks, Recreation and Historic Preservation, Cazenovia, New York, Russell A. Grills, Historic Site Manager; Marsh-Billings-Rockefeller National Historic Park, Woodstock, Vermont, Janet Houghton, Curator; Mead Art Museum, Amherst College, Massachusetts, Stephen Fischer, Registrar; Museum of Art, Rhode Island School of Design, Providence, Maureen O'Brien, Curator; Museum of the City of New York, Andrea Henderson Fahnestock, Curator of Paintings and Sculpture; Munson-Williams-Proctor Institute, Museum of Art, Ithaca, New York, Paul Schweizer, Director, and Maggie Mazullo, Registrar; Museum of Fine Arts, Boston, Elliot Davis, John Moors Cabot Chair, Erica Hirshler, Croll Senior Curator of Paintings, and Carol Troyen, Curator of Paintings; National Academy of Design, Museum and School of Fine Arts, New York, Annette Blaugrund, Director, and David Dearinger, Chief Curator; The Nelson-Atkins Museum of Art, Kansas City, Missouri, Margaret Conrads, Samuel Sosland Curator of American Art; New Britain Museum of American Art, Connecticut, Douglas Hyland, Director; Olana State Historic Site, New York Office of Parks, Recreation and Historic Preservation, Hudson, New York, Evelyn Trebilcock, Curator; The Pennsylvania Academy of the Fine Arts, Philadelphia, Silvia Yount, former Curator; Philadelphia Museum of Art, former Robert E. McNeil, Jr. Curator of American Art Darrel Sewall, and W. Douglas Paschall, former Research Associate; Seattle Art Museum, Chio Ishikawa, Chief Curator, and Liz Andrus, Curatorial Coordinator; Seventh Regiment Fund, New York, Kenyon FitzGerald, President; Saint Johnsbury Athenaeum, Vermont, David Weinstein, Chair, Collections Committee, Anne Lawless, former Manager of Curatorial

Activities, Lorna Higgs, Athenaeum Administrator, and Sarah Lawrence, former Curator; Springfield Art Museums, Springfield, Massachusetts, Elizabeth Ziegler, Assistant Curator; Spencer Museum of Art, University of Kansas, Lawrence, Susan Earl, Curator, and Laura Pasch, Assistant Registrar; Sweet Briar Museum, Sweet Briar College, Virginia, Rebecca Massie Lane, Director of College Galleries and Arts Management, and Nancy McDearmon; Terra Museum of American Art, Chicago, Elizabeth Glassman, Director, Catherine Ricciardelli, Director, Exhibitions and Collections, Shelley Roman, Assistant Curator, Stephanie Mayer, Curatorial Assistant, and Leo Kelly, Rights and Reproductions Coordinator; Museo Thyssen-Bornemisza, Madrid, D. Tomas Lorens, Director, and Lucia Cassol, Registrar; The Toledo Museum of Art, Lawrence W. Nichols, Curator, European Painting and Sculpture before 1900; Wadsworth Atheneum, Hartford, Elizabeth Mankin Kornhauser, Chief Curator and Krieble Curator of American Paintings and Sculpture, and Amy Ellis, former Assistant Curator; Washington University Gallery of Art, Saint Louis, Mark S. Weill, Director, Sara Rowe Hignite, Registrar, and Tori Durrer, Graduate Assistant; Westmoreland Museum of Art, Greensburg, Pennsylvania, Judith O'Toole, Director, and Barbara Jones, Curator; Williams College Museum of Art, Williamstown, Massachusetts, Vivian Patterson, Curator of Collections, and Nancy Mowll Matthews, Eugene Prendergast Curator; Williamstown, Massachusetts, Conservation Center, Thomas Branchick, Executive Director; Yale University Art Gallery, New Haven, Helen Cooper, Curator, American Painting.

Without our good friends in the commercial art galleries and auction houses in New York and elsewhere we simply could not have located scores of Gifford paintings in private collections, several of which are included in the exhibition. For their generous cooperation as well as their enthusiastic assistance in manifold ways, we are delighted to cite those colleagues: Alexander and Laurel Acevedo, Alexander Gallery, New York; Michael Altman and Eileen Dady, Michael N. Altman and Company, New York; James Berry-Hill, Fred, David, and Daisy Hill, and Bruce Weber, Berry-Hill Galleries, Inc., New York; Jeffrey Brown, Brown-Corbin Fine Art, Lincoln, Massachusetts; Paul Provost and Eric Widing, Christie's, New York; Tom Colville, Thomas Colville Fine Art, New Haven; Jeff Cooley, The Cooley Gallery, Old Lyme, Connecticut; Edward T. Wilson, Fund for Fine Arts, Bethesda, Maryland; John, Joel, and Joshua Garzoli, Garzoli Gallery, San Rafael, California; Howard Godel, Elizabeth Stallman, and Katherine Baumgartner, Godel and Co., Inc., Fine Art, New York; Stuart Feld, M. P. Naud, Eric Baumgartner, Allison Smith, and Lucy B. Toole, Hirschl & Adler Galleries, Inc.,

New York; Allan, Mary, and Colleen Kollar, A. J. Kollar Fine Paintings, Seattle; Vance Jordan, Vance Jordan Fine Art, New York; Martha Fleischman, Lillian Brenwasser, and Jayne Kuchna, Kennedy Galleries, New York; Susan Menconi and Andrew Schoelkopf, Menconi and Schoelkopf, New York; Betty Krulik and Melissa Lesan, Phillips, de Pury and Luxembourg New York; Peter Rathbone, Alison Cooney, and Elizabeth F. Byrns, Sotheby's, Inc., New York; Ira Spanierman, Ralph Sessions, and Lyle C. Gray, Spanierman Gallery, New York; Deedee Wigmore, D. Wigmore Fine Art, New York; Paul Worman; the late Richard York and Meredith Ward, Richard York Gallery, New York.

For their aid and hospitality during the course of our Gifford survey and research, we would also like to thank several individuals: Barbara and Ted Alfond; the late Arthur G. Altschul; Patricia Altschul; Mary Ann Apicella; Ann and Tom Barwick; Heidi and Max Berry; John Boos; R. Alexander Boyle; Allan Bulley; Don Christensen; Tom Davies; Susan G. Detweiler; Jerrilyn Dodds; Louisa and Robert Duemling; Blair Effron; Sandra K. Feldman; Robert Fischer; Doris Gaudette; William H. Gerdts; Walter T. Goldfarb, M.D.; Elizabeth Gosnell; Holcombe T. Green; Vince Griski; Linda Guest; Linda M. Gunn; Charles Hillburn; Peter Jung; Kevin Landry; Senator Patrick Leahy; Sam Lehrman; Paula and Peter Lunder; Bridget Manoogian; Harriet Moore; Colonel Merl M. Moore; David Nisinson; Washburn and Susan Oberwager; Robert Peiser; Meg Perlman; Sam Pryor; Sharon Rockefeller; David Rust; Denise and Andrew Saul; the late Peter Terian; Elliot and Kristen Vesell; and Jack Warner.

We owe a special debt of gratitude to Alicia Bochi, Gerald L. Carr, Vivian Chill, Claire A. Conway, Sanford and Ingrid Gifford, Adam Greenhalgh, Ethan Lasser, Catherine Lawrence, Mary Lublin, Lenore Scendo, and the pioneer of Gifford studies, Ila Weiss.

The William Cullen Bryant Fellows at The Metropolitan Museum of Art made possible the publication of this volume. Early stages of Kevin Avery's research and travel were supported by a grant from the Overbrook Foundation. At the Metropolitan, the exhibition was generously funded by Deedee and Barrie Wigmore; at the National Gallery by the Henry Luce Foundation. To those benefactors we offer our deepest thanks.

Kevin J. Avery
Associate Curator
The Metropolitan Museum of Art,
New York

Franklin Kelly
Senior Curator of American and British Paintings
National Gallery of Art,
Washington, D.C.

LENDERS TO THE EXHIBITION

UNITED STATES

Bethesda, Maryland, Edward T. Wilson, Fund for Fine Arts, cat. no. 4

Bloomington, Indiana, Indiana University Art Museum, cat. no. 28

Boston, Museum of Fine Arts, cat. no. 53

Cambridge, Massachusetts, Fogg Art Museum, Harvard University Art Museums, cat. no. 59

Cazenovia, New York, Lorenzo State Historic Site, New York State Office of Parks, Recreation and Historic Preservation, cat. no. 16

Chicago

 The Art Institute of Chicago, cat. no. 19

 Terra Foundation for the Arts, Daniel J. Terra Collection, cat. nos. 41, 42

Cleveland, The Cleveland Museum of Art, cat. no. 40

Detroit, The Detroit Institute of Arts, cat. no. 52

Duxbury, Massachusetts, Art Complex Museum, cat. no. 1

Fort Worth, Amon Carter Museum, cat. no. 50

Hartford, Wadsworth Atheneum, Museum of Art, cat. no. 44

Manchester, New Hampshire, Currier Museum of Art, cat. no. 26

New Haven, Thomas Colville Fine Art, LLC, cat. no. 37

New York

 Berry-Hill Galleries, Inc., cat. no. 3

 The Metropolitan Museum of Art, cat. nos. 21, 51

 National Academy of Design, cat. no. 10

 Seventh Regiment Fund, cat. no. 34

Saint Louis, Washington University Gallery of Art, cat. nos. 11, 56

Seattle, Seattle Art Museum, cat. no. 57

Springfield, Massachusetts, George Walter Vincent Smith Art Museum, cat. no. 9

Syracuse, New York, Everson Museum of Art, cat. no. 64

Toledo, The Toledo Museum of Art, cat. nos. 6, 12

Utica, New York, Munson-Williams-Proctor Institute, Museum of Art, cat. nos. 60, 67

Washington, D.C.

 Corcoran Gallery of Art, cat. no. 70

 National Gallery of Art, cat. no. 49

SPAIN

Madrid, Carmen Thyssen-Bornemisza Collection on loan at the Museo Thyssen-Bornemisza, cat. no. 17

*Private collection*s

Cheryl and Blair Effron, cat. no. 36

Family of the Artist, cat. no. 22

Jo Ann and Julian Ganz, Jr., cat. nos. 24, 33, 39, 45, 47

Jack Hollihan and Mary Ann Apicella, cat. no. 2

Mr. and Mrs. Jack Kay, cat. no. 13

Manoogian Collection, cat. no. 8

Robert S. Peiser, Jr., and Dr. Peter K. Zucker, Ashburn, Virginia, cat. no. 5

Andrew and Denise Saul, Katonah, New York, cat. no. 18

Peter and Juliana Terian Collection of American Art, cat. no. 23

Deedee and Barrie Wigmore, New York, cat. no. 62

Erving and Joyce Wolf, cat. no. 15

Anonymous lenders, cat. nos. 7, 14, 20, 25, 27, 29, 30, 31, 32, 35, 38, 43, 46, 48, 54, 55, 57, 58, 61, 63, 65, 66, 68, 69

HUDSON RIVER SCHOOL VISIONS

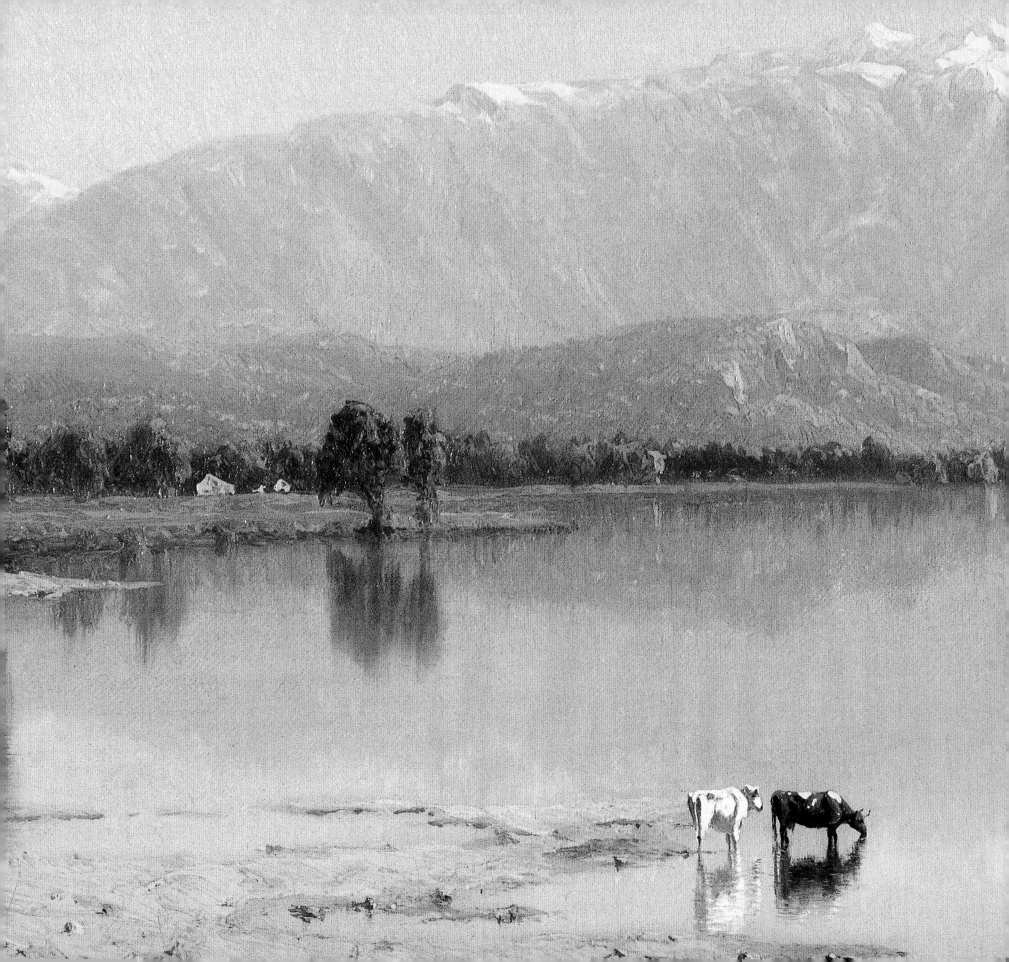

NATURE DISTILLED: GIFFORD'S VISION OF LANDSCAPE

FRANKLIN KELLY

"In [Gifford's] opinion—and the opinion is correct—an artist is simply a poet. . . . Both the painter and the poet strive to reproduce the impressions which they have received from the beautiful things in Nature. If these impressions can be reproduced in words, it is the business of the poet to reproduce them. If they are subtle and elude the grasp of words, it is the business of the painter to reproduce them."

George William Sheldon, 1877[1]

"GIFFORD's art was poetic and reminiscent. It was not realistic in the formal sense. It was nature passed through the alembic of a finely organized sensibility."

John Ferguson Weir, 1880[2]

Sanford Gifford had many friends, and, during his lifetime and after, many of those friends tried to verbalize just what it was that made his paintings so distinctively beautiful, so particularly special and different, and so unmistakably his own. It is never easy to find words, whether spoken or written, that can adequately convey the full richness of specific incidences of perception, whether of an actual landscape scene, a painted one, or, indeed, of anything else. Our perceptions of the world around us come via the senses of sight, smell, touch, hearing, and taste, which provide information that allows for emotional and intellectual interpretation of what we experience as reality. One hardly need have any special knowledge of the theories and sciences of perception and cognition to appreciate just how intricately complex and complicated these processes are and how elusive articulating them can be. Nevertheless, leaving aside the conundrum of precisely what reality is or whether there even is such a thing, it can be said that some experiences are easier to describe than are others. The act of picking up a rock, feeling its texture and weight, seeing its coloration and shape, and even tasting it, smelling it, and hearing the sounds it makes when striking other surfaces, may be challenging to convey accurately to another person, but it is surely less so than verbalizing the experience of listening to a symphony, or watching a game of baseball, or seeing a painting. Although we routinely attempt such descriptions, words, quite simply, often fail us.

Such was the case with Gifford's contemporaries, who found it frustratingly difficult to describe cogently the effect his works had on them. Frequently, they resorted to using words that were themselves allusive and elusive, words such as "poetic," "sympathetic," "profound," "graceful," "sensitive," and "solemn." They also regularly associated Gifford's art with his personality, hoping to explain the paintings by explaining the man. As Weir wrote, "An earnest simplicity characterized GIFFORD, a reverence for truth, for sincerity—and these qualities of his fine temperament penetrated his art."[3] Such observations are not without merit, and they can aid understanding. The opening sentences of Henry T. Tuckerman's discussion of Gifford and his work in his 1867 *Book of the Artists* seem, upon first reading, to assess the artist's character

and his art perfectly: "If we were to select one of our landscape-painters as an example of artistic intelligence—by which we mean the power of knowledge in the use of means, the choice of subjects, and the wise direction of executive skill—we should confidently designate Sanford R. Gifford. His best pictures can be not merely seen, but *contemplated* with entire satisfaction."[4] Tuckerman's words are, however, ultimately rather vague: Precisely what, for instance, was the difference between "seeing" a picture and "contemplating" one? It is not that these words ring false in connection with Gifford's paintings, for that is not so. They simply do not fully account for them. Indeed, it is telling that one of the most astute observers of American art in the 1860s and 1870s, Eugene Benson, freely admitted in 1866 the challenge posed in writing about Gifford's art. As he observed:

> *If Mr. Gifford's picture* [Hunter Mountain, Twilight; *cat. no. 41*] *were less complete in the rendering of its theme, we might write more about it; but because it is so entirely so it is difficult to give it another expression, that is, transpose it into language. We may say of it, as George Sand said of the Requiem of Mozart—one could write a fine poem while listening to it, but it would be a poem only, and not a description or a translation; so in looking at "Hunter Mountain Twilight," one might be moved to say many fine words, but they would be words and not the picture: the picture is complete, and in art an accomplished fact, and it renders futile any new expression.*[5]

Just a few weeks before writing that assessment, Benson had struggled to come to terms with Gifford in an article comparing his work to that of George Inness.[6] He found the two painters the "most original and interesting, as they are the most pronounced in their traits, of painters whom we call American." For Benson, "Gifford, more than any American landscape painter, attains the beautiful, and expresses serenity without weakness." Benson was well aware that there were those—particularly the devoted American followers of the British Pre-Raphaelite painters, who, in this country, formed the Association for the Advancement of Truth in Art and published the journal *The New Path*—who judged Gifford deficient in the accurate depiction of nature.[7] Their views were most widely disseminated by Clarence Cook, the fulminating critic for the *New-York Daily Tribune*, who railed at American artists'

unquestioning acceptance of "the dogma that a something called Beauty is the end, and not Truth."[8] Anticipating such criticism, Benson wrote, "There are those who will question our estimate of Gifford, and they will speak to us of what they call his unreality, and they will say he represents nature under phases known only to himself." Benson then deftly turned that potential deficiency into an advantage: "It is one of Gifford's claims to distinction that his choice of subject is never common, and that he treats exceptional phases of nature. He does not paint the familiar and pastoral . . . he paints the great and beautiful."[9]

For anyone who admires Gifford's art, Benson's defense seems just. It is, however, framed as a traditional narrative of opposition—in this case, of those who, like Gifford, championed the great and the beautiful, versus those advocates of "truth to nature" whose subjects (and aesthetics) were potentially base and commonplace. For Benson, Gifford's art was evocative rather than descriptive, and poetic rather than literal, and thus had value far in excess of the slavish imitation he felt Cook and others advocated. Still, Benson could not in the end explain how Gifford's art achieved its effect; his review cited above clearly said as much. The best explanation is still that so eloquently articulated in 1880 by Gifford's friend and fellow painter John F. Weir (see fig. 1).

Weir wrote: "GIFFORD's art was poetic and reminiscent. It was not realistic in the formal sense."[10] That assessment may seem to suggest that Weir, like Benson, accepted that the reality of Gifford's art rendered "futile any new expression," but that is belied by his next sentence, surely the most beautifully apt that has ever been written about the painter. Gifford's art, according to Weir, "was nature passed through the alembic of a finely organized sensibility." An alembic is a vessel used for the distillation of raw materials into essences. Commonly associated with alchemy, the alembic was an agent of purification but also of intensification: Substances passed through it thus emerged transformed. In the same way, Gifford's paintings presented nature purified and intensified by the "finely organized sensibility" of his aesthetic. They did not attempt to replicate the experience of an actual place but, instead, transformed it into something else entirely: an "essence" of such experience, a pictorial extract containing all of its important qualities. If Weir's assessment, so evocative of the transmuting processes of artistic alchemy, does

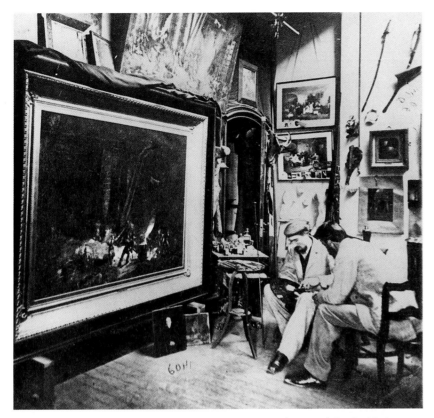

Figure 1. Photographer unknown. John Ferguson Weir and (probably) Sanford Robinson Gifford (right) in Weir's studio. Yale University Library, New Haven. John Ferguson Weir Papers, Manuscripts and Archives

come to the very heart of Gifford's aesthetic, then we must consider how he managed to develop such personal and special qualities as a landscape painter.

Gifford was born in 1823, contemporary with the artists who would make the American landscape school of the 1850s, 1860s, and 1870s one of the most creatively vital of the nineteenth century. With Thomas Cole's death in 1848, seniority in the Hudson River School literally lay with Asher B. Durand (b. 1796), but it was the younger generation that would introduce the most significant innovations and advancements over the following decades. The eldest of the group was John Frederick Kensett (b. 1816), but all of the key figures were within fifteen years of his age: Martin Johnson Heade (b. 1819), Thomas Worthington Whittredge (b. 1820), Jasper Francis Cropsey (b. 1823), George Inness (b. 1825), Frederic Edwin Church (b. 1826), Jervis McEntee (b. 1828), and Albert Bierstadt (b. 1830). The works of these men embraced a wide

variety of stylistic approaches and influences, and depicted many different geographical areas. Nevertheless, they were alike enough in their allegiances and methods (except for Heade, who was regarded as eccentric, and Inness, who was considered too infatuated with foreign art) for their contemporaries to deem them a "school." In spite of the differences between a work by Kensett and one by Church, these artists shared a consensus, loose though it may have been, as to what landscape painting aesthetically and intellectually should be about and for. Kensett might have pursued one end of the scale in his quiet marines (see fig. 2) and Church the opposite (see fig. 3), but their contemporaries, like later observers, managed to account for the differences as acceptable variations within an overall norm. With Gifford, as we have seen, it was more difficult; it was not that he did not belong with the others, for clearly he did. Rather, it seems, in some fundamental, even inexpressible way, he also created works that achieved something that those of his fellow artists did not.

Gifford's formative years laid the foundations for his particular characteristics as an artist.[11] He was alone among his contemporaries in actually having been born and raised in the very center of the Hudson River Valley (about which, see the essay by Kevin Avery, below), and the only one to have attended college (he was at Brown University in 1842–43). His family was sufficiently prosperous that he would never have any financial worries. This, in turn, left him free to pursue his art with little concern for the vagaries of popular taste. "Mr. Gifford," wrote an unidentified author about 1880, "having placed himself in a position of pecuniary independence, was not obliged to paint what are commonly known as 'pot boilers.'"[12] Moreover, his family supported (albeit with some initial reservations) and encouraged his artistic leanings. Gifford was close to his brother Charles: "My oldest brother had a taste for the Fine Arts; and one of the greatest pleasures of my boyhood was to look at and study the collection of engravings which covered the walls of his room."[13]

Still, Gifford's artistic training, minimal as it was, was not unusual for his era. Although he did not enjoy the honor and advantage of studying with Thomas Cole, as Church did, or have the opportunity to attend one of Europe's established academies, as Bierstadt did, he was not lacking in some formal instruction. In 1845, he went to New York to work with "John Rubens Smith [1775–1849], an accomplished drawing master," with whom he studied

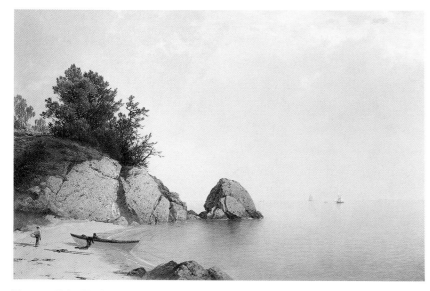

Figure 2. John Frederick Kensett. *The Beach at Beverly,* about 1869–72. Oil on canvas. National Gallery of Art, Washington, D.C. Gift of Frederick Sturges, Jr.

Figure 3. Frederic Edwin Church. *Twilight in the Wilderness,* 1860. Oil on canvas. The Cleveland Museum of Art, Mr. and Mrs. William Marlatt Fund

drawing, perspective, and anatomy.[14] Gifford also drew from casts after antique sculptures and from life at the National Academy of Design, and attended lectures on anatomy at the Crosby Street Medical College. According to S. G. W. Benjamin, this would be Gifford's only "regular art education. . . . He early visited the studios of Europe, it is true, and carefully looked at the methods of the foreign masters; but he followed none, conscious that, after one has learned certain principles and a technical knowledge of colors and drawing, he should then study nature with great love and fidelity, and try to represent it in his own way."[15]

At first, Gifford focused on portrait painting and figure studies, but in 1845–46 he turned his attention to landscape. As he recalled, "During the summer of 1846 I made several pedestrian tours in the Catskill Mts., and the Berkshire Hills, and made a good many sketches from nature. These studies, together with the great admiration I felt for the works of Cole, developed a strong interest in landscape art, and opened my eyes to a keener perception and more intelligent enjoyment of nature. Having once enjoyed the absolute freedom of the landscape artist's life, I was unable to return to portrait painting. From this time my direction in art was determined."[16]

Gifford's invocation of Cole was all but *de rigueur* for landscape painters of his generation (especially when cited in retrospect), but the older artist's influence may seem less obvious in his work than it is in that of Cropsey and of Church, to name Cole's closest followers.[17] Tuckerman, however, noted: "Few of our landscape-painters have been more directly influenced in their artistic development by the example of Cole, than Gifford."[18] In 1848, Gifford, like others in New York, had the opportunity to see the largest display of Cole's work ever assembled, the "Exhibition of the Paintings of the Late Thomas Cole" held at the American Art-Union.[19] We do not know with certainty that he attended—although it is hard to imagine that he did not— nor do we know which works might have particularly interested him. Nevertheless, it is easy to see that several might have drawn his attention. Paintings from Cole's maturity, such as *View from Mount Holyoke, Northampton, Massachusetts, after a Thunderstorm—The Oxbow* (fig. 110), *A View of the Mountain Pass Called the Notch of the White Mountains* (*Crawford Notch*) (fig. 4), and *The Hunter's Return* (fig. 5), surely would have powerfully suggested how rich American scenery could be in providing subject matter. Similarly, Cole's *Ruins of the Aqueducts in the Compagna di Roma* (1843; Wadsworth Atheneum,

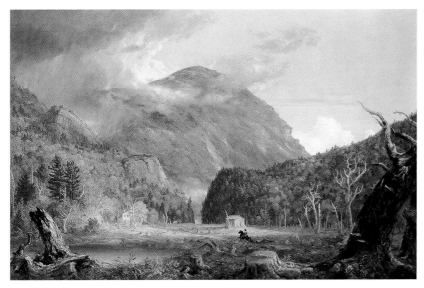

Figure 4. Thomas Cole. *A View of the Mountain Pass Called the Notch of the White Mountains* (*Crawford Notch*), 1839. Oil on canvas. National Gallery of Art, Washington, D.C. Andrew W. Mellon Fund

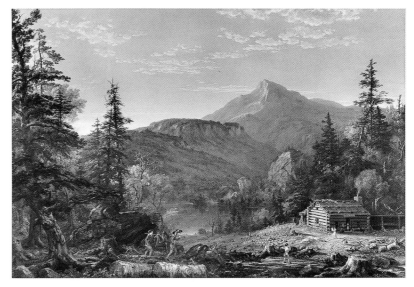

Figure 5. Thoms Cole. *The Hunter's Return,* 1845. Oil on canvas. Amon Carter Museum, Fort Worth

Museum of Art, Hartford) and *Ruins of Kenilworth Castle* (1847; Whereabouts unknown) may have inspired Gifford to visit those places and paint pictures of the same ruins (see fig. 41).[20] Perhaps *American Lake Scene* (1844; The Detroit Institute of Arts), one of Cole's most radiantly light-filled late works, also struck a resonant chord with Gifford.

Gifford's friend Worthington Whittredge seemed to discount the influence of Cole when he noted: "If I remember rightly he said in general terms that no historical or legendary interest attached to the landscape could help the landscape painter. . . . The dead, the ruined, the weak, did not interest him."[21] By this reckoning, Cole's vision of landscape, always animated by past, present, and future associations, would have held no appeal for Gifford. Still, there was much in Cole's art that did inspire him. When Gifford made his professional debut in 1847, exhibiting *Lake Scene, on the Catskill,* at the National Academy of Design and *View on the Kauterskill Creek* at the American Art-Union (both, Whereabouts unknown), the sites he depicted were indelibly associated in the public mind with Cole.[22] Two paintings, presumably intended as a pair and shown in 1848, *The Past* and *The Present,* suggest (from their titles) at least the general tenor of Cole's historicizing style and perhaps

the specific influence of his pendant pictures, *The Departure* and *The Return* (1837; Corcoran Gallery of Art, Washington, D.C.) and *Past* and *Present* (1838; Mead Art Museum, Amherst College, Amherst, Massachusetts).[23] Gifford's earliest known exhibition picture, *Solitude* (cat. no. 1), also reasonably has been compared with *Desolation*, the final painting in Cole's great five-part series "The Course of Empire" (completed in 1836; The New-York Historical Society).[24]

Early critical responses to Gifford's landscapes were limited. A writer for *The Literary World* in 1848 was "much pleased with the two or three small landscapes by Mr. Gifford. He is but a young artist. . . . He has evidently studied nature diligently, and though his pictures show timidity, yet they are impressed with truth."[25] In fact, little attention was paid to his work until the early 1850s. One of the first substantive discussions of his art appeared in a review of the National Academy exhibition of 1852 in *The Literary World*. The critic, after characterizing Cropsey as "influenced by [Cole] to too great a degree," and expressing qualified admiration for Kensett's *A Reminiscence of the White Mountains* (1852; Manoogian Collection), next considered Church the ascendant star of the American landscape school.

"Church is an artist of whom very much may be expected, if he will but apply himself to the disciplining of his faculties. Good pictures cannot be made without deep thought, and however great an artist's talent, he will never succeed in impressing himself entirely on his age without careful elaboration and application of those principles that are the foundation of art." Although concluding that Church could still with careful study "be one of the lights of our rising school," this critic deemed his handling "palpable, not subtle or studied, and the whole seems rather the result of natural feeling than close thought."[26]

Dismissing William W. Wotherspoon (1821–1888) and Inness as "men of considerable natural talent, ruined by false and affected methods," the writer then turned to Gifford:

We look to Gifford as one who will have a great influence on American landscape, when he shall have arrived at the full expression of his motives. His feeling for the higher qualities of landscape, space, light, and refinement of form, are more than indicated in his present works, and when he shall have overcome the feebleness of execution, which is always found with earnest, diffident feeling and high aim, he will express himself with the greater decision and correctness; and if he pursue the course of study which his own feeling must point out to him, he will certainly attain to high power. We have no young artist more sincere in his feeling, or less corrupted by erroneous ideas; but he must study detail, especially with reference to particular character, in his foliage and foreground objects.[27]

This critique, although it praised Gifford for seeking "the higher qualities of landscape," mistook his suppression of foreground detail for a fault, rather than for what was likely an attempt to maintain pictorial unity.[28]

In the same year, George William Curtis, writing in the *New-York Daily Tribune,* observed: "Mr. Gifford exhibits one of his dreamy summer landscapes [*Landscape*; Whereabouts unknown]. Stoddard sings exquisitely of a scene, 'Bathed in atmospheres of sleep,' and the line might well be the motto of many of Mr. Gifford's pictures . . . the feeling of the whole scene is sweet and poetic. Yet that dreamy haze is the atmosphere of

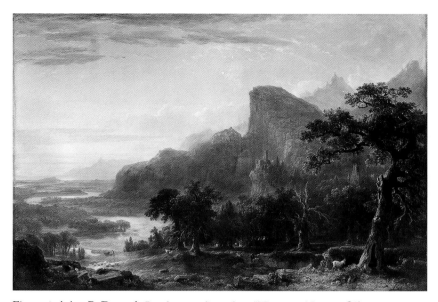

Figure 6. Asher B. Durand. *Landscape—Scene from "Thanatopsis",* 1850. Oil on canvas. The Metropolitan Museum of Art, New York. Gift of J. Pierpont Morgan, 1911

the Lotus, and may seduce the artist from a healthy sincerity."[29] Curtis (1824–1892) was among the most perceptive and informed observers writing about the New York art scene during the early 1850s. His time at the *Tribune* was brief and his exhibition reviews cover only the years 1851–52. His reflections were invariably insightful, for, unlike most of his fellow art critics, who generally simply described what they saw, Curtis always tried to look beyond the obvious in the paintings he reviewed. He sought deeper meaning and something more than just the veneer of truthfulness that so often satisfied others. Acquainted with Ralph Waldo Emerson (he spent two years in Emerson's community at Brook Farm in Massachusetts), Curtis also knew other key figures in the Transcendentalist movement, including Henry David Thoreau and Margaret Fuller. In 1846, he went to Europe, where he would remain for four years, and, while abroad, formed friendships with Kensett, Thomas Hicks, and the sculptor Thomas Crawford. He returned to America in 1850 and, after his two years at the *Tribune,* pursued his own literary ambitions; later in his career he contributed to *Putnam's Magazine* and served as the editor of *Harper's Weekly* (1863–69).

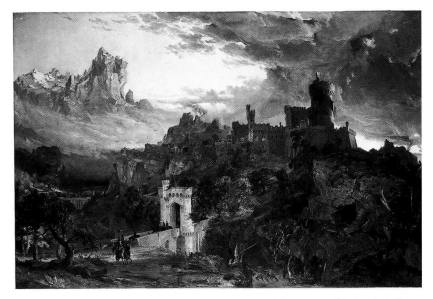

Figure 7. Jasper Francis Cropsey. *The Spirit of War,* 1851. Oil on canvas. National Gallery of Art, Washington, D.C. Avalon Fund

Curtis's tenure at the *Tribune* coincided with a period of considerable flux in the school of American landscape painting, with several artists creating dramatic allegorical and imaginary works that were clearly efforts at reviving Cole's "higher style of landscape."[30] Among the most prominent were Church's *Twilight, "Short aribiter 'twixt day and night"* (1850; fig. 75), Durand's *Landscape—Scene from "Thanatopsis"* (1850; fig. 6), Cropsey's *The Spirit of War* (fig. 7) and *The Spirit of Peace* (1851; Woodmere Art Museum, Philadelphia), Church's *The Deluge* (1851; Whereabouts unknown), and Durand's *God's Judgment on Gog* (1852; Chrysler Museum, Norfolk). In evaluating these works, Curtis's critical stance was essentially that of a literary figure, rather than an artistic one, and he was concerned primarily with how well an artist expressed the subject of his painting and how successful he was in evoking the appropriate mood or sentiment in the viewer.[31] He was unsparing in his criticism of works that he felt failed to achieve these ends; of Church's *The Deluge,* he wrote, "The artist here comes boldly in contrast with great names and without success . . . the present conception of the Deluge, without offering anything essentially new in the conception, is inadequate. . . . Is there anything in this work that would not occur to any tyro who proposed to paint the Deluge?"[32] His critique of Durand's *God's Judgment on Gog* the following year was even harsher, and sparked an acrimonious debate with the artist's friends and followers.[33]

Gifford was surely aware of these controversies and he must have counted himself fortunate not to have been subjected to such condemnation. If he had any inclination to take up the challenge of revitalizing Cole's historical/allegorical mode, these events without doubt would have served as a strong deterrent. Certainly, none of the works he exhibited at the National Academy and the Art-Union in 1850–52—such as *Scene in the Catskills* (cat. no. 2)—was obviously of that type (those that are unlocated can be judged only by their titles). Although Gifford may have felt that he had been lagging behind such painters as Cropsey and Church in securing a prominent position within the school, these events would have offered an opportunity to catch up by paying allegiance to the other side of Cole's art, which celebrated the wonders of American nature. In 1854, he debuted the most important pictures he had yet painted—a pair of large-scale oval canvases entitled *Morning in the Adirondacks* and *Sunset in the Shawangunk Mountains* (fig. 8, 9).[34] Also known as *Sunrise in the Adirondacks* and *Sunset in the Catskills*, these paintings, with their opposition of sunrise and sunset and depiction of familiar American scenery, referenced both Cole's imaginary pendants, such as *Past* and *Present,* and his portrayals of similar locales.[35] Cropsey, following Cole's example, had, in his wholly invented pictures *The Spirit of War* and *The Spirit of Peace,* located sunrise (in the former) and sunset (in the latter) in different areas of the globe and at widely separated moments in history. Gifford, however, localized the geography and brought the chronology into the present. One can easily imagine that the dawn that breaks in the swirling mists of the Adirondacks marks the beginning of the same day that ends more serenely in its pendant. The National Academy audience of 1854 would have recognized the dual homage to Cole: on the one hand, to his use of paired pictures to establish narrative possibilities and, on the other, to his fondness for the mountain scenery of the upper Hudson River Valley. Although judged "slightly monotonous in color" by one critic, they must have been well received by Gifford's fellow artists, for he was elected to full membership in the National Academy that May.[36]

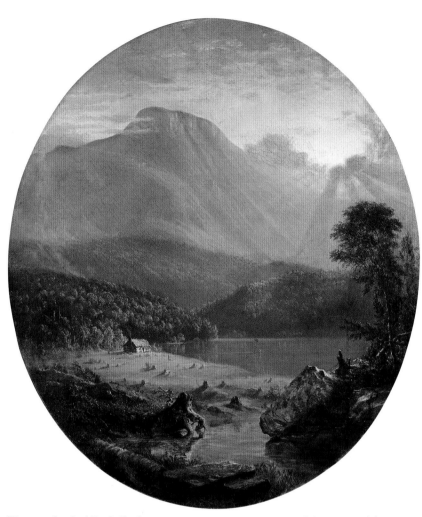

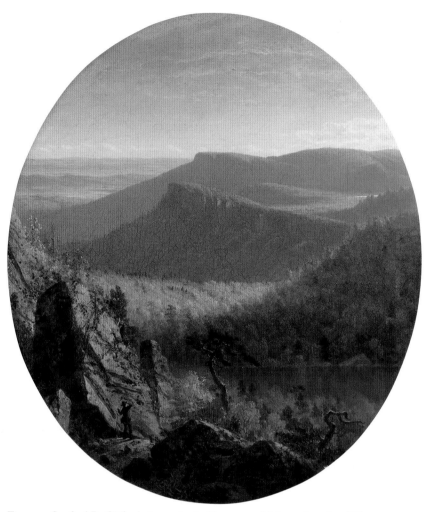

Figure 8. Sanford R. Gifford. *Morning in the Adirondacks,* 1854. Oil on canvas. The Warner Collection. Gulf States Paper Corporation, Tuscaloosa

Figure 9. Sanford R. Gifford. *Sunset in the Shawangunk Mountains,* 1854. Oil on canvas. The Warner Collection. Gulf States Paper Corporation, Tuscaloosa

The following year, Gifford sailed for Europe, where he would remain until late 1857. As a consequence of the detailed letters he wrote to his family, this period (together with his second European journey in 1868–69) is the most thoroughly documented part of his career.[37] While abroad he not only assimilated at firsthand the experience of famous natural landscapes but he also felt the aesthetic impact of painted landscapes by the Old Masters as well as by more recently active artists such as John Constable, J. M. W. Turner, and members of the French Barbizon school. Turner represented the greatest challenge, for Gifford found it difficult to reconcile John Ruskin's admiring analyses with the "shamefully careless" handling he saw in some of the artist's works.[38] Gradually, however, he began to appreciate the special qualities of Turner's art. On June 9, 1855, he finally saw what he deemed "some really fine Turners," *The Burning of the Houses of Lords and Commons, October 16, 1834* (fig. 38), and *Depositing of John Bellini's Three Pictures in la Chiesa Redentore, Venice* (1841; Private collection).[39] Gifford sent a note to *The Crayon* describing the experience:

Here I at last saw something of that magnificent light and color which Ruskin claims for his favorite master, and which I must say fully warrants his eloquent eulogies. "The Grand Canal" [sic] I take to be a good example of the best characteristic of Turner's later style. To give it fair play, it should be looked at from a little distance, and free rein given to the imagination. The whole picture is very light, and the effect gay and brilliant. It is indeed splendid in its bright mid-day sunlight, and in the gorgeous procession of the barges that advances down the canal, there is a varied brilliancy of color I have never seen equalled. In the forms there is great infinity as well as indefiniteness.[40]

After a visit to Ruskin himself that September, Gifford reached an understanding unequaled by most of his contemporaries in the American landscape school. Conversing with Ruskin, he admitted his unease with "the liberties" he felt Turner often took with reality. Ruskin countered that Turner "treated his subject as a poet, and not as a topographer; that he painted the *impression* the scene made upon his mind, rather than literal scenes."[41] As he matured as a landscape painter, that was precisely what Gifford himself would strive to do.

Gifford's letters indicate that he was receptive to the aesthetics of the Barbizon school and admired, as he wrote, its "poetic conception of the beauty of common things."[42] He made repeated visits to the Louvre, studying not just the great collections of paintings but the antiquities as well. He judged the Venus de Milo "the noblest female figure extant," and arranged to have a "half size copy . . . in plaster very accurately reduced," shipped home (it is visible in an illustration of his studio: see fig. 10).[43] Almost immediately upon arriving in Paris he visited the Exposition Universelle, a massive display of international achievements in industry and culture inspired by the first of such fairs, London's Great Exhibition of the Works of Industry of All Nations, held in the Crystal Palace in 1851. He looked carefully at the contributions of the English school, especially those by the Pre-Raphaelites, with which he found particular fault. Of John Everett Millais's *Ophelia* (1851–52; Tate Britain, London) he noted, "Like the first works of all young artists whose aim is absolute truth, it is crude in color, hard in lines, and wanting in atmosphere."[44] Conversely, he particularly admired the contemporary French landscape

paintings, in which he found that "everything like finish and elaboration of detail is sacrificed to the unity of effect."

Gifford sent a letter signed "G" to *The Crayon* discussing the "Exhibition of Fine Arts in Paris."[45] Noting that there were close to "six thousand works of Art in Painting, Sculpture, Architecture, and Engraving . . . from various countries," he lamented that the United States was not better represented. After stating that it was not his "purpose to write an essay upon the different schools or styles of Art to be found at the Exposition," he then set out the basics of his own aesthetic. "First, then (for myself), I like a work of Art if I like the subject. Secondly, I like it if the subject is well treated. Sometimes a good subject is badly treated, or the reverse. . . . Unity is the great necessity; whatever the work may be, let us have unity, consistency, harmony." He then discussed three works with the "necessary element of *Unity*; works whose

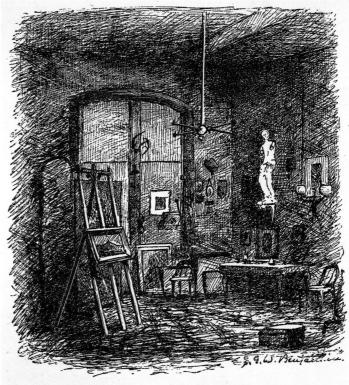

MR. S. R. GIFFORD'S STUDIO.

Figure 10. Artist unknown. *Mr. S. R. Gifford's Studio.* Engraving. From S. G. W. Benjamin, *Our American Artists* (Boston: 1879)

various parts are all kept in subordination to the leading idea." These were Thomas Couture's *Les Romains de la décadence* (1847; Musée d'Orsay, Paris), Charles-Louis Muller's *L'Appel des dernières victimes de la Terreur* (1850; originally in the Musée du Luxembourg, Paris, and currently displayed at the Musée de la Révolution Française, Vizille; another version of this painting was owned by John Jacob Astor in New York), and Léon Benouville's *Saint François d'Assise, transporté mourant à Sainte-Marie-des-Anges, bénit la ville d'Assise* (fig. 11) of 1853. Gifford concluded with a comparison of the French and English schools. "No work," he wrote, "could afford a stronger contrast to what is called the Pre-Raphaelite school than this work of Benonville [*sic*]. In my humble opinion, it would furnish serious food for reflection to the admirers of that school. It would teach that now, as ever, serious subjects should be largely treated, and that the attention should not be diverted to details, if the feelings are to be appealed to. Subordination is the great law of Art, as well as of Nature, and the moment that balance of parts is lost, unity is destroyed." Gifford could just as well have been describing his own mature style, which would appear almost fully formed in 1857 with *Lake Nemi* (cat. no. 6). He had already made his commitment to precisely what Clarence Cook would decry some years later, "that a something called Beauty is the end, and not Truth."

Following his return to America in September 1857, Gifford set up quarters in the new Tenth Street Studio Building in New York—"an experiment, intended to provide studios for artists, accompanied with an exhibition-room."[46]

He was now situated in the veritable center of the American landscape school.[47] By the end of 1858 the building was filled; joining Gifford were Church, John Casilear, Kensett, William Hart, and Jervis McEntee (who became a close friend), followed by Bierstadt and Whittredge in 1861. Gifford reintroduced his work to the New York art world by submitting eight pictures to the 1858 National Academy exhibition. The most important was the large *Lake Nemi* (cat. no. 6), which, even though generally admired, was considered by one writer "'Turneresque' almost to the point of plagiarism."[48] The following year, he unveiled his first true masterpiece of American scenery, *Mansfield Mountain* (cat. no. 8). Shown initially at the National Academy, the painting subsequently was on view at the Boston Athenaeum. Writing about that summer exhibition, one critic observed: "Those who cannot get away from business to see nature among the mountains or by the sea, cannot do better than to visit the Athenaeum gallery and behold nature in art. . . . Among those [paintings] which are new, are several by Gifford, the most poetical of our American artists, whose pictures are like poet's dreams. His paintings have a light shade and coloring peculiar to themselves, and they are his children bearing the impress of his genius. There is soul [*sic*] beauty about them."[49] Comparing the slopes of Mansfield to "the Chinese wall, sharp, steep, angular, almost as if laid by human hands," this writer concluded, "It is as if we stood there inhaling the freshening breeze. It is an ascent of Mansfield without the aching brows, the sweating brain."

In 1860, Gifford exhibited a sequel to his *Mansfield Mountain*, the equally

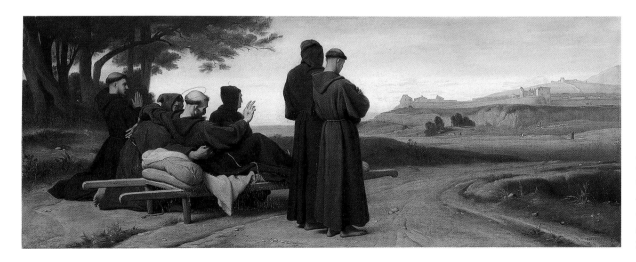

Figure 11. Léon Benouville. *Saint François d'Assise, transporté mourant à Sainte-Marie-des-Anges, bénit la ville d'Assise (The Dying Saint Francis of Assisi Carried to Santa Maria degli Angeli, Blessing the Town of Assisi)*. Oil on canvas, 1853. Réunion des Musées Nationaux, Paris

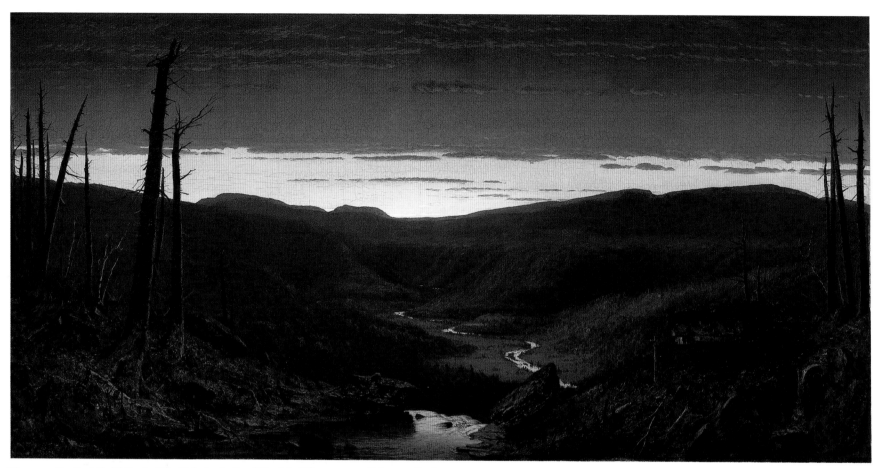

Figure 12. Sanford R. Gifford. *A Twilight in the Catskills*, 1861. Oil on canvas. Private collection

radiant but very differently conceived *The Wilderness* (cat. no. 12). Now well on his way to establishing a place in the mainstream of American landscape painting, he suddenly changed direction the following year, after apparently taking exception to certain observations about his work. According to one report, having "heard that somebody had said that he could not paint anything but warmth, the charge so nettled him that he immediately prepared to astonish some of his admirers by producing the impressive exposition entitled '*Kauterskill Clove, Twilight*'."[50] Only with the recent rediscovery of that painting, now called *A Twilight in the Catskills* (fig. 12), can we appreciate just how radical a departure this was for Gifford.[51] Critics were nothing less than astonished. The *New-York Times* deemed it the "landscape attraction of the present exhibition beyond question." The writer continued, "It is in this Debatable Land, between ability with self-consciousness and ability without it, that the sphere of sentiment in Art lies, and it is in this land that GIFFORD is peculiarly at home. Golden haze, aerial sheen, rich mists and dreams of 'cloud-land, gorgeous-land,' fall like dim curtains over his forest and fields, the whole abounding far more in poetic feeling than in developed thought. Thus far Mr. GIFFORD has culminated in this picture—but we anticipate from him other works in which he will grapple with more difficult problems of color, and be less indebted to startling or peculiar phenomena, however congenial, to aid him."[52]

For a writer in *Harper's Weekly*, who also considered the painting the "most important landscape in the Exhibition," it recalled those of another artist:

"The picture undeniably reminds you of some earlier works by Church, in which the same general effect was represented; but that is only a resemblance of subject."[53] The comparison was obviously to Church's series of resplendent sunsets of the 1850s, which climaxed in *Twilight in the Wilderness* (fig. 3), and one can easily appreciate both the similarities and differences. Eugene Benson, writing in the *New-York Commercial Advertiser,* observed: "Church, Kensett, and Gifford, are a trio, illustrating dissimilar aspects of nature, and each alike true to their subject, but as different in spirit and style as Claude, Salvator Rosa, and Pousan [*sic*]. The spirit of Church's pictures is high and self-sustained; they show a fondness for broad sweeping plains and towering mountains, in a word for the *extent* and complexity of natural scenery. Kensett, on the other hand, seems to be in love with the simplest and most ordinary aspects of nature, and dwells with a loving spirit in forest nooks or sylvan retreats, and wanders along our seacoasts drinking the melody of their sound while he reproduces the beauty of their forms. The sentiment of his pictures is serene and poetic, reminding us of Bryant's descriptions of scenery; they are full of repose. Gifford, in opposition to both of the former, is *intense* in spirit. He seems to have more *depth* of feeling."[54]

Even at this early date, Benson was struggling to explain Gifford's art. His article began by observing: "The personality of a man is the most sacred thing about him. It is the direct expression of his soul." However, he went on to say, "what has all this to do with S. R. Gifford? We will explain! The subject of our notice is not less remarkable in his person than in his works. He recalls to us Motley's descriptions of the Spanish grandee."[55] Going on to say that "the man's works are, to a great extent, the supplement to his character," Benson then turned his attention to Gifford's paintings, which he considered "among the great achievements of artistic power." He continued: "The first and most striking characteristic is a love of *sunshine*—sunshine tempered by the thick hazy atmosphere of Indian Summer. Most of his paintings are representations of afternoon effects, and would seem to indicate that the artist had imprisoned the very essence of Italian Summer, and fastened it forever in his nature. There is a feeling about them as of opium—of a day just this side of the Orient. They are American in character; Oriental in feeling." The "better illustration," Benson felt, was "that they seem to represent the . . . land described in Tennyson's Lotus Eaters,—'a land where all things seemed the same.'" He then quoted from the poem:

A land of streams! some like a downward smoke,
Slow-dropping veils of thinnest lawn, did go;
And some through wavering lights and shadows broke;
Rolling a slumberous sheet of foam below.

And again, a land where—

The charmed sunset lingered low adown
In the red West: through mountain clefts the dale
Was seen far inland, and the yellow down
Bordered with palm, and many a winding vale
And meadow . . .[56]

Tennyson's poem was inspired by the account in Book IX of Homer's *Odyssey,* wherein Odysseus and his men were blown to the land of the Lotus-eaters, who existed on the flowers of the lotus, an opium-like drug that made men apathetic.[57] That Benson would draw an analogy between Gifford's paintings and opium, and Tennyson's poem in particular, was perhaps risky, for his contemporaries would have been severely critical of drug use and of the indolence and apathy that accompanied it. He made sure, however, to disassociate "the external character" of Gifford's pictures from "the external aspect of his person." Concluding that Gifford was a "presence of no ordinary power, and . . . of no commonplace thought," Benson ended by opining that the artist would continue to grow and advance in his art so that, "like Titian, his last works shall show the fulfilment [*sic*] of the promise of his youth."

Despite having demonstrated in *A Twilight in the Catskills* his ability to extract the maximum emotional value from the subject of the American landscape at twilight, Gifford "did not pursue the new course long."[58] From this point on, he would work to refine and expand the style of tonalist painting he had earlier pursued in *Lake Nemi, Mansfield Mountain,* and *The Wilderness.* If his art never again attempted a level of drama comparable to that found in *A Twilight in the Catskills,* it nevertheless gained immeasurably from his ongoing explorations of the formal possibilities of the more suggestively expressive

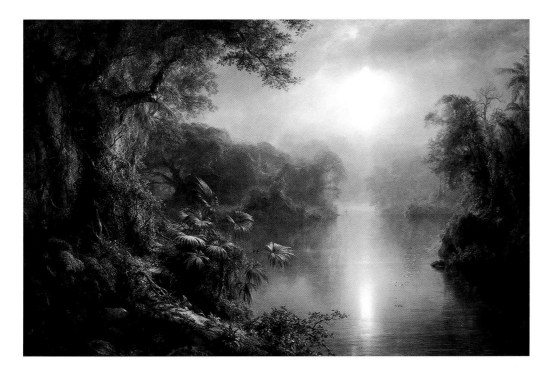

Figure 13. Frederic Edwin Church. *Morning in the Tropics,* 1877. Oil on canvas. National Gallery of Art, Washington, D.C. Gift of the Avalon Foundation

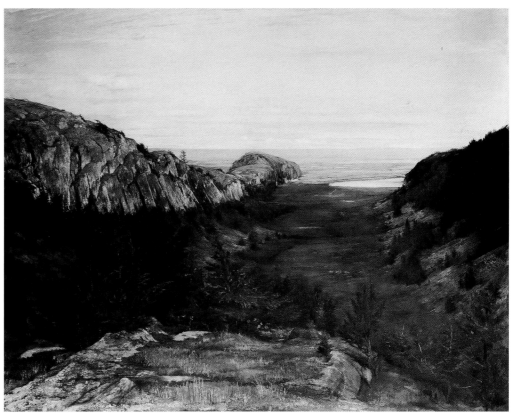

Figure 14. John La Farge. *The Last Valley—Paradise Rocks,* 1867–68. Oil on canvas. National Gallery of Art, Washington, D.C. Gaillard F. Ravenel and Frances P. Smyth-Ravenel Fund

evocation of the experience of place and sensation that would be the hallmark of his mature art.

During the 1860s, Gifford perfected his richly emotive style of landscape. As one observer wrote of *A Twilight in the Adirondacks* (see cat. nos. 37, 38) in 1864: "It is meant for those who have loved and seen nature through their own eyes and not through pictures. Mr. Gifford's picture is a wonderful realization of what is most transient and beautiful in the world. . . . He has fixed the fleeting; he has made permanent what is most transient."[59] However, criticism of his "mannerisms" was becoming increasingly common: "We should really like to know," demanded a critic in the *New-York Daily Tribune*, "whether Mr. Gifford is ever going to show us Nature under any other aspect than this one of vaporous obscurity."[60]

Following the upheavals of the Civil War, the American landscape school began to fragment.[61] "This entire school of landscape-painters," observed one writer in 1877, was "the product of the public taste as it existed before the war. The public mind was in greater repose, less cosmopolitan."[62] No longer unified in their belief that landscapes could serve as visual metaphors for national unity and well-being, the various painters began seeking different artistic goals and strategies. Kensett pursued an increasingly pared-down aesthetic that had little relevance for others; Heade persisted in going his own way; Cropsey became ever more enamored of autumnal scenes, which he would continue to paint for the rest of his life; Bierstadt specialized in scenes of the American West, which he vigorously marketed to wealthy businessmen; and Church more and more devoted himself to his family and to the construction of Olana, his grand estate on the banks of the Hudson. On the rare occasions Church did essay important large-scale paintings after 1870, such as *Morning in the Tropics* (fig. 13), his pictorial language was more restrained and suggestive than it had been earlier in his career. A few artists who were never associated with the school—most notably John La Farge (see fig. 14)—drew attention, and some acclaim, as early as the mid-1860s with works that deliberately eschewed the compositional and stylistic methods of the older generation. Although Gifford's friends Whittredge and McEntee remained faithful to the prewar aesthetics of the school for a time, they, too, would eventually move on to more painterly and suggestive modes.

In his 1879 article on Gifford, S. G. W. Benjamin reiterated that his art did not suffer from the shortcomings that contributed to the demise of the Hudson River School:

If there has been a fault in this school of American landscape art, it has been, perhaps, in endeavoring to get too much in a picture, in trying to be too literal; so that the great attention given to the details has excited wonder rather than stimulated the imagination, and has marred the impression of general effect which should be the chief idea in a work of art. For the materials an artist has at his command are, at best, so weak compared with nature, which is ever toned and harmonized by the atmosphere, that it is very easy to lose sight of the leading idea of the painting.

Our later artists, as I have explained in previous papers, are painting in a broader style. Mr. Kensett, although in most respects belonging to the old school of American landscape art, treated his subjects more broadly than many, and the same may be said of Mr. Sandford [sic] R. Gifford. The main effect in his works is atmospheric. None have surpassed him in rendering the splendor of sunset skies, and the tender sheen of light reflected on still water.[63]

One need only compare Benjamin's words with those written by Gifford himself almost twenty-five years earlier in his 1855 letter from Paris to *The Crayon* to see how closely they follow the artist's own views.

Having never fully embraced the pictorially descriptive and morally didactic stance typical of the Hudson River School painters during the 1850s, Gifford did not need to reform his art to suit the changing climate of taste. Appreciation and understanding of his art grew markedly in the postwar period. Writing in 1866, a critic, after comparing the effects of a beautiful painting to "a light, smiling, gentlemanlike intoxication," noted of the newly finished *A Home in the Wilderness* (cat. no. 40) that it could be:

briefly described but not easily expressed. . . . If we could command the mellowest and most lucid words, and make sentences luminous, and, in movement, placid as the swell of the summer sea, we might express the

largeness, the calm, the harmony, and the soft radiance of Gifford's "Home in the Wilderness." Fancy living in a room with such a picture! Thackeray was appalled at the idea of living in a room with the formal and rigid pictures of David, in which the fixed and staring heroes of antiquity pose in heroic mood, and glare like lay figures. . . . Facing Gifford's picture we feel sorry that we cannot live in the room with it. It is so beautiful that even to look at it makes you grateful.[64]

As this evaluation makes clear, the warm, sensuous appeal of Gifford's art played to emotions that contrasted starkly with the cool intellectualism of the Neoclassical—or, as another writer observed, with regard to *Hunter Mountain, Twilight* (cat. no. 41):

> [*It*] *revealed . . . how well he is penetrated with the spirit of his subject, how completely he gives himself to nature and makes his art merely a lucid medium of expression. But in art Gifford is not what we call a man of ideas. He is a man who receives impressions and who takes hold of the leading traits of nature. He is too much of a painter, too perfect an artist, to be a man of ideas; men of ideas always give us less perfect art, are content with suggestions and show greatness with fragments; but Gifford is an artist, he exacts completeness and is disturbed by a faulty or half-communicated story.*[65]

Similarly admiring evaluations would greet Gifford's art for the rest of his career. Although the occasional criticisms continued—"We are led to ask why the fog [in his pictures] never lifts," wrote one visitor to the Centennial Exposition—far more common was praise for his "imagination in art."[66] Among the most notable accounts of Gifford and his art during the final years of his life—and, indeed, one of the most interesting analyses of his work ever attempted—was George William Sheldon's "How One Landscape-Painter Paints," published in *The Art Journal* in 1877.[67] Invoking the by-then-familiar difficulty in giving verbal expression to visual sensations, Sheldon went on to describe Gifford's approach, both intellectual and physical, to painting. Given Sheldon's occasional use of direct quotations and paraphrases, it is likely that the discussion was sanctioned by the artist himself.[68] According to Sheldon,

Gifford's first question was, "What causes all this Beauty?" In order to provide an answer and reproduce such beauty on canvas, the artist had to understand "the means which Nature has used. . . . With Mr. Gifford landscape-painting is air-painting; and his endeavor is to imitate the colour of the air, to use the oppositions of light and dark and colour that he sees before him. If the forms are represented as they are in Nature under atmospheric conditions of light, dark, and colour, these forms will look as they look in Nature, and will produce the same effect."

Sheldon traced the artist's working methods, starting with his quick recording of "anything which vividly impresses him, and which he therefore wishes to reproduce," in a small pencil sketch. While these rapid sketches did not "seem to amount to much," they were sufficient to help Gifford "keep clear in his memory the scenes that have impressed him, even though he should delay further work for months or for years." Once he was ready to take up a particular subject, the artist next produced an oil sketch that served "the purpose of defining to him just what he wants to do," while also helping him "to decide what he does not want to do."[69] Such a sketch allowed for experimentation and, after Gifford was satisfied, it would function as "a model in miniature" for the larger painting to come.

As related by Sheldon—although at this point he seems to veer toward a highly romanticized view of the artist as working with a trance-like fervor—Gifford would spend as much as twelve hours at a time on a picture, beginning to paint right after sunrise and continuing until just before sunset. His first act would be to stain the white canvas with "a solution of turpentine and burnt sienna" so that the colors he would subsequently apply would not appear too brilliant. He would then draw with a "white-chalk crayon . . . the picture he expects to paint."[70] After arranging the colors on his palette, Gifford would commence painting "the horizon of the sky," which would serve as "the keynote of the picture—that is to say, it governs the impression, determining whether the impression shall be gay or grave, lively or severe." After the painting was produced, the artist would slowly begin "the work of criticism, of correction, of completion"; he liked "to keep [a] picture in his studio as long as possible."[71] Gifford's final act was to varnish "the finished picture so many times with boiled oil, or some other semi-transparent or translucent substance,

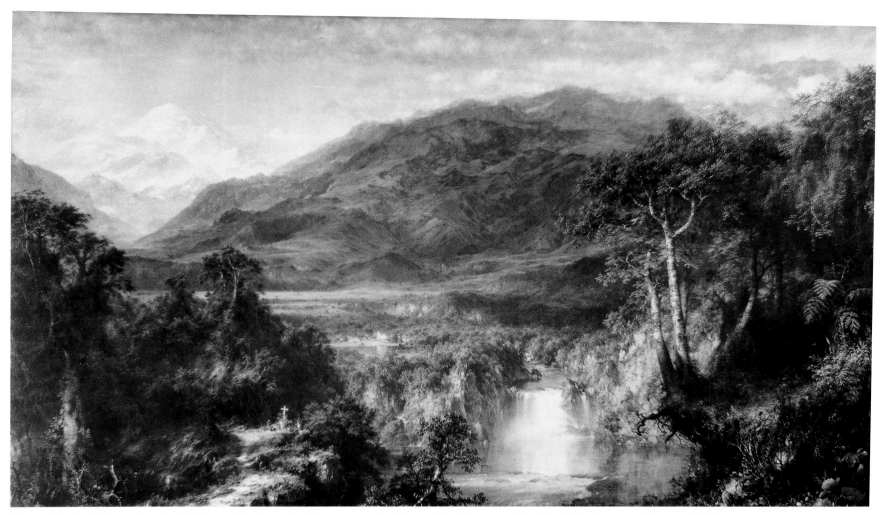

Figure 15. Frederic Edwin Church. *The Heart of the Andes,* 1859. Oil on canvas. The Metropolitan Museum of Art, New York. Bequest of Margaret E. Dows, 1909

that a veil [was] made between the canvas and the spectator's eye—a veil which corresponds to the natural veil of the atmosphere."[72] The result was that viewers would look through this "veil" and see light "reflected and refracted just as it is through the atmosphere—reflections and refractions which, though unseen, are nevertheless felt. The surface of the picture, therefore, ceases to be opaque; it becomes transparent, and we look through it upon and into the scene beyond."

If we consider the aggregate of critical response to Gifford's work over his career, along with the ideas about art that credibly may be attributed to him—and with an appreciation of how his pictures continue to function visually—

it is easy to see why his contemporaries found it so challenging to explain him. It was not that they were deficient in some way; as we have seen, many of them wrote eloquently and elegantly of the effect that his works had on them. Rather, it was that seeing his paintings set into motion visual experiences that were unique, and that could not be re-created as verbal narratives. That was no easier than it would be to reproduce in words the effect of hearing music or poetry. Eugene Benson saw this perfectly when he wrote, "One might be moved to say many fine words, but they would be words and not the picture: the picture is complete, and in art an accomplished fact, and it renders futile any new expression."[73] Gifford himself made a synesthetic observation about

the experience of viewing one of Michelangelo's famous *Slave*s in the Louvre: "In this, as in all the works of Michelangelo that I have seen, the action is such as does not permit a definite interpretation. It speaks to the imagination, not to the intellect. And this is the secret of its power. The imagination conjures up a hundred different solutions, and accepts them all rather than any single one. A work of this kind affects me in the same way as the finest music, and is in the same way beyond the range of physical interpretation."[74]

As early as 1852, Gifford's art was seen as evoking "that dreamy haze that is the atmosphere of the Lotus"; the association was made again by Eugene Benson in 1861 and by yet another writer in 1872.[75] Implicit in such evaluations was that to contemplate Gifford's paintings was not in any sense to experience a re-creation of reality but to encounter something else, something inherently more attuned to the emotions and the senses than to the intellect. Paintings that emphasized detail at the expense of pictorial unity might provide an approximation of what specific places *looked* like, but they could not capture the sense of *seeing* and of *feeling* that would occur with actually being physically present in those places. Perhaps that is why Tuckerman wrote that Gifford's "best pictures can be not merely seen, but *contemplated* with entire satisfaction." A painting such as Frederic Church's *The Heart of the Andes* (fig. 15) may have succeeded to an unprecedented degree in allowing viewers to see both the breadth and the detail of a faraway part of the world, but it did so through description rather than evocation. Nor could Cole's use of "historical or legendary interest" help achieve what Gifford sought, for such associations would divert viewers' thoughts to narratives that might be rich in meaning and moral content but that were not necessarily part of the actual experience of place. Very early in his career, Gifford had understood, as he said, that "serious subjects should be largely treated . . . if the feelings are to be appealed to."[76] This was evident in his assessment of the French paintings he praised in 1855 for their "unity," in which "various parts are all kept in subordination to the leading idea" so attention was not "diverted to details." It was precisely this superiority of the general over the specific that led him to admire the Venus de Milo as the "noblest female figure extant." Its nobility lay not in its detailing of the specific, nor in its referencing of the historical, but in its perfect synthesis of all that made up the beauty of the female form. In this way,

the minor and the trivial were not allowed to interfere with what was most important. Gifford's discussion of Turner's art with Ruskin had helped him understand that the artist's approach was "as a poet, not as a topographer," and that his most important goal was to express the "impression the scene made upon his mind rather than literal scenes."

As Sheldon observed, a poet might convey such impressions in words, but if they were beyond the "grasp of words," it was up to the painter "to reproduce them." That is why Gifford could be praised for being "too much of a painter, too perfect an artist, to be a man of ideas; men of ideas always give us less perfect art."[77] Or, as another admirer of Gifford's works noted when contemplating one of his pictures of the Palisades at sunset (see fig. 159): "Just here is seen an advantage which the painter has over the poet. Each would feel as keenly the effect of such beauty, but words could not reproduce that effect. What is needed is not a master of language, but a master of color."[78] If Gifford's paintings managed to achieve through visual means that which defied verbal description, how did they succeed in doing so? His paintings were not, according to contemporary evaluations, "copies of nature."[79] He did not "paint nature as he saw it, and in all probability never essayed to do so. To him a 'picture' . . . was a transfiguration after some receipt perfectly known to him, rather than a selection and arrangement of natural material."[80] Gifford's art was "not the mere statement of fact, but a lucid reminiscence, a passional [*sic*] rendering of Nature in such a way as to kindle the emotions and address the imagination."[81] He saw, and painted, "those potent truths that underlie the superficial aspects that engage the common mind or attract the common eye."[82]

Gifford's paintings, then, did not copy nature, were not mere statements of fact, and did not depend on connections to the historic and legendary. Instead, they were addressed to the emotions and the imagination. They engaged viewers in an exercise of seeing that was not interrupted by any distractions, whether associations or specific details. In this way, the act of viewing the picture became a self-contained one, removing the observer from everything but the actuality of the present. We experience the present only for the indeterminate moment before it recedes into the past and gives way to the future, suspended between retrospection and expectation. Gifford's paintings thus did something that the works of most of his contemporaries could not. Like those

of George Inness, they were not meant to evoke other places or other ideas but to assert their own reality as works of art (as we have seen, Benson already had linked the two artists in 1866).[83] Their paintings were not windows to some other world or time but rather had to be enjoyed for what they were. Seeing a painting by Gifford was thus an experience complete in itself.

By all accounts, Gifford was well loved by those who knew him. He was described as quiet and gentlemanly, highly intelligent, but modest and even shy, generous and friendly, but also something of a loner. According to his friend Whittredge, he "was fond of flowers . . . [and] fond of reading . . . affectionate, even tender in his disposition."[84] Yet, he was also capable of leaving on an extended trip abroad with nothing but a small bag and without telling his friends his exact plans, reappearing two years later with only the same bag and going "to his studio as if nothing had happened."[85] In 1877, shortly before turning fifty-four, he secretly married Mary Canfield, "the widow of an old friend and school mate."[86] He kept their union hidden from even his closest friends for months. One need not resort to psychobiography to glean from such observations that Gifford's personality was complex and complicated. Moreover, it is known that he suffered from depression. Although Gifford "loved the light," he was also sometimes in the "cavernous depths of shade."[87] Whatever else we may try to understand of his character, there can be no doubt that he was capable of intense feelings. "In order to create," observed Weir, "the poet and the artist must feel more intensely than is common."[88] He also believed art should attempt to express the power of such emotions, and that to do so required the artist to serve, through his paintings, as an interpreter—"to communicate to others, by means of art, in a form at once beautiful and poetic, the emotional experience of a firm sensibility looking calmly upon nature."[89] In the end, however, it cannot be an analysis of the man that explains his art, but rather the obverse. We can, indeed, best appreciate Gifford precisely as his friend Weir advised: "If we could look upon [his] pictures in silence . . . we should form a better estimate of the man than by hearing even the best that may be said of him."[90] It is impossible to imagine a more fitting epitaph.

1. Sheldon 1877, p. 284. In this essay I have drawn on the fine work of others who, in recent years, have tried to understand the unique nature of Gifford's art. In particular, I am indebted to Ila Weiss (1968/1977 and 1987) and Nicolai Cikovsky, Jr. (1970). I have also profited from the observations of Angela Miller (1993, pp. 243–88), and from discussions with Heidi Applegate and Adam Greenhalgh. My own attempts to account for Gifford's special qualities as a landscape painter—should they seem to contradict or diverge from the findings of these scholars—must be understood as alternative readings only and not assertions of any final, unassailable conclusions.

2. Weir 1880, p. 20. Extracts from Weir's address were published in the *Memorial Catalogue*, pp. 7–11.

3. Weir 1880, p. 22.

4. Tuckerman 1966, p. 524.

5. Benson 1866b. Here, Benson used the *nom de plume* "Sordello"; he also wrote for the *New-York Commercial Advertiser* under the name "Proteus."

6. Benson 1866a.

7. For a discussion of Benson and his writings on art see Nicolai Cikovsky, Jr., "The School of War," in Cikovsky and Kelly et al. 1995, pp. 26–34. On the American followers of Ruskin see Ferber and Gerdts 1985.

8. Cook 1864a.

9. Benson 1866a.

10. Weir 1880, p. 20.

11. See the discussions in Weiss 1968/1977, pp. 6–16; Cikovsky 1970, pp. 8–9; Weiss 1987, pp. 46–68.

12. Unidentified clipping, Library, Smithsonian American Art Museum, Washington, D.C.

13. Gifford, Frothingham Letter, manuscript, Archives of American Art.

14. Ibid.

15. Benjamin 1879, p. 307.

16. Gifford, Frothingham Letter, manuscript, Archives of American Art. Although Gifford gave the date as 1846, the first work listed in the *Memorial Catalogue*, on page 13, is "Kauterskill Lake. Dated 1845."

17. In an essay about Cole's influence on younger painters, J. Gray Sweeney, following earlier observations in Cikovsky 1970, illustrated only one work by Gifford, *Solitude* of 1848 (cat. no. 1), which he tentatively proposed as a memorial to Cole; he also mentioned *The Past* and *The Present*; see J. Gray Sweeney, "The Advantages of Genius and Virtue: Thomas Cole's Influence, 1848–58," in Truettner and Wallach, eds. 1994, pp. 112–35.

18. Tuckerman 1966, p. 526.

19. Over eighty works were shown at the American Art-Union, and additional pictures, including "The Course of Empire" series, were on view at the New-York Gallery of the Fine Arts.

20. For example, *The Roman Campagna* (1859; The Frances Lehman Loeb Art Center, Vassar College, Poughkeepsie, New York) and *Kenilworth Castle* (1858; fig. 41).

21. "Address by W. Whittredge," in *Memorial Meeting*, pp. 35–36.

22. Gifford's public debut as an artist came slightly later than it did for others of his generation; Cropsey began exhibiting at the National Academy in 1843, Inness in 1844, Church in 1845, and Whittredge in 1846.

23. The two were not, however, shown together (the former was exhibited at the National Academy, the latter at the American Art-Union); today, the whereabouts of both are unknown.

24. Cikovsky 1970, p. 13.

25. "The Fine Arts: National Academy Exhibition," *The Literary World,* May 20, 1848, p. 310; Weiss 1987, p. 65, suggests that this review may have been the result of Gifford's friendship with Evert Duyckinck, the *Literary World*'s co-owner and editor. However, similar reviews are found in the *Morning Courier and New York Enquirer.*

26. *The Literary World,* May 8, 1852, p. 332.

27. Ibid.

28. The only work the critic specifically addressed was No. 345, *A View on the Hudson* (Whereabouts unknown), which he considered "a most excellent picture, having nothing in its way to ask for."

29. [George William Curtis], "The Fine Arts. Exhibition of the National Academy. VII," *New-York Daily Tribune,* June 7, 1852, p. 5. Richard Henry Stoddard (1825–1903) was a member of a circle of authors and artists in New York that included Gifford; see Weiss 1987, pp. 21–45. The quotation is from Stoddard's poem "The South" (1851): "And dim the gulfs, and gorges blue, / With all the wooded passes deep; / All steeped in haze, and washed in dew, / And bathed in atmospheres of Sleep."

30. For a discussion of these developments see Kelly 1988, pp. 26–42; Sweeney, "The Advantages of Genius and Virtue," in Truettner and Wallach, eds. 1994, pp. 116–26.

31. See John P. Simoni, "Art Critics and Criticism in Nineteenth Century America," Ph.D. diss., Ohio State University, 1952, p. 21.

32. G[eorge]. W[illiam]. C[urtis]., "The Fine Arts. The National Academy of Design. III," *New-York Daily Tribune,* May 10, 1851, p. 5.

33. [George William Curtis], "Fine Arts. Exhibition of the National Academy. V," *New-York Daily Tribune,* May 20, 1852, pp. 5–6. Among those who came to Durand's defense was the sculptor Horatio Greenough: He himself had experienced the sting of critical and popular condemnation when his monumental *George Washington* (Smithsonian American Art Museum, Washington, D.C.) had been unveiled in 1840; for details of the incident and reprints of the correspondence between the two camps see John Durand, *The Life and Times of A. B. Durand* (New York: Charles Scribner's Sons, 1894), pp. 174–75, 218–22; Simoni, "Art Critics," pp. 18–21.

34. On these, see Franklin Kelly, "American Landscape Pairs of the 1850's," *Antiques* 146, no. 5 (November 1994), pp. 653–54. Both were owned by "Wm. H. Ames," as were Gifford's two other exhibited pictures, *The River Bank* (no. 160) and *The Juniata* (no. 165), but their whereabouts are unknown today. These were apparently the pictures listed in the *Memorial Catalogue* as numbers 51 and 52, respectively: *The River-Bank* and *Autumn;* both were dated 1854, measured 12 x 16 inches (oval), were owned by Miss Isabel M. Ames; and were likely also a pair.

35. For example, *Memorial Catalogue,* numbers 54, 55. The Shawangunks, at the southern end of the Catskill range (see cat. no. 36), are usually referred to by that name; they are, however, part of the same chain of mountains, which undoubtedly explains the change in title given in the *Memorial Catalogue.*

36. "The Fine Arts. Exhibition of the National Academy. (Second Article)," *New-York Daily Tribune,* April 22, 1854, p. 6.

37. See Heidi Applegate's essay in this catalogue and Weiss 1968/1977, pp. 68–128; Cikovsky 1970, p. 9; Weiss 1987, pp. 69–80.

38. Gifford, European Letters, vol. 1, June 7, 1855, p. 21.

39. Ibid., June 9, 1855, p. 23.

40. "Sketchings. The Sketcher. No. VI," *The Crayon* 2, no. 4 (July 25, 1855), p. 56. Although the note was unsigned and credited only to a "friend in London," there is no doubt Gifford wrote it, because it repeats *verbatim* some of the statements in his journal. As Weiss 1987 points out (p. 69), John Durand, one of the editors of *The Crayon,* had asked Gifford to serve as a regular correspondent while abroad, but he declined.

41. Gifford, European Letters, vol. 1, September 25, 1855, p. 111.

42. Ibid., September 29, 1855, p. 116.

43. Ibid., October 12, 1855, p. 125.

44. Ibid., September 29, 1855, p. 116.

45. Dated October 15, 1855 (Gifford 1855). In his letter of the same date (Gifford, European Letters, vol. 1, p. 128), Gifford recorded that he "spent the day at the Beaux Arts." Given the close correspondence of the writing in *The Crayon* with that in Gifford's letters, and especially his stress on pictorial unity, the attribution of this letter to him seems certain. It is thus an important public declaration of his aesthetic theories and preferences. Curiously, however, it has not figured in past discussions of Gifford and his art. Weiss 1987 (p. 73) has noted that while in Paris Gifford spent time with Christopher Pearse Cranch and Theodore Rossiter, both of whom were correspondents for *The Crayon.*

46. "The Artists' Building in Tenth Street," *The Crayon* 5, no. 2 (February 1858), p. 55.

47. See G[arnett]. McC[oy]., "Visits, Parties, and Cats in the Hall: The Tenth Street Studio Building and Its Inmates in the Nineteenth Century," *Journal of the Archives of American Art* 6, no. 1 (January 1966), pp. 1–8; Annette Blaugrund, "The Tenth Street Studio Building: A Roster, 1857–1895," *The American Art Journal* 14, no. 2 (Spring 1982), pp. 64–71.

48. "The Fine Arts. Exhibition of the National Academy of Design," *The New-York Times,* May 8, 1858, p. 2.

49. *Boston Evening Transcript,* August 1, 1859.

50. Sheldon, in Sheldon and Weir 1880.

51. Greenhalgh 2001.

52. *The New-York Times,* April 21, 1861. The quotation was from Samuel Taylor Coleridge's "Fancy in Nubibus; or, the Poet in the Clouds" (1817).

53. "The Lounger. The Academy Exhibition," *Harper's Weekly* 5, no. 223 (April 6, 1861), p. 211.

54. Benson 1861.

55. "Motley" was presumably John Lothrop Motley (1814–1877), an American historian, novelist, and diplomat.

Figure 16. After Sanford R. Gifford. *Pallanza—Lago Maggiore.* Engraving. From S. G. W. Benjamin, *Our American Artists* (Boston: 1879)

56. Benson omitted several verses of the poem.

57. George William Curtis had made this association some years earlier.

58. Sheldon, in Sheldon and Weir 1880.

59. *The Round Table,* April 30, 1864.

60. *New-York Daily Tribune,* April 30, 1864.

61. See Doreen Bolger Burke and Catherine Hoover Voorsanger, "The Hudson River School in Eclipse," in Howat et al. 1987, pp. 71–90, 95–98, for a discussion (which also includes valuable observations about Gifford) of this decline.

62. The Editor [A. T. Rice], "The Progress of Painting in America," *The North American Review* 124, no. 256 (May–June 1877), p. 456; quoted in Burke and Voorsanger, "The Hudson River School in Eclipse," p. 71.

63. Benjamin 1879, p. 309. Benjamin chose to illustrate Gifford's work by including an engraving after his now-unlocated "chief picture" *Pallanza—Lago Maggiore* (fig. 16). For a discussion of this work see Weiss 1987, pp. 279–80.

64. "Art Feuilleton," *New-York Commercial Advertiser,* February 27, 1866, p. [2].

65. *The Round Table,* May 19, 1866.

66. Swinnerton 1876; "National Academy of Design. First Notice," *The New York Evening Post,* April 22, 1868, p. 1.

67. Sheldon 1877.

68. As noted in Weiss 1987 (pp. 151–53), Sheldon (who was the art editor of New York's *Evening Post*) must have visited Gifford's studio and conducted interviews with him on several occasions before writing the *Art Journal* article. Although it is not signed, Sheldon repeats much of the information in his obituary of Gifford published in the *Post* on August 30, 1880. The article was not written by John F. Weir, as is stated in Miller 1993, pp. 257–58; the obituary was by Sheldon, to which a letter by Weir was appended (Sheldon and Weir 1880).

69. Sheldon (1877, p. 284) makes no mention here of Gifford working on oil sketches *en plein air,* but studies such as the one for *The View from South Mountain in the Catskills, a Sketch* (cat. no. 55), are clear evidence of this practice. Given that Sheldon's discussion dates from late in the artist's career, it cannot be assumed that he necessarily correctly recounted Gifford's earlier methods. Later in the article (p. 285), Sheldon does describe Gifford sometimes making "a dozen sketches of the same scene" and repeatedly visiting the site, which certainly implies the practice of sketching *en plein air.*

70. Again, here Sheldon's description (p. 284) does not fully accord with what is known of Gifford's working methods throughout his career; the use of thin pencil lines to sketch in a composition is evident in many of his canvases where the translucency of his pigments has grown over time (or through over cleaning), making them easily visible.

71. Sheldon's observations at this point (pp. 284–85) are interestingly suggestive of those he would make about Inness a few years later; see George William Sheldon, "George Inness," *Harper's Weekly* 26, no. 1322 (April 22, 1882), p. 244. Inness himself wrote of his *Sunset in the Woods* (1891; Corcoran Gallery of Art, Washington, D.C.) that he worked on it over a period of many years before he "obtained any idea commensurate with the impression received on the spot" (Letter from George Inness to Thomas B. Clarke, July 23, 1891; Massachusetts Historical Society, Boston; quoted in Cikovsky and Quick 1985, p. 184). Discussions devoted to Albert Pinkham Ryder in subsequent years would also stress his drawn-out process of working on pictures over long periods. The common element here was undoubtedly the nascent idea of what would be a key tenet of modernist aesthetics—namely, the primacy of the artistic process as the means to portray sensation and impression rather than specificity and detail.

72. Sheldon 1877, p. 285. Although Gifford's use of "boiled oil" is mentioned in most modern discussions of his art, it is difficult to know exactly what this substance was. Linseed oil, generally made by cold-pressing flax seeds and filtering the resultant liquid, was sometimes boiled to purify it for use as a medium. To enhance this medium's ability to dry, it could also be boiled with the addition of heavy metal elements (what is called boiled linseed oil today is not actually boiled, but only heated in the presence of soluble agents added to accelerate drying; it is frequently used as a wood preservative and stain). Boiled linseed oil would have to be thinned with turpentine or another solvent to work as a painting varnish. Many artists' handbooks published in the nineteenth century called for a painter to apply a diluted coating of oil to unify mat and glossy surface areas prior to applying the final glazings. This was a process known as "oiling out." Such oil can have a somewhat darker, even slightly reddish tint; this feature might have made the process especially attractive to Gifford, although, if applied in the very thin layers recommended at the time, its effect on the tones of the painting would have been subtle. Given that it is a layer that could be soluble when paintings are cleaned, it is worth keeping in mind that even apparently well-preserved pictures, because they might lack Gifford's original toned oil coating, may appear brighter today than the artist intended. Generally, however, properly applied oiling-out layers usually do survive conscientious cleanings. If this oil layer were applied too thickly it would darken considerably over time, and, if Gifford occasionally had not followed common practice and applied the layer too

thickly, attempts to remove this in later cleanings of his paintings might explain why many of them have suffered greatly from over cleaning and removal of glazes. Gifford was sensitive to the dangers of cleaning; he observed (Gifford, European Letters, vol. 1, June 5, 1855, p. 19) that some of the Claudes in the National Gallery, London, had "suffered a good deal in cleaning," and worried that if the Turners were cleaned "much if not all that constitutes their charm will disappear. There is so much scumbling & glazing they could not stand the ordeal." I am grateful to Michael Swicklik of the National Gallery of Art's paintings conservation department for discussing these issues with me.

73. See Benson's review of the National Academy's 1866 exhibition (Benson 1866b). Of course, one obviously can say that all paintings have to be seen to be understood; the point here is that the difficulty of describing such visual experiences inevitably varies.

74. Gifford, European Letters, vol. 1, December 7, 1855, p. 149.

75. See note 29, above; note 54, above; and "Private Art Collections of Phila./I.—Mr. James L. Claghorn's Gallery," 1872, quoted in Twelve American Masterpieces, exhib. cat., New York, Spanierman Gallery (New York: 1998), pp. 29–30.

76. See Gifford's letter to The Crayon, as cited in note 45, above.

77. The Round Table, May 19, 1866.

78. The New York Evening Post, April 21, 1877.

79. The New York Evening Post, September 1, 1880.

80. The Nation, September 9, 1880.

81. Weir 1873, p. 146.

82. Weir 1880, p. 20.

83. Benson 1866a.

84. "Address by W. Whittredge," in Memorial Meeting, pp. 40, 41, 43.

85. Ibid., p. 42.

86. Letter from Sanford Robinson Gifford to John F. Weir, December 12, 1877 (John F. Weir Papers, Yale University Library, New Haven); quoted in Weiss 1987, p. 148. According to an article in The Independent ("Fine Arts," January 10, 1878, p. 9), "Mr. Sandford [sic] R. Gifford surprised himself by committing matrimony with the widow of an old friend on a balmy day last June, and surprised his friends by keeping the fact to himself till about the middle of December."

87. Weir 1880, pp. 23, 12, respectively.

88. Ibid., p. 23.

89. Ibid., p. 18.

90. Ibid., p. 12.

GIFFORD AND THE CATSKILLS

KEVIN J. AVERY

After [Gifford] left Brown University and returned to his home in Hudson, where his father was in active business, he was pressed to choose some occupation which might serve him for a livelihood. This was no easy task. Betwixt his desire to please his father, and at the same time to please himself, he soon found himself in doubt. At length in no happy mood he started off one morning for the fields, and finally brought up on the top of Mount Merrino [sic], a high hill to the South of Hudson, overlooking the river, and with a clear view of the Catskill Mountains. Here he stretched himself in the shadow of a tree until as he expressed it, he came to the conclusion that any of the pursuits which had been suggested were good enough for him, but that he was good for nothing for any of them. This was a step forward.

Below him on the opposite side of the river lay the village of Catskill, its roofs and windows glistening in the sun. There was one house standing in that village which was in full view, around which we may well believe there was a halo of light that morning, which lighted up the path which he was to follow. This was the house and studio of THOMAS COLE, the father of a long line of American landscape painters.

It was not long after this before [Gifford's] name began to appear in the catalogues of the old Art Union and of the Academy of Design. . . .

We were told that [Gifford] was born in Saratoga County. As an artist he was born in the Catskill Mountains. He loved them as he loved his mother, and he could not long stay away from either. No autumn came that he did not visit them, and for a long period of his artist life he went in summer to the Catskills as a boy goes to school.

Address by W[orthington]. Whittredge
Gifford Memorial Meeting of The Century . . . November 19, 1880[1]

The beginning and much of the text of Whittredge's *Memorial Meeting* souvenir of Gifford, which he essentially repeated in his autobiographical memoir of 1905, speak directly to the preponderance of New York State subject matter—especially, the Catskill Mountains—in the artist's work. To be sure, as Heidi Applegate details in her essay below, on Gifford's travels, his scope was wide: His early output was strongly flavored by New England themes, and, as early as 1855, by European sites; the latter figured prominently in his oeuvre in the last decade of his life—with an admixture of American western subjects. Yet, even among the fraternity of artists that acquired the name "Hudson River School," Gifford appears to stand out for the numbers and variety of his views of the Hudson River; the Catskill, Adirondack, and Shawangunk Mountains; and Long Island, executed during his relatively brief, if productive, career.

About 250, at least, of the approximately 700 landscapes by Gifford listed in the Metropolitan Museum's *Memorial Catalogue* of his work depict scenes in New York State, compared to fewer than 200 foreign and about 90 New England subjects.[2] Well over 100 are of sites in the Catskills—by far the largest single representation of a specific region in Gifford's oeuvre. However, over sixty of the paintings are of the Hudson River itself and its environs, including more than a dozen of Gifford's hometown, Hudson, and its sur-

Opposite: Sanford R. Gifford. *A Gorge in the Mountains.* Detail of catalogue number 21

Figure 17. Sanford R. Gifford. *Mount Merino and the City of Hudson, in Autumn,* about 1851–52. Oil on canvas. Albany Institute of History and Art, New York

roundings (see cat. no. 35). Gifford's professional artistic career began in 1847, but not with any of those pictures: He painted his first such work, *A Study near Hudson, N.Y.,* in October 1851.[3] Still, the affection for his youthful haunts, manifested not only in his art but in the evidence of Gifford's devotion to his parents and siblings and in the perennial visits to the family homestead, would suggest Hudson as the starting point for a consideration of his Catskill paintings.

Mount Merino—the actual subject of most of Gifford's paintings of Hudson and its vicinity—is said to have acquired its name from a Spanish breed of sheep formerly raised on a farm nearby. The hill is the principal geographic landmark in Hudson as well as the southern boundary of South Bay, which constitutes the foreground of these same works by Gifford.[4] The city of Hudson, portrayed distantly in a few of the artist's early paintings (see fig. 17), occupies a sloping plateau projecting into the Hudson and separating North and South Bays. Before the Revolution, the site was called Claverack Landing—that is, the harbor of the town of Claverack, located today a few miles southeast of Hudson. According to tradition, the landing was the north-

ernmost point to which the English navigator Henry Hudson took his ship, the *Half Moon,* before proceeding north in smaller craft; his name was given to Claverack Landing at the incorporation of Hudson in 1785 by an association of whalers from Nantucket Island. During the rebellion they had scouted locations on the Hudson River for the purpose of securing their industry from the threat of a British blockade of Nantucket. Shipbuilding commenced instantly, and in 1784 the three-hundred-ton *Hudson* was christened and launched from what, the following year, became the town's eponymous port. By 1790, Hudson listed twenty-five schooners in its registry. Whaling continued to be a local industry for years, but so did a wide-ranging trade in shad, herring, timber, hides, and country produce—sufficient activity for the city to compete commercially with New York and Albany. In 1797, Hudson missed the honor of becoming the state capital by a single vote in the legislature.[5]

The War of 1812 and the Panic of 1837 put an end to whaling in Hudson; it would be supplanted by, among other industries, iron production, another early staple of commerce in the Hudson Valley.[6] That was the trade that Sanford's father, Elihu Gifford (fig. 18), adopted in 1823, the year Sanford was born, when he moved to Hudson, from Greenfield in Saratoga County, with his wife, Eliza Starbuck Gifford. Abandoning his former occupation as a leather tanner and shoemaker, which he had taken over from his father, he bought a partnership in an iron foundry established in Hudson about a decade earlier, which was renamed Starbuck, Gifford and Company. Even if the firm's primary name did not suggest the vital backing of Elihu's wife's family in launching his new business, the presence in Hudson of descendants of the original Nantucket settlers from the Starbuck side of Sanford Gifford's parentage provides some indication of why the family settled there.[7]

Elihu Gifford's commercial success was rapid: In 1831, he assumed sole proprietorship of the foundry. Later in the same decade, he founded the Farmers' Bank (which he presided over for the next twenty-five years) and organized the Hudson and Berkshire Railroad, facilitating trade with New England. Before mid-century, as the Hudson River Railroad was being extended to the city, he spearheaded the establishment of the large Hudson Iron Company works on the river, remaining one of its trustees while continuing to manage his original foundry in the eastern part of Hudson. In the

1850s, Elihu brought his sons James and William into the business and in 1863, at the time he retired from the presidency of the bank, he sold the foundry to them. The brothers diversified into turbine and tool production, and the business survived for at least another generation.[8]

Elihu and Eliza Gifford seem to have been a fortuitous mixture of the public and private. Eliza bore six sons (of which Sanford was the third) and five daughters, and her "kindly, charitable impulses," reinforced by her Baptist sympathies, led her to found and direct the Hudson Orphan Asylum in 1846.[9] Elihu became active in the Franklin Library Association and a trustee of the Hudson Academy, where Sanford and several of his brothers were educated. Curiously, Elihu Gifford was indifferent to political power, and—with one exception, in 1845—declined "invitations" to serve on the Common Council.[10] He appeared to be uncomfortable with imposing his authority, even domestically, and, indeed, his first son, Charles, described him as "one of the kindest men in the world, perfectly upright . . . [he] hates meanness with a perfect hatred," adding that he possessed "an infinite sense of what is just and right . . . [and was] liberal and free in his opinions."[11] Despite his moral rectitude, he did not espouse Christianity, and Sanford, for one, followed his father's resistance to religious dogma.[12]

Both sons declined the opportunity to participate in their father's successful enterprises. Although at least two of Sanford's younger brothers joined Elihu at the iron foundry, as many as three of the others, including Charles and (as Whittredge's tribute indicates) Sanford, had difficulty deciding on a vocation.[13] Like Sanford, Charles was also artistically inclined, and migrated west to pursue a shaky career in landscape gardening, regretting his privileged upbringing when he confided in a letter to his future wife in 1850: "Though I had very superior advantages (of education &c) to [my father's], I have often wished that I had been nurtured in the hard school through which he passed."[14] The self-doubt suggested in this comment must have been an innate

Figure 18. Artist unknown. *Elihu Gifford.* Engraving after a photograph by F. Forshew, in Franklin Ellis, *History of Columbia County, New York* (Philadelphia, 1878)

feature of Charles's personality, for he was treated professionally for depression and headaches, the effects of which he alleviated with chloral hydrate; his overreliance on the compound led to his death in 1861.[15] Sanford, too, was periodically seized by a dispiritedness that prevented him from working.[16] However, his early integration into the New York community of artists and literati; the bachelorhood that he preserved, and that afforded him the relative freedom to travel; his perennial excursions to sketch in the field, which he pursued at home and abroad; the regular studio habits that he adhered to and the total absorption in painting, which he evidently enjoyed; and, not least of all, the enduring admiration his work generated from colleagues, critics, and patrons allowed him to maintain his stability and self-esteem—despite what his contemporaries described as his personal reserve and hesitancy to speak. Indeed, partly through the appeal of his art, such social lacunae became virtues, endowing him with what his colleagues perceived as a kind of noble mystique.[17] In Sanford's pencil likenesses of himself and his brother Charles (see figs. 19, 20) both of them leave the same impression on the viewer: Their heads are bowed, their expressions grave, and their eyes seem to glower at the spectator. However, one also discerns in Sanford's double self-portrait the adoption, as early as 1853, of a professional persona, which turns his somewhat downcast attitude into one of purposefulness and propriety. In the double portrait he appears tastefully, and even aesthetically, groomed, with and without his hat.

As one already might have gathered, in Hudson, Sanford Gifford's early sympathy for art in general, and for landscapes in particular, was not merely shared but was also nurtured by his older brother. Much later in his life, the artist recalled, "It was one of the greatest pleasures of my boyhood to look at and study the miscellaneous collection of engravings which covered the walls of [Charles's] room."[18] It would seem that Charles's acquisition of such a collection ultimately must have derived from the high regard for education shared

Figure 19. Sanford R. Gifford. *Charles Gifford,* 1846. Black chalk, highlighted with white, on buff paper. Museum of Fine Arts, Boston. The M. and M. Karolik Collection of American Watercolors, Drawings, and Prints, 1800–1875

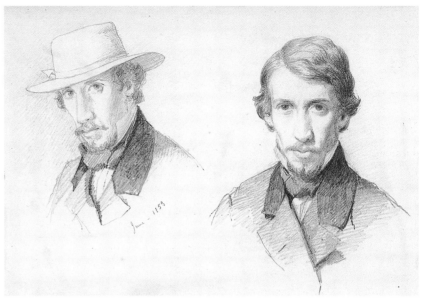

Figure 20. Sanford R. Gifford. *Double Self-Portrait,* June 1853. Graphite. Collection Family of the Artist

by their parents. Yet, by 1844, Hudson also was enriched by exposure to art and culture, aside from what could be gained at the local academy, in the form of an influence that Gifford later would neglect to acknowledge: the presence of the portraitist and landscape painter Henry Ary (about 1807–1859).

Ary's arrival in Hudson would seem to have been critical to Sanford's (and possibly Charles's) choice of a vocation. He probably represented the earliest known personal link between Gifford and Thomas Cole, since in about 1844 Ary had moved to Hudson from Catskill, where Cole had been living since 1836. At Ary's death, it was reported that he had been practicing portraiture in Catskill when "under the influence of the lamented Cole, his attention was directed to the study of landscape art."[19] We can only speculate that it was Cole's presence in the same town that ultimately discouraged Ary from professionally practicing landscape painting there. At any rate, in Hudson, Ary worked in both genres. Sanford's older brother Frederick commissioned portraits of himself and his wife from Ary, but he also purchased one of the artist's numerous landscapes of local scenery that included Mount Merino (see, for example, fig. 21); the latter work was exhibited at the American Art-Union in New York in 1845.[20] In his house in Milwaukee, Charles hung pictures by Ary and by Sanford next to one another.[21] A few years later, Sanford and Ary would sketch together in the Catskills, but they undoubtedly crossed paths

earlier on, when this Cole disciple first arrived in Hudson—a supposition that seems likely in view of Sanford's and Charles's interest in art and the commissions Ary is known to have received from the Gifford siblings. It is not hard to imagine that, after he dropped out of Brown University in 1844 and struggled to persuade his father to let him study art, Gifford might well have strengthened his case by citing Henry Ary as a role model. That Gifford first journeyed to New York to prepare for a career as a portrait painter may be a measure not merely of his father's liberal sentiments but also of the latter's acknowledgment of Ary's local success in this métier. Yet, Gifford soon changed his mind, and decided to become a landscape painter—perhaps as a result of Ary's early efforts at communicating to him both by word and by example Cole's reputation and ideals.

Ary's landscapes surely were influenced by Cole's, although only those that were pastoral in character—not the paintings in the Sublime mode for which Cole had gained popularity in New York in the 1820s. It would be natural, for example, to compare almost any one of Ary's views of South Bay and Mount Merino (see fig. 21) with the classical formula Cole adopted in several of his Catskill pictures (see fig. 22), in which the umbrageous trees framing the foreground at the right focus attention on the water in the middle distance and the hills in the background. In Ary's work, the main feature is Mount Merino;

in Cole's, the prospect includes the profiles of Round Top and Kaaterskill High Peak in the Catskills. Despite Ary's limitations, when compared with the artistry of Cole, the tall proportions of his pictures and their formulaic modulations of light and shadow anticipate the picturesque values favored by Thomas Doughty and by Alvan Fisher.

Gifford began to paint views of Mount Merino shortly after 1850, contemporaneous with or subsequent to Ary's efforts; except for the surviving early example,[22] the pictures date from 1859 and later, following his first trip to Europe (see fig. 104). The paintings generally adopt Ary's southern prospect, with Mount Merino as the main subject, but, aside from the greater technical sophistication one would expect from Gifford, they depart from Ary's precedent in a significant respect. Gifford made the Catskills—not merely Mount Merino—an integral component of the prospect across South Bay. Ary had barely acknowledged the mountains beyond Mount Merino, even partly obscuring them with the trees that establish his foregrounds. Gifford not only omitted the trees but utilized his characteristic horizontal format to accommodate the broad profile of the Catskill Mountain range miles away—

and nowhere more so than in catalogue number 35. This contrast notwithstanding, it may be further significant that the earliest of these pictures dates from 1859, the year of Ary's death.

The succession of Gifford's Hudson River subjects, after the initial works depicting the town of Hudson and then Mount Merino, occurs in direct relation to the distance of their locales from the Gifford homestead: From 1866 to 1868, and again in 1878, he painted the Highlands, Hook Mountain, High Tor, Piermont, and other sites near or on the Tappan Zee and Haverstraw Bay (see cat. nos. 42, 43, 46, 65), the widest points on the river.[23] Only in the late 1870s did his range of subject matter expand to include the southernmost part of the Hudson near his home in New York City—as, for example, in *A Sunset, Bay of New York* (cat. no. 64), and *Sunset Over the Palisades on the Hudson* (cat. no. 69). In all these later instances, the appeal of the subjects probably was suggested by work he had completed elsewhere. The vast expanse of water and the distant landfall at Tappan Zee and Haverstraw Bay may have evoked for Gifford the coastal New England and mid-Atlantic themes that had fascinated him earlier in the decade, and the Hudson River subjects essayed by such colleagues

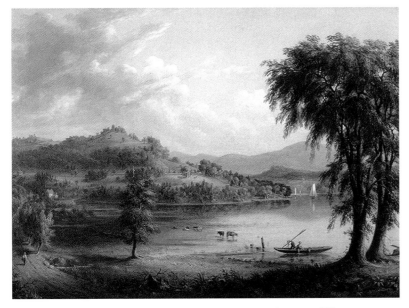

Figure 21. Henry Ary. *View of South Bay and Mount Merino,* 1847. Oil on canvas. Robert Jenkins House Museum, Hendrick Hudson Chapter National Society of the Daughters of the American Revolution, Hudson, New York

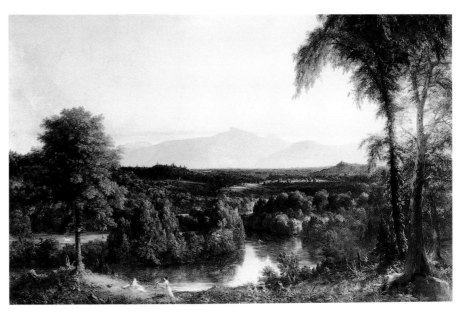

Figure 22. Thomas Cole. *View on the Catskill—Early Autumn,* 1836–37. Oil on canvas. The Metropolitan Museum of Art, New York. Gift in Memory of Jonathan Sturges, by his children, 1895

Figure 23. Arnold Guyot and Ernest Sandoz. *Map of the Catskill Mountains* (detail), 1879. Engraved by J. Schedler. The New York Public Library, Astor, Lenox and Tilden Foundations. Map Division. Shown here is the eastern Catskill region, including the vicinity of the Catskill Mountain House and Kaaterskill Clove

as James Suydam, Albert Bierstadt, and Samuel Colman, at that time or shortly before.[24] In Gifford's Hudson subjects of the 1870s—especially the two scenes looking directly up or down the river, with the sails of a sloop poised on the taut horizon (see cat. nos. 64, 69)—the artist seems to have applied the spare aesthetic of his Venetian and Constantinople pictures (see cat. nos. 56, 59), produced after his second European sojourn, which were so coveted by patrons in the 1870s.

Despite the significance of Hudson for Gifford throughout his career—as Whittredge suggests—it remained for the artist less a subject than the prime

vantage point for access to the artistic and tourist havens in the Northeast, particularly in New York State, especially to Thomas Cole's beloved Catskills, rising up in the south, across the river from Mount Merino. Three of Gifford's first four recorded paintings are of sites near the famed Catskill Mountain House (whose pale form he probably also could have descried from Mount Merino or even from Hudson's "Promenade" overlooking the river); the first of these, *Kauterskill Lake*, dated 1845, and his earliest picture known today, *Kauterskill Falls* (fig. 133), correspond in their subject matter to two of the first three paintings that Cole showed in New York.[25] On his primary excursions

to the eastern Catskills, Gifford may have been aware of this, even if he never actually saw Cole's original Catskill paintings: Two contemporary travel books had cited Cole's pictures of natural attractions near the Mountain House.[26] More concertedly than any of his peers, Gifford succeeded Cole as a pictorialist and popularizer of the Catskill Mountains.

Yet, while Cole may have been the earliest pictorialist, he was not the first to promote the region (see fig. 23). As Kenneth Myers and others have demonstrated, that distinction belonged chiefly to the Knickerbocker authors Washington Irving and James Fenimore Cooper.[27] Cooper's *The Pioneers* (1823), the introductory novel in his "Leatherstocking Tales," celebrated— through its hero, Natty Bumppo—the wondrous view of the Hudson River Valley from the escarpment at Pine Orchard (on which the Catskill Mountain House would be built the following year) and the dizzying heights of nearby Kaaterskill Falls (see cat. no. 52).[28] However, Cooper could never have approached those sites had not early-nineteenth-century entrepreneurs constructed roads through the rugged interiors of the Catskills, providing settlers with access to western New York State before the opening of the Erie Canal and serving the newly established leather-tanning industry, which depended on tannin from the bark of the hemlock trees that once had dominated the Catskill forests. Privileged sightseers like Cooper took advantage of the roads, and the steamboat brought visitors from New York City. Thus, by the 1820s, the Catskill overlook became the site of the first rude accommodation to be erected there; called Pine Orchard House, it later would be enlarged several times and eventually renamed the Catskill Mountain House.[29] The Mountain House did not become a favored artists' resort—although a number of painters occasionally stayed there—but, rather, turned into a haven for buyers of Catskill Mountain views, which first Cole and subsequently Gifford and others were only too eager to supply them with.

After the 1820s, when Catskill subjects first catapulted him to fame, Cole focused more on painting Catskill village pastorales (reflecting his residence in the valley; see fig. 22) in which the eastern range of the mountains appears only in the backgrounds.[30] However, by the early 1840s Cole began focusing again on the mountaintops themselves. In May 1845, when Gifford began to study art in New York and painted *Kauterskill Lake,* "the first landscape that

Mr. Gifford had framed,"[31] Cole exhibited a major picture at the National Academy of Design, *A View of Two Lakes and Mountain House, Catskill Mountains, Morning* (fig. 87), in which he depicted the renowned hotel and North and South lakes, set against the eastern Catskill range, as seen from nearby North Mountain. Cole's renewed interest in the Catskills was no doubt informed by at least two other factors that probably also affected Gifford at this critical juncture in his professional life. Popular enthusiasm for the Mountain House and its vicinity was being recharged by Charles L. Beach, the owner of a local stagecoach line, who assumed control of the Mountain House in 1839 and full ownership in 1846. That year, Beach began cosmetic improvements on the hotel itself, but of greater importance for visitors and artists was his creation of more hiking trails for them on the surrounding North and South Mountain lands that he had purchased. Eyeing Beach's measures appreciatively, a sawmill operator named Ira Scribner opened a boardinghouse near Kaaterskill Falls. Beach also had published *The Scenery of the Catskill Mountains* (Catskill, New York: 1842), the first guide to the Mountain House and its environs, in which he included extensive excerpts from Irving, Cooper, the poet William Cullen Bryant, and several native and foreign travel writers who had visited the hotel in the 1830s (fig. 24).[32]

The viewpoint of Cole's painting suggests that he was one of the beneficiaries of Beach's improvements, as do Gifford's Catskill paintings—particularly those from the Civil War era. Moreover, Cole was not alone on his later incursions in the Catskills. In the mid-1840s, he had accepted a few students in his Catskill village studio, the first of whom was Frederic Church of Hartford, three years Gifford's junior.[33] Church would become the leading painter among Cole's followers in New York, as well as Gifford's most influential contemporary, and, later, friend and colleague.[34] From 1844 to 1846, Cole and Church sketched frequently in the Catskills—at the same time that Ary moved from Catskill to Hudson. Gifford may have learned of Cole's pedagogy from Ary, although it is not inconceivable that Gifford might have encountered Cole and Church in the Catskills as early as 1845.[35] The important point here is that, if we accept Gifford's (and Whittredge's) claims that Cole's example was the critical factor in his choice of a career and his decision to specialize in landscape painting in the mid-1840s, then Cole's new vocation,

Figure 24. Cover of Charles L. Beach's *The Scenery of the Catskill Mountains* (New York, 1846 edition). The New York Society Library

drawings. That study may have been the basis for the figure in the foreground of the first known painting by Gifford to anticipate his signature atmospheric work of 1850, *Scene in the Catskills* (cat. no. 2), which was sold to the American Art-Union the same year.[37] The presumed sketches (see fig. 65) for this work appear to have been executed on the plateau in Haines Falls, overlooking Kaaterskill Clove, not far from where, years later, the artist would sketch Hunter Mountain (see fig. 113). As both sketch and painting indicate, the breadth of the picture space is the result not only of the diminishing perspective of the mountain range (possibly including Hunter Mountain) in the background but of the clearing of the terrain of trees—just their stumps are visible at the left—and of the placement of the humble dwellings in order to plot the recession of the tableland toward the declining sunlight. In the foreground the artist contrived a hollow to amplify the void and to accommodate the golden light and dusty air. The figure's gesture suggests that he is screening his eyes from the direct rays of the sun—a gesture that would become a virtual requirement for the spectator of Gifford's Civil War-era paintings, in which the blinding sun so often predominates.

One may wonder whether Gifford would have continued to identify himself so intimately and extensively with the Catskills were it not for the Civil War. His sketchbooks and paintings from the first decade of his career show him reaching well beyond New York State to New Hampshire, Vermont, Pennsylvania, and Ohio for subject matter, and he followed those travels with his first Grand Tour of Europe from 1855 to 1857. Even after his return, his wanderlust impelled him to venture farther north through New England, to Maine and Nova Scotia. The earliest works with native subjects among the "chief pictures" that he identified late in his career are *Mansfield Mountain* of 1859 (in Vermont; cat. no. 8) and *A September Afternoon on the Chenango* of 1860 (in Pennsylvania; Whereabouts unknown).[38] Surely, one would add another painting that, inexplicably, he omitted: *The Wilderness* of 1860 (probably Mount Katahdin, Maine; cat. no. 12). His "chief pictures" from 1861 to 1866 were dominated by Catskill, Adirondack, and Shawangunk Mountain subjects, but at least two other major Catskill paintings, absent from Gifford's list, might be included: the Metropolitan Museum's *A Gorge in the Mountains* of 1862 (cat. no. 21) and *South Mountain, in the Catskills,* of 1864 (Where-

in Catskill, as a teacher of landscape painting to another young aspirant, could only have whetted Gifford's desire and determination to pursue his goal.

The 1846 *Kauterskill Falls* (fig. 133) is similar to many of Gifford's other early pictures in its vertical format and its composition of closely observed woodland motifs, echoing the *plein air* studies and even some of the salon paintings of Asher B. Durand.[36] In addition, the apparent prevalence, in the artist's oeuvre, of several horizontal compositions of streams in the Catskills and elsewhere also may reflect Gifford's lifelong passion for fishing. Together, these images suggest that the young artist spent most of his time, early on, in the Catskills, deep in Kaaterskill Clove, mastering the fundamentals of tree and rock anatomy and composition. Ary accompanied Gifford on at least some of his sketching excursions, and is identified as the figure seen seated on the banks of Schoharie Kill (see fig. 25) in one of Gifford's 1849 sketchbook

abouts unknown). Indeed, over half of Gifford's more than one hundred *recorded* Catskill subjects were produced during a period equal to one-seventh of his career, from 1861 through 1866, and reflect nearly annual sketching campaigns during these same years.

Gifford's military service surely was a major factor in his regular visits to the Catskills. In 1861, he volunteered to serve with the New York Seventh Regiment of the National Guard based in New York City, and spent part of each spring and summer, until 1863, protecting Baltimore and Washington, D.C. (see fig. 33, below). His duties limited the scope and duration of his customary trips to sketch in the field in warm weather, but also reflected what he conveyed in the few surviving letters to his family and friends: his longing in stressful times both for them and for his "home" in the countryside—Hudson, of course, and perhaps the Catskills, even more.[39] Whittredge's remarks about Gifford—which introduce this essay—were accurate not only in a metaphorical and idealizing sense: He might just as easily have said that Gifford loved the Catskills *because* he loved his mother, his father, and those of his siblings who remained in Hudson. This fealty and devotion to his family must have

Figure 25. Sanford R. Gifford. *"H[enry] Ary on Schoharie Kill July 25th 1849"* (from the sketchbook inscribed "1849, Catskill Mtns., Sacandaga & Hudson"). Graphite. Albany Institute of History and Art, New York. Gift of Marian Gifford Johnson Shaw (Mrs. William F. Shaw) and Mrs. George G. Cummings

been heightened all the more by the loss, not only of Charles, in May 1861, but of his younger brother Edward, in the summer of 1863, the latter a casualty of the war.[40] By 1860, Gifford had become friendly with several individuals in New York, whom he probably was instrumental in attracting to the Catskills. Prominent among them were Candace and Tom Wheeler, who had met Gifford in Rome and saw him regularly at the receptions in the Tenth Street Studio Building and when he was their frequent guest—often, along with other artists and even his sisters Julia and Mary—at Nestledown, their Long Island retreat (now part of Queens).[41]

In Düsseldorf and in Rome, Gifford had befriended the Midwesterner Worthington Whittredge (see fig. 26), and they renewed their acquaintance when Whittredge arrived at the Studio Building in early 1860. Whittredge was about to embark on his professional American career after many years of study in Europe, primarily at the Düsseldorf Academy, and thus he was unfamiliar with the scenery of the eastern United States. In December 1860, Whittredge and Gifford were reported to be at work on paintings based on Catskill sketches made the summer before.[42] Gifford undoubtedly served as his companion's guide. Years later, Whittredge recalled that Gifford "hunted up a little house in Kaaterskill Clove, in which lived a family of plain country folk," whom Gifford persuaded to take him in.[43] Soon, according to Whittredge, other artists joined him there, until they were driven away by the increasing numbers of tourists who discovered the place. Whittredge identified the house as "Scribner's," which had, indeed, opened its doors, above Kaaterskill Falls, about 1846, and it is likely that Gifford boarded there on his early excursions in the Catskills. However, Whittredge refers to the house as being *in* the clove, as does at least one 1860 sketch by Gifford entitled *"Bracketts—July 29"* (fig. 27); this suggests that Whittredge was confusing the house of Ira Scribner with that of George Brockett, who owned a farm on Kaaterskill Creek (see fig. 28), at the base of the clove, and evidently began taking in boarders considerably later than Scribner.[44]

Jervis McEntee (fig. 29), who became one of Gifford's closest friends, almost certainly joined Gifford and Whittredge in the Catskills in the summer of 1860 and thereafter.[45] McEntee had instantly won Gifford's regard in the autumn of 1857, when he ceded to him the studio both artists had sought

Figure 27. Sanford R. Gifford. *"Brocketts July 29"* (from the sketchbook of Maryland, Virginia, and New York subjects, 1860). Graphite on off-white wove paper (now darkened). Fogg Art Museum, Harvard University Art Museums, Cambridge, Massachusetts. Gift of Sanford Gifford, M.D.

Figure 26. Sanford R. Gifford. *Landscape and Portrait Study of Worthington Whittredge* (from the sketchbook of New York subjects, 1860–63). Graphite on buff wove paper. Fogg Art Museum, Harvard University Art Museums, Cambridge, Massachusetts. Gift of Sanford Gifford, M.D.

Figure 28. James R. Brevoort. *"Brocketts, CatsClove–"* (from a sketchbook of landscape subjects, 1863–65). Graphite, Paul Worman Fine Art, New York

Figure 29. A. A. Turner. Jervis McEntee, about 1870. Carte de visite. The Metropolitan Museum of Art, New York. The Albert Ten Eyck Gardner Collection, Gift of the Centennial Committee, 1970

By 1860, the range of tourist literature on the Catskills served to heighten interest in the region already generated by these three artists and by their patrons, which would prevail during the Civil War years. For example, *The Scenery of the Catskill Mountains,* cited above in connection with the improvements in the 1840s to the Catskill Mountain House and its grounds, was reprinted in 1860 with two additional accounts by current "celebrity" visitors—one of whom was the then renowned travel writer, poet, and amateur artist Bayard Taylor (see fig. 30). Taylor numbered McEntee and Gifford among his closest friends in New York's artistic community, and is said to have limned idealized portraits of them in his poem "The Picture of St. John," published in 1866.[48] He had met them well before then, and, in fact, had been Gifford's neighbor in Rome in 1857. For Taylor, in the reprinted essay, as for Gifford at that time, a trip to the Catskills represented an opportunity to become reacquainted with one of America's most popular resorts.[49] Taylor also refocused attention on the prospects afforded by the paths established by Charles Beach around the Mountain House in the 1840s, the views from which Gifford was

Figure 30. Thomas Hicks. *Bayard Taylor,* 1855. Oil on canvas, National Portrait Gallery, Smithsonian Institution, Washington, D.C.

in the newly opened Tenth Street Studio Building.[46] Unlike Whittredge, yet like Gifford, McEntee had deep roots in the Hudson River Valley, having been born and raised in Roundout, New York, in Ulster County, neighboring the old colonial capital of Kingston, just a few miles south of the Catskills. McEntee had studied with Church in 1851–52 and had worked in the Catskills well before his association with Gifford and Whittredge. McEntee was probably even more attached than Gifford was to his ancestral home upstate, which he frequented during the warm weather and whose surroundings became the subject of many of his paintings.[47] Although a student of their respective pictures seldom would mistake the vision and style of each of the three artists, the terrain described in their pictures throughout the Civil War years often reflects their shared sketching campaigns.

Figure 31. Frederic Edwin Church. *Our Banner in the Sky,* about 1861. Oil on paper. Olana State Historic Site, New York State Office of Parks, Recreation and Historic Preservation, Hudson, New York

among the first to paint. For Taylor, it was "a quarter of an hour before sunset," not the sunrise that all previous writers had celebrated, that was "perhaps the best moment of the day for the Catskill panorama" as seen from the escarpment.[50] Taylor added that "no visitor to Catskill should neglect a visit to the North and South mountains. The views from these points, although almost identical with that from the House, have yet different foregrounds, and embrace additional segments of the horizon."[51] His reference to "a weather-beaten pine, which, springing from the mountain-side below, lifts its head just to the level of [North Rock]," together with the "visible fluid" of the atmosphere perceptible from the same place, as well as his preference for the sunset panorama, vividly anticipate Gifford's own interpretation of the Mountain House and the Hudson River Valley (see cat. no. 27).[52] Gifford's National Academy colleague T. Addison Richards, in his *Appletons' Illustrated Hand-book of American Travel* of 1861, specifically cited South Mountain's "brink of huge cliffs" as the vantage point both of the "[Hudson] river and valley, and the wonderful pass of the Kauterskill, through the mountain chain westward."[53] Those are precisely the two prospects that the artist would

idealize in at least three major paintings in the Civil War years. Indeed, the transfiguring vision of some of those pictures seems compatible with the religious sentiments associated with the prospect from South Mountain and the Sunday services evidently practiced there. In "A Sabbath in the Catskills," which concluded the 1860 edition of the guide, the New York divine Theodore L. Cuyler referred to the worshipers at the hotel who, "with [prayer]book in hand, strolled up into the thickets towards South Mountain."[54]

The studies Gifford made between July and September 1860 indicate that he (and presumably Whittredge and McEntee) spent days hiking on and around the trail skirting South Mountain (today called the Escarpment Trail) and visited Kaaterskill Falls (where, on August 3, he drew the prospect from the cavern behind the falls, as seen in Cole's 1826 painting [Wadsworth Atheneum, Museum of Art, Hartford]) as well as Haines Falls, at the western end of the clove, where he sketched the view toward the Hudson River Valley that was developed into *Twilight Park (Kauterskill Clove, from Haines Falls)* (cat. no. 25).[55] However, as early as July 31, he had made what is his first known drawing of the panorama of the clove from a ledge possibly above Hillyer's Ravine, on the less-frequented, south side of the gorge (see fig. 78)—a site he seems not to have visited before and seldom, if ever, visited again.[56] Nonetheless, this sketch led to his first major version of the at least three large clove pictures, from successive years, which would contribute indelibly to Gifford's reputation. All of these works depicted the view from the east, into the interior of the mountains, rather than from the west, toward the Hudson River Valley, which Cole and other artists had preferred.

We are fortunate that *A Twilight in the Catskills* of 1861 (fig. 12) has been rediscovered, after an absence from public view virtually since it was first exhibited in April 1861, at the National Academy of Design. Nothing in Gifford's previous work (or in much of what came later) prepares the spectator for the almost lurid effect of the infernal glow of the just-departed sun, visible beneath the smoldering blanket of clouds, and below, the gloomy gorge abandoned by the light of day. The surprisingly Expressionist tenor of the picture is abetted by the conspicuously skeletal trees, either charred or withered, that, silhouetted against the yellow and red light, frame the scene. A black bear (or cub) is seen wandering from the left toward the stream in

the foreground flowing away from the viewer, down an unseen waterfall, to the creek in the gorge (presumably, Kaaterskill Creek). The liquid looks less like water than lava. Indeed, critics at the time were struck by "the brilliancy of this picture [that] almost fills the room."[57]

As enigmatic as it is, *A Twilight in the Catskills* probably evolved from a certain logic of response and reaction to both aesthetic and personal forces. The previous summer had seen the revival of Gifford's career-long preoccupation with the Catskills, and his most sustained and significant sketching campaign there. When he positioned himself on the south side of the clove in late July, Gifford's thoughts may well have been on his recent—and first—"chief picture" with an American subject, *Mansfield Mountain* (cat. no. 8), a panoramic scene, illuminated by the declining sun, viewed from a mountaintop. Although he actually may have witnessed the sunset that he depicted in *A Twilight in the Catskills,* his sketch provides little indication of this. George Sheldon recalled that late in Gifford's career the artist was stung by the early criticism of his atmospheric Indian summer landscapes (already conspicuous in *The Wilderness* [cat. no. 12]) and was determined to prove that he could do something different.[58] Undoubtedly, the recent example of Frederic Church's spectacular *Twilight in the Wilderness* (1860; fig. 3), reinterpreted the following year as Union propaganda in the lithograph *Our Banner in the Sky* (see fig. 31), helped Gifford to achieve his goal as well as to distinguish his own vision, derived from Church's example.[59] In *A Twilight in the Catskills,* Gifford distanced himself from Church not merely in his title, which identifies his painting with the terrain made famous by Cole, but in his decision to emphasize aspects of the Sublime. That the two works were completed on the eve of the Civil War may be interpreted as both momentous and elegiacal. Yet, Church's picture is also a triumphant expression, and, in its lithographic form, becomes a celestial national clarion. Gifford's version of twilight seems concertedly ruinous, forbidding, foreboding, even tragic—as Sheldon perceived, "lowering, strange, almost awful"—and thus more personal than Church's twilight scene.

Long before the rediscovery of *A Twilight in the Catskills,* Ila Weiss had speculated on the significance of the brittle foreground trees, sharp rock forms, and expiring light of *A Lake Twilight* (cat. no. 14), a smaller picture also painted in 1861, which conveyed "the general feeling of malaise that antici-

pated the Civil War" and that preoccupied Gifford and his colleagues.[60] For Gifford, personally, she added, there was also the possible effect of the sharp decline in the mental state of his brother Charles[61]—who, from Charles's letters, appears to have been suffering from severe manic depression. Charles had come to New York for a "water cure" in the winter of 1859, and Sanford saw him at least once, and probably several times; then, as his condition worsened through the fall of 1860, Sanford and two of his siblings visited Charles at his home in Milwaukee.[62] Charles died in May 1861, just after Gifford sent *A Twilight in the Catskills* to the National Academy and volunteered with the Seventh Regiment. If *A Lake Twilight* can be seen as having been affected by those circumstances, surely they figure even more visibly in the unsparing impression made by *A Twilight in the Catskills.* Its relevance to pre–Civil War anxiety only seems confirmed by Gifford's next twilight "chief picture," *Baltimore, 1862— Twilight* (fig. 32), exhibited at the National Academy in 1863—its subject, of course, a direct reflection of Gifford's military service (see fig. 33) in 1862 at Fort Federal Hill in Baltimore.[63] In the painting, the same high contrast of burning sky (minus the clouds of *A Twilight in the Catskills*) and dark terrain— here, the parapet of the fort—is set off by a lone sentinel with bayoneted rifle and several church spires in the distance; these forms, however sparsely they populate the scene, recall the spiny trees of *A Twilight in the Catskills.*

Both the 1861 and 1862 twilight pictures might well have affected the work of McEntee, who, in the same 1863 Academy exhibition, showed his *Virginia in 1862* (Whereabouts unknown), a depiction of an abandoned battlefield with a burned-out homestead.[64] Furthermore, one of Whittredge's handsomest pictures, *Twilight in the Shawangunks* (1865; fig. 107), which resulted from an 1864 sketching campaign with Gifford and McEntee, is unquestionably a descendant of Gifford's *A Twilight in the Catskills,*[65] as is Gifford's own *Hunter Mountain, Twilight,* of 1866 (cat. no. 41).

On July 31, 1861, exactly a year after executing the sketch that became *A Twilight in the Catskills,* Gifford—probably once more with Whittredge (see fig. 26)—was again drawing the panorama of the clove to the west, this time from the north side, on South Mountain.[66] He paused to sketch somewhere on the escarpment trail, perhaps at either of the rocky outcroppings later called Inspiration Point and Sunset Rock.[67] The sketch may have been

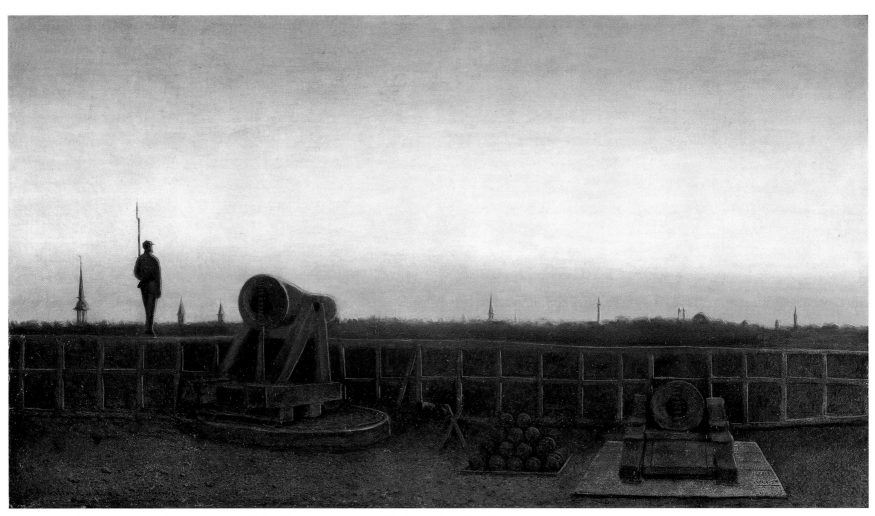

Figure 32. Sanford R. Gifford. *Baltimore, 1862—Twilight.* Oil on canvas. Seventh Regiment Fund, New York

the first of the series that summer that eventually resulted in both the Metropolitan Museum's *A Gorge in the Mountains* (cat. no. 21; until recently, identified variously as *Kauterskill Clove* and *Kauterskill Falls*) and *Kauterskill Clove* (Whereabouts unknown; see the study, fig. 85), exhibited at the National Academy in 1863.[68] He no doubt supplemented his impressions of the site on a much briefer excursion to the Catskills in October of the following year. Home from his military tour in Baltimore in early September, he embarked on a walking tour through the Berkshires with Whittredge and the

sculptor Launt Thompson. Gifford had tried to induce McEntee to join him on a Catskill sketching campaign in the "beautiful Autumn weather," inviting him "to take a day or two . . . to see the color," and adding, "I don't think I can feel quite easy in my conscience to go to [New York] without paying my respects to the mountains."[69] The autumn color that Gifford referred to undoubtedly contributed to the Indian summer warmth of both paintings.

In the pencil version and the oil of *A Gorge in the Mountains,* the conception evolved from a panoramic view of the clove situated amid the mountain

ridges to a vertical image of the site, emphasizing its depth by eliminating the surrounding hills. As seen in the earlier painting (cat. no. 21), the gorge became like a chalice filled with air, which dominates the picture space from edge to edge. In the subsequent work (see fig. 85), the muscular walls of the gorge were compressed and boldly modeled by a sunburst that serves to accentuate them. Gifford's preoccupation with his subject matter at this time appears almost obsessive when one takes into account not only the three successive major pictures but also the many related sketches and studies (four are included here) and several of the variants of *A Gorge in the Mountains*, which would preoccupy him until the end of his life (see fig. 34).[70] The gorge became an archetypal image in his oeuvre, and despite the many times he returned to the locale to sketch there, he was essentially eliciting the scene from his memory and imagination.

The same might be said even for *A Gorge in the Mountains* itself. Through the many stages of distillation of his original record of the site, the artist migrated spiritually from the angst suggested in *A Twilight in the Catskills* of the previous year to a mood of reminiscence and yearning. He articulated his emotions about the Catskills in at least one of the letters he wrote while on duty in Baltimore in July 1862. As he told his friends the Wheelers, "Your most welcome letters came to me last week and made my heart to be glad. Their lively descriptions of the goings on at Nestledown and in the Catskills was almost like being there myself – they somehow make me think I have a right to be there, taking it easy at Nestledown, or climbing with you and Lamb and Mac among the cloves of the Catskills, but when under the hallucination I go to the gate of the Fort and am rudely roused from my dreams by the sentry sharply bringing his musket to 'arms port!' and an abrupt 'Halt'! – 'Your pass'! . . . I find myself obliged to right-about, and limit my walk to the round of the parapet, or mingle again with the busy-idle crowd in the quarters."[71]

One could argue that *A Gorge in the Mountains* merely represents the artist reverting to his signature aerial vision, discernible as early as 1850 in *Scene in the Catskills* (cat. no. 2), which he combined with the brilliant Turneresque sun that he essayed in his first "chief picture," *Lake Nemi* (cat. no. 6), and later adapted to *Mansfield Mountain* (cat. no. 8), but in reprising these features in a vertical composition, Gifford may have perfected his light and atmospheric

Figure 33. Photographer unknown. Sanford R. Gifford on National Guard Duty, early 1860s. Archives of American Art, Smithsonian Institution, Washington, D.C.

aesthetic, as well as his professed ideals of unity and balance, which would characterize his mature works.[72] While the sketches (compare fig. 80 and 81) suggest that the choice of format evolved on paper, it is the oil images (cat. nos. 22–24) that evince a deliberate and progressive distortion of the actual terrain of the clove to echo the sun's circular shape, as if the gorge were somehow its product. The veiled light fills the now-curved contours of the clove, while the birch tree, the rocks in the foreground, and the shadows of the mountain at the right continue the arc of the blue sky around the sun's yellow penumbra. The foreground elements in particular hint at the convention— seen almost too frequently elsewhere in Gifford's work—of the ovate, vignette-like landscape composition, typically realized in a vertical format. Moreover, the delicate reach of the birch tree toward the elusive solar oculus, and the enveloping, womb-like form of the clove in the 1862 picture intimate the progressive anthropomorphism of the conception. It reminds us that the upright format accommodates figural art and portraiture more readily than

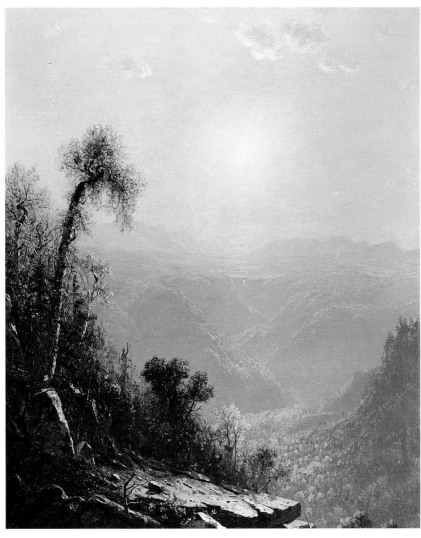

Figure 34. Sanford R. Gifford. *October in the Catskills*, 1880. Oil on canvas. Los Angeles County Museum of Art. Gift of Mr. and Mrs. J. Douglas Pardee, Mr. and Mrs. John McGreevey, and Mr. and Mrs. Charles C. Shoemaker

landscape. In any case, the image evolved into something so highly conceptual that Gifford's use of a generic title that does not identify the site must have seemed to him the most appropriate option at the time.

As Gerald L. Carr has persuasively demonstrated, *A Gorge in the Mountains* and *Kauterskill Clove* were formulated virtually in tandem.[73] The 1861 pencil sketches certainly suggest that both pictures were synthesized from the same original records of the view from the clove to Haines Falls, from Inspiration

Point or Sunset Rock. The 1862 date of *A Gorge in the Mountains* and its exhibition in the Artists' Studio Reception at the Tenth Street Studio Building late that year confirm that it was the first of the two ideas amplified into a large painting; when that picture was sold to Morris K. Jesup, probably in early 1863, Gifford enlarged one of his alternative oil compositions (see fig. 85) of the site. Two such works are known, both showing the artist returning to a more geographically accurate depiction of the clove toward Haines Falls as a mountain cleft, and in each picture he reestablishes the point of view from the north wall of the clove, from where the pencil sketches, too, were made. (Indeed, the lofty viewpoint, well above the foreground elements, makes the spectator feel as if he were hovering high above the scene.) The iconic central axis developed in the earlier picture, including the sun and waterfall, gives way to a more dynamic X-shaped configuration, with the clove as the principal diagonal and the sunburst and the foreground rocks establishing a secondary diagonal thrust. A bear was added on the foreground rocks and, as contemporary descriptions indicate, was retained in the large version.[74] Yet, even there (although the large painting's disappearance makes it impossible today to know for sure), Gifford must have thickened the atmospheric film modifying the prospect to a degree not reflected in the oil studies but approximating that of *A Gorge in the Mountains*. When *Kauterskill Clove* was shown at the National Academy in the spring of 1863, at least some critics seem to have confused it with the painting exhibited at the Artists' Studio Reception late in the previous year. One writer went so far as to say, "We see no reason to revise last winter's verdict [of "the audacity shown by Gifford"], now that ["Kaaterskill gorge"], plus a few more finishing touches, hangs in the Academy."[75] Clearly, the earlier picture had made an indelible impression, and the artist's many subsequent variations on it suggest that he and, presumably, his patrons preferred that version of the subject.[76] Moreover, the next year, at the Academy, he would show that he still had not exhausted his repertoire of dream-like visions from South Mountain.

Gifford included a sunburst effect similar to that of *Kauterskill Clove* in his 1864 *Camp of the Seventh Regiment, near Frederick, Maryland, in July 1863* (cat. no. 34), which was prompted by his last tour of duty with the National Guard, from July to August 1863. He left the regiment about the time (August 8) that

his brother Edward, a major in the 128th New York Regiment, died in Louisiana, several weeks after escaping from a Confederate prison and swimming across the Mississippi River. The turning point of the war had occurred at Gettysburg in early July, and, from the camp at Frederick, Gifford witnessed both the retreating Confederate forces and the Northern armies marching south through the Washington, D.C., area.[77] Then, Gifford and his regiment were called upon to help put down the draft riots raging in New York City in mid-July. Ironically, as he reported, it was the only time that he fired his gun in action: "We popped away wherever a head popped out [of a window] or a man appeared on a roof." This latest call to action left Gifford drained, and he hoped "there will soon be enough U.S. troops to let us off."[78] With the death of his brother Edward only weeks later, the events of that summer were devastating enough for Gifford and his family to end his soldiering for good.

Liberated from military duty but no doubt emotionally oppressed by his brother's passing, he chose the deep forests of the Adirondacks as his primary destination for two weeks in September 1863, traveling north past Lake George and Lake Champlain. On this trip, Gifford made the drawings (see fig. 94) that became the brooding and almost surrealistic *A Coming Storm* (cat. no. 29), believed to have been finished and sold in 1863, according to the *Memorial Catalogue*, number 718 (at least one of the oil studies for the picture is dated that year, and was originally—and erroneously—identified as a Catskills scene).[79] It would be hard to dismiss the supposition that the transcendent light beneath the arcing pall of rain clouds in that picture reflected the artist's grief and stoicism following Edward's recent death. For Edwin Booth, owner of the *Coming Storm* (presumably cat. no. 29), the picture came to signify mourning, for the actor exhibited the painting at the National Academy in April 1865 after the assassination of President Lincoln by John Wilkes Booth, his brother, who, in turn, was himself shot weeks later by Federal troops. Herman Melville acknowledged the picture's tragic import for Edwin Booth in a poem that alludes to the painting's title.[80]

The artist's testimony does not actually indicate that he visited the Catskills in 1863, but such a trip is suggested by a number of works: a few thumbnail compositions of Kaaterskill Clove that immediately follow the Adirondack drawings in his 1863 sketchbook; at least two oil studies, recorded in the *Memorial Catalogue*, of views from South Mountain, one of which is dated 1863; and the exhibition at the National Academy the following year of a large picture, *South Mountain—Catskills* (Whereabouts unknown; see the discussions for cat. nos. 54, 55).[81] The last picture was shown along with *Twilight in the Adirondacks* of 1864 (Adirondack Museum, Blue Mountain Lake, New York; see cat. no. 37), and its reported emphasis on atmosphere may have represented a calculated alternative to the scene of the Adirondacks at dusk. What is clear from descriptions of the South Mountain picture is that it was not a view *of* the mountain but, as the titles of the two oil sketches indicate, *from* it. The viewpoint from the escarpment trail shifted from Haines Falls in the southwest (as in *A Gorge in the Mountains* and *Kauterskill Clove* of the two preceding years) to the Hudson River Valley in the southeast. In size, *South Mountain* was nearly identical to *The View from South Mountain, in the Catskills* (fig. 136), of nine years later, and it also must have closely approximated the later picture in its atmospheric qualities: The critic Clarence Cook harshly attacked Gifford for "dissolving the mountain side [opposite the viewer] and the valley in vapor."[82] In his opinion, this strategy robbed the spectator of a sense of height. Yet another visitor to the exhibition, evidently familiar with the panorama as seen from the escarpment trail, reveled in those glimmering focal details—"the winding Hudson with its tiny sails, the square dent where lies the lake in the Shawangunk range"[83]—that the artist would articulate in his otherwise filmy vista. It is probably a measure of the similarity between the two large South Mountain views that Gifford exhibited the later work at the Brooklyn Art Association in 1873 but did not send it to the Academy in 1874.[84]

The 1864 season marks the only certain interruption in Gifford's annual Catskill sojourns in the Civil War years and in the major pictures that usually resulted from these trips. On his principal summer sketching tour, in July–August 1864, Gifford visited Mount Desert Island (see cat. no. 39) off the coast of Maine, the White Mountains of New Hampshire, and the New England coast with his sister Mary; then, in September, he and Whittredge went on a camping trip into the Shawangunks, several miles south of the Catskills.[85] This last excursion was the source of the variant views of the so-called Trapps of the Shawangunks that Gifford and Whittredge sent to the National Academy

in the spring of 1865: Whittredge submitted the aforementioned *Twilight in the Shawangunks* (fig. 107), which evokes his colleague's *A Twilight in the Catskills* (fig. 12), and Gifford was represented by *The Shawangunk Mountains* (Whereabouts unknown; see cat. no. 36), which probably approximated the aerial effects of *South Mountain—Catskills.*[86]

Gifford's share in the national trauma of Lincoln's assassination in April 1865 might be said to have been manifested that spring in the exhibition of his painting *Coming Storm.* However, the country's loss in 1865 both preceded and followed personal ones for the artist: In January, his surviving older brother, Frederick, died, and in late August, while Gifford was revisiting the White Mountains, his companion, the artist James Suydam, fell seriously ill. Gifford nursed him even after the arrival of Suydam's kin, who insisted that Gifford leave when he himself became sick. Suydam died only days later.[87] Gifford admitted to having been "troubled" in the winter of 1864–65, and it must have been with a mixture of exhaustion and relief that, in late September, he visited his familiar Catskill haunt of South Mountain, very likely with Whittredge and McEntee.[88]

Gifford's initial activity at South Mountain remains somewhat puzzling, for he made two drawings of the scene, and as many as five oil sketches and studies in just a few days (see cat. no. 55), despite the fact that, only recently, he had completed the large picture *South Mountain—Catskills* and exhibited it in 1864.[89] These multiple images suggest that he wanted to give the subject yet another try; however, they languished until 1873, when he took up the theme again and produced one more large picture (see fig. 136). Furthermore, in the same sketchbook he also reprised several other subjects that he had painted before, among them the view toward Haines Falls and the Catskill Mountain House as seen from North Mountain.[90] Thus, Gifford's autumn visit to the Catskills in 1865 took on the quality of a deliberate review of the sites that he had made his own artistically in the Civil War era.

However, among those drawings cited, a single one, depicting cleared forests and farmland with Hunter Mountain as a backdrop (see fig. 113), is new. It is also the only certain graphic source for *Hunter Mountain, Twilight* (cat. no. 41), perhaps Gifford's most memorable painting, which he sent to the National Academy in 1866 and to the Paris Exposition Universelle the

following year. Given the range of subjects in the 1865 Catskill drawings (described above), the artist followed a certain logic in going to Hunter Mountain. Rising over 4,000 feet and then thought to be the tallest summit in the Catskills, Hunter Mountain therefore was a landmark, and the most prominent mountain visible beyond those that overlooked the clove itself.[91] It forms the background of the prospect from Kaaterskill Falls and could be seen as well from Inspiration Point and Sunset Rock on the escarpment trail. To approach it, Gifford and his companions had to walk southwest to the Catskill Plateau in the town of Haines Falls, above the present-day community of Twilight Park, and they all recorded the experience.[92] Gifford's drawing and, especially, an 1866 painting by Whittredge (see fig. 35) may indicate why the locality had not attracted them before. The countryside was largely cultivated, and in the foreground the artists depict a rock- and stump-strewn slope, picket fences, and a house nestled in the middle distance. Whittredge's painting, a remarkably uninflected late-morning view, represents farmland extending as far as the base of the mountain and divided by thin stands of autumn trees, while the brown slopes of Hunter Mountain itself suggest bare foliage at the higher altitude. If the view appears to have little appeal as a subject for a landscape—and Whittredge's interpretation, it must be said, is hardly compelling—Gifford's interest may have been prompted by his earlier study (see fig. 111), in the same sketchbook, of a settler's log cabin beneath Mount Hayes near Gorham, New Hampshire, drawn in late August (just before the onset of Suydam's illness). In New Hampshire, Gifford had devoted several sketchbook pages to gathering the pictorial data he would need for *A Home in the Wilderness* (cat. no. 40), the painting he began the following fall or early winter. The view toward Hunter Mountain probably affected him in a comparable way but, as Weiss has suggested, it intrigued him less as a wilderness outpost than as a secondary settlement on redeveloped land.[93] (The locale may have been a site on which hemlock trees were stripped for the tanning industry; until about 1850, the land at the base of Hunter Mountain was occupied by one of the largest tanneries in the Catskills.)[94] Moreover, even in his sketch, Gifford seems to have perceived in the view pictorial rhythms that Whittredge ignored: for example, an attenuated oval suggested by the echo of the mountain ridge in the terrestrial basin subtly fashioned from the trees,

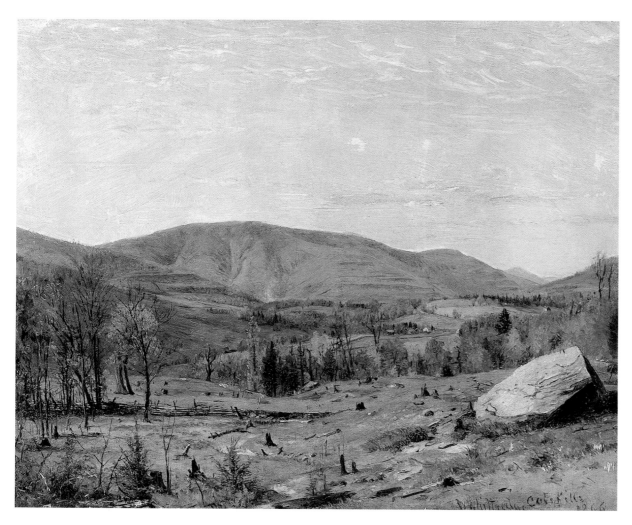

Figure 35. Worthington Whittredge. *Autumn, Hunter Mountain*, 1866. Oil on board. Private collection

the stumps, and the stones. The artist clarified the correspondence of curved forms in the successive oil studies (see fig. 114), so that, in the final version, the terrain appears to dip expressively in the foreground, accented by the withered stream reflecting the sky, as if the land were yielding to the weight of the mountain.

The key to the mournful emotional resonance of the setting, however, is the selection of twilight to illuminate it. Given the size of the painting, its broad proportions, and the Catskill subject, one naturally traces its roots to the 1861 *A Twilight in the Catskills* (fig. 12). With its barely modulated sky, modified texture, and overall warm tonality, *Hunter Mountain, Twilight,* is nowhere near as assertive and momentous as the earlier picture; it appears, rather, to derive its poetic mood from *A Winter Twilight* (cat. no. 28) and, perhaps even

more notably, from *Baltimore, 1862—Twilight* (fig. 32); its relationship to the latter work may not have been simply a formal one. The postbellum overtones of *Hunter Mountain, Twilight,* seem clear within a purely historical and artistic context yet are strengthened by other circumstantial factors: That the picture was sent to the Paris Exposition, partnered with the identically sized *A Home in the Wilderness* (cat. no. 40), suggests that, given their subjects, they were considered as complements, if not actually as pendants. Whether or not *A Home in the Wilderness* was intended as a morning scene (as is proposed in the entry on the picture, below) does little to weaken the impression it conveys of an Early American settlement—like those Cole had painted—whereas *Hunter Mountain, Twilight,* presents an unmistakably rural America, expressing the current postwar mood.[95] Perhaps Jervis McEntee's lost *Virginia in*

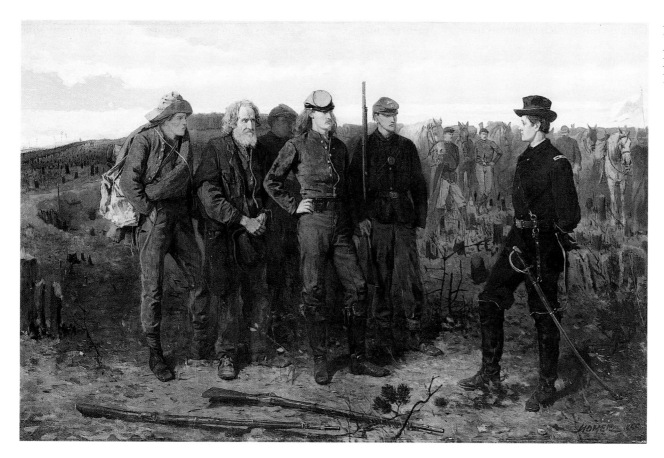

Figure 36. Winslow Homer. *Prisoners from the Front*, 1866. Oil on canvas. The Metropolitan Museum of Art, New York. Gift of Mrs. Frank B. Porter, 1922

1862, with its reported features of abandoned battlefield and ruined homestead, influenced Gifford's taste for such imagery but, regrettably, its effect, if any, cannot be measured.[96]

Another possible artistic context for understanding the unusual iconography of *Hunter Mountain, Twilight*, is the stump-filled battlefield of the exactly contemporaneous *Prisoners from the Front* (fig. 36), Winslow Homer's summary testament to the Union victory, the Confederate defeat, and the mandate for national reunification. Also exhibited at the National Academy in 1866, *Prisoners from the Front* undoubtedly was the most talked-about painting there, and it cemented the reputation of the thirty-year-old Homer, who had been elected to full membership in the Academy only the previous year.[97] He was reported to be at work on the picture in February 1866, precisely when Gifford was putting the finishing touches on his *Home in the Wilderness* (cat. no. 40) and probably just beginning *Hunter Mountain, Twilight*.[98] Although

the two artists were separated in age by nearly a generation, and their studios were in different buildings, there is no question that they knew one another at least through the Academy, and they both had an ardent advocate in the critic Eugene Benson.[99] There is also intriguing circumstantial evidence of Gifford's interest in Homer's Civil War paintings. For example, Gifford's own *Camp of the Seventh Regiment, near Frederick, Maryland, in July 1863* (cat. no. 34), of 1864, his fourth and final military painting, distinguishes itself from his previous three efforts in the care that he lavished on the figural groups and individuals portrayed in various domestic activities—the kind of anecdotal detail more classically and trenchantly represented in Homer's first exhibited painting, *Home, Sweet Home* (fig. 103), shown at the National Academy the year before.[100] This proposed influence on Gifford tends to be supported by his presumed acquisition, later on, of one of Homer's Civil War paintings: the small, upright panel *Trooper Meditating Beside a Grave* (fig. 37), of 1865.

Gifford's father owned this modest but affecting picture, which doubtless had special resonance for a parent of three sons who had died during the Civil War—one of them a direct casualty of the conflict—as it would have had for Sanford, himself a veteran. While the circumstances of the painting's acquisition are not known, Sanford almost certainly was instrumental in obtaining it, and, for a time, may even have owned it.[101]

To be sure, proposing a connection between the expressive use of landscape in *Hunter Mountain, Twilight,* and *Prisoners from the Front* also serves to underscore the gulf—not only in age but in vision—between the Romantic landscape painter on the one hand, and the reportorial figure painter on the other. Assuming that Gifford's picture actually expresses postwar sentiment, unlike *Prisoners from the Front* it does so only obliquely. What is certain, however, is that in 1866, both artists wielded the language of landscape to address—one evocatively, the other explicitly—the somber peace in the Union victory.

A Twilight in the Catskills and *Hunter Mountain, Twilight,* serve as distinctive bookends to Gifford's serious artistic engagement with the Catskills. The latter picture, exhibited at the National Academy in 1866, was the last of his Catskill subjects to be submitted there, although he hardly ceased his nearly annual sojourns to the mountains or his paintings of them. (Gifford actually went to the Catskills twice in 1866, and, during the rest of his life he missed going only four times.)[102] One senses, however, a change in the character of his Catskills visits. McEntee remained a regular companion, but Whittredge less so, and, increasingly, the trips sound more like social parties than sketching campaigns. In the autumn of 1869, McEntee, Eastman Johnson, and their wives joined Gifford at Scribner's; in 1873 and 1874, Gifford's younger sister, Mary, along with Candace and Tom Wheeler, accompanied him to the large, new, and very inviting Laurel House near Kaaterskill Falls.[103]

Accordingly, paintings with Catskill subjects diminished both in number and ambition. In a decade and a half, Gifford painted just four Catskill pictures over twenty inches in either width or height (one was *The View from South Mountain, in the Catskills* [fig. 136]), but at least two and perhaps three of these larger works (see fig. 34) are variations of compositions that originated in the Civil War years (see cat. no. 21).[104] The rest of the works are chiefly sketches, studies, and cabinet paintings, which is not to discount their

quality—many of them, such as *Kauterskill Falls* (cat. no. 52), are gem-like in effect—only to distinguish the artist's level of engagement, as compared with the works from the Civil War years, and, presumably, the varying prestige of the patrons who commissioned or otherwise acquired them.

In accord with the reduced quantity and scale of Gifford's Catskill paintings were the alternative—often more modest—venues he chose for their display, among them, the Century Association, the Union League Club, commercial galleries in New York, art and philanthropic associations, art schools, expositions, fairs, and historical societies in major cities in the United States.

Gifford supplanted the Catskills with landscape subjects that were chiefly European in theme. They were nothing new in his work, but his second trip

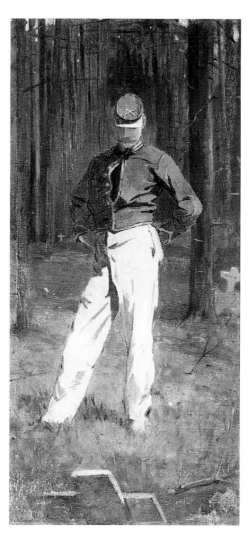

Figure 37. Winslow Homer. *Trooper Meditating Beside a Grave,* 1865. Oil on canvas. Joslyn Art Museum, Omaha. Gift of Dr. Harold Gifford and Ann Gifford Forbes

abroad, in 1868–69, to the Middle East as well as to Europe, would yield a plethora of fresh material for paintings. Moreover, the Gilded Age saw an expanded class of wealthy travelers, who supplied the demand for those subjects. Gifford readily accommodated them, and advertised his new, large Venetian, Greek, and Egyptian views—leavened with images of the Atlantic Coast (see cat. nos. 45, 61, 63), the Hudson River (see cat. nos. 35, 42, 43, 46, 64, 69), and even a scene of the Western Territories, generated by his trip in 1870—that he reserved for the National Academy.[105] Concurrently, the Catskill Mountain House and vicinity had begun to lose some of its novelty and charm for the kind of tourists—aficionados of the picturesque—who had originally flocked to the region and enthusiastically purchased artists' depictions of the local scenery; many of these now had the means to partake of the speedier and safer transportation available and thus to travel farther afield.[106] While Gifford would not entirely follow in their wake and desert his beloved Catskills, neither could he ignore the dictates of the art market. By the time of the Centennial, to be American was to be cosmopolitan.

The author wishes to acknowledge the fine scholarship of Ila Weiss, Kenneth Myers, and Adam Greenhalgh, whose work, respectively, on Sanford R. Gifford, the culture of the Catskills, and Gifford's *Twilight in the Catskills* is liberally reflected in the text and frequently cited in the notes to this essay. For assistance with research, the author is grateful to Vivian Chill, Claire Conway, Ethan Lasser, and Catherine Lawrence.

1. "Address by W. Whittredge," in *Memorial Meeting*, pp. 33–34, 43.

2. *A Memorial Catalogue of the Paintings of Sanford Robinson Gifford, N.A., with a Biographical and Critical Essay by Prof. John F. Weir, of the Yale School of Fine Arts* (New York: The Metropolitan Museum of Art, 1881); hereafter, *Memorial Catalogue*.

3. Ibid., p. 15, no. 39.

4. See [Freeman Hunt], *Letters About the Hudson River, and Its Vicinity, Written in 1835–1837*, 3rd ed. (New York: Freeman Hunt & Co., 1837), p. 216; Ruth Piwonka and Roderic H. Blackburn, *A Visible Heritage, Columbia County, New York: A History in Art and Architecture* (Kinderhook, New York: The Columbia County Historical Society, 1977), p. 126.

5. This summary of Hudson's history is assembled from the following sources: John Bevan and N. Colchester Yron, *Historical, Descriptive and Illustrated Atlas of the Cities, Towns and Villages on the Lines of the Hudson River & New-York Central Railroads with Views of Factories and Works of Principal Business Firms* (New York: Francis Hart & Co., 1862), p. 54; Carmer 1968, p. 127; and Arthur G. Adams, *The Hudson Through the Years*, 3rd ed. (1983; New York: Fordham University Press, 1996), p. 34.

6. Bevan and Yron, *Historical, Descriptive and Illustrated Atlas*, p. 54; Carmer 1968, pp. 125–29.

7. Ellis 1878, p. 185; Charles Elliott Fitch, *Encyclopedia of Biography of New York*, 8 vols. (1916–25; New York: The American Historical Society, 1923), p. 282.

8. Fitch, *Encyclopedia of Biography of New York*, p. 282; Stephen B. Miller, *Historical Sketches of Hudson, Embracing the Settlement of the City, City Government, Business Enterprises, Churches, Press, Schools, Libraries, & c.* (1862; reprint, Hudson, New York: Hendrick Hudson Chapter, National Society of the Daughters of the American Revolution, 1985), p. 42; "Death of Elihu Gifford," *Hudson Register*, May 9, 1889, clipping in McEntee Diaries, May 2, 1889.

9. Fitch, *Encyclopedia of Biography of New York*, p. 282; Miller, *Historical Sketches of Hudson*, p. 84.

10. Ellis 1878, p. 185; Miller, *Historical Sketches of Hudson*, pp. 72, 118.

11. Letter from Charles Gifford to Mary Child, his future wife, October 8, 1850, in Gifford Family Records and Letters, vol. 1; quoted in Weiss 1987, p. 53.

12. According to his friend John Ferguson Weir, Gifford had told his mother before his death that "she must be satisfied with his faith" for "he did not feel with her the necessity for formal professions." Letter from John Ferguson Weir to Mrs. Weir, September 1, 1850; quoted in Weiss 1987, p. 40.

13. See W. V. Hackett, *The Hudson City and Columbia County Directory, for the Year 1862–3 . . .* (Albany, New York: J. Munsell, 1862), p. 34; *Columbia County at the End of the Century: A Historical Record of Its Formation and Settlement, Its Resources, Its Institutions, Its Industries, and Its People . . . Published and Edited under the Auspices of the Hudson Gazette*, 2 vols. (Hudson, New York: The Record Printing and Publishing Co., 1900), vol. 1, pp. 343–44; Fitch, *Encyclopedia of Biography of New York*, p. 282: William H. and James Gifford, the fourth and fifth sons of Elihu, purchased the Gifford foundry on Columbia Street from their father in 1863, the year that Edward Gifford, Elihu's sixth and youngest son, died in the Civil War. Before the death of Frederick Gifford, Elihu's second son, in 1865, the city directory listed him as a dealer in agricultural implements, and living, along with William, in his father's house at 336 Diamond Street (James lived at 335 Diamond). See also the letter from Dr. Sanford Gifford to Ila Weiss, August 8, 1966 (Archives of American Art, Reel 688, frame 3), in which James's extensive traveling earlier in his life for his "ill health" is compared with Charles's psychic maladies.

14. Letter from Charles Gifford to Mary Child, October 8, 1850, in Gifford Family Records and Letters, vol. 1.

15. Weiss 1987, pp. 52–53, 90; see also Charles's 1859–60 correspondence in Gifford Family Records and Letters, vol. 1, especially the letter from Charles to Mary Child Gifford, New York, January 20, 1859, describing his water-cure therapy at

"Dr. Taylor's" on Sixth Avenue. Charles's condition is also discussed in a letter from Dr. Sanford Gifford to Ila Weiss, August 17, 1966 (Archives of American Art, Reel 688, frames 1–3).

16. The most notable expression of this malaise occurred in Rome in the winter of 1857 when, in a letter to his father, he referred to his "depression of spirits. This has delayed and injured my work, which has made the matter worse. . . . My bodily health is not bad—a headache is all that troubles me. I struggle against this depression, but have not been able to shake it off. Were the spring open I would leave Rome and seek some relief in the variety and excitement of traveling." Letter from Sanford Robinson Gifford to his father, Elihu Gifford, February 5, 1857, in Gifford, European Letters, vol. 1, p. 125. See also the letter from Sanford Robinson Gifford to his sister Mary, April 27, 1863, in which he speaks of being "disabled from work for a month past—not thoroughly sick, but just enough out of tune to prevent my doing anything." He continues, "Yesterday for the first time I got to work again. Oh! what a pleasure it is after so long a period of imbecility to feel the returning power and capacity of work!" At the Century Association Memorial Meeting in honor of Gifford, in November 1880, John Ferguson Weir summarized Gifford's psychological vulnerability in euphemistic terms: "[Gifford's] placidity of . . . surface was an indication of the depth of the stream that flowed within, whose floods, and swirls, and eddies often caught him from the light and carried him into cavernous depths of shade; but there was a stoicism in GIFFORD's character that never forsook him" (see Weir 1880, p. 12).

17. See the excellent chapter, "Poetry: A Circle of Friends," in Weiss 1987, pp. 21–45, in which Gifford's cultural community in New York is discussed. See also the accounts of Gifford's personality and demeanor in Weir's, Whittredge's, and Jervis McEntee's remarks in *Memorial Meeting*, pp. 12, 29–30, 35, 39–43, 52–53; and *The Art Journal* 1880, p. 319.

18. Gifford, Frothingham Letter, manuscript (Collection Sanford Gifford, M.D.). As early as 1855, Gifford wrote to his father after his first visit to the National Gallery in London, "Most of these pictures have been familiar to me since I was a child, when I used to delight in overhauling Charles' prints in his sanctum in the old house. . . . So I found myself quite at home when I came in the presence of the originals" (Letter from Sanford Robinson Gifford to his father, Elihu Gifford, London, June 8, 1855; in Gifford, European Letters, vol. 1, p. 20).

19. "Obituary," *The Crayon* 6, no. 4 (April 1859), p. 132; on Ary see also Minick 1950.

20. See Weiss 1987, p. 49; see also the letter from Charles Gifford to Sanford Robinson Gifford, December 24, 1849, in Gifford Family Records and Letters, vol. 1. Charles also displayed in his house a picture entitled *My Own Mama* by Frederick, evidently an amateur painter himself, but admitted to Sanford, "[I] wish I had another [of your own] in place of 'My Own Mama'."

21. See the letter from Charles to Sanford cited in note 20, above.

22. Besides figure 17, see *Memorial Catalogue*, nos. 200, 208, and 224.

23. *Hudson River Highlands* (Private collection), a 5½ x 10-inch canvas now mounted on board, illustrated in Weiss 1987, p. 261, and dated to about 1867, may be identifiable with one of three small, undated Hudson River "sketches" (numbers 472–

474), approximating its size, listed under "Studies and Sketches of uncertain date, probably between 1857 and 1868" in the *Memorial Catalogue*.

24. The relationship of the 1866–68 Hudson River views to the slightly earlier and contemporaneous paintings of the New England and New Jersey shore was first suggested in Weiss 1968/1977, pp. xvii, 271–72. Paintings of identical or related subjects by other artists include James Suydam's *Hook Mountain, Hudson River* (about 1863; Whereabouts unknown), cited in Weiss 1987, p. 260; Albert Bierstadt's *View on the Hudson Looking Across the Tappan Zee Toward Hook Mountain* (1866; Private collection); and Samuel Colman's *Looking North from Ossining, New York* (1867; Hudson River Museum, Yonkers, New York).

25. For example, Thomas Cole's *Lake with Dead Trees* (1825; fig. 63), and *Kaaterskill Falls* (1825, Whereabouts unknown; 1826 replica, Wadsworth Atheneum, Museum of Art, Hartford); the pictures are discussed in Parry 1988, pp. 23–24, 40–43.

26. See [James K. Paulding], *The New Mirror for Travellers; and Guide to the Springs, by an Amateur* (New York: G. & C. Carvill, 1828), p. 144: "Messrs. Wall and Cole, two fine artists, admirable in their different, we might almost say, opposite styles, have illustrated the scenery of the Kaatskill, by more than one picture of singular excellence"; [A. T. Goodrich], *The North American Tourist* (New York: A. T. Goodrich, 1839), p. 34: "There are other inducements for travelers disposed . . . to seek out gratification and amusement to visit [Kaaterskill Falls] and the other spots that the magic touches of Cole the artist have brought to the public admiration." These and other guidebooks on or including the Catskill resorts are surveyed in the excellent catalogue by Myers et al. 1987, pp. 33–71 (citations above on p. 49).

27. See Myers et al. 1987, pp. 33–37. On the importance of Irving and Cooper to the popularization of the Catskill Mountain resorts see also Van Zandt 1966, pp. 42, 193–94.

28. Leatherstocking's remarks on the view from the escarpment and of a nearby two-tiered waterfall that is unmistakably Kaaterskill Falls are quoted in Myers et al. 1987, p. 35.

29. The history of Catskill roads and turnpikes is summarized in Myers et al. 1987, pp. 29–32; and Evers 1972, pp. 389–91.

30. In the 1830s, Cole visited Europe twice, and his major projects were his two allegorical series, "The Course of Empire" (1834–36; The New-York Historical Society) and "The Voyage of Life" (1840; Munson-Williams-Proctor Institute, Museum of Art, Utica, New York). His landscapes from the same period, many of them showing views of the Catskills from the village of Catskill where he lived, are illustrated and discussed in Parry 1988, pp. 107–290, esp. pp. 286–90; see also Myers et al. 1987, pp. 114–18.

31. *Memorial Catalogue*, p. 13, no. 1.

32. Beach's and Scribner's enterprises are described in Myers et al. 1987, pp. 66–69, and in Van Zandt 1966, pp. 45–70. For a discussion of Cole's *View of Two Lakes and the Mountain House* see Parry 1988, pp. 303–5, and Myers et al. 1987, pp. 117–18. Gifford certainly was a guest at Scribner's, but his only documented stay there was with Jervis McEntee and Eastman Johnson and their wives in September 1869 (Weiss 1987, p. 126). Whittredge (Baur, ed. 1942, p. 59) identified "Scribner's Boarding

House" as the "little house in Kaaterskill Clove" that Gifford had discovered "many years ago" and to which he attracted a whole company of artists; Scribner's, however, was above Kaaterskill Falls.

33. Church's acceptance by Cole as his pupil is described in Parry 1988, pp. 299–300, and Cole's other student, Benjamin McConkey, whom he took on in 1845, is discussed on pp. 311, 321; see also Kelly et al. 1989, pp. 34–35.

34. Church and Gifford were both among the original tenants of the Tenth Street Studio Building, and Church's Civil War–era paintings exerted a significant influence on Gifford's work. Only in the 1870s, however, can their friendship be substantively documented: In 1877 and in 1879, Gifford accepted Church's invitation to join him, his wife, and several others at Church's campsite on Lake Millinocket in Maine (see cat. no. 68). Church also served as a pallbearer at Gifford's funeral in Hudson, New York. For a description of the Maine outings see Weiss 1987, pp. 148–49, 156–57, 159–60.

35. Cole's and Church's Catskill excursions are documented in the scores of drawings (Cooper-Hewitt National Museum of Design, New York) that the younger artist made and annotated with place names and dates in the summers of 1844 and 1845; these are cited in Huntington 1960, pp. 19–20. Gifford, in the autobiographical letter to the Reverend O. B. Frothingham, of November 6, 1874 (Gifford, Frothingham Letter, manuscript, Archives of American Art, Reel D10, frame 1220), claimed to have sketched in 1846 in the Catskills as well as in the Berkshires, where Church (Huntington 1960, p. 20) was active that summer.

36. Weiss 1987, p. 177. For a thorough consideration of Durand's *plein air* studies see David B. Lawall, "Asher Brown Durand: His Art and Art Theory in Relation to His Times," Ph.D. diss., Princeton University, 1966 (reprint, New York and London: Garland Publishing, 1977), pp. 319–80.

37. Weiss (1987, pp. 177–78) proposed a connection between the sketch and the figure in *Scene in the Catskills*. See AAFA and AAU Exhibition Record 1953, p. 145 (1850), no. 33.

38. Gifford's "A List of Some of My Chief Pictures" was appended to the autobiographical letter he wrote to O. B. Frothingham on November 6, 1874; see Gifford, Frothingham Letter, for the location of the various copies.

39. See, for example, the often-cited letter from Sanford Robinson Gifford, Mount Clare Station, Baltimore, July 27, 1862, to Candace and Tom Wheeler, beginning "My dear friends at Nestledown," in Gifford Family Records and Letters, vol. 1.

40. See Weiss 1987, pp. 51–53, 97–98. See also the letters from Charles and Mary Gifford to Elihu and Eliza Starbuck Gifford, October 1, 1860, and November 9, 1860, discussing Charles's last illness; the postscript by Alice Carter Gifford describing Charles's death; and "Notes from [the] Journal of James Gifford [brother of Sanford], 1829–1905," which contains an account of Edward Gifford's death, in Gifford Family Records and Letters, vol. 1.

41. See Weiss 1987, pp. 83–84. See also the letter from Elihu Gifford to Mary Child Gifford [widow of Charles], October 24, 1863, in Gifford Family Records and Letters, vol. 1, in which Gifford's father mentions how much Mary, Julia, and Sanford enjoy their stays with "friends at Jamaica, L.I."

42. The 1860 sketchbook of Maryland, Virginia, and New York subjects is inscribed "S R Gifford 15 10th St. New York, 1860" (Harvard University Art Museums, Cambridge, Massachusetts), and on microfilm (Archives of American Art, Reel 688, no. 8, frames 322–331). On Whittredge's early career in New York see Janson 1989, pp. 70–81; and Myers et al. 1987, p. 191.

43. Baur, ed. 1942, p. 59.

44. Brockett's is identified in Weiss 1987, p. 90, and in Myers et al. 1987, pp. 134, 137 n. 9.

45. Myers et al. 1987, p. 137 n. 10, cites July 1860 Catskill sketches by McEntee in the collections of the Corcoran Gallery of Art, Washington, D.C.; Yale University Art Gallery, New Haven; and Albany Institute of History and Art, New York. See also figure 26. Gifford's portrait sketch of Whittredge includes the back of another figure, probably McEntee.

46. "Address by Jervis McEntee," in *Memorial Meeting*, p. 49.

47. On McEntee see Kevin J. Avery, "McEntee, Jervis," in *ANB* 1999, vol. 15, pp. 33–35; Sweeney 1997; and Myers et al. 1987, pp. 163–64.

48. Weiss 1987, pp. 22–26, describes Taylor's close ties to McEntee and Gifford.

49. Taylor 1860, pp. 40–46.

50. Ibid., p. 42.

51. Ibid., p. 43.

52. Ibid.

53. Richards 1861, p. 145.

54. *The Scenery of the Catskill Mountains . . .* (1842; New York: D. Fanshaw Publisher [1860 ?]), p. 48.

55. The drawing is in the 1860 sketchbook of Maryland, Virginia, and New York subjects, inscribed "S R Gifford 15 10th St. New York, 1860" (Harvard University Art Museums, Cambridge, Massachusetts), and on microfilm (Archives of American Art, Reel 688, no. 9, frame 322).

56. Ibid.; see also Greenhalgh 2001, p. 58.

57. Cook 1861.

58. See Sheldon 1877, p. 285: "The popular estimate nettled him. [Gifford] saw other things in Nature as beautiful as an Indian-summer landscape. He resolved to show that he could produce them also."

59. For a full discussion of the relationship between Church's and Gifford's pictures see Franklin Kelly's essay in this catalogue; for the definitive treatment of Church's *Twilight* and its relationship to *Our Banner in the Sky* see Kelly 1988, pp. 119, 123–24.

60. See Weiss 1968/1977, pp. 204–5.

61. Ibid.

62. See especially the letters from Charles to Mary Child Gifford, January 20 and February 3, 1859, addressed from "Dr. Taylor's / Cor. 38th St. & 6th Ave. / New York," describing his treatment and his thoughts "of self-destruction as the only means of escape" from his condition. In the second letter he recounts a visit to Sanford's studio, where his brother was at work on a large picture. See also the letter from Charles Gifford to his parents, October 1, 1860, in which he tells them what "great pleasure [it is] for me to have [siblings] Mary, Sanford, and William

here—though I am sorry enough not to have been able to make their visit as interesting as it ought to have been." Earlier in the same missive he details his extreme mood changes: "Sometimes it seems bright and hopeful—at others, so dark and cheerless that I have not the heart to think of it. These fluctuations have been so violent and of so long continuance as to have induced a disordered state of mind and body which greatly aggravates the original difficulty"; in Gifford Family Records and Letters, vol. 1.

63. See Weiss 1987, pp. 92, 94–95, 228.

64. Sweeney 1997, p. 8.

65. Franklin Kelly, "Thomas Worthington Whittredge (1820–1910), *Twilight on the Shawangunk Mountains*," in *American Paintings from the Manoogian Collection*, exhib. cat., Washington, D.C., National Gallery of Art and traveled (Washington, D.C.: 1989), p. 26.

66. The drawing is in the 1860–63 sketchbook of New York subjects, inscribed "S R Gifford 15 10th St. New York" (Harvard University Art Museums, Cambridge, Massachusetts), and on microfilm (Archives of American Art, Reel 688, no. 9, frame 350).

67. Sunset Rock and the view of Haines Falls as seen from it are the subjects of two engravings postdating Gifford's earliest paintings of the clove from that location; one is Thomas Nast's *Sketches Among the Catskill Mountains* (1866), the other, by Harry Fenn, was published in William Cullen Bryant's *Picturesque America*, vol. 2 (New York: D. Appleton and Company, 1874), p. 131. Both are discussed and illustrated in Myers et al. 1987, pp. 55, 131–32, pl. 89.

68. With regard to Gifford's Kaaterskill Clove paintings of 1862 and 1863, summarized in catalogue numbers 21–25, their original identities, the chronology of their formulation in the studio, relevant exhibitions, and press responses are thoroughly explicated in Carr 2003.

69. See Weiss 1987, p. 95; Letter from Sanford Robinson Gifford to Jervis McEntee, October 8, 1862; Fineberg Papers, Archives of American Art, Reel D30, frames 437–438.

70. The *Memorial Catalogue* lists three studies or sketches of Kaaterskill Clove, numbers 264, 265, 270, dated or sold in 1862. Number 307, "Kauterskill Clove,—a Study for a Picture," is listed with paintings dated 1863; numbers 295–303, one of which (302) is dated 1863, and numbers 306–319 all have titles locating the subjects in or around Kaaterskill Clove. Number 317, "A Sketch of the Hudson River Valley, from South Mountain, in the Catskills," also is dated 1863.

71. Letter from Sanford Robinson Gifford, Mount Clare Station, Baltimore, July 27, 1862, to Candace and Tom Wheeler, beginning "My dear friends at Nestledown," in Gifford Family Records and Letters, vol. 1.

72. For Gifford's aesthetic ideals see the essay by Franklin Kelly, above; see also Weiss 1987, pp. 31–33.

73. Carr 2003.

74. "National Academy of Design. First Gallery," *The World* (New York), April 24, 1863, p. 4; quoted in Carr 2003.

75. *The New York Evening Post*, May 16, 1863; cited in Carr 2003.

76. Besides figure 34, see also *Autumn in the Catskills* (1870–71; The Parthenon, Metropolitan Board of Parks and Recreation, Centennial Park, Nashville; *Memorial Catalogue*, no. 578), illustrated in Weiss 1987, p. 292; *October in the Catskills* (1880; Private collection; *Memorial Catalogue*, no. 719), illustrated in *The Hudson River School: Congenial Observations*, exhib. cat., New York, Alexander Gallery (New York: 1987), no. 17. In addition, Gifford produced several versions of a variation of *A Gorge in the Mountains* identified at the time, mistakenly or not, with Adirondack scenery; this was *An October Afternoon* (1865; Unknown private collection), exhibited at the National Academy of Design in 1866. With the title *Sunset in the Adirondacks*, it was included (and illustrated) in Cikovsky 1970, p. 56, possibly in a cut-down state; a version of the same picture was illustrated as an engraving in G. W. Sheldon, *American Painters* (Sheldon 1881), opposite p. 15. (More than any of the paintings, the engraving depicts mountain and lake imagery more identifiable with the Adirondacks.) At least three related small paintings are known: *An October Afternoon, a Small Study* (1865; possibly *Memorial Catalogue*, no. 411; Robert Hull Fleming Museum, University of Vermont, Burlington), and *An October Afternoon* (1868; Private collection; *Memorial Catalogue*, no. 464), both illustrated in Weiss 1987, p. 252, and *An October Afternoon* (n.d.; Private collection).

77. See Weiss 1987, pp. 97–98, 228–29; for more on Edward Gifford's Civil War involvement and the circumstances of his death see Anna R. Bradbury, *History of the City of Hudson, New York, with Biographical Sketches of Henry Hudson and Robert Fulton* (Hudson, New York: Record Printing and Publishing Co., 1908), p. 161, and "Notes from the Journal of James Gifford, 1829–1905," in Gifford Family Records and Letters, vol. 1. For Sanford Gifford's description of his camp at Frederick, Maryland, see the letter to his father, Elihu Gifford, July 9, 1863, in ibid.; quoted in catalogue number 34.

78. Letter from Sanford Robinson Gifford to "Phoebe," July 18, 1863, in Gifford Family Records and Letters, vol. 1.

79. See Weiss 1987, pp. 238–39.

80. Herman Melville, "'The Coming Storm'; A Picture by S. R. Gifford, and owned by E. B. Included in the N. A. Exhibition, April, 1865," in *Battle-Pieces* (1866), reprinted in Hennig Cohen, ed., *The Battle-Pieces of Herman Melville* (New York: Thomas Yoseloff, 1963), pp. 131–32 (see cat. nos. 29–32).

81. Weiss 1987, p. 99. The Kaaterskill Clove drawings are in the 1860–63 sketchbook of New York subjects, inscribed "S R Gifford 15 10th St. New York" (Harvard University Art Museums, Cambridge, Massachusetts), and on microfilm (Archives of American Art, Reel 688, no. 9, frame 398). See also *Memorial Catalogue*, numbers 317, 318: "A Sketch of the Hudson River Valley, from South Mountain, in the Catskills" and "A Sketch from South Mountain, in the Catskills, looking across the Clove"; number 319 is called simply "A Sketch of South Mountain, Catskills"; the picture exhibited in 1864 is undoubtedly number 348, "South Mountain, in the Catskills. Dated 1864. Size, 22 x 42."

82. Cook 1864b.

83. *The Continental Monthly*, June 1864, p. 686.

84. See Brooklyn Art Association Exhibition Index 1970, p. 202, Dec. '73, nos. 127, 350: Both works are called "South Mountain, Catskills," and both are listed for sale; one of them, a "large and characteristic landscape" presumably identifiable with figure 136, was reviewed in *The Brooklyn Daily Eagle*, December 18, 1873.

85. Weiss 1987, pp. 100–101. The Shawangunk drawings are in a sketchbook of New York, Maine, and Massachusetts subjects executed from 1863 to 1865, inscribed "S R Gifford 15 10th St. New York" (Harvard University Art Museums, Cambridge, Massachusetts), and on microfilm (Archives of American Art, Reel 688, no. 10, frames 401, 443, 473, 474). Shawangunk drawings are also in an 1861–62 sketchbook, inscribed "7th Reg & Catskills, 61" (Albany Institute of History and Art, New York; 1966.13.3).

86. NAD Exhibition Record (1861–1900) 1973, vol. 1, p. 341, 1865, no. 349; vol. 2, p. 1024, 1865, no. 205.

87. Weiss 1987, pp. 103–4.

88. Letter from Sanford Robinson Gifford to Candace and Tom Wheeler [then in Germany], February 1, 1866: "My dear friends . . . I have been troubled very much, as I was last winter, and with the same disinclination to visit anybody, even my near friends," in Gifford Family Records and Letters, vol. 3.

89. Two drawings, including figure 137, of the view from South Mountain, one dated [September] 27, are in a sketchbook of New Hampshire and New York subjects (The Frances Lehman Loeb Art Center, Vassar College, Poughkeepsie, New York; nos. 38.14.4.17, 19; Archives of American Art, Reel 254, frames 112–113). The oil sketches and studies (including cat. no. 55), three of them entitled "A Sketch of a Fallen Tree in the Catskills" and one "A Study of a Fallen Tree-Trunk," are listed in the *Memorial Catalogue* (numbers 398–402).

90. The sketchbook contains New Hampshire and New York subjects (The Frances Lehman Loeb Art Center, Vassar College, Poughkeepsie, New York; 38.14.4). The Catskill Mountain House and Kaaterskill Clove drawings are 38.14.4.24–28, are also on microfilm (Archives of American Art, Reel D254, frames 115–117).

91. See Van Loan 1881, p. 80: "Next to Stony Clove is the Hunter Mountain, 4,052 feet high—the highest peak of the Catskills in Greene County, and the highest peak in sight *from* the Slide Mountain. The owner of the Hunter Mountain, with a clerical friend *and a carpenter's water-level*, made the ascent a year or so ago; . . . and the mountain peak 16 miles away was evidently higher than his favorite mountain; and not until then did it get noised about, and afterwards proved to be a fact, that the Slide Mountain is the highest of the Catskill range."

92. At least two undated paintings of Hunter Mountain by McEntee, showing what appears to be the same homestead as that in Gifford's and Whittredge's pictures, are known: One, *Autumnal Landscape* (Private collection), is illustrated in Myers et al. 1987, p. 164, plate 109; the other, *October in the Catskills* (1866; Collection Albert Roberts), is illustrated in Sweeney 1997, p. 22, plate 10.

93. Weiss 1987, pp. 257, 259. I believe, however, that Weiss mistakenly identifies the planar rock in the left foreground as representing "the ruined masonry of the chimney of the first [settlement on the site]—a log cabin, presumably." The highly striated stone to which she refers, although masonry-like in appearance and undoubtedly sculpted by the artist to coordinate with the ovate composition of the picture, is characteristic of the geology of the eastern Catskills.

94. For a history of the Catskill tanning industry see Evers 1972, pp. 332–50, 384–92; see also Van Zandt 1966, pp. 15–19, 125, 291; Myers et al. 1987, pp. 29–30.

95. See Weiss 1987, pp. 253–57, for her arguments linking Gifford's "home in the wilderness" subjects to Cole's 1847 *Home in the Woods* (Reynolda House Museum of American Art, Winston-Salem, North Carolina).

96. See Sweeney 1997, p. 8.

97. For a thorough discussion of *Prisoners from the Front* see Simpson et al. 1988, pp. 247–59; Cikovsky and Kelly et al. 1995, pp. 26–27, 55–58; and American Paintings in MMA II 1985, pp. 437–45.

98. Cikovsky and Kelly et al. 1995, p. 55; see also catalogue number 40 and the letter from Sanford Robinson Gifford to "My dear friends [Candace and Tom Wheeler in Germany]," February 1, 1866, in which Gifford reported having completed one-and-a-half pictures in his studio that winter. The finished work, described as upright, evidently was *An October Afternoon* (Whereabouts unknown; *Memorial Catalogue*, no. 412: "Dated 1865. Size, 54 x 41."); the other large picture, which was "half done," must have been *A Home in the Wilderness*, which a critic for the *New York Evening Post* (February 27, 1866) referred to as "just finished." *Hunter Mountain, Twilight*, therefore, dated 1866, probably was begun about the same time and completed in time for the National Academy exhibition in April.

99. Benson wrote successively for the *New-York Commercial Advertiser* under the pseudonym "Proteus," and for the *New York Evening Post* under the pseudonym "Sordello." His advocacy of Gifford's work is cited and discussed in Carr 2003, and in Cikovsky and Kelly et al. 1995, pp. 28, 30.

100. For *Home, Sweet Home*, see Simpson et al. 1988, pp. 142–47, and Cikovsky and Kelly et al. 1995, pp. 22–23, 40–41. The proposed relationship between the two pictures is also discussed in catalogue number 34.

101. The painting is discussed at length in Simpson et al. 1988, pp. 227–31. *Trooper Meditating Beside a Grave* is undoubtedly the Homer painting identified simply as "Soldier" in an 1886 codicil to the 1865 "Last Will and Testament" of Elihu Gifford. The picture is included in section E of the codicil's eighth article, listing Elihu's "pictures and other works of art" intended for the children of his deceased son, Charles. Charles's descendants donated the painting to the Joslyn Art Museum in Omaha in 1960, and, as reflected in correspondence in the archives of the museum, their traditionally held belief was that the painting was part of an exchange of pictures between Gifford and Homer, who were also said to have sketched together outdoors. This account has never been verified. I am grateful to Penelope Smith, Registrar at the Joslyn Art Museum, for this information.

102. The 1877 interruption in Gifford's annual visits to the Catskills possibly reflected his marriage, which he did not reveal to friends or family for months. Although Whittredge and McEntee expected Gifford to join them in the Catskills in October 1875, he evidently did not, and probably also skipped the following year. For these

exceptions as well as his Catskill visits see Weiss 1987, pp. 108, 109, 111, 128, 134, 135, 138, 142, 145, 147, 149, 155, 157.

103. Ibid., pp. 111, 138, 142.

104. *Memorial Catalogue*, no. 608 (*The View from South Mountain, in the Catskills*, 1873 [fig. 136]); 618 (*The Path to the Mountain House, in the Catskills* [1874; 27 x 20 in.; Whereabouts unknown]); 712 (*October in the Catskills* [1879; 24 x 34 in.; Whereabouts unknown]); and 719 (*October in the Catskills* [1880; fig. 34]). One other late Catskills painting, no. 724 (*A Mountain Gorge* [Whereabouts unknown]), owned by J. P. Morgan, may well have been a large work, but both its date and size are unrecorded.

105. NAD Exhibition Record (1861–1900) 1973, vol. 1, p. 342, 1874, no. 220, "Sunset on the Sweetwater, Wyoming Ter." (Whereabouts unknown); this is the only picture with a Western subject that Gifford showed at the National Academy of Design.

106. Myers et al. 1987, pp. 74–76.

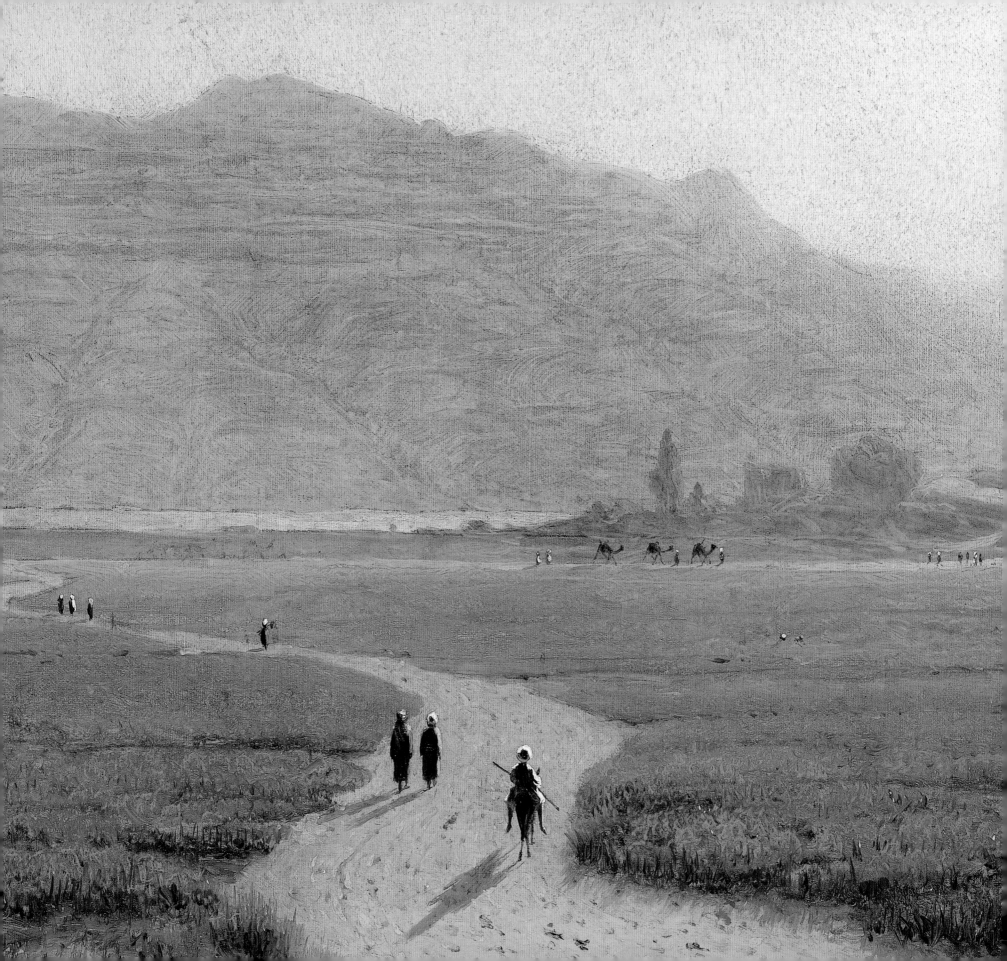

A TRAVELER BY INSTINCT

HEIDI APPLEGATE

> "*[The] record of events relating to the life of our friend Gifford . . . suggest[s] to the mind a wanderer, a pilgrim in search of his Mecca, a fore-taste of which he has given us in his pictures.*"
>
> John Ferguson Weir, 1880[1]

> "*He was a traveler by instinct. . . . I think I could have gone with Gifford to the ends of the earth, and I should have chosen to have gone in his way, for I always found his way was the best way.*"
>
> Jervis McEntee, 1880[2]

Sanford Robinson Gifford's two trips to Europe, one to the Near East, and two to the American West resulted in paintings that comprised nearly half of what he considered to be the best examples of his artistic production.[3] He never spent extended periods of time living abroad (as did Kensett, Whittredge, and Cropsey), but among his contemporaries only Church traveled more widely. Gifford made both of his major trips abroad at the moment when travel to these places was becoming—as Daniel Boorstin has termed it—a commodity, and one could sign on for a package tour. The firm of Thomas Cook advertised its first such tour of the Continent in 1856, and, in 1869, announced its first trip to the Holy Land. The enormous popularity of travel literature throughout the nineteenth century was instrumental in inspiring thousands of Americans to venture across the Atlantic. Paul Fussell describes this "heydey" of travel writing: "For the first time in history, travel was convenient, and ships and trains took you where you wanted to go. At the same time, mass tourism, with its homogenizing simplifications and conveniences, had not yet displaced genuine, individual, eccentric travel."[4] The main distinction between travel and tourism was that the former was work, characterized by uncertainties,

fatigue, and potential danger, while the latter was pleasure seeking, comfortable, and safe: "The traveler was active; he went strenuously in search of people, of adventure, of experience. The tourist is passive; he expects interesting things to happen to him. He goes 'sight-seeing.'"[5] Although Gifford's trips abroad were motivated by different purposes, each fell somewhere between travel and tourism. By contrast, on his trips to the American West, he became part surveyor, part photographer, and part explorer, and adapted his approach to depicting the western landscape accordingly. The ways in which Gifford viewed the various far-flung lands through which he journeyed were affected by his experience of each place, whether as a student, traveler, tourist, or explorer, so that the artistic results of his travels were significantly varied as well.

MAY 1855 – SEPTEMBER 1857

Gifford's first trip to Europe was the standard Grand Tour. His main purpose was to visit the major picturesque sites and the prized art collections through-

Opposite: Sanford R. Gifford. *Siout, Egypt.* Detail of catalogue number 49

out Europe, studying and sketching the Old Masters while personally assessing their worth. He also had secured several commissions for English and Italian subjects that would occupy him during the winter months abroad. Following several weeks in London, Gifford passed three months "walking and sketching, chiefly in Warwickshire, the Lake district and the Scotch Highlands."[6] He spent the first winter in Paris, where he met the artist Jean-François Millet, and was strongly impressed by Barbizon painting. In the spring of 1856, Gifford traveled through Belgium, Holland, Switzerland, Germany, and northern Italy; in the winter of 1856–57, he set up a studio in Rome, among a wide circle of fellow American artists. The following May, he and Albert Bierstadt walked most of the way through the Abruzzi and down to Naples, stayed for a month on the island of Capri, climbed Mount Vesuvius, and visited the ruins of Paestum. Gifford spent two weeks in Venice, traveled through the Tyrol and Bavaria to Vienna and Prague, and then made his way back to Paris and London before sailing home to New York.

Both trips abroad are fully documented in a series of sixty-three letters that Gifford wrote in the form of a journal and sent home to his father, requesting that they be kept together as a record of his travels.[7] Gifford's excitement, upon docking in Liverpool after eleven days at sea, is palpable in his journal entry. He could not fall asleep, for he was overwhelmed by the "sight and touch of this *new* world. . . . Not until I was fairly on shore and snug in my curtained bed, did I feel that . . . in earnest I was a wanderer."[8] His approach to exploring London reflects his general mode of taking in a new city or site on his various travels: "I did not go in [the National Gallery]—nor did I enter Westminster Abbey, the houses of Parliament, or Westminster Hall. . . . I felt like one who has come suddenly in complete possession of a great and long-sought prize. He needs a little time to bring his mind up to the level of his good fortune—he hesitates to enter instantly and rashly upon its enjoyment. I wished also to get rid of the city in some measure by a rapid glance at its general features so that I might bring a more tranquil mind to the examination of objects of special interest."[9]

Gifford's most intense study of art collections and modern exhibitions was conducted in London and Paris in 1855 and 1856. In England, Ruskin was his mental companion as he viewed paintings by European masters as well as British art. He often noted his agreement or disagreement with the author of *Modern Painters,* when, for the first time, he saw the pictures described by Ruskin. Gifford's initial disappointment with Turner's "careless and slovenly" manner was—following a visit and discussion with Ruskin—tempered into an understanding of the importance of the imagination in the realization of paintings that were about "the <u>impression</u> the scene had made on [the artist's] mind, rather than the literal scene."[10] Gifford sketched *Grand Canal, Venice,* and *The Burning of the Houses of Lords and Commons, October 16, 1834* (fig. 38), and wrote, "At last I have seen some really fine Turners." He described both pictures as "splendid in light and gorgeous in color," with "great <u>infinity</u> as well as great indefiniteness in the forms. . . . This kind of Turner must be looked at from a little distance, and the rein given to the imagination. They extinguish every other picture near them."[11]

Such lessons were reaffirmed by his study of Michelangelo's *Slave* in the Louvre, a work that he described as defying any single interpretation, and that "speaks to the imagination, not to the intellect."[12] Gifford devoted considerable time to the study of modern French painting at the annual Salon, and particularly, at the Exposition Universelle of 1855 in Paris, which he visited numerous times. He enjoyed "the rare opportunity . . . of seeing the best in the world brought into immediate comparison—an opportunity which will probably never occur again within my lifetime." In Gifford's assessment, the Americans were "indifferently represented," while the English school, despite including "some of the best works of its living masters," looked "weak and poor . . . beside the vigorous and powerful pencils of the French school. . . . In the French landscape everything like finish and elaboration of detail is sacrificed to the unity of the effect to be produced. . . . The subjects are mostly of the simplest and most meagre description; but by the remarkable truth of color and tone, joined to a poetic perception of the beauty of common things, they are made beautiful."[13]

As Nicolai Cikovsky, Jr., has noted, Gifford "realized new possibilities of pictorial expression" through the study of European art, but his own works did not suddenly become different from those that predated his travels, and he did not "radically [alter] the pictorial formulas that he inherited from Cole."[14] Gifford went on to take great pleasure in his study of the Dutch and

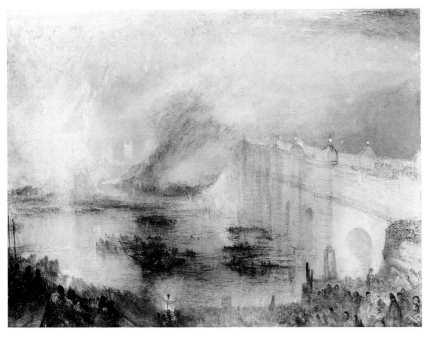

Figure 38. J. M. W. Turner. *The Burning of the Houses of Lords and Commons, October 16, 1834.* Oil on canvas. Philadelphia Museum of Art, John Howard McFadden Collection

Flemish schools, stating, "I leave them with a much higher appreciation of their splendid qualities as painters than I brought with me," but by the end of his stay in Paris, he had solidified his thoughts on the relative value of studying European art. "The harm which sometimes happens to American painters from too long a sojourn in Europe can not come from travel which brings one in constant intercourse with nature. It arises I think from subjecting oneself too long to the influence of a particular school of painting by the extended residence at the seat of that school. It must be beneficial to an artist to be acquainted with those qualities in the different schools which give them their vitality and individuality. He has only to take care that their 'methods' and their 'manners' do not usurp the place of nature with[in] him. As to myself, perhaps I do not surrender myself sufficiently to the influence of the art I find about me. The 'golden mean' in art is about as difficult to follow as it is in life."[15]

Thomas Cole was frequently on Gifford's mind in England—a Canaletto at the National Gallery reminded him of Cole's pure color, and he recalled

Cole's painting (now unlocated) of Kenilworth Castle when sketching there himself. Gifford's assessment of the potential harm of European study echoes the older artist's concern that American painters were in danger of losing the ability to appreciate and depict in a straightforward manner the untainted, "less fashionable and unfamed American scenery" after travel and study in Europe.[16]

To maintain his reliance on the influences of nature, Gifford much preferred traveling on foot through the countryside to sight-seeing in cities, which he termed "the most fatiguing of all occupations," although he diligently made the rounds of all the required attractions. At the end of two weeks, Gifford wrote: "I am quite at home in London now; but I am heartily tired of it and of sight-seeing—of which a good deal remains to be done. It is very laborious business & I long to be away and quietly at work in the country. It will be a fortnight before I can go; there are many pictures that I must see."[17] He expressed similar sentiments in Paris: "I rejoice to say that the tiresome business of sight-seeing draws to a close." He described Versailles, one of his last stops, as "tiresome . . . in the extreme," with its too-grand scale and "wearisome" formality. He found French gardens in general to be "excessively tedious."[18]

Once headed for the country, Gifford pared down his luggage, taking only what he needed for each excursion and sending some of his things home and his trunk ahead to the next major city. Gifford's packing list is so close to the famous advice provided by Bayard Taylor in *Views A-Foot* as to seem modeled on it. In his extraordinarily successful account of European travel, Taylor recommended carrying no more than "fifteen pounds . . . knapsack included. A single suit of good dark cloth, with a supply of linen, will be amply sufficient."[19] His list also included a slouched hat, a good cane, a guidebook, pocket compass, and one or two pocket editions of classic authors. When Gifford left London for the countryside, he wrote: "I had the curiosity to put my haversack on the scales of a weigher who has his station here. . . . The weight of my bag and its contents was fifteen pounds. In it I have three shirts, one pair of socks, sketch box & extra colors . . . maps, Black's Tourist, two thin books for journal, notes and expenses, tobacco & pipe, a few cigars, an extra haversack, matches, fish line and hooks, tooth brush, sewing apparatus, handkerchiefs, and a few other little things. I have only the gray woolen suit that I

stand in—no overcoat. I would have been glad to take a black coat for social purposes, but that would double the bulk of my luggage, and so I preferred to deprive myself of what a black coat might possibly bring me."[20] His pack had increased in weight by the time he reached the Highlands (despite sending his extra haversack home with another traveler at Oban). He described crossing nearly thirty miles of barren moors with his "knapsack, maud, umbrella case and contents weigh[ing] 26 pounds." After covering another sixteen miles the following day, Gifford discovered eight blisters when he took off his stockings that night.[21]

He bought other things as he needed them—a shawl for cold weather in the Highlands, shoes in Switzerland, a campstool in Bonn, and new guidebooks and paints as he set off for each successive segment of his journey. Amazingly enough, the only items he forgot to bring along for the trip were his sketching umbrella and campstool, and he was willing to send his "heavy and useless sketch box, colors, etc.," back to London while touring the Lake District.[22] He was also generally quite frugal, finding cheap means of sending catalogues, prints, photographs, guidebooks, and other acquisitions home, taking hotel rooms briefly before locating less expensive options, and in Paris he made a "series of experiments in cheap dining places."[23] Upon leaving England, Gifford wrote, "I have been economical, while at the same time I have denied myself nothing that I thought would be to my advantage. . . . In traveling, I have, except in one or two instances, always gone in the second class carriages, which I find 'quite good enough for the likes o' me,' and in most cases I have eschewed fashionable hotels, where one is apt to get a large bill and small accommodation."[24] Whittredge recalled that "Gifford lived in Rome in the most unostentatious manner. Abundantly able to provide elegant apartments for himself, with a separate studio, he preferred to hunt Rome over to find a single room where he could over-look the city, and look out upon the evening sky."[25] Gifford did seek out inexpensive lodgings in the big cities, but when traveling, and for short stays, he went for the obvious foreign hotels—the Hôtel de Londres (with the American and British flags flying) in Chamonix or the Grand Hôtel New York in Florence—for convenience, to save time, and because of the greater likelihood of meeting fellow Americans or Englishmen at dinner.

Although Gifford was a vigorous and independent traveler—he declared that "one's thoughts are sometimes the best companions he can have,"[26] and he would not let the lack of company dissuade him from going alone to places he had come to see—traveling companions nevertheless were of great importance to him, and he nearly always had one, or several, that he met en route. Two of his major trips were planned in conjunction with particular individuals—the McEntees in 1868, and Kensett and Whittredge in 1870 (the journey West)—and, in both cases, he abandoned them almost immediately, preferring his own plans. He seemed to enjoy the spontaneity of travel and the variety of people he encountered on the way, especially on his first trip to Europe. The large communities of expatriate artists in Paris and in Rome made it unnecessary to know much beyond basic French or Italian, and despite his professed belief in the importance of speaking the languages of the regions that he visited, he dismissed his tutors in order to economize. He became fast friends with the American painter Edwin White and the Irish artist Dickey Hearne in Paris. After four days of sight-seeing with a Mr. Curling in Florence, Gifford wrote, "I have never met a more agreeable traveling companion, or one whose society I have enjoyed more. It was like parting with an old and tried friend."[27] Gifford relished making new acquaintances, mingling in society, and seemingly had people to call upon, or was contacted himself, nearly everywhere he went throughout Europe. The similarity of the routes followed by his fellow tourists is demonstrated by the numerous and repeated encounters he had with others over the course of his journey. At a hotel in The Hague, he ran into two students from Brown University and stayed with them on and off as they traveled through Germany and Switzerland, meeting up with them again in Rome five months later. The importance of a companion increased when exploring less well-traveled places, both for company and safety, and Gifford relished his good fortune in finding someone to accompany him on an Italian adventure. In Rome, he and Albert Bierstadt discussed possible routes for a southern sketching trip: "Bierstadt and I have determined to go through the Abruzzi to Naples. . . . All the artists who have been there say it is the most Italian part of Italy. Strangers rarely ever go there; so there is scarcely any accommodation for travelers. . . . B. and I will walk most of the way, making digressions among the mountains as the scenery etc.

invite. We will shoulder our knapsacks, and expect to rough it through to N. in about a fortnight."[28]

Gifford made his travel arrangements as he went, whether for passage by train, carriage, or steamship. He frequently resorted to walking, particularly when he had to wait for public transportation, and he made numerous lengthy hikes in Scotland and in Italy—the longest, probably, a forty-nine-mile trek over the Simplon pass. He was not impervious to the common stomach maladies, but would often remedy them with a stiff walk, even though roads were terrible or non-existent in less heavily traveled areas. On returning to Paestum, he wrote, "The road was so bad we risked breaking our necks if we staid [*sic*] in the cart, and so we walked all the way."[29] Gifford commented on the newly completed rail line from Frascati to Rome, and the experience of being "whizzed along by the grand lines of the aqueducts," which enabled him to reach Rome from the Campagna in half an hour.[30] His itinerary seemed only on rare occasions to be determined by the availability of a conveyance, and planning ahead was seldom required, whether for popular or remote destinations. Deciding his route on the spur of the moment was the main difference between Gifford and a Thomas Cook tourist, who partook of all manner of prearranged conveniences—guides, hotel reservations, and security—as well as immunity from contingencies. When he chose to, Gifford traveled no less luxuriously than the common tourist (in the East, in particular), but he hired his guides himself, based on the recommendations of others who had gone before him, those he encountered as he went, and according to his immediate circumstances. In this regard, his mode of travel was well informed, but also spontaneous and uncertain, and he remained in charge of all minute decisions along the way.

Gifford's temperament was well suited to the kind of impromptu decision making required of self-guided travel. He rarely plotted his next round of activity more than two weeks in advance, and was not distraught when companions failed to show up or when plans were undone because of letters gone astray or received too late. In London, after missing one train and then catching the wrong one, he was content to "philosophically set down the day as a comedy of errors."[31] While his expectations about certain sites were sometimes disappointed—he felt that The Trossachs in Scotland, the Italian Lakes (on first viewing), Vienna, and the trip up the Danube had all been overpraised—he hardly ever seemed to regret decisions he made about where to go and which route to take. As McEntee recalled, "I am sure I never knew a man less affected in his personal conduct by surrounding influences or conditions. . . . Seldom disconcerted or annoyed by trifling vexations; always equable and serene, interested in everything about him, enterprising to see everything worth seeing—qualities which made him a most delightful traveling companion."[32]

To a certain extent, Gifford devoted parts of his trip to painting and others simply to traveling. In early May 1856, he wrote from Paris, "I have got done with my painting, and for sometime past have been doing nothing but studying Italian, and going about."[33] In this respect, he lived life abroad much as he did at home, working in his New York studio in winter and traveling to sketch during the rest of the year. Being cooped up in the city frustrated and depressed him. The previous December in Paris, he wrote, "Life has become rather regular and monotonous." The long, dark, and wet Paris winter included "an idle, dispirited, lonely, homesick, miserable day," and Rome similarly brought "constant rain, with a chilling comfortless atmosphere." He wrote home of "suffer[ing] much from depression of spirits," and longed for the spring, when he could "seek some relief in the variety and excitement of traveling," but was willing to wait for the best conditions to visit the places he had come to see.[34]

Nonetheless, weather had little effect on his good humor when he was caught up "in the variety and excitement" of travel. After missing a coach and deciding to walk to an inn nine miles over a highland pass, through a torrential downpour, Gifford "rejoiced that we did not go back to the inn and wait for pleasanter weather. Had we done so, we should have missed seeing the pass under its grandest aspect; and without the storm and rain, we could not have had such a singular and magnificent display of water-works."[35] Nor was he particularly distressed at losing time due to an incompetent guide. While crossing Monte Mottarone on the way to Stresa, Gifford discovered that the man he had hired to carry his luggage had disappeared, having returned to Orta (with the luggage) convinced that Gifford had been murdered by robbers on the mountain. The entire town was relieved to see Gifford come back

alive, and the magistrate agreed that the guide had become disoriented and frightened on the mountain and imagined an encounter with four thieves who told him the artist was dead. Gifford's wry assessment of the fiasco was simply: "The whole affair has amused me very much, the more so that at first it looked a little mysterious, and to the people of Orta quite tragical [*sic*]. The most tragical part of it was that it cost me 25 francs (for *carretta* [small cart] and messenger) and a day's time."[36]

Even as he partook of many of the services and conveniences provided for tourists, he emphatically did not like being viewed as one himself, and he railed against those traps that detracted from the enjoyment of his favorite places. Gifford was strongly impressed by the changing light of sun on snow on the high peaks of Switzerland (see fig. 39), and he included lengthy and detailed descriptions of these effects in his letters, most likely to serve as references when he later re-created the experience in oil. He described crowded hotels throughout the region and wrote humorously of reaching the summit of Rigi, for a view of the Bernese Alps, only to find a hotel on the top "crammed with 200 or 300 people who had come to see the sun set and rise."[37]

Although he stayed there that night for the same purpose, it is clear that he did not associate himself with the crowd, which he saw as much more intently focused on the meals that followed than on the "painful duty" of waiting for the sun's performance to end. His most intense diatribe was reserved for the Falls of Berchenback, in the midst of some of the most breathtaking alpine scenery of all:

I was so irritated by the contemptible littleness of the proprietor who has so fenced off the principal point of view that it is impossible to see the fall[s] without going into a house and looking at it through 7 by 9 windows. There you are presented with a book and invited to subscribe something for the construction of paths and other conveniences which prevent you from seeing the falls. As if this was not a sufficient insult to add to the injury, you are further invited to purchase some of their villainous Swiss carvings, chamois, spoons, and other rascally wooden trash, such as is poked in your face in every hotel, along every mountain path, at the top of every mountain, at the foot of every glacier, and everywhere in Switzerland where the path

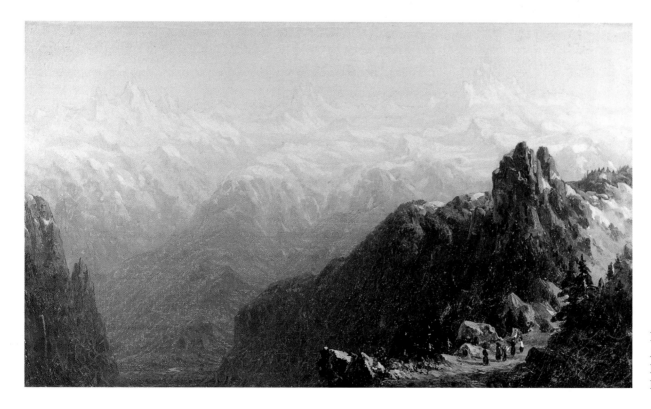

Figure 39. Sanford R. Gifford. *Sunrise on the Bernese Alps*, 1858. Oil on canvas. The Frances Lehman Loeb Art Center, Vassar College, Poughkeepsie, New York. Gift of Matthew Vassar

leads you into grand and magnificent scenery. There is no escape from it; the grander the scenery the greater the quantity and the more infamous the quality of the carving.[38]

Gifford quickly became skillful at avoiding impertinent guides. In Edinburgh, he was able to examine the monuments and enjoy the view from Calton Hill, "having first summarily dispatched one of the pertinacious guides who infest such places, who had fastened upon me and was giving me, to my great annoyance, much valuable information."[39] He frequently paid such individuals to get rid of them and only engaged them when he was not confident of his route. In Switzerland, he often hired someone to carry his knapsack for long climbs, praising one such man as "a capital, good natured fellow, and as strong as a horse. He carried our three knapsacks, weighing together more than 50 pounds, as if they had been playthings."[40] Gifford was pleased when he was able to engage guides that friends or other travelers had recommended, and was fortunate enough to have Albert Smith's guide for part of the crossing of the Alps and Alexander von Humboldt's at Vesuvius, while in certain places where tourists were still a rarity he might have the company of the American consul. In Italy, he noted that the principal purpose of a guide was to keep beggars away, and his letters are full of accounts of being "unmercifully fleeced" by useless *ciceroni,* who provided such invaluable services as running to keep up with him. He quickly learned to never pay more than half of whatever sum was demanded of him, and he would not back down when gondoliers or train conductors insisted on higher fares. "They think all foreigners are fools, and get very angry when they don't submit to be[ing] swindled—as many of them do rather than have any bother with the rascals."[41]

Whittredge's famous and oft-quoted recollection of Gifford's statement that "no historical or legendary interest attached to landscape could help the landscape painter . . . for he was looking into nature to find some quality which was in full harmony with himself, and which he could turn to the best account as an artist,"[42] warrants some consideration in the context of Gifford's European works. His interest in the relationship of monumental architecture to the surrounding landscape is evident in the vast majority of his Old World subjects. Gifford sketched the leading sites and monuments, and literary associations—if not always historical ones, as well—were unquestionably impor-

tant to his experience of a place. He habitually traveled with literature: Sir Walter Scott's *Rob Roy* in the Highlands, Henry Wadsworth Longfellow's *Hyperion* in Heidelberg, Charles Dickens's *Pictures from Italy* en route to that country. He made reference to specific authors at Windsor, Warwick, Kenilworth, Stratford, Stirling, and the Château de Chillon, and read or quoted from the works inspired by these sites as he sat sketching near them. At Kenilworth, he wrote, "The genius of Scott has invested these magnificent remains with a far livelier interest than bald history would ever give them."[43] Gifford's letters contain numerous descriptions of the fine old ruins he visited along the banks of the Rhine, refuting Whittredge's claim that, "as we came to the old castles jutting out in black outlines against the sky, and frequently presenting really picturesque effects, he seemed to care but little for them."[44] Gifford described Rheinstein (fig. 40) as "most picturesquely placed on the summit,"[45] and returned to the subject several times over the course of his career. The vertical orientation, low vantage point, and the central interest in looming architectural elements, characteristic of both *Kenilworth Castle* (fig. 41) and *Rheinstein,* provide an impression of how a traveler would experience these places, approaching them from below and gazing upward in wonder. Gifford made pencil sketches of other sites from similar low vantage points, but more commonly—and almost invariably, for his formal, finished paintings—he situated castles and other architectural monuments in the middle distance of a broadly framed, horizontal view (see cat. nos. 4, 7, 26). He did indicate one of the major problems of famous sites for the traveling artist, also in his account of visiting Kenilworth: "The gay lords and ladies, and knights, and squires of the imagination [conjured up by reading Scott] are, however, very apt to be jostled by the numerous parties of sight-seers who are always wandering about the ruins." Crowded sites made for difficult sketching, or, at the least, meant that one sketched with an audience. "Fifty children (more or less) surrounded me and watched my progress with applauding interest."[46]

JUNE 1868 – SEPTEMBER 1869

The purpose behind Gifford's second journey abroad varied considerably from what had motivated him thirteen years earlier, and the works of art that

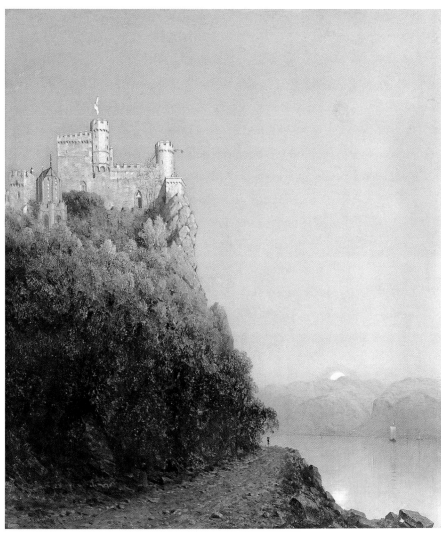

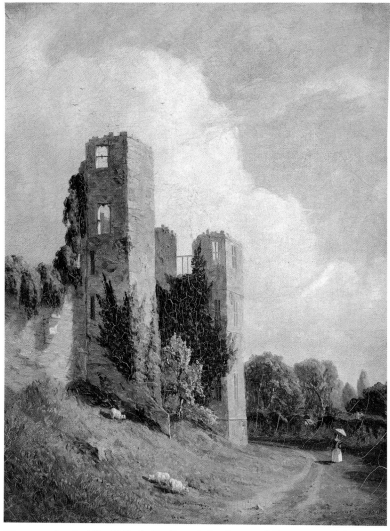

Figure 40. Sanford R. Gifford. *Rheinstein*, 1872–74. Oil on canvas. Washington University Gallery of Art, Saint Louis. Bequest of Charles Parsons, 1905

Figure 41. Sanford R. Gifford. *Kenilworth Castle*, 1858. Oil on canvas. Private collection

resulted correspondingly differed as well. In 1855, he had intended to make a Grand Tour of Europe to complete his artistic training; in 1868, he traveled mainly for pleasure and also to search for new subjects beyond the Mediterranean. Gifford's desire to visit the East was stimulated partly by the travel plans of other Tenth Street Studio Building residents (Frederic Church had left for the Holy Land the previous fall), partly by hearing tales and reading the travel accounts of his friends Bayard Taylor and George William

Curtis,[47] and also perhaps in response to increasing criticism that his work was becoming repetitive and mannered.[48] During the European segment of his second trip abroad he spent more time exploring and sketching those sites—in particular, the Swiss Alps and Venice—that earlier had captured his imagination. In Rome, Gifford enjoyed the company of a large community of American artists including George P. A. Healy, who painted his portrait there (see fig. 42).

On June 12, 1868, Gifford arrived in England with his close friend Jervis McEntee and McEntee's wife. After giving them a quick tour of Stratford and Kenilworth—two of his favorite places from his previous trip—and after several days of sight-seeing with them in London, Gifford proceeded on his own to Paris and Switzerland, with plans to meet the McEntees again in Rome in the fall. Gifford had no apparent desire to see specific works of art or exhibitions in London or Paris, apart from the Paris Salon, of which he wrote, "I am very glad I shortened my stay in London in order to see it. This is the last day. . . . The chief strength lies in the figure pictures. There were perhaps four or five good landscapes. In the Royal Academy there was not one of first rate merit."[49] His view of the relative achievements of modern British and French art had not changed. Following his visit to the Salon, he "bought and read Kinglake's *Eothen*,[50] and studied maps of the East. The East is assuming more & more importance in my mind. It will probably take more time than I have allotted to it."[51] Indeed, much of his time in Paris was given over to planning for the trip. He mentions "talking with Mr. Goupil" about Gérôme's travels, and worries over the risks involved in going to Petra (Gérôme's party had been attacked by bedouins there), adding he spent the afternoon sketching "sphynxes [*sic*] and other things Egyptian" at the Louvre as "a preparatory study for next winter." On June 26, he wrote that he had spent "all day at home studying maps and guide books of the East."[52] In July, while hiking through the Alps, he met an English clergyman who had traveled in the East and from whom he received "much useful information," as he noted in a letter home. In October, after two weeks in Rome, his preoccupation with the impending trip continued to interfere with his work: "I have not taken a studio yet, as I am so uncertain when I shall leave Rome for the East."[53] In November, he helped McEntee settle into Roman life, describing himself as his friend's "interpreter and dragoman."[54] Egypt was uppermost in his mind throughout these six months of travel, and had been so almost from the moment he arrived in Europe.

Figure 42. George P. A. Healy. *Sanford Robinson Gifford,* about 1868. Oil on canvas. The Detroit Institute of Arts, Founders' Society Purchase, Merrill Fund

Gifford's method of touring Europe differed significantly from his approach to the East. An adventurous traveler, he preferred getting about on foot, readily abandoned his companions for the sites he had come to see, and generally resisted limitations and restrictions on his mobility. While in Italy, Gifford wrote to McEntee asking him "to dispose of his wife in some way" so the two men could explore the Italian coast, perhaps hoping to re-create the kind of sketching tour he had made with Bierstadt on his first trip. "In expeditions of this nature in a region that is little known, the necessity of looking after ladies would interfere seriously with the freedom of movement which to me is absolutely necessary."[55] Despite Bayard Taylor's warnings against travel in Calabria and Sicily "on account of brigands," and without McEntee to accompany him, Gifford persisted in his plans to go to these places on his own. "I do not apprehend any trouble. The chance of any particular person falling in with these miserables is so exceedingly small that it would be foolish to abandon one's purpose on account of it. It will, however, make me very careful in my movements and it may circumscribe them more than I would like. When I get down there I can find out all about it, and move accordingly."[56] In the end, Gifford followed the American consul's advice that it was far from safe to explore these regions alone, and he kept to the coast, traveling by steamer between sites and towns. He also decided against climbing Etna by himself in bad weather.

Gifford strictly adhered to traditional routes in Egypt and Syria, recognizing that a good traveling companion was of the utmost importance on the eastern trip. In August, he was still trying to time his travels, as he wrote: "It is probable I will not leave Rome before the first or 15th of January. If I had a companion of the right stamp I would go now instead of waiting; and go through Syria in the autumn instead of the spring."[57] In Rome, he waited nearly a month, "hoping some agreeable companion for my eastern tour might turn up. As none appeared who wanted to go at the same time and do the same things that I wanted, I came off alone,

trusting to the chance of meeting some one to make a party with at Cairo."[58] Once in Egypt, he altered his plans significantly, for the sake of specific companionship, and eventually found a congenial group of Americans to accompany him up the Nile; however, he did not continue with them through Syria when he discovered older, closer friends waiting for him in Cairo who preferred a different route. Not surprisingly, he felt less confident of his surroundings and less inclined to wander off on his own, out of concern for his personal safety, once he left Europe. Goupil's account of Gérôme's close call at Petra was enough to persuade him not to go there, in addition to Church's harrowing tales, which he undoubtedly heard in Rome.[59] Despite the extensive ground he covered, Gifford never made the transition from tourist to traveler in Egypt or the Holy Land. He valued his freedom less, rarely strayed far from the group, and tailored his activities to the needs of the female members of his traveling party. Only twice did he leave the others to sketch (at Aswān and near Thebes), and on several occasions he longed for the company of his sister and the McEntees.[60]

Gifford had arrived in Egypt in January 1869. From Alexandria, he took the train to Cairo, where he went first to the Citadel, which overlooked the city (see fig. 43): "There is a magnificent view from the Citadel over the domes and elegant minarets of the city, with its palm trees and gardens, to the Nile (3 miles); and beyond that, over the broad verdant plain to the bare yellow desert, on the edge of which, breaking the horizon, rise the massive pyramids of Geezeh [sic]. They are about eight or ten miles off. Their shadowed sides are as blue and tender as the shadows of the Catskills."[61] With the aid of the American consul, Gifford gained access to numerous mosques in Cairo that he otherwise would have been barred from entering, and described their architecture and ornament in great detail.[62] He befriended a family of American tourists and with them paid an impromptu visit to the palace of the viceroy's nephew (including his harem, albeit unoccupied), from which he came away "much pleased with the little glimpse into the domestic life of a Turkish pasha."[63] He experienced the "luxurious languor" of a Turkish bath, and, along with another American tourist and an English clergyman, paid a few pounds to have the entire establishment to themselves ("to make sure of clean water"), and he frequently indulged in smoking the chibouk and nargileh. He received

an invitation through the American consul to attend a "rare, sumptuous and regal" ball at the Palace of Gezeereh in celebration of the eighteenth anniversary of the viceroy's accession to the throne.[64] He witnessed a procession of the Mecca caravan, which, he reported, was "gorgeous, strange and barbarous in the extreme," and the whirling dervishes made him "almost sea-sick."[65] Perhaps more than any other activity, Gifford greatly enjoyed describing the clothing and features of the various ranks and races of people he observed. From his first moment in Egypt, he was immediately and powerfully struck by "the infinite variety, picturesqueness and splendor of the costumes, with their rich and startling contrast of black and white and pure colors—running through every shade." He praised Gérôme for even attempting to depict them, and for doing a better job than anyone else, but believed that his pictures fell far short of capturing "the richness, the fullness, the variety and the abandonment of the real thing."[66] Gifford referred to Gérôme again in a lengthy description of the French artist's depiction of an outrunner, whose role was to precede important personages in the narrow streets of Cairo (see fig. 44): "He runs at

Figure 43. Photographer unknown. View of Cairo from the Citadel, with the pyramids in the distance, about 1860. Library of Congress, Washington D.C. Prints and Photographs Division

full speed thro' the crowd, shouting and warning people. He usually wears a gold embroidered jacket, a white tunic and very large flowing sleeves which, spreading as he flies along, makes him look like a bird. Persons of high rank and wealth have two of these runners, and at night these are accompanied by two others carrying large flaming torches to light the way. Gérôme has made a very good picture of these runners—two Nubians preceding a pasha, who is coming out of a city gate on horseback, and attended by his suite."[67] At the viceroy's ball, "the oriental costumes, flowing robes and splendid colors of the turbaned Turks and Arab sheiks" delighted Gifford above all else, and he deemed the "black evening dress of the civilized world, white cravated, tail-coated and ugly compared with the dignified flowing drapery and barbarous splendor of the oriental."[68]

From Cairo he made day trips to nearby sites, including the pyramids at Giza, which he would have found more inspiring but for the intrusiveness of the Arab guides, who hauled tourists to the top. Following this ordeal, Gifford wrote, "The sphinx did not make a very profound impression upon me (filled with lunch and irritated by the arab crew). It is nevertheless majestic and imposing."[69] On January 22, Gifford hired a *dahabeah* (a private riverboat) with five other American tourists he met in Cairo, and on January 27, they set sail for the first cataract of the Nile, a trip of over one thousand miles back and forth that took them forty-four days. Gifford debated making the journey by steamship, but opted for the more luxurious and flexible private *dahabeah*, which allowed travelers roughly fifteen days for sight-seeing, instead of the four or five by steamer. In a letter to his father he described a typical day on the Nile: "We breakfast at 9 o'c, then go ashore, walk or shoot, while the men track [tow the boat from shore]. About 11 o'c the wind generally springs up, when we go on board and lounge, read, write or paint til 4 p.m., when we dine, getting through about 5 o'c in time to go on deck to enjoy the light of the low sun on the rosy and purple Arabian hills, the sunset and the twilight. Then it is too cold to remain out longer. Tea at 7—then reading, writing, conversation, cribbage, euchre and checkers until about 11 or 12, when we get to bed."[70] Gifford's boat, as was standard practice, took advantage of the wind while sailing upstream, then drifted back with the current, stopping off at sites along the return trip.

Figure 44. Jean-Léon Gérôme. *The Runners of the Pasha,* about 1865. Oil on wood. The New-York Historical Society. The Robert L. Stuart Collection, On permanent loan from The New York Public Library

Over the course of his river journey, Gifford painted major monuments, including the pyramids, Beni Hasan, and the Colossi of Memnon (see fig. 45), of which he wrote, "These great Colossi sitting silent, solemn, and majestic in the midst of the plain, take hold of the imagination more than anything I have seen in Egypt."[71] However, most of his Egyptian works are Nile River scenes (see cat. no. 48), commensurate with the amount of time he spent on the boat and also with the difficulty he regularly described of sketching in crowded tourist spots or trying to go off on his own. From Cairo he took the train to Suez, where he toured the nearly completed canal, then sailed by steamer to Jaffa from Port Said, and embarked on a thirty-two-day tour of Jerusalem, Syria, and Lebanon by caravan. Because he spent much of this time on horseback, he sketched infrequently, and no oil studies or paintings resulted from this part of his journey. Camped in the ruins of Baalbek, Gifford wrote in detail about the temples, adding, "I saw many things that I would like to paint—but I made not a line. It is useless for me to attempt such things without plenty of time. I have long since given up the expectation of making anything of the East. To do that one must either come alone or with one artist friend and have plenty of time and a large amount of money."[72]

In the East, Gifford altered his perception of travel and of other travelers. He read the Koran, as well as Washington Irving's *Life of Mahomet* and *Mahomet and His Successors,* along the journey, but made no attempt to learn the local languages and rarely associated with the native inhabitants, apart from hired guides or the Egyptian royalty he happened to meet. He stayed in foreign hotels in the Frank quarters of Cairo and of Constantinople, and sought out other American tourists. Yet, there is a striking similarity to Bayard Taylor, a traveler who "went native," adopting the costumes and manner of the Egyptians but who also lived lavishly, in that both remained apart from their subjects. Larzer Ziff's observations of Taylor, "Witnessing scenes first-hand, he was, uncannily, as detached from them by the frame of his gliding boat as is his reader by the frame of the printed page,"[73] also could be applied to the viewers of Gifford's scenes, for whom the frames of the paintings served to contain and reify the Orient. Much like his experience in Europe, Gifford received visits and paid his respects to other foreigners he met in the course of the eastern journey, encountered New York acquaintances, and crossed paths with former companions. The parlor of the *dahabeah* was a place for entertaining and exchanging visits on the river, while his tent served the same purpose along the caravan route in Syria. Describing his social life at the camp at Jaffa, he listed numerous dinner guests and evening visitors on Easter Sunday, three guests the previous evening, and four more callers the following day.[74] The extravagant amenities and treatment that Europeans and Americans received (and could afford) in Egypt—Gifford's Nile boat had a crew of seventeen for just six people—distinguished Eastern travel from that in Europe, and commonly led Westerners to assume imperial attitudes toward the indigenous peoples.[75] The native crew members carried tourists from their boats to shore, and served as "pointer, retriever and gamebag" for hunting along the Nile. Gifford made frequent, and sometimes violent, use of his cane to "route" beggars or Arabs who followed or disturbed him while he sketched.[76] He enjoyed the luxuries he experienced, the introductions and entrée to dignitaries and palaces, and he hired guides to provide the necessities—food, entertainment, access to the major monuments, and also adequate protection. Gifford's entourage was never robbed, but other travelers he encountered along his route did not fare as well. In Jerusalem, Gifford wrote

of camping near a group of "Cook's excursionists, a party of 25 English people. We did not like the proximity and proposed to move our camp next day to the Jaffa Gate." The Cook group was robbed in the night, most likely by its own bedouin escort. Gifford recorded that, as a result, his party "had a guard of Turkish soldiers sent by the Pasha at the request of our consul," and that they were similarly well armed and protected by an escort of Turkish soldiers on a three-day journey to Bethlehem.[77] Although the Cook group was not much larger than Gifford's (twenty-two horses and mules, fourteen

Figure 45. Sanford R. Gifford. *Colossi of Memnon,* 1872–78. Oil on canvas. Collection Alexandra and Michael Altman

men, two ladies, and four tents), his comments imply the disdain he felt for organized tours; the ability of his own, privately arranged guides to secure reliable guards; and the superior services provided by the American government abroad.[78]

In late April, 1869, Gifford sailed from Beirut to Greece, where he immersed himself in an exacting study of the Parthenon. He was surprised to discover certain irregularities in the architecture, particularly the variability of the width between the columns and also the convex curvature of the temple's various elements, and remarked in his journal, "There is hardly a straight line in the whole building."[79] The photographer William James Stillman was also then at work on the Acropolis, gathering material for an album that would be published in London the following year (see fig. 46). Gifford declined Stillman's invitation to accompany him as he documented other temples in Greece, but noted that on his last day sketching there Stillman gave him a photograph made on the Acropolis.[80] As Stillman was concerned with capturing the same unexpected features of the Parthenon that interested Gifford, it is not improbable that the photographer and painter informed each other's studies. From Athens, Gifford took a steamship to Istanbul, staying there a week before sailing up the Danube to Budapest, traveling on to Vienna by train, and then heading for Venice by way of Salzburg, Innsbruck, and Verona, where he found Ruskin and the Longfellows registered at his hotel. As he was leaving Istanbul, Gifford received a letter from his sister Mary asking him to join her in Brussels (she had sailed to London with a friend in the fall of 1868, spent nearly two months with Gifford in Rome the previous winter, and then continued traveling with the McEntees in Europe when her brother left for Egypt). Gifford had hoped to meet her in Venice but several letters had gone astray and she had already started for home. Much as he had looked forward to spending the summer traveling with her, and despite the fact that he was ready to head home himself, he could not give up the opportunity to see Venice again, which became "his last, great—in the artistic sense, greatest—experience of foreign travel."[81] Gifford was relieved to be at rest in a familiar city after so long a period of travel in the East, and he extended his stay from a few days to six weeks. His 1857 characterization of Venice as "the most peculiar and most beautiful of all the cities I have visited" was

Figure 46. William James Stillman. Profile of the eastern façade [of the Parthenon], showing the curvature of the stylobate. From William James Stillman, *The Acropolis of Athens, Illustrated Picturesquely and Architecturally in Photography* (1870)

reconfirmed in 1869. Even after he had seen Cairo, Damascus, and Istanbul, Venice remained for Gifford "the loveliest, the most glorious and the most superior of cities."[82] He made numerous sketches, the majority from water level, and, like his paintings of the Nile and the Bosphorus, they included the picturesque sails of boats. In the view north to the snowcapped Apennines seen in *Near Venice* (fig. 47), Gifford also incorporated the landscape feature that he had often considered to be the most highly affecting on his earlier European travels: "There is nothing more exquisite in nature than a range of snow mts. seen in a fine day from a distance of 20 or 30 miles. They look as if made of pearls and opals—so soft, so exquisite, so negative and so lovely are the tones of color."[83]

Gifford constantly refers to "commanding" panoramic views throughout Europe and the East; as was common practice among travelers, he consistently climbed to the highest peaks on the mountains or up into the towers to look out over the cities he was visiting and their surroundings. If the painter's

Figure 47. Sanford R. Gifford. *Near Venice,* 1869. Oil on paper, mounted on canvas. Edward T. Wilson, Fund for Fine Arts, Bethesda, Maryland

omniscient viewpoint from on high can be likened to the sort of imperialist observations made by travel writers of the same period, Gifford partook of these views, described them in his journal, sketched them on occasion, but rarely painted them. Nearly all of his foreign subjects are composed as low, wide vistas, characterized by distant figures who pass through and across an expansive landscape. In Egypt, this was primarily a function of the desert topography, but it was also partly determined by the impracticality of sketching the most impressive scenes, the access to which was from places that were invariably mobbed, such as the tops of the pyramids or the Citadel overlooking Cairo. Apart from the early tower pictures and the later western sketches,

most of Gifford's other "travel" views resemble his American subjects in their compositions and orientation. *In the Catskills* (cat. no. 20) and *South Bay on the Hudson, near Hudson, New York* (cat. no. 35), both from the early 1860s, and *Near Palermo* (cat. no. 17) and *Siout, Egypt* (cat. no. 49), from a decade later, all share a similar arrangement of formal elements. In each instance, a road or river leads into the middle distance, with an open expanse of water or field to the right and mountains in the distance. *Lake Nemi* (cat. no. 6), from his first trip abroad, may have inspired subsequent American panoramic subjects—*Mansfield Mountain* and *The Artist Sketching at Mount Desert, Maine* (cat. nos. 8–10, 39)—but it, too, provided an experience not unlike that of viewing an American landscape. As Whittredge wrote, with regard to *Lake Nemi* (cat. no. 6), "It was treated in such a way that an American familiar with some of the small lakes among our hills could easily as he stood before it imagine himself at home."[84] Those elements that appealed to Gifford's artistic sensibility abroad were often the very same that informed the images he produced at home, and the popularity of his art was confirmed by the positive public reviews and sales of his works with foreign and American subjects alike.

THE AMERICAN WEST: THE SUMMERS OF 1870 AND 1874

In the summer of 1870, Gifford made use of newly completed rail connections for a sketching trip to Colorado with his friends Worthington Whittredge and John Frederick Kensett. However, upon meeting Ferdinand V. Hayden in Denver, Gifford decided to join the United States Geological Survey of Wyoming and the surrounding territories, and spent six weeks with the expedition (see fig. 48), mainly assisting the official survey photographer, William Henry Jackson. Jackson's photographs, diaries, and autobiography are often the best record of Gifford's first western experience, as few of the artist's letters survive.[85] Gifford's penchant for long treks and travel by horseback served him well on the trip. As Jackson recalled, "For every mile on the map we covered between two and three on the ground—up mountainside, down stream bed, across country—to gather rock specimens, to survey and map, and to paint and photograph."[86] Hayden's survey reports document Gifford's aid to Jackson in procuring photographic negatives of certain regions, while Jackson

noted days when Gifford and other members of the expedition took over all photographic duties themselves. The oil sketches that Gifford made of the survey camp at La Bonté are near replicas of views photographed by Jackson, while, at other times, Jackson photographed Gifford, documenting the painter at work (see cat. no. 50); it is easy to imagine artist and photographer framing their scenes together. As Jackson wrote, recalling this collaborative enterprise many years later, "He was much interested in my photography, from the very beginning of . . . our journey and was my inseparable companion on the side-trips, or other occasions when separated from the main party for making photographs. I think his artistic discernment and advice was largely resp[o]nsible for whatever there was of excellence in my own compositions."[87] In addition to their shared artistic production, Jackson and Gifford greatly enjoyed the thrill of hunting buffalo, and Gifford later remembered the spirit of his horse as it made "a splendid dash over the plain, trying his speed with Jackson's high-shouldered 'Giraffe'—or when he let himself go—in the excitement of the buffalo chase."[88] When Gifford left the survey at Fort Bridger (to rejoin Whittredge and Kensett in Colorado, by way of Salt Lake City), Jackson wrote in his diary that he was "very sorry to lose Mr. G," and subsequent correspondence and planned visits to New York testify to their continued friendship.[89]

Ila Weiss suggests that Gifford was compelled to join Hayden's expedition out of an artistic desire to study the more unusual and challenging geologic features of the Wyoming landscape as well as by the prospect of "adventure and excitement that could rival that of his Eastern trip."[90] Gifford was further reminded of his eastern travels during the summer of 1874 in California, Oregon, British Columbia, and Alaska. He described the region surrounding the Columbia River as "wild and strange," like Egypt. "The blazing mid-day sun, the naked, barren mountains, the black rocks, and the rushing river and drifting sands are more like Africa than America."[91] Gifford traveled alone in 1874, taking the Central Pacific Railroad from Nevada to San Francisco, over the High Sierras and the newly finished pass near Donner Lake. He spent a week in San Francisco, and went by ship and stagecoach to Oregon, "the hardest and toughest ride I ever had." In noting the difference between traveling by train and coach, Gifford demonstrated that he had no reservations about

Figure 48. William Henry Jackson. Sanford R. Gifford (standing, third from left), with the members of the Survey, in camp at Red Butte, at the junction of the North Platte and Sweetwater Rivers. Photograph. United States Geological Survey, Denver

"being sent like a package" out West.[92] He clearly preferred the newer, more comfortable means of transportation: "At last when I was nearly wearied out by the terrible ride, we bowled and bounced and leaped over the last mountain, and in the early dawn rattled and banged through the last magnificent Canon, through gigantic pines and spruces, and then out into the park-like oaks of the foothills, and we were at Roseburg, the southern station of the Oregon and California R.R. Weak and wounded, sick and sore, I tumbled into the car, and into a sleep which lasted pretty much all day."[93] From Astoria, Oregon, Gifford took a steamship to Alaska in early August 1874, returning by way of Vancouver two weeks later. He made stops in Tacoma and Portland, a trip up the Columbia River to The Dalles, and spent several days salmon

fishing before sailing to San Francisco in late September for the train east. No written account survives of the Alaska portion of the journey; he sketched infrequently, and the only oil paintings to result from the entire trip are of Mount Rainier (see cat. nos. 57, 58) and a view near Colfax, California.[94]

Gifford made roughly the same number of oil sketches during his first trip West as he did during a similar period of time spent on the Nile, which is remarkable given the rapid pace of the Hayden survey, the great distances covered on foot and on horseback, and also the amount of time Gifford devoted to photography and to assisting the expedition in general. Only one oil sketch is documented from Gifford's 1874 solo journey to the Pacific Northwest, which would seem to suggest that he was inspired by the concerted activity of

the survey team to produce his own record of the Wyoming Territory, in contrast to four years later, when he was more interested in a fishing holiday and exploring the far reaches of the country than in artistic production. Initially, he may have planned a return sketching trip to the Northwest, which might explain his scant output in 1874, but a second trip never materialized.[95]

Gifford's major paintings from his first European trip were primarily commissions, completed in his studios in Paris and in Rome, and incorporating features of the European landscape into his developing aesthetic. On the second trip, his subjects were more of his own choosing. Fewer familiar sites were worked into his important pictures, except for the Parthenon (see cat. no. 70) and the Colossi of Memnon, the two tourist attractions that had affected him most deeply at the time, and that also became the subjects of paintings that he had considerable difficulty finishing. His preference was to make a first sweep of a new city or site, returning to sketch and paint after gaining an overall impression, and, to a certain extent, the entire first trip to Europe can be considered such a preliminary experience. Those places that he revisited for further study years later (Switzerland, the Italian Lakes, and Venice, in particular) often inspired Gifford's fullest creative activity. As a tourist in Egypt, Gifford produced his most successful works during uninterrupted time in a boat on the Nile; when he sketched alone, in the early morning; or when he kept his distance from popular sites—while his companions went forth to brave the crush of sightseers. There were spontaneous successes, too—*Siout, Egypt* (cat. no. 49), perhaps the best example from the second trip. In this otherwise unremarkable city on the Nile—a location not typically inundated with other tourists—he enjoyed a stunning moment of the setting sun.

As Gifford became a different kind of traveler on his western journeys, his artistic focus changed. Joining the Hayden expedition in Wyoming, he functioned as a member of a scientific and documentary project, and his vision was informed by the pace and the purpose of the survey team. This is not to say that Gifford's western views are more exacting or less determined by his own mature and well-established artistic practice but, rather, that they were the product of a shared experience, with a photographer as his "sketching" companion instead of a fellow painter. In this case, Gifford's interest in obtaining panoramic views from commanding elevations in Wyoming was appar-

ently superceded by his study of how the camera could be used to capture recession into deep space.

THE ARTIST AS TRAVEL WRITER

Gifford left a splendid visual record of the majority of his travel adventures in the form of his paintings, but he also deserves consideration for his accomplishments as a travel writer. His European letters provide rich accounts of the experiences and impressions of an informed, intelligent observer, and although certain correspondence to friends in New York was featured in widely circulated periodicals, very little of what he wrote was ever published.[96] The main difference between the travel diaries from Gifford's two trips abroad is their shift in emphasis. The letters from the 1855–57 European trip are replete with lengthy descriptions of architecture, paintings, and artifacts—a catalogue of his acquired knowledge—while, on his second trip, except for certain mosques in Cairo, for Baalbek, and for the Acropolis, he had no desire to record the details of such places. After visiting the Temple of Abydos, Gifford wrote, "[It] is one of the most interesting I have seen, both for its paintings and sculptures. But I have neither time nor space to describe temples, believing you will be more interested in the simple story of our daily lives and movements."[97] His letters from the East are largely given over to the people he encounters— their costumes, behavior, and curious practices. If the descriptions he provided in the 1850s, on the first trip, were colored by his concentration on historical and literary reading material, twelve years later they were influenced by travel literature. That he chose to read *Eothen* when preparing for his visit to Egypt demonstrates Gifford's concern with matters beyond those of practical planning. As Jan Morris writes, in an introduction to a recent edition of *Eothen,* "There was never a travel book more intensely subjective and selective, more immune to the orthodox demands of descriptive reportage. . . . it is not the travel that is important in this work, only the traces it left upon its author's very particular sensibility."[98] By 1868, Gifford was without question more focused on experiences than monuments, and his notes often reflected the style of whatever he was reading; his writing is also regularly tinged with the wit and humor that he had expressed only occasionally in his earlier journal.

Indeed, some of Gifford's more acerbic passages, from 1868–69, anticipate Mark Twain's *The Innocents Abroad* (published in July 1869, two months before Gifford's return from many of the same sites described in that book), and his account of the steamer passage or of visits to the popular attractions in Egypt could almost as well be by Twain. There was perhaps no better indication of how pervasive tourism had become than the possibility that one could earn a living simply writing about the tourists themselves and their amusing habits, rather than about the places they went to see.[99]

While Gifford's accounts of his eastern sojourn often are reminiscent of those by Taylor and by Kinglake, they emulate most directly that of Michael Angelo Titmarsh (the pseudonym adopted by William Thackeray) in the first published editions of his *Notes of a Journey from Cornhill to Grand Cairo*. Gifford mentions reading Thackeray while in Cairo,[100] and, as Thackeray was freshest in his mind, it is not surprising that the way in which the artist described many of his adventures as a tourist closely echoes Thackeray's humorous impressions. Thackeray relates that when he first saw the pyramids it was with "a feeling of shame that the view of them should awaken no respect," and he adds that no one in his party was seriously moved, being more occupied with breakfast at the moment. All he could say was, "I confess, for my part, that the pyramids are very big." Gifford cited his source of inspiration when he wrote home of the pyramids, "We crossed the Nile to Cairo—confessing (with Michel [*sic*] Angelo Titmarsh) that the pyramids are 'big.'"[101] Like Thackeray, Gifford found it impossible to convey what he saw from the top of the monuments, in part because of the "impudent" Arabs, who descended on tourists and insisted on hauling them up, demanding pay all the way.[102] Gifford evokes Thackeray in his description of the view from the Citadel, and also in his preference for the older mosques and other architecture in Cairo devoid of European influences. Most importantly, Thackeray tended to reserve his lyricism for the lesser attractions and referred to many of the scenes he encountered as "pictures." The similarity in approach to travel of the writer and the painter is summed up in Thackeray's response to the view of Constantinople from the Bosphorus: "A scene of such delightful liveliness and beauty, that one never tires of looking at it. I lost a great number of the sights in and round Constantinople, through the beauty of this admirable scene: but what are sights after all? And isn't that the best sight which makes you most happy?"[103] Bayard Taylor expressed the same sentiment in *Views A-Foot*: "Some landscapes have a character of beauty which harmonizes thrillingly with the mood in which we look upon them, till we forget admiration in the glow of spontaneous attachment."[104] For Gifford, as for Thackeray, Constantinople, seen from the port, resembled a "a vision of fairy land," and he went on to write that he "never tired of going up and down [the Golden Horn] in the luxurious but tottlish caique," and begged off participating in excursions with his group to have more time on the water.[105]

The reception of Gifford's foreign scenes was undoubtedly influenced by images conjured up by the immensely popular travel literature of the period, and his paintings often can be read as visual counterparts to well-known narrative accounts. Although Gifford had stated, "My whole eastern tour as far as artistic acquisition goes amounts to nothing,"[106] a visitor to Gifford's studio in November 1869 (only weeks after the artist's return) predicted, "Gifford's studies in the East will result in several works of great value. His genius is deeply Oriental, and he has seized the true sentiment of Oriental life and scenery."[107] If Gifford was sometimes disparaged for steeping earlier American scenes "in that vague, shimmering, sandy hue, until the spectator believes that he sees only a mirage, and not the fair, substantial reality of earth and sky and sea,"[108] these very same elusive (and desert-like) qualities that the reviewer went on to call "so marked a mannerism" made Gifford brilliantly suited to portray the East. Gifford's genius was in rendering sunlight, atmosphere, and imagination combined, and his forms become lost in these associations, as would the viewer seeking escape in the distant lands that the artist depicted.

I want to express my appreciation to Nicolai Cikovsky, Jr., June Hargrove, Elizabeth Hutchinson, and Franklin Kelly for their help in formulating ideas about Gifford as a traveler. I am also grateful for the support of a Robert H. Smith Fellowship, as well as to the National Gallery of Art, Washington, D.C.

1. Weir 1880, p. 15.

2. "Address by Jervis McEntee," in *Memorial Meeting*, pp. 53–54.

3. Gifford included a list of his "chief pictures" at the end of a brief autobiography that he wrote in the form of a letter to O. B. Frothingham in 1874. The list is included as an Appendix in Weiss 1987, pp. 327–30. Of the fifty paintings on this list, twenty-four are of foreign and Western subjects.

4. Paul Fussell, ed., *The Norton Book of Travel* (New York: W. W. Norton & Co., 1987), p. 273.

5. Daniel J. Boorstin, "From Traveler to Tourist: The Lost Art of Travel," chap. 3 in *The Image or What Happened to the American Dream* (New York: Atheneum, 1962), p. 85. See also Eric J. Leed, *The Mind of the Traveler: From Gilgamesh to Global Tourism* ([New York]: Basic Books, 1991), pp. 9–10; Fussell, *The Norton Book of Travel*, pp. 651–52. James Buzard provides an in-depth analysis of the tourist/traveler dichotomy in *The Beaten Track: European Tourism, Literature, and the Ways to Culture, 1800–1918* (Oxford: Clarendon Press, 1993), and argues that these two "value-laden concept[s]" together "make up a binary opposition fundamental to and characteristic of modern culture" (pp. 3, 18). See John Urry, *The Tourist Gaze: Leisure and Travel in Contemporary Societies* (London: Sage Publications, 1990), pp. 7–12, for an overview of the theoretical debates concerning the distinctions between tourists and travelers.

6. Gifford, Frothingham Letter, manuscript (Archives of American Art, Reel D10, frame 1221).

7. The letters were converted in the 1870s to a three-volume typescript (491 pages), now in the Archives of American Art, Reel D21; hereafter, Gifford, European Letters.

8. Gifford, European Letters, vol. 1, pp. 9–10.

9. Ibid., p. 12.

10. Ibid., pp. 13, 111.

11. Ibid., p. 23. See Cikovsky 1970, pp. 14–15, for Gifford's discussions with Ruskin over Turner's fidelity to nature and Gifford's objections to Turner's lack of respect for the configurations and appearances of reality. See also Joseph R. Goldyne, *J. M. W. Turner: Works on Paper from American Collections*, exhib. cat., Berkeley, University Art Museum (Berkeley: 1975), pp. 27–29; Barbara Novak, *Nature and Culture: American Landscape and Painting, 1825–1875* (New York: Oxford University Press, 1980), p. 249, on Gifford and Turner. In 1868, Gifford recorded only positive impressions of Turner's works; see Gifford, European Letters, vol. 3, p. 6.

12. Gifford, European Letters, vol. 1, p. 149.

13. Ibid., pp. 115–16.

14. Cikovsky 1970, p. 16.

15. Gifford, European Letters, vol. 2, p. 41, vol. 1, p. 162, respectively.

16. Thomas Cole, "Essay on American Scenery," *The American Monthly Magazine* (New York), 7, n.s., 1 (January 1836), p. 4. Reprinted in John W. McCoubrey, ed., *American Art, 1700–1960: Sources and Documents,* Sources and Documents in the History of Art (Englewood Cliffs, New Jersey: Prentice-Hall, 1965), p. 101.

17. Gifford, European Letters, vol. 1, pp. 16, 24. Similarly, he wrote of his visit to Dulwich, "After paying my respects to the pictures, among which I found but few of much interest, I gave myself up to what was far more delightful—a ramble of a couple of hours through the beautiful country" (p. 28).

18. Ibid., pp. 127, 133–34.

19. J. Bayard Taylor, *Views A-Foot: Or Europe Seen with Knapsack and Staff,* 9th ed. (1846; New York: George P. Putnam, 1850), p. 398.

20. Gifford, European Letters, vol. 1, p. 44. Gifford famously made up for the lack of evening dress in Cairo by borrowing a suit from the headwaiter of his hotel. See "Address by Jervis McEntee," in *Memorial Meeting*, pp. 53–54.

21. Gifford, European Letters, vol. 1, pp. 90–91.

22. Ibid., pp. 35, 100.

23. Ibid., pp. 66, 122.

24. Ibid., p. 107. Gifford spent 260 pounds during 1856, and noted that the cost of living in Paris was about the same as in New York, and in Düsseldorf half that of New York or Paris; Gifford, European Letters, vol. 1, pp. 119–20; vol. 2, pp. 45, 128. In 1868, he noted that "the cost of hotels, guides, etc. is at least half as much again as when I was in Switzerland before," and that the cost of living in Cairo, "with the expenses of moving about and of sight seeing, is about double that of Europe"; see Gifford, European Letters, vol. 3, pp. 20, 62.

25. "Address by W. Whittredge," in *Memorial Meeting*, p. 38.

26. Gifford, European Letters, vol. 1, p. 102.

27. Ibid., vol. 2, p. 108.

28. Ibid., p. 151.

29. Ibid., p. 165.

30. Ibid., pp. 122–23.

31. Ibid., vol. 1, p. 29.

32. "Address by Jervis McEntee," in *Memorial Meeting*, p. 53.

33. Gifford, European Letters, vol. 2, p. 14.

34. Ibid., vol. 1, pp. 143, 163; vol. 2, pp. 125–26.

35. Ibid., vol. 1, p. 90.

36. Ibid., vol. 3, p. 22.

37. Ibid., vol. 2, p. 81. Gifford may have sought out this particular experience inspired by Cole's impressions from his 1841 visit to the Bernese Alps. Cole described the mountains, seen through "the hazy atmosphere of the morning," as "the most wonderful and sublime view that I ever beheld." Louis Legrand Noble, *The Life and Works of Thomas Cole,* edited by Elliot S. Vesell (1853; Cambridge, Massachusetts: The Belknap Press, 1964), pp. 228–29. Gifford also echoes Cole in his emphasis on the "strange and supernatural" beauty of the snowcapped peaks in Switzerland.

38. Gifford, European Letters, vol. 2, p. 80.

39. Ibid., vol. 1, p. 76.

40. Ibid., vol. 2, pp. 87, 89.

41. Ibid., pp. 154–55, 165–66, 174.

42. "Address by W. Whittredge," in *Memorial Meeting*, pp. 35–36.

43. Gifford, European Letters, vol. 1, p. 57.

44. "Address by W. Whittredge," in *Memorial Meeting*, p. 36.

45. Gifford, European Letters, vol. 2, p. 56.

46. Ibid., vol. 1, pp. 58, 61.

47. George William Curtis's *Nile Notes of a Howadji* was first issued from 1846 to 1850 in serial form in the *New-York Daily Tribune*; Bayard Taylor's *A Journey to Central Africa* was published in 1854. Taylor also lectured extensively on his travels and was a frequent visitor to the Tenth Street Studio Building. Weir recalled a "delightful" dinner in Gifford's studio, at which Bayard Taylor was listed among the guests. See Baur, ed., 1942, pp. 47–48. Gifford almost certainly discussed his travel plans with Taylor, as he hired the same dragoman for his journey from Jaffa to Beirut that Taylor had engaged on the Nile. As early as 1855, on meeting a group of Americans just back from the East, Gifford mentioned that they "all speak of their sojourn in the East as very interesting"; see Gifford, European Letters, vol. 1, p. 139.

48. See Cikovsky 1970, pp. 17–18, and Howat et al. 1987, p. 73.

49. Gifford, European Letters, vol. 3, p. 7.

50. Alexander William Kinglake's account of his travels in the Near East (*Eothen* is Greek for "from the early dawn" or "from the East") was first published in 1844 and quickly sold out six editions.

51. Gifford, European Letters, vol. 3, p. 7.

52. Ibid., pp. 7, 9.

53. Ibid., pp. 18, 47.

54. Ibid., p. 50.

55. Ibid., p. 28.

56. Ibid., pp. 31–32.

57. Ibid., p. 29.

58. Ibid., p. 54.

59. See John Davis, "Frederic Church's 'Sacred Geography,'" *Smithsonian Studies in American Art* 1, no. 1 (Spring 1987), p. 83.

60. Gifford, European Letters, vol. 3, p. 90.

61. Ibid., p. 59. Gifford frequently likened aspects of the European and Egyptian landscapes to similar features in America: He compared the Apennines with the Catskills, the Rhine with the Hudson, the Libyan mountains with the Palisades, the dunes of Jebel Darhoot with the south shore of Long Island, the cataract at Aswān with the rapids above Niagara, and the Golden Horn and Heights of Beyoğlu (Pera) with the East River and Brooklyn Heights. See Leed, *The Mind of the Traveler*, pp. 67–68, on this common practice of travelers as a means of appropriating sites to the known and familiar world.

62. Gifford, European Letters, vol. 3, p. 63.

63. Ibid., p. 64.

64. Ibid., pp. 64–67.

65. Ibid., pp. 69–70.

66. Ibid., p. 56. In a letter to his sister describing the same impression of the costumes in Alexandria, Gifford went on to say, "If I could paint the figures and costumes I see I would make Gérôme howl and fall on his knees and beg for mercy" (Letter from Sanford Robinson Gifford to Mary Gifford, January 8, 1869; in Gifford Papers (Archives of American Art, Reel D10, frame 1217).

67. Gifford, European Letters, vol. 3, p. 58. The painting was purchased from Goupil in 1867 by the Knoedler Gallery in New York, where it was exhibited until it was sold to Robert Stuart the following year.

68. Ibid., p. 66.

69. Ibid., p. 61.

70. Ibid., p. 74.

71. Ibid., p. 84.

72. Ibid., p. 110.

73. Larzer Ziff, *Return Passages: Great American Travel Writing, 1780–1910* (New Haven and London: Yale University Press, 2000), p. 134.

74. Gifford, European Letters, vol. 3, pp. 99–100.

75. See Fussell, *The Norton Book of Travel*, p. 13, on travel as a means of elevating one's status in the social hierarchy, and Dean MacCannell, *The Tourist: A New Theory of the Leisure Class* (1976; Berkeley and Los Angeles: University of California Press, 1999), p. 40, on the combination of respectful admiration and disgust that makes up the tourist's attitude; together, they provide "a moral stability to the modern touristic consciousness that extends beyond immediate social relationships to the structure and organization of the total society."

76. Gifford 1869, and Gifford, European Letters, vol. 3, pp. 74, 105–6.

77. Gifford, European Letters, vol. 3, pp. 97–99.

78. See Jonathan Culler, "The Semiotics of Tourism," chap. 9 in *Framing the Sign: Criticism and Its Institutions* (Norman, Oklahoma, and London: University of Oklahoma Press, 1988), pp. 156–57, on the denigration of tourists by other travelers as part of "an attempt to convince oneself that one is not a tourist."

79. Gifford, European Letters, vol. 3, p. 117.

80. Ibid., pp. 120–21.

81. Weiss 1987, p. 125.

82. Gifford, European Letters, vol. 2, p. 175, vol. 3, p. 129.

83. Ibid., vol. 3, pp. 52–53.

84. "Address by W. Whittredge," in *Memorial Meeting*, p. 37.

85. Additional photographs of the expedition appear in Weiss 1987, pp. 285–91.

86. William Henry Jackson, *Time Exposure: The Autobiography of William Henry Jackson* (New York: G. P. Putnam's Sons, 1940), p. 189.

87. Letter from William Henry Jackson to Mrs. Sanford R. Gifford, December 27, 1940; Collection Sanford Gifford, M.D.; quoted in Weiss 1987, p. 284.

88. Letter from Sanford Robinson Gifford to Ferdinand V. Hayden, January 6, 1871; National Archives, College Park, Maryland, Record group 57, microfilm M623, reel 2.

89. William Henry Jackson, "Diaries," September 15, 1870; The New York Public Library, Manuscript Division; Letter from Sanford Robinson Gifford to Ferdinand V. Hayden, July 14, 1871; National Archives, College Park, Maryland, Record group 57, microfilm M623, reel 2.

90. Weiss 1987, p. 130.

91. Letter from Sanford Robinson Gifford to Elihu Gifford, September 27, 1874; Collection Sanford Gifford, M.D.; quoted in Weiss 1987, p. 141.

92. This is a reference to Ruskin's derisive description of train travel: "The whole system of railroad travelling is addressed to people who, being in a hurry, are therefore, for the time being, miserable. No one would travel in that manner who could help it. . . . The railroad is in all its relations a matter of earnest business, to be got through as soon as possible. It transmutes a man from a traveller into a living parcel." *The Works of John Ruskin*, vol. 8, *The Seven Lamps of Architecture*, edited by E. T. Cook and Alexander Wedderburn (London: George Allen, 1903), p. 159.

93. Letter from Sanford Robinson Gifford to Elihu Gifford, August 10, 1874; Collection Sanford Gifford, M.D.; quoted in Weiss 1987, p. 140.

94. Illustrated in Moure 1973, p. 23.

95. "Art," *The Arcadian* 3, no. 17 (January 7, 187[5]), p. 13.

96. Gifford sent John Durand his comments on several paintings in the 1855 Exposition Universelle, which were published in *The Crayon* in 1855; his letter to Richard Butler, of February 10, 1869, was published in *The New York Evening Post*. See Gifford 1855; Gifford 1869.

97. Gifford, European Letters, vol. 3, p. 86.

98. Alexander [William] Kinglake, *Eothen or Traces of Travel Brought Home from the East,* with an introduction by Jan Morris (Oxford and New York: Oxford University Press, 1982), pp. ix–x. See also Barbara Kreiger's introduction to the 1996 edition (Marlboro, Vermont: Marlboro Press): "[*Eothen* was] not written for those who will follow, but intended as a literary version of a journey, a recreation of the author's encounter with the unfamiliar, a testing of his sensibility" (p. xiv).

99. See Ziff, *Return Passages,* pp. 13, 185, 193, on *The Innocents Abroad* as antitravel and also as the most popular travel book ever written by an American. An 1875 article on travel in *The Arcadian* (4, no. 2 [September 25, 1875], p. 10) reflects the by then quite common air of ridicule directed toward the fashionable tourist.

100. Gifford, European Letters, vol. 3, p. 65.

101. William Makepeace Thackeray, *Notes of a Journey from Cornhill to Grand Cairo* (1840; Heathfield: Cockbird Press, 1991), pp. 128–29; Gifford, European Letters, vol. 3, p. 68.

102. Thackeray, *Notes of a Journey,* pp. 148–49; Gifford, European Letters, vol. 3, p. 61.

103. Thackeray, *Notes of a Journey,* p. 65.

104. Taylor, *Views A-Foot,* pp. 350–51.

105. Gifford, European Letters, vol. 3, pp. 122, 125–26.

106. Ibid., p. 110.

107. S. S. C., "Literary and Art Notes," *The Galaxy* 8, no. 5 (November 1869), p. 719.

108. "The Lounger. National Academy," *Harper's Weekly* 4, no. 173 (April 21, 1860), p. 243.

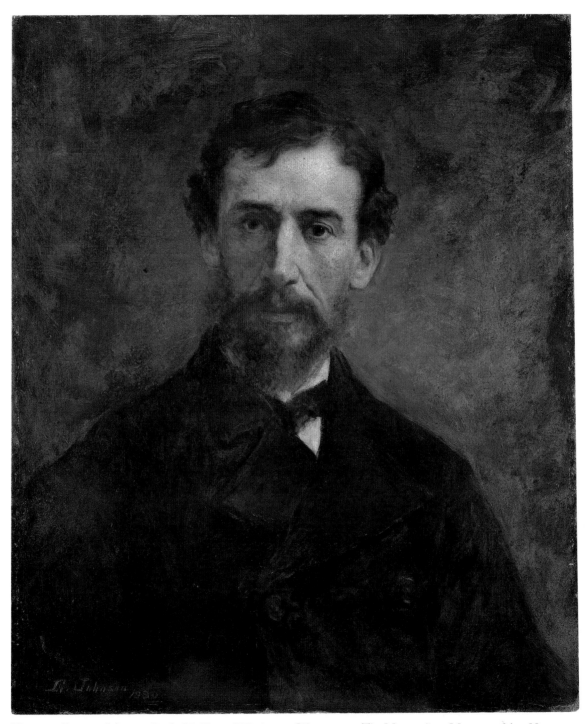

Figure 49. Eastman Johnson. *Sanford Robinson Gifford*, 1880. Oil on canvas. The Metropolitan Museum of Art, New York. Gift of Richard Butler, 1888

TASTES IN TRANSITION: GIFFORD'S PATRONS

ELEANOR JONES HARVEY

On Sunday, August 29, 1880, Sanford Robinson Gifford (see fig. 49) passed away at the age of fifty-seven, after suffering a final bout of malarial fever. As news of his death spread throughout the art world in New York, the eulogies from his patrons and colleagues made it clear that he was a man who would be sorely missed. Gifford's passing was marked by two significant events: a memorial exhibition of sixty-two paintings took place in November 1880 at the Century Association, and a larger one was held at The Metropolitan Museum of Art from October 1880 to March 1881. As remarkable as the exhibitions themselves was the publication of the *Memorial Catalogue of the Paintings of Sanford Robinson Gifford, N. A.* in 1881. Gifford's close friend Jervis McEntee had sorted through the artist's account books and studio to compile a detailed, chronological listing of all of the known pictures in Gifford's oeuvre.[1] For the Century, John Ferguson Weir, another of Gifford's closest friends, delivered a moving eulogy that blended admiration for the artist's career with a prescient assessment of the shift in the taste for landscape painting that Gifford's oeuvre represented. That shift coincided with the transition from the Hudson River School era —epitomized by the works of Thomas Cole—to the Gilded Age, typified by an international preference favoring the Barbizon-inflected landscapes of Corot. In Weir's view, Gifford's paintings managed to satisfy both tastes without compromising their originality, according Gifford a unique place among American landscape painters.

A third event was equally important in honoring Gifford at his death. Early in 1881, Thomas Kirby & Sons conducted a two-night auction of over six hundred paintings and oil sketches from Gifford's estate. The list of paintings to be sold provided yet another roughly chronological accounting of Gifford's oeuvre. An annotated copy of the catalogue, containing the purchasers and the prices paid, contributes a detailed indication of the interest in Gifford's work generated by his passing. The task of compiling each of those lists was daunting and exhausting, but the fruits of those labors afforded modern scholars a road map of the artist's career and working method, and a tantalizing compendium of Gifford's mature work—much of which, for now, remains unlocated.

Taken together, the *Memorial Catalogue* and the catalogue of the estate sale offer more than a roster of the artist's paintings. They enumerate the patrons who supported Gifford during his lifetime, as well as the men and women who were drawn to Gifford's works at the time of his death. Those lists—of paintings and of patrons—are crucial to an understanding both of Gifford's artistic process and of his philosophy of painting. These factors, in turn, help to explain the range of supporters found on those lists, and situate Gifford as a transitional figure between the Hudson River School and the Gilded Age.

Gifford's place in that transition is not immediately obvious. Born in 1823, he emerged as a mature artist during the same decade as Frederic E. Church (1826–1900), but his career and his patronage soon developed a far different

trajectory. That difference is revealed in Gifford's professed admiration for Thomas Cole's philosophy of landscape painting, summed up in Cole's preference for allowing "time to draw a veil" over the common details of a scene in order to achieve a poetic and metaphorical sensibility in a painting. With the rise in popularity of Ruskin's "Truth to Nature," both of Cole's students, Church and Asher B. Durand, would distance themselves from their mentor's credo. Instead, they proclaimed their devotion to direct observation and oil sketches made in the field as the basis of their most successful works, without the kind of studio-bound amalgamation of time and place characteristic of Cole's paintings. This quasi-scientific approach found much favor with patrons building collections in the 1840s through the 1860s, notably—in Church's case—with William H. Osborne, William T. Blodgett, and John T. Johnston.

However, for Gifford, Cole's dictum did not translate into an abrogation of close observation but provoked a reassessment of what those moments in nature meant. Gifford's pattern, often repeated throughout his thirty-year career, was to begin outdoors by recording the natural scenery in a sketchbook and then synthesizing those records into thumbnail pencil studies.[2] Returning indoors, he first painted a small oil sketch, followed by a medium-scale study (a small finished painting), which culminated in an even larger painting of the same subject. Some of the largest and most significant of these final versions Gifford called his "chief pictures," and they became the core of his mature oeuvre. In this regard, the *Memorial Catalogue* serves one of its most important functions: The chronological list of paintings often contains the consecutive groupings of increasingly larger-scale pictures with the same subject. Thus, the net result of Gifford's working method is a distillation process in which each subsequent version of a subject removes it another step further from nature—the inverse of Church's effort to maintain the spontaneity of the oil sketch in his "Great Pictures."

Gifford's "chief pictures" and his other large versions of additional subjects do not display a *plein air* exactitude but, rather, are meditations on the perception of landscape. By updating Cole's philosophy, Gifford developed a more metaphorical philosophical approach to landscape painting, which had more in common with the manner of George Inness (1825–1894) than with

that of his Hudson River School colleagues. The Swedenborgian inflection in Inness's landscapes removed them from reality, as the artist pursued a more spiritually abstract mood in his work.[3] John Ferguson Weir had identified this penchant in Gifford's art, and in his eulogy had articulated perhaps the most astute consideration of Gifford's goals as an artist. Weir defined his friend's attitude toward painting as "nature passed through the alembic of a finely organized sensibility"—a wonderfully poetic evocation of the distillation of place and experience that is a hallmark of Gifford's best work.[4] Often categorized as a member of the Hudson River School's "second generation," Gifford was, in fact, less a follower than a man blazing his own idiosyncratic path toward a very different landscape aesthetic. In his mature works, atmosphere emerged as a primary subject, and nature served as the vehicle for its expression—which made him an artist quite unlike his principal colleagues, Church and Inness, each of whose careers overlapped Gifford's in its entirety.

The distinctions did not end with Gifford's style, but carried over to his patrons. Little has been said about the group of men and women who were attracted to Gifford's paintings, or about the genesis of their interest in Gifford's art. Who were the men and women who helped sustain Gifford's career during his lifetime? What does the evidence of their patronage, and of those who acquired works from the sale of his estate, say about Gifford's painting philosophy, and his appeal to a different and newer generation of art collectors? Based on information in the *Memorial Catalogue* and on the results of the estate sale, Gifford's supporters fell into several distinct categories, comprising, on the one hand, several of the leading devotees of Hudson River School landscapes and, on the other, a cadre of Gilded Age collectors embarking on their first foray into the art world. In addition to family and colleagues, Gifford's patrons included a tightly knit group of close friends, among them some of the foremost civic leaders and connoisseurs of his day. Taken in turn, these loosely defined groups shed light on Gifford's life, his work, and his popularity.

A reconsideration of Gifford's style and subject matter is crucial to an understanding of this patronage, for both artist and patron occupied a transitional period between the heyday of the Hudson River School and the flourishing of the Gilded Age in the closing decades of the nineteenth century. That shift augured the change in taste from a pre-Civil War landscape aes-

thetic predicated on manifest destiny to a postwar fascination with a metaphorically and atmospherically charged view of nature at home and abroad.

The Hudson River School collectors were by and large self-made businessmen, who came to appreciate art as their wealth accrued. Among the more familiar names in the first group are those of Robert Hoe and Robert M. Olyphant of New York, Charles Parsons of Saint Louis (see cat. nos. 11, 56), and William T. Walters of Baltimore (see cat. no. 7). Lists of the holdings of each of these men indicate that they often owned several pictures by such landscapists as Church, Cole, and Durand. Olyphant began his collection in the early 1850s, purchasing works by Cole and Church; twenty-five years later, he had amassed 162 paintings by sixty-seven artists, and when he sold his collection in 1877 it included landscapes by Cole, Durand, Church, David Johnson, Jasper Cropsey, John Casilear, Thomas Hicks, Gifford, John Frederick Kensett, William S. Haseltine, Worthington Whittredge, and Alexander Wyant. Although Olyphant had paid more for the painting by Church than for the Gifford, by 1877 taste had shifted and, at the Olyphant sale, works by Gifford and Kensett brought many of the highest prices.[5]

Another of Gifford's prominent Hudson River School-era patrons was Marshall O. Roberts (1814–1880), who made his money managing government steamship mail service, but got his start as a profiteer in the steamship trade during the Civil War. Roberts also financed Cyrus Field's first transatlantic cable venture. At the time that Roberts's collection of American art was profiled in *The Crayon*, it comprised primarily landscape paintings and genre scenes by Church, Kensett, Durand, as well as by Régis Gignoux, William Jacob Hays, William Tylee Ranney, and Daniel Huntington, but Emanuel Leutze's *Washington Crossing the Delaware* was its undisputed centerpiece.[6]

Gifford was popular with his colleagues, many of whom remarked on his congeniality, and the array of artists who acquired examples of his work during his lifetime is impressive: McEntee, Casilear, Vincent Colyer, J. M. Falconer, George Fuller, John LaFarge, Samuel V. Hunt, Rufus Moore, Erastus Dow Palmer, Louis Prang, James Smillie, and John Ferguson Weir. At the sale of his estate, many of his friends purchased an additional work by Gifford for their own collections.

Gifford also attracted a group of patrons who were not primarily considered art collectors but who shared some facet of the artist's passion for landscape—including Othniel Charles Marsh, a professor of paleontology at Yale University, and James W. Pinchot, who founded Yale's School of Forestry. Marsh (1831–1899), one of America's most celebrated paleontologists, developed an acute interest in Gifford's oeuvre. In 1880, he owned a single work by Gifford; yet, at the artist's estate sale, he purchased twenty-nine others over the course of the two days. We do not know if the artist and the scientist ever met, or if Weir, a fellow Yale professor, was the link between the two men.

Known as O. C., Marsh was the nephew of the millionaire George Peabody, and in 1869, at the age of twenty-one, Marsh inherited the dowry Peabody had given his mother. Peabody continued to support his sister's son, during his education at Andover and at Yale (class of 1860), and through his graduate studies at Yale and in Germany. Marsh persuaded his uncle to found the Peabody Museum of Natural History at Yale in 1866, the same year the young scholar was named professor of paleontology, and he went on to become the museum's first curator, eventually holding the position of director. With Peabody's fortune, Marsh set about building the collections now housed at Yale.[7]

Between 1870 and 1873, Marsh led four expeditions west. Intriguingly, his itinerary in 1870 overlapped that of Gifford, who was also in Wyoming that summer to accompany Ferdinand V. Hayden's surveying expedition. No record exists to confirm that the two men met; however, each traveled with a military escort, and Hayden noted in his journal the army outposts they visited. Something clearly triggered a response to the American landscape in Marsh, as he went on to amass "seventy-five oils, all by American artists, and which include no less than twenty-eight examples of Sandford [*sic*] Gifford and nineteen of Worthington Whittredge."[8] Both artists were in Colorado and in Wyoming in 1870, which suggests that it was the appreciation of this particular landscape that they had in common. Marsh's holdings represented the full spectrum of these artists' careers.

Marsh would adopt a higher profile in the years to come. During his foray west, in 1874, he met the Oglala Sioux leader Red Cloud (see fig. 50), and the two men became close friends, with Marsh taking up the Sioux cause over broken treaties in the Black Hills.[9] By the 1880s, Marsh regularly frequented The Metropolitan Museum of Art's semi-annual receptions, which were attended by the leading collectors and patrons of the Museum.[10]

James W. Pinchot, a wallpaper merchant, who was chair of the Museum's committee on art, was also a personal friend of Gifford. *Hunter Mountain, Twilight* (cat. no. 41), was one of seven paintings by the artist that Pinchot owned.[11] Gifford's place in the Pinchot family was sufficiently close that he was godfather to James and Mary Pinchot's son Gifford Pinchot, the prominent environmentalist. James Pinchot's passion for environmental issues had prompted him to found the Yale School of Forestry in 1900, a legacy he passed on to his son. However, he was interested enough in art that Gifford and McEntee at one point tried to convince him to found "a permanent gallery of art" as an alternative outlet for sales.[12]

The Pinchots and the McEntees moved in the same social circles as Gifford, which included an impressive constellation of authors who were also the artist's patrons, such as Richard and Elizabeth Stoddard and Edmund Clarence Stedman. They were part of a much larger association of artists and writers whose paths crossed during the middle decades of the century.[13] A common thread binding together this disparate group was their reverence for the American landscape, as represented in art and in literature. Although Gifford remained a bachelor until two years before his death, he attracted a following among strong-willed and controversial women in the arts, and Elizabeth Drew Barstow Stoddard appeared to be a particular favorite. An outspoken feminist poet and critic, she shared Gifford's high regard for landscape as a powerful metaphor for human emotion; her novels portrayed "New England life in which self-reliance, isolation and strangeness are synonymous with the landscape itself."[14] She dedicated her third novel, *Temple House*, to Gifford, and he reciprocated with a small painting intended for her birthday.[15]

One of his closest friends was Candace Wheeler, best remembered for her contributions to American decorative arts and design, including her orchestration of the Women's Building at the 1893 World's Columbian Exposition in Chicago. An early supporter of American art and a habituée of the Tenth Street Studio Building, she entertained a broad cross section of artists at her home, in addition to Gifford. In 1883, her love of rural landscape inspired her to found Onteora, a summer colony for artists and writers in the Catskills.[16] The philosophy behind Onteora was the simple evocation of a sensibility that must have appealed to Gifford as well: "I have found that if we come close

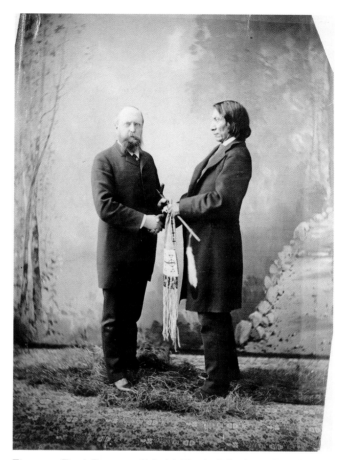

Figure 50. Frank Bowman. Othniel Charles Marsh and Red Cloud, 1833. Albumen silver print. National Portrait Gallery, Smithsonian Institution, Washington, D.C.

to the ground, real worries disappear."[17] Gifford's correspondence with the Wheeler family is affectionate, indicative of the kind of intimate personal associations the artist shared with a wide spectrum of individuals.

The bulk of Gifford's surviving correspondence takes the form of letters to his family and friends, most of which were written while the artist was abroad; however, he also wrote extensively about his experiences with the Seventh Regiment in the Civil War. Even during his tours of duty, Gifford was able to meet new patrons. Jervis McEntee, Elizabeth Stoddard, and Tom and Candace Wheeler all knew George Buchanan Coale, a Baltimore collector, whom Gifford visited while he was stationed in Maryland in 1863. Gifford

enjoyed dinner at Coale's home, and reciprocated at parties in his Tenth Street studio.[18] They developed a close enough relationship that they traveled together briefly in Europe in 1868, and went on a fishing trip in Michigan in the summer of 1871, fishing being one of Gifford's lifelong passions.

The founding of The Metropolitan Museum of Art united a group of Gifford's most influential patrons, the majority of whom also belonged to the two leading social clubs in the city: the Century and the Union League. Gifford was a member of all three organizations, placing him in an enviable niche in the cultural milieu of the city. Many of Gifford's supporters formed a loosely knit confederation of businessmen and art enthusiasts who traveled in the same circles. It is not unusual to see mention of several patrons in an article focused on a single person; in many cases, they officiated on each other's boards, frequented the same social clubs, and in a considerable number of instances served as pallbearers for their friends and other civic leaders—as Richard Butler did for Gifford.

Two of the staunchest collectors of Gifford's work are not well known outside of those intertwined business and social circles. Foremost among his lifetime patrons was Richard Butler (see fig. 51), one of the group of founders of The Metropolitan Museum of Art and a member of the inaugural board of trustees. In addition, Butler was chairman of the Art Committee of the Union League Club and belonged to the Century Association, the Grolier Club, and numerous other social organizations.[19] Born in 1831 in Ohio, Richard Butler came to New York in 1846, and started his career as a partner in the brokerage firm of Howard, Sanger & Co. After three decades in manufacturing, he was named president of the Rubber Comb and Jewelry Factory of Morris County, New Jersey; in 1883, it would become the Butler Hard Rubber Company, which manufactured the "Ace" brand of rubber products ranging from bowling balls to ladies' combs. (Rubber was gradually supplanting whalebone as the preferred material for such household goods—a trend that enabled Butler to make his fortune.) Subsequently called the American Hard Rubber Company, its headquarters were in the town of Butler, New Jersey, named in his honor. Butler also served as secretary of the American Statue of Liberty Committee (chaired by Joseph Pulitzer), which spearheaded a twelve-year funding campaign to erect Bartholdi's gift in New York Harbor.[20]

Figure 51. Photographer unknown. Richard Butler, about 1870. Carte de visite. Century Association Archives Foundation

Butler clearly was a trusted friend. Gifford named him co-executor of his estate, along with his nephew Paul Gifford, and Butler, in turn, appointed Jervis McEntee to the committee charged with organizing the Gifford "Memorial Exhibition" and compiling the catalogue at The Metropolitan Museum of Art. As further measure of his regard for the artist, Butler—whose company built houses for its employees—named one of the streets in the area for Gifford on the day that he died, "as a tribute to his memory. . . . the artist had visited the place only a short time prior to his death, and was so charmed with the beautiful mountain scenery that he looked forward with great pleasure to the time when he would return and add bits of the picturesque landscape to his collection. Alas! His hopes were not realized; and as his works remain a monument to his industry and devotion to the art he loved, so does Gifford Street betoken the appreciation of his friends and their sorrow at his untimely passing."[21] Gifford Street appears as a vignette in Isidor Lewi's

history of the town of Butler, on a page devoted to the Rubber Comb and Jewelry Factory.

Richard Butler already owned three of Gifford's paintings, including *San Giorgio, Venice* (Whereabouts unknown), of 1870, which he commissioned while Gifford was in Rome;[22] *Hook Mountain, near Nyack, New York,* of 1867 (Private collection); and an intimate work entitled *Red Buttes, Wyoming Territory* (Whereabouts unknown), of 1870, a small equestrian self-portrait based on a photograph taken of the artist by his traveling companion the photographer William Henry Jackson. Butler's admiration for Gifford was such that he purchased an additional forty works from the two sessions of the artist's estate sale (see cat. no. 61 and fig. 114).

Butler remained close to the Gifford family even after the artist's death, and in 1887 he inherited from Gifford's widow the portrait of Sanford Gifford by Eastman Johnson, which he donated to the Metropolitan Museum (see fig. 49). In addition, he presented the Metropolitan with a portrait bust of Gifford by Launt Thompson (see Frontispiece), modeled from life. Upon Butler's death, the written tributes in his honor call attention both to his civic service and to his impressive collection of American art, much of which was given or bequeathed, as well, to the Metropolitan Museum.[23]

Like Richard Butler, Samuel P. Avery and Vincent Colyer, too, served on the Art Committee of the Union League Club and were drafted as members of the inaugural committee of the Metropolitan. Among the new museum's patrons, Gifford enjoyed the support of such men as Thomas B. Clarke, whose collection of American art—in particular, his works by Homer—would establish him as the leading collector of his era; and Dr. Fessenden Otis, a physician who would help to diagnose Gifford's fatal ailment.[24] Morris K. Jesup (see fig. 52), president of the American Museum of Natural History and an underwriter of then-Lieutenant Robert Peary's expedition to the Arctic, made the Metropolitan the beneficiary of his collecting interests, bequeathing Gifford's *A Gorge in the Mountains* (cat. no. 21) along with other significant paintings by Kensett and Church.[25] Similarly, a number of Gifford's patrons

Figure 52. Photographer unknown. Morris K. Jesup, about 1870. Carte de visite. Century Association Archives Foundation

belonged to a group of subscribers—which included William E. Dodge, Jr.; Robert M. Olyphant; Robert Gordon; Morris K. Jesup; and Gifford himself—who pooled funds to purchase major works of art for the Museum.[26]

Robert Gordon, like Richard Butler, was not known principally as a collector. A member of the firm of Maitland, Phelps, & Co., and of the Century and the Union League clubs, he was a founder of The Metropolitan Museum of Art, serving on the board of trustees and as treasurer. Although he moved to London in 1887, taking his collection of American art with him,[27] he was fêted, nevertheless, on a return trip to New York in 1894, by such Gifford patrons as Samuel P. Avery, Charles Stewart Smith, Cornelius Vanderbilt, Salem H. Wales, Richard Butler, Morris K. Jesup, and James W. Pinchot.[28] Gordon's favorite painting by Gifford was the monumental *Tivoli* of 1870 (fig. 53), one of the artist's "chief pictures."[29] As Gordon noted with pride, "Gifford is now painting for me a splendid picture . . . the result of his recent visit to Italy. It is a view near Tivoli, looking toward Rome. . . . It is, I believe, literally true to nature, except in the foreground, where a little license has been taken for artistic effect."[30] It would be Gordon who would select the mid-size version of the artist's views of the Parthenon from Gifford's estate sale for acquisition by the Century Association.

Despite one critic's lament that the larger view of the Parthenon had not been acquired by the Metropolitan, that "chief picture" (see cat. no. 70) went, instead, to the Corcoran Gallery of Art in Washington, D.C., purchased for $5,100 on its behalf by the president of the Corcoran's board, Samuel Hay Kauffmann.[31] Kauffmann (1829–1906), a Washington, D.C., newspaper magnate and prominent art collector, belonged to numerous social and philanthropic societies both there and in New York, and became an authority on equestrian statues.[32] Kauffmann already owned two paintings by Gifford—views of Mount Merino in the Catskills, and of Echo Lake in New Hampshire, both acquired during the 1860s—which may have influenced his decision to purchase *Ruins of the Parthenon* (cat. no. 70) for the Corcoran.

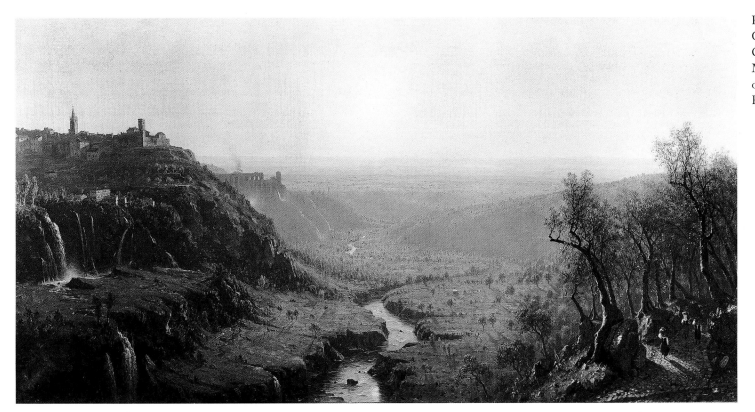

Figure 53. Sanford R. Gifford. *Tivoli*, 1870. Oil on canvas. The Metropolitan Museum of Art, New York. Gift of Robert Gordon, 1912

The year Gifford died, the Century Association boasted over fifty members who owned paintings by him and whose names were recorded in the Metropolitan Museum's *Memorial Catalogue*.[33] Gifford, himself, had become a member in 1859, and counted numerous Centurions among his friends and patrons, notably, Robert L. Stuart, Robert Olyphant, Richard Butler, Robert Gordon, Samuel P. Avery, Michael Knoedler, Rev. Henry Whitney Bellows, and Tom Wheeler. In fact, as Ila Weiss has pointed out, close to half of the large-scale paintings by Gifford sold in New York City between 1862 and 1878 were purchased by Centurions.[34] Similarly, the Union League Club, founded in 1863 as a consequence of the Civil War, had numerous members who were also patrons, with plenty of overlap between the rosters of the two organizations. Five Union League Club officers in 1880 were among Gifford's patrons, including Butler, as were over twenty of the resident members.[35] Artist Vincent Colyer owned seven of Gifford's paintings, and, as noted above, served on the Union League Club's Art Committee along with Gifford, Avery, Kensett, and Calvert Vaux, another Gifford patron.

Gifford also enjoyed the admiration of a small group of powerful clergymen of various faiths, and he associated with two of the leading Unitarian ministers of his era. Like Edmund Clarence Stedman and Calvert Vaux,[36] Gifford was a member of the congregation of Octavius Brooks Frothingham, an influential radical Unitarian, who wrote art criticism for the *New York Herald Tribune*.[37] The Reverend Mr. Bellows (see fig. 54), also a prominent Unitarian minister, belonged to the larger committee convened to found The Metropolitan Museum of Art in 1869. He had been an inaugural member of the Century Association and an officer of the Union League Club, and presided over Gifford's funeral at the request of the artist's family.[38] During the 1850s, Bellows wrote for *The Crayon*; later, he served as president of the Sanitary Commission.[39] While Gifford did not write specifically about his religious beliefs, his European letters are replete with descriptions of the various churches of different faiths he visited while overseas. Whether by design or curiosity, Gifford appeared to be seeking some unifying thread among these various religious houses—which, perhaps, raises the question as to the nature

and purpose of light in his paintings, from a spiritual perspective. Gifford finished three semesters at Brown University studying philosophy and religion, and thus his temperament may well have led him to introduce a more palpable metaphorical content into his art.

In the art world, the best known of the clerics was the Reverend Elias Magoon, a Baptist minister, who amassed a fine collection of oil sketches and small paintings by numerous landscape painters of the mid-nineteenth century. Although his expressed preference was for American scenes, he accepted from Gifford four oil sketches, all of European subjects.[40] By 1864, Magoon had sold his collection to Matthew Vassar to form the core of Vassar College's art gallery. Closest to the Gifford family was the Reverend T. Stafford Drowne (1823–1897), a graduate of Brown University (1845), who, by 1858, was Rector of Saint Paul's Episcopal Church in Brooklyn, where he remained head of the congregation into the 1870s.[41] Drowne met Gifford early in the artist's career, and eventually owned nine of his paintings, ranging from family portraits to English landscapes; these were listed in the *Memorial Catalogue*.

Out of the 278 individuals recorded in the *Memorial Catalogue* as owners of Gifford's paintings during his lifetime, forty-eight were women; a number of them were single, but some, like Mrs. Samuel Colt, were listed separately from their husbands (see cat. no. 44). Belle Worsham (later Mrs. Collis P. Huntington), Laura Curtis Bullard, and Helen Munson Williams also numbered among his patrons. Each of these women had begun acquiring art during the 1870s, and in several cases, after being widowed, they used their inheritances to establish their own identities as collectors. One such example was Mrs. Helen Elizabeth Munson Williams (1824–1894) of Utica, New York, the widow of James Watson Williams, whose fifty-thousand-dollar bequest founded the Munson-Williams Memorial, today the Munson-Williams-Proctor Institute, Museum of Art.[42] Mrs. Williams (see fig. 55) had enjoyed a cultured upbringing, complete with a rigorous education at the Utica Female Academy, and was allowed to accompany her father on business trips on the East Coast.[43] After her husband's death, in 1873, she and her two daughters embarked on a series of trips to New York City as well as to Europe, and spent lavishly on jewelry and art, and on furniture from Cottier & Co., Alexander T. Stewart, and Herter Brothers, demonstrating an eye for the

finest contemporary designs. Between 1876 and 1881, she purchased thirty-one major paintings and many more works on paper,[44] and came to know several of the artists whose works she acquired, including Albert Bierstadt and Henry Darby; the latter painted all of the family portraits.[45] An astute businesswoman and investor, Helen Williams owned stock in railroads, coal and iron companies, and mills, as well as rental properties. She also held government and municipal bonds. At her death, her estate was valued at more than five million dollars.[46]

Helen Williams's interest in American art preceded the formation of her collection of Barbizon works. In 1878, she purchased Church's *Sunset* (fig. 72), and the following year Gifford's *The Galleries of the Stelvio—Lake Como* (cat. no. 67), both from the Utica Art Association.[47] At Daniel Cottier's urging, she acquired a painting by Corot, and, in her correspondence, made it clear that this was an avant-garde move for a resident of upstate New York.[48] Emboldened by this purchase, she turned her attention to the French Barbizon artists during the late 1870s and the 1880s, buying works from several New York dealers who also handled Gifford's paintings, among them William Schaus and Michael

Figure 54. Photographer unknown. Henry W. Bellows, about 1870. Carte de visite. Century Association Archives Foundation

Knoedler. Her choice of dealers allied her with several New York City Gilded Age fortunes and collections in the making—notably, those of William H. Vanderbilt, J. Pierpont Morgan, and Alexander T. Stewart.[49]

At the other end of the spectrum was Laura Curtis Bullard (see fig. 56), a prominent suffragette. Laura and her father, Jeremiah Curtis, a patron of The Metropolitan Museum of Art, shared a love of American art.[50] He had amassed a large fortune manufacturing patent medicines. Originally from Maine, Mr. Curtis built the state's first railroad and was nominated as the abolitionist candidate for governor. Between 1857 and 1859, Laura Bullard visited Gifford's studio, acquiring four landscapes directly from the artist; the subjects ranged from Mansfield Mountain and Mount Washington to the Roman Campagna, all locations familiar to her. In 1870, Laura Bullard purchased the suffragette newspaper *The Revolution* from Elizabeth Cady Stanton, and kept it going for eighteen months as a literary and social journal until it was absorbed by the *New York Liberal Christian,* a prominent Unitarian newspaper.[51] In one of her first editorials, Laura Bullard wrote that women were "created by God an independent being, with individual duties and individual rights," and were enjoined to develop their individual talents for the greater improvement of their families and society—views that were widely criticized at the time. The following year, she published an article on the African-American sculptor Edmonia Lewis, which serves as a model of her appreciation of art and her interest in championing the talents of women.[52] Like Candace Wheeler and Elizabeth Drew Barstow Stoddard, Laura Bullard crafted a prominent public persona in the literary arts. All three women possessed the sharp wit and artistic temperament Gifford appreciated in his female friends.

One of the more colorful collectors of either gender was Arabella Duval Yarrington Worsham Huntington Huntington (see fig. 57). The circumstances of Arabella's past have made her an attractive candidate for speculative biography, but clearly she succeeded in creating a prominent role for herself in New York society. The details of Arabella's birth and childhood are obscured by conflicting information but, by 1870, she was living in style in New York and was listed in the city directory as Mrs. Belle Worsham, although there may never have been a Mr. Worsham. Collis P. Huntington, president of the Central Pacific and Southern Pacific railroads and one of

Figure 55. Henry F. Darby. *Helen Munson Williams,* about 1855. Oil on canvas. Munson-Williams-Proctor Institute, Museum of Art, Utica, New York

Figure 56. Artist unknown. *Laura Curtis Bullard,* about 1878. Oil on canvas. Collection Lucy Miller

California's "big four" railroad magnates, paid for the house in which she and her mother resided. Most biographers agree that Arabella was Huntington's mistress for the next fifteen years, and, until his first wife's death, traveled with him as his "niece."[53] Nine months after the onset of this relationship, Arabella left for Texas, where she gave birth to a son, Archer Milton, whose paternity was ascribed either to the putative Mr. Worsham, or to Collis himself. After Collis and Arabella married in 1884, he legally adopted her son, who took the name Archer Huntington.[54]

Regardless of these complications, Arabella possessed a superb design sense, completely furnishing her home at 4 West Fifty-fifth Street herself, to highly complimentary reviews. After her marriage to Collis, Arabella sold her house to John D. Rockefeller, Sr., who was so impressed with her taste that he reportedly changed virtually nothing during the years that he lived there. Belle, as she was known, was then approximately thirty-four years old and Collis was sixty-two. Their marriage lasted until his death, at the age of seventy-eight, in 1900, by which time the Huntingtons had amassed a large fortune valued at over two hundred million dollars. Arabella inherited two-thirds of that sum, making her the richest woman in America; Collis left the remaining third to his favorite nephew and business partner, Henry E. Huntington.[55] Thirteen years after Collis's death, Arabella wed Henry Huntington. Theirs was a bi-coastal marriage, as Henry developed his estate in San Marino, California. While he collected rare books (now housed in the Huntington Library), his new wife purchased the paintings that would form the core of the adjoining art gallery—notably, Gainsborough's *Blue Boy* and Reynolds's *Sarah Siddons as the Tragic Muse*.

Arabella's interest in American art followed the typical Gilded Age trajectory, peaking early, only to be superceded by an intense period of collecting European paintings and decorative arts. While she was still known as Mrs. Belle Worsham, Arabella purchased Kensett's *Summer Day on Conesus Lake* (The Metropolitan Museum of Art),[56] and, probably during the 1870s, Gifford's *The Golden Horn, Constantinople* (see cat. no. 60). Her tastes clearly

Figure 57. Renée de Mirmont. *Arabella Huntington,* about 1880. Watercolor on ivory. Huntington Library, Art Collections, and Botanical Gardens, San Marino, California

strayed from American paintings toward European art under the influence of the dealer Joseph Duveen, from whom she acquired fine art and furniture for a period of over twenty years. The Henry E. Huntington Art Gallery in San Marino and the California Palace of the Legion of Honor in San Francisco were the beneficiaries of the European art from her collection.[57]

America's then-emerging millionaire industrialists, whose names are still associated with Gilded Age society such as J. P. Morgan, John Jacob Astor, William H. Vanderbilt, and Thomas B. Clarke, began by collecting Gifford's paintings before moving on to the work of other artists, both American and European—collections for which they are justifiably far better known. The same network of social contacts—club memberships, gallery events, and museum affiliations—that facilitated these men's collecting strategies permitted an artist such as Gifford to expand his clientele.

Accompanying the cultivation by artists of patrons at exclusive social clubs was the gradual shift in the market away from the purchase of paintings directly from the artist, frequently in the course of a studio visit, as well as the emergence of galleries and dealers. Jervis McEntee, among others, complained, "We are more and more impressed with the fact that we shall ultimately have to get more dealers to interest themselves in our work or we shall sink out of sight."[58] His lament ignores the root problem his generation of artists faced: the change in taste, away from the Hudson River School aesthetic. An additional factor influencing the market was the sale of entire art collections while the patron was still alive (as distinct from estate sales). Often, the collections on the block comprised American paintings, whose owners intended to use the proceeds of the auctions to pursue fashionable European works of art. Examples of this phenomenon include the sales of Samuel P. Avery's American art collection in 1867 and of Thomas B. Clarke's collection in 1899.

Thomas B. Clarke (1848–1931) began acquiring American paintings in 1872, when he was in his early twenties. Having made his fortune as a lace and linen

Figure 58. George Cruikshank. *Samuel. P. Avery. Fine Art Room. 88 Fifth Avenue,* 1873. Engraving. The New-York Historical Society. Landauer Collection

Figure 59. Photographer unknown. Samuel P. Avery, about 1870. Carte de visite. Century Association Archives Foundation

manufacturer by the time he was forty, he devoted much of his energy to promoting American art, and in 1883 established a prize at the National Academy of Design for the best picture painted in America.[59] He noted that one could buy better American pictures than European art at a lower price. Still, by the time of the 1899 Clarke sale, one reviewer observed that "the majority of his canvases are worth at least double" what he paid for them.[60] In the sale were over thirty-five paintings by George Inness, ten works by Dwight William Tryon, seven canvases by Alexander H. Wyant, five paintings each by Homer Martin and William Merritt Chase, an astonishing thirty works by Winslow Homer, and single paintings by John LaFarge, Worthington Whittredge, and Sanford Gifford.[61] Clarke's interest in Gifford was peripheral, as was the case with so many of the emerging Gilded Age patrons: He had purchased his two works from the artist himself in 1878–79.

One of the best-known collectors and dealers in America was Samuel Putnam Avery (1822–1904), who began by acquiring American art, including numerous landscape paintings by most of the prominent artists of his day (see fig. 58, 59). He belonged to the first generation of dealers in American art, helping to shape the secondary market for American paintings as well as championing European

artists of the Barbizon and Hague schools. After he sold his collection of American art at auction in 1867, he turned his attention to European painting.[62] Avery was attracted to both large and small pictures, recognizing the aesthetic power of an artist's finished oil sketches as early as the 1850s.[63] He also commissioned works of art on behalf of private collectors, among them Gifford patrons Robert M. Olyphant, Robert Hoe, William H. Vanderbilt, and Robert L. Stuart.[64] At the time of the artist's death, Avery owned six paintings by Gifford, and he purchased four others from the estate sale. Whether Avery bought paintings for himself or for clients, his patronage underscored the enduring interest in Gifford's works, which appealed to admirers of the earlier generation of Hudson River School artists as well as to those Gilded Age collectors whose interest lay in European art.

Avery was not alone in his enthusiasm for both American and European art. Seth Morton Vose, who owned Gifford's *Villa Malta, Rome* (fig. 60), and Daniel Cottier both showed the works of Corot, Daubigny, and other European artists alongside their American counterparts, and it is thus little wonder that their clients had no hesitation about mixing American and European art in their own collections. Corot, in particular, was singled out

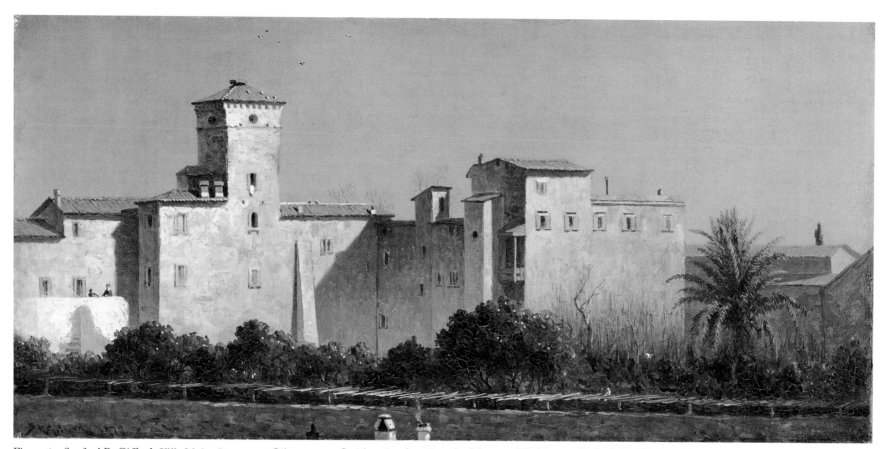

Figure 60. Sanford R. Gifford. *Villa Malta, Rome,* 1879. Oil on canvas. Smithsonian American Art Museum, Washington, D.C. Gift of William T. Evans

for high praise after his death in 1875, when he was hailed as "the greatest painter of our time, because he best represents what the spirit of the time has to express in plastic art, without . . . the defect of material detail."[65]

The underlying reasons for Corot's popularity help explain Gifford's appeal to the same group of collectors. In focusing on the idea rather than on the details of execution, Gifford, like Corot, placed as much emphasis on the viewer's emotional response to the work as on his appreciation of its nominal subject.[66] The Civil War had made it impossible to sustain the confidence in manifest destiny that permeated the early works of Church and Bierstadt. This was supplanted by the paintings of artists like Gifford, or Inness, that augured a different vision in which specificity of place was less important than

the emphasis on provoking a subjective emotional reaction to the picture itself. John Ferguson Weir's assessment of Gifford's allure underscores the similarity with which his paintings were evaluated by critics, patrons, and dealers alike: "The works of Sanford R. Gifford seem to us the just exponent of that which is highest, fullest, ripest—most poetic and profound—in landscape. . . . Most varied in his powers; interpreting every expression of the landscape with the most appreciative sense of its subjective subtleties; preeminently the artist in his just estimate of the values inherent in the sensible realities of nature; sustained, free, and finished in his method—the attractions of Mr. Gifford's style are forcible and many. . . . The same elevated thought *breathes* through them all."[67]

In a pivotal article entitled "An Unfinished Discussion on Finish," the unidentified writer might well have been commenting on Gifford's work when he wrote, "It is best because it renders the best—the *idea*. The other work is like that of statisticians—facts and details which render the body of a thing, but do not touch the soul."[68] Lauded as much for his sensibilities as for his subjects, Gifford occupied a position at the crossroads of taste during a particularly unsettled period in American art. Gifford's dual emphasis on sensibility, conveyed by his treatment of light and atmosphere, coupled with admiration for the scenery and locales he chose as his subjects, made him the ideal candidate for these patrons. At Gifford's death in 1880, the outpouring of grief from his friends and supporters served as a symbolic funeral for the fading Hudson River School aesthetic. This shift in taste would carry over into the Gilded Age and beyond, to the threshold of early Modernism, when a new generation of artists and patrons would again redefine the appreciation of landscape in American art.

I would like to extend my thanks to Dr. Sandra K. Feldman, who conducted much of the primary research on Gifford's patrons found in this essay, and Ms. Lyle C. Gray, who compiled files on the provenances of Gifford's paintings while serving as the McDermott Graduate Fellow at the Dallas Museum of Art.

1. The specificity of information listed in the *Memorial Catalogue* suggests that Jervis McEntee worked from Gifford's account books, which have since disappeared. References to early paintings carry ownership information that occasionally includes the date of sale, suggesting that Gifford had kept generally methodical records, and confirming that his patronage base extended far beyond New York City.
2. Sheldon 1877.
3. For a consideration of Inness's career and the impact of the Swedenborgian faith on his art see Cikovsky and Quick 1985.
4. Weir 1880, p. 20.
5. *Mr. Robert M. Olyphant's Collection of Paintings by American Artists . . . Tuesday and Wednesday Evenings, December 18 and 19, 1877, at Chickering Hall, New York. R. Somerville, Auctioneer*; annotated copy of sales catalogue, Courtesy John Driscoll, Babcock Galleries, New York.
6. "Sketchings. Our Private Collections. No. IV.," *The Crayon* 3, no. 8 (August 1856), p. 249. Roberts subsequently acquired three works by Gifford during the 1860s (all unlocated today), including a painting of Quebec mentioned in Henry T. Tuckerman's *Book of the Artists*, and a pair of works listed in the *Memorial Catalogue* entitled *A Road in the Woods* (1863; Private collection) and *The New Jersey Shore at Seabright* (1867; Whereabouts unknown).
7. The collections included vertebrate and invertebrate fossils, fossil footprints, osteological specimens, and archaeological and ethnographic artifacts. "O.C. Marsh: A Centennial Celebration," cached at Yale University's Peabody Museum website {http://www.peabody.yale.edu/people/whoswho/MarshOC.html}. Marsh's career was marred by over twenty years of public feuding with his chief rival, Edward Drinker Cope, including allegations that each man had sabotaged the other's paleontological excavations. In spite of this, both men managed to make seminal contributions to American paleontology—notably, to the dinosaur fossil record. Between them, Marsh and Cope identified and named over 130 species of dinosaurs.
David Rains Wallace, *The Bonehunters' Revenge: Dinosaurs, Greed, and the Greatest Scientific Feud of the Gilded Age* (Boston: Houghton Mifflin Company, 1999), gives a fascinating account of their lives and their celebrated feud. Among Marsh's lasting contributions was his groundbreaking work on early fossil horses found in Wyoming—evidence that bolstered Charles Darwin's controversial theory of evolution. See "Fossil Horses: Othniel Charles Marsh's Proof for Darwin's Theory of Evolution," cached at {http://www.geocities.com/ResearchTriangle/Lab/3773/OC_Marsh.html}.
8. "The Week in Art," *The New-York Times*, February 24, 1900, *Saturday Review of Books and Art*, p. 122. The reviewer was less than impressed with the caliber of Marsh's collection, preferring his holdings of Asian ceramics.
9. Frank H. Goodyear III, "Curator's Choice: *Red Cloud and Othniel C. Marsh*," *Profile* (Winter 2001); cached at the National Portrait Gallery website {http://www.npg.si.edu/pubs/profile/spr02/redcloud.htm}. See also "Red Cloud Visits a Friend. The Great Indian Chief the Guest of Prof. Marsh in New-Haven," *The New-York Times*, January 21, 1883, p. 1.
10. "In and About the City. Reception at the Museum. A Crowd Views the Pictures While the Light Lasts," *The New-York Times*, November 8, 1892, p. 3.
11. Pinchot also owned Worthington Whittredge's *The Old Hunting Grounds* of 1864.
12. McEntee Diaries, entry for December 1879; quoted in Weiss 1987, p. 148.
13. Weiss 1987, pp. 107–11.
14. Anne-Marie Ford, "Emily Dickinson and Elizabeth Barstow Stoddard," *American Studies in Britain* 84 (Spring–Summer 2001); cached at {http://www.baas.ac.uk/resources/asib/asibtoc.asp?issue=84}.
15. The work in question was *Eagle Lake, Mount Desert, Maine*, painted in 1867. See Weiss 1987, pp. 108ff.
16. Wheeler helped decorate the Hartford home of Mark Twain, who was a visitor to Onteora. For a thorough treatment of Wheeler's life see Amelia Peck and Carol Irish, *Candace Wheeler: The Art and Enterprise of American Design, 1875–1900*, exhib. cat., New York, The Metropolitan Museum of Art (New York: 2001).
17. Jane Curley, "Candace Wheeler, Wise Woman and Muse of American Decorative Arts," *The Hemlock* (Spring 2001); cached at {http://www.mths.org/themhemlock/hemsp01.html}.

18. Weiss 1987, p. 82.

19. "Death List of a Day. Richard Butler," *The New-York Times,* November 13, 1902, p. 9.

20. "About the Kinney Hose Co. No. 1 of Butler Fire Dept.," cached at the Kinney Hose Co. No. 1 of Butler Fire Department home page {http://www.fire-ems.net/firedept/view/Butler2NJ}. See also note 19, above.

21. Isidor Lewi, "The Village of Butler," in *History of Morris County, New Jersey, with Illustrations and Biographical Sketches of Prominent Citizens and Pioneers* (New York: W. W. Munsell & Co., 1882), p. 397. Citation courtesy of Dr. T. R. Laabs, Director, The Butler Free Public Library, Butler, New Jersey.

22. Weiss 1987, p. 129.

23. *Richard Butler. . . . Address by the Reverend Donald Sage Mackay, D. D.* ([New York]: Privately printed for his friends, 1903). This volume is a compendium of eulogies and memorial addresses by the various organizations to which Butler belonged, and letters sent to the family by close friends. Copy courtesy of Dr. T. R. Laabs, Director, The Butler Free Public Library, Butler, New Jersey.

24. Weiss 1987, p. 159. Otis sold his collection of American art in 1890, including paintings by Church, McEntee, Durand, Kensett, Bierstadt, Whittredge, Haseltine, and Gifford. See Skalet 1980, p. 230.

25. Jesup was also president of the International Society of Americanists, the Peary Arctic Club, and the Audubon Society. In addition to his direct bequests to the Metropolitan Museum, he established an acquisitions fund bearing his name. "Morris K. Jesup Is Dead at 77," *The New-York Times,* January 23, 1908, p. 6.

26. In this case, the painting the group helped purchase was Henry Peters Gray's *The Wages of War* (The Metropolitan Museum of Art, New York; American Paintings in MMA II 1985, p. 104). In 1899, when Thomas B. Clarke dispersed his famous collection of American art, a similar group of patrons joined together to buy George Inness's *Delaware Valley* for The Metropolitan Museum of Art. Among the group were five of Gifford's patrons: William E. Dodge, Collis P. Huntington, Cornelius Vanderbilt, Heber R. Bishop, and Morris K. Jesup (American Paintings in MMA II 1985, p. 250).

27. "The Founding of the Museum of Art. Speech of Samuel P. Avery at the Dinner to Robert Gordon," *The New-York Times,* December 9, 1894, p. 2. Letter from Robert Gordon to David Maitland Armstrong, April 9, 1886; published in Armstrong 1920, pp. 325–26. Gordon asserts, "I am beginning to find that I made no mistake in investing as I did in American pictures. They attract a great deal of attention in my house, few good pictures having found their way to this side. In my dining-room, which is large, I have Wyant's 'Old Clearing' over the fireplace, with Gifford's 'Tivoli' and 'Mansfield Mountain' flanking it, all three being cleverly lighted by lamps with reflectors. . . . We had the American Minister, Mr. Phelps, dining with us on Tuesday and he greatly enjoyed the Gifford and Wyant"; quoted in American Paintings in MMA II 1985, p. 177.

28. "Dinner to Robert Gordon. The Guest of the Trustees of The Metropolitan Museum of Art," *The New-York Times,* December 8, 1894, p. 6. For the last seventeen years of Gordon's tenure in New York he also sponsored the Gordon Medal, a curling trophy awarded by the National Curling Club. See "For the Gordon Medal. To-day's Championship Rink Curling at Hoboken," *The New-York Times,* January 15, 1896, p. 6.

29. Gordon presented the painting as a gift to The Metropolitan Museum of Art in 1912.

30. Letter from Robert Gordon to David Maitland Armstrong, March 1870; published in Armstrong 1920, p. 325; quoted in American Paintings in MMA II 1985, pp. 175–76.

31. "Art Notes. S. R. Gifford's *Ruins of the Parthenon* Sells for $5100 and Goes to the Corcoran Gallery, Washington" (unidentified clipping); information courtesy of Marissa K. Borgoyne, Archivist, Corcoran Gallery of Art, Washington, D.C.

32. Kauffmann belonged to the Grolier Club, the National Arts Club, and the National Sculpture Society in New York, and was a member of the Philosophical Society, the Shakespeare Society, and the National Geographic Society in Washington, D.C. See "Samuel H. Kauffmann Dead. Washington Evening Star Proprietor a Well-Known Art Connoisseur," *The New-York Times,* March 16, 1906, p. 9. See also "The Equestrian Statues. S. H. Kauffmann of Washington Says About 285 Are in Existence. Has Investigated the Matter," *The New-York Times,* April 10, 1899, p. 5.

33. Century Association, *Reports of the Treasurer and Board of Management for the Year 1880* (New York: Wm. C. Martin, 1881); courtesy of Jonathan Harding, Curator, The Century Club, New York; copy courtesy of Sandra Feldman.

34. Weiss 1987, p. 343 n. 29.

35. *The Union League Club of New York Annual Reports . . .* (January 8, 1880); courtesy of Arthur Lawrence, Librarian and Archivist, Union League Club, New York; copy courtesy of Sandra Feldman.

36. The architect Calvert Vaux, who was married to Jervis McEntee's sister, was one of Gifford's patrons and was also part of his social circle.

37. Weiss 1987, pp. 40–42.

38. *The New-York Times,* August 30, 1880; *The New York Evening Post,* September 1, 1880.

39. Weiss 1987, pp. 40–41.

40. Harvey 1998, pp. 86–87; see also "Sketchings. Our Private Collections. No. VI.," *The Crayon* 3, no. 12 (December 1856), p. 374.

41. "II. The Episcopal Churches," cached at {http://www.panix.com/cassidy/STILES/EPISCOPALCHURCHES.html}.

42. "The Munson-Williams Memorial," *The New-York Times,* December 2, 1896, p. 3.

43. Anna Tobin D'Ambrosio, "With Style and Propriety: The Evolution of the Decorative Arts Collection at the Munson-Williams-Proctor Institute Museum of Art," in *Masterpieces of American Furniture from the Munson-Williams-Proctor Institute,* edited by Anna Tobin D'Ambrosio, exhib. cat., Utica, Munson-Williams-Proctor Institute; Cincinnati Art Museum (Utica: 1999), p. 10.

44. Anna Tobin D'Ambrosio, "The Vision of a Victorian Collector: Helen Munson Williams," *Nineteenth Century* 18, no. 1 (Spring 1998), p. 11.

45. Ibid., p. 12.

46. D'Ambrosio, "With Style and Propriety: The Evolution of the Decorative Arts Collection at the Munson-Williams-Proctor Institute Museum of Art," p. 148 n. 19.

47. See note 45, above. See also Maria Watson Williams, "Inventory of Valuables Purchased by Mrs. J. Watson Williams at Different Times, with Date of Purchase and Value at Time of Purchase. March 3, 1888"; manuscript at Oneida County Historical Society, Utica, New York.

48. "I am well aware that if I should purchase it, it will be for the gratification chiefly of myself and that there will be a great difference of opinion concerning it among my friends. Indeed, I was told by a gentleman in New York whose judgment was recommended to me that if I wished to buy a picture that artists would dispute about, I would buy a Corot." Letter from Helen Munson Williams to Daniel Cottier, February 9, 1878; Helen Munson Williams Correspondence, cor. 125.2, Oneida County Historical Society, Utica, New York; quoted in D'Ambrosio, "The Vision of a Victorian Collector: Helen Munson Williams," p. 13.

49. Ibid., p. 12.

50. Jeremiah Curtis purchased Elihu Vedder's *The Lost Mind* (The Metropolitan Museum of Art, New York), which he bequeathed to his daughter. Eventually, the painting was given by her daughter-in-law to the Metropolitan Museum in Laura Bullard's honor; see American Paintings in MMA II 1985, p. 505.

51. [Matilda Joslyn Gage], "Woman in Newspapers," chap. 2 in *History of Woman Suffrage,* edited by Elizabeth Cady Stanton, Susan B. Anthony, and Matilda Joslyn Gage, 6 vols., vol. 1 (New York: Fowler & Wells, Publishers, 1881), pp. 46–47; cached at {http://www.pinn.net/~sunshine/gage/features/newsppr1.html}.

52. Laura Curtis Bullard, "Edmonia Lewis," *The Revolution* (New York) 7 (April 20, 1871).

53. According to one family history, Arabella helped nurse Elizabeth Stoddard, the first Mrs. Huntington, during the latter's bout with cancer that ended with her death in October 1883. [Jeanne Huntington Cullen], "John Archer Worsham and Annette and Arabella Duval Yarrington," [*The Los Angeles Times,* 2001]; cached at {http://freepages.genealogy.rootsweb.com/~worshamwasham/john_archer.htm}.

54. Stephen Birmingham, *The Grandes Dames* (New York: Simon and Schuster, 1982),

p. 188. See also Kevin Starr, *Inventing the Dream: California Through the Progressive Era* (New York and Oxford: Oxford University Press, 1985).

55. [Cullen], "John Archer Worsham and Annette and Arabella Duval Yarrington."

56. American Paintings in MMA II 1985, pp. 36–37.

57. Her son, Archer, oversaw the gift of Arabella's collection of eighteenth-century French paintings to the California Palace of the Legion of Honor in San Francisco.

58. McEntee Diaries, entry for Thursday, October 19, 1876.

59. *The New-York Times,* January 4, 1899.

60. Skalet 1980, pp. 144ff.

61. H. Barbara Weinberg, "Thomas B. Clarke, Foremost Patron of American Art from 1872 to 1899," *The American Art Journal* 8, no. 1 (May 1976), pp. 52–83. This article includes a complete checklist of Clarke's collection of American art, pp. 71–83.

62. "Auction Sales," *The New-York Times,* February 4, 1867, p. 6.

63. Harvey 1998, pp. 88–89ff.

64. Annette Blaugrund, *The Tenth Street Studio Building: Artist-Entrepreneurs from the Hudson River School to the American Impressionists,* exhib. cat., Southampton, New York, The Parrish Art Museum (Southampton, New York: 1997), pp. 98–99.

65. [William C. Brownell], "The Younger Painters of America. Second Paper," *Scribner's Monthly* 20, no. 3 (July 1880), p. 326; quoted in Elizabeth Broun et al., *Albert Pinkham Ryder,* exhib. cat., Washington, D.C., National Museum of American Art; The Brooklyn Museum (Washington, D.C., and London: Smithsonian Institution Press, 1989), p. 57.

66. Weiss 1987, pp. 30ff., notes the interest in exotic locales and in classical literature among devotees of Gifford's works as a symptom of their alienation from their own era and from the difficulties of postwar America.

67. Weir 1873, p. 145.

68. "An Unfinished Discussion on Finish," *The Art Journal* (New York), n.s., 5 (October 1879), p. 316.

Catalogue

The paintings in the catalogue are arranged generally in chronological order. Exceptions to that order occur when several paintings are grouped with others that have comparable subjects, and all are discussed in a single entry. The order in such entries is based on the date of the first painting discussed, and the works that follow usually are numbered according to the sequence in which they are discussed therein. With regard to the titles of paintings, an attempt has been made to use the earliest known titles, taken either from exhibition records or from the artist's own inscription on the back of a canvas or a stretcher. When this information was not available, but when the work could be associated with one listed in the Metropolitan Museum's 1881 *Memorial Catalogue of the Paintings of Sanford Robinson Gifford, N. A.*, that title has been used. In a few cases, the original titles misidentified the subject or were in some way misleading or insufficiently descriptive; for those works, the titles adopted in Ila Weiss's 1987 monograph *Poetic Landscape: The Art and Experience of Sanford R. Gifford* were retained. Otherwise, if the owner of a painting voiced a preference for a title, we honored that suggestion.

Additional data supplied for each painting consists of the exact or approximate date; the medium and support; dimensions, in inches and centimeters; the signature and date and/or inscriptions, if applicable; the item number and complete listing in the *Memorial Catalogue*, when these were easily determined or a connection seemed plausible; records of exhibitions (city, venue, date, and the title under which the work was shown) up to and including the Gifford "Memorial Exhibition" of 1880–81, where such exhibitions could be traced or convincingly proposed; and the present owner of the painting.

Solitude, 1848

Oil on canvas, 22 x 29¾ in. (55.9 x 75.6 cm)
Signed and dated, lower left: S. R. Gifford. / 1848
Exhibited: American Art-Union, New York, 1849, no. 34.
Art Complex Museum, Duxbury, Massachusetts

Solitude is Gifford's earliest known exhibited painting, and is based on material in his earliest surviving sketchbook of landscape studies, dated 1847–48.[1] The sketchbook contains drawings of sites in the southeastern Catskill Mountains and in Lake George; it was there that the full-page pencil view, from which this painting was derived, was drawn on July 20, 1848 (see fig. 61).

The study is a discrete full-page composition, as are many of Gifford's early pencil sketches, and its meticulous delineation (if not its modeling, which is slight) anticipates the painstakingly descriptive brushwork that distinguishes *Solitude* from most of Gifford's later paintings. The major alteration from the drawing to the painting lies in the artist's expansion of the picture space longitudinally to make room for the sky and clouds, which, in general, appears to distance the viewer from the scene, reducing the scale of the motifs slightly, in a way that became a familiar compositional strategy in much of his subsequent work. Only in the painting does Gifford introduce broad tonal divisions of light and dark: These are embodied in the dominant pine trees, in the forested slope in the middle distance, and in the immediate foreground. He also rusticates the foreground, filling it with rocks and scraggly tree trunks that echo the shaggy character of the pine trees on the left and the virgin forest growth throughout the scene.

In its atmospheric clarity and unusual textural description, *Solitude* undoubtedly reflects the dexterity demonstrated by the emerging *wunderkind* of the second generation of New York landscape painters, Frederic Edwin Church. In the 1848 National Academy of Design exhibition, for example, Church showed *View near*

Stockbridge (1847; Private collection),[2] whose elaborate cloud formations, typical of that artist's work, anticipate the complexity and dynamic of Gifford's clouds in *Solitude*—qualities that he did not often seek in his later work. It is also fruitful to compare Gifford's labors in portraying the pine trees in his picture with Church's efforts at rendering the conifers framing the prospect at the right in his *July Sunset* (fig. 62), exhibited at the National Academy of Design in 1847.[3] In none of the comparisons could one claim that Gifford attains Church's standard, but in this early composition at least it seems clearly to be a guide.

Of course, Gifford's admitted inspiration in his early career was Thomas Cole, Church's teacher and the founder of the New York school of landscape painting, who had lived and worked in Catskill, just a few miles away from Hudson, where Gifford was raised. In its low viewpoint on the distant mountain and foreground lake, Gifford's *Solitude* recalls one of Cole's earliest paintings, *Lake with Dead Trees* (fig. 63), and, in the sweep of the clouds, Cole's later *View of Schroon Mountain, Essex County, New York, after a Storm* (fig. 64).

However, *Solitude* evokes Cole perhaps more in theme than in form. Throughout his mature career, Gifford seldom, if ever, addressed landscape in historical, allegorical, or symbolic terms, as Cole frequently had done. Yet, in 1847–48, Gifford painted two pictures, *The Past* and *The Present* (both now unlocated), which, in title at least, echo a well-known pair of historical landscapes by Cole (1838; Corcoran Gallery of Art, Washington, D.C.). Regardless of how faithful *Solitude* is to the site it represents, the title underscores its conceptual nature,[4]

Figure 61. Sanford R. Gifford. "*July 20ᵗʰ Lake George*" (from the sketchbook inscribed "1847–48, Marbletown, Catskills, & Lake George"), 1848. Graphite on cream wove paper. The Frances Lehman Loeb Art Center, Vassar College, Poughkeepsie, New York. Gift of Miss Edith Wilkinson, Class of 1889

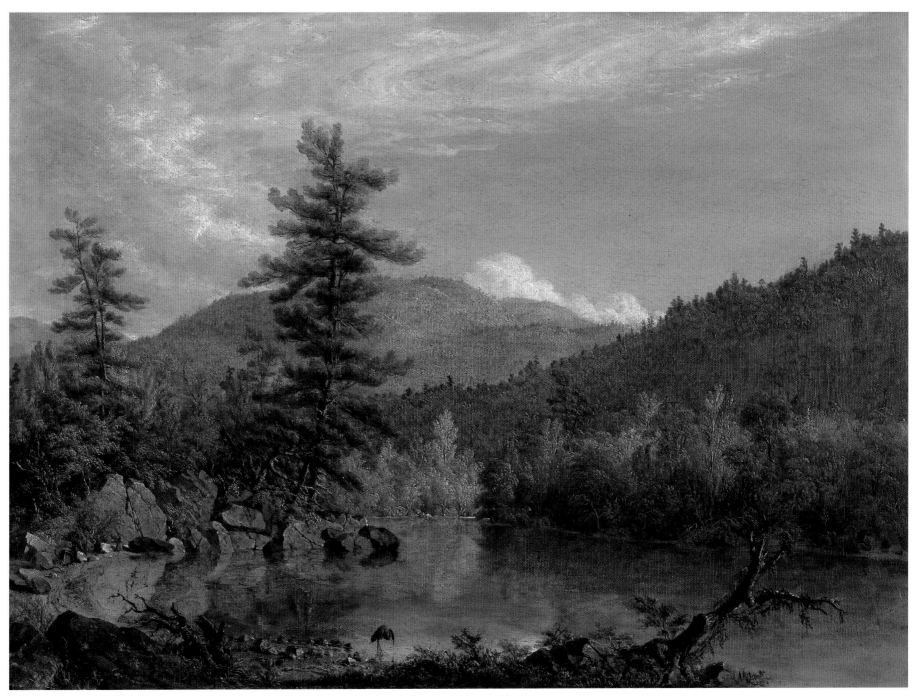

Cat. 1

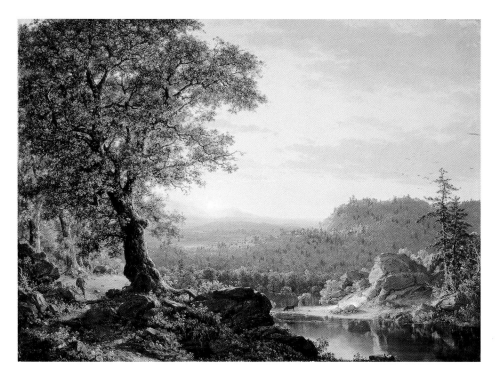

Figure 62. Frederic Edwin Church. *July Sunset*, 1847. Oil on canvas. Manoogian Collection

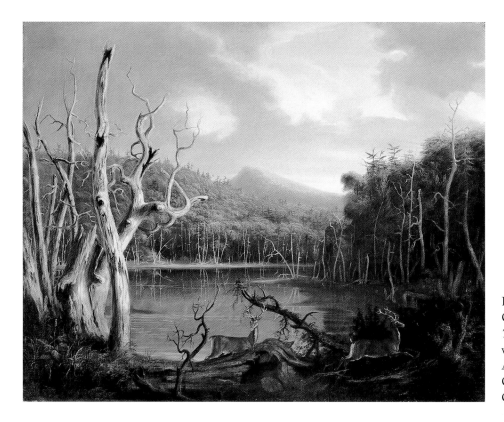

Figure 63. Thomas Cole. *Lake with Dead Trees*, 1825. Oil on canvas. Allen Memorial Art Museum, Oberlin College, Ohio. Gift of Charles F. Olney, 1904

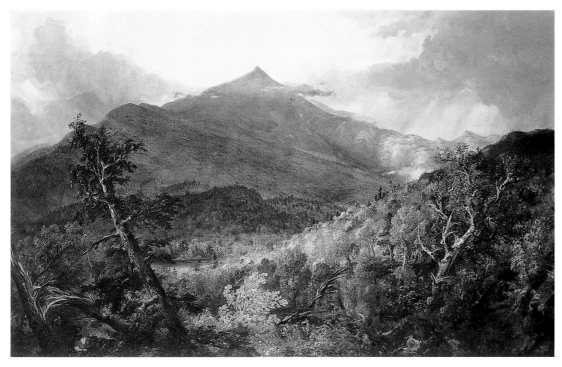

Figure 64. Thomas Cole. *View of Schroon Mountain, Essex County, New York, after a Storm*, 1838. Oil on canvas. The Cleveland Museum of Art. Hinman B. Hurlbut Collection

emphasized by the "solitary heron," emblematic of solitude and meditation, which Gifford inserted in the foreground.[5] This feature, too, Gifford may have borrowed from Cole, who included a heron, most notably, in *Desolation,* the last of his five pictures that comprise the allegorical series "The Course of Empire" of 1834–36 (The New-York Historical Society). Moreover, given the timing of the picture's creation—presumably, the winter of 1848—it is tempting to consider the possible resonance in this work of Cole's death in February of that year, an event that inspired painted memorials by Church and by Asher B. Durand.[6]

KJA

1. Weiss 1987, pp. 172–73, 332. The sketchbook, inscribed "1847–48, Marbletown, Catskills, & Lake George," is in the collection of The Frances Lehman Loeb Art Center, Vassar College, Poughkeepsie, New York (38.14.1).

2. NAD Exhibition Record (1826–1860) 1943, vol. 1, p. 80 (1848), no. 290; illustrated in Kelly 1988, p. 11.

3. NAD Exhibition Record (1826–1860) 1943, vol. 1, p. 80 (1847), no. 173; illustrated in Kelly 1988, p. 10.

4. Weiss 1987, p. 172; *Memorial Catalogue,* p. 13, no. 3; NAD Exhibition Record (1826–1860) 1943, vol. 1, p. 181 (1848), no. 107.

5. AAFA and AA-U Exhibition Record 1953, p. 144 (1849), no. 34: "A lake in the mountains, with a solitary heron drinking." For the symbolism of the heron see Dom Pierre Miquel, *Dictionnaire symbolique des animaux: Zoologie mystique* (Paris: Le Léopard d'Or, 1991), pp. 101–8.

6. For Church's *To the Memory of Cole* (1848; Private collection) see Kelly 1988, pp. 19–21; for Durand's *Kindred Spirits* (1849; New York Public Library, Astor, Lenox, and Tilden Collections) see Barbara Dayer Gallati in Howat et al. 1987, pp. 108–10.

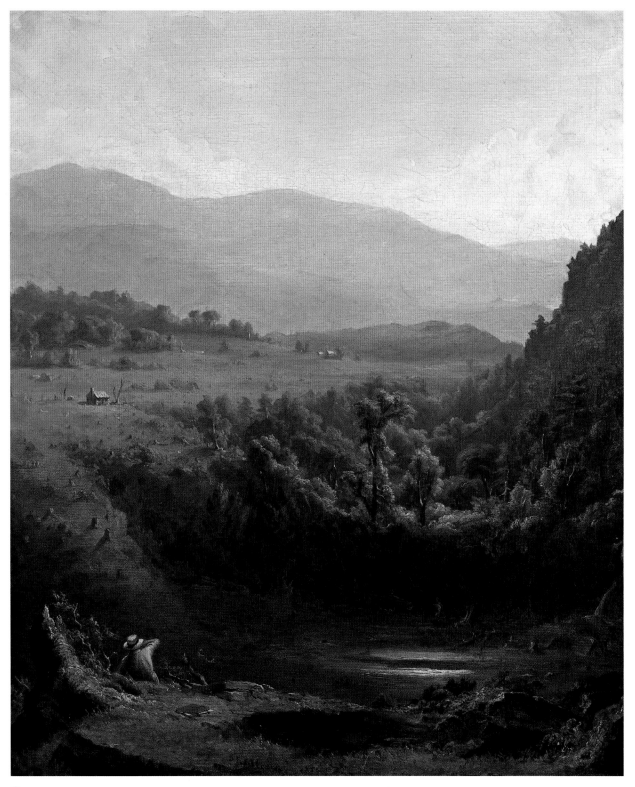

Cat. 2

Scene in the Catskills, 1850

Oil on canvas, 24 x 20 in. (61 x 50.8 cm)
Signed and dated, bottom center: S R Gifford 1850
MC 35, "A Scene in the Catskills. Size, 20 x 24. Sold in 1850,
through the American Art Union, to Charles F. Neilson."
Exhibited: American Art-Union, New York, 1850, no. 133.
Collection Jack Hollihan and Mary Ann Apicella

Scene in the Catskills, only the thirty-fifth painting
listed in the *Memorial Catalogue of the Paintings of
Sanford Robinson Gifford, N. A.,* reveals the first indica-
tions of Gifford's signature style of diffused light and
atmosphere—and the hollowing out of the terrain to
accommodate those intangible phenomena—that would
consistently mark his production after his first trip to
Europe, from 1855 to 1857.

The genesis of the painting was a postage-stamp-
sized compositional sketch—one of four on the same
page—that Gifford made on July 18, 1849 (see fig. 65),
on a tour, in the company of the Hudson, New York,
painter Henry Ary, of the central Catskill Mountains;
they traveled north up the Schoharie River and over to
Gifford's birthplace in Greenfield in Saratoga County.[1]
The painting follows the broad contours and even some
of the details of the sketch, which shows a narrow valley
diminishing obliquely between a mountain ridge in the
background and a steep forested slope nearer at hand at
the right. Particularly as modeled in light and dark in
the painting, the design is—as Ila Weiss has observed—
reminiscent of Thomas Cole's late masterwork, *Genesee
Scenery (Mountain Landscape with Waterfall)* of 1847
(fig. 66), which Gifford could have seen at the memorial
exhibition of Cole's work at the American Art-Union in
New York in 1848.[2] Like Cole's painting, Gifford's also
includes a rustic homestead on the sloping plain in the
middle distance.

There are, however, important departures from the
presumed Cole model that suggest other possible
influences and portend the aesthetic preoccupations

Figure 65. Sanford R. Gifford. *Landscape Studies,
"July 18, 1849"* (from the sketchbook inscribed "1849,
Catskill Mts., Sacandaga & Hudson"). Graphite. Albany
Institute of History and Art, New York. Gift of Marian
Gifford Johnson Shaw (Mrs. William F. Shaw) and
Mrs. George G. Cummings

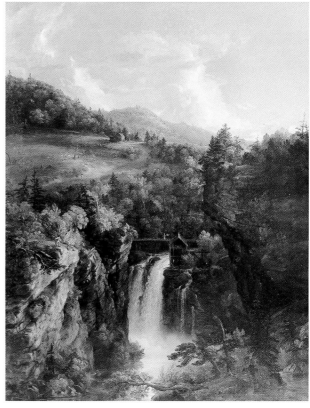

Figure 66. Thomas Cole. *Genesee Scenery (Mountain Landscape
with Waterfall),* 1847. Oil on canvas. Museum of Art, Rhode
Island School of Design, Providence. Jesse H. Metcalf Fund

that single out Gifford's mature style. In the painting,
Gifford, in effect, deepened the foreground of his
drawing to make room for a bowl-like depression con-
taining a small pool of water to carry the light of the
sky into the dark lower register of the composition.
The waterfall in Cole's picture functions in a compara-
ble way, with the important and telling difference that
the cascade, along with the turbulent clouds in his sky,
exemplifies the older artist's spirited temperament as
surely as the placid pool, relatively undifferentiated

sky, milder and dustier light, and less dramatic
chiaroscuro of *Scene in the Catskills* betoken the "calm"
to which Gifford's friend John Ferguson Weir referred
at the meeting held in memory of the artist in 1880.
Similarly revealing is the contrast of the relative pro-
jection of Cole's terrain in the earlier picture—the
imposing rocks in the left foreground, the water issuing
toward the viewer, the silhouette of the pine tree inter-
rupting the aerial lightening of the receding ridge—
with the yielding character of Gifford's setting, both

in the foreground and in the more atmospherically modulated background ridge.

In his leaning pose, the figure of the artist (his portfolio is on the ground, to his right)—along with the echoing tree stump, the other light accent in the foreground—defers to the space before him as he gestures (if only perhaps to screen his eyes) toward the sunlight that warms the plain and gently gilds the forest cover. With such features Gifford not only distinguishes his artistic identity from that of his primary inspiration but anticipates his own defining work of the Civil War era in both subject and treatment: Catskill Mountain pictures such as the Metropolitan Museum's *A Gorge in the Mountains* (cat. no. 21) and *Hunter Mountain, Twilight* (cat. no. 41), with their more dazzling and starker light effects, respectively, and their luminous and atmospheric convexities of terrain.

KJA

1. Weiss 1987, pp. 63, 177–78.
2. Ibid., p. 177; Parry 1988, p. 370, reprints the catalogue of the Thomas Cole memorial exhibition, in which Cole's picture was number 48, and was titled *Genesee Falls, N.Y.*

3
⎯

Sunset in the Wilderness with Approaching Rain, about 1852–53

Oil on canvas, 7¼ x 11¼ in. (18.4 x 28.6 cm)
Berry-Hill Galleries, Inc., New York

This dramatically colored and vigorously painted sketch is not dated, nor can it be associated with any of the works shown in the "Memorial Exhibition." From a rocky foreground with a small figure, the view moves across a body of water to a singular, distinctively shaped mountain. To the right, the sky is filled with dark clouds and streaks of rain; to the left, richly tactile strokes of yellow, orange, and red pigments describe the sunset. The specific topography is not identifiable, and may have been the product of the artist's imagination. On a page of an 1851 sketchbook (Harvard University Art Museums, Cambridge, Massachusetts), the artist drew several small landscape compositions, each carefully ruled off in rectangular format; one of these was the source of the present picture.[1]

Although modest in scale, the painting has tremendous power, both in its sweeping atmospheric drama and in the almost frenetic energy of the brushwork. Moreover, it is for Gifford an unusually somber and brooding image, with some three-quarters of its surface dominated by dark browns and blacks. Given these

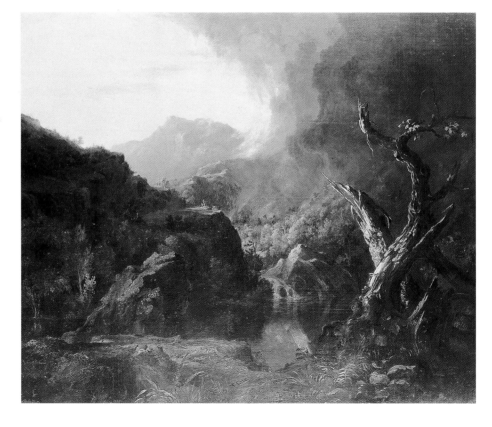

Figure 67. Thomas Cole. *Landscape with Tree Trunks,* 1828. Oil on canvas. Rhode Island School of Design, Museum of Art, Providence. Walter H. Kimball Fund

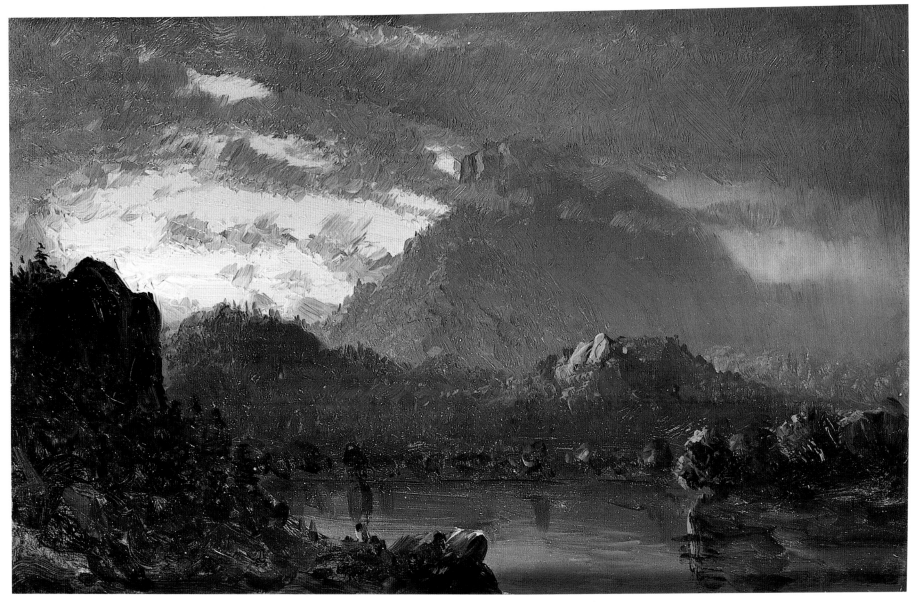

Cat. 3

characteristics, *Sunset in the Wilderness with Approaching Rain* likely dates from early in Gifford's career—in particular, from the years when he was most under the influence of Thomas Cole. While any number of prototypes from the older artist's work might be suggested, the closest affinities are found in paintings from Gifford's own early years, such as *Mountain Sunrise* (1826; Private collection) and *Landscape with Tree Trunks* of 1828 (fig. 67). In such paintings, a sense of nature's tumultuous energy is expressed with a heightened intensity that is often found in Cole's historical and allegorical pictures but only seldom in his pure landscapes.

No large composition based on this sketch is known today. Weiss proposed that this work, along with a cooler-hued and less stormy small painting of similar topography

(*Indian Scouting Canoes* of 1853; Private collection), may have been preliminary studies for the then unlocated large-scale pair of pictures, *Morning in the Adirondacks* and *Sunset in the Shawangunk Mountains* of 1854 (fig. 8, 9).² However, that reasonable conjecture was belied by the subsequent reappearance of these long-untraced paintings, which depict very different scenery. Gifford seems, instead, to have been experimenting with a specific composition, first worked out in small scale in pencil, under varying conditions of light and atmosphere. While the results in a work like *Sunset in the Wilderness with Approaching Rain* might at first seem to predict little of the future course of his art, it is precisely that sense of experimentation that would become central to his aesthetic.　　　　　　F K

1. Weiss 1987, pp. 181–83; the sketchbook page is illustrated on p. 182.
2. Ibid., pp. 183–84.

4
——

Study for Windsor Castle, about 1855

Oil on canvas, 6⅜ x 9⅝ in. (16.2 x 24.4 cm)
Signed, lower left: S R Gifford
Collection Edward T. Wilson, Fund for Fine Arts,
Bethesda, Maryland

5
——

A Sketch of Derwentwater, 1855

Oil on paper, mounted on canvas, 7 x 10 in. (17.8 x 25.4 cm)
Dated on the stretcher, on the verso: September 9th, 1855;
estate stamp on the verso
MC 76, "A Sketch of Derwentwater. Dated September 9th,
1855. Size, 7 x 9½. Owned by the Estate."
Collection Robert S. Peiser, Jr., and Dr. Peter K. Zucker,
Ashburn, Virginia

Gifford set out on his first European tour, sailing from New York on May 16, 1855.¹ For him, this was to be a learning experience, a "pilgrimage," as he termed it.² He spent the first part of the summer primarily in London, but on July 9 he embarked on an extended sketching trip to study the English and Scottish countrysides. He arrived in Windsor at four o'clock in the afternoon; that evening, taking advantage of the English summer's long hours of daylight, he made "a sketch of the castle from Datchett Head, in the Home Park . . . the place where the Merry Wives of Windsor got Fallstaff [*sic*] a ducking."³ On the following day, his birthday, Gifford sketched Windsor Castle from the Thames, and toured the State Apartments, admiring, in particular, the van Dycks. The 11th was rainy, but there was "a fine 'effect' on the castle just before sunset. It crowns a bluff, and at this time its regal towers and battlements were relieved in warm sunlight against the dark sullen gray of the clouds behind them; high over them arched a brilliant rainbow."⁴ Twelve days later, Gifford, by then in Kenilworth, made an oil sketch of Windsor, presumably the small work now in the Museum of Art, Rhode Island School of Design.⁵ He developed that composition in the present, slightly larger picture, making it more balanced and unified. The brushwork, although less staccato, is nevertheless remarkably free and vigorous, with the bright colors and highlights adding to the sense of animation. Gifford subsequently executed larger paintings of the castle seen from a similar vantage point, including *Windsor Castle* (about 1859; George Walter Vincent Smith Art Museum, Springfield, Massachusetts) and *Windsor Castle* (1860; The Fine Arts Museums of San Francisco), but under different effects of light and weather.

Gifford returned briefly to London, but was off again on August 4. The last two weeks of the trip were spent in September in the English Lake District; by the 20th of the month, he would be resettled in London. Among the commissions Gifford had secured before leaving America was one from his early patron, the Reverend T. Stafford Drowne, for a view of Derwentwater, the widest body of water in the Lake District. On September 7, Gifford traveled by coach into Keswick, the principal city in the area, regretting that he had not walked there:

*The morning was clouded, and I had some way got the notion that the road was uninteresting. For three miles it ran along the shaded shore of Bassanthwaite [Bassenthwaite Lake], and then continued through the rich and beautiful valley of the Derwent. On the left, across the vale, rose the huge masses of Skiddaw, and on the right the rugged rocks of Barrugh Fells. Scattered over the wooded vale, and snuggled in the green recesses of the hills, gleaned through the trees, [were] the clean white-washed walls of cottages and farm houses, and here and there a handsome villa. It was very delightful, after two weeks of constant rain in Scotland, among savage mountains, barren and desolate moors, and lonely lochs, to find myself transported at once into a region where beauty reigned instead of desolate grandeur—where the wildness of fine mountain scenery was softened and contrasted with the rich cultivation of the vales and lower slopes—with luxuriant foliage—and all enlivened by the bright homesteads peeping from the trees, and by the cheerful presence of men. I have never seen so beautiful a combination of mountain, lake, and cultivated vale as there is about the shores of Derwentwater; and I doubt if there be many equal to it in the world.*⁶

Gifford's admiring words, although they aptly captured his impressions, also may indicate that he was expecting to find the scenery of Derwentwater particu-

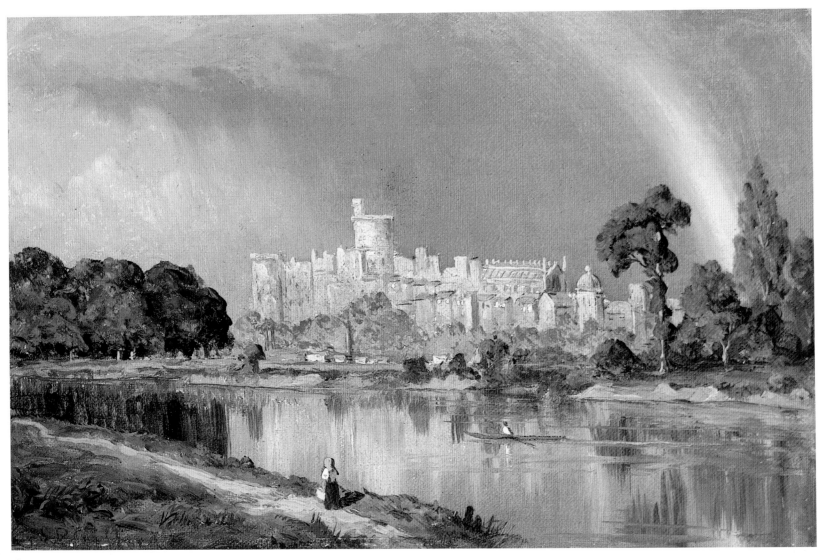

Cat. 4

larly beautiful. Perhaps his patron Drowne, who had requested a painting of this scenery, had traveled there himself, and had spoken of his own reactions, or else Gifford may have read descriptions in travel literature. In volume three of his *Modern Painters,* John Ruskin recorded his acquaintance with the area, and the importance it held for him: "The first thing which I remember, as an event in life, was being taken by my nurse to the brow of Friar's Crag on Derwent Water."[7] Although it is tempting to speculate that Drowne or Gifford knew of the connection with Ruskin, Friar's Crag—"small

rocky promontory jutting into the lake, about ¾ M. from the town [of Keswick]"—had long been a popular vantage point for viewing the lake and the surrounding mountains.[8] Gifford went there (apparently for the second time) on September 9: "Walked to Friar's Crag on the lake, and finished a sketch I had begun before."[9]

That sketch was probably done in pencil and subsequently developed into the present work.[10] The latter is one of the most appealing pictures from early in Gifford's career. The free handling of paint, reminiscent of his studies of Windsor; the lively play of light and

shadow; and the energized patterns of clouds and sky are redolent of the immediate and the informal. Yet, the composition is carefully ordered and balanced, achieving a strong sense of pictorial unity and repose. In the larger version executed for Drowne, painted in Paris in early January 1856, Gifford followed the sketch closely, although he eliminated the lively passages depicting logs, branches, and rocks at the lower edge. The finished picture seems somewhat leaden in comparison, possibly because of its less than perfect condition.[11] A decade later, however, Gifford would succeed in capturing a

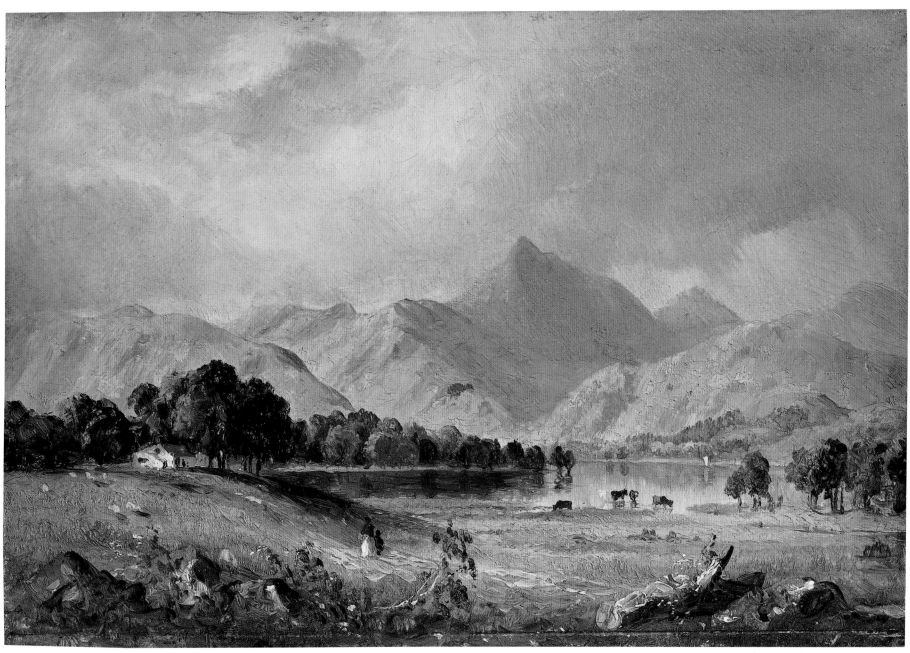

Cat. 5

comparable feeling of the vitality of nature on a large scale, with the great *A Passing Storm in the Adirondacks* of 1866 (cat. no. 44).

F K

1. Cikovsky 1970, p. 9; Weiss 1987, p. 69.

2. Gifford, European Letters, vol. 1, May 28, 1855, p. 9; also quoted in Cikovsky 1970, p. 9.

3. Gifford, European Letters, vol. 1, July 9, 1855, p. 45.

4. Ibid., September 11, 1855, p. 46.

5. The sketch measures 4¼ x 7¼ inches; ibid., p. 58; Weiss 1987, p. 189.

6. Gifford, European Letters, vol. 1, September 14, 1855, pp. 98–99; also partially quoted in Cikovsky 1970, p. 22, and in Weiss 1987, pp. 190–91.

7. John Ruskin, *Modern Painters* [vol. 3], vol. 5 of *The Works of John Ruskin*, edited by E. T. Cook and Alexander Wedderburn (London: George Allen, 1904), p. 365.

8. K[arl]. Baedeker, *Great Britain: Handbook for Travellers*, 2nd ed. (Leipzig: Karl Baedeker, 1890), p. 393.

9. Gifford, European Letters, vol. 1, May 9, 1855, p. 100.

10. Weiss 1968/1977, p. 134.

11. An 8½ x 15½-inch version of the same composition, dated 1862 (MC 272), was sold at Sotheby's, New York, May 30, 1985, no. 17.

Lake Nemi, 1856–57

Oil on canvas, 39⅝ x 60⅜ in. (100.6 x 153.4 cm)
Signed and dated, on the verso: Nemi / S. R. Gifford / Rome
1856–57
MC 107, "Lago di Nemi. Dated Rome, 1856–7. Size, 40 x 60.
Owned by Mrs. M. L. Alger, New London, Conn."
Exhibited: National Academy of Design, New York, 1858,
no. 460; Yale College, New Haven, August 1858, no. 157; Young
Men's Association, Troy, New York, 1859, no. 67, and 1860,
no. 108.
The Toledo Museum of Art. Purchased with funds from The
Florence Scott Libbey Bequest in memory of her father,
Maurice A. Scott

With the exhibition of *Lake Nemi* at the National
Academy of Design in New York in 1858, Gifford emerged
as one of the premier representatives of the second genera-
tion of New York landscape painters eventually called
the Hudson River School. The artist had been highly
regarded earlier, but little by him had been seen since he
departed in 1855 on his first trip to Europe, where he
remained for two years. Completed in Rome in the winter
of 1856–57, the painting was Gifford's largest and most
significant work to date. Indeed, he never again painted a
picture of this size. In the artist's own "List of Some of
My Chief Pictures," first composed in 1874, *Lake Nemi*
was the first entry.[1] The painting was remarkable in at
least two other ways: It was one of the earliest of a large
number of European subjects that were to mark Gifford's
production, especially in the last decade of his career
(1870–80), making him, among the painters who suc-
ceeded Thomas Cole, probably the most prominent sup-
plier of Old World scenes to the swelling class of New
Yorkers who could travel abroad.[2] *Lake Nemi* was the first
major painting by Gifford to incorporate what became
nearly a trademark of his art—the setting sun as a radiant
focal point, its light a tonal unifier of his compositions.

As the detailed journals of his two European tours
demonstrate, Gifford was the most ardent and articulate

of the many American painters who toured and worked
in Europe in the 1850s. For most of those artists, as for
him, the Grand Tour would not have been complete
without a trip to Italy. However, as venturesome a trav-
eler as Gifford was, the range of motifs that made their
way into his sketchbooks reflected the standard pictur-
esque sites visited by tourists as well as by the artists
who accommodated them.[3] Lake Nemi, situated in an
extinct volcanic crater seventeen miles southeast of
Rome, had been represented by scores of Continental,
British, and American artists, among them Turner and
Cole, both of whom had visited Italy twice in the 1830s.[4]
Cole's Italian pictures may well have been the principal
impetus in luring Gifford to Italy, but *Lake Nemi*, with
its blazing central sunset, marks the clear beginning of
Gifford's lifelong debt to Turner. His taste for Turner's
art was formed initially by prints of the latter's work that
adorned the Gifford family home in Hudson, including
one print presumably after the master's watercolor of
Lake Nemi for James Hakewill's *Picturesque Tour of Italy*
(see fig. 68), published between 1818 and 1820;[5] also in
the house, there was a book of prints of masterpieces in
London's National Gallery that included reproductions
of Turner's pictures.[6] The artist also had read the
English critic John Ruskin's homage to Turner—the first
volume of his *Modern Painters* (1843)—so that when
Gifford finally sailed for England in 1855 and then
toured the National Gallery, it was with a sense both of
high anticipation and comforting familiarity; he fol-
lowed this up with an interview with Ruskin himself at
the critic's home, Denmark Hill. There he admired even
more Turners—the watercolors that Ruskin had col-
lected, among them possibly the one that had served as
the source for the *Lake Nemi* engraving in Hakewill,
which, although Gifford did not specifically cite it, he
knew from home.[7]

It seems less than surprising, then, that, once he
arrived in Rome over a year later, Gifford not only

should have made Lake Nemi the subject of his most
ambitious painting to date but that he adopted a view-
point overlooking the lake that approximates the per-
spective in Turner's image—with the difference that
Gifford expanded the visual scope to include the entire
circle of the lake's boundaries comprising the rim
of the crater. By accident, or maybe by design, he
evokes more concertedly the image of the lake as the
"Speculum Dianae," or mirror of the Roman goddess
of fertility.

As for the Turneresque—and, for Gifford, signature—
solar glow that virtually originates in this picture, its
basis in actual experience was at least partly lunar. On
October 6, 1856, Gifford and fellow artists Worthington
Whittredge, Albert Bierstadt, William Stanley
Haseltine, William Beard, and Thomas Buchanan Read
began a walking tour of the Alban Hills near Rome,
arriving at Albano the first evening "in time to see the
sun set splendidly in the sea over Ostia";[8] the following
day, they came to the lake ("fringed with fine trees
which droop into its waters, back of these rise the lofty
banks, in parts richly wooded, in parts showing the bare
cliffs"),[9] spending much of the afternoon on its shores,
and found quarters at an inn in the town of Nemi. From
his window, Gifford witnessed a cooler, perhaps starker,
version of the effect—"one of the most beautiful I have
ever seen"—that he would produce in the oil:

*We were high up above the lake. On one side in the fore-
ground were some picturesque houses and ruined walls –
A tall dark cypress, rising out of a high mass of foliage, cut
strongly against the lake, distance and sky. Far below, the
still lake reflected the full moon, and the hights [sic] of the
further shore which, crested by the walls and campanile of
Gensano, were relieved highly against the light and misty
expanse of the Campagna, while still further beyond, a long
line of silver light, the reflection of the moon, told where the
sea was.[10]*

Gifford made two pencil sketches of the view and, also during October, at least two small preparatory oil studies for the large picture, which he began near the end of the same month.[11] *Lake Nemi* was part of an ambitious painting campaign that resulted in three sizable paintings; these occupied—and, in a measure, confined—him through much of the chilly and rainy Roman winter of 1856–57.[12] "I have not been very well either in body or in mind, and have suffered much from depression of the spirits," he confessed in a letter to his parents. "I seem to be doing so little good in my studio that I often think it would be better for me to leave it. It seems worse than useless to work on in this fruitless way. My bodily health is not bad—a headache is all that troubles me. I struggle against this depression, but have not been able to shake it off. Were the spring open I would leave Rome and seek some relief in the variety and excitement of traveling."[13]

Yet, Gifford's labors were amply repaid by what was, besides the largest picture he ever essayed, one of his strongest compositions and perhaps the richest tonally of all the sun paintings that would come to represent his accomplishment. Never again in such works would the foreground function so imposingly and classically, with the silhouette of the cypress tree mediating effectively between the architecture, whose verticality it echoes, and the lake, whose disk-like form it repeats. The spatial plane beyond, warmly suffused with light, turns the surface of the lake into an oculus opening onto another firmament, while the "long line of silver light" of the moon's reflection, which Gifford described in his letter, gleams like white gold under the declining sun that has supplanted it.

The warm reception that *Lake Nemi* received at the National Academy of Design exhibition in 1858 was preceded by advance notice of its completion even before it left Rome.[14] Despite the *New-York Times* critic's perception of Gifford's debt to Turner reaching "almost to the point of plagiarism," he nonetheless deemed *Lake Nemi* "a decidedly vigorous and noble painting."[15] Another reviewer of the exhibition instantly recognized the artist's poetic instinct and nostalgic tendency: "*Lake*

Nemi, is a lovely recollection of one of the loveliest landscapes of Italy. It is full of tenderness and tranquillity, and entirely Italian in its sentiment and impression. One would not soon tire of watching it; and its beauty would steal in unobtrusively upon every mood."[16] Another writer cited the "luminous atmosphere" of *Lake Nemi,*[17] an effect that would engender admiration for the artist, despite the "general similarity of color and tone" his taste for that effect imposed on his submissions to the Academy, in 1858 and throughout his career.[18]

The painting originally was purchased by C. C. Alger of Newburgh, New York.

K J A

1. For the history of Gifford's *Lake Nemi* see Weiss 1987, pp. 76–77, 194–97, 328 ("List of Some of My Chief Pictures"); Weiss 1968/1977, pp. 145–48.
2. See the *Memorial Catalogue.* Of the 731 Gifford paintings compiled in the catalogue, 208, or twenty-eight percent, are of Old World subjects. After Gifford's second trip abroad, forty-six percent of his works had Old World themes.
3. For a review of the Grand Tour experiences of American landscape painters see Theodore E. Stebbins, Jr., "American Painters and the Lure of Italy," in Stebbins et al. 1992, pp. 42–54.
4. For the history of Lake Nemi as an attraction for artists and tourists see the entries on the present painting and on George Inness's version of the subject by Eleanor Jones and Janet L.

Comey, respectively, in Stebbins et al. 1992, pp. 296–97, 310–11.
5. Section E of a codicil, dated September 27, 1886, to the 1865 will of Elihu Gifford, Sanford's father, cites "Nemi & Old Temeraire Engravings—aft. Turner" to be bequeathed to the children of his deceased son Charles. Samuel Middiman and John Pye's engraving *Lake of Nemi,* produced for Hakewill's *Picturesque Tour of Italy,* is the only one with this subject after Turner's work; for a full citation of it see W. G. Rawlinson, *The Engraved Work of J. M. W. Turner, R.A.,* 2 vols. (London: Macmillan and Co., 1908–13), vol. 1, p. 83.
6. Letter from Sanford Robinson Gifford to his father, Elihu Gifford, London, June 3, 1855, Gifford, European Letters, vol. 1, pp. 19–20: "On the 5th [of May] . . . we went to the *National Gallery,* where we staid [sic] from 10 till 4½ o'c. and looked at 44 out of the 226 works that compose the collection—the Claudes, the Turners, Vandykes [sic], Pousins [sic], Rubens and a part of the Titians. . . . (You will find all these pictures in the red covered 'Nat. Gallery' in our library.) . . . As you have the engravings of all these Nat. Gal. pictures, there is no need of my speaking further about them. The notes I made were mostly technical. Most of these pictures have been familiar to me since I was a child; when I used to delight in overhauling Charles' prints in his sanctum in the old house—the little bed room between the kitchen chamber and the front hall. So I found myself quite at home when I came in the presence of the originals."
7. Letter from Sanford Robinson Gifford to his father, Elihu Gifford, September 25, 1855, ibid., pp. 109–12, especially p. 111. Gifford identified "Bridge at Coblentz," "Lucerne," and "Nottingham" as three of Ruskin's "numerous and very fine" Turner watercolors that he especially admired. For the *Lake Nemi* in the collection that served as the source of the engraving in Hakewill see Wilton 1979, p. 382, no. 711; see also [John Ruskin], *Notes by Mr. Ruskin on his Collection of Drawings by the Late*

Figure 68. Samuel Middiman and John Pye, after J. M. W. Turner. *Lake of Nemi,* 1819. Engraving on copper. The British Museum, London

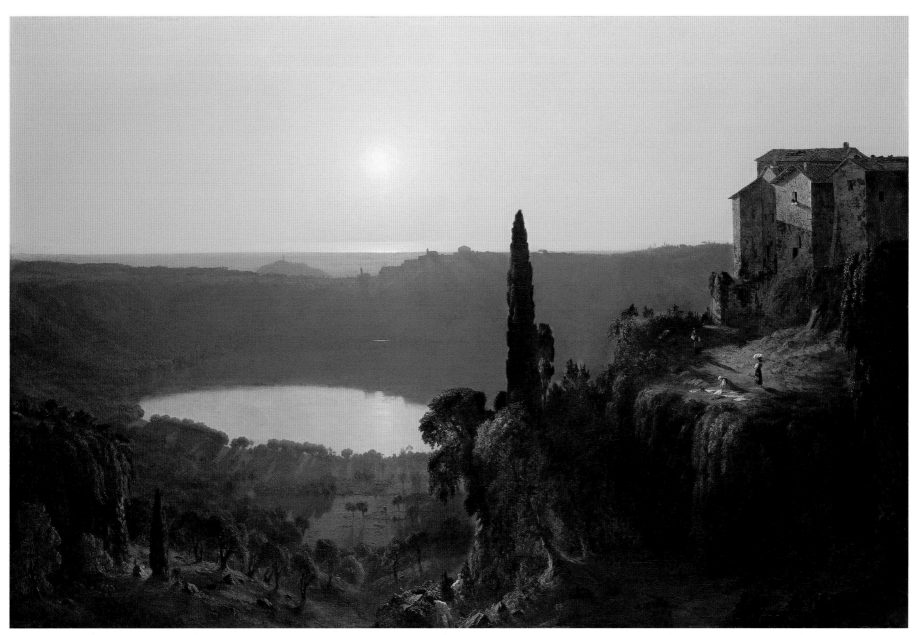

Cat. 6

J. M. W. Turner, R. A., exhib. cat., London, The Fine Arts Society (London: 1878), p. 164.

8. Letter from Sanford Robinson Gifford to his father, Elihu Gifford, Rome, October 15, 1856, Gifford, European Letters, vol. 2, p. 121.

9. Ibid., p. 122.

10. Ibid.

11. The drawings, in an 1856–58 sketchbook of Italian subjects (Harvard University Art Museums, Cambridge, Massachusetts), and on microfilm (Archives of American Art), Reel 688, frames 294, 296–297), are both dated October 6, probably mistakenly, since Gifford's European letters, quoted in the text, indicate that he was in Albano on that date, arrived, via Ariccia, at Lake Nemi on October 7, and stayed there that night. The earliest recorded oil sketch, in a group of as many as five such studies, listed in the

Memorial Catalogue under number 99 as dated October 7, 1856, and measuring 10 x 14 inches, is not known today; number 101, listed as dated October 23, 1856, and measuring 10 x 14½ inches, may be the oil sketch initialed and dated "Rome Oct. 21. '56," measuring 10⅜ x 14¼ inches, now in the Collection of Jo Ann and Julian Ganz, Jr. Another picture is listed in the *Memorial Catalogue* under number 115 as "Lago di Nemi"; its date is unknown and the measurements are given as 14 x 20 inches. In a letter to his father dated May 22, 1857, Gifford mentioned that on April 17 he had made an oil sketch of Lake Nemi for a family friend. For illustrations and discussions of the known oil sketches and one of the drawings in relation to the present picture see Harvey 1998, pp. 204–7.

12. Weiss 1987, pp. 76, 193–98. Besides *Lake Nemi,* Gifford painted the 20 x 30-inch *La Riviera di Ponente* (Private collection), a 30 x 40-inch *Lake Como* (Whereabouts unknown), and the 53 x 41-

inch *Valley of the Lauterbrunnen, Canton of Berne, Switzerland— the Jungfrau in the Distance* (Brown University, Providence). See also the Letter from Sanford Robinson Gifford to his father, Elihu Gifford, Rome, February 5, 1857, Gifford, European Letters, vol. 2, p. 126: "The winter in Rome has been about as unpleasant as it could be. For sixty days we have had scarcely a fine one . . . it has been almost a constant rain, with a chilling comfortless atmosphere. This is 'sunny Italy'."

13. Ibid., p. 125.

14. *The Crayon* 1857.

15. "The Fine Arts. Exhibition of the National Academy of Design," *The New-York Times,* May 8, 1858, p. 2.

16. *Harper's Weekly,* May 8, 1858.

17. *The Crayon* 1858, p. 147.

18. *Harper's Weekly,* May 8, 1858.

7

The Castle of Chillon, 1859

Oil on canvas, 12 x 20 in. (30.5 x 50.8 cm)
Signed and dated, lower left: S R Gifford–1859.
MC 179, "The Castle of Chillon. Size, 12 x 20. Sold in 1859 to
W. T. Walters, Baltimore, Md.; present owner unknown."
Exhibited: Possibly Dodworth Studio Building, New York,
"Artists' Reception," February 1860.
Private collection

Scenically situated on the shores of Switzerland's Lake Geneva, the Château de Chillon has long been a popular tourist destination, especially following the publication in 1816 of the poem by George Gordon, Lord Byron, "The Prisoner of Chillon." The poem is written as a monologue delivered by a historical character, the patriot François de Bonnivard (1496–1570?), who was imprisoned with his six brothers in the castle's dungeon. When Gifford visited Chillon on July 15, 1856, Byron was on his mind:

From Villeneuve we all walked about a mile down the lake shore (Lake Leman) to the castle of Chillon. It is a large and picturesque old pile. The steel blue waters of the lake wash its base on three sides. We visited the vaulted prison, where for six long years the "Prisoner of Chillon" wore his chains. In one of the stone columns (the one on which Byron's name is deeply cut, with a hundred others) the ring remains to which he was bound. A narrow space half round the column is deeply worn with his footsteps:

> *'twas trod*
> *Until his very steps have left a trace*
> *Worn as if the cold pavement were a sod,*
> *By Bonnivard! May none those marks efface!*
> *For they appeal from tyranny to God."*

While the others were inspecting the rest of the chateau, I mounted a wall down below the road and in a blazing sun, the perspiration streaming down my face, made a very hot and hasty sketch.[1]

Gifford translated the 6½ x 9½-inch oil sketch on paper into this elegant work, completed in 1859.[2] One surely would not know—judging from the cool blues of the lake, the distant mountain, and the radiant sky— that it was inspired by "a very hot and hasty sketch." This painting is likely the one that Gifford exhibited in early February 1860 at an "Artists' Reception" at the Dodworth Studio Building in New York, where it was favorably noticed: "Gifford's 'Castle of Chillon'—an admirable example of this favorite artist's works—was also a picture before which the crowd lingered."[3] The painting was purchased by the Baltimore collector William Thompson Walters (1820–1894), at that time a leading patron of contemporary American artists; by 1861 he owned "one of the finest private collections in the country," with works by American landscape painters occupying "the most prominent place."[4] Included were such major paintings as John F. Kensett's *Evening on the Hudson* (1860; Virginia Museum of Fine Arts, Richmond), Asher B. Durand's *In the Catskills* (1859; Walters Art Gallery, Baltimore) and *Sunday Morning* (1860; New Britain Museum of American Art, Connecticut), and Frederic Church's *Twilight in the Wilderness* (1860; fig. 3). Walters, a strong Southern

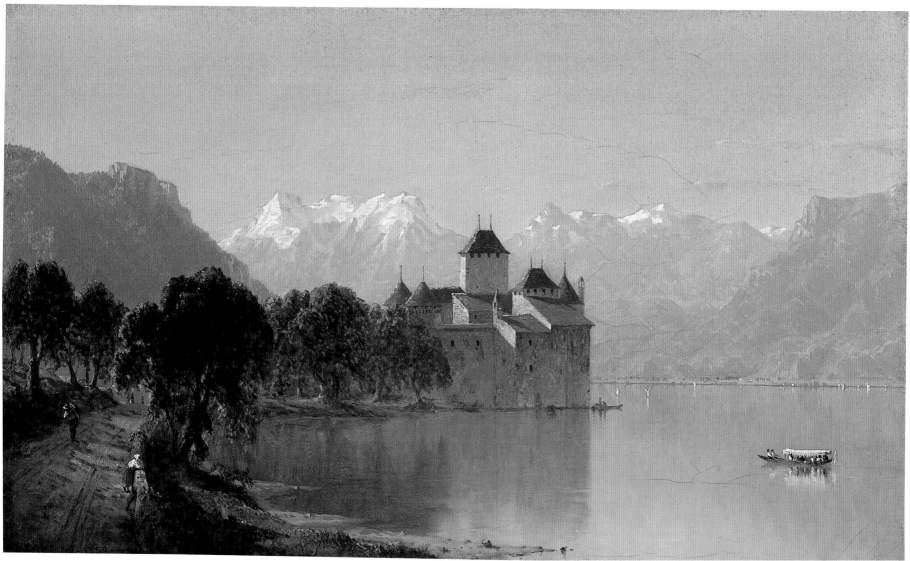

Cat. 7

sympathizer, lost interest in American landscape paint-ing after the outbreak of the Civil War in 1861, and eventually sold most of his collection.

The artist returned to this subject in 1875 for one of his "chief pictures" (see fig. 144). Using a distant vantage point, Gifford diminished the prominence of the castle itself and widened the composition to encompass a more spacious panoramic view. F K

1. Gifford, European Letters, vol. 2, July 15, 1856, p. 75; the lines Gifford quoted are not from "The Prisoner of Chillon," but from Byron's "Sonnet on Chillon." Gifford (like Byron) did not use the name Lake Geneva, but instead Lake Leman (Lac Léman in French), which was derived from the Roman name for the lake, Lacus Lemanus.
2. The first sketch was sold by Richard Bourne Auctioneers, Hyannis, Massachusetts, August 12, 1980, no. 104. Another small version, dated 1861 (7⅛ x 12 inches; formerly, Hull Gallery, Washington, D.C.), is considered by Weiss (1987, p. 207) to be an intermediary study between these two that was subsequently dated.
3. "Fine Arts. Artists' Reception," *The Home Journal* 2 (February 18, 1860), p. 5.
4. M. G. S., "Art Matters in Baltimore," *Boston Evening Transcript*, March 4, 1861, pp. 1–2.

Mansfield Mountain, 1859

Oil on canvas, 30 x 60 in. (76.2 x 152.4 cm)
Signed and dated, lower right: S R Gifford. 1859.
MC 138, "Mansfield Mountain. Size, 30 x 60. Sold in 1858–9 to
J. Harrison, Jr."
Exhibited: National Academy of Design, New York, April
1859; Boston Athenaeum, 1859, no. 283, as "Mansfield
Mountain, Vermont"; Harrison Collection, Philadelphia, about
1870, no. 24, as "Landscape, 'Mansfield Mountain, Vermont'";
Harrison Collection, Philadelphia, 1870, no. 57, as "Landscape.
Mansfield Mountain, Vermont."
Manoogian Collection

9

A Sketch of Mansfield Mountain, 1858

Oil on canvas, 7 x 14 in. (17.8 x 35.6 cm)
Signed and dated, lower left: S R Gifford 1858
MC 132, "A Sketch of Mansfield Mountain. Dated 1858. Size,
7 x 14. Owned by G. W. V. Smith, Springfield, Mass."
George Walter Vincent Smith Art Museum, Springfield,
Massachusetts

10

Mount Mansfield, 1859

Oil on canvas, 10½ x 20 in. (26.7 x 50.8 cm)
Signed and dated, lower left: S R Gifford 1859.
MC 172, "Mount Mansfield. Not dated. Size, 11 x 20. Owned
by the National Academy of Design."
Exhibited: Artists' Fund Society, New York, 1865, no. 47, as
"Mt. Mansfield."
National Academy of Design, New York. Bequest of James A.
Suydam, 1865

Although Vermont's Green Mountains were slower to
attract tourist travel than New York's Catskills or the
White Mountains of New Hampshire, by the 1850s

they were becoming increasingly well known. Mount
Mansfield, a group of peaks that loosely resemble the
features of a human face and, at 4,393 feet, the highest
elevation in Vermont, soon became a favorite destination.
In 1858, a carriage path and a hotel were built in the area
between the Nose and the Chin, the two peaks shown (at
the left and the right, respectively) in catalogue numbers 8
and 9.[1] The view from the summit to the west was espe-
cially celebrated: "The whole valley of Lake Champlain
appears spread out as a map, bounded by the lofty and
picturesque Adirondacks on the south-west, and, opening
in the north-west into the valley of the St. Lawrence."[2]

Having returned to America from Europe in
September 1857, Gifford established himself in a studio
in the new Tenth Street Studio Building. He showed his
Lake Nemi (cat. no. 6) at the National Academy of Design
the following spring, and by then must have been think-
ing of where he could find material for a suitable sequel
based on American scenery. That summer he went on a
sketching tour with his friend and fellow artist Richard
Hubbard in Pennsylvania and in New York, ending up,
in August, in the Green Mountains. According to one

report, they were joined there by another painter: "Jerome
Thompson, the artist, is with Gifford and Hubbard (both
just returned from Europe) sketching on Mansfield
Mountain, in Vermont. They are the first artists who have
sketched there, and they pronounce the place equal in
interest to Mount Washington, and in every way a
charming spot." This report also noted that Thompson
was contemplating "(as one of the fruits of his sketches
there) a picture to be called 'The Benighted [sic] Party on
Mansfield Mountain,'" that would be "something well
worth seeing."[3] Thompson completed that work, entitled
The Belated Party on Mansfield Mountain and now in The
Metropolitan Museum of Art (see fig. 69), in 1858, and
submitted it to the National Academy of Design in 1859,
where it was exhibited along with the present work.
Gifford's and Thompson's paintings are similar in vantage
point, time of day depicted, and size, but very different in
mood, and conceivably might have been painted in com-
petition. An anonymous account of an ascent of Mount
Mansfield in the summer of 1858, published in The
Knickerbocker in 1860, rapturously described a sunset from
the summit that reads almost as a verbal counterpart to

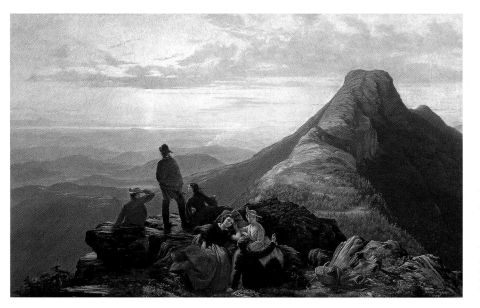

Figure 69. Jerome B.
Thompson. The Belated
Party on Mansfield
Mountain, 1858. Oil on
canvas. The Metropolitan
Museum of Art, New
York. Rogers Fund, 1969

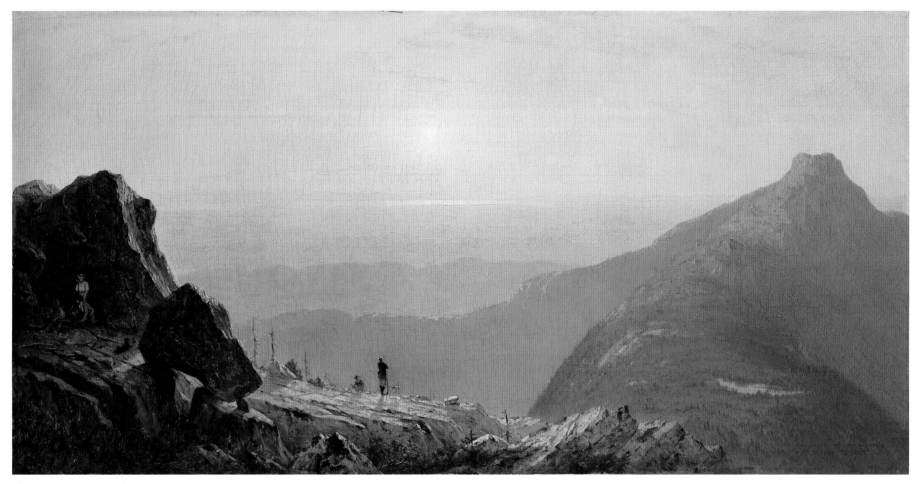

Cat. 8

Gifford's painting. It also cast aspersions on fashionable tourists and vacationers, lamenting that, after their arrival, "the rocks, which for centuries untold had been invaded only by the winds, or felt that fall of snow-flake, should be strewed all over with the crumbs and fragments of a pic-nic."[4] This critique may have been inspired by Thompson's painting, which prominently features such a picnic.[5]

While there are several works included in the *Memorial Catalogue* that were described as "sketches" of Mount Mansfield, none that conceivably might have been painted *in situ* is known today. The small version seen here is almost certainly a product of the studio (like *Study for The View from South Mountain, in the Catskills*, cat. no. 54), perhaps based on pencil drawings and other oil sketches.[6] The large, finished painting followed the composition of the sketch closely, although Gifford moved the vantage point back, diminishing the size of the figures. The sketch includes only two figures, but the large picture shows two additional men (who are starting a campfire) in the shadow of the large rock at the far left. Gifford also changed the pinkish coloration of the middle distance in the sketch to a yellow tonality that is more unified with the glowing atmosphere above.

Mansfield Mountain (cat. no. 8) was greeted with extravagant praise when it appeared at the National Academy. "The subject is one of immense difficulty," wrote a critic for *The Home Journal*, "as the gradation of color and aerial perspective is so subtle, and at the same time the forms are so varied and full, it is scarcely within the province of Art to more than suggest so extensive a panorama."[7] Another writer, who considered Gifford "the most poetical of our American artists, whose pictures are like poet's dreams," pronounced the picture "the next best thing to a scramble up the rocks . . . a beautiful painting."[8] Yet another deemed it "a fine specimen of atmospheric effect. You seem to stand with those figures on the stern, splintered ridge, and gaze over through the bright mist that fills the yawning abyss, at

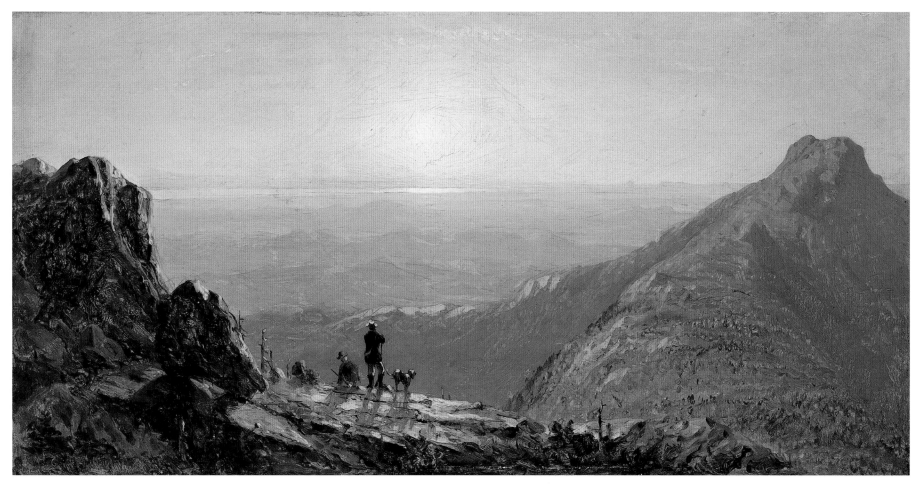

Cat. 9

the swelling mountain chain that soars up cloud-like into, rather than against the sky."[9] The artist himself acknowledged the importance of this painting for his early career, listing it second (after *Lake Nemi*) on his roster of "chief pictures."

Gifford chose a more distant view of the mountain for catalogue number 10, the composition of which may have been repeated in several other (now lost) pictures listed in the *Memorial Catalogue*.[10] The depiction of two Native Americans at the lower center establishes a very different context than that of the earlier versions. The white men who climbed the mountain to admire the scene below would have served as ready surrogates for those viewers of the painting in New York or Boston, enabling them to imaginatively transport themselves to the site. For some, this would have evoked merely the pleasures of a scenic vista, while others might have felt the sense of power and privilege inherent in what Michel Foucault has defined as the "sovereign gaze."[11] In either case, however, the experience would have been grounded in the present, yet, the inclusion of the Native Americans established a different temporal frame—that of a romanticized past before the coming of European civilization displaced them and forever changed the primeval wilderness. The energized sense of wonder of the white men gazing into the light-filled distance was now superseded by a more elegiac tone, one less about the promises of discovery and the future and more about a past that could never be recovered.

F K

1. W. Storrs Lee, *The Green Mountains of Vermont* (New York: Henry Holt and Company, 1955), pp. 206–7; cited by Kevin J. Avery, "Jerome Thompson: *The Belated Party on Mansfield*

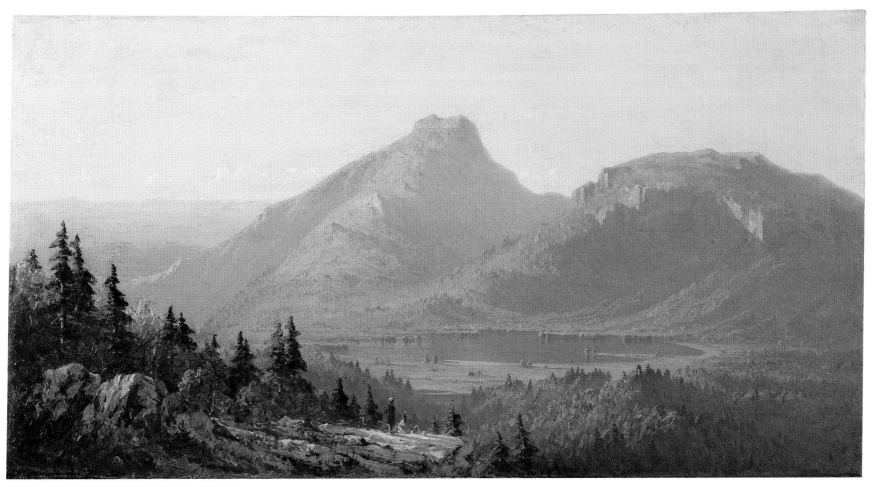

Cat. 10

Mountain," in Howat et al. 1987, p. 147. For an excellent discussion of the rise of tourism in the vicinity of Mount Mansfield and a thorough examination of catalogue number 8 see Christopher Kent Wilson, "Sanford Robinson Gifford: *Mount Mansfield, 1858,*" in [Nicolai Cikovsky, Jr., et al.], *American Paintings from the Manoogian Collection,* exhib. cat., Washington, D.C., National Gallery of Art, and traveled (Washington, D.C.: 1989), pp. 44–46.

2. Z[adock]. Thompson, *Northern Guide: Lake George . . .* (Burlington, Vermont: S. B. Nichols, 1854), pp. 34–35; quoted by Wilson, "*Mount Mansfield,*" p. 44.

3. "Fine Arts," *The Home Journal* (September 4, 1858), p. 3.

4. "Adventures on a Mountain-Top," *The Knickerbocker* 55, no. 4 (April 1860), p. 362; see also Wilson, "*Mount Mansfield,*" pp. 44–46.

5. As Wilson has noted, the author of this article stated that he had received his walking stick from his ancestor "Resolved Hubbard," raising the possibility that he was Gifford's friend Richard Hubbard. Hubbard himself had a major painting of Mount Mansfield (Whereabouts unknown) on view at the National Academy of Design that spring.

6. See Harvey 1998, pp. 208–9, for a discussion of the Springfield picture.

7. "Fine Arts. National Academy of Design," *The Home Journal* (June 18, 1859), p. 2. This writer did find fault with the "hue of this picture," describing it as "too yellow and painty."

8. *Boston Evening Transcript,* August 1, 1859. This writer saw the painting on view at the Boston Athenaeum.

9. "The Athenaeum Gallery," *Ballou's Pictorial Drawing-Room Companion,* August 20, 1859, p. 122.

10. For example, no. 137: *Mansfield Mountain* (10½ x 20 inches); no. 164: *Mansfield Lake* (10 x 20 inches); and no. 168: *Mansfield Mountain* (10½ x 20 inches).

11. On the relationship of Foucault's theories to nineteenth-century American landscape painting see, in particular, Alan Wallach, "Making a Picture of the View from Mount Holyoke," *Bulletin of the Detroit Institute of Arts* 66, no. 1 (1990), pp. 37–38.

Early October in the White Mountains, 1860

Oil on canvas, 14⅛ x 24 in. (35.9 x 61 cm)
Signed and dated, lower left: S R Gifford 1860
MC 225, "Early October in the White Mountains. Painted in 1861. Size, 12 x 24. Owned by John R. Shepley, St. Louis, Mo."
Exhibited: Western Academy of Art, Saint Louis, "First Annual Exhibition," 1860, no. 11; Mississippi Valley Sanitary Fair, Saint Louis, 1864, no. 266; possibly Saint Louis Mercantile Library, October 1871, no. 79, as "White Mountain Scenery"; Crow Museum, Saint Louis School and Museum of Fine Arts, Washington University, Loan Exhibition, 1881.
Washington University Gallery of Art, Saint Louis. Bequest of Charles Parsons, 1905

Gifford's travels in the summer of 1859 took him to New Hampshire's White Mountains, which he had first visited in 1854.[1] His 1859 trip lasted at least into the early fall, for it was said that he had been "studying autumnal scenery" that resulted in a "portfolio filled with fine studies and sketches."[2] The basis for this serenely beau-

tiful painting was likely a drawing (see fig. 70) inscribed "Shelburne-July 30th 59," which was further developed in an oil sketch (see fig. 71). The village of Shelburne is on the Androscoggin River just west of the Maine-New Hampshire border, and offers excellent views from the east of the northernmost section of the Presidential Range. Thomas Starr King considered this among the most scenic approaches to the White Mountains, citing specifically "the brilliant meadows, proud of their arching elms; the full broad Androscoggin, whose charming islands on a still day rise from it like emeralds from liquid silver; the grand Scotch-looking hills that guard it; the firm lines of the White Mountain ridge . . . the splendid symmetry that bursts upon us when the whole mass of Madison is seen throned over the valley."[3] The best time to observe this view, according to King, was "between five and seven of the afternoon. Then the lights are softest, and the shadows richest on the foliage of the islands of the river, and on the lower mountain sides. And then the gigantic gray pyramid of Madison

with its pointed apex, back of which peers the ragged crest of Adams, shows to best advantage."[4]

In this painting, Gifford depicted a view at a time of day that correlated closely with King's description. The sharp light of afternoon that reveals the foreground rocks and other details with vivid clarity gradually softens atmospherically in the distance, so that the contours of the mountains are as much suggested as described. Framing trees, *repoussoir* elements, and other aspects of traditional Claudian compositional formulas are completely absent, giving the painting a remarkable sense of reductivity and spareness. Also notable is the simplified geometry that divides the painting into two equal bands of earth and sky, with only the central mountain peaks (which are themselves visually echoed by the placement of the two cows in the foreground) reaching above the center line.

In 1860, *Early October in the White Mountains* was sent to Saint Louis, where it was shown in the first exhibition of the newly formed Western Academy of Art.[5] The picture later entered the collection of one of that

Figure 70. Sanford R. Gifford. "*Shelburne-July 30th 59*" (from the sketchbook of Nova Scotia and New Hampshire subjects, 1859). Graphite, with traces of white gouache, on beige wove paper. The Frances Lehman Loeb Art Center, Vassar College, Poughkeepsie, New York, Gift of Miss Edith Wilkinson, Class of 1889

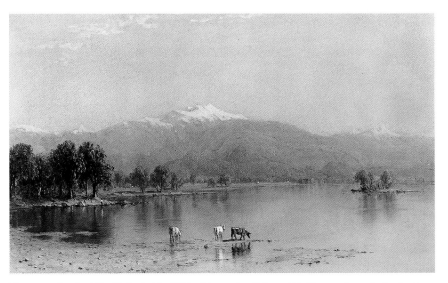

Figure 71. Sanford R. Gifford. *The White Mountains* (*Mount Washington from the Saco*), 1871. Oil on canvas. New Britain Museum of Art, Connecticut. Stephen B. Lawrence Fund

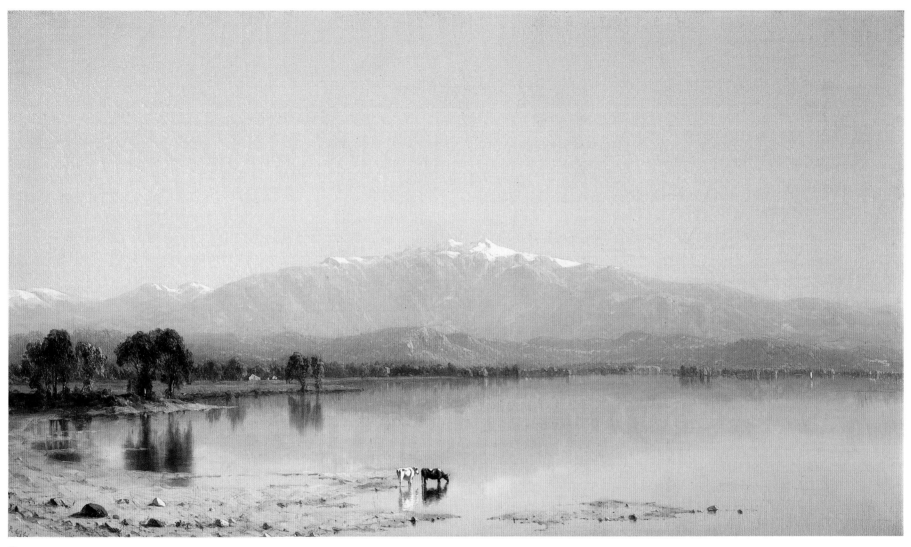

Cat. 11

city's leading art patrons of the later nineteenth century, Charles Parsons. Parsons lent it to the inaugural exhibition in 1881 of Washington University's Saint Louis School and Museum of Fine Arts, the first art museum to be established west of the Mississippi.[6] There, the painting was admired by one writer as "a work of charming qualities. The whole scene is expressive of the utmost peacefulness. The smooth lake, the fine mountains, and the motionless trees, all give the impression of perfect repose; while the rich, harmonious tone of color is like a tranquil breath of satisfied completeness."[7]

F K

1. According to the author of "The Fine Arts," *The New York Evening Post,* April 25, 1855, p. 2: "Gifford has just completed two small pictures, both views in the vicinity of the White Mountains." Several works associated with this trip are known today, including *Mountain Valley (From the Ledge, North Conway)* (about 1854; Mead Art Museum, Amherst College, Massachusetts), *Mount Washington from the Saco* (about 1855; Private collection), and *Mount Washington from the Saco* (1855; Collection William Nathaniel Banks).
2. "Personal," *The Home Journal* (October 8, 1859), p. 2; "Personal," *The Home Journal* (November 12, 1859), p. 2.
3. Thomas Starr King, *The White Hills: Their Legends, Landscape, and Poetry* (1859; Boston: Estes and Lauriat, 1887), pp. 246–47.
4. Ibid., p. 279. As Weiss (1987, p. 213) has noted, King may well have been with Gifford during his 1859 tour of the White Mountains.
5. *Catalogue of the First Annual Exhibition of the Western Academy of Art* (Saint Louis: Western Academy of Art, 1860), p. 10, no. 182, lists the work as *Early September in the White Mountains,* lent by J. R. Shepley.
6. Jane E. Neidhardt, ed., *A Gallery of Modern Art at Washington University in St. Louis* (Saint Louis: Washington University Gallery of Art, 1994), p. 11.
7. William McKendree Bryant, "The Loan Exhibition at the Crow Museum," *The Western* 7 (1881), p. 413. The museum was located in the Crow Memorial Building at the university. Bryant went on to write a book, *Philosophy of Landscape Painting* (Saint Louis: The St. Louis News Co., 1882), which was based largely on the European and American works in the Parsons collection.

The Wilderness, 1860

Oil on canvas, 30 x 54⁵⁄₁₆ in. (76.2 x 138 cm)
Signed and dated, lower left: S. R. Gifford 1860.
MC 204, "In the Wilderness. Size, 30 x 52. Sold in 1860 to
Harrison Maynard, Boston, Mass.; present owner unknown."
Exhibited: National Academy of Design, New York, April
1860, no. 561
The Toledo Museum of Art. Purchased with funds from The
Florence Scott Libbey Bequest in memory of her father,
Maurice A. Scott

13

The Wilderness, 1861

Oil on canvas, 12 x 22 in. (30.5 x 55.9 cm)
Signed and dated, lower left: S R Gifford 18[6]1
Collection Mr. and Mrs. Jack Kay

Gifford followed the successful exhibition of his
Mansfield Mountain (cat. no. 8) at the National Academy
of Design in 1859 with the similarly sized but very
differently conceived *The Wilderness* of 1860. Whereas
the earlier painting has prominent mountain peaks
flanking each side of the composition and a spatial void
in the center, the focal point of *The Wilderness* is a single
distant pyramidal mountain lying beyond a still lake that
fills the lower third of the picture. As such, the painting
effectively fused two compositional schemes Gifford had
investigated in such works as the small 1859 *Mount
Mansfield* (cat. no. 10), with its dominant central moun-
tain, and *Early October in the White Mountains* (cat. no. 11),
with its tranquil body of water extending across the fore-
ground. As in *Mount Mansfield*, Gifford's inclusion of
Native Americans in *The Wilderness*, and his use of
the subtitle, "Home of the red brow'd hunter race," in
the National Academy exhibition catalogue, established
a very different human drama than that enacted by the
white men he showed so energetically scaling Mount

Mansfield in the large exhibition picture of the year before.

The immediate inspiration for these paintings was
the artist's trip in the summer of 1859, which took him
and fellow artist George H. Boughton to Nova Scotia,
Maine, and New Hampshire. In a letter to the collector
the Reverend Elias L. Magoon, Gifford wrote:
"Boughton and I, fired by accounts we have read and
heard of the scenery and people of Nova Scotia, have
made an alliance offensive and defensive for an expedi-
tion into that land of 'Blue Noses,' Arcadians [*sic*], and
'Forest Primeval.' We will probably get away thitherward
by the first of July."[1] Gifford was also apparently the
author of a letter published in *The Crayon* in September
1859 in which he lamented the lack of the type of
scenery he sought: "There was not a sign of the 'forest
primeval—the murmuring pines and the hemlocks' that
the poet sings of. . . . By the way, Longfellow's descrip-
tion of the scenery is not wonderfully accurate."[2]
Gifford's sketchbook of July–August 1859 (The Frances
Lehman Loeb Art Center, Vassar College, Poughkeepsie,
New York) contains only a few drawings of Nova Scotia

scenery, but he did make a number of sketches of the
local Micmac and their tepees and canoes.[3] In the letter
to *The Crayon* the writer also described time spent with
the Micmac: "We paddled about in their canoes, and in
the evening had a pow-wow and smoked a pipe with
them about the fire in a wigwam." The details Gifford
included in *The Wilderness*—the woman in native dress
standing by the water, the overturned canoe on the
bank, the tepee with a papoose propped against the
entrance, the slain deer hanging from the boulder, and
the man crossing the lake in another canoe—all evoke
an idealized and nostalgic view of Native Americans
living in perfect harmony with the natural world. In the
distance, the massive mountain stands like a sentinel,
suggesting a timeless permanence and stability that
Gifford and his contemporaries knew perfectly well were
impossible for Native Americans, who were already "fast
passing away from the face of the earth."[4]

Although likely not meant to portray a specific
mountain in an identifiable location, the shape of the
peak in *The Wilderness* suggests that of Mount Katahdin

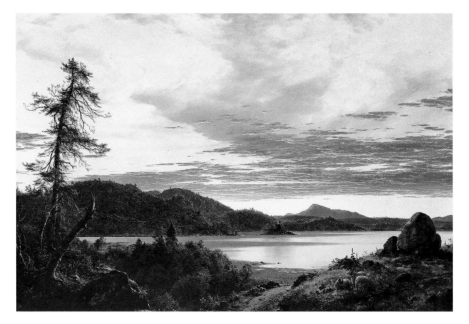

Figure 72. Frederic Edwin
Church. *Sunset*, 1856. Oil on
canvas. Munson-Williams-
Proctor Institute, Museum
of Art, Utica, New York

Cat. 12

in Maine. There is no evidence that Gifford had yet visited Katahdin, which lies in a remote area of the state that the writer Theodore Winthrop described as "New England's wildest wilderness."[5] Winthrop had traveled to Katahdin in the summer of 1856 with his friend Frederic Church, who, like Gifford, would later on establish a studio in the Tenth Street Studio Building. Perhaps Church shared his sketches of Katahdin with Gifford, or showed him his 1856 painting *Sunset* (fig. 72), in which the mountain, while less prominently sited, is a close prototype for that in *The Wilderness*.[6] One wonders also whether the two painters might have been engaged

in a little friendly competition in the winter of 1859–60, for while Gifford was working on his large picture Church was busy with his own summa of untouched American scenery, *Twilight in the Wilderness* (fig. 3).

Gifford seems to have first devised the overall scheme of *The Wilderness* in a small oil study (see fig. 73) that was probably painted in 1860 but subsequently dated 1861 when it was sold.[7] The finished painting, seen by a writer for *The Home Journal* in March 1860, was pronounced "the best he has painted." This writer continued: "It does one good to sit an hour with Gifford; to muse over the warm, glowing atmosphere, and the rich mellow foliage

which give such a dream-like charm to his landscapes. You see at once that he has the eye of a true poet. . . . There is something so soft, so balmy, and yet so bewitching in the leafy vestments of Gifford's hills and dales. . . . His sequestered lakes remind you of scenes in other lands."[8] Surprisingly, *The Wilderness* received little attention when it was shown at the National Academy, where it must have stood out as one of the most impressive landscapes on view (Church exhibited his *Twilight in the Wilderness* by itself at Goupil's gallery in New York). Henry T. Tuckerman did, however, take note of it (and of *A Coming Storm*, cat. no. 29) in his 1867 *Book of*

Cat. 13

Figure 73. Sanford R. Gifford. *Lake Scene —Mountain Background,* 1861. Oil on canvas. Addison Gallery of American Art, Phillips Academy, Andover, Massachusetts. Bequest of Candace C. Stimson

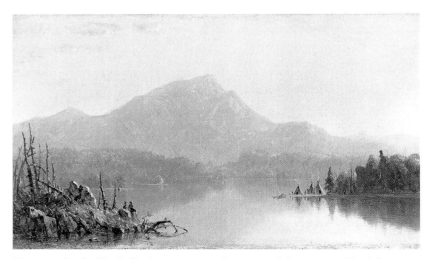

Figure 74. Sanford R. Gifford. *Indian Lake,* about 1869. Oil on canvas, Mead Art Museum, Amherst College, Massachusetts. Gift of Walter Knight Sturges

the Artists: "There is a scope, a masterly treatment of light and shade, full of reality and often poetically suggestive, as in nature and perspective; while ridge, hollow, precipice, glen, and summit in the mountains are divided by a seeming space which is one of the most subtle illusions of the art."[9]

Others must have been equally admiring, for there are several smaller, less ambitious variants of *The Wilderness* that may have been commissions or at least produced by the artist for immediate sale. These include *Indian Lake* (fig. 74), where the form of the mountain is reversed; *Indian Summer* (about 1861; Private collection); and the elegantly reductive 1861 work also known as *The Wilderness* (cat. no. 13).[10] In this painting, the watery foreground is relieved only by small bits of land at the

lower right corner of the composition. A jumble of angular boulders flanked by wiry pine trees is rhymed in larger scale directly across the lake, where a massive overhang shelters a group of tepees. The distinctive strata of these rocks are in turn echoed by what appears to be the same geological seam running across the flank of the mountain, and leading the eye into the luminous distance. F K

1. Quoted in Weiss 1968/1977, p. 184, who suggests that one of Gifford's sources may have been Frederick S. Cozzens's book *Acadia: or, A Month with the Blue Noses* (New York: Derby & Jackson, 1859). E. Cobham Brewer, in *Dictionary of Phrase and Fable*, rev. ed. (London: Cassell and Company; Philadelphia: J. B. Lippincott, 1898), explained the use of the term "Blue Noses" for Nova Scotians: "'Pray, sir,' said one of my fellow-passengers, 'can you tell me the reason why the Nova Scotians are called "Blue-noses"?' 'It is the name of a potato,' said I, 'which they produce in the greatest perfection, and boast to be the best in the world. The Americans have, in consequence, given them the nickname of *Blue Noses*'."—*Haliburton: Sam Stick*. Information from {http://www.bartleby.com}, November 18, 2002.

2. "Country Correspondence. N——, July 26, 1859," *The Crayon* 6, no. 9 (September 1859), pp. 285, 286; quoted in Weiss 1968/1977, p. 185.

3. See Kevin J. Avery, "Sanford R. Gifford: *The Wilderness*, 1860," in Howat et al. 1987, pp. 218–19.

4. "The Indians in American Art," *The Crayon* 3, no. 1 (January 1856), p. 28; quoted in Weiss 1968/1977, p. 180.

5. Theodore Winthrop, *Life in the Open Air, and Other Papers* (Boston: Ticknor and Fields, 1863), p. 50.

6. Weiss 1968/1977, p. 196, also suggests this.

7. Weiss 1987, p. 220; (this is possibly number 210 in the *Memorial Catalogue*: "A Sketch in the Wilderness").

8. *The Home Journal*, March 24, 1860.

9. Tuckerman 1966, p. 527.

10. Weiss 1987, pp. 218–23.

14

A Lake Twilight, 1861

Oil on canvas, 15½ x 27½ in. (39.4 x 69.9 cm)
Signed and dated, lower right: S. R. Gifford. 1861
MC 233, as "A Lake Twilight. Size, 16 x 28. Sold in 1861 to the Young Men's Association, Troy, N.Y.; present owner unknown."
Exhibited: Possibly Young Men's Association, Troy, New York, 1861, no. 7, as "Sunset."
Private collection

15

Sunset, 1863

Oil on canvas, 9½ x 15½ in. (24.1 x 39.4 cm)
Signed and dated, lower right: S R Gifford 1863
Exhibited: Possibly Artists' Fund Society, New York, December 1864, no. 7; possibly Century Association, New York, "Gifford Memorial Meeting of the Century," November 1880, no. 16.
Collection Erving and Joyce Wolf

A Lake Twilight and *Sunset* are two in a series of paintings that Gifford began in 1861 and that introduce an alternative to the atmospheric mode for which he had achieved notice since his return from Europe in 1857. The impetus behind all these paintings undoubtedly was Frederic Church's well-known *Twilight in the Wilderness* (fig. 3) of just a year earlier. In that picture, Church brought to spectacular culmination a succession of sunset and crepuscular subjects that he had been producing, to considerable critical notice, throughout the 1850s.[1] *Twilight in the Wilderness* was the largest, and the most dramatic, acclaimed, and significant of those exercises. Exhibited on the eve of the Civil War, the painting was a paean to America's unspoiled terrain; it was even exploited by the artist himself, after the outbreak of war, as Union propaganda, when he modified its features to resemble Old Glory unfurled over the landscape—an image published as a lithograph and entitled *Our Banner in the Sky* (see fig. 31).[2] In corresponding paintings such as *A Lake Twilight*, Gifford never indulged in the technical

showmanship of Church, nor the popularizing streak revealed in the patriotic recasting of *Twilight in the Wilderness*. *A Lake Twilight* is less evocative of that picture than of some of Church's more modest productions that led up to it, wherein the mountains in the foreground at the left, enclosing a valley or lake, are silhouetted against the light of the sky, which is intensely yellow at the right where the sun has just set (see fig. 75).[3] Gifford's painting not only references those earlier paintings by Church but looks ahead to the culmination of his own pictures in this mode, *Hunter Mountain, Twilight* (cat. no. 41).

However, the recent discovery of *A Twilight in the Catskills* (fig. 12), the heretofore unlocated Gifford masterwork of 1861, shows that the artist essayed the subject of twilight on a far more ambitious and expressive scale in the same year as *A Lake Twilight*, and in ways that further inform the relationship between his own and Church's efforts in this vein.[4] *A Twilight in the Catskills* is a larger, starkly dramatic, and more brooding work than Gifford had ever painted and, indeed, would

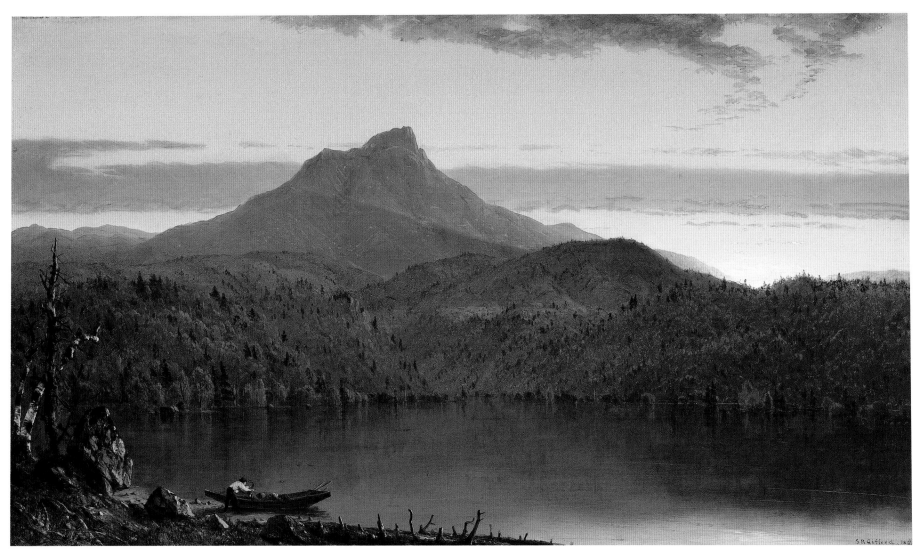

Cat. 14

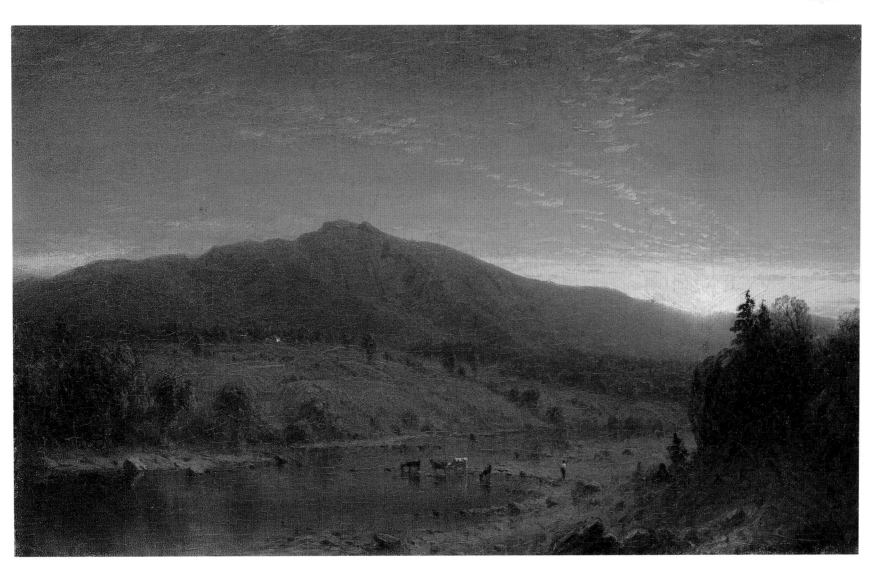

Cat. 15

ever paint again. While it still lacks the baroque flourish of Church's picture from the previous year, its vast expanse of hot, cloud-laden sky above the silhouetted mountain and valley and, especially, the brutish, charred-looking trees in the foreground, tighten the relationship between his and Church's best-known works of this type.

A Lake Twilight is a considerably milder picture than *A Twilight in the Catskills,* although perhaps a vestige of the harshness of the former painting is detectable in the analogously spiny forms of the fallen log, the withered tree, the antlers of the dead buck being grasped by the boatman in the foreground, and the bristling tops of the conifers silhouetted against the background light. The effect is underscored, of course, by the toothy peak of the principal mountain, whose identity, nevertheless, is ambiguous. An old label on the back of the picture, rediscovered when the painting resurfaced and was sold in the 1960s, gave the title as "In the Green Mountains, Vt."[5] That designation, the appearance of the peak itself, and the fact that Gifford sketched in Vermont in August 1858 suggest that the mountain is Camels Hump, which is represented (from a different angle) in *A Sketch on the Huntington River, Vermont* (cat. no. 18).[6] However, Gifford was in New Hampshire's White Mountains in 1858, and again in 1859, and his biographer rightly notes the "Chocorua-like focal peak"—referring to New Hampshire's Mount Chocorua, whose profile resembles that of Camels Hump—in a painting by Gifford called *Indian Summer* (Private collection).[7] The existence of a fine oil study for *A Lake Twilight,* called *Twilight Mountain* (1860; Lorenzo State Historic Site, Cazenovia, New York),[8] in which the mountain is similarly shaped but more generalized, suggests that the artist may not have had either peak specifically in mind—hence, perhaps, the explanation behind the thematic (rather than the topographical) title of each painting.

The similarity between the compositions and the depictions of the mountain in *A Lake Twilight* and the preparatory study on the one hand, and *Indian Summer* and a smaller, related picture (see fig. 74) on the other, is evidence that, as early as 1860–61, Gifford had begun

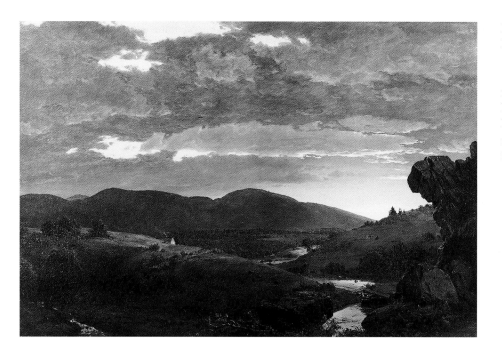

Figure 75. Frederic Edwin Church. *Twilight, "Short arbiter 'twixt day and night,"* 1850. Oil on canvas. Newark Museum, New Jersey. Purchase, 1956, Wallace M. Scudder Bequest Fund

exploiting the same compositional foil for light and atmospheric variations in different paintings, anticipating such "series" as his *A Twilight in the Adirondacks* subjects of 1862 and 1864. *Indian Summer* and its smaller version are both veiled in a hazy afternoon mist, evoking Gifford's "chief picture" of 1860, *The Wilderness* (cat. no. 12). In both *A Lake Twilight* and the preparatory study, as in *A Twilight in the Catskills,* the "chief picture" of 1861, such atmospheric effects are supplanted by the crepuscular sky.

It is difficult to say whether Gifford, like Church, was expressing any personal or nationalistic sentiments with *A Lake Twilight* and *A Twilight in the Catskills,* but the notion cannot be dismissed. In Gifford's *Baltimore, 1862 —Twilight* (fig. 32), he invoked the late-day hour with a lonely sentry at Fort Federal Hill echoing the spires of the guarded city in the background. The ravaged, light-charged terrain of Kaaterskill Clove in the 1861 picture and in *A Lake Twilight* of the same year might well have been affected not merely by the climate of the Civil War but by the contemporaneous death of his beloved but troubled brother Charles, who had contributed to Gifford's youthful artistic awakening.[9]

Painted just two years after *A Lake Twilight, Sunset* is a light and atmospheric variation on a composition entitled *Landscape and Cows* (Whereabouts unknown) formulated four years earlier from impressions probably gathered in Nova Scotia and in New England in the summer of 1859.[10] This was the same excursion—made with his friend the artist George Boughton—during which Gifford presumably collected the materials for such significant paintings as *The Wilderness* (cat. no. 12) and several views of the White Mountains (see cat. no. 11).[11] None of the known sketches from that trip corresponds exactly to the imagery of *Landscape and Cows,* although the picture is generically similar to sketches made in late July 1859 of Mount Washington and Mount Madison, respectively, from Shelburne and Gorham, New Hampshire, along the Androscoggin River.[12] It possibly also relates to another more ambitious composition of 1863, *On the Androscoggin* (Private collection), which appears to portray the same mountain (possibly Mount Madison, without snow) as that in *Landscape and Cows* and in *Sunset,* but from a greater distance that accommodates more trees and a settlement along the banks of the river in the foreground.[13]

With a smolderingly overcast sky, the infernal glow at the right, the bold *repoussoir* of trees and terrain to set it off, and the reflective eye of the window of the house left of center, *Sunset* recalls even more strongly than *A Lake Twilight* the pastoral late-day subjects of Frederic Church of the 1850s—particularly, *Twilight, "Short arbiter 'twixt day and night"* (fig. 75)—and Gifford's own *A Twilight in the Catskills* (fig. 12). Characteristically, Gifford restrains light and dark contrasts of sky and earth in his work, seeking a more reflected warmth overall. From *A Lake Twilight,* he repeats the accent of tapering cirrus-like clouds to the right of the mountain's summit, here set in relief—rather than silhouetted, as in the earlier picture—against the overcast sky above. To the compositional elements of *Landscape with Cows,* Gifford added a cowherd in *Sunset,* forecasting the

figures and the general ambience of *Hunter Mountain, Twilight* (cat. no. 41).

K J A

1. For Church's twilight pictures see Kelly 1988, pp. 26–34, 82–87, 102–22.
2. Ibid., pp. 119, 123, 125; see also Doreen Bolger Burke, "Frederic Edwin Church and 'The Banner of Dawn,'" *The American Art Journal* 14, no. 2 (Spring 1982), pp. 39–46.
3. Besides *Twilight, "Short arbiter 'twixt day and night,"* of 1850, see *Mount Ktaadn* [Katahdin] (1853; Yale University Art Gallery), *Sunset* (1856; fig. 72), and *Twilight* (about 1856–58; Private collection).
4. See Greenhalgh 2001.
5. Information courtesy of the Vose Galleries, Boston, in a phone conversation of March 18, 1986, in connection with my research for an entry on this picture in Howat et al. 1987, pp. 221–22 n. 6.
6. Weiss 1987, pp. 85–86. As noted in Howat et al. 1987, p. 221 n. 6, the profile conforms closely with the mountains in two paintings by John Frederick Kensett securely identified as views of Camels Hump.
7. Weiss 1987, p. 223 (illustration p. 222).
8. The study, *Twilight Mountain,* is illustrated in Weiss 1987, p. 225.
9. Sanford's relationship with Charles is described in Weiss 1987, pp. 51–53. A connection between Charles's death and the character of Gifford's work in the early Civil War years is proposed by Weiss 1968/1977, pp. 206–7.
10. *Landscape with Cows* is illustrated in Cikovsky 1970, no. 17, p. 44.
11. Weiss 1987, pp. 87–88.
12. For the sketch inscribed "Shelburne-July 30th 59" see figure 70. Both that study and one inscribed "Gorham, July 19th-59-" are included in an 1859 sketchbook of Nova Scotia and New Hampshire subjects in the collection of The Frances Lehman Loeb Art Center, Vassar College, Poughkeepsie, New York (38.14.3), and on microfilm (Archives of American Art, Reel D254, frames 94, 95).
13. Illustrated in Weiss 1987, p. 216.

16

La Marina Grande, Capri, 1861

Oil on canvas, 12½ x 22½ in. (31.8 x 57.2 cm)
Signed and dated, lower left: S R Gifford / 1861.
MC 230, "Capri. Dated 1861. Size, 12 x 22. Owned by Mrs. Ledyard Lincklaen, Cazenovia, N. Y."
Exhibited: National Academy of Design, New York, 1861, no. 206.
Lorenzo State Historic Site, New York State Office of Parks, Recreation and Historic Preservation, Cazenovia, New York

17

Near Palermo, 1874

Oil on canvas, 15¾ x 29½ in. (40 x 75 cm)
Signed and dated, lower left: S R Gifford. 1874
MC 619 [31.], "The Road by the Sea, near Palermo, Sicily. Dated 1874. Size, 16 x 30. Owned by Miss Mary Gifford [the artist's sister], Hudson, N.Y."

Exhibited: Possibly Century Association, New York, February 1874, no. 27; possibly Brooklyn Art Association, April 1874, no. 338; National Academy of Design, New York, 1876, no. 312; possibly Yale School of Fine Arts, New Haven, 1874, no. 60, as "Near Palermo, Sicily"; The Metropolitan Museum of Art, New York, "Memorial Exhibition," October 1880–March 1881, no. 31. Carmen Thyssen-Bornemisza Collection on loan at the Museo Thyssen-Bornemisza, Madrid

La Marina Grande, Capri, and *Near Palermo* represent two southern Italian coastal subjects inspired by each of Gifford's visits to that region, in 1857 and in 1868. As is the case with his scenes of the Italian Lake District (see cat. nos. 33, 51), also the products of his sojourns, they could not present a more striking contrast. The earlier picture appears distinctly more synthetic than the later one, seemingly based chiefly on recollection, as filtered through exposure to the idealized views of J. M. W. Turner.

However, this quality would not have resulted merely from casual observation of the site on Gifford's part. He spent one month on the island of Capri in June 1857 while touring southern Italy with Albert Bierstadt—an exponent of the Düsseldorf school, who would later achieve fame as the leading painter of the American West. The two had met in Switzerland the previous year, and had resumed their association in Rome.[1] In his letters to his father in Hudson, New York, Gifford sketched a profile of the isle, and described its features, as seen from aboard the ferry from Naples:

The island is about four miles long, and ten around. The shores are very precipitous. There are only two places to land—the Marina Grande on the Naples side, and [the] Piccola Marina on the other. The village of Capri is on the top of the ridge between them. Ana Capri is on the high table-land, the only access to it is by 500 or 600 steps cut in

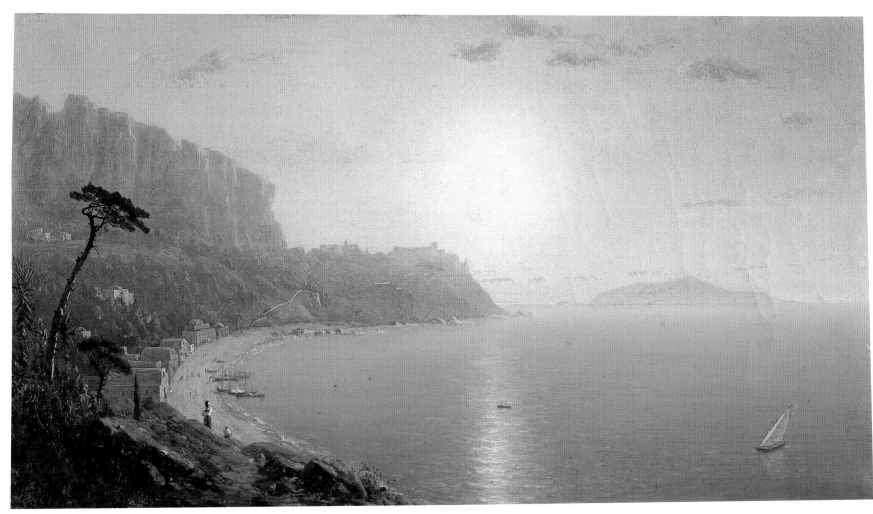

Cat. 16

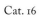

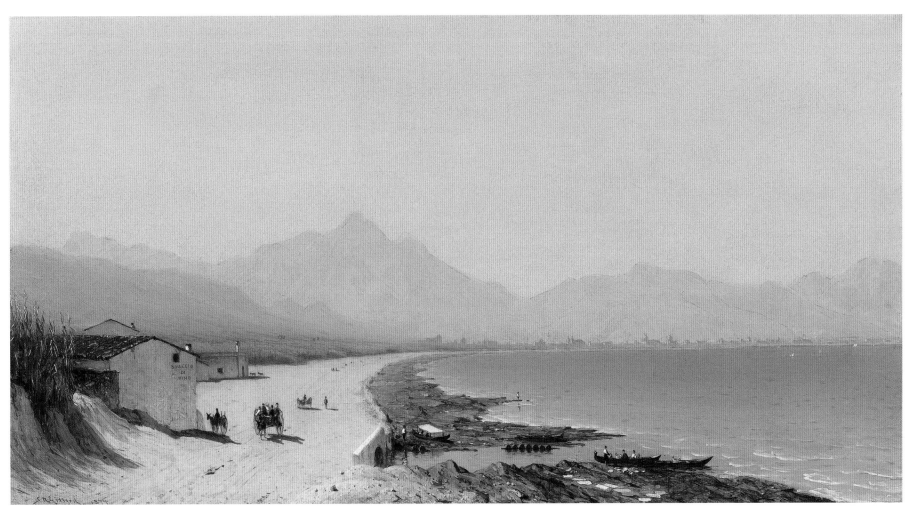

Cat. 17

Figure 76. Sanford R. Gifford. *"Road to Bagaria, near Palermo"* (from the sketchbook inscribed "Maggiore, Como, Sicily, Rome, Genoa, 1868"). Graphite. The Brooklyn Museum of Art. Gift of Miss Jennie E. Branscomb

the face of the cliff. Took a walk along the wild broken precipices of the south side. The rock is of limestone, and in this part of the island takes the form [of] "aiguilles" [spires]. Natural arches and grottos abound. We ascended to the ruins of the Palace of Tiberius, on the highest eastern point, and to the "Pharos," a perpendicular precipice of fearful depth, from which Tiberius had his victims thrown.[2]

During their lengthy stay, the two artists made many sketches of the beaches, producing some of their most vivid *plein air* works in oil. In addition, Gifford drew several portraits in pencil of his companion bent over his paint box or waving his hat from a windblown promontory.[3] However, when comparing the paintings by Gifford and Bierstadt—executed out of doors, as they worked side by side—what is both striking as well as relevant to the qualities of *La Marina Grande, Capri,* is the pervasive blondness of Gifford's perception of the Mediterranean light on the beach and especially on the

water, as opposed to Bierstadt's inclination toward bold contrasts of light and dark.[4]

For all Gifford's artistic activity at Capri, no drawings clearly related to the view depicted in *La Marina Grande* survive, although the *Memorial Catalogue* lists an undated and unlocated *Sunset at Capri,* measuring 9½ x 15½ inches, which may have been a study for the present work.[5] To attain the vantage point suggested by that picture, Gifford would have had to reach the high ground by partly ascending Monte San Michele, which overlooks the beach of La Marina Grande from the east. Behind him would have been the still loftier Monte Tiberio, the site of the "palace" (Villa Jovis) that he mentioned in his letter. Opposite are the towering cliffs of Capodimonte, and the island in the distance is Ischia, which, like Capri at the southern end, guards the entrance to the Bay of Naples at the north.

While the view is essentially accurate, the general composition—as is also evidenced by Gifford's contem-

poraneous paintings of American and other European subjects—suggests strains of reminiscence, invention, and idealization in the formulation of the picture. With its solar glow, almost blinding luminosity, dominant blue-and-yellow palette, lofty point of view, simplified curvilinear composition dominated by the shoreline and the contours of the cliffs, and lilting pine tree, the painting is one of Gifford's more identifiable homages to Turner, whose work was first evoked in the 1858 *Lake Nemi* (cat. no. 6). However, by comparison, *Lake Nemi* evinced pronounced tonal contrasts, which, in subsequent paintings, Gifford would heighten as he intensified the chromatic key—as, for instance, in his New England subjects, such as *Mansfield Mountain* of 1859 (cat. no. 8), and *The Wilderness* (cat. no. 12) and *Early October in the White Mountains* (cat. no. 11), both of 1860. Yet, with the almost too harmonious converging perspectives of curving cliffs, tree, shore, and architecture, *La Marina Grande, Capri,* unlike its immediate precedents, not only recalls the fanciful and nostalgic views by Turner but even the allegorical pictures of Thomas Cole and Asher B. Durand (see fig. 6).[6] The lyrical accent provided by the Italian pine tree was not forgotten by Gifford when, in the following year, he chose to place a white birch in the foreground of *A Gorge in the Mountains* and in several related studies (see cat. nos. 21, 23, 24). Also, in *La Marina Grande, Capri,* Gifford tentatively introduced a motif that he effectively would recycle in subsequent water scenes—a broken arch of cloud puffs—for example, in such late pictures as *Fire Island Beach* (cat. no. 63) and *Sunset Over the Palisades on the Hudson* (cat. no. 69).

Ledyard Lincklaen, an heir to agents of the Holland Land Company, who settled in Cazenovia, New York, in the early nineteenth century, commissioned *La Marina Grande, Capri,* from Gifford as a gift to his wife, to adorn their ancestral home.[7] Ledyard also must have specifically requested the autograph note from Gifford in which the artist—erroneously, or for Mrs. Lincklaen's benefit—located the "Baths of Tiberius" within the setting depicted, "on the extremity of the promontory at the further end of the beach . . . although they make no

figure in the picture." With what sounds like both sincerity and ingratiation, he added, "I can truly say I regard [the painting] as one of the best I have ever painted in purity of color and quality of light."[8]

Executed five years after Gifford's second trip abroad, *Near Palermo* reads like a revision of *La Marina Grande, Capri*, adhering closely to a specific locality.[9] In this case, it is the view west toward Palermo and the mountains encircling the fertile plain called the "Conca d'Oro" (or "golden shell"), from a slight elevation on the coastal road between the city and Bagheria, a town about 7½ miles east. Regrettably, Gifford's European diary, recorded in the form of his letters home, lacks the pages corresponding to the sketchbook images of his explorations around Palermo between September 20 and 26, 1868. Still, a full-page drawing (see fig. 76) made about September 22 or 23 includes all of the major and most of the minor features of the painting: the opaque planes of blue water and the off-white road divided by a strip of rocky, seaweed-covered shore; the wayside buildings; the fishermen and their boats— even the patches of their "white cloths," which, the artist noted on the drawing, were stretched upon the shore—the travelers and their carriages on the road, and the Lilliputian domes and towers of Palermo's skyline, silhouetted against the towering, ragged mountain range of the Conca d'Oro. The acute shadows cast by the figures and the houses indicate a high, late-morning Mediterranean sun already blazing over the scene.

An undated work, *The Road by the Sea, near Palermo, Sicily, a Sketch*, assumed to have been executed in 1868 while Gifford was abroad, is listed in the *Memorial Catalogue* but is not known today.[10] His refinement of the drawing, through the stages of a surviving 8 x 15-inch oil study dated 1873 and the present picture, consisted of the customary slight scaling down of the relative size of the figures and of such features as the city's skyline and the mountain range in the distance, so as to create an overall effect that is more horizontal than that of the initial sketch. Most significant, however, is the vivid rendering of the blanching Mediterranean sunlight and the

simmering atmosphere, achieved by means of the darkening of the shadows in the foreground and the ultimate unification of the pervasive tonality in the two oils: From oil study to final painting, Gifford lightened both the road and the background mountains so that the latter are now nearly indistinguishable from the sky. The bright reflected light of the road on the shadowed wall of the foreground building is particularly effective in conveying the Saharan daytime heat in Sicily, situated just a few hundred miles north of Africa's northern coast. Indeed, it seems possible that the artist's subsequent sojourn in the Middle and Near East informed his recollections of Sicily, when he decided to translate his drawing into color on canvas; for example, in the same year, 1874, Gifford painted *Siout, Egypt* (cat. no. 49). On the other hand, Gifford's own upstate New York region was a regular reference point of comparison or contrast wherever he traveled. Only days before arriving in Palermo, in the vicinity of Mount Etna, Gifford was affected by a letter he had just received from his brother-in-law Robert Wilkenson: "[It] made my heart yearn, as it often does, for those dear old mountains [the Catskills]."[11] Departing from Palermo by boat, he observed not only that in the "beautiful afternoon . . . the mountains which half encircle Palermo and the plain [*sic*] of the 'Conca d'Oro' never looked more beautiful than they did when we steamed away from them" but that "the Mediterranean was as tranquil as the Hudson."[12] These words serve to remind us that such homegrown subjects as that captured in Gifford's *South Bay, on the Hudson, near Hudson, New York* (cat. no. 35), undoubtedly stimulated the artist's interest in the Sicilian prospect, which he rapidly jotted down in his sketchbook in September 1868.

By 1876, when Gifford submitted *Near Palermo* to the annual exhibition at the National Academy of Design, it had become the property of his favorite sister, Mary. The effect of the blinding glare of the midday sun and the intense heat, exceptional even for Gifford, did not divert reviewers of the exhibition, although it did provoke one critic to insist—not quite accurately, however—that "Gifford never sees a landscape's rose-tint, but rather

golden-toned; but what delicious depths, mystery, sentiment, and feeling in his yellow mists!"[13]

<div align="right">K J A</div>

1. Weiss 1987, pp. 74, 76–77.
2. Letter from Sanford Robinson Gifford to his father, Elihu Gifford, in Gifford, European Letters, vol. 2, June 25, 1857, pp. 158–59.
3. The portraits of Bierstadt are in Gifford's 1856–58 sketchbook (Harvard University Art Museums, Cambridge, Massachusetts), and on microfilm (Archives of American Art, Reel 688, frames 266–275 [Capri]); see also the illustrations in Weiss 1987, p. 78.
4. Gifford's *La Marina Grande, Capri* (1857; Private collection), and *La Marina Grande, near Sorrento* (1857; Museum of Fine Arts, Boston), and Bierstadt's *On the Beach at Capri* (1857; Wadsworth Atheneum, Museum of Art, Hartford) and *Fishing Boats at Capri* (June 14, 1857; Museum of Fine Arts, Boston) are illustrated in Weiss 1987, pp. 200, 201, 202.
5. *Memorial Catalogue*, p. 23, no. 229.
6. Besides figure 6, see Cole's *Study for the Pilgrim of the World on His Journey* (about 1846–47; Albany Institute of History and Art, New York), illustrated in Parry 1988, p. 356.
7. "Guide to the Ledyard Family Papers: Biographical Note," Division of Rare and Manuscript Collections, Cornell University Library, cached at {http://www.rmc.library.cornell.edu/EAD/htmldocs/RMM01912.html}; and Daniel H. Weiskotten, "Biography of Jonathan Denise Ledyard (1793 to 1874); Obituary from the *Cazenovia Republican*, January 22, 1874; and Biography from Smith's 1880 *History of Chenango and Madison Counties*," cached at {http://www.rootsweb.com/~nyccazen/Biographies/LedyardJDSr.html}, April 1, 2003.
8. Letter from Sanford Robinson Gifford to Mrs. Ledyard Lincklaen, April 22, 1861; quoted in Weiss 1968/1977, p. 172.
9. For a discussion of the painting see Weiss 1987, pp. 118, 295–97, and Weiss 1977, p. 98. One of the oil studies is discussed in Weiss 1968/1977, pp. 312–13.
10. *Memorial Catalogue*, p. 36, no. 511.
11. Letter from Sanford Robinson Gifford to his father, Elihu Gifford, Palermo, September 20, 1868, in Gifford, European Letters, vol. 3, p. 40.
12. Letter from Sanford Robinson Gifford to his father, Elihu Gifford, Rome, October 7, 1868, in Gifford, European Letters, vol. 3, p. 44.
13. "The National Academy of Design. (Second Notice.)," *The Art Journal* (New York) 2 (1876), p. 190.

A Sketch on the Huntington River, Vermont, about 1861

Oil on canvas, mounted on wood, 14⅞ x 11 in. (37.8 x 27.9 cm)
Estate stamp, on the verso of the original canvas: S.R. Gifford
Sale
Probably MC 147, "A Sketch on the Huntington River, Vermont. Not dated. Size, 14 x 10. Owned by the Estate."
Collection Andrew and Denise Saul, Katonah, New York

No known drawings illuminate the important group of paintings that resulted from Gifford's sketching campaign with fellow landscape painter Richard Hubbard through northeastern Pennsylvania, lower New York State, Vermont, and New Hampshire in July and August 1858.[1] It was the artist's first American excursion after his return from a two-year sojourn in Europe. The group of pictures includes at least three views of Mount Mansfield (see cat. nos. 8–10), Gifford's first "chief picture" of an American subject, as well as *A Sketch on the Huntington River, Vermont,* which most likely may be identified with an undated painting listed in the *Memorial Catalogue* as "A Sketch on the Huntington River, Vermont. Size, 14 x 10."[2]

A Sketch on the Huntington River, Vermont possesses the hallmarks of a picture that was begun on site. It is painted with a density of detail in the foreground remarkable for Gifford, save when he sketched outdoors, and the naturalistic daylight in the background appears unmodified by the "poetic" sunset or twilight effects that the artist was apt to impose on finished compositions and studies for them. It may be significant that there is no record that the painting was ever exhibited, and it remained in Gifford's possession until his death;[3] however, although Gifford often dated *plein air* sketches, specifying not only the year but the month and frequently even the day, he did not date this painting.

In the naturalism of its conception and in its vertical format *A Sketch on the Huntington Riverr, Vermont* seems indebted to the compositions of forest interiors by Asher B. Durand, such as *In the Woods* (fig. 77), which that artist had adapted from his far fresher *plein air* oils. Yet, Gifford's tall, narrow, straighter, and more prosaic tree trunks, illuminated by the raking sunlight, and the wider opening into the background, are even closer in spirit to the few known paintings of the American artist and critic and Ruskin disciple William Stillman.[4] It is precisely this kind of vertical woodland composition that Gifford's friend Worthington Whittredge also essayed immediately upon his arrival home from Europe in 1860.[5]

While the pictorial type of *A Sketch on the Huntington River, Vermont* is virtually unique in Gifford's oeuvre, it may be interpreted alternatively as a prototype of a composition that became quite familiar in his later work: the vignette, well exemplified here by *Hook Mountain on the Hudson River* (cat. no. 43) and *Kauterskill Falls* (cat. no. 52). Gifford had experimented with this arrangement at least

Figure 77. Asher B. Durand. *In the Woods*, 1855. Oil on canvas. The Metropolitan Museum of Art, New York. Gift in memory of Jonathan Sturges by his children, 1895

once, prior to *A Sketch on the Huntington River, Vermont* in two paintings (both, Private collection) of Genoa's Riviera di Ponente, painted in 1856 and 1857, respectively.[6] In *A Sketch on the Huntington River, Vermont,* however, Gifford clearly resisted the arch-like bowing of the trees characteristic of the compositional type exemplified by the vignette in response to what, indeed, may have been an authentic "outdoor studio" exercise, only to revisit the more picturesque mode in his post-Civil War paintings.

Strengthening the interpretation of this painting as a vignette is the artist's deliberate framing of a natural landmark with trees—as in *Hook Mountain on the Hudson River* and *Kauterskill Falls*—only here it is Camels Hump, the lofty and distinctive peak of Vermont's Green Mountains just twenty-five miles south of Mount Mansfield, with the Huntington River, a tributary of the Winooski, below it. Each mountain offers spectacular views west to Lake Champlain and New York's Adirondack Mountains and east to New Hampshire's White Mountains. Hotel accommodations were available on both summits by the late 1850s, but ready access to Mansfield's higher perch was a novelty in 1858 when Gifford and his party arrived in the region.[7] His paintings do not reflect the ascent of Camels Hump, and that peak may be portrayed in just one other of Gifford's works: his *A Lake Twilight* (cat. no. 14), dating to the same period.　　KJA

1. Weiss 1987, pp. 85–86. The group of paintings resulting from this expedition probably includes the following numbers in the *Memorial Catalogue:* 129–152, 156, 157, 161, 163, 164, 172, 173, 175, 176, 181–185, 194–196, 201, 202.
2. *Memorial Catalogue,* p. 20, no. 147.
3. Ibid.: "Owned by the Estate."
4. The paintings by Durand and Stillman are discussed and illustrated in Howat et al. 1987, pp. 113–15. For the Durand see also American Paintings in MMA 1 1994, pp. 424–28; for the Stillman see Ferber and Gerdts 1985, pp. 277–78.
5. See, for example, Whittredge's *Study of West Point* (1860; Whereabouts unknown), illustrated in Janson 1989, p. 74, fig. 49.
6. The larger known version of the subject (Private collection) is illustrated in Weiss 1987, p. 193.
7. The views from Camels Hump and Mount Mansfield are touted, and the access to them described, in Z[adock]. Thompson, *Northern Guide: Lake George . . .* (Burlington, Vermont: S. B. Nichols, 1854); a summary history of the hotels on their summits is given in W. Storrs Lee, *The Green Mountains of Vermont* (New York: Henry Holt and Company, 1955), pp. 204–10.

Cat. 18

Cat. 19

19

A Mist Rising at Sunset in the Catskills,
about 1861

Oil on canvas, 6¾ x 9½ in. (17.1 x 24.1 cm)
MC 191, "A Mist Rising at Sunset in the Catskills. Not dated.
Size, 6½ x 8. Owned by the Estate."
The Art Institute of Chicago. Gift of Jamee J. and Marshall
Field (1988.217)

20

In the Catskills (A Catskill Study), 1861

Oil on canvas, 14¼ x 24 in. (36.2 x 61 cm)
Signed and dated, lower left: S R Gifford / 1861
MC 217, "A Catskill Study. Size, 14 x 24. Sold in 1861 to J. L.
Claghorn, Philadelphia, Pa., and by him through Leavitt &
Co.; present owner unknown."
Exhibited: The Pennsylvania Academy of the Fine Arts,
Philadelphia, "Thirty-Eighth Annual Exhibition," 1861,
no. 528; United States Christian Commission, The
Pennsylvania Academy of the Fine Arts, Philadelphia,
"Exhibition of a Private Collection," 1864, no. 184;
Philadelphia Union League Club, "Third Art Reception,"

October 28–31, 1873, no. 127, as "Autumn in the Catskills."
Private collection

Considered together, these two paintings offer revealing
information concerning the differences in size, degree
of finish, and compositional complexity of works that
Gifford designated "sketches" and "studies" to distin-
guish them from his more fully realized large-scale pic-
tures. Although not dated, the small sketch may have
been produced in September 1861 when Gifford visited
Lake Mohonk in the Shawangunk Mountains with his
friends and fellow artists Jervis McEntee, Worthington
Whittredge, and John White.[1] McEntee painted a very

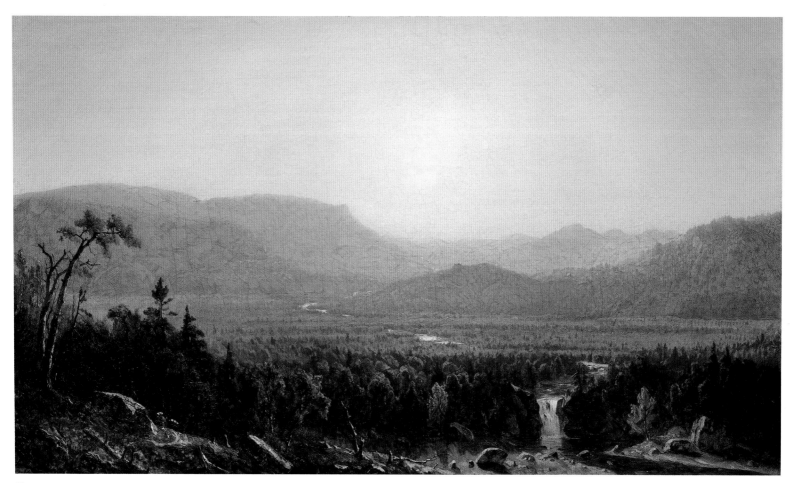

Cat. 20

similar but larger picture (Private collection, New York), suggesting that he and Gifford actually may have been working together or, at the least, closely influencing one another's efforts.[2]

Whatever the case, this is a particularly fine example of Gifford's oil sketches: freely, yet surely painted; beautifully colored; and very likely executed *en plein air*. Even if it was a product of the studio—and Gifford often produced small oil sketches based on pencil drawings made in the field—its sense of fresh immediacy certainly was intended by the artist to give it the feel of an open-air work.[3]

In the Catskills, by contrast, is too substantial and too carefully composed and painted to have been done out

of doors. The view is to the west toward the Catskill Mountains and across the Kiskatom Flats from a vantage point just south of the town of Catskill.[4] The centrally located late-afternoon sun bathes the scene in shimmering light, and the brown-gold tonality of the landscape conveys a feeling of autumn. Gifford's handling of paint, although looser and seemingly more spontaneous in comparison to that seen in larger works from the same year (compare, for example, *A Twilight in the Catskills,* fig. 12), is nevertheless more deliberately controlled and less assertive than in *A Mist Rising at Sunset in the Catskills*. In the smaller sketch, the brushwork draws attention to the existence of the paint itself as much as it describes the forms portrayed; *In the Catskills*

reveals a handling of paint that is more restrained and functions more in the service of pictorial unity.

It is likely that Gifford painted *In the Catskills* with a subsequent larger and even more precisely finished version in mind. However, no such work is known to exist today, nor do contemporary sources, including the *Memorial Catalogue,* record one. Still, Gifford clearly thought well of the picture, for he sent it to represent him in the Thirty-Eighth Annual Exhibition held at The Pennsylvania Academy of the Fine Arts in Philadelphia in 1861.[5] There, it was purchased by James L. Claghorn, an important collector who was then president of the Academy. In 1872, it was admired by a writer for *Lippincott's Magazine,* who observed: "Gifford, in a

Catskill view, depicts dreamily a luscious, lotus-eating land of faëry."[6] When the painting was sold at auction in New York in 1877, yet another writer cited it as evidence that Gifford's early works were superior to those he was then creating: "[It] has a freshness and boldness which his late work sadly wants."[7]

F K

1. See Harvey 1998, pp. 214–15.
2. McEntee's painting is an oil on panel, 17¾ x 23¾ inches, and is illustrated in Harvey 1998, p. 215; as Harvey notes, the terrain represented in McEntee's painting is different from that seen in Gifford's.
3. In his account of Gifford's working methods, Sheldon (1877, p. 284) noted that, "When he sees anything which vividly impresses him, and which he therefore wishes to reproduce, he makes a little sketch of it in pencil on a card about as large as an ordinary visiting-card. . . . The next step is to make a larger sketch, this time in oil, where what has already been done in black-and-white is repeated in colour. To this sketch, which is about twelve inches by eight, he devotes an hour or two."
4. This information was provided to the Spanierman Gallery by Ila Weiss and published in *Twelve American Masterpieces*, exhib. cat., New York, Spanierman Gallery (New York: 1998), pp. 26–30.
5. Ibid., p. 30.
6. "Private Art Collections of Phila. I.—Mr. James L. Claghorn's Gallery," *Lippincott's Magazine* (April 1872), pp. 437, 442; quoted in *Twelve American Masterpieces*, pp. 29–30.
7. "The Claghorn Collection of Paintings," *The New-York Times*, April 14, 1877, p. 3; quoted in *Twelve American Masterpieces*, p. 30.

21

A Gorge in the Mountains (*Kauterskill Clove*), 1862

Oil on canvas, 48 x 39⅞ in. (121.9 x 101.3 cm)
Signed and dated, lower left: S R Gifford / 1862
MC 276, "Kauterskill Falls. Dated 1862. Size, 40 x 48. Owned by Morris K. Jesup."
Exhibited: Studio Building, West Tenth Street, New York, "Artists' Studio Reception," December 1862; Artists' Fund Society, New York, November 1863, no. 86, as "A Gorge in the Mountain"; The Metropolitan Museum of Art and National Academy of Design, New York, "Centennial Loan Exhibition of Paintings," 1876, no. 188, as "Kauterskill Falls"; Century Association, New York, "Gifford Memorial Meeting of the Century," November 1880, no. 29, as "Waterloo Falls."
The Metropolitan Museum of Art, New York. Bequest of Maria DeWitt Jesup, from the collection of her husband, Morris K. Jesup, 1914 (15.30.62)

22

A Sketch in Kauterskill Clove, 1861

Oil on canvas, 13¼ x 11¼ in. (33.7 x 28.6 cm)
Signed and dated, lower left: S R Gifford 1861
Possibly MC 296 [107.], "A Sketch in Kaatskill Clove. Not dated. Size, 12½ x 10. Owned by the Estate."
Collection Family of the Artist

23

Kauterskill Clove, in the Catskills, 1862

Oil on canvas, 9⁹⁄₁₆ x 8½ in. (24.3 x 21.6 cm)
Initialed and dated, lower left: SRG 62
Possibly MC 407, "A Sketch of Kauterskill Clove. Size, 8 x 10. Sold in 1865 to J. P. Waters, and by him to Leavitt & Co.; present owner unknown."; MC 265, "A Small Sketch of Kauterskill Clove. Sold in 1862 to Mr. Halliday."; MC 295 [107.], "A Sketch in Kauterskill Clove. Not dated. Size, 8 x 6½. Owned by the Estate."
Exhibited: Possibly The Metropolitan Museum of Art, New York, "Memorial Exhibition," October 1880–March 1881, no. 107.
Peter and Juliana Terian Collection of American Art

24

Kauterskill Clove, in the Catskills, 1862

Oil on canvas, 12⅞ x 11¹⁄₁₆ in. (32.7 x 28.1 cm)
Signed and dated, lower left: S R Gifford / 1862
MC 264 [18.], "Kauterskill Clove, in the Catskills. Dated 1862. Size, 12½ x 10. Owned by Robert Gordon."
Exhibited: The Metropolitan Museum of Art, New York, "Memorial Exhibition," October 1880–March 1881, no. 18, as "A Mountain Gorge, a study. Robert Gordon Collection."
Collection Jo Ann and Julian Ganz, Jr.

25

Twilight Park (*Kauterskill Clove, from Haines Falls*), about 1860–61

Oil on canvas, 8¾ x 14⅜ in. (22.2 x 36.5 cm)
Signed, on the stretcher: S R Gifford
Inscribed, on the stretcher: Bought by [Julia ?] B. [Wilkinson ?] 1881
Private collection, Seattle

Among the best-known, most admired, and signature paintings in Gifford's oeuvre was one called, until recently, *Kauterskill Clove* (cat. no. 21). That the subject is an idealization of the clove in the eastern Catskill Mountains that Gifford so often visited and so variously represented is indisputable, but as early as 1876, before Gifford's death, the painting's owner, Morris K. Jesup, appears to have referred to it as *Kauterskill Falls*.[1] The title changed to *Kauterskill Clove* by the time the picture was acquired by the Metropolitan Museum in 1915, as a bequest from Jesup's widow.[2] The earlier name indicated a confusion with the subject of catalogue number 52, which depicts the cascade located in a cleft in the north side of Kaaterskill Clove and is not visible in the present picture. The cascade portrayed in catalogue numbers 21–25 is Haines Falls, at the western terminus of Kaaterskill Clove. Twice in the twentieth century the title of the painting was changed to reflect the actual site represented,[3] and seemed to have been confirmed by a contemporary

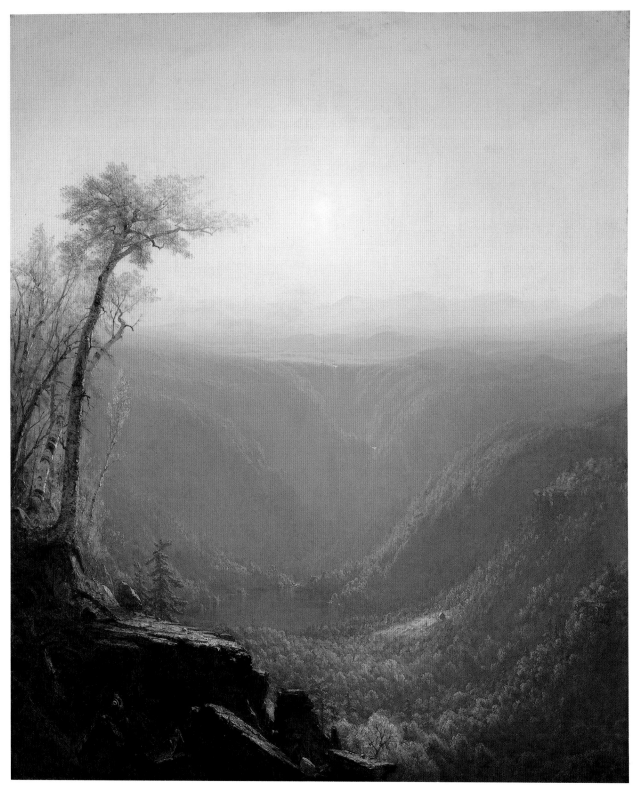

Cat. 21

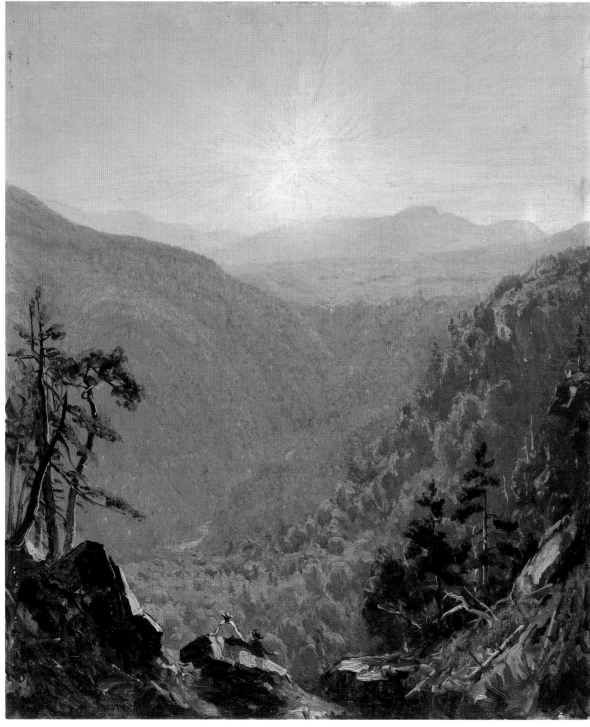

Cat. 22

newspaper review of an unlocated Gifford painting dated 1863 called *Kauterskill Clove,* which was acquired that year by a Baltimore collector named D. Willis James.[4] Exhibited at the National Academy of Design in April 1863, *Kauterskill Clove* was discussed in terms that strongly suggested it was little more than a replica of the painting owned by Jesup;[5] there was no evidence, on the other hand, that catalogue number 21 was exhibited before 1876.

However, Gerald L. Carr has uncovered just such evidence: an article about Gifford published in the *New York Leader* in December 1862 that not only describes unmistakably the features of catalogue number 21 but reveals its original title, *A Gorge in the Mountains.*[6] Moreover, other descriptions of the 1863 painting *Kauterskill Clove,* and of its formulation, also unearthed by Carr, have helped identify two studies for the painting that distinguish it as an independent rendering of the site represented in *A Gorge in the Mountains.* Both the new documentation and the recent discoveries of a previously unlocated painting show that in the space of three years Gifford produced as many major and distinct interpretations of Kaaterskill Clove.

Of course, as the titles in the Gifford *Memorial Catalogue* attest, Gifford's most frequently painted subject was Kaaterskill (or Kauterskill, Kaatskill, or Catskill) Clove; it was not often represented by other artists. Thomas Cole, in 1827, and Asher B. Durand, in 1849 and 1866, essayed depictions of the clove, but Cole's 1827 picture (New Britain Museum of American Art, Connecticut) and Durand's canvas of 1866 (Century Association, New York) portrayed the site from the west, opening out into the Hudson River Valley. Durand's 1849 *Kindred Spirits* (New York Public Library) shows a generic Catskill gorge that resists ready identification. In a small picture (cat. no. 25), Gifford is known, only once, to have depicted the gorge from the west, but in *A Gorge in the Mountains* he seems to have originated the view in the opposing direction, toward Haines Falls, from a lofty, indeterminate perch.

Gifford's most intense engagement with the subject of the clove occurred just before, and between, his first two tours of duty with the National Guard during the

Civil War.[7] Sheer constraints of time and circumstance may have discouraged wider traveling to sketch, but, in addition, the Catskills were near Gifford's family home in Hudson, New York, where he regularly returned for visits. Moreover, his affection for the clove may well have been nourished, in turn, by his recurring aesthetic involvement with the site. Months before he executed *A Gorge in the Mountains* and *Baltimore, 1862—Twilight* (fig. 32)—a Civil War twilight scene with a silhouetted sentry, which was exhibited with the Metropolitan Museum's picture in Gifford's Tenth Street studio in February 1863[8]—the artist wrote from Baltimore to friends in New York in appreciation, and with a measure of envy, for their descriptions of trips in the Catskills. He declared that reading their accounts was "almost like being there myself—they somehow make me think I have a right to be there . . . climbing with you . . . among the cloves of the Catskills, but when under the hallucination I go to the gate of the Fort and am rudely roused from my dreams by the sentry sharply bringing his musket to 'arms port'! and an abrupt 'Halt'!—'Your pass'! . . . I find myself obliged to right-about, and limit my walk to the round of the parapet, or mingle again with the busy-idle crowd in the quarters."[9]

A Gorge in the Mountains and *Kauterskill Clove,* along with the numerous sketches and studies for them, make an apt foil for the artist's characterization of himself as under a kind of hypnotic trance induced by yearnings for "the cloves of the Catskills." Collectively, these works and the similarly composed and illumined pictures of Kaaterskill Clove of subsequent years—extending up to the time of Gifford's death in 1880—represent a curious revision, even the antithesis, of Gifford's first major treatment of the clove, the recently rediscovered *A Twilight in the Catskills* (fig. 12), which he exhibited to such effect and acclaim at the National Academy of Design in 1861.[10] Not only did the artist return, in the latter pictures, to the warm, spatial, and atmospheric style with which he had made his mark as early as the exhibition of *Lake Nemi* (cat. no. 6) in 1858 but he also reprised the vision that had characterized his first major picture with an American subject, *Mansfield Mountain* (cat. no. 8).[11]

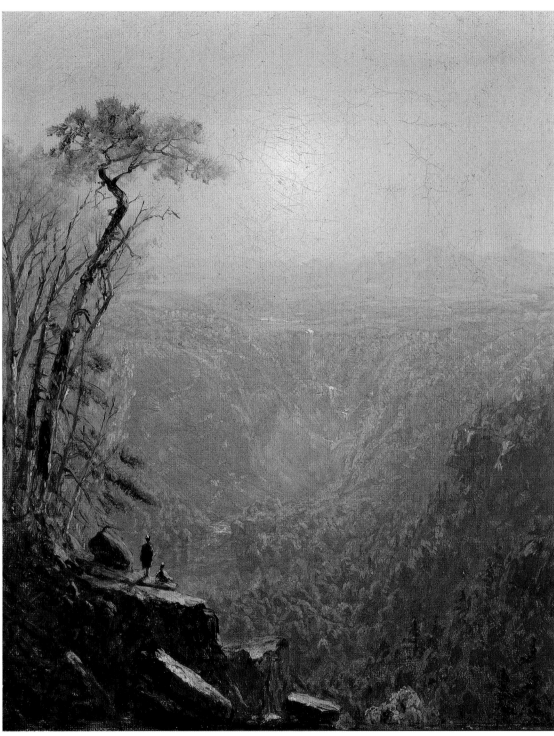

Cat. 23

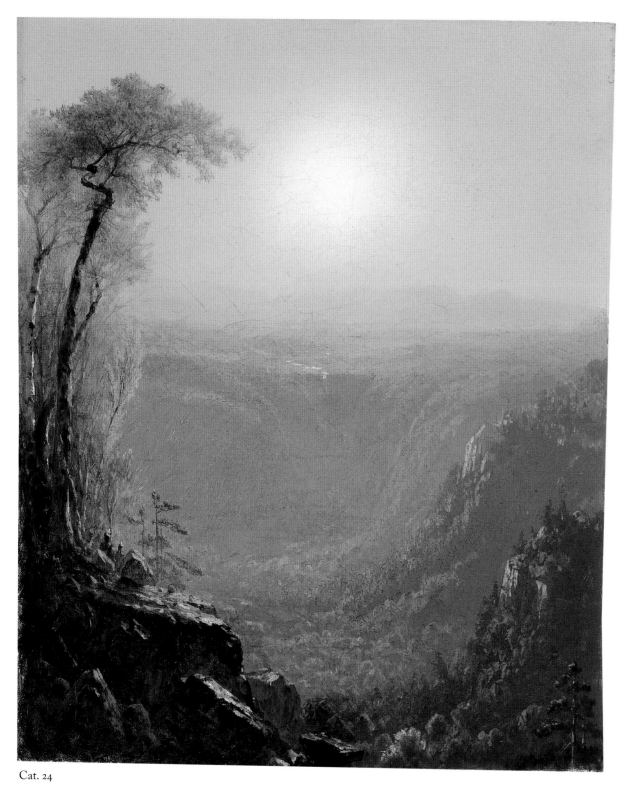

Cat. 24

The formulation of *A Gorge in the Mountains* is an ideal study in the transformative and distilling idealization central to Gifford's art in particular and to Hudson River School painting in general. As early as the summer of 1860, Gifford and his fellow painters Worthington Whittredge and Jervis McEntee boarded with a farm family named Brockett (see fig. 27, 28), in the clove.[12] On July 31, the artist sketched the forested chasm, from the south wall looking west to Haines Falls, in a horizontal format (see fig. 78) that is reflected in the twilight picture of 1861 (see fig. 12). The initial sketch of the clove to the east, from Haines Falls, and two "postage-stamp" compositions (see fig. 79), one square and one horizontal, based on the sketch, were recorded on a single sheet during this 1860 campaign. *Twilight Park* (*Kauterskill Clove, from Haines Falls*) (cat. no. 25), the small painting that follows Cole's formula, corresponds to the horizontal drawing. This painting and the related sketches may explain the appearance, in the foreground of *A Twilight in the Catskills,* of a waterfall where there is not one in reality. The artist simply may have conflated the foreground, including Haines Falls from the east view (see cat. no. 25), with the western prospect (see fig. 78) into a twilight scene.[13] Whatever the case, the 1860 sketching campaign resulted in horizontal paintings.

The following summer, again with Whittredge and McEntee, Gifford continued to sketch in the clove, working chiefly from the north rim looking west (see fig. 80). He began experimenting with vertical-format views taken from, or near, a ledge formerly called Sunset Rock, and today known as Inspiration Point, on or about August 15.[14] In addition, he began to compose a prospect of the pubis-like cavity of Haines Falls framed by foreground trees (see fig. 81), including one with overarching limbs that forecasts the design of *A Gorge in the Mountains.* In the earliest known oil sketch related to the Metropolitan Museum's picture (see cat. no. 22), the artist explored the idea of the clove not as a mountain cleft but as a hollow: The relatively occluded gorge in the pencil sketch was opened up in the oil study by

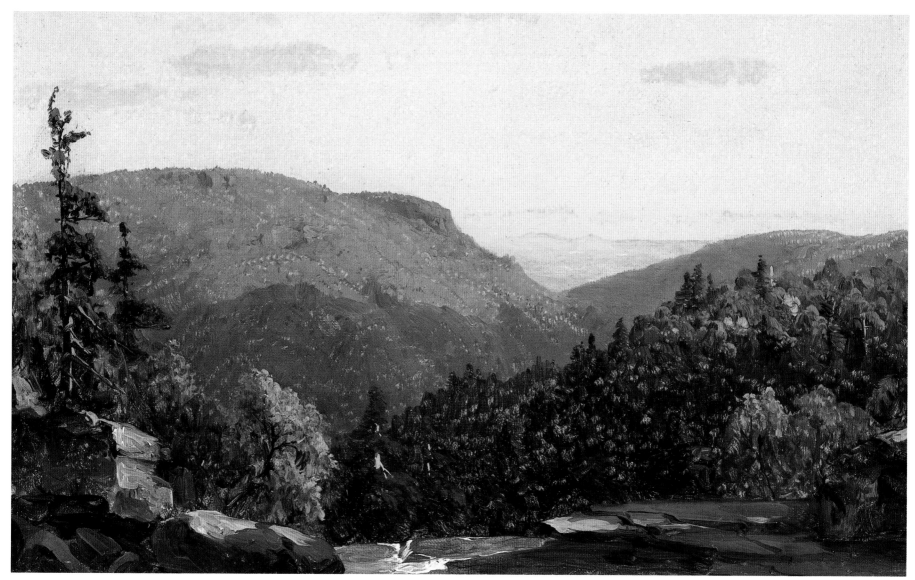

Cat. 25

Figure 78. Sanford R. Gifford. *"Kauterskill Clove July 31ˢᵗ"* (from the sketchbook of Maryland, Virginia, and New York subjects, 1860). Graphite and gouache on off-white wove paper (now darkened). Fogg Art Museum, Harvard University Art Museums, Cambridge, Massachusetts. Gift of Sanford Gifford, M.D.

Figure 80. Sanford R. Gifford. *"Kauterskill Clove July 31ˢᵗ, 1861"* (from the sketchbook of New York subjects, 1860–63). Graphite on buff wove paper. Fogg Art Museum, Harvard University Art Museums, Cambridge, Massachusetts. Gift of Sanford Gifford, M.D.

Figure 79. Sanford R. Gifford. *Kaaterskill Clove from Haines Falls: Three Sketches* (from the sketchbook of Maryland, Virginia, and New York subjects, 1860). Graphite on off-white wove paper (now darkened). Fogg Art Museum, Harvard University Art Museums, Cambridge, Massachusetts. Gift of Sanford Gifford, M.D.

diminishing the size and presence of the surrounding trees. Gifford also began to develop the foreground as a semicircle to echo the draping walls of the clove, perhaps even to accord with the shape of the sun, which he introduced into the composition for the first time. In the initial oil study, too, the artist already tended toward a central point of view, hovering somewhere between the north and south walls of the gorge. In one way, this deliberate ambiguity had a basis in experience: The rocks in the oil study originated in the shapes of those he quickly recorded on the left in another 1861 sketch of the clove, looking in the opposing direction—east—toward the Hudson River Valley (see fig. 82).

In the two oil studies that followed (see cat. nos. 23, 24), all of the essentials of the final composition were established. Gifford revised the foreground yet again by further strengthening the arboreal *repoussoir*: a birch tree with a crooked top that seems to leap up and outward toward the sun, rising from a fortified rocky platform occupied by two figures of Indians. In the background, the hilly, sloping plain surrounding Haines Falls flattens out, reminiscent in its golden tonality and radiant disklike sun, of the central plain in Frederic Church's renowned 1855 painting *The Andes of Ecuador* (fig. 83). In the smaller and presumably earlier study (see cat. no. 23), the new refinements were rapidly executed: The artist managed effects of distant gilded foliage using the bristles of a dry brush to remove pigment, thus partly exposing the beige ground and producing an illusion of gray-green haze. In the later study (cat. no. 24)—and the finished painting—the same areas of shadow in the clove were articulated with muted violet glazes, and

three minor if telling enhancements occur. As in the final painting, the artist modeled the projecting ledges at the right more clearly into concentric quarter rings, and, in so doing, developed the conceptual role of the terrain in expressing the sun's radiating light. The plain in the background becomes flatter, and the Indians are partially concealed by rocks on the foreground ledge. With this alteration, the artist seems a step closer toward his decision, apparent in the Metropolitan Museum's painting, to eliminate the figures altogether from the rock—if not from the foreground.

In the large version of the composition, several of the essentials noted in the study were further adjusted. Most significantly, the foreground tree was reconsidered yet again—reduced in size and simplified so as not to rival the sun's primacy and to align better with the implied arc of its light. The defining role that the sun ultimately assumed in the painting was made more explicit by the introduction of rays streaming through the forest and flanking the waterfall, whose function as a focal point is heightened—metaphysically—as the axis of the beams branching out around it. Gifford multiplied and softened the ledges of the clove, creating a more calculated perspective toward Haines Falls, thus amplifying the bowl-like space on a large scale that could now accommodate the addition of a lake and a cabin at the base of the gorge.

Figure 81. Sanford R. Gifford. *Kaaterskill Clove to the West* (from a sketchbook inscribed "7th Reg. & Catskills, 61," 1861–62). Graphite. Albany Institute of History and Art, New York. Gift of Marian Gifford Johnson Shaw (Mrs. William F. Shaw) and Mrs. George G. Cummings

Figure 82. Sanford R. Gifford. *Kaaterskill Clove to the East* (from a sketchbook inscribed "7th Reg. & Catskills, 61," 1861–62). Graphite. Albany Institute of History and Art, New York. Gift of Marian Gifford Johnson Shaw (Mrs. William F. Shaw) and Mrs. George G. Cummings

Figure 83. Frederic Edwin Church. *The Andes of Ecuador*, 1855. Oil on canvas. Reynolda House, Museum of American Art, Winston-Salem, North Carolina

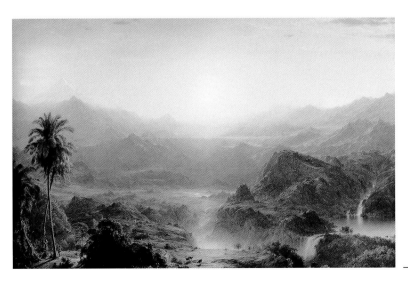

Perhaps the most curious change in the large painting is the apparent absence of staffage—the Indians and backwoodsmen found in the artist's paintings to date, and afterward—as if the light epiphany he formulated so deliberately had become too rarified for a human audience. Yet, contemplation of the picture reveals the figures (now partially abraded) of a hunter and his dog clambering to the top of the platform (see p. 24). The pairing of a hunter and a dog was prefigured in the artist's *Mansfield Mountain* of 1859 (cat. no. 8). However, there, the figures are silhouetted conspicuously in the foreground in a conventional manner. The reasons underlying Gifford's decision to include—yet to suppress—such figures in the foreground of *A Gorge in the Mountains* only can be surmised. Surely, the human figure, relative to the radiant spectacle beyond, creates an expectation in the viewer, even a slight element of suspense, for what the hunter *will* see when he reaches the platform. The conceit contributes a delayed frisson to our admiration of the painting's general effect.

Furthermore, despite the presence of the hunter and the dog in *Mansfield Mountain,* their inclusion in the Kaaterskill Clove setting evokes for students and devotees of Washington Irving (one of Gifford's favorite authors) his most famous character, Rip Van Winkle, and his faithful dog, Wolf.[15] In Irving's canonical tale, Wolf accompanied Rip on the fateful day on which he would begin his twenty-year nap at sunset on a knoll overlooking "a deep mountain glen" in the Catskills, later popularly assumed to be Kaaterskill Clove.[16] Indeed, the pose of Gifford's dog (see p. 24)—odd, because it is descending as its master ascends—is virtually identical to that of the wizened Wolf growling suspiciously at the long absent Rip in one of Felix O. C. Darley's 1848 illustrations for "Rip Van Winkle" (see fig. 84). To be sure, Gifford's light-rimmed gorge is the stuff of dreams, consonant with the associations his figures awaken in us.

The formulation of *A Gorge in the Mountains* may have taken many months. As early as March 1862, Gifford showed what was probably one of the studies

for the picture (see cat. nos. 22–24) at the Dodworth Studio Building but, contrary to the expectations of a contemporary reporter, did not exhibit catalogue number 21 at the National Academy of Design that April. During the summer of 1862, Gifford served his second tour of duty in Maryland with the Seventh Regiment of New York, spent time sketching again late in the season, and in the autumn had produced a study for a new clove picture. A critic described this view of the gorge as "darkened here and there by the fleeting shadow of a moving cloud" but illuminated by "caressing sunlight that slants down." Gifford developed the study and at least one other (see fig. 85) into the *Kauterskill Clove* (Whereabouts unknown), which he exhibited at the Academy the following year. Critics described that picture as "a ravine wrapped in a passing rain cloud, with the sun breaking through the half-obscuring mist to illumine one side with an almost royal radiance," and noted the presence of a bear in the foreground.[17] Those features correspond precisely with their counterparts in figure 85. Presumably, then, completion of *A Gorge in the Mountains,* shown at the Artists' Studio Reception at

Figure 84. Felix O. C. Darley. Illustration for Washington Irving's "Rip Van Winkle," 1848. Lithograph. The Metropolitan Museum of Art, New York. Gift of Mrs. Frederic F. Durand, 1933

the end of 1862, had been interrupted by work on the preparatory stages of the 1863 painting.

At the initial showing of *A Gorge in the Mountains* (cat. no. 21), the *New York Leader*'s critic Robert Barry Coffin, writing under the pseudonym Barry Gray, hailed it as Gifford's "greatest work of art" to date. He specifically mentioned the upright format, exact dimensions, and all of its details at length—the afternoon sun, the waterfall, the lake and cabin at the base of the clove, the "graceful" birch tree—right down to the "figure of a hunter, with dog and gun, clambering up the rugged and steep cliffs in the foreground," which the artist had "very properly made . . . so unobtrusive, blending them, as it were, with the rocks which form their background, that the eye fails at first to perceive them at all." Yet, Coffin kept circling back to the picture's general effect of "color and light" and the "halo of almost supernatural glory" radiated by the sun as the stimulus of sentiments that, in contemplating Gifford's pictures, transcended mere admiration for the artist's representational mastery:

One is apt to forget . . . that it is a picture only that is before him; he no longer sees the scene portrayed; but is borne on memory back to the summer days of long ago, when, as a boy, he stood upon a craggy mountain top, building fair castles among the clouds floating around his feet; or when, as a lover, resting on a grassy knoll, under umbrageous trees, he dreamed of love, and glory, and romance. As sometimes, when listening to a song we fail to hear, or understand, the words, accepting only the music which fills our ears and permeates our being, so, in looking at this artist's pictures, we cease to see that which is before us, and recognize only the sentiment which pervades it. This, to me, is the truest and most satisfactory test of the excellence of any picture.[18]

Eugene Benson of the *New-York Commercial Advertiser,* calling himself Proteus, ratified Coffin's paean to Gifford's aestheticism in terms almost Whitmanesque in their sensuousness: "This picture is a picture of the poet. None more so. And sitting before it, bathed in the affluence and warmth of its light, luxuriating in its color, having our thought steeped in the delicious indolence of

Figure 85. Sanford R. Gifford. *Kauterskill Clove: A Study,* 1862. Oil on canvas. Collection Jamee J. and Marshall Field

its atmosphere, and aroused by the magnificence and wealth of its spirit, we have no care, but, sun-steeped at noon, ask that every pore of our body may become a gate through which sensation may flow, and every nerve an avenue along which may course the subtle messengers charged with the secret of its beauty."[19]

Despite the absence of *A Gorge in the Mountains* from the Academy exhibition in April, its indelible effect on its admirers, as well as its symbiotic relationship, in terms of its subject and formulation, to *Kauterskill Clove,* caused at least one reviewer to mistake the latter picture for the former:

We have heretofore recorded our satisfaction with the audacity shown by Gifford in selecting Kaaterskill gorge for a subject. We see no reason to revise last winter's verdict, now that the picture, plus a few more finishing touches, hangs in the

Academy. The precipitation of one's whole artistic ability and reputation into a chasm several hundred times larger than that which Quintus Curtius stopped for the good of Rome, is a piece of boldness only justified by its success. Gifford has so bathed this vast unrelieved depression in the face of nature with broad yellow sunshine, and interpreted its giant distances by such curiously skilful [sic] gradations of distinctness in its forest lining from ridge to base, that one begins to admire a gorge as he does a mountain—in fact, as the largest kind of mountain turned inside out.[20]

The ambiguity regarding the two pictures persisted, and the literature suggests that the memory of the former painting remained more indelible than that of the latter. In 1864, an admirer cited "two remarkable pictures" of the clove by Gifford to salute him as "that rare artist and genuine son of Helios." In his *Book of the Artists* of 1867, Henry T. Tuckerman extolled a "Catskill Clove" by Gifford in words that more readily evoke *A Gorge in the Mountains* than *Kauterskill Clove,* and in the same year a clergyman quoted the *Post* review, which had confused the two pictures, to tout the splendors of Kaaterskill Clove in a Catskill Mountains guidebook.[21] Gifford's interpretations of the subject became the signature ones, for better or worse. In 1870, the critic of *The Nation* invoked Gifford's "Catskill valley . . . of several years ago" to warn younger painters against emulating pictures "in such a tempting way mannered."[22] Nonetheless, as late as the Centennial year, a reviewer of a loan exhibition at the Metropolitan Museum welcomed the inclusion from Morris K. Jesup's collection of a "large and richly toned scene in the Catskills, by S. R. Gifford."[23]

K J A

1. *Centennial Loan Exhibition* 1876, no. 188, p. 21.
2. Burroughs 1915a, p. 22; Burroughs 1915b, pp. 67–68.
3. The Archives of the Department of American Paintings and Sculpture at the Metropolitan Museum indicate that in June 1962 associate curator Albert Ten Eyck Gardner changed the title back to *Kauterskill Falls,* probably on the basis of the reference to the Jesup picture in the *Memorial Catalogue,* where it is listed as number 276. The painting did not officially become *Kauterskill Clove* again until the publication of American Paintings in MMA II 1985, pp. 170–73.
4. NAD Exhibition Record (1861–1900) 1973, vol. 1, no. 15, p. 341.
5. *The New York Evening Post,* May 16, 1863. The review is quoted below in the text.
6. Barry Gray [Robert Barry Coffin], "Gifford, The Artist," *The New York Leader,* December 27, 1862, p. 1. The article is quoted below and in Carr 2003.
7. Weiss 1987, pp. 90–93, 229–31; Myers et al. 1987, pp. 134–35.
8. *The New York Evening Post,* February 5, 1863.
9. Letter from Sanford Robinson Gifford, Mount Clare Station, B. & O. R.R., Baltimore, July 27, 1862, to "My dear friends at Nestledown," in Gifford Family Records and Letters, vol. 1.
10. For a thorough description of this picture and the contemporary response to it see Greenhalgh 2001.
11. *Mansfield Mountain* and *Kauterskill Clove* were compared for their "misty style" by a critic in *The New-York Times,* June 24, 1863; quoted in Weiss 1987, p. 96.
12. Weiss 1987, p. 90; Myers et al. 1987, p. 134.
13. Gifford also may have used an 1860 drawing of Kaaterskill Falls as the model for the waterfall in *A Twilight in the Catskills* (fig. 12), as argued in Greenhalgh 2001.
14. These sketches are in a book of drawings from 1861 (Albany Institute of History and Art, New York; 1966.13.3). See Myers et al. 1987, p. 131, pl. 89, for an 1873 illustration by Harry Fenn of the view from Sunset Rock, which is quite close to Gifford's drawing. The modern identification of Inspiration Point with Sunset Rock can be found at {www.mths.org/landmarks/sunset_rock-south_mountain.html}, August 2, 2002.
15. Weiss (1968/1977, p. xxvii) originally made the association between Irving's tale and Gifford's painting.
16. "Rip Van Winkle," in *The Sketchbook of Geoffrey Crayon, Gent.* [1819–20], in Washington Irving, *History, Tales and Sketches* (New York: Library of America, 1983), pp. 767–85; see especially p. 774.
17. See "Proteus" [Eugene Benson], "Art Intelligence. Recent Works in the Studios of Albany and New York, Piloty's Nero, & Co.," *New-York Commercial Advertiser,* October 29, 1862, p. 1; "Atticus," "Art Feuilleton: Academy of Design Exhibition—No. 2," *The New York Leader,* May 2, 1863, p. 1, and "National Academy of Design. First Gallery," *The World* (New York), April 24, 1863, p. 4; all three are noted in Carr 2003.
18. Barry Gray, "Gifford the Artist," *The New York Leader,* December 27, 1862, p. 1. I am grateful to Gerald L. Carr for providing me with a copy of this review.
19. Benson 1862.
20. *The New York Evening Post,* May 16, 1863.
21. Pychowska 1864, pp. 272–73; quoted in Myers et al. 1987, p. 135. See also Tuckerman 1966, p. 527; Rockwell 1867, pp. 320–21.
22. *The Nation,* June 2, 1870.
23. *The New York Evening Post,* June 19, 1876.

Torre dei Schiavi—Roman Campagna, about 1857–62

Oil on canvas, 8½ x 15¾ in. (21.6 x 40 cm)
Possibly MC 261, "La Torre degli Schiavi, a Sketch. Sold in 1862 to Mr. Halliday."
Exhibited: Possibly Brooklyn Art Association, March 1862, no. 63; possibly The Metropolitan Museum of Art, New York, "Loan Exhibition of Paintings," October 1874, no. 51, as "Torre dei Schiavi."
Currier Museum of Art, Manchester, New Hampshire.
Bequest of Henry Melville Fuller

Like Thomas Cole and many other American artists, Gifford traveled to Europe to enrich his learning and artistic experience. For Gifford, as for many Northern European artists dating back as far as the sixteenth century, the defining destination of the Grand Tour was Italy, and, especially, Rome. He was in Italy for nearly one year of the two he spent in Europe (from June 1855 to September 1857), and for eight months of that time he was based in Rome; it was in Rome that Gifford painted his first "chief picture," *Lake Nemi* (cat. no. 6).[1] Indeed, the slow execution of *Nemi* and a few other works during the winter of 1856–57 may have been the single most significant pretext for the artist's long stay in Rome; it seems all the more remarkable now that Gifford painted so few works with Roman themes: none, in fact, of sites within the city walls, and only two other subjects in addition to Lake Nemi—a Roman aqueduct and the Torre dei Schiavi.

Both monuments were popular tourist attractions in the *Campagna*, the vast, arid plain surrounding Rome, and had been depicted frequently. Cole's large 1832 painting of the aqueduct (Gallery of Art, Washington University, Saint Louis) was one of his better-known works in his day, and even was cited by N. P. Willis in his widely read travel book, *Pencillings by the Way,* first published in 1836.[2] By the 1850s, the Torre dei Schiavi had become, if anything, even more frequented by

artists, especially Americans. Built by the Gordian emperors in the third century A.D., the Torre dei Schiavi comprises a complex of ruins, the most intact of which remains the cylindrical Pantheon-like structure in Gifford's picture. This was the mausoleum of the villa and, probably partly due to its condition and function, is its most represented component. However, several other factors lent an artistic cachet to the site. It had been constructed on gently rising ground that, framed on two sides by distant mountains, endowed its architectural remnants with a stark monumentality and poetic resonance. By the 1830s, the German artists of Rome had made the Torre dei Schiavi the site of their annual Walpurgisnacht carnival, which, by mid-century, was attracting artists and tourists of other nationalities. Moreover, for antebellum Americans, in particular, the very significance of the name of the site, the "Tower of Slaves," may have added topical import to the moral air of fallen empire embodied by the ruin.[3]

On April 20, 1857, in the company of Albert

Bierstadt, Gifford made a drawing of several of the Torre ruins, including the mausoleum as seen from the opposite side.[4] Number 112 in the *Memorial Catalogue* of Gifford's work lists an oil (now lost), of the same date, entitled "A Sketch of Torre degli Schiavi."[5] Again with Bierstadt, in early May, Gifford crossed the *Campagna* en route to the Alban Hills, and on May 7 he drew a small composition of the *Campagna* with a shepherd like the one on the right in the painting.[6] However, no drawing for the painting is now known, and it is possible that the painting, which is undated, was at least begun *en plein air,* and is the same work as number 261, "La Torre degli Schiavi, a Sketch," listed in the *Memorial Catalogue.* Whatever the origins of the present picture and presumably the (now lost) larger version of it dated 1862, Gifford fell back on the conventional aspect of the mausoleum, adopted by artists such as Edward Lear and Gifford's New York colleague Jasper F. Cropsey, showing its punctured side—faintly evocative of a broken skull— backed by the Sabine mountains in the airy distance (see

Figure 86. Jasper F. Cropsey. *Torre dei Schiavi, the Roman Campagna,* 1853. Graphite and gouache, with brown and gray ink wash, on dark buff wove paper. The Metropolitan Museum of Art, New York. Purchase, Charles and Anita Blatt Gift, 1970

Cat. 26

fig. 86).[7] Gifford's interpretation does distinguish itself in a few respects. His Torre is slenderer, more removed from the viewer, and therefore less towering. The artist obscured the roundel windows of the second story that stare sightlessly out of the images by most other artists, and he relegated the building closer to the margins of the picture space. The Sabine range stands higher in relation to the tower and—atypically—is crowned with snow. Gifford actually may not have observed the snow in May, although undoubtedly he had admired it the previous February. He wrote to his father then that, "No snow falls on the Campagna; but the mountains that border it, the Sabine Appenines [*sic*] and often the Alban hills are covered with it. In a fine day they are very beautiful, half lost in the warm atmosphere of the horizon."[8] The inclusion of snow here may have had a formal function, to distribute some of the pallor of the tower's interior wall over the expanse of the picture space. Clearly, the dip in the terrain around the tower, accentuated by the shadows of the clouds on the plain, is calculated to echo the central mountain peak above it, so that the landscape itself assumes an unusual share of pictorial interest. Indeed, with its "bookends" of ruins and a human figure at either side of the composition, this interpretation of an antique subject in conception not only matches the artist's own aqueduct paintings but, remarkably, anticipates the crowning "chief picture" of

Gifford's career, *Ruins of the Parthenon* (cat. no. 70), painted two decades later.[9] In that work, the rear of the Parthenon on one side and the porch of the Erectheum on the other frame a prospect of the Saronic Gulf. As the artist himself said of that painting, it was less a homage to a classical monument than it was "a picture of a day"—surely a fit description also of *Torre dei Schiavi*.[10]

An even wider-angle, 15 x 30-inch work also entitled *Torre dei Schiavi—Roman Campagna* (Whereabouts unknown), which Gifford later included on his list of "chief pictures," was shown at the National Academy of Design in New York in 1862. "Though eminently quiet and subdued in effect," according to the *New-York Times*, the critic regarded it as "one of the most taking pictures in the gallery."[11] Acknowledging the "low broken tower, a shepherd and his sheep" in the foreground, the *Evening Post* reviewer was captivated by the "wide

sweep of flower-decked Campagna, and in the distance blue mountains tipped with snow. The picture is as rich in golden light as a real Italian noon-day."[12]

KJA

1. Gifford's first European journey is described in Weiss 1987, pp. 69–80; for the artist's letters from Europe to his family in Hudson, New York, see Gifford, *European Letters*.
2. Willis's reference to "Cole's picture of the Roman Campagna . . . one of the finest landscapes ever painted," as he admired the aqueduct, is quoted in Kevin J. Avery, "Selling the Sublime and the Beautiful: New York Landscape Painting and Tourism," in Voorsanger and Howat, eds. 2000, pp. 127–28.
3. For the history of the Torre dei Schiavi, artistic representations of it, and its political resonance for pre-Civil War Americans see Eldredge 1987.
4. The sketchbook, inscribed "English Academy, Rome, 1856–1857," is in the collection of the Albany Institute of History and Art, New York (1966.13.5). For Gifford's description of his excursion with Bierstadt see Gifford, *European Letters*, vol. 2, May 2, 1857, pp. 146–47.
5. The full listing is on page 18 of the *Memorial Catalogue*, number 112: "A Sketch of Torre degli Schiavi. Dated April 20th, 1857. Size, 10 x 14. Owned by the Estate."
6. Gifford, *European Letters*, vol. 1, May 2, 1857. The drawing of the shepherd is included in the sketchbook of Italian subjects, of 1856–58 (Harvard University Art Museums, Cambridge, Massachusetts); and on microfilm (Archives of American Art, Reel 688, frame 293). Comparable studies of shepherds leaning on staffs are dated December 28, 1856 (frames 242, 243).
7. For Lear's and Cropsey's pictures see Eldredge 1987, p. 25, fig. 11, p. 26, fig. 12.
8. Letter from Sanford Robinson Gifford to his father, Elihu Gifford, February 5, 1857, in Gifford, *European Letters*, vol. 2, p. 126.
9. Gifford's two known aqueduct paintings, the smaller of which is dated 1859 (The Frances Lehman Loeb Art Center, Vassar College, Poughkeepsie, New York), are illustrated in Weiss 1987, pp. 203–4.
10. *The Art Journal* 1880, p. 319.
11. *The New-York Times*, April 24, 1862.
12. *The New York Evening Post*, April 17, 1862.

27

The Catskill Mountain House, 1862

Oil on canvas, 9 5/16 x 18 1/2 in. (23.7 x 47 cm)
Signed and dated, lower left: S R Gifford '62
Probably MC 278, "The Catskill Mountain House. Size, 9 x 18. Sold in 1862 to William Allen."
Private collection

Gifford spent substantial parts of the summers of 1860 and 1861 in the Catskills on sketching tours that are richly reflected in his paintings of the early Civil War years: principally, in at least three ambitious pictures of Kaaterskill Clove (see cat. no. 21, and see fig. 12, 85).[1] Worthington Whittredge, who was with Gifford during both summers, later recalled that, "The particular part of the Catskills which . . . pleased Gifford best, was the summit, or the region round about the Mountain

House. Upon the edges of the cliffs of North and South Mountains, overlooking the great plain and the Hudson River, how often his feet have stood! The very lichens there remember him."[2] No Gifford painting evokes Whittredge's description better than *The Catskill Mountain House,* in whose broad visual sweep the artist included both North and South Mountain, overlooking the Mountain House at the right and the vast Hudson River Valley at the left. Indeed, the wide-angle inclusiveness is what distinguishes Gifford's version of the subject from virtually all of its many precedents by various artists, especially the well-known interpretations by Thomas Cole (see fig. 87), the founder of the New York school of landscape painting and Gifford's original source of inspiration, and that by his contemporary

Jasper F. Cropsey (1855; The Minneapolis Institute of Art).[3] The views by both of those artists better portrayed the famed hotel itself, the lakes in its backyard, and the foil of the eastern range of the Catskills, but Gifford included—at least in part—the hotel's own chief attraction: the panorama of the valley, over two thousand feet below its front porch. All three artists assumed the approximate vantage point of the so-called "Artist's Rock" north of the Mountain House,[4] but only Gifford, in characteristic fashion, appears to have pulled back somewhat farther, adjusting his perspective to gather in more space—indeed, to establish with his panoramic format an almost literal sight line reaching from the white accent of the figure in the foreground to the Mountain House in the distance, at the center, and

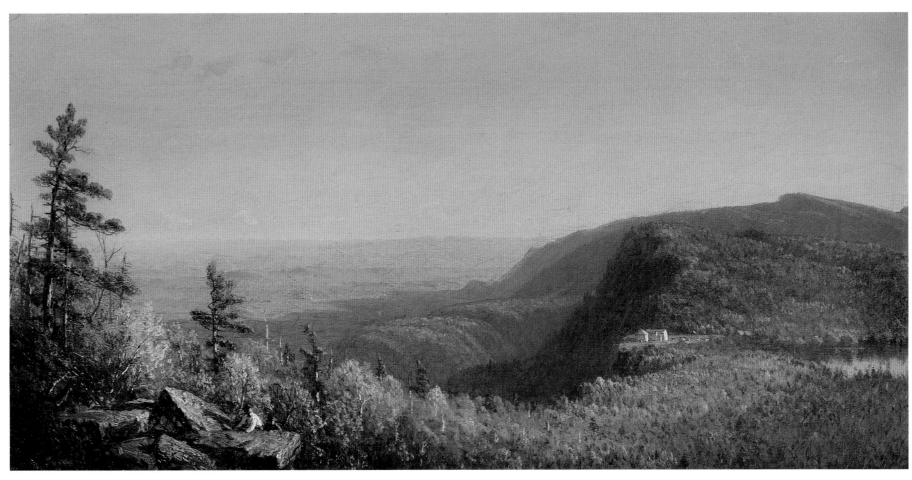

Cat. 27

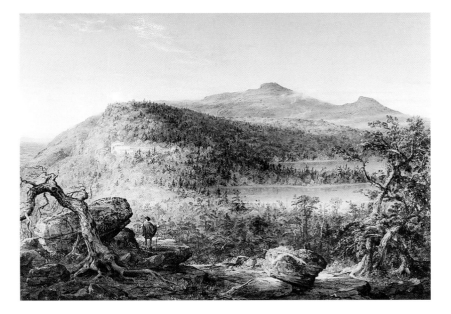

Figure 87. Thomas Cole. *A View of Two Lakes and Mountain House, Catskill Mountains, Morning,* 1844. Oil on canvas. The Brooklyn Museum of Art. Dick S. Ramsey Fund

Figure 88. Sanford R. Gifford. Compositional sketch for *The Catskill Mountain House* (from the sketchbook inscribed "7th Reg. & Catskills, 61," 1861–62). Graphite. Albany Institute of History and Art, New York. Gift of Marian Gifford Johnson Shaw (Mrs. William F. Shaw) and Mrs. George G. Cummings

echoed faintly in the minute pale highlights of the dwellings in the remote valley. This lofty perception most closely approximates that of James Fenimore Cooper's fictional character Natty Bumppo (or Leatherstocking), whose paean to the view from Pine Orchard, the Mountain House site, in the best-selling *The Pioneers* (1823) helped fuel the creation and promotion of the hotel: "'The [Hudson] river was in sight for seventy miles, looking like a curled shaving, under my feet, though it was eight long miles to its banks. I saw the hills in the Hampshire grants, the high lands of the river, and all that God had done or man could do. . . . If being the best part of a mile in the air, and having men's farms and housen at your feet, with rivers looking like ribands, and mountains bigger than the 'Vision,' seeming to be haystacks of green grass under you, gives any satisfaction to a man, I can recommend the spot.'"[5]

Gifford, moreover, opted to represent the scene not at sunrise or even in the morning, as most artists had, up to then, but near sunset, precisely at the time and with the exact light effect about which his friend the travel writer Bayard Taylor had waxed admiringly in an 1860 description of the view from the Mountain House ledge: "It was a quarter of an hour before sunset—perhaps the best moment of the day for the Catskill panorama. The shadows of the mountain-tops reached nearly to the Hudson, while the sun, directly down the [Kaaterskill] Clove, interposed a thin wedge of golden luster between. The farm-houses on a thousand hills beyond the river sparkled in the glow, and the Berkshire Mountains swam in a luminous, rosy mist. The shadows strode eastward at the rate of a league a minute as we gazed."[6]

Interestingly, the presumed position of the sun here, shining directly down the east-west axis of Kaaterskill Clove beyond South Mountain and gilding the forest at the clove's entrance, corresponds precisely to its location in the artist's *A Gorge in the Mountains* (cat. no. 21) of the same year, wherein the viewer stares directly up into the sun's dazzling light.

There was a fitting precedent for the artist to indulge in more space and light in *The Catskill Mountain House* (cat no. 27): his own first "chief picture" with an American subject, *Mansfield Mountain* (cat. no. 8), of 1859. In that work, he had framed the view toward distant Lake Champlain with two of Mansfield's peaks. When he sketched near the Catskill Mountain House in mid-August 1861, he experimented with "postage-stamp" compositions of the view. In two of them the parenthetical motif at the left is chiefly rock, distinctly recalling *Mansfield Mountain*,[7] but in a third pencil composition (see fig. 88) a tall pine tree functions as the principal framing element at the left—the compositional device he selected for the painting. As in *Mansfield Mountain*, Gifford chose the late-day hour, but since the view is to the southeast rather than northwest, the light saturates the terrain instead of dissolving it.

Perhaps because major paintings (see cat. no. 21) of the nearby Kaaterskill Clove occupied so much of his attention and were so well received in the Civil War years, or simply because a larger version was never requested, it appears that Gifford did not develop *The Catskill Mountain House* beyond the relatively modest scale of this picture, which corresponds closely to other finely wrought studies for larger works in his oeuvre,

including a few in the present exhibition. Still, it is quite possible that he did contemplate a more ambitious version. In a sketchbook (The Frances Lehman Loeb Art Center, Vassar College, Poughkeepsie, New York) of 1865–66, Gifford executed a larger and more detailed pencil study of this scene, and also experimented with two compositions of a view of the Mountain House from a point more directly north of it, permitting the horizon of the river valley to extend to the left border of the picture without interruption.[8] He transformed one of those sketches into a small painting (Private collection), but once again, perhaps in deference to his more significant pictorial ideas, the conception apparently never was developed into a larger work.[9]

KJA

1. Weiss 1987, pp. 90, 93, 229–32.
2. *Memorial Meeting*, p. 44.
3. Cropsey's painting, nearly identical to Cole's, is illustrated in Howat et al. 1987, p. 204.
4. The rock is still a landmark on the Escarpment Trail in Catskill State Park. It is cited in "North Lake—South Lake Loop, 10 Mile Escarpment Hike 3," cached at {http://www.ulster.net/~hrmm/catskills/northlake_hike.html}, June 16, 2003, mile 5.1.
5. James Fenimore Cooper, *The Pioneers* (1823), in *The Leatherstocking Tales*, vol. 1 (New York: The Library of America, 1985), pp. 295, 296.
6. Taylor 1860, p. 42.
7. All of the sketches, including the one shown in figure 88, are found in a sketchbook inscribed "7th Reg. & Catskills, 61" and designated volume 5 (Albany Institute of History and Art, New York; 1966.13.3).
8. The studies in this sketchbook (38.14.4; The Frances Lehman Loeb Art Center, Vassar College, Poughkeepsie, New York), which is not inscribed, are dated 1865 and 1866.
9. *A View near the Catskill Mountain House* (about 1865; Private collection) is illustrated in Weiss 1987, p. 233.

A Winter Twilight, 1862

Oil on canvas, 15½ x 30¹⁄₁₆ in. (39.4 x 76.3 cm)
Signed and dated, lower right: S R Gifford 1862
MC 258 [59.], "A Winter Twilight. Dated 1862. Size, 16 x 32.
Owned by L. A. Shattuck, Boston, Mass."
Exhibited: Possibly Brooklyn Art Association, March 1862,
no. 76; National Academy of Design, New York, 1862, no. 421;
possibly Boston Athenaeum, 1864, no. 376, as "Landscape
(owned by L. A. Shattuck)"; The Metropolitan Museum of
Art, New York, "Memorial Exhibition," October 1880–March
1881, no. 59, as "The First Skating of the Season."
Indiana University Art Museum, Bloomington. Morton and
Marie Bradley Memorial Collection

Figure 89. Sanford R. Gifford. *Study of a Pond or a Creek* (from the sketchbook inscribed "7th Reg. & Catskills, 61," 1861–62). Graphite. Albany Institute of History and Art, New York. Gift of Marian Gifford Johnson Shaw (Mrs. William F. Shaw) and Mrs. George G. Cummings

The lovely and understated *A Winter Twilight* must have been rapidly formulated. It originated in sketches that Gifford made in the winter of 1861–62 while—as far as is known—he remained in New York City and vicinity;[1] the finished picture was completed by February 1862 and shown at the National Academy of Design in late April, and possibly at the Brooklyn Art Association a month earlier.[2] Some of the sketches— vertical in format and vignette-like in style—were made along the Bronx River in December 1861, and presumably correspond to four undated (and now unlocated) paintings listed in the *Memorial Catalogue*.[3] Following those sketches, in the same book, is one of a pond or creek bounded by trees and reeds and with a few dwellings in the background (see fig. 89)—apparently the setting on which that of *A Winter Twilight* is based—which precedes two more studies of three men donning ice skates (see fig. 90, 91); these last drawings were used for the three central figures in the painting. That the landscape drawing and the figure studies are connected is suggested by the small, bold vertical pencil strokes on the water in the sketch in approximately the location occupied by the figures in the painting. At least one oil study (now unlocated) for the picture is recorded.[4]

Figure 90. Sanford R. Gifford. Figure studies for *A Winter Twilight* (from the sketchbook inscribed "7th Reg. & Catskills, 61," 1861–62). Graphite. Albany Institute of History and Art, New York. Gift of Marian Gifford Johnson Shaw (Mrs. William F. Shaw) and Mrs. George G. Cummings

The precise setting depicted in the drawing for *A Winter Twilight* is impossible to determine, but the Bronx River studies near it in the sketchbook, as well as a succeeding sketch, evocative of the site shown in the later painting *An Indian Summer's Day on the Hudson—Tappan Zee* (cat. no. 46), suggest that the location is in the area of the lower Hudson River and not, for example, in the vicinity of Gifford's family home in Hudson, New York. The landscape drawing presents virtually no hint of the time of day in which it was made, but the figures were illuminated by a high over-head light slightly to their left—in short, indicative of the full light of day. Given this feature, the economical sketchiness of the landscape elements (echoing the character of the drawing), and the fact that the details of *A Winter Twilight* do not follow very closely those

Figure 91. Sanford R. Gifford. Figure study for *A Winter Twilight* (from the sketchbook inscribed "7th Reg. & Catskills, 61," 1861–62). Graphite. Albany Institute of History and Art, New York. Gift of Marian Gifford Johnson Shaw (Mrs. William F. Shaw) and Mrs. George G. Cummings

Figure 92. George Boughton. *Winter Twilight, near Albany, N. Y.,* 1858. Oil on linen. The New-York Historical Society

The prosaic character of the terrain, its human occupants, and the hibernal subject—a rare departure for Gifford—prompt speculation on the possible influence on the artist of his contemporaries. For example, in 1858, George Boughton, a Tenth Street Studio Building colleague with whom Gifford would tour New England and Nova Scotia in 1859, exhibited *Winter Twilight, near Albany, N.Y.* (fig. 92), a picture with very comparable features and design, to favorable notice at the National Academy of Design.[5] In subsequent years, Boughton repeated that success with such works as *Frosty Morning* and *Frozen Stream* (both, Whereabouts unknown).[6] Another Studio Building neighbor, Louis Rémy Mignot, was also something of a specialist in twilight and winter landscapes. In 1861, Mignot showed two pictures, *Winter Morning* and *Winter Twilight* (both, Whereabouts unknown), in Troy, New York (where Gifford regularly exhibited his

in the drawing, it seems likely that the site was exploited as a simple terrestrial vehicle for the twilight effects that Gifford began to explore in works of the previous year, *A Twilight in the Catskills* (fig. 12) and *A Lake Twilight* (cat. no. 14), and that he would continue to develop in *Baltimore, 1862—Twilight* (fig. 32), and *Hunter Mountain, Twilight* (cat. no. 41), whose sickle moon is prefigured in the present picture.

Figure 93. Louis Rémy Mignot. *Sunset, Winter,* 1862. Oil on canvas. Georgia Museum of Art, University of Georgia, Athens. On extended loan from the West Foundation, Inc., Atlanta

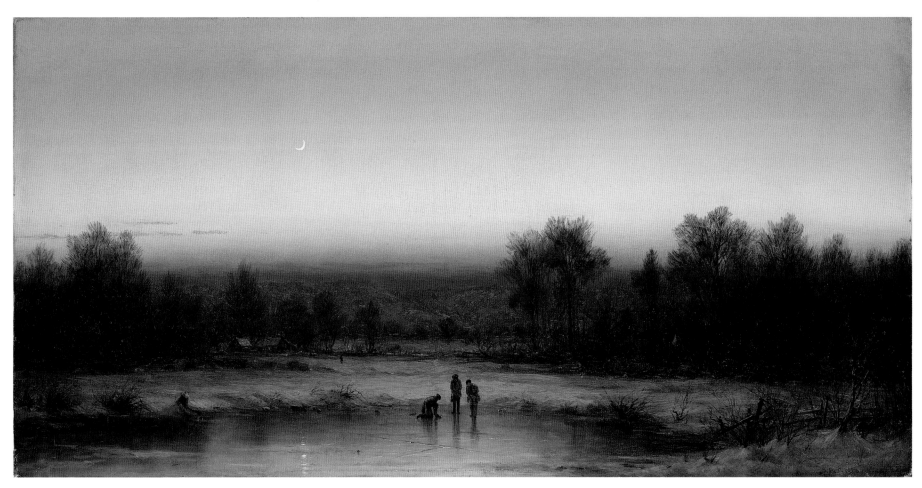

Cat. 28

own pictures).[7] Simultaneously, Mignot's submission to the National Academy of Design was *Twilight on the Passaic* (1861; Private collection), which anticipates not only the silhouetted naked trees overlooking the water in Gifford's picture but the sickle moon reflected on its surface (or, in Gifford's case, on the ice). The following year, when Gifford was at work on *A Winter Twilight,* Mignot painted *Sunset, Winter* (fig. 93), which was among the offerings in the June auction of his work.[8] Gifford's summary handling of the leafless trees in his picture seems almost a criticism of the virtual Pre-Raphaelite fastidiousness of Mignot's style and, as Weiss points out, seems Barbizon in spirit—indeed, it looks ahead to the horizontal

compositions of fields bordered by trees made familiar by the American Barbizon painter Dwight Tryon in the 1890s.

A Winter Twilight was included in the annual exhibition at the National Academy of Design in April–May 1862 along with *Torre dei Schiavi—Roman Campagna* (see cat. no. 26) and Gifford's first two Civil War subjects, *Sunday Morning in the Camp of the Seventh Regiment near Washington, D.C.* (Union League Club, New York), and *Bivouac of the Seventh Regiment—Arlington Heights, Virginia* (Seventh Regiment Fund, on loan to The Metropolitan Museum of Art). The juxtaposition is urious because at least one of the figures in the pencil sketches for *A Winter Twilight* (fig. 90) appears to wear

a military uniform, although Gifford ultimately opted for suppressing that association in the corresponding figure in the painting. Well before it reached the National Academy exhibition in April 1862, *A Winter Twilight* had captured the attention of a New England critic, who saw the painting at a reception in the Tenth Street Studio Building in February. Somewhat stricken by the appearance and demeanor of the artist himself, whom he described as "a quiet, self-contained and gentle mannered man, with only a slight hint of his dangerous mania in his dark eyes," the correspondent then turned to the painting, praising it as "one of his happiest efforts, if that can be called an effort, which seems to have glided upon the canvas at the touch of an enchanter's

wand. Just such a transfigured, sunset, snow scene as in my childhood—how far back it seems!—used to take my breath away with its still, dream-like beauty. Snow, and ice, and crescent moon, and dismantled trees; but the rosy light, the *dolce far niente,* the Gifford spell, is over all."[9] In the days preceding the National Academy exhibition, the New York critic Eugene Benson, writing under the pseudonym, "Proteus," eagerly heralded *A Winter Twilight* as one of Gifford's "most consummate works . . . with a sky flushed ruby red like the wine in Belshazzar's cups."[10] At the exhibition itself, however, the picture may have been disadvantageously hung and was relatively unnoticed, but one reviewer admired its "marked contrast of color, the well-managed sweep of foreground, and [its] peculiar atmospheric effect."[11]

KJA

1. Weiss 1987, p. 93.
2. See the *Memorial Catalogue,* number 257, "A Sketch of Winter Twilight. Size, 8 x 15. Sold in 1862 to William P. Wright," and number 438, "A Winter Twilight. Size, 8 x 15. Sold in 1867 to F. C. Adams." The work exhibited in Brooklyn may have been one of the two preparatory sketches; see Brooklyn Art Association Exhibition Index 1970, p. 201. Number 257 in the *Memorial Catalogue* probably was the painting shown at the Weehawken Gallery in New Jersey in 1862 or 1863, as number 43, "First Skating of the Season"; number 438 in the *Memorial Catalogue* may have been exhibited, under its same title, as number 42, at the Derby Gallery, New York, in 1867. Both pictures are listed in NMAA Index 1986, vol. 2, p. 1416, nos. 35390, 35391; see also p. 1423, no. 35575, *Winter Sunset, Boys on Ice,* which was number 238 in the exhibition at the North-Western Sanitary Fair, Chicago, in 1865, and also may have been identical with either number 257 or 438 in the *Memorial Catalogue.*
3. The sketches are in volume 5 of a series of books inscribed "7th Reg. & Catskills, 61" (Albany Institute of History and Art, New York; 1966.13.3); see the *Memorial Catalogue,* numbers 221–223; two are entitled "A Sketch on the Bronx River, N.Y.," and one, "Autumn on the Bronx." See also NAD Exhibition Record (1861–1900) 1973, vol. 1, p. 341 (1867), no. 550, "Bronx River."
4. See note 2, above. Neither of the smaller paintings identified as "A Winter Twilight" had a recorded date, and one of them was sold in 1867, making a connection between the latter and catalogue number 28 uncertain.
5. For Boughton's *Winter Twilight* see American Paintings in NYHS 1982, vol. 1, no. 182, p. 75.
6. NAD Exhibition Record (1826–1860) 1943, vol. 1, p. 45 (1859), no. 437 (1860), no. 380.
7. The paintings, which may have been pendants, were numbered 197 and 198 in the exhibition at the Young Men's Association in Troy. See NMAA Index 1986, vol. 4, p. 2419, nos. 61861, 61864.
8. Katherine E. Manthorne, with John W. Coffey, *Louis Rémy Mignot,* exhib. cat., Raleigh, The North Carolina Museum of Art; New York, National Academy of Design (Washington, D.C., and London: Smithsonian Institution Press, 1996), pp. 94–95, 124–25, 192, nos. 59, 196, and 71, respectively.
9. "From New York. Fresh Gossip of Books, Authors, Art and Artists. From Our Own Correspondent. New York, February 12, 1862," *Springfield* [Massachusetts] *Weekly Republican,* February 15, 1862, p. 1; also quoted in Carr 2003.
10. "Proteus" [Eugene Benson], "Art in New York. National Academy of Design," *New-York Commercial Advertiser,* April 4, 1862, p. 1; quoted in Carr 2003.
11. *The New-York Times,* April 27, 1862.

29

A Coming Storm, about 1863/80

Oil on canvas, 28 x 42 in. (71.7 x 106.7 cm)
Probably MC 718, "A Coming Storm in the Catskills. First painted and sold about 1863, but subsequently bought back, repainted, and dated 1880. Size 28 x 42. Owned by Elisha Gunn, Springfield, Mass."
Exhibited: Probably Maryland State Fair, Baltimore, April 1864, no. 60, as "A Thunder Storm in the Catskills"; National Academy of Design, New York, 1865, no. 85, as "Coming Storm"; possibly Brooklyn Art Association, April 1876, no. 320, as "A Coming Storm."
Private collection, on loan to the Philadelphia Museum of Art

30

A Coming Storm on Lake George, about 1863

Oil on canvas, 10 x 17⅞ in. (25.4 x 45.4 cm)
Private collection

31

A Sudden Storm, Lake George (Coming Rain, Lake George), about 1877

Oil on canvas, 18 x 31¼ in. (45.7 x 79.4 cm)
Signed and dated, lower right: S R Gifford 187[7?]
Possibly MC 561 [26.], "A Coming Shower over Black Mountain, Lake George. Dated 1871. Size, 18 x 34. Owned by the Estate."
Exhibited: Probably Brooklyn Art Association, December 1877, no. 408, as "A Sudden Storm, Lake George"; probably The Pennsylvania Academy of the Fine Arts, Philadelphia, 1880, no. 104, as "Coming Rain: Lake George."
Private collection

32

A Sunrise on Lake George, 1877–79

Oil on canvas, 16¼ x 30¼ in. (41.3 x 76.8 cm)
Signed and dated, lower right: S R Gifford 1877-9
MC 662, "A Sunrise on Lake George. Dated September, 1877. Size, 16 x 30. Owned by George Kemp."
Private collection

Gifford's nearly annual Catskill sojourns in the Civil War years were augmented by a tour of the Berkshires in 1863 and, in September, by a trip to Lake George and the Adirondacks. This followed his last tour of National Guard duty in the South that summer—a cessation that may have been occasioned by the death in July of his brother Edward, a prisoner of war, who had succumbed to the effects of swimming to his freedom across the Mississippi River.[1] On one page of his sketchbook from that trip, Gifford made two small drawings of storm

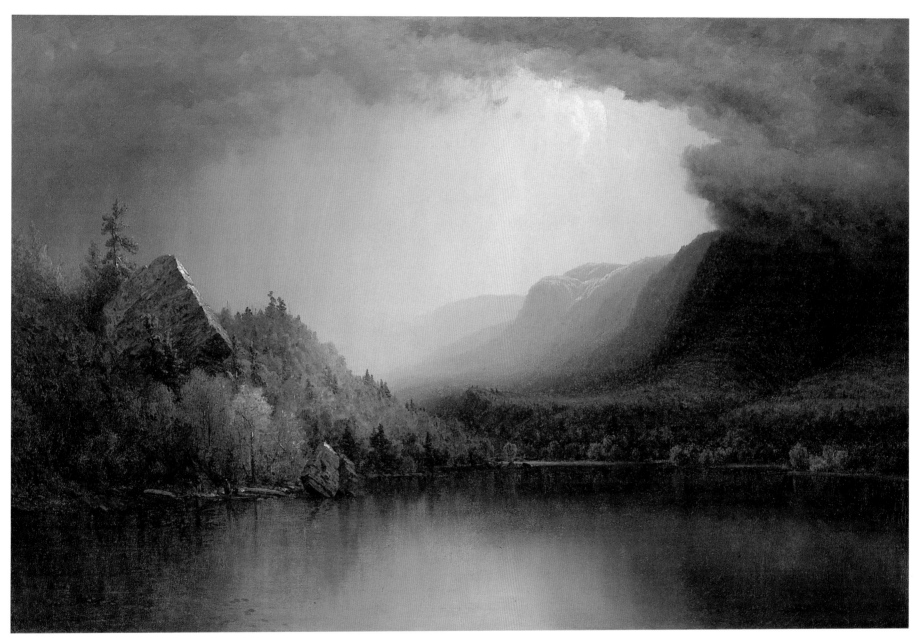

Cat. 29

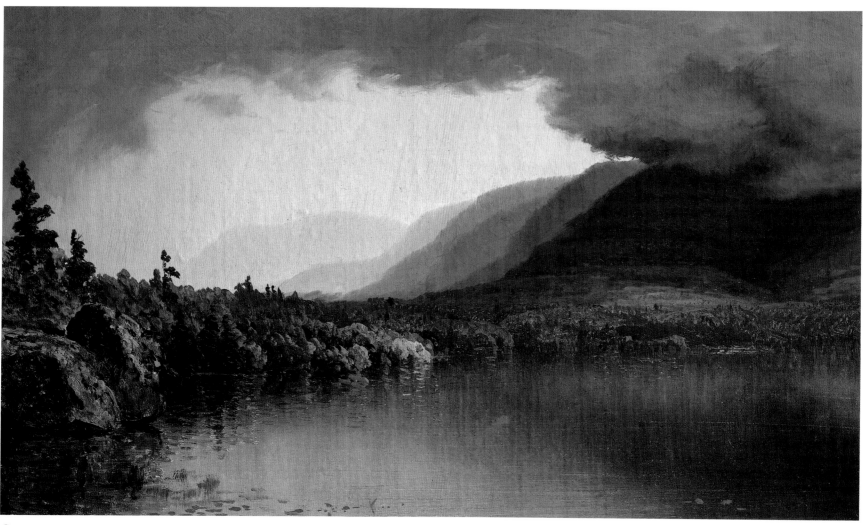

Cat. 30

clouds arching over a mountain lake (see fig. 94).[2] Each drawing seems less a close record of specific topography and of a meteorological event than a composite of the actual scene, with the more distinctly bordered lower study possibly an elaboration of the one above. The upper drawing is the wider of the two, and with its sketches of canoes in the foreground, may reflect more closely the actual experience of the place and time on which the compositions presumably were based. Here, the axis of the composition has been moved to the left, where the two conifers balance the mountain and arrest the image.

In the lower sketch the artist opted for symmetry, with the pall of clouds arching across the top of the scene and a great boulder now inserted at the left as a counter-weight to the mountain at the right. Both compositions were rehearsed in two oil studies each measuring eighteen inches wide. In catalogue number 30, based on the upper drawing, Gifford darkened the clouds and shadows and tonally developed a succession of overlapping mountains receding toward the left background. The other oil study (Butler Institute of American Art, Youngstown, Ohio), dated 1863, follows the lower draw-

ing and establishes the essential motifs of the present, large version.

As Gifford's biographer has pointed out, even in the drawing stage both compositions recall the works of Thomas Cole, with their vortices of light framed by storm clouds.[3] These include a few historical depictions of war, including *Landscape with Figures: A Scene from "The Last of the Mohicans"* (fig. 95) and *Destruction,* from the better-known allegorical series, "The Course of Empire" (1834–36; The New-York Historical Society). To these precursors one should add the work of

Gifford's chief European influence, J. M. W. Turner, especially *Snow Storm: Hannibal and His Army Crossing the Alps* (fig. 96), one of the latter's most famous canvases even in his day, which Gifford could have seen in England in 1855, or in the engraving published in Samuel Rogers's *Italy* (1830).[4] Whether or not the drawings were done in the field, the initial ideas for *A Coming Storm* were highly conceptual and seemingly more artistic than natural in inspiration. Their character strengthens the argument that here the artist was exploiting landscape motifs for a more personal and topical expression, once again challenging the expectations of his audience. As one visitor to his studio in 1863 remarked, when describing an unidentified painting in

terms very reminiscent of *A Coming Storm*: "The cavillers at Gifford's sun-freighted pictures will probably find this work more to their liking."[5]

That work could be catalogue number 29, which, in its original state, probably followed the oil study more closely than it does today. The foreground of the study is much darker, and the mountains on the right are nearly silhouettes. In the painting, the artist admitted much more of the light of the sky into the foreground so that it models the shoulders of the mountains, illuminates the forest at the left, and is reflected on a broader area of the lake's surface. As Weiss suggests, the differences between the study and the painting may very well indicate the alterations Gifford is reported to have made before his death.[6]

When a Gifford painting entitled *A Coming Storm*— probably catalogue number 29—was exhibited along with the artist's *Hampton Beach* and *Shawangunk Mountains* (see cat. no. 36) at the National Academy of Design in New York in 1865, the artistry of its execution was admired equally, but when applied to the sublime, tenebrous subject, it seemed to one critic somehow "meretricious": "As in looking at a flashing, beautiful, yet

Figure 94. Compositional studies for *A Coming Storm* (from the sketchbook of Maryland and New York subjects, 1862–63). Graphite. Albany Institute of History and Art, New York. Gift of Marian Gifford Johnson Shaw (Mrs. William F. Shaw) and Mrs. George G. Cummings

Figure 95. Thomas Cole. *Landscape with Figures: A Scene from "The Last of the Mohicans,"* 1826. Terra Foundation for the Arts, Daniel J. Terra Collection, Chicago

Figure 96. J. M. W. Turner. *Snow Storm: Hannibal and His Army Crossing the Alps,* 1812. Oil on canvas. Tate Britain, London. Clore Collection

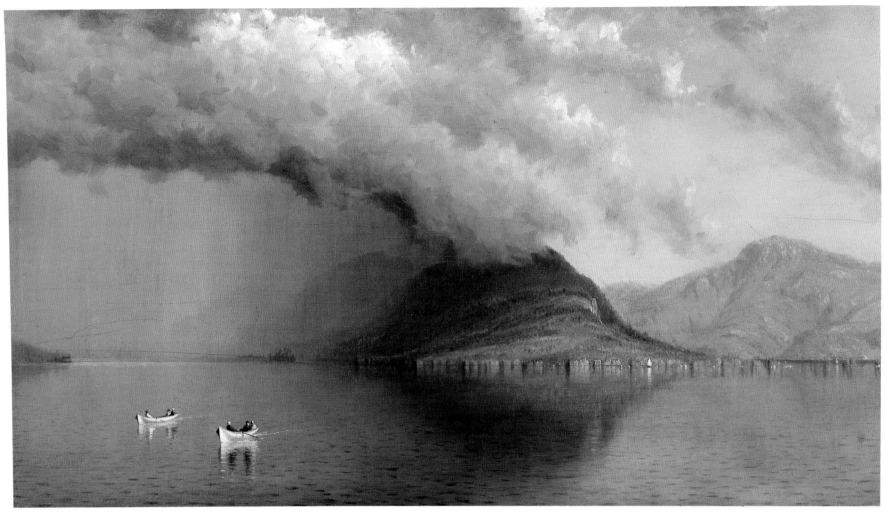

Cat. 31

noisy woman, we may think, but dare not breathe our doubts, so we distrust this brilliant and effective landscape, but cannot convict it of weakness or untruth. Yet the smoothness, nicety, and almost formal opposition of masses and correspondence of color, or what is technically called balance of color, obtrudes the picture-making art."[7]

If we cannot be certain of the topical motivations underlying the creation of catalogue number 29, there can be little doubt about the significance of the exhibition of a painting entitled *Coming Storm* in April 1865. The picture's owner was Edwin Booth, the Shakespearean actor and the brother of the actor John Wilkes Booth,

who had assassinated Abraham Lincoln on April 14, 1865, and was himself killed by Federal troops less than two weeks later, about the time of the opening of the exhibition at the National Academy. Edwin Booth had finished a remarkably successful run as Hamlet in New York City and was about to reprise his role in Boston when he learned of his brother's deed. Filled with shame and an unfounded fear of public censure, he retired from acting for the remainder of 1865. Thus it hardly seems coincidental that the picture submitted to the Academy was of an approaching storm; completed as early as 1863 and owned by the brother of the president's assassin, the work took on a symbolic significance as a token of the

grief the actor shared with the nation, and perhaps was even a sign of contrition on Booth's part. For Gifford, it also may have served as an outlet for his somber frame of mind, aggravated not only by Lincoln's death but by that of another brother, Frederick, in January 1865.[8] Surely, the author and poet Herman Melville, the brother of one of the exhibition's sponsors, felt its impact: "'The Coming Storm'; A Picture by S. R. Gifford, and owned by E. B. Included in the N. A. Exhibition, April, 1865" was the title of a poem in Melville's *Battle-Pieces,* published in 1866.[9] The poem is really an apologia for the actor, acknowledging his burden and his signature stage role, and pondering the

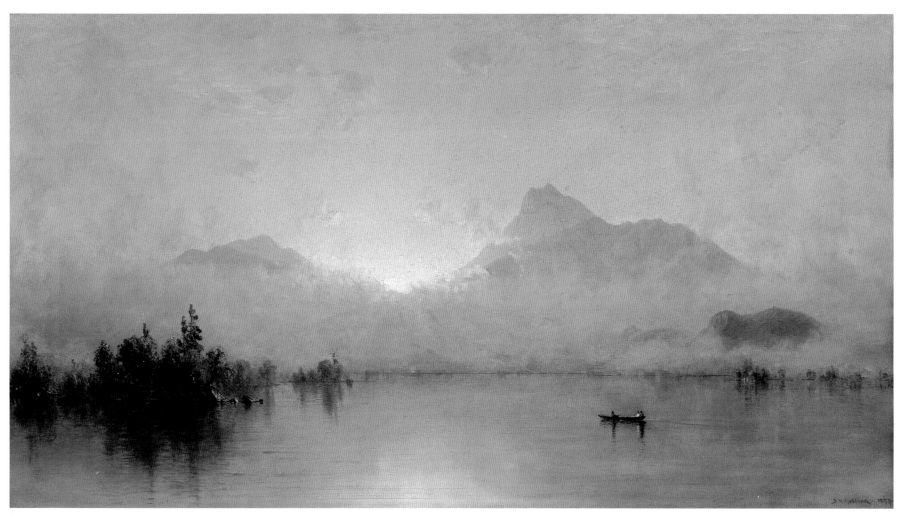

Cat. 32

bitter wisdom his avocation affords him along with his receptivity to the "Sublime" in "this picture," the description of which is highly evocative of catalogue number 29:

All feeling hearts must feel for him
Who felt this picture. Presage dim—
Dim inklings from the shadowy sphere
Fixed him and fascinated here.

A demon-cloud like the mountain one
Burst on a spirit as mild
As this urned lake, the home of shades.
But Shakespeare's pensive child

Never the lines had lightly scanned,
Steeped in fable, steeped in fate;
The Hamlet in his heart was 'ware,
Such hearts can antedate.

No utter surprise can come to him
Who reaches Shakespeare's core;
That which we seek and shun is there—
Man's final lore.[10]

If catalogue number 29 was, indeed, bought back by Gifford, as was reported in the *Memorial Catalogue* in the listing for number 718, "A Coming Storm in the Catskills," this may have occurred about 1876. That year,

Gifford offered *A Coming Storm* for $1,550—a steep price for what must have been a sizable picture that, again, was described in terms evocative of catalogue number 29, with the added misinformation that the site depicted was in the Catskills.[11] The Brooklyn critics were unreservedly laudatory, their remarks suggesting that if catalogue number 29 and Booth's picture were one and the same, Gifford may have retouched it, for "it differs essentially in an artistic point of view from any storm picture heretofore sent from his easel, in the fact that it possesses force, strength, and a real grasp of nature in one of its most interesting phases."[12]

Whatever picture was the one called *A Coming Storm,*

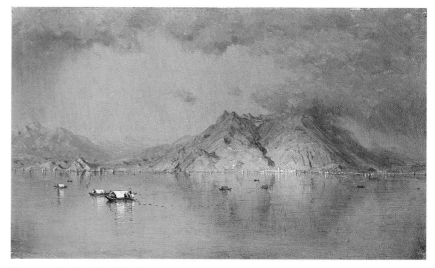

Figure 97. Sanford R. Gifford. Compositional study for *A Sudden Storm, Lake George* (from the sketchbook of Maine and New York subjects, 1873–79). Graphite on olive-brown wove paper. The Frances Lehman Loeb Art Center, Vassar College, Poughkeepsie, New York. Gift of Miss Edith Wilkinson, Class of 1889

Figure 98. Sanford R. Gifford. *Monte Ferro from Lake Maggiore,* 1868. Oil on canvas. Private collection

exhibited in 1876, it must be distinct from catalogue number 31, which probably was the one shown at the Brooklyn Art Association in December 1877 with its present title, *A Sudden Storm, Lake George,* and offered for sale for seven hundred dollars, a sum appropriate for a Gifford painting of its size at that time.[13] The date on the picture has been interpreted as 1871, but that reading must be erroneous, for the work is almost certainly the one exhibited in Brooklyn in 1877. Not only are both the original pencil sketch (see fig. 97) and one of the oil studies (Whereabouts unknown) dated 1873 but the painting was specifically described by Clarence Cook as "just finished" in a report published in the *New-York Daily Tribune* in June 1877. Adopting the metaphor of a skilled fisherman, which Gifford was, Cook admired his reflexes in hooking "a fleeting effect in a storm on Lake George . . . which the artist has caught while boating on the lake. It was a furious gust of rain and wind, such as one would describe in central New York as a white squall, which came down over the hills in a narrow track, leaving one-half the sky clear and filling the rest of it with the most ominous sort of appearances. The

white skiffs of the pleasure seekers in the foreground are flying at the top of their speed for shelter."[14]

Given its presumed basis in actual experience, *A Sudden Storm, Lake George,* must be an instance of the artist revisiting the earlier, more conceptual, and perhaps deliberately symbolic design of *A Coming Storm,* which—save for the elegance of its technique—might have been painted in the previous generation. In *A Sudden Storm,* Gifford expanded on the initial conception horizontally so that the brooding mountain now serves as the axis of the design, separating the stormy from the clear side of the composition. Whereas the former picture literally evoked the past, with its inclusion of Indians on the lakeshore, *A Sudden Storm* is, as Cook suggests in his reference to "the white skiffs of the pleasure seekers," a finely wrought tourists' souvenir, akin to John Kensett's paintings of the same site. The bad weather passes but does not monopolize the picture space—as in the earlier work—nor does it as immediately threaten the spectator or the occupants of the canoes. Strengthening this impression are two factors, in addition to Cook's testimony: The sketch (see fig. 97)

on which the picture is based, although outlined like a compositional "rehearsal," seems based on something quickly observed rather than contrived. In the painting, the storm effect is a considerable embellishment on the milder, more buoyant suspension of the clouds in the study, and most of the lakeshore recorded on the left side there has been eliminated. Inasmuch as Gifford aestheticized his original observation or idea, he probably also was prompted by another, more evident "tourist souvenir"—*Monte Ferro from Lake Maggiore* (Picker Art Gallery, Colgate University, Hamilton, New York; see the oil study, fig. 98), a forty-inch "chief picture" with arching storm clouds, painted in 1871 from sketches made on site in Italy in July 1868 and sold to James Colgate.[15] Indeed, that painting, with its oval, light-filled opening on the left, as in *A Sudden Storm,* yet with its total obscurity on the right, as in the earlier *A Coming Storm,* clearly seems to be an intermediary between the artist's Lake George storm subjects. Perhaps the most striking artistic indulgence in *A Sudden Storm,* however, is the broad execution of the storm clouds and the dashes of pigment denoting

the wavelets in the foreground, suggestive of the artist's late painterly style.

The bifurcated meteorological effect of *A Sudden Storm, Lake George*—as well as the combination of fact and artifice in its formulation—might prompt completely opposing responses in contemporary observers. Whereas Cook's explanation in June 1877—apparently derived from the artist's testimony, in addition to his own reaction—was that Gifford had captured a peculiar but genuine weather phenomenon, the reviewer of the Brooklyn Art Association exhibition in December felt challenged by what he initially read as one of the artist's "poetical interpretations of nature, in which the clouds and sunshine struggle for the ascendancy without any great conflict of nature. . . . One can scarcely realize that this is nature, but it is painted with so much feeling and so charmingly withal that it must be accepted as such in spite of any seeming inconsistency."[16]

The supposition that *A Sudden Storm, Lake George,* constitutes in part a reworking of *A Coming Storm* is further strengthened by Gifford's return, also in 1877, to the 1863 sketches on which the earlier picture was based for what may be his last Lake George subject, *A Sunrise on Lake George* (cat. no. 32). On the recto of the sheet in the 1863 sketchbook containing the compositional studies for *A Coming Storm* is another pair of compositional drawings (see fig. 99) bearing the unmistakable origins of the thirty-inch painting begun fourteen years later and evidently not completed until the year before Gifford's death. That the artist had tested the subject in oils more or less simultaneously with his formulation of *A Coming Storm* is indicated by the *Memorial Catalogue* record of at least one picture (Whereabouts unknown), dated 1863 and measuring 10 x 15 inches, entitled *A Misty Sunrise on Lake George.*[17]

The precedent for catalogue number 32 may be found in *Morning in the Adirondacks* (fig. 8), one of a pair of large, oval paintings—among the finest pictures from Gifford's early career—that the artist completed in 1854. At the same time, the impact of actual experience cannot be discounted here, even if prompted by travel literature. Long before Gifford visited Lake George, the Yale

scientist Benjamin Silliman helped popularize the spectacle of a sunrise breaking over the mountains bounding the eastern shore of the lake in language remarkably evocative of Gifford's painting:

The retreat of the vapour [from the lake's surface] formed a very beautiful part of the scenery; it was the moveable light drapery, which, at first, adorning the bosom of the lake, soon after began to retire up the sides of the mountains, and to gather itself into delicate curtains and festoons. . . . Opposite to us, in the direction towards the rising sun, was a place or notch, lower than the general ridge of the mountains, and formed by the intersecting curves of two declivities.

Precisely through this place was poured upon us the first rays, which darted down, as if in lines of burnished gold, diverging and distinct as in a diagram; the rim of the eastern mountains was fringed with fire for many a mile; the numerous islands, so elegantly sprinkled through the lake . . . now received the direct rays of the sun, and formed so many gilded gardens; at last came the sun, "rejoicing in his strength," and, as he raised the upper edge of his burning disk into view, in a circle of celestial fire, the sight was too glorious to behold; it seemed, as the full orb was disclosed, as if he looked down with complacency, into one of the most beautiful spots in this lower world, and, as if gloriously representing his great Creator, he pronounced "it all very good." . . . I have not exaggerated the effect.[18]

One can only speculate, from what is already known and may be surmised about the motivation, expression, and interpretation of *A Coming Storm,* that the Civil War climate in which it was created was not conducive to the artist's full realization—or to a patron's commission—of a sunnier pendant, more placid in conception, such as *A Sunrise on Lake George.* Moreover, also in 1863 the artist had essayed and then exhibited an approximation of the sunburst (if not sunrise) effect of catalogue number 32 in the large (now lost) *Kauterskill Clove* (see the study, fig. 85), and reprised it the following year in *Camp of the Seventh Regiment, near Frederick, Maryland, in July 1863* (cat. no. 34). *A Sunrise on Lake George* follows logically after *A Sudden Storm, Lake George,* of about 1877, with which it shares almost identical dimensions and

Figure 99. Sanford R. Gifford. Studies for *A Sunrise on Lake George* (from the sketchbook of Maryland and New York subjects, 1862–63). Graphite. Albany Institute of History and Art, New York. Gift of Marian Gifford Johnson Shaw (Mrs. William F. Shaw) and Mrs. George G. Cummings

comparable painterly qualities. Also more consistent with Gifford's paintings of the 1870s than with those of the Civil War period is the more planar spatial character and the elimination of foreground *repoussoirs* in catalogue number 32. Whatever the consistency of its design and features with the unlocated oil sketch of 1863, catalogue number 32 seems informed by more austere later compositions such as *Mount Rainier, Bay of Tacoma— Puget Sound* (1875; cat. no. 57). KJA

1. Weiss 1987, pp. 97–98.
2. Ibid., p. 313.
3. Ibid., pp. 237–38.
4. Butlin and Joll 1984, vol. 1, pp. 88–90, vol. 2, pl. 131.
5. *The New York Evening Post*, December 1, 1863.
6. Weiss 1987, pp. 238–39.
7. Benson 1865.
8. Weiss 1987, pp. 102–3.
9. Hennig Cohen, ed., *The Battle-Pieces of Herman Melville* (New York: Thomas Yoseloff, 1963), pp. 14–15, 268–70; Stanton Garner, *The Civil War World of Herman Melville* (Lawrence, Kansas: University Press of Kansas, 1993), pp. 386–87, 400–401; Robert Milder, "The Rhetoric of Melville's *Battle-Pieces*," *Nineteenth-Century Literature* 44, no. 2 (September 1989), pp. 187–89.
10. Quoted in Cohen, *The Battle-Pieces of Herman Melville*, pp. 131–32.
11. Brooklyn Art Association Exhibition Index 1970, p. 202, April 1876, no. 320; *The Brooklyn Daily Eagle*, April 25, 1876.
12. *The Brooklyn Daily Eagle*, April 25, 1876.
13. Brooklyn Art Association Exhibition Index 1970, p. 202, December 1877, no. 408.
14. Cook 1877.
15. Weiss 1987, pp. 268–69, 328.
16. *The Brooklyn Daily Eagle*, December 2, 1877.
17. *Memorial Catalogue*, p. 28, numbers 333, *333; according to these listings, there may have been two small pictures with that title, one belonging in 1880 to J. A. Dean and the other to J. W. Pinchot.
18. Benjamin Silliman, *A Tour to Quebec in the Autumn of 1819* (London: Sir Richard Phillips and Co., 1822), pp. 50–51.

33

Lago di Garda, Italy, 1863

Oil on canvas, 10 5/8 x 16 3/4 in. (27 x 42.5 cm)
Signed and dated, lower left: S R Gifford 1863
MC 342 [44.], "Lago di Garda, Italy. Dated 1863. Size, 9 x 16. Owned by D. H. McAlpin."
Collection Jo Ann and Julian Ganz, Jr.

On July 23, 1857, Gifford left Venice to travel in northern Italy. After spending five hours seeing the sights in Verona, he reached Peschiera, at the southern end of Lago di Garda.[1] Known by the Romans as "Lacus Benacus," Garda is the largest of the region's lakes, stretching thirty-four miles from Peschiera to Riva, Austria, at its northern tip.[2] The next day he left on an Austrian steamer for Riva, admiring the views of the surrounding Tyrolean Alps and the "very pure and beautiful blue" waters of the lake. When he reached the town, Gifford went for a walk along the western shore of the lake, on the "Brescia Road which winds along the face of the precipices, often hollowed out of the perpendicular rock at a great height above the water." From a vantage point to the south, he sketched Riva, "finely situated at the head of the lake in an amphitheatre of noble mountains."[3]

Gifford's on-site study of Riva is lost and no other depictions of the subject predating this example are known. The compositional scheme he used for *Lago di Garda, Italy*, with a view over an expanse of water toward buildings in the distance, recalls that of his *Lago Maggiore* (1854; see fig. 130).[4] He would adopt this same format for several subsequent works, among them, *Near Venice* (fig. 47), *San Giorgio—Venice* (1870; Whereabouts unknown), and *Isola Bella in Lago Maggiore* (cat. no. 51).[5] Gifford's meticulous recording of the buildings makes a number of them easily identifiable, including the tall structure at the left, Torre di Apponale, which was built in 1220 for defense of the town and later raised in height and extensively modified.[6] At the far right is the multi-towered castle known as the Rocca, first constructed in the twelfth century and renovated and enlarged several times since. Seen between these two, but slightly further inland, is the south flank of the church of Santa Maria Assunta, begun in the early twelfth century but completely redecorated in 1728.[7]

The present work served as the basis for a mid-sized painting, also completed in 1863,[8] in which the sense of expansive space is increased and unified by an enveloping luminous atmosphere.[9] This larger painting is possibly identical to the "Lake Garda" owned by the important Baltimore collector J. Stricker Jenkins, whose collection was auctioned in New York in 1876.[10] At that sale, Gifford's painting brought three hundred dollars—a price higher than would have been paid for a small-scale sketch but less than a larger work would have commanded.
F K

1. Gifford's account of the journey from Venice to Riva is found in his letter of August 10, 1857; see Gifford, European Letters, vol. 2, pp. 175–76.
2. Karl Baedeker, *Northern Italy Including Leghorn, Florence, Ravenna, the Island of Corsica, and Routes through France, Switzerland, and Austria* (Leipzig: Karl Baedeker, 1895), p. 191.
3. Gifford, European Letters, vol. 2, p. 176.
4. As noted in Weiss 1987, p. 205, this 5 3/4 x 10 1/4-inch work likely was related to a large painting with the same title exhibited in 1858 at the National Academy but now lost.
5. An engraving entitled *San Giorgio—Venice*, which Gifford included on his list of "chief pictures," is illustrated in Edward Strahan [Earl Shinn], *The Masterpieces of the Centennial International Exhibition*, 3 vols. (Philadelphia: Gebbiet & Barrie, 1876–78), vol. 1, p. 50.
6. Information from {http://www.lagodigardamagazine.com}, March 14, 2003; see also Baedeker, *Northern Italy*, pp. 194–95; Weiss 1987, p. 239.
7. See {http://www.lagodigardamagazine.com}, March 14, 2003.
8. That picture, which measures 20 x 32 inches (Private collection), presumably is the one listed as number 291 in the *Memorial Catalogue*: "Riva, Lago di Garda. Dated 1863. Size, 18 x 32. Owned by Isaac T. Frost"; it is illustrated in Cikovsky 1970, p. 51, and Alexander Gallery 1986, pl. 25.
9. See Weiss 1987, p. 239.
10. The sale was announced in *The New York Evening Post*, May 2, 1876, p. [2], and May 3, 1876, p. [2]. Results were reported in "The Jenkins Sale of Pictures," *The New York Evening Post*, May 4, 1876, p. [2]; "Art and Artists," *Boston Evening Transcript*, May 10, 1876, p. 6. Jenkins owned an important collection of pictures by contemporary American and European artists, including John F. Kensett's masterful *View on the Hudson* (1865; Baltimore Museum of Art).

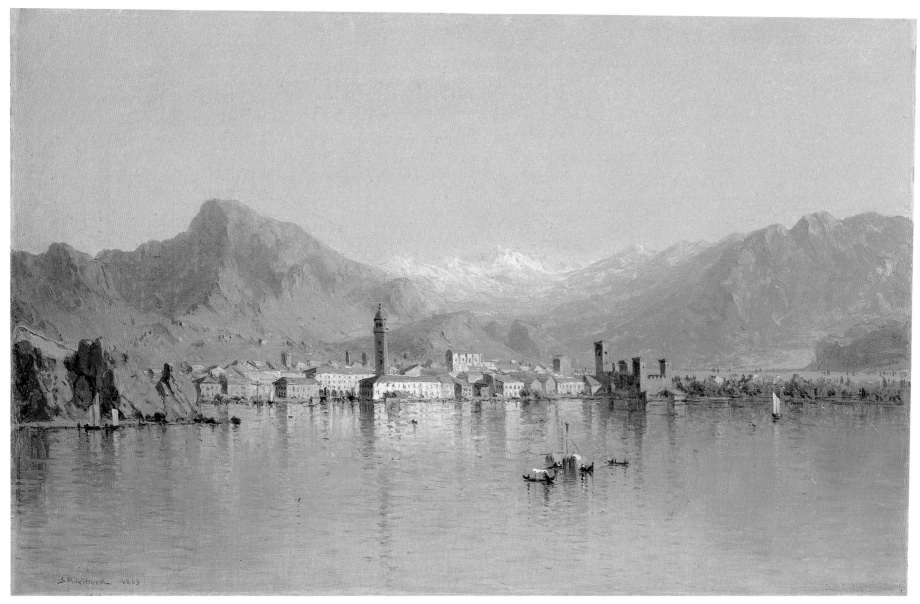

Cat. 33

Camp of the Seventh Regiment, near Frederick, Maryland, in July 1863, 1864

Oil on canvas, 18 x 30 in. (45.7 x 76.2 cm)
Signed and dated, lower right: S. R. Gifford. 1864.
MC 354, "The Camp of the Seventh Regiment, near Frederick, Md., in July, 1863. Dated 1864. Size, 18 x 30. Owned by the Seventh Regiment, N. G. S. N. Y."
Exhibited: Possibly Artists' Fund Society, New York, 1864, no. 207, as "Camp of the 7ᵗʰ Regt., N.Y.N.G., Near Frederick, Md., July, 1863"; Brooklyn Art Association, March 1865, no. 157, as "Camp 7ᵗʰ Regiment"; National Academy of Design, New York, "Centennial Loan Exhibition of Paintings," 1876, no. 238, as "7ᵗʰ Regiment Camp near Frederick, Maryland, July, 1863"; National Academy of Design, New York, "Mr. Robert M. Olyphant's Collection of Paintings by American Artists," December 18 and 19, 1877, no. 150.
Seventh Regiment Fund, New York

Camp of the Seventh Regiment, near Frederick, Maryland, in July 1863, is the last of four Civil War subjects that Gifford executed based on his three tours of duty with the Seventh Regiment of the New York National Guard in the spring and summer of 1861, 1862, and 1863. One could claim that, among the four paintings, Gifford covered—intentionally or not—virtually the complete diurnal cycle. The 1861 *Sunday Morning in the Camp of the Seventh Regiment near Washington, D.C.* (Union League Club, New York), and *Bivouac of the Seventh Regiment—Arlington Heights, Virginia* (Seventh Regiment Fund), represent full daylight and moonlight, respectively. The effect of the 1862 painting *Baltimore, 1862—Twilight* (fig. 32), is specified in its title, and *Camp of the Seventh Regiment* is set in late afternoon, with the sun breaking through rain clouds. All of the pictures are of approximately the same size and, like most of the contemporaneous early paintings of Winslow Homer, none is actually a battle scene but each is based fairly closely on what the artist actually experienced as a soldier chiefly on the domestic front in either camp or fort.

Indeed, none of the pictures seems to stem more directly from personal recollection than this one. Gifford described the scene vividly to his father on July 9, 1863, just days after the Battle of Gettysburg, the turning point of the war. Both Union and Confederate forces were heading south, the former in pursuit, the latter in flight, and the Seventh Regiment (dressed in its Guardsman grays) received many Southerners as prisoners.[1] Even under the circumstances, the artist could not ignore the fine landscape:

We are in beautiful country. The fields where not too near the camp are covered with a rich harvest. The line of the South Mountain runs about three miles west of us. . . .

We came into this field . . . in the rain and bivouacked in the mud. It did not take long to strip the neighboring fences of their remaining rails, and thatch them with sheaves of wheat from the next field. It seemed a pity to waste the rich grain, but after all it was not wasted, for it made very comfortable beds and pretty good thatches. Many of our men, who were not in an enterprising "Mess" rolled themselves in their blankets and soaked all night in the mud in a drenching rain. Our men . . . got ourselves up a very secure shelter with a five-barred gate, some wheat sheaves and some rails. The next afternoon it cleared and the ground is now fast drying up.[2]

Looking west to South Mountain, Gifford reported on the "fine opportunity of seeing almost the entire Army of the Potomac. The apparently endless lines of infantry and artillery and supply trains of the different corps are constantly filing past in full sight on the different roads leading to the [Potomac] river."[3]

The artist made a cursory sketch (see fig. 100) of the panorama of the profile of the ridge with lean-tos scattered in the foreground. In an 1863 oil study (Private collection) half the size of the present picture, he elaborated on and clarified the essentials of the sketch. He shifted

the principal lean-to and its neighbors in the foreground to the right in order to align one of the angles of its roof with the slopes of the hills and the diagonal thrust he was developing in the cumuli—from behind which the sun breaks out—at the upper left. In the left foreground he introduced what appears to be a sutler's lean-to, which marks the beginning of a second diagonal progression of the structures, plotting the space into the

Figure 100. Sanford R. Gifford. Study for *Camp of the Seventh Regiment* (from the sketchbook of Maryland and New York subjects, 1862–63). Graphite. Albany Institute of History and Art, New York. Gift of Marian Gifford Johnson Shaw (Mrs. William F. Shaw) and Mrs. George G. Cummings

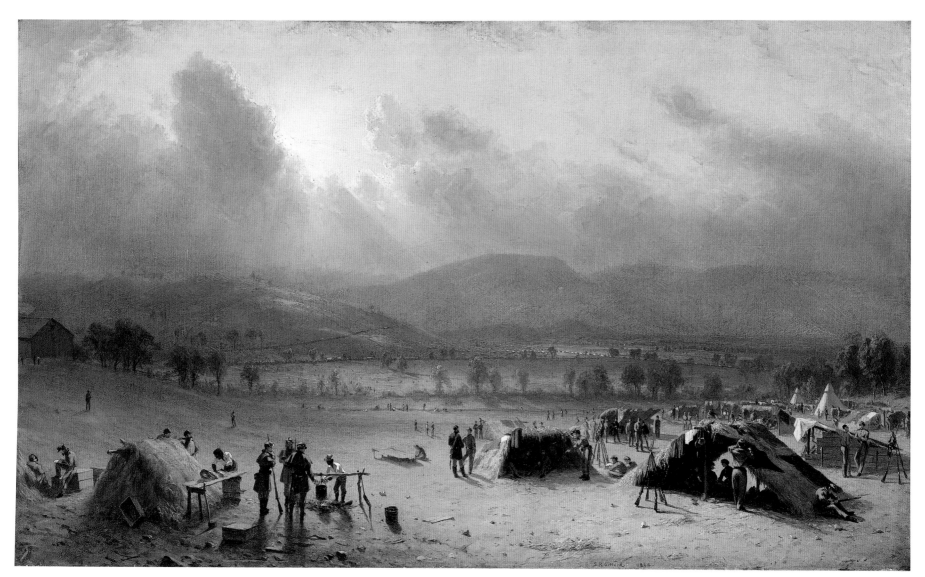

Cat. 34

right middle distance, which is highlighted by pale tents and drying laundry that balance the gilded clouds. Figures of guardsmen in various poses found on other pages of the same sketchbook were incorporated into the foreground of the study and even more were included in the large picture, forming a small catalogue of quotidian camp life: From left to right, they are seen writing letters, cooking, eating (while standing up), hanging wash, sleeping or resting under a makeshift tarp, talking, and cleaning muskets (see the sketches, fig. 101, 102). Sentries are posted on the peripheries, and in the middle distance, along a narrow stream below the line of trees, even the washing of laundry is suggested. Of all Gifford's Civil War subjects, this one is most evocative of the kind of theme that was just beginning to make Winslow Homer's

Figure 101. Sanford R. Gifford. *Soldier Cleaning His Musket* (from the sketchbook of Maryland and New York subjects, 1862–63). Graphite. Albany Institute of History and Art, New York. Gift of Marian Gifford Johnson Shaw (Mrs. William F. Shaw) and Mrs. George G. Cummings

Figure 102. Sanford R. Gifford. *Silhouettes of Soldiers* (from the sketchbook of Maryland and New York subjects, 1862–63). Graphite. Albany Institute of History and Art, New York. Gift of Marian Gifford Johnson Shaw (Mrs. William F. Shaw) and Mrs. George G. Cummings

chant and railroad captain Robert M. Olyphant. It was exhibited at the Artists' Fund Society in December 1864 and at the Brooklyn Art Association the following year, where it was cited for its "fidelity to detail rarely seen."[4] Sold at the auction of Olyphant's collection of American paintings in December 1877, the work presumably was purchased by the Seventh Regiment, which, in any case, owned it by 1880.[5]

KJA

1. Weiss 1987, pp. 97–98.
2. Letter from Sanford Robinson Gifford to his father, Elihu Gifford, "In camp near Frederick, Md.," July 9, 1863, in Gifford Family Records and Letters, vol. 1.
3. Ibid.
4. "Brooklyn Art Association," *The Brooklyn Daily Eagle*, March 22, 1865, p. [2].
5. *Mr. Robert M. Olyphant's Collection of Paintings by American Artists . . . December 18 and 19, 1877,* sale cat. (New York: R. Somerville, 1877), no. 150.

early reputation at this time—especially, his *Home, Sweet Home* (fig. 103), exhibited at the National Academy of Design in 1863.

Gifford, of course, was a landscape painter, and what he presents as much describes the panorama of the military campaign as it details the world of the soldier. The sunburst—which may be artistically informed by one of his Kaaterskill Clove compositions of the previous year (see fig. 85)—does not merely document the retreating rains that he described to his father, but for the artist it may have signified the aftermath of Gettysburg. The viewer witnesses the spreading of the sun's providential light over the landscape and its Union occupants, and, in the background, the registering of its glinting reflections

on the host of Union infantry and wagon trains winding their way southward into the mountains. *Camp of the Seventh Regiment* seems a fitting close to Gifford's Civil War series: It revisits the spatial extremes of *Sunday Morning in the Camp of the Seventh Regiment, near Washington, D.C.,* with its religious service in the foreground giving way to a distant prospect of the nation's capital (which the Seventh Regiment was posted to defend). The sacred overtones here are only implicit, but the drama in the sky, scarcely suggested in Gifford's original drawing, is unmistakably portentous, lending the vista, with its migrating armies, the faint flavor of the historical landscapes of Turner and John Martin.

Camp of the Seventh Regiment was sold to the mer-

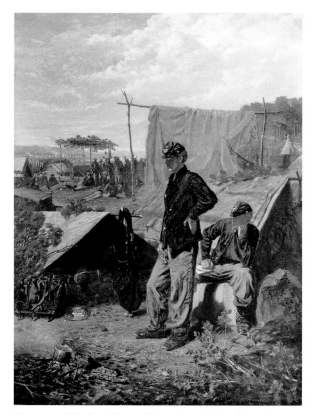

Figure 103. Winslow Homer. *Home, Sweet Home,* about 1863. Oil on canvas. National Gallery of Art, Washington, D.C. Patrons' Permanent Fund

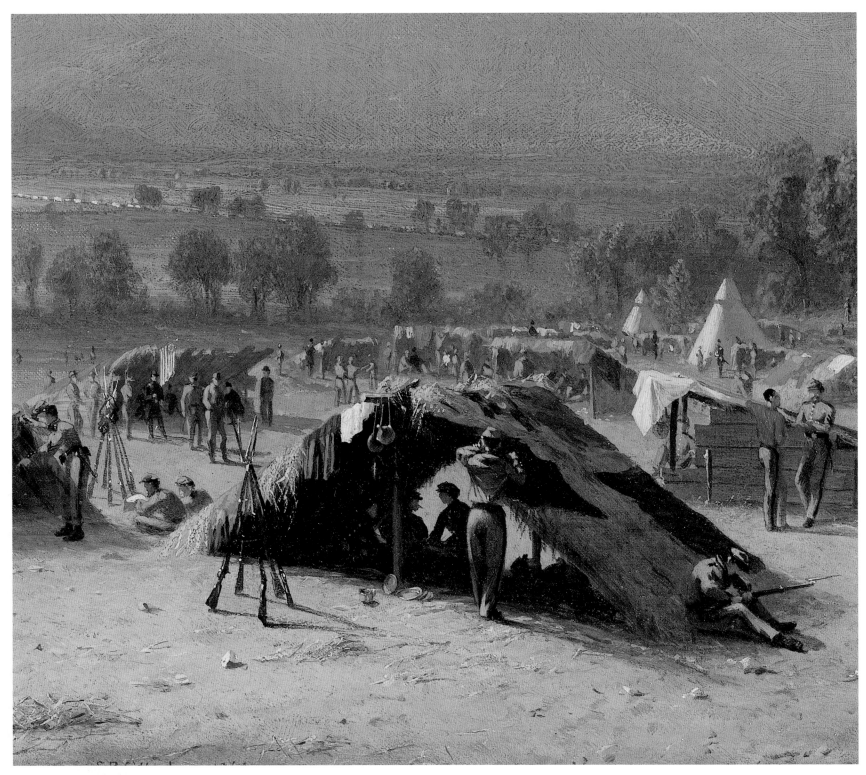

Cat. 34 (detail)

South Bay, on the Hudson, near Hudson, New York, 1864

Oil on canvas, 12 ¼ x 25 ½ in. (31.1 x 64.8 cm)
Signed and dated, lower left: 1864— S R Gifford
MC 378 [75.]: "South Bay, on the Hudson, near Hudson, N.Y.
Dated 1864. Size, 12 x 25. Owned by Robert Gordon."
Exhibited: Probably Boston Athenaeum, 1865, no. 265, as "On
the Hudson"; The Metropolitan Museum of Art, New York,
"Memorial Exhibition," October 1880–March 1881, no. 75, as
"View on the Hudson, near Hudson, N.Y."
Private collection, courtesy of Garzoli Gallery, San Rafael,
California

of at least eleven paintings by Gifford of Mount
Merino, seen here and in most of the known paintings
to the south, and including South Bay in the fore-
ground. The artist exhibited the first recorded version of
the subject (Whereabouts unknown) at the National
Academy of Design in New York in 1851; the last known
version, *Mount Merino and the Catskills at Twilight*
(Private collection), is dated 1867.[1] All had a precedent
in several paintings (see fig. 21) of the same scene by a
local artist in Hudson, Henry Ary, who may have been

Gifford's first art instructor and was certainly a sketch-
ing companion in the Catskills and elsewhere in
Gifford's early days as a landscape painter.[2]

Mount Merino is the most conspicuous natural land-
mark visible from Hudson, Gifford's hometown, and was
renowned for the splendid vista from its summit, particu-
larly of the Catskill Mountains to the southwest. Indeed,
according to Worthington Whittredge, it was while
contemplating the view, also overlooking Thomas Cole's
house in the village of Catskill, that Gifford decided to
become a painter.[3] North of Mount Merino, erected on
pilings in South Bay, and presumably behind the specta-
tor's vantage point in the painting, was the iron foundry
of which Gifford's father was a trustee. The foundry was
built in 1851, the same year in which the Hudson Railroad
line was constructed across South Bay from the foot of
Mount Merino and the artist exhibited his first recorded
painting of the landmark. In all the known versions of
the subject, the railroad line does not appear, which obvi-
ously reflects a deliberate choice on Gifford's part.[4]

Whereas Ary's depictions of the landmark evoke the
classical landscapes of Thomas Doughty, Alvan Fisher,

Figure 105. Sanford R. Gifford. *Compositional Studies of
South Bay and Mount Merino* (from the sketchbook of
Maine and New York subjects, 1864). Graphite. Fogg Art
Museum, Harvard University Art Museums, Cambridge,
Massachusetts. Gift of Sanford Gifford, M.D.

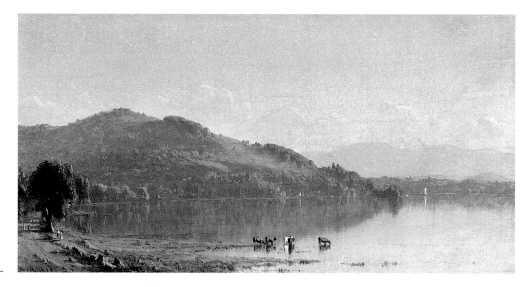

Figure 104. Sanford R. Gifford. *Mount Merino on the Hudson,*
1859. Oil on canvas. Private collection

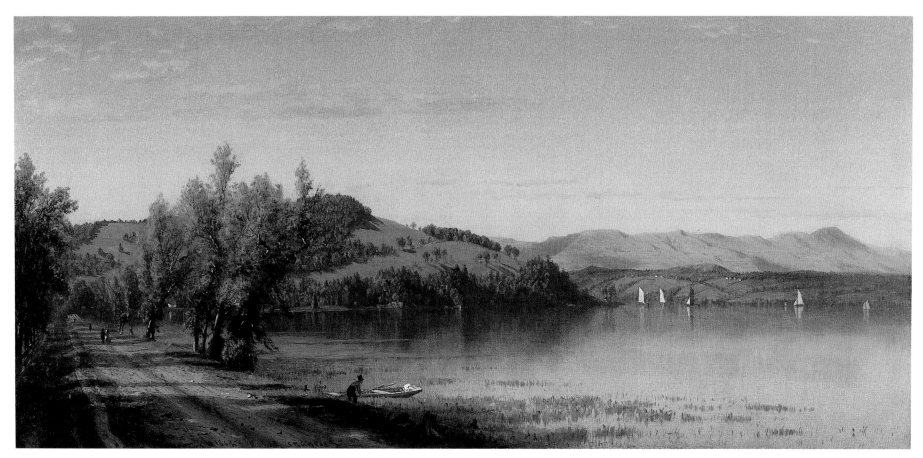

Cat. 35

and even of Thomas Cole, when Gifford returned to the Mount Merino subject in the late 1850s (see fig. 104), following his first trip to Europe, he abandoned the umbrageous trees that defined the foregrounds of Ary's pictures as well as of his own early paintings. Typically, he widened the overall proportions and exploited only the more distant trees lining the promenade at the left to set off the imposing form of Mount Merino;[5] at the right, where Ary reflexively had positioned trees in the foreground, Gifford allowed the nearly haze-smothered profile of the distant Catskill range to imply extension well beyond the borders of the image. The panoramic scope of these pictures, their terrestrial breadth, and their afternoon ambience look forward to Gifford's *Hook Mountain, near Nyack, on the Hudson* (fig. 116).

For the present work, however, Gifford made fresh sketches of the locale (see fig. 105), probably in early October, following trips the previous summer and early autumn to Maine and New England and the Shawangunk Mountains near New Paltz, New York.[6] Both in the simple compositional drawing and in the painting, he revised his earlier conception in significant ways. Principally, he executed the sketch in the light of morning, and increased the presence of the road in the left foreground (presumably Bay Road, now part of route 96, which ran along the shore of South Bay)[7] and emphasized the trees. The latter distinctly became willows, unlike the undefined deciduous trees of the earlier pictures. Below the first compositional sketch he not only made close studies for the figures on the road and for the

marsh grasses sprouting from the river shore but noted the identity of the trees and of several light and aerial phenomena: "water blue as mountain shadows," "wheel tracks lighter than [road?]," "fence light," and "willows warm green." The reference to "fence light" seems at variance with the silhouetted form of the fence in both the sketches and the painting, except for the contrasting sunlight that highlights the top and glows between the slats—which is probably what the artist was referring to. Gifford transferred the sketch and his verbal impressions fairly directly to the painting, with one important alteration: he extended the composition of this drawing (and of his earlier versions of the subject) considerably to the right. The Catskills in the background assumed more prominence from the clear morning light that modeled

their forms and consequently took on a stronger function in the design. The artist may have contrived the peak at the far right to punctuate the composition at that end with an echo of Mount Merino's crown. Several sailboats and dwellings on the distant western shore of the Hudson supply focal highlights at the right. Subtler accents animate the busier left part of the picture: a house at the foot of Mount Merino, a distant couple in the lane, and, in the foreground, a man pushing a bateau into the river (the figure seems to have been lifted directly from Gifford's 1861 *A Lake Twilight;* cat. no. 14). The morning is nearly cloudless; the soft loaf-like forms that differentiate the sky at the upper left intentionally balance the horizontal stands of marsh grass in the foreground, and seem to have been executed—perhaps as an afterthought—by whisking off wet pigment so that the warm ground became partially exposed.

The prominent New York collector Robert Gordon purchased *South Bay, on the Hudson, near Hudson, New York*; it probably was included in the annual exhibition at the Boston Athenaeum in 1865 and again in the memorial exhibition of Gifford's work at the Metropolitan Museum in 1880. The artist adopted essentially the same compositional scheme nearly a decade later for his *Near Palermo* (cat. no. 17).

The page containing the sketch for *South Bay, on the Hudson,* includes another study of the same subject (minus the foreground features), shaded to suggest twilight or an overcast day. That sketch may well have been the source of *Mount Merino and the Catskills at Twilight* (1867; Private collection), the last known picture by Gifford of this subject.[8]

KJA

1. NAD Exhibition Record (1826–1860) 1943, vol. 1, p. 181 (1851), no. 87; *Memorial Catalogue,* numbers 42, 48, 56, 200, 205, 208, 224, 348, 378, 451.
2. On Ary see the essay by Kevin J. Avery, above; Weiss 1987, pp. 49–51; Minick 1950.
3. "Address by W. Whittredge," in *Memorial Meeting,* pp. 33–34; Weiss 1987, p. 49.
4. Weiss 1987, pp. 47–49, 245.
5. See, for example, *Mount Merino, on the Hudson* (1859; sale cat., Christie's, New York, November 29, 2001); illustrated in Alexander Gallery 1986, no. 9.
6. Weiss 1987, pp. 100–101.
7. "Seeing South Bay: The Visual Heritage of the Hudson-Mt. Merino Viewshed," cached at {http://www.warrenstreet.com/SouthBAY/southBAYphotos.htm}, October 4, 2002.
8. Discussed and illustrated in Alexander Gallery 1986, no. 14.

36

The Shawangunk Mountains, 1864

Oil on canvas, 9 x 16 in. (22.9 x 40.6 cm)
Signed and dated, lower left: S. R. Gifford / 1864
MC 372, "The Shawangunk Mountains, a Sketch. Dated 1864. Size, 9 x 15. Owned by John T. Wilson."
Collection Cheryl and Blair Effron

Gifford's first visit to the environs of Lake Mohonk in the Shawangunk Mountains must have been in the early 1850s because his *Sunset in the Shawangunk Mountains* (fig. 9) depicts a scene in that immediate locale. An 1861 trip resulted in at least two studies of the same view southwest from the vicinity of Eagle Cliff toward the escarpments known as the Trapps and the Near Trapps.[1] The Shawangunks are situated in southern New York State, and although they are not as famous as the neighboring Catskills, they include some of the most dramatically rugged scenery in the entire region.[2] The mountains are generally wild and rocky, with steep slopes and dangerous precipices formed of raised beds of hard pink and white sandstone.[3] Much of the land in the area had been cleared for farming by the early nineteenth century, but at mid-century some of the more difficult terrain, especially along the mountain ridges, had returned to wild growth.[4] Given their proximity to New York City, it was not long before the Shawangunks were attracting tourists and sportsmen, some of whom were drawn to the ten-room tavern at Lake Mohonk that was in operation by 1859.[5] For many artists and travelers, the scenery in the vicinity of the lake, with "enormous masses of granite," intricate thickets of "laurel and evergreen trees," and "magnificent views of the Wallkill and Hudson River valleys on the east, and the Warwarsing valley and the Catskills on the west," surpassed even that of the famous Catskill Mountain House farther to the north.[6] Gifford's 1854 painting and the two sketches from his 1861 visit indicate that he was among the first to recognize the scenery's artistic potential.

Gifford's return to the area in 1864 is documented in a sketchbook drawing (see fig. 106) and in four works listed in the *Memorial Catalogue: The Shawangunk Mountains, a Sketch* (no. 372; the present work), *A Sketch of Sunset from the Shawangunk Mountains, N. Y.* (no. 373), *A Sketch from the Shawangunk Mountains, N. Y.* (no. 374), and *The Shawangunk Mountains* (no. 375). The last painting, listed as 30 x 48 inches, was designated by Gifford as one of his "chief pictures," and was shown at the National Academy of Design in 1865. This may have been the work that a writer for *The New York Evening Post* saw in the artist's studio in June 1864: "Gifford is just completing another of those warm, glowing pictures so typical of summer time and characteristic of our

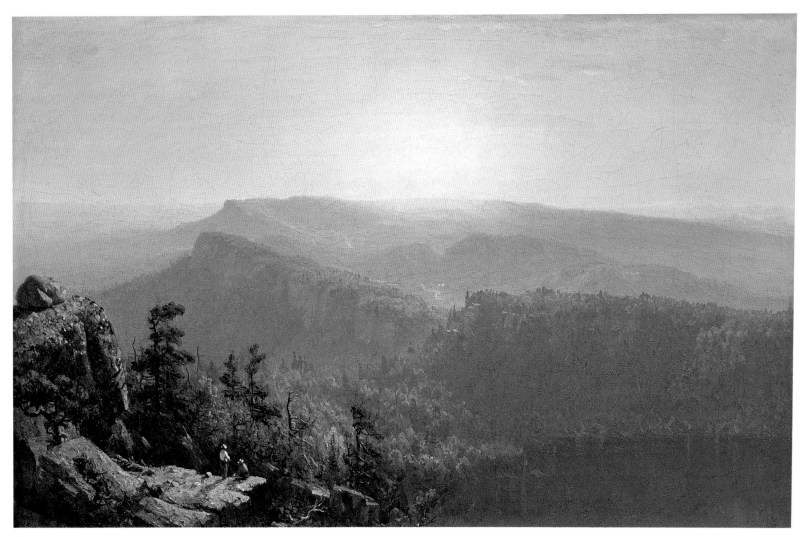

Cat. 36

Figure 106. Sanford R. Gifford. *View of the Trapps, Shawangunk Mountains* (from the sketchbook of Maine and New York subjects, 1864). Graphite on off-white paper (now darkened). Fogg Art Museum, Harvard University Art Museums, Cambridge, Massachusetts. Gift of Sanford Gifford, M.D.

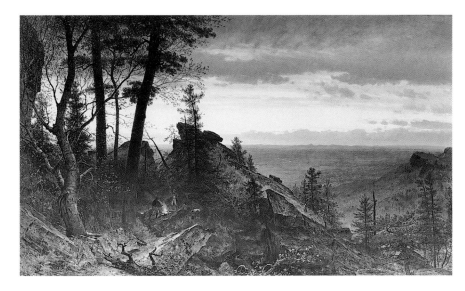

Figure 107. Worthington Whittredge. *Twilight on the Shawangunks,* 1865. Oil on canvas. Manoogian Collection

into the sunset. In Gifford's composition, the point of view is pulled back, creating a more sweeping expanse of space and revealing far more of the surrounding land-scape. The two artists' approaches to portraying the light and atmosphere of sunset also differ. Whittredge's sky is broken with long, sweeping bands of deep pink clouds and passages of yellow that balance the weight of the lower half of the composition; the sun itself is no longer visible. In Gifford's picture, the sun hangs just above the horizon, flooding the landscape with radiant light. The colors of the sky are cooler and more restrained and the features of the peaks and valleys in the distance are soft-ened by veils of luminous atmosphere.

F K

climate, in which his pencil delights and excels, entitled 'The Shawangunk,' a mountain range in Ulster county. The near hills, the deep gorge and the wide extent of country over which the eye passes before it touches the horizon, are finely depicted."[7] The critic for the *New-York Times* was even more complimentary:

The old and well-known style of the artist comes back to us here. A vast expanse of fretted mountain ridge, exposing to our view all the secret ways of those altitudes, stretches before us. The scene is suffused with that gorgeous sunlight which Mr. GIFFORD admires so inordinately. The perspective and general sense of space are superb, whilst the wholeness of the texture of the picture is thoroughly artistic. Few even of those who object to Mr. GIFFORD'S mannerisms will hesi-tate to give this fine work the position to which it is fairly

entitled. There is one thing, too, which may be conveniently mentioned here. Mr. GIFFORD'S mannerism is essentially and peculiarly his own. In its worst form it is yet redeemed by solid characteristics of great and unmistakable power.[8]

It is possible that the present work, masterfully con-ceived and with an impact that belies its relatively small size, was Gifford's final study for the finished painting. If so, it suggests that he deliberately may have chosen a different vantage point from that of his friend Whittredge, in the latter's own major depiction of Shawangunk scenery (see fig. 107), which would also be included in the 1865 National Academy exhibition.

Whittredge's painting is essentially divided diago-nally, with one half presenting a detailed depiction of trees, thickets, rocks, and hunters, and the other a view

1. These studies are listed in the *Memorial Catalogue*; no. 218: "The Traps, Shawangunk Mountains, N. Y.; a Sketch. Not dated. Size, 4 x 8. Owned by the Estate," and no. 219: "The Traps, Shawangunk Mountains, N. Y. Not dated. Size, 9½ x 15. Owned by the Estate." I am grateful to John D. Cooper of the Mohonk Mountain House, who in 1987 provided me with information about the area around Lake Mohonk.
2. See Philip H. Smith, *Legends of the Shawangunk (Shon-Gum) and Its Environs* (Syracuse, New York: Syracuse University Press, 1965); Bradley Snyder, *The Shawangunk Mountains: A History of Nature and Man* (New Paltz, New York: Mohonk Preserve, 1981).
3. *New York: A Guide to the Empire State* (New York: Oxford University Press, 1940), p. 403. The name Shawangunk was said to have derived from the Native American word for "white rock."
4. Snyder, *The Shawangunk,* p. 27.
5. Ibid.
6. Unsigned, "Lake Mohunk (Paltz Point), A New and Delightful Summer Resort" (pamphlet); quoted in Snyder, *The Shawangunk,* p. 29. Mohonk is often spelled "Mohunk."
7. "Fine Arts," *The New York Evening Post,* June 9, 1864, p. 1.
8. "National Academy of Design—East Room," *The New-York Times,* June 7, 1865, p. 4.

37

A Twilight in the Adirondacks, 1864

Oil on canvas, 10½ x 18½ in. (26.7 x 47 cm)
Signed and dated, lower right: S R Gifford [6]4
MC 344 [48.], "A Twilight in the Adirondacks. Dated 1864.
Size, 10½ x 18½. Owned by Robert Gordon."
Exhibited: Possibly Brooklyn Art Association, Fall 1875 (not
catalogued; reviewed in *The Brooklyn Daily Eagle,* December 1,
1875); The Metropolitan Museum of Art, New York,
"Memorial Exhibition," October 1880–March 1881, no. 48, as
"In the Wilderness, a Study."
Thomas Colville Fine Art, LLC, New Haven

38

A Twilight in the Adirondacks, about 1864

Oil on canvas, 11 x 18½ in. (27.9 x 47 cm)
Signed and dated, lower right: S R Gifford. 186[4 ?]
Private collection

These paintings represent two of the at least four known versions of *A Twilight in the Adirondacks.* Catalogue number 37 is closest in appearance to the "chief picture" originally purchased by Charles Ludington and exhibited at the National Academy of Design in New York in 1864, and now preserved (in a cut-down state) in the Adirondack Museum in Blue Mountain Lake, New York.

The composition of the four paintings was prefigured in several lake scenes that Gifford formulated after his trip to upper New England and Canada in 1859; these included *The Wilderness,* of 1860 (cat. no. 12).[1] Indeed, the origins of the present work may date back to about 1852, when Gifford produced *Camping-Out in the Adirondacks* (Whereabouts unknown), based on his first trip to New York State's wildest region during the previous summer.[2] The artist was reminded of the liberating sensation of living amid the "glorious forest primeval" of the Adirondacks, as he referred to them, even in Paris four years later: He was soothed by memories of "those

lakes that reflect in their crystal depths their dense fringes of pine, hemlock, maple and birch; those wooded mountains, and the wild free life. I think of them with always increasing love."[3] When he returned there in mid-September 1863, as in 1851, one of his companions was the landscape painter Richard Hubbard, and this time Gifford's good friend Jervis McEntee completed the party.[4] An almost two-week circuit in the eastern Adirondacks brought them eventually to Lake Placid and Bennett's Pond, on whose shores Gifford made the sketches that appear to have provided the raw material for *A Twilight in the Adirondacks.*[5] The drawing inscribed "Mt. McIntyre from Lake Placid–Sept 27th 1863" (see fig. 108) appears to be the closest source: The sketch features pine trees and rocks along the nearer shore and outlining the profile of Mount McIntyre, perhaps inspiring the focal peak in the background of the painting. This hypothesis is strengthened by the title of a (now lost) small painting, *Twilight on Lake Placid in the Adirondacks,* which was listed in the *Memorial Catalogue* as dated 1864 and measuring 10 x 14 inches.

Tracing the development of the composition seems complicated by the fact that the two earlier versions appear to be dated 1862—before the artist's second trip to the Adirondacks. As Weiss points out, the inscriptions on both works are ambiguous at best: The one on catalogue number 38 is possibly defaced, and the date may not even have been inscribed by Gifford; probably correctly, she ascribes them to about 1863 and 1864, respectively.[6] The smaller and very likely the earlier of the two works (Private collection) rehearses the essentially yellow post-sundown effect of the last two paintings, but in rawer, cooler terms, in gradations from the yellow-orange horizon through yellow and pale green to aqua at the top of the image. In the second version (cat. no. 38), Gifford fell back on the hotter scarlet-and-yellow crepuscular cast of his 1862 *A Winter Twilight* (cat. no. 28) and *Baltimore, 1862—Twilight* (fig. 32), even

eliminating the clouds at the top in the preceding version in accordance with the clear skies of his 1862 twilights. In catalogue number 37, the artist largely resolved his conception, returning to the yellowish cast but softening and mellowing it, making it more consistent throughout the upper register, and modifying the mountain silhouette to lessen its contrast with the sky and to allow it to recede in the distance. The latter strategy was part of a larger scheme to develop the space of the composition. It is not until catalogue number 37 that one distinctly perceives the diminution of the forested shoreline toward the focal mountain, because only now are the treetops better defined against the lightened profile of the mountain and palpably modeled by the warm, reflected light of the sky. Gifford used his pigments to drape the passages between the hills with mist, to lend them greater clarity. In general, the articulation of catalogue number 37 represents a marked advance over its predecessors. In all versions, the fire warming the campsite and its four occupants (probably, Gifford's party of artists in addition to a guide) varies in intensity and hue in keeping with the respective light and color scheme.

Critics welcomed the large version of *A Twilight in the Adirondacks* when it was included in the National Academy annual exhibition in April 1864.[7] George Arnold of *The New York Leader* acknowledged the "sweet, and pure, and poetic" qualities of Gifford's pictures in general while conceding that,

Their fault, when they have any, is lack of strength. Many of them are more like landscapes seen in dreams than real combinations of wood and rock and water and sky. . . . But in this "Twilight in the Adirondacks," everything is real. The artist has here exhibited all his good, and none of his inferior qualities. There is a wonderful liquid light in the sky—the "bed of daffodil sky" that Tennyson speaks of—and in its lovely depths the small few clouds actually float, tranquilly suspended. It is not paint, and you can't imagine it to be

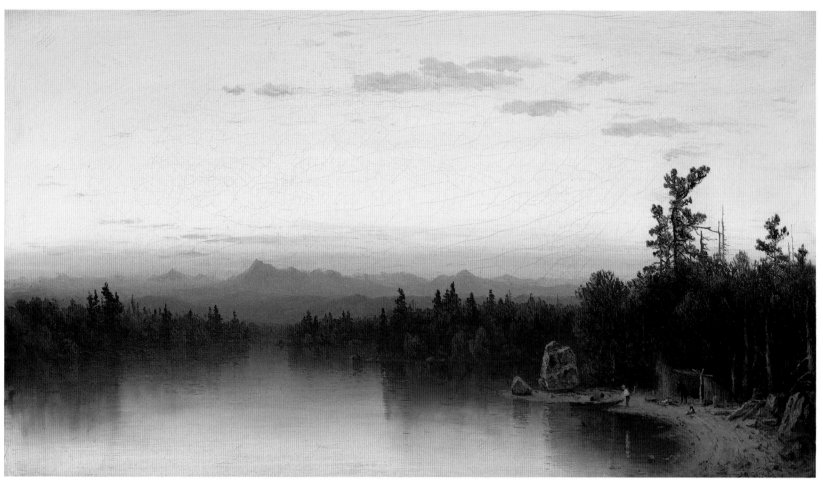

Cat. 37

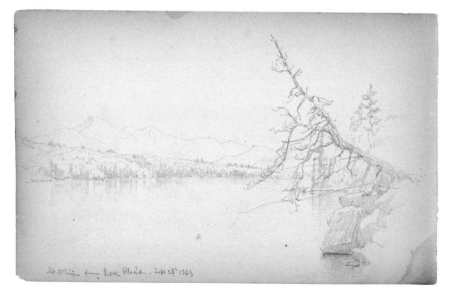

Figure 108. Sanford R. Gifford. *Mt. McIntyre from Lake Placid–Sept 27ᵗʰ 1863* (from the sketchbook of New York subjects, 1860–63). Graphite on buff wove paper. Fogg Art Museum, Harvard University Art Museums, Cambridge, Massachusetts. Gift of Sanford Gifford, M.D.

paint. It is aether and vapor. . . . The trees and mountains—the latter mingling their amaranth with the hazy gold of the sky—are reflected tremulously in the lake, and peaceful serenity reigns everywhere.

It is impossible to describe such a picture. You must see it. There is nothing remarkable about it except the effect it produces upon you.[8]

The *Post* critic distilled the liquid metaphor to typecast Gifford as a vintner:

"Winy" is the title by which Gifford must be handed down through the generations of art-literature. His Kaatskill Gorge [see cat. no. 21, A Gorge in the Mountains] was Amontillado; his present Kaatskill picture is old Madeira;

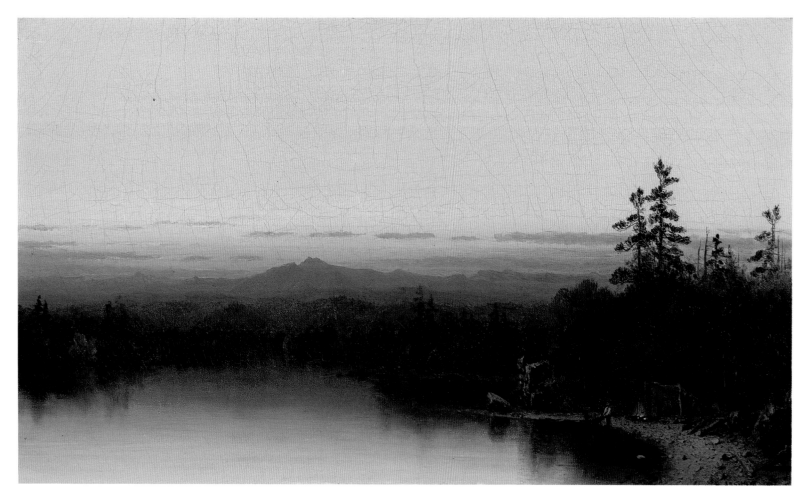

Cat. 38

his Mansfield Mountain [—Sunset] was choice port, and his [Twilight in the] Adirondacks are a glorified claret. Gifford has never painted a picture of more exquisite gradations than this last. . . . There are few men who share equally with Gifford the faculty of technical keeping. He always seems to us to have felt all his scene at once; not by bits, like a Chinese puzzle.[9]

Undoubtedly alluding to the fact-filled panoramas of Frederic Church (see fig. 15) and Albert Bierstadt, the reviewer concluded his critique by declaring, with reference to Gifford, "The creative as distinct from the collective mind is one of the surest patents of genius."[10] As late as 1875, a version of *A Twilight in the Adirondacks* was submitted to the winter exhibition of the Brooklyn

Art Association; on this occasion the *Brooklyn Daily Eagle* reviewer, like George Arnold above, distinguished the work as a "really truthful picture" compared to Gifford's "sunny canvases which have been admired more for their prettiness."[11]

K J A

1. Other examples of this type of composition, in addition to catalogue numbers 37 and 38, are *A Lake in the Wilderness, a Sketch* (about 1860; Private collection), and *Lake Scene* (1861; Addison Gallery of American Art, Phillips Academy, Andover, Massachusetts); both are illustrated in Weiss 1987, pp. 218, 220.
2. *Memorial Catalogue*, p. 15, no. 41, "Camping-Out in the Adirondacks. Size, 14 x 20."
3. Gifford, European Letters, vol. 1, p. 135; quoted in Weiss 1987, p. 98.
4. Weiss 1987, p. 98.
5. The sketchbook of New York State subjects, of 1863–65, is inscribed: "S R Gifford, 15 10th St. New York" (Harvard University Art Museums, Cambridge, Massachusetts), and on microfilm (Archives of American Art, Reel 688, frames 387–395).
6. Weiss 1987, pp. 241–42.
7. Ibid., p. 242; Mandel 1990, pp. 58–60.
8. Arnold 1864.
9. *The New York Evening Post*, May 21, 1864.
10. Ibid.
11. *The Brooklyn Daily Eagle*, December 1, 1875.

The Artist Sketching at Mount Desert, Maine,
1864–65

Oil on canvas, 11 x 19 in. (27.9 x 48.3 cm)
Signed and dated, lower right: S R Gifford / 1865 / mt. [?] /
July 22, 1864
Possibly MC 385, "A View from Green Mountain, Mount
Desert, Me. Dated 1865. Size, 12 x 19. Owned by Miss A. M.
Williams, Augusta, Me."
Exhibited: Possibly Artists' Fund Society, New York,
December 1865, no. 50, as "Green Mountain, Mt. Desert";
possibly National Academy of Design, New York, "The
Collection of Paintings of the Late Mr. John F. Kensett," 1873,
no. 789, as "A Study from Nature—Mt. Desert, by
GIFFORD."
Collection Jo Ann and Julian Ganz, Jr.

Among Gifford's best-known paintings today, *The Artist
Sketching at Mount Desert, Maine,* is notable for several
reasons. First, although relatively small in size, it is the
most ambitious and the most finished painting of
Mount Desert by him currently known. Second, the
inclusion in the scene of an artist (most likely Gifford
himself) calls attention to the fact that this is a painting,
not an imaginary window to some perceived reality.[1]
Third, the artist's paraphernalia—paint box, palette,
brushes, umbrella, campstool, and, most importantly, the
oil sketch pinned to the lid of the box—all remind the
viewer of the agency of the artist in re-creating on can-
vas what lies before him.

Gifford was at Mount Desert in 1864 and 1865. He
may have been inspired to go there by the example of
others, including Thomas Cole and Frederic Church,
who had painted there earlier. It is also possible that an
acquaintance, Dr. S. Weir Mitchell of Philadelphia, was
somehow involved.[2] Mitchell had visited Gifford's stu-
dio in New York, and also regularly summered at Mount
Desert; his connections with Gifford, however, remain
unclear. In a sketchbook drawing dated "July 15th 64"
(Fogg Art Museum, Harvard University Art Museums,
Cambridge, Massachusetts), Gifford recorded the view
seen in this painting, from Green Mountain south
toward Otter Cove. No artist before him is known to
have chosen this particular view as the subject for a
painting. The *Memorial Catalogue* lists at least ten works
by Gifford that represent Mount Desert scenery, yet
only one, number 379: "Eagle Lake, at Mount Desert,
Me." (13 x 24 inches), is larger than the present picture.[3]

Jervis McEntee was with Gifford at Mount Desert in
1864, and his oil sketch dated "July 17, 1864" (see fig. 109),
depicts a scene very like that in *The Artist Sketching at
Mount Desert, Maine.* It includes a figure in a similar pose
and location, perhaps Gifford or McEntee, although
there is no paint box or other item present to indicate
that this is a painter. Indeed, what is most striking about

Figure 109. Jervis McEntee. *Mount Desert Island, Maine,* 1864. Oil on canvas. Private
collection

Figure 110. Thomas Cole. *View from Mount Holyoke, Northampton, Massachusetts, after a
Thunderstorm—The Oxbow,* 1836. Oil on canvas. The Metropolitan Museum of Art,
New York. Gift of Mrs. Russell Sage, 1908

Cat. 39

Gifford's picture is that we, as viewers, are invited to observe an artist in the very act of creation. By locating himself in the field of vision, and by showing himself painting the scene that lies before him, Gifford acknowledged both the primacy of the natural world as inspiration, and the centrality of the artist as its interpreter. The comparison to Thomas Cole's *View from Mount Holyoke, Northampton, Massachusetts, after a Thunderstorm—The Oxbow* (fig. 110), which Gifford could have seen at the Cole memorial exhibition in New York in 1848, often has been made, and with good reason, but it is interesting, as well, to note just how different Gifford's painting is from the work of the older artist. *The Oxbow* is a classic large-scale Hudson River School composition (although one based on an actual view), with tall framing trees, a sweeping vista, and dramatic effects of light and weather. Moreover, painted when Cole was completing his monumental five-part series, "The Course of Empire" (1836; The New-York Historical Society), it, too—through its juxtaposition of wild and pastoral scenery—is a meditation on the tensions between nature and civilization. Cole himself plays a relatively minor role visually (but not thematically), being almost lost in the thickets and boulders that surround him. *The Artist Sketching at Mount Desert, Maine,* by contrast, is a remarkably spare composition of three basic elements: a triangular swath of rocks in

the foreground, an expanse of forested land in the middle distance, and a bluish gray band of sea and sky. The figure of the artist is far more prominent than in *The Oxbow,* catching the viewer's eye almost immediately. The difference, ultimately, is one of emphasis. *The Oxbow* is a landscape in which we see an artist,

but one that figures only minimally in the overall composition. *The Artist Sketching at Mount Desert, Maine,* on the other hand, is an image of an artist at work in a landscape, but here man and nature are more equally balanced.

F K

1. It is difficult to imagine that, in the present picture, Gifford has not depicted himself. Not only does the close proximity of the figure to the paint box and other items imply a personal association with them but the correspondence of the sketch pinned to the lid of the box with catalogue number 39 clearly points to Gifford's authorship.
2. John Wilmerding, *The Artist's Mount Desert: American Painters on the Maine Coast* (Princeton: Princeton University Press, 1994), p. 131.
3. *Memorial Catalogue,* numbers 365–371, 379, 385.

40

A Home in the Wilderness, 1866

Oil on canvas, 30¼ x 53⁷⁄₁₆ in. (76.8 x 135.7 cm)
Signed and dated, lower right: S R Gifford. 1866.
MC 416, "A Home in the Wilderness. Dated 1866. Size, 30 x 54. Owned by James M. Hartshorne."
Exhibited: Exposition Universelle, Paris, 1867, no. 19, as "Un Intérieur dans le désert"; National Academy of Design, New York, Exhibition of the American Society of Painters in Water Colors, "Works from the American Art Department of the Paris Universal Exposition," 1867, no. 683.
The Cleveland Museum of Art, Mr. and Mrs. William H. Marlatt Fund; The Butkin Foundation; Dorothy Burnham Memorial Collection and various donors by exchange (1970.162)

A Home in the Wilderness is one of three "chief pictures" by Gifford painted in 1866, and for several reasons may be regarded as a complement to *Hunter Mountain, Twilight* (cat. no. 41).[1] The two paintings are virtually the same size, share similar subject matter (the wilderness and rural settlements, respectively), perhaps depict complementary times of day (sunrise and twilight), and were selected to represent the artist at the Exposition Universelle in Paris in 1867. Considering these circumstances and the year in which they were painted, one is tempted to look to them for the iconography of American settlements with both ante- and postbellum overtones.

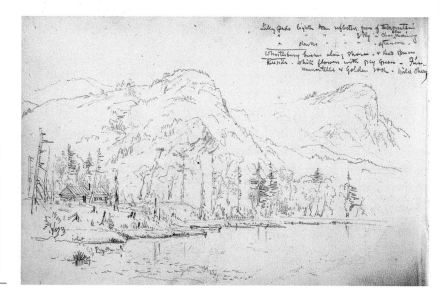

Figure 111. Sanford R. Gifford. *Sketch of Mount Hayes, Gorham, New Hampshire* (from the sketchbook of New Hampshire and New York subjects, 1865–66). Graphite on cream wove paper. The Frances Lehman Loeb Art Center, Vassar College, Poughkeepsie, New York. Gift of Miss Edith Wilkinson, Class of 1889

Figure 112. Sanford R. Gifford. "*Mount Hayes Aug 27ᵗʰ*" (from the sketchbook of New Hampshire and New York subjects, 1865–66). Graphite on cream wove paper. The Frances Lehman Loeb Art Center, Vassar College, Poughkeepsie, New York. Gift of Miss Edith Wilkinson, Class of 1889

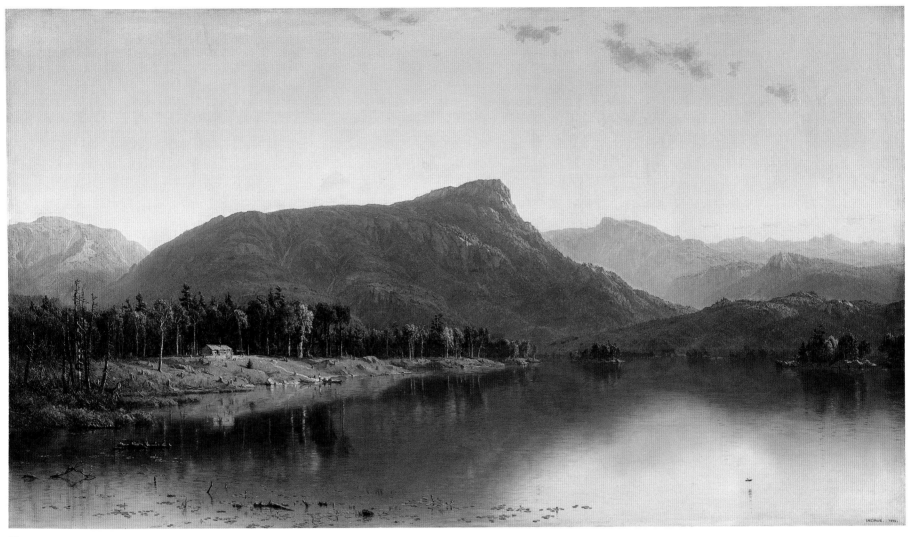

Cat. 40

Gifford's 1865–66 sketchbook opens with his drawings for *A Home in the Wilderness,* one of which is dated August 27 [1865], and also includes studies for *The View from South Mountain in the Catskills* (fig. 136); *Hunter Mountain, Twilight* (cat. no. 41); and *Hook Mountain on the Hudson River* (cat. no. 43). The adoption of a new sketchbook may indicate a break of sorts in the sketching campaign of 1865, which was resumed under somewhat trying circumstances. In July and during much of

August, Gifford worked at sites along the Massachusetts coast and in the Conway, New Hampshire, area in the company of the landscape painter and collector James Suydam, who was in delicate health. In late August, Gifford headed north for Gorham, New Hampshire, while Suydam stayed behind, intending to follow shortly. Scarcely had Gifford completed several sketches of Mount Hayes (see fig. 111, 112), northeast of Gorham, when a telegram called him back to Conway and alerted

him to Suydam's worsening condition. He nursed the artist—evidently at the expense of his own health—until Suydam's brothers arrived in early September and they and the attending doctor insisted that Gifford leave. He sketched Mote Mountain and the Saco River Valley on September 3 and 5; the hiatus in the sketchbook between those dates and September 23, when he was in the Catskills working on the drawing for *Hunter Mountain, Twilight,* undoubtedly partly reflects the

pause for Suydam's funeral following his death in New York on September 15.[2]

What probably attracted Gifford to the setting of Mount Hayes was its evocation of the "home in the woods" landscapes of Frederic Church and especially of Thomas Cole. In 1847, the date of Gifford's first exhibition in New York, Cole's *Home in the Woods* (Reynolda House, Museum of American Art, Winston-Salem, North Carolina; see the similar *Hunter's Return* by Cole, fig. 5) was hailed in the annual show at the American Art-Union.[3] With its differently proportioned foreground and background motifs, Cole's composition prefaces, in reverse, the arrangement of lake, mountain, and backwoods log cabin that Gifford came upon at Mount Hayes. Indeed, the sphinx-like profile of Mount Hayes that evolved in the painting virtually echoes the mountain on the horizon in Cole's picture. In such works as *Home by the Lake* (Collection Jo Ann and Julian Ganz, Jr.), Cole's pupil Frederic Church presaged the relationships in scale of mountain and cabin that Gifford not merely discovered in the rustic scene at Mount Hayes but that he would exaggerate in the course of sketching there. Besides the mountain, his initial drawing (fig. 111) recorded, at close hand, the cabin near its base, and included detailed (for Gifford) notes on the appearance of such features as the lily pads in the water in morning and afternoon light. On the following page, dated August 27 (see fig. 112), he deftly sketched those lily pads, and some fallen logs, on the foreshortened plane of the water. By then, he had also withdrawn from the vicinity of the cabin to the opposite shore of the lake to compose the larger aspect of the mountain and its environs from afar, the impression that formed the basis for his only known oil study of the subject (Collection Jo Ann and Julian Ganz, Jr.). Before leaving Mount Hayes, he drew the summit once more from an angle that accentuated its thrust and sharpness, approximating the effect he would seek in the oil study and even emphasize in the large painting that followed.

The study, measuring about 9 x 15 inches, embellished the composition, with the familiar aim of amplifying the conception. Gifford cleared the immediate foreground

of shoreline, leaving only a scattering of lily pads and drifting logs, and his relegation of the major forms to the middle distance and the background was reminiscent of the composition of Mount Katahdin seen on the distant lakeshore in his *The Wilderness* (cat. no. 12). Beyond Mount Hayes, he contrived a succession of summits, varying the profiles as well as the light that pervades so many of his works, usually to indicate either an early or late time of day. The exact hour is at best ambiguous. Ila Weiss and at least one of Gifford's contemporaries believed that the time is evening. Weiss justified her supposition based on Gifford's inscription that the lily pads were "darker than reflected sky in afternoon," as they appear in the painting (and, correspondingly, "lighter than reflected sky in clear blue morning").[4] However, it could be argued as readily that Gifford had sunrise on his mind as he painted the study and the first large version, for his notes certainly indicate that he was at the site in the "clear blue morning" and "afternoon" but not at sundown. He surely drew Mount Hayes from the west, facing east, for its orientation is north to south with its summit to the south. Finally, a dawn or sunrise effect, as stated above, complements the twilight setting of *Hunter Mountain*, Gifford's other homestead scene of 1866, the original drawing for which was executed less than a month later than the one for Mount Hayes, and which was partnered with *A Home in the Wilderness* at the Exposition Universelle.

In this "chief picture," Gifford widened the proportions of the canvas (as he did with *Hunter Mountain, Twilight*), darkened and honed the silhouette of Mount Hayes and its reflection, and reduced the scale of the forest, especially on the right. Gifford evidently had trouble completing *A Home in the Wilderness*. In a letter of February 1, 1866, he wrote that he had accomplished "one picture and a half" that winter, describing the finished work as a "large upright picture . . . [with] as much light and sunshine as I could squeeze out of my paint tubes."[5] The upright picture undoubtedly was *An October Afternoon* (Whereabouts unknown), reportedly measuring 54 x 31 inches, which he submitted to the National Academy exhibition that spring along with

Hunter Mountain, Twilight. The "half-done" painting that he worked on for "about six weeks, and then was obliged to abandon" must have been catalogue number 40. However, by February 27, a *New York Evening Post* critic reported that Gifford had "just finished one of his finest works, a large and beautiful landscape called 'A Home in the Wilderness' . . . a picture most refreshing to the tired eye and overworked brain, and imparting to the spectator something of its own harmony and serenity." The critic continued in this vein, speaking clearly to the tonic influence of second-generation Hudson River School painting on a society wearied by war and the pressures of the industrial urban milieu that America was fast becoming:

When we think what human life, even daily experience, is to the most of us, a disordered, broken, incongruous, intermittent thing at best, often unsightly as a ragged edge or a threadbare surface, and full of failures or beginnings, we are the more surprised and delighted by Mr. Gifford's works. . . . If you would look at a landscape that expresses the sweetness of dignity and the beauty of repose, you must look at Gifford's "Evening over the Settler's Home" [A Home in the Wilderness], *and you will not have to look long before the dreamlike beauty of nature will have replaced all the torturing cares that sit enthroned as kings, or ranged as jailors, in your most personal life. It is just here that the ministry of the beautiful is illustrated, and we are made to feel how various and finely we are organized; how well we are protected by these side influences from the insanity of one impression, one idea, one thought. Genius is God's commissioned agent to lift men out of grooves, to change their impressions, to soothe them when they are in tumult, to rouse them when they stagnate.*[6]

Deep appreciation notwithstanding, *A Home in the Wilderness*, unlike *Hunter Mountain, Twilight* was not sent to the National Academy of Design exhibition in April. It reappeared, with *Hunter Mountain*, at the Exposition Universelle, and, with the contingent of works selected for that venue, it was shown again at the exhibition of the American Society of Painters in Water Color later in 1867 at the National Academy. At the Paris Exposition, where the American pictures were

hung at "the fag end of a gallery," according to a British critic, *A Home in the Wilderness* garnered no specific comment.[7] However, a lithograph reportedly was made of the painting by Goupil's in Paris in 1867. By 1880, the painting had been sold to James M. Hartshorne; it is not known to have been seen again until the late 1960s, when it surfaced at a New York dealer's and, in 1970, was purchased by The Cleveland Museum of Art. A second large version of *A Home in the Wilderness* (Hunter Museum of American Art, Chattanooga) is said to have

been begun by Gifford about 1867 or 1869 but was left unfinished at his death, and was completed by John Bunyan Bristol at the request of Gifford's widow.[8]

KJA

1. Weiss 1987, p. 328. Besides *Hunter Mountain, Twilight*, the other "chief picture" was *A Passing Storm in the Adirondacks* (cat. no. 44).
2. Ibid., pp. 103–5.
3. See the glowing review of *Home in the Woods* in the October 23, 1847, issue of *The Literary World* (New York); quoted in Parry 1988, p. 339, fig. 275. For an expanded discussion of Gifford's picture in relation to Cole's see Weiss 1987, pp. 253–55.
4. Weiss 1968/1977, p. 260. See also *The New York Evening Post* review quoted in the text (see note 6, below).
5. Letter from Sanford Robinson Gifford to the Wheelers in Rome, New York, February 1, 1866, in Gifford Family Records and Letters, vol. 3.
6. *The New York Evening Post*, February 27, 1866.
7. *The Art-Journal* 1867, p. 248.
8. A copy of the report on Gifford's *A Home in the Wilderness* by Ila Weiss, dated December 4, 1996, is in the file on the present painting at The Cleveland Museum of Art.

41

Hunter Mountain, Twilight, 1866

Oil on canvas, 30⅝ x 54⅛ in. (77.8 x 137.5 cm)
Signed and dated, lower right: S. R. Gifford 1866.
Inscribed, on the verso: Hunter Mountain / S. R. Gifford pinxit MC 417 [20.], "Hunter Mountain, in the Catskills, after Sunset. Dated 1866. Size, 30½ x 54. Owned by J. W. Pinchot."
Exhibited: National Academy of Design, New York, 1866, no. 360; Exposition Universelle, Paris, 1867, no. 18, as "Twilight on Mt. Hunter"; National Academy of Design, New York, Exhibition of the American Society of Painters in Water Colors, "Works from the American Art Department of the Paris Universal Exposition," 1867, no. 669, as "Twilight on Mount Hunter"; Yale School of Fine Arts, New Haven, 1870, no. 10, as "Hunter Mountain," and July 6, 1871, no. 85, as "Twilight on Hunter Mountain," and 1871, no. 53, as "Twilight on Hunter Mountain, Catskill," and 1874, no. 44, as "Hunter Mountain, Catskill," and 1875, no. 10, as "Hunter Mountain, Catskill"; National Academy of Design, New York, "Loan Exhibition in Aid of the Society of Decorative Arts," 1878, no. 82, as "Hunter Mountain"; The Metropolitan Museum of Art, New York, "Centennial Loan Exhibition of Paintings," 1876, no. 181, as "Hunter Mt., Catskills"; The Metropolitan Museum of Art, New York, "Memorial Exhibition," October 1880–March 1881, no. 20, as "Hunter Mountain, Catskill Mountains." Terra Foundation for the Arts, Daniel J. Terra Collection, Chicago

Hunter Mountain, Twilight, was one of Gifford's most-acclaimed pictures in his lifetime, and, since it resurfaced in the 1960s, it has regained much of its reputation. Then, as now, viewers have been struck by its simple eloquence, and, indeed, by its somberness in relation to the sun-suffused vistas of such works as *Mansfield Mountain* (cat. no. 8) and *A Gorge in the Mountains* (cat. no. 21) with which the artist became so quickly identified—an association that is still true today. As a result of the recent rediscovery as well of *A Twilight in the Catskills* (fig. 12), we now know that the moving, even stark, effect of *Hunter Mountain, Twilight*, had a precedent in a major painting by Gifford of nearly identical dimensions exhibited at the start of the Civil War. As with *A Lake Twilight* (cat. no. 14) and *Baltimore, 1862—Twilight* (fig. 32), in *Hunter Mountain, Twilight*, Gifford clearly resolved to avoid the brooding and brutish features of *A Twilight in the Catskills*, although in its size, subject, and light effects it more closely recalls that picture than the others cited. In a somewhat different way from *A Twilight in the Catskills* —for example, the juxtaposition in *Hunter Mountain* of the blue form of the mountain silhouetted against the horizon of a yellow sky—the artist pays homage here,

too, to Frederic Church's *Twilight in the Wilderness* of 1860 (fig. 3).

The composition of *Hunter Mountain, Twilight*, originated in a single small pencil study (see fig. 113) made in late September or early October 1865, during a Catskill sketching campaign that also yielded the original drawings for the much later *The View from South Mountain, in the Catskills* (fig. 136).[1] As he had earlier, Gifford returned to his favorite local haunt, the ledges of South Mountain that formed the southern rim of Kaaterskill Clove. From there he must have walked around the western terminus of the clove past Haines Falls and up the rise, to the recently cleared land above what is today a private community called Twilight Park (in the town of Haines Falls; see cat. no. 25). There, he discovered the scene that gave rise to the composition of the painting: the recumbent ridge of Hunter Mountain framed by gently rising slopes at either side. Nestled in the shallow valley east of the mountain was a stump-littered clearing with a house and barn and a few cows, suggesting a dairy farm. The lightly indicated contours of the forms in the drawing give no indication of the time of day that Gifford was there.

In the course of the fall and possibly the winter, the artist developed the idea in as many as three small oil studies. Probably the earliest and most diminutive of these, measuring 7¼ x 11½ inches (Private collection), follows the drawing most closely. It retains something of the drawing's crowdedness while establishing the warm, pervasive twilight gloom and yellowish horizon, sun-gilded cloud accents, and sickle moon prefigured in the artist's *A Winter Twilight* (cat. no. 28) of 1862. Already here, too, Gifford began to develop the staffage by adding a human figure, a farmer driving the cows toward the barn in the middle distance. In a seventeen-inch-wide study dated October 9, 1865 (see fig. 114)—executed only weeks, at most, after the drawing—Gifford embellished the foreground, inserting more stones among the stumps, and introduced the narrow streamlet for the cows. This reflective accent in the terrain helped clarify the diagonal spatial progression from the left foreground to the dwelling in the middle distance at the right.

In the large painting, Gifford significantly amplified the whole conception by widening the proportions of the picture to twice the height, extending the principal motif by stretching its whale-like hump, and adding two overlapping peaks at the right. With a gray wisp of smoke rising from the settlement at its base, in the distance, Hunter Mountain assumes a grandeur in repose reminiscent of that of the great Cordillera range occupying the background of Church's *The Heart of the Andes* (fig. 15). The artist also reduced in number and size the stumps and stones in the October 9, 1865, study, so that they would not compete with the impression of the mountain, would allow the light of the sky to be reflected calmly in the foreground depression, and would mirror to some extent the mountain's form. Accordingly, the whole middle distance, trees, and buildings appear diminished in size and presence beneath the great hill looming beyond them. Indeed, it is remarkable to observe how, in the presumed progression from original drawing to final painting, the barely visible ridge of Hunter Mountain sleeping beyond a random-looking human settlement assumes pictorial preeminence. The simplified features of the painting are further enlivened in a curious fashion not notable in Gifford's other "chief pictures." Employing a technique detectable in numerous oil studies, the artist stippled the fresh paint layer of the mountain and plain with the dry bristles and, perhaps, the butt end of his brush, revealing the beige ground, to convey the texture of distant foliage. The technique also literally perforates the mountain forms, aerating them with the declining light.

Although Gifford's studies indicate that he conceived the painting in the fall, he may not have begun the large picture until the following winter. As late as February 27, 1866, a critic who praised the artist's *A Home in the Wilderness* as having just been completed failed to cite the presence in the studio of *Hunter Mountain, Twilight*;[2] thus, it probably had not yet been started or, less likely, was not in a presentable state. Parts of the surface (as described above) suggest that the picture was painted with little hesitation. At any rate, the work was delivered to the National Academy of Design by the opening of the annual spring exhibition in late April, by which

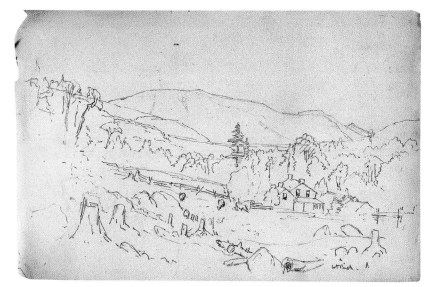

Figure 113. Sanford R. Gifford. Sketch for *Hunter Mountain, Twilight* (from the sketchbook of New Hampshire and New York subjects, 1865–66). Graphite on cream wove paper. The Frances Lehman Loeb Art Center, Vassar College, Poughkeepsie, New York. Gift of Miss Edith Wilkinson, Class of 1889

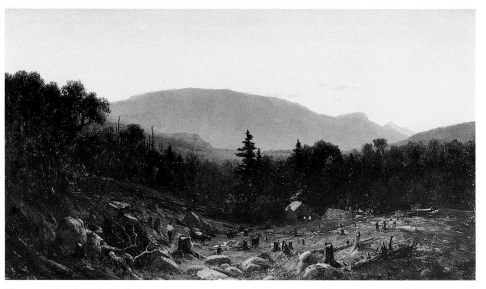

Figure 114. Sanford R. Gifford. *A Sketch of Hunter Mountain, Catskills,* October 9, 1865. Oil on canvas. Collection James D. Terra

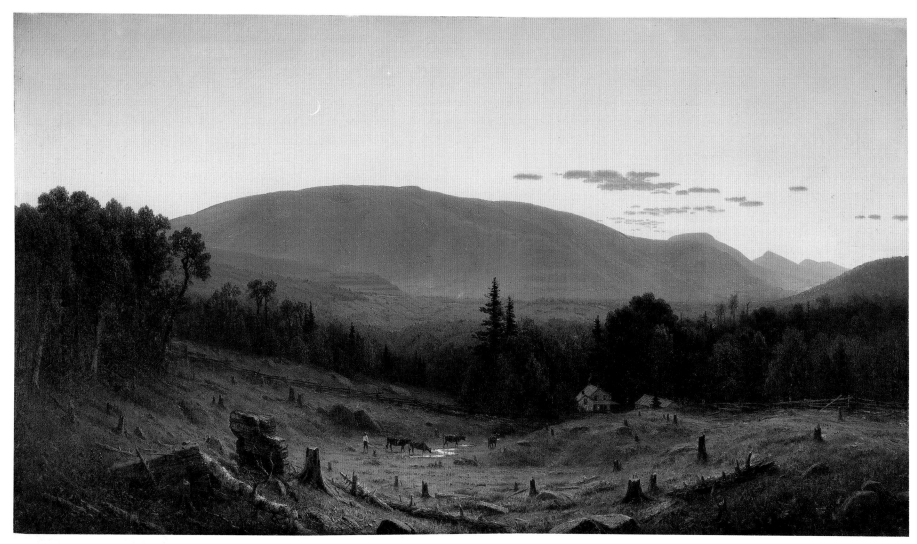

Cat. 41

time it had already been sold to the prominent merchant and close friend of Gifford and his colleagues, James W. Pinchot.[3] (Gifford was godfather to Pinchot's first son and his namesake, Gifford, born a year earlier, who would go on to become America's first professional forester.)[4]

Gifford's success with *Hunter Mountain, Twilight,* may be measured by the response of Clarence Cook, critic of the *New-York Daily Tribune,* chief American advocate of the English aesthete John Ruskin's "truth to nature" credo, ardent champion of the American Pre-Raphaelites, and the bane of the New York school of landscape painters. Contrasting the painting with the "unhealthy vagaries" of *An October Afternoon* (Whereabouts unknown)—Gifford's other entry in the National Academy exhibition—and, doubtless, like *A Gorge in the Mountains* (cat. no. 21), the type of picture for which the painter was renowned, Cook allowed that *Hunter Mountain, Twilight,* "has in it a finer mountain range than we have seen this many a day on canvas. . . . May we not hope that the pleasure his 'Hunter Mountain' has given, *may* move Mr. Gifford to employ his undoubted talent in faithful renderings of nature rather than in those fantastic and unreal landscapes in which he seems so much to delight, and which can have no meaning and no satisfaction for any one familiar with the aspects of nature herself."[5]

Even for the artist's partisans, Gifford's *An October Afternoon,* although admired for being "classic in design, mellow in color, and glowing and luminous without broadness of effect," fell short. It lacked the

novelty [of] the impressive landscape entitled 'Hunter Mountain, Twilight,' that best expresses the intensity and disciplined strength of Mr. Gifford's genius. A more perfect piece of mountain drawing, or a more wonderful rendering of the lovely and intense color of a mountain form at twilight, we have never seen. . . . What an idea of silence and endurance is expressed by that mountain! its large flowing outlines smiting abruptly against the fading light, resting there sentinel-like, while Night creeps into every cleft of its mighty sides, and the last clouds linger, and flush and deepen in tint as the sun goes from the lucid air. What depth and clearness of tone! what largeness and delicacy of form! Certainly Mr. Gifford knows the mountain, and he has expressed with intensity and grace the solemnity of the color and the beauty of his subject. . . . We may say of [Hunter Mountain], as George Sand said of the Requiem of Mozart—one could write a fine poem while listening to it, but it would be a poem only, and not a description or a translation; so in looking at "Hunter Mountain Twilight," one might be moved to say many fine words, but they would be words and not the picture; the picture is complete, and in art an accomplished fact, and it renders futile any new expression.[6]

Hunter Mountain, Twilight, and *A Home in the Wilderness* were selected for inclusion in the Paris Exposition Universelle in 1867, along with the works of seventy other American artists. Even before that, however, foreign critics had taken notice of the picture—among them, a Briton who "stood with pleasure" in front of it at the National Academy and perceptively observed "from the nature of the subject . . . [that it had] a more sombre character than the majority of Mr. Gifford's pictures. There is a fine feeling of the mystery of twilight in it, and great variety of detail in the foreground objects."[7] The American contributions to the exposition had been tardily chosen and the entries poorly hung. All but ignored by French critics, Gifford's pictures were cited by other British reviewers for being "poetic in thought, and warm in tone."[8]

K J A

1. See Weiss 1987, pp. 259–60, for a similar discussion of the painting's formulation.
2. *The New York Evening Post,* February 27, 1866; quoted in the discussion of catalogue number 40.
3. NAD Exhibition Record (1861–1900) 1973, vol. 1, p. 341, 1866, no. 360.
4. Char Miller, *Gifford Pinchot and the Making of Modern Environmentalism* (Washington, D.C.: Island Press/Shearwater Books, 2001), pp. 34, 108–11; see also the letter from Sanford Robinson Gifford to his father, Elihu Gifford, Astoria, Oregon, August 10, 1874, in which the artist tells of a visit to a relative of James Pinchot's wife, who showed him "a portrait of my Godchild Gifford Pinchot."
5. Cook 1866.
6. Benson 1866b.
7. "Fine Arts. National Academy of Design. II," *The Albion* 44, no. 19 (May 12, 1866), p. 225.
8. *The Art-Journal* 1867, p. 248.

Morning on the Hudson, Haverstraw Bay, 1866

Oil on canvas, 14¼ x 30¼ in. (36.2 x 76.8 cm)
Signed and dated, lower left: S. R Gifford . 1866
MC 426 [101.], "Morning on Haverstraw Bay in the Hudson.
Dated 1866. Size, 14 x 30. Owned by George Whitney,
Philadelphia, Penn."
Exhibited: Possibly Artists' Fund Society, New York, 1866,
no. 40; The Pennsylvania Academy of the Fine Arts,
Philadelphia, 1867, no. 82; The Metropolitan Museum of Art,
New York, "Memorial Exhibition," October 1880–March 1881,
no. 101, as "Morning on the Hudson."
Terra Foundation for the Arts, Daniel J. Terra Collection,
Chicago

Hook Mountain on the Hudson River, 1867

Oil on canvas, 12 x 9 in. (30.5 x 22.9 cm)
Signed, lower right: S R Gifford; dated, lower left: 1[8]67
MC 440, "Hook Mountain on the Hudson River. Dated 1867.
Size, 11 x 13. Owned by Mrs. R. F. Wilkinson, Poughkeepsie,
N.Y."
Private collection

Studies for *Morning on the Hudson, Haverstraw Bay,* and
Hook Mountain on the Hudson River originated within
the space of a few hours or, at most, days, in late
September 1866, but only drawings for the latter are
known.[1] They follow studies in the sketchbook including
Gifford's "Campaign of the Season" of 1866, his third
excursion to the Adirondacks, and precede drawings of
the Catskill Mountain House. As Weiss points out, the
artist's interest in visiting that part of the river may have
been prompted by his having seen a painting by his
friend James Suydam, *Hook Mountain, Hudson River*
(Whereabouts unknown), either at the National
Academy of Design in 1866, following the latter's death,
or perhaps in 1863, when it was first exhibited and

elicited high praise.[2] Other artists explored the subject of
Hook Mountain at this time, among them Albert
Bierstadt and Samuel Colman.[3]

Gifford's viewpoints for both pictures are within sev-
eral miles of each other on the eastern shore of the
Hudson River, and his earliest known images—in the
case of *Morning on the Hudson, Haverstraw Bay,* a beau-
tiful oil study possibly made on site (see fig. 115)—indi-
cate morning and late-afternoon working sessions. The
direction of the views, moreover, is complementary:
Morning on the Hudson looks northwest from Ossining,
New York, from the immediate vicinity of the famous
Sing Sing Penitentiary. The focal mountain, on the
western shore at Haverstraw, New York, is High Tor, ris-
ing more than eight hundred feet above the river. Hook
Mountain, viewed toward the southwest from the south-
ern shore of Croton Point, about two miles north of
Ossining, is second in height only to High Tor among
the Palisades that line the river's western shore from
New York City to Haverstraw.[4] It is distinctly possible
that, initially, Gifford entertained the idea of the two
subjects as pendants. *A Study of Morning on Haverstraw
Bay, Hudson River* (fig. 115), is nearly the same size (9 x 19
inches) as *Hook Mountain, near Nyack, on the Hudson* (8⅛ x
19 inches; fig. 116), the earliest of his extant paintings of
Hook Mountain; both pictures remained in Gifford's
possession until his death. Ultimately, however, perhaps
due to a specific commission, the artist developed the
two subjects independently, beginning with *Morning on
the Hudson, Haverstraw Bay.*

It is easy to see the appeal of the former subjects with
reference to the artist's own Turneresque Lake Maggiore
(see fig. 130) and Lake Garda works (see cat. no. 33), exe-
cuted during and after his first trip to Europe of 1855–57.
Study of Morning on Haverstraw Bay, indeed, may have
been painted wholly, or perhaps partly, on site. However,
the lone shad boat at the center anchoring the composi-
tion of hills rising from a distant shoreline owes too

much to the scheme of his earlier European subjects to
be merely an incidental record—and, after all, the par-
ticular location on the river lent itself to an analogous
pictorial strategy. Haverstraw Bay and the adjoining
Tappan Zee are the widest (about three miles) parts of
the Hudson River and those most resembling lakes.

Morning on the Hudson went through at least two
stages of development. The earliest study (see fig. 115)
suggests that the artist observed the site after sunrise, for
the overall tonality is dictated by the cool blues of the
sky and water, except for the warm beige clouds and
their reflections that he achieved by wiping off pigment
to reveal the ground. Perhaps the barely larger version
of the composition dated 1868 (Private collection) was
begun in 1866, for there Gifford began to warm the
composition with the introduction of pink in the cloud
band for a pre-sunrise effect. He multiplies the number
of sailboats balancing the composition at the left and
right and plots the space back to them with two more
shad boats. In catalogue number 42, as in many of
Gifford's "chief pictures," the overall tonality became
decidedly warmer, the position of the shad boats was
adjusted, the sailboats at the left were reduced in scale,
and even the string of fishnet floats trailing from the
focal shad boat assumed a more lyrical curve, echoing
the slopes of High Tor directly above it.

At least four drawings of Hook Mountain rehearse
the motifs and designs of the one horizontal and at least
three vertical vignette-style versions of the subject.
These last pictures revive the scheme of *A Sketch on the
Huntington River, Vermont* (cat. no. 18), and prefigure
Kauterskill Falls (cat. no. 52) of 1871. Gifford's initial
sketch was probably the one where he actually ruled the
plane of the Hudson River on which he would build his
outline of Hook Mountain (see fig. 117). Then he turned
the sketchbook vertically, and at the top of the opposite
page he worked out a summary composition derived
from the larger sketch in which he included a curving

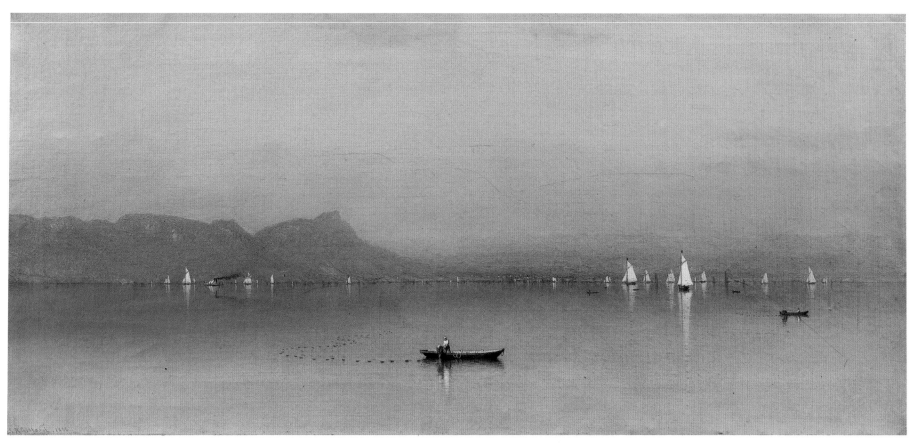

Cat. 42

Figure 115. Sanford R. Gifford. *A Study of Morning on Haverstraw Bay, Hudson River*, 1866. Oil on canvas. Private collection, New England

Figure 116. Sanford R. Gifford. *Hook Mountain, near Nyack, on the Hudson*, 1866. Oil on canvas. Yale University Art Gallery, New Haven. Given by Miss Annette I. Young in memory of Professor D. Cady Eaton and Mr. Innis Young

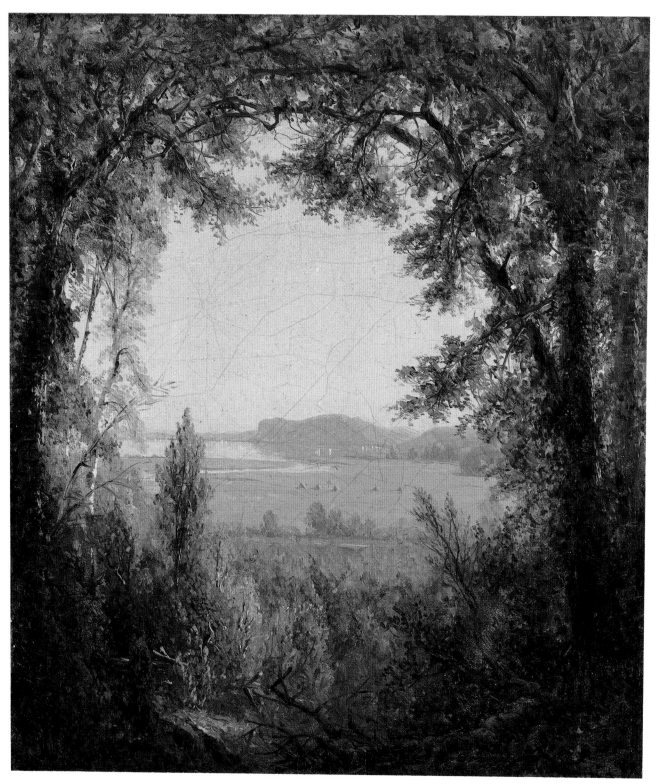

Cat. 43

Figure 117. Sanford R. Gifford. *Study of Hook Mountain* (from the sketchbook of New Hampshire and New York subjects, 1865–66). Graphite on cream wove paper. The Frances Lehman Loeb Art Center, Vassar College, Poughkeepsie, New York. Gift of Miss Edith Wilkinson, Class of 1889

Figure 118. Sanford R. Gifford. Study for *Hook Mountain, near Nyack, New York* (from the sketchbook of New Hampshire and New York subjects, 1865–66). Graphite on cream wove paper. The Frances Lehman Loeb Art Center, Vassar College, Poughkeepsie, New York. Gift of Miss Edith Wilkinson, Class of 1889

Figure 119. Sanford R. Gifford. Compositional studies for *Hook Mountain on the Hudson River* (from the sketchbook of New Hampshire and New York subjects, 1865–66). Graphite on cream wove paper. The Frances Lehman Loeb Art Center, Vassar College, Poughkeepsie, New York. Gift of Miss Edith Wilkinson, Class of 1889

beach in the foreground prefiguring the horizontal painting (see fig. 118). Under this composition he made a separate sketch of the tower of an Italian-style villa near the tip of Croton Point, undoubtedly the residence of R. T. Underhill, M.D., who, with a brother, owned the peninsula.[5] The tower reappears only in the horizontal painting. On the following double page of the sketchbook (see fig. 119), Gifford virtually repeated the first drawing, but added delicate shading to indicate the afternoon light catching the mountain's crest and the tops of the trees on Croton Point in the foreground. Encircling the central part of this drawing is a ghostly wreath of what appear to have been conifer sprigs once pressed into the pages of the sketchbook. They suggest the vignette-like composition that Gifford drew at the top of the same double page turned vertically. Presumably, the vignette was executed on site, for the artist annotated it with the names of the trees—"walnut & ivy / Young locusts / oak & ivy"; he also seems to have retreated inland from Croton Point to a place more distant from Hook Mountain than is suggested in the other studies.

Catalogue number 43 is the smallest and probably the earliest of the three known versions of Hook Mountain based on the vignette drawing.[6] In these works, the spatial planes increased by at least one, with the insertion in the foreground of the overarching trees and, in the middle distance, of a broad tract of marsh complete with a winding creek and haystacks replacing the curving beach in the horizontal version. The peculiar hump of the mountain itself is further removed from the viewer than in the horizontal painting but its presence is emphasized not only by the arboreal arch but by a tree at the left that blocks the view of the Palisade headlands beyond Hook Mountain to the south. The atmosphere in catalogue number 43 looks virtually cloudless; in the succeeding vertical versions, which increase incrementally in size to $16\frac{1}{4}$ x 14 inches, Gifford embellished the cumulus clouds that softly, and in miniature, repeat the arch of the trees.

The ultimate version of *Hook Mountain on the Hudson River* was sold to Gifford's patron and good friend Richard Butler.[7] However, the composition never seems to have been amplified to the size of most of Gifford's "chief pictures," and, unlike *Morning on the Hudson, Haverstraw Bay,* no nineteenth-century exhibitions of Gifford's Hook Mountain paintings are known. It may be simply that the artist never received a commission for a large version of the subject, or else that he preferred that his effort not be compared with that by his lamented late colleague Suydam. K J A

1. A sketchbook of New Hampshire and New York subjects is in the collection of The Frances Lehman Loeb Art Center, Vassar College, Poughkeepsie, New York (38.14.4), and on microfilm (Archives of American Art, Reel D254); the Hook Mountain drawings are frames 129, 130.
2. Weiss 1987, p. 260.
3. For Bierstadt's *View on the Hudson Looking across the Tappan Zee toward Hook Mountain* (1866; Private collection) see *Important American Paintings, Drawings and Sculpture*, sale cat., Sotheby's, New York, December 5, 1985, no. 61; for Colman's *Looking North from Ossining, New York* (1867; The Hudson River Museum, Yonkers, New York), see Howat 1972, pl. 25.
4. For information about Hook Mountain and High Tor see Wilfred Blanch Talman, *How Things Began . . . in Rockland County and Places Nearby* (New City, New York: The Historical Society of Rockland County, 1977), p. 55; Paul Wilstach, *Hudson River Landings* (Indianapolis: The Bobbs-Merrill Company, 1933), p. 215; David Cole, *History of Rockland County, New York, with Biographical Sketches of Its Prominent Men* (New York: J. B. Beers & Co., 1884), p. 17.
5. Lossing 1866, pp. 303–4.
6. The other two versions are also in private collections: one is no. 439 in the *Memorial Catalogue*; the other is not listed.
7. See the *Memorial Catalogue*, no. 439 [43.], where the picture is listed as "Hook Mountain, near Nyack, N. Y."; it is illustrated, as an engraving, opposite page 33, and entitled "Rockland [On the Hudson]."

A Passing Storm in the Adirondacks, 1866

Oil on canvas, 37¾ x 54 in. (95.9 x 137.2 cm)
Signed and dated, lower right: S R. Gifford. 1866.
MC 428, "A Passing Storm in the Adirondacks. Dated 1866.
Size, 37 x 54. Owned by Mrs. Samuel Colt, Hartford, Conn."
Wadsworth Atheneum, Museum of Art, Hartford. Bequest of
Elizabeth Hart Jarvis Colt

Gifford began work on the painting *A Passing Storm in the Adirondacks* in the spring of 1866 on the express commission of Mrs. Samuel Colt, the wife of the renowned firearms manufacturer from Hartford, Connecticut. Mrs. Colt was then completing an elaborate picture gallery on the second floor of her mansion, Armsmear, and was ordering pictures from a variety of contemporary artists, including Frederic Church and Albert Bierstadt.[1] Gifford undoubtedly felt some pressure about the prestige of the commission, for in June he sent Mrs. Colt an elaborate description of the work in progress so that she might "know what to look for":

The scene, though not intended to be exact as a portrait, is founded on a view in the Adirondack Mountains. The time is about 3 o'clock in the afternoon of a summer day. Over the large mountain which fills the middle of the picture there is passing a thin, illuminated, veil of rain, which gradually thickens to the extreme right into a dense shower. From a wide opening in the sky over the mountain the sunlight bursts from behind a cloud, and passes over the whole central portion of the picture, illuminating the rain-veil, the rugged flanks of the mountain, the foot-hills, and the valley below. A still stream winds through the meadows at the bottom of the picture. On a low point under a mass of trees on the farther side of the stream are some cattle, which, with the trees and mountains, are reflected in the quiet water. The subject interests me very much, and I hope to produce a picture worthy of it, and such an one as will be satisfactory to you. I think the picture will be finished in December next.[2]

Gifford's choice of subject for Mrs. Colt's picture was no doubt prompted by his very recent visit, in August and September, to the Lake Placid region of the Adirondacks; he arrived via Lake George and Elizabethtown, in the company of his sister Mary and Jervis McEntee and his wife, Gertrude.[3] The evidence in his sketchbooks indicates, however, that he made few studies on this journey, returning instead to material that he had gathered on his camping trip with McEntee and Richard Hubbard in the Adirondacks in the summer of 1863 (see cat. nos. 29, 37). Other factors also may have affected his choice of subject matter. *Coming Storm* (probably cat. no. 29, based on Lake George scenery observed in 1863) had been one of the stars of the 1865 National Academy of Design exhibition, and it may be that Gifford wished to supply Mrs. Colt with a comparable picture of the Adirondack region, simply changing the precise setting, varying the composition, and fine tuning the storm effect from an approaching to a departing one. In this respect, Gifford perhaps was influenced by his colleague Frederic Church, who was at work on his own commission from Mrs. Colt. In 1867, Church finished *The Vale of Saint Thomas, Jamaica* (Wadsworth Atheneum, Museum of Art, Hartford), a seven-foot tropical panorama depicting an approaching or passing storm and a winding river.[4] Earlier, in 1866, Gifford himself had completed *Hunter Mountain, Twilight* (cat. no. 41), and *A Home in the Wilderness* (cat. no. 40), paintings that include, respectively, a Catskill homestead at dusk and a New Hampshire cabin in the wilderness, probably at dawn. Gifford might well have conceived the subject of *A Passing Storm in the Adirondacks,* with its farmhouses in the distance and cattle watering nearer to the viewer, beneath a stormy afternoon canopy, as the culmination of a trio of complementary pictures.

Surely, a passing-storm effect did not merely vary the 1865 *Coming Storm* by incorporating the sunburst that Gifford described to Mrs. Colt, but it was in accord as well with the national mood of relief and thanksgiving following the end of the Civil War. The notion that such sentiment may have been intended by Gifford in *A Passing Storm in the Adirondacks* is strengthened by the similarity and close chronological correspondence between its design and Gifford's *Camp of the Seventh Regiment near Frederick, Maryland, in July 1863* (cat. no. 34). That picture is a considerably smaller essay on the

Figure 120. Sanford R. Gifford. Compositional studies for *A Passing Storm in the Adirondacks* (from the sketchbook of Maryland and New York subjects, 1862–63). Graphite. Albany Institute of History and Art, New York. Gift of Marion Gifford Johnson Shaw (Mrs. William F. Shaw) and Mrs. George G. Cummings

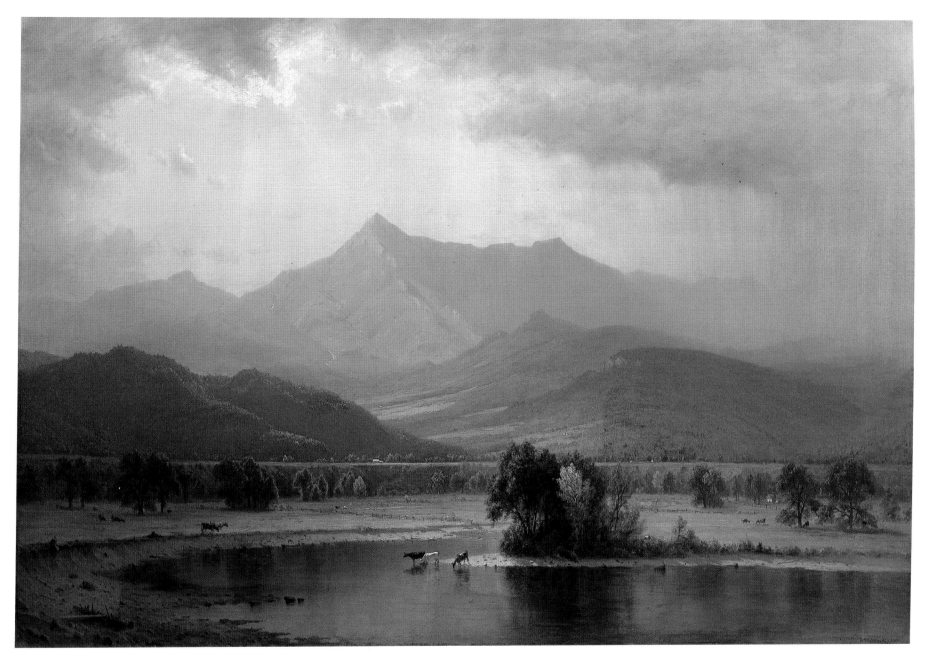

Cat. 44

Figure 121. Sanford R. Gifford. *"Keene Pass–Sept 20th 1863 Elizabethtown"* (from the sketchbook of Maryland and New York subjects, 1862–63). Graphite. Albany Institute of History and Art, New York. Gift of Marian Gifford Johnson Shaw (Mrs. William F. Shaw) and Mrs. George G. Cummings

Figure 122. Sanford R. Gifford. *Sketch on the Ausable* [?] *River* (from the sketchbook of Maryland and New York subjects, 1862–63). Graphite. Albany Institute of History and Art, New York. Gift of Marian Gifford Johnson Shaw (Mrs. William F. Shaw) and Mrs. George G. Cummings

passing storm, which Gifford literally observed from the campsite in July 1863—just days after the critical Union victory at Gettysburg—when he also noted (and later painted into his picture) the Northern armies in the distance moving south. For all their superficial differences, the design and overall effect of *Camp of the Seventh Regiment* and of *A Passing Storm* are comparable, not only in the common presence of the light and clouds, but in the background ridges parallel to the picture plane, the pastoral valleys in the foreground, and the corresponding *repoussoirs* at the lower right—lean-tos in the former picture and a

copse of trees in the latter—that echo and balance the gilded cloud forms at the upper left. Interestingly, the sketches for *Camp of the Seventh Regiment* barely indicated the cumulus clouds from which, in the painting, the sun breaks out, casting its light diagonally and theatrically across the middle distance and the foreground. That phenomenon was better rehearsed in one of two postage-stamp-sized compositional sketches (see fig. 120) anticipating *A Passing Storm in the Adirondacks,* drawn on a later page of the same sketchbook. It was those sketches, made in the Keene Valley near Elizabethtown, New York,

in September 1863, on one of a group of sheets that includes records of mountain profiles, studies of grazing cattle, farmhouses, and a stand of trees along a riverbank (see fig. 121, 122)—all undoubtedly informing the iconography of the 1866 painting—to which Gifford returned for the design of *A Passing Storm.* As Ila Weiss has suggested, Gifford's probable sharpening of the peaks of the double-humped mountains in the Elizabethtown area, whose profiles he recorded, was very much in character. Those peaks might well have belonged to the Gothics, or to the even taller Giant Mountain, conspicuous in that region. The body of water in the foreground most likely was inspired by the east branch of the Ausable River, identified in some of the 1863 drawings. Gifford himself testified, however, that the scene is not "exact as a portrait."

There are no known oil studies for *A Passing Storm,* which is surprising in view of the fact that the artist typically made one or more small versions of a composition in which he refined the imagery of his major subjects, presumably keeping these in the studio for the consideration of prospective patrons. Once again, the nature of the commission may have dictated a more direct execution, for Gifford's words to Mrs. Colt suggest that her order was not based on anything she had seen in his studio and that the choice of subject had been left to him.

Likewise, the circumstances of the commission may explain why the large composition, which Gifford later designated a "chief picture," seems never to have been exhibited publicly. The Colts accepted his painting, but it did not necessarily occupy a privileged place in their collection. Contemporary photographs show that whereas paintings by Church and Bierstadt were displayed "on the line" in the new gallery, Gifford's was hung higher up; however, like their works, Gifford's picture was situated at or near the center of one of the long walls.[5]

KJA

1. American Paintings in Wadsworth Atheneum 1996, vol. 2, p. 404.
2. Letter from Sanford Robinson Gifford to Mrs. Samuel Colt, June 15 (?), 1866; quoted in ibid.
3. Weiss 1968/1977, pp. 248–49; Weiss 1987, pp. 109, 260.
4. American Paintings in Wadsworth Atheneum 1996, vol. 2, p. 406.
5. See ibid., vol. 1, p. 29, for a contemporaneous photograph of the Colts' gallery showing *A Passing Storm in the Adirondacks.*

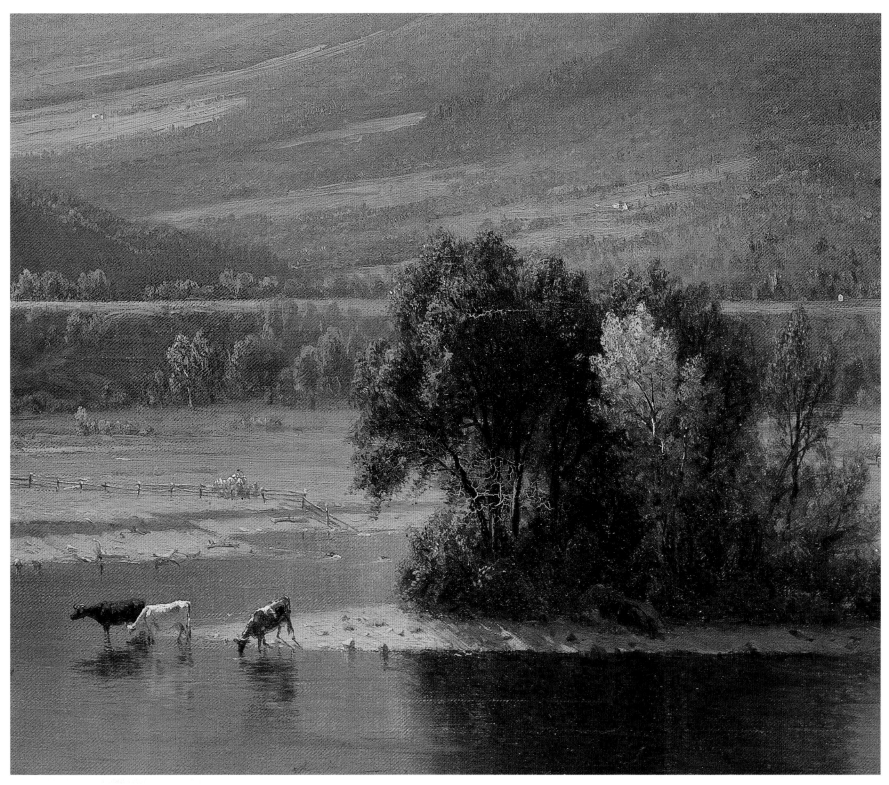

Cat. 44 (detail)

Long Branch Beach, 1867

Oil on canvas, 9 x 19 ½ in. (22.9 x 49.5 cm)
Signed and dated, lower right: S R Gifford 1867
MC 414, "Long Branch Beach. Not dated. Size, 10 x 20.
Owned by J. B. Bostwick, Brooklyn, N. Y."
Collection Jo Ann and Julian Ganz, Jr.

By the late 1860s, the beach at Long Branch, New Jersey, had become a popular tourist destination. As a writer for *The Round Table* observed in the year Gifford painted this picture, "There must be a subtle, potent charm in a place which yearly attracts thousands of pleasure-seekers and is rapidly coming to rank first among the watering-places of the Union. Less brilliant, perhaps, than Saratoga, less select than Newport, it is probably gayer than either, and certainly quite as popular."[1] The writer's use of the phrases "less brilliant" and "less select" suggested some order of class distinction between those who frequented Long Branch and the mainstays of other, more established resorts. That difference was made explicit by another writer in 1871: "Its nearness to the metropolis [New York] . . . puts it under the peculiar disadvantages of a place accessible to the 'rough-scuff' for a day's pleasuring. . . . The atmosphere of the place is sensuous, crass, and earthy. . . . Wealth there is in plenty, but it is the wealth of the *nouveaux riches,* who have earned their money a good deal faster than they have learned how to spend it."[2]

It is not known why Gifford chose to visit Long Branch and to depict it in several works. The younger Winslow Homer went there two years later, perhaps on the suggestion of his employer, *Harper's Weekly,* which published two wood engravings by him of Long Branch subjects. In Homer's prints, as in the one oil known to have resulted from the experience (see fig. 123), figures are featured prominently. Homer seems to have been emphasizing one of the most remarked-upon aspects of Long Branch's social makeup—namely, its democratic character: "Representatives of all classes are to be met, heavy merchants, railroad magnates, distinguished soldiers, editors, musicians, politicians and divines, and all are on an easy level of temporary equality," wrote one observer in 1868.[3] If Gifford was similarly interested in the details of American modern life, his painting hardly suggests it. Instead of the elegantly dressed men and women who promenade so prominently in Homer's images, the figures in Gifford's painting are far off in the middle distance, making it difficult to distinguish them as anything more than individuals, let alone to determine their social class. Nevertheless, this is clearly not a scene of laboring fishermen or others who might work

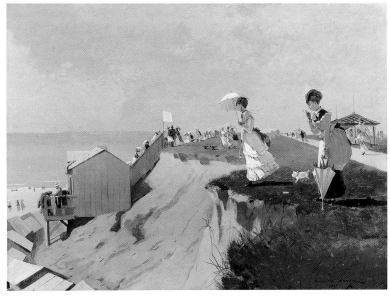

Figure 123. Winslow Homer. *Long Branch, New Jersey,* 1869. Oil on canvas. Museum of Fine Arts, Boston. The Hayden Collection, Charles Henry Hayden Fund, 1941

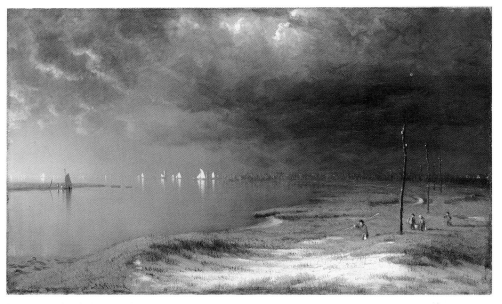

Figure 124. Sanford R. Gifford. *The Mouth of the Shrewsbury River,* 1867. Oil on canvas. Private collection

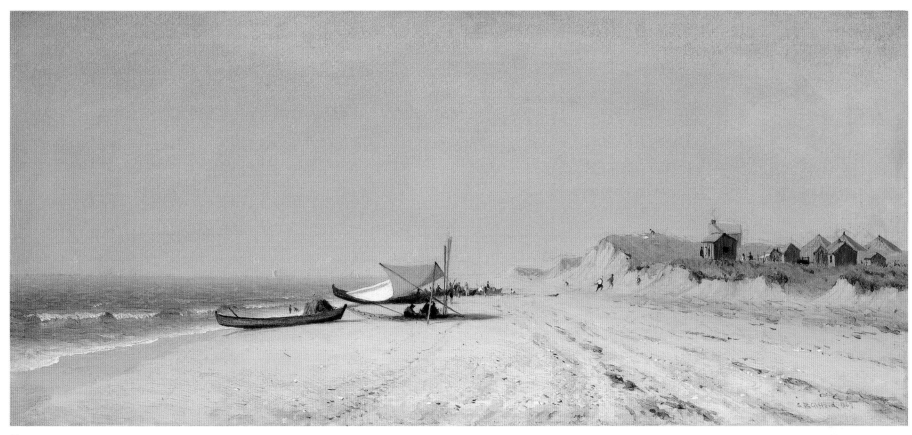

Cat. 45

along the shore, for these people seem to be enjoying the pleasures of the beach. The small structures just above the sand bluffs appear to be bathhouses similar to those seen in Homer's images of Long Branch, and thus speak of an environment of leisure rather than labor.

Gifford painted a larger (14¼ x 30-inch), virtually identical version of this work, also dated 1867 (Whereabouts unknown).[4] An even larger picture (measuring 23 x 42 inches but now lost), entitled *Sunrise on the Sea-Shore,* also was based on Long Branch scenery. Acquired by the important collector Robert Hoe, and included on Gifford's list of "chief pictures," it

was accorded special praise in Tuckerman's *Book of the Artists* for being "more masterly still, depicting only sea and sky as they appear at sunrise from the low shores of New Jersey at Long Branch, with no accessories—bare, solitary, vast, elemental nature—with such truth in wave and air, in strand and horizon, in light and perspective as to captivate the eye, as the lone sea-shore itself does in its sublime reality."[5]

The scenery of the New Jersey coast furnished the subject for another "chief picture," *Sunset Over the Mouth of the Shrewsbury River, Sandy Hook, N.J.* (1868; Whereabouts unknown), which was greatly admired

by Gifford's contemporaries. Judging from a recently discovered smaller version of that painting (see fig. 124), it must have been one of his most dramatically effective and richly colored storm pictures.

F K

1. "Long Branch," *The Round Table* 6 (July 6, 1867), p. 8; quoted in Cikovsky and Kelly et al. 1995, p. 79.
2. "Long Branch—The American Boulogne," *Every Saturday* (Boston) 3 (August 26, 1871), p. 215; quoted in Cikovsky and Kelly et al. 1995, pp. 79–80.
3. "The Watering Places. Long Branch," *The New York Evening Post,* July 28, 1868; quoted in Cikovsky and Kelly et al. 1995, p. 80.
4. Illustrated in Weiss 1987, p. 264.
5. Tuckerman 1966, p. 525.

An Indian Summer's Day on the Hudson—
Tappan Zee, 1868

Oil on canvas, 14 x 30 in. (35.6 x 76.2 cm)
Signed and dated, lower left: S R Gifford 1868
MC 457, "An Indian Summer's Day on Tappan Zee.
Dated 1868. Size, 14 x 30. Owned by William Sellers,
Philadelphia, Pa."
Exhibited: Brooklyn Art Association, March 1868, no. 239, as
"An Indian Summer Day"; National Academy of Design, New
York, April 1868, no. 331, as "Indian Summer's Day on the
Hudson-Tappen [*sic*] Zee."
Private collection, Washington, D.C.

Gifford's exploration of the possibilities of minimalist compositions was unrivaled among landscape painters of his generation. Despite that, works such as *An Indian Summer's Day on the Hudson—Tappan Zee* are still so radically simplified and pared down that they approach a point of aesthetic emptiness. If one were to imagine removing the triangular wedge formed by the spit of land and trees and their reflection at the right side of the composition, and the scattered boats, only an expanse of glowing water and sky would be left. The pencil line ruling the horizon (which would not, of course, have been visible originally) is the sole demarcation of the junction between the two zones. Although some of John F. Kensett's "Last Summer's Work" paintings (see fig. 125) are equally reductive, they were executed later, and it is unclear whether or not he regarded them as finished.[1] Kensett did not live to exhibit any of these works publicly, and it is uncertain whether he would have even considered doing so. Gifford, however, did not hesitate to show *An Indian Summer's Day on the Hudson—Tappan Zee,* sending it first to the Brooklyn Art Association in March 1868 and then to the annual exhibition at the National Academy of Design that year.[2]

Gifford's interest in the scenery of the lower Hudson River is evinced by several works listed in the *Memorial Catalogue* portraying sites in that area. Among them are *Hook Mountain, near Nyack, on the Hudson* (fig. 116), *Hook Mountain on the Hudson River* (cat. no. 43), and *Morning on the Hudson, Haverstraw Bay* (cat. no. 42). *An Indian Summer's Day on the Hudson—Tappan Zee* focuses almost entirely on the river itself, with the mountains on the distant shoreline all but invisible in the haze.[3] For some twelve miles between Piermont and Haverstraw Bay, the Hudson expands in width to over two miles. Famous as the site of many important historical events, the region was even better known as the legendary abode of ghosts and goblins.[4] Early Dutch settlers called it a "Zee" (from the Dutch for "sea"), a term they freely applied to any large body of water; "Tappan" was a Native American word meaning "cold springs."[5] Many observers considered the Tappan Zee the beginning of a more hygienic and healthier climate zone that continued up the river. It was even theorized that a so-called Death Line, dividing the area to the north from the malaria-prone and miasmic urban environments to the south, was located somewhere in the vicinity of the Tappan Zee.[6]

The warm oranges and golds of *An Indian Summer's Day on the Hudson—Tappan Zee* differ markedly from the

Figure 125. John F. Kensett. *Eaton's Neck, Long Island*, 1872. Oil on canvas. The Metropolitan Museum of Art, New York. Gift of Thomas Kensett, 1874

Figure 126. Sanford R. Gifford. *Claverack Creek*, 1862–68. Oil on canvas. Edward T. Wilson, Fund for Fine Arts, Bethesda, Maryland

Cat. 46

cooler hues found in such paintings as *Morning on the Hudson, Haverstraw Bay*. At this same time, Gifford was employing similar tonalities in a series of works depicting Claverack Creek, on the east side of the river near Hudson (see fig. 126). The compositional schemes of these paintings, with a triangular wedge of land extending into a calm body of water, resemble that of the Tappan Zee picture, but with land, rather than water, continuing the vista at the left. FK

1. On these see Oswaldo Rodriguez Roque, "The Last Summer's Work," in Driscoll and Howat et al. 1985, pp. 137–61.
2. Brooklyn Art Association Exhibition Index 1970, p. 202. According to Weiss 1987, p. III, the painting was listed for sale for $1,000, and by the time of the National Academy exhibition it had been sold to William Sellers of Philadelphia.
3. A similar view may have been depicted in a painting entitled *An Afternoon View on Tappan Zee* now unlocated but listed in the *Memorial Catalogue*, under number 470, as 7 1/2 x 14 1/2 inches, and owned by a Mr. James R. Osgood of Boston.
4. *New York: A Guide to the Empire State* (New York: Oxford University Press, 1940), p. 621.
5. Arthur G. Adams, *The Hudson: A Guidebook to the River* (Albany, New York: State University of New York Press, 1981), p. 120.
6. Raymond J. O'Brien, *American Sublime: Landscape and Scenery of the Lower Hudson Valley* (New York: Columbia University Press, 1981), p. 230; based on information in N[athaniel]. P. Willis, *Out-doors at Idlewild; or, The Shaping of a Home on the Banks of the Hudson* (New York: C. Scribner, 1855), pp. 399–400. New York's well-known charity The Fresh Air Fund was established in 1877 to provide free summer vacations in more healthful climates for the city's poorest children.

47

Assouan, Egypt, A Sketch, 1869

Oil on canvas, 5⅞ x 13¼ in. (14.9 x 33.7 cm)
Signed and dated, lower right: S R Gifford Assouan Feb. 69.
MC 524 [54.], "Assouan, Egypt, a Sketch. Dated February,
1869. Size, 6 x 13½. Owned by the Estate."
Collection Jo Ann and Julian Ganz, Jr.

48

On the Nile, 1871

Oil on canvas, 17 x 31 in. (43.2 x 78.7 cm)
Signed and dated, lower right: S. R. Gifford 187[1]
MC 580 [8.], "On the Nile. Dated 1872. Size, 17 x 31. Owned by
J. I. Nesmith, Brooklyn, N. Y."
Exhibited: Brooklyn Art Association, "Twenty-fifth Exhibition
of Pictures," December 1872, no. 225; Centennial Exhibition,
Philadelphia, 1876, no. 24.
Private collection

49

Siout, Egypt, 1874

Oil on canvas, 21 x 40 in. (53.3 x 101.6 cm)
Signed and dated, lower right: S. R Gifford. 1874
MC 620 [114.], "Siout, Egypt. Dated 1874. Size, 21 x 40. Owned
by J. I. Nesmith, Brooklyn, N. Y."
Exhibited: Possibly Chicago Interstate Industrial Exposition,
1876, no. 201, as "Siout, the Capital of Upper Egypt"; Brooklyn
Art Association, April 1879, no. 342.
National Gallery of Art, Washington, D.C. New Century Art
Fund, Gift of Joan and David Maxwell (1999.7.1)

Many nineteenth-century American landscape painters
traveled abroad in search of subjects, but Gifford was
one of the few who ventured beyond England and the
Continent. Early in 1869 he sailed from Naples to
Alexandria, Egypt. Following three weeks in Cairo, he
covered more than one thousand miles, for six weeks,

with five other Americans on board a *dahabeah,* a tradi-
tional Nile sailing vessel.[1] None of the other passengers
was an artist, and Gifford felt he had little time for
sketching, although at least eight works with Egyptian
subjects, from February and March 1869, are listed in the
Memorial Catalogue.[2] In a letter published in April 1869
in New York's *Evening Post,* he admitted: "It is so easy to
lie on the deck cushions and read pleasant books, under
this broad, pure and tender sky, and look off now and
then at the fringes of waving palms, and at the golden
light and delicate purple shadows of the Arabian and
Libian [*sic*] mountains."[3] Nevertheless, there were
moments of artistic inspiration. One day he noted that
the weather was "like our most exquisite summer; the
sky cloudless, pure and delicate; the sun is mighty and
magnificent. The long distance tints of the . . . desert be
like strings of pearls and opals on the horizon."[4]

By this point in his career, Gifford had on many
occasions painted the sands of America's northeastern
beaches (see, for example, cat. no. 45), but the seemingly
limitless expanses he encountered in the Egyptian
deserts were altogether different. As the artist wrote:
"Early in the morning I went out into the desert to
make some notes. This wild, strange scenery, so desolate
and savage, interests me more than anything I have seen
in Egypt."[5]

In the vicinity of Aswān (Gifford used the French
spelling, "Assouan"), the Nile flows through a landscape
of richly colored amber sands punctuated by dramatic
outcroppings of granite. No large-scale painting of
desert scenery apparently resulted from his experiences
there, but two smaller works, *A Sketch on the Desert in
Egypt* (1869; Private collection) and catalogue number
47, are known today. *Assouan, Egypt, A Sketch,* reveals
Gifford trying to establish a compositional format for a
scene totally devoid of any of the usual features of tradi-
tional landscape paintings. There were no trees; no
streams, lakes, or other bodies of water; and no tall
mountains closing off the view in the distance. Gifford

created four distinct compositional zones: foreground,
middle distance, far space, and sky: a jumble of broken
boulders on the right that sits atop a triangular hillock of
sand; an expanse of smooth sand in the center that
echoes in reverse the wedge shape of the foreground; a
larger range of granite hills sweeping into the distance
from the left; and a cool field of atmospheric blue that
takes up over half the canvas. A group of figures riding
camels enters the picture from the left edge, seemingly
on a journey that will take them along the receding
space of the middle distance. This strikingly spare and
elegant image continues the strain of simplified compo-
sitions seen in such works as *An Indian Summer's Day on
the Hudson—Tappan Zee* (cat. no. 46).

Myriad sailing vessels plied the waters of the Nile,
and Gifford found the *dahabeahs,* such as the one that
conveyed him and his companions up the river, espe-
cially appealing. As he wrote, "Their beautiful sails . . .
look like the wings of birds."[6] Several of his Egyptian
pictures focus on the Nile's watercraft, including *On the
Nile,* the only work depicting the scenery of that land to
be listed among Gifford's "chief pictures." Developed
from a smaller study dated "7 March 1869" (see fig. 127),
this is surely among Gifford's most understated, yet
beautiful, works.[7] Equally appealing is its exquisite
palette—George Sheldon found Gifford's Egyptian
paintings "marked by the greatest purity of colouring"—
with the shimmering bands of blue water and sky bro-
ken only by a narrow strip of warm earth tones demar-
cating the shoreline.[8] The triangular shape of a great
lateen sail thrusts upward into the sky, mirrored by its
reflection in the water below, so that, as Gifford
observed, it does suggest the wings of a bird. The critic
for the *New-York Daily Tribune* found the subject espe-
cially well suited to Gifford's style: "Mr. S. R. Gifford,
too, shows by his 'On the Nile' how his love for certain
effects of light can develop new force in him when it has
undeniable conditions of nature to work upon. His for-
mer pictures were never completely satisfactory because

Cat. 47

we could not find their justification in the American scenery from which they professed to be taken. But here on the Nile the artist has found an atmosphere that suits his talent, and we wish we may see an abundant record of his observations."[9]

On March 4, Gifford reached the village of Siout (the spelling of the town's name has varied considerably over the years; today it is known as Aysut), which was situated in an extensive and fertile plain below the Libyan Hills, at the head of the great caravan route that extended through the Libyan Desert to the Sudan. The town was known for its picturesqueness and its history, having been the capital of the thirteenth nome (province) of Upper Egypt during antiquity and the birthplace of Plotinus, the great Neoplatonic philosopher. In his journal,

Gifford described the view that inspired catalogue number 49: "Looking westward, the town with its domes and minarets lay between us and the sun, bathed in a rich and beautiful atmosphere. Behind, on the right, were the yellow cliffs of the Lybian [sic] mts., running back into the tender grades of distance. Between us and the town were fields of grain, golden green with the transparent light. On the right was a tent with sheep and beautiful horses, the sunlight sparkling on a splendid white stallion. On the left the road ran in, with a fountain and figures of men and women and camels. The whole glowing and gleaming under the low sun."[10]

Siout, Egypt, based on a 7 x 12-inch sketch (*A Sketch near Siout, Egypt*; MC 525) and the slightly larger *Siout, Egypt* (fig. 128), is the most ambitious of Gifford's

known Egyptian works and ably demonstrates his mastery of both atmospheric and linear perspective.[11] The glowing light gives tonal unity and balance to the overall composition and reveals the many details of the scene with exceptional clarity. The result is a work that is less about the physical facts of the subject depicted and more about the very act of perceiving. One of Gifford's paintings with the same setting received a lengthy notice in *The New York Evening Post*:

The Valley of the Nile is not what would be called a picturesque region; the forms of nature there are not, generally speaking, beautiful objects in themselves, nor of that infinite variety which in Europe keeps the eye active and charmed no matter which way it turns. The sentiment of the Nile is

Cat. 48

Figure 127. Sanford R. Gifford. *A Sketch on the Nile*, 1869. Oil on canvas. Private collection

Cat. 49

Figure 128. Sanford R. Gifford. *Siout,
Egypt*, 1869. Oil on canvas. Berry-Hill
Galleries, Inc., New York

rather one of simple grandeur. . . . [It] however, can be made picturesque in art by proper treatment. We are satisfied of this on seeing at Goupil's gallery a fresh picture from Mr. S. R. Gifford's easel, representing a view near Osioot, one of the principal towns on the river. The picture is composed of barren mountains in the background on the left, a portion of the town, relieving on the sky, in the middle ground on the right, and, in the foreground, the fertile plain extending back to the low elevation on which the town is built.

All of this is visible through that pure, delicate atmosphere which, if not peculiar to the Nile, is more impressive there than elsewhere, blending the whole together, and which—one of the main subtleties of landscape art—Mr. Gifford always renders with signal success.[12]

F K

1. Weiss 1987, p. 121. See also Heidi Stoltzfus Applegate, "Sanford Robinson Gifford in the Orient," M.A. thesis, University of Maryland, 2001.
2. Weiss 1987, p. 121; see *Memorial Catalogue*, numbers 520–527.
3. Gifford 1869.
4. Ibid.
5. Letter from Sanford Robinson Gifford, Egypt, February 16, 1869, Gifford, European Letters, vol. 3.
6. Gifford 1869.
7. See Weiss 1987, p. 293; the smaller version was sold at Phillips de Pury & Luxembourg, New York, December 3, 2002, no. 30.
8. Sheldon 1876, p. 203.
9. "Art. The Brooklyn Association. Twenty-fifth Exhibition of Pictures," *New-York Daily Tribune*, December 14, 1872.
10. Letter from Sanford Robinson Gifford, Egypt, March 4, 1867, Gifford, European Letters, vol. 3; quoted in Cikovsky 1970, p. 29.
11. A painting entitled *Siout, Egypt* (16 x 30 in.), is listed in the *Memorial Catalogue* (no. 542) as having been sold in 1869 to G. B. Lansing. Like *On the Nile*, the present *Siout, Egypt*, was owned by J. I. Nesmith of Brooklyn.
12. *The New York Evening Post*, March 3, 1870.

50

Valley of the Chug Water, Wyoming Territory, 1870

Oil on canvas, 7¾ x 12⅞ in. (19.7 x 32.7 cm)
Inscribed, lower left: Valley of the Chug Water Wyoming Terr Aug 9th, 1870.
Amon Carter Museum, Fort Worth

In the summer of 1870, Gifford made his first journey west, traveling with his friends and fellow artists Worthington Whittredge and John F. Kensett to Colorado.[1] Soon after they arrived, however, Gifford left them to join Colonel Ferdinand V. Hayden on a trip to the Wyoming Territory. Whittredge described Gifford's departure: "When he accompanied Kensett and myself to the Rocky Mountains he started fully equipped for work, but when he arrived there, where distances were deceptive, he became an easy prey to Col. Hayden, who offered him a horse. He left us and his sketch box in cold blood in the midst of inspiring scenery. We neither saw nor heard from him for several months, until one rainy day on the plains we met him travelling alone in the fog towards our ranch by the aid of his compass. He had done literally nothing in the way of work during a whole summer spent in a picturesque region."[2] In spite of what Whittredge

indicated, Gifford did take his paint box with him, as the existence of this study proves. Moreover, several other small works depicting Wyoming scenery are listed in the *Memorial Catalogue*, suggesting that even if Gifford was not especially productive, neither was he entirely idle.

The photographer William Henry Jackson was also a member of the Hayden party, and he and Gifford worked together and became friends. As Jackson noted: "He was much interested in my photography, from the very beginning of . . . our journey and was my inseparable companion on the side-trips, or other occasions when separated from the main party for making photographs.

Figure 129. William Henry Jackson. Sanford R. Gifford (seated) sketching the Valley of the Chugwater, about 1870. Photograph. Denver Public Library, Western History Collection

Cat. 50

I think his artistic discernment and advice was largely resp[o]nsible for whatever there was of excellence in my own compositions."[3] Hayden equally valued Gifford's contributions, and observed that he "rendered us most efficient aid, and by his genial nature endeared himself to all."[4] On August 7, Hayden, Gifford, Jackson, and several others followed the valley of Lodge Pole Creek into the Black Hills to Chugwater Creek, a tributary of the Laramie River.

The creek runs "through a dreary wilderness of rock, sand, and clay, almost entirely devoid of vegetation," but with "many natural curiosities."[5] On August 9, Gifford produced this sketch of one such "natural curiosity," an outcropping of castellated rock in the Triassic Chugwater formation. The geology of the area took shape some sixty million years ago, during the rise of the Wind River Range to the west. The rising and tilting of underlying strata exposed rocks more

susceptible to erosion that subsequently wore away, leaving buttes and mesas of harder stone. The characteristic red color of the Chugwater formations, evident in Gifford's sketch, is the result of oxidized iron between and on the grains of the rock.[6]

Jackson recorded his friend at work on this oil sketch in a photograph (see fig. 129). As in *The Artist Sketching at Mount Desert, Maine* (cat. no. 39), here we see Gifford seated on his campstool, with his paint box on his lap

(more evidence of the inaccuracy of Whittredge's account), and the sketch itself positioned in the lid. The photograph does not, however, show the tiny figure standing to the left of the central formation that appears in Gifford's painting. Perhaps he had not yet arrived, had already departed, or had simply been added by Gifford. Whatever the case, his presence establishes a sense of scale for the image. Even though the painting itself is small, it is clear that the expanse of landscape it

depicts is quite vast. Indeed, no other artist among Gifford's contemporaries could express so much with so little. F K

1. See Moure 1973.
2. Baur, ed. 1942, p. 60; quoted in Harvey 1998, p. 222.
3. Letter from William H. Jackson to Mrs. S. R. Gifford, December 27, 1940 (Collection Sanford Gifford, M.D.); quoted in Weiss 1987, p. 284.
4. F. V. Hayden, *Preliminary Report of the United States Geological Survey of Wyoming and Portions of Contiguous Territories* (*Being a Second Annual Report of Progress*) *Conducted under the Authority of the Secretary of the Interior* (Washington, D.C.: Government Printing Office, 1871), p. 5; quoted in Weiss 1987, p. 133.
5. Rufus B. Sage, *Rocky Mountain Life; or, Startling Scenes and Perilous Adventures in the Far West, during an Expedition of Three Years* (1846; Boston: Thayer & Eldridge, 1859); quoted in {http://www.wyomingtalesandtrails.com/swan.html}, December 4, 2002.
6. See {http://www.wy.blm.gov/lfo/rec/redcanyon.html}, December 4, 2002.

51

Isola Bella in Lago Maggiore, 1871

Oil on canvas, 20¼ x 36 in. (51.4 x 91.4 cm)
Signed and dated, lower right: S. R Gifford 187[1]
Inscribed, on the verso: Lago Maggiore / S. R. Gifford pinxit 1871; canvas stamp: GOUPIL & CO. [badly faded]
MC 571, "Isola Bella in Lago Maggiore. Dated 1871. Size, 20 x 34. Owned by William B. Northrup."
Exhibited: Possibly Brooklyn Art Association, New York, March 1871, no. 168, as "Lake Maggiore"; possibly Century Association, New York, May 1871, no. 4, as "Lake Maggiore Evening Scene"; possibly Yale University School of Fine Arts, New Haven, July 1871, no. 3, as "Lago Maggiore. Isola Bella."
The Metropolitan Museum of Art, New York. Gift of Colonel Charles A. Fowler, 1921 (21.115.1)

There may be no better example of the refinement of Gifford's vision during his career than a comparison of the present work, painted after his second trip to Europe in 1868–69, and the artist's early pictures of Lake Maggiore (see fig. 130), completed after his first European trip of 1855–57. To be sure, Gifford had somewhat contrasting responses to the site on each journey. In late August 1856, he was accompanied in the region successively by a "Mr. Tetley, of Leeds," an Englishman, and two former fellow students from Brown University. With the Englishman at Maggiore he explored Isola Madre and Isola Bella, even staying overnight on the latter, with its "terraced and pinnacled pyramid" of a gar-

den—the creation of the noble Borromeo family, which still owns the Borromean islands. Gifford decided that Isola Bella was "too fantastic for good taste," and a few days later he deemed the Italian lakes in general over-rated.[1] Accordingly, in all his known paintings—based on his first visit—of the popular view from the shore at or near Stresa, looking up Maggiore's stubby western branch toward Baveno, he excluded Isola Bella, the nearest and most conspicuous of the three major islands at this site. The dwellings on the Isola dei Pescatori and Baveno, at the right and the left, respectively, in the middle distance function as pale focal points, with the space between them

in the immediate foreground anchored by a fishing boat, whose own highlights are provided by the shirts of the fishermen. All the recorded post-1856 paintings were morning views in which the towering snowcapped Alps bordering the lake are emphasized.

In late July 1868, Gifford again visited the Italian lake district for several days, but this time solely in the company of a guide, and his experiences and perception of Lake Maggiore sound quite different: "We . . . crossed the northern arm of the lake to Intra (a large manufacturing town) and skirted the shore to Palanza [*sic*], which is the chief town of the Province, and then

Figure 130. Sanford R. Gifford. *Lago Maggiore*, 1854. Oil on canvas. The Frances Lehman Loeb Art Center, Vassar College, Poughkeepsie, New York. Gift of Matthew Vassar

Cat. 51

crossed [the western arm] by Isola Madre and Isola Bella to Stressa [*sic*]—a good long row for 'Moise,' my handsome, manly-looking oarsman. It was a perfect day, not too hot. I have come to the conclusion that this part of Maggiore is the finest of all the Italian lakes."² In short, Gifford spent what seems to have been nearly a full day on the water, and presumably would have concluded his "perfect day" again at Stresa but with a view of the sunset beyond the mountains on the opposite shore, casting the mountain ranges into silhouette. Whether or not he sketched it then, no drawing of this effect is known, although he recorded most of the

Figure 131. Sanford R. Gifford. "*Santa Catarina* [sic]—*Miracolo San* [sic] *Alberto—July 31 st 1868*" (from the sketchbook inscribed "Maggiore, Como, Sicily, Rome, Genoa, 1868"). Graphite and gouache. The Brooklyn Museum of Art. Gift of Miss Jennie B. Branscomb

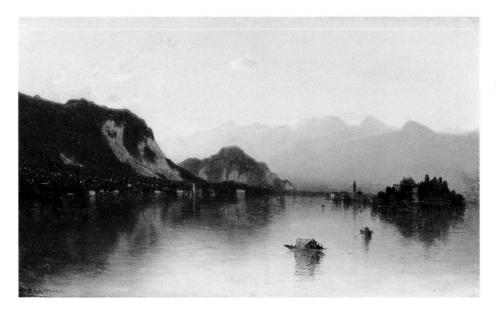

Figure 132. Sanford R. Gifford. *Isola Bella in Lago Maggiore,* about 1868. Oil and graphite on paper, mounted on canvas. Private collection

topography in the background of his drawing of Santa Caterina (see fig. 131), executed on July 31, the day of his boat ride. Four days later, at Bellagio on Lake Como, suffering "the first rainy day since I left Manhattan," Gifford got out his paint box and "made [a] sketch in oil of a sunset on Lake Maggiore." This is undoubtedly the 8 x 13-inch picture (see fig. 132) in which Gifford rapidly established all of the essentials of the composition of the present work—now including Isola Bella at the extreme right and more of the shoreline cliffs at the left.

When Gifford moved on to the oil study (reportedly 13 x 24 inches; Whereabouts unknown) and then to the present painting, he extended the width of the canvas to nearly twice the height, thus further accommodating the profile of the mountains at either side. What had been, in the post-1856 views, an essentially symmetrical image of the snowcapped Alps, modeled by the bright morning sunlight and enclosing a lake punctuated by pale architecture and staffage, became, in the post-1868 version of the same scene, a suave arrangement of horizontal, overlapping planes set on the water, with the filmy light of sunset sandwiched between them. Except for the sunset effect, the conception is reminiscent not only of the artist's own 1860s compositions, such as *Morning on the Hudson, Haverstraw Bay* (cat. no. 42), but also, despite its

saturated color, of Gifford's colleague John F. Kensett's late paintings of Lake George. Meanwhile, the idea of the sunset flowing obliquely down the channel made by the mountains framing the lake might well have been informed by Albert Bierstadt's Yosemite Valley landscapes.[3] In the large version, Gifford accentuated the flatness and transparency of the sketch with several modifications: He lightened the silhouette of the left mountain, thus reducing the contrast with the sun-suffused background ridge, and he seems to have toned down as well the original intensity of the sunset's glow and significantly reduced both the apparent (in life) and relative (in the picture) size of the Isola dei Pescatori. In doing so, Gifford made the design even less symmetrical and more open-ended at the right than in the sketch, in accord with the idea of a right-to-left flood of light. The reduction in size also tended to suppress, along with the shade enveloping most of the island, the "terraced and pinnacled" effect of the Borromean gardens that he had disliked. By diminishing the island, the artist achieved a more harmonious pictorial relationship between the Isola dei Pescatori to its left and the pleasure boat nearest the viewer, whose location now supplies a delicate compositional weight in the watery void between Isola Bella and the pyramidal hill of the shore in the middle

distance. In the final painting, Gifford also refined an idea that he rehearsed in the oil sketch: He configured the clouds at the left so that they aligned with the naturally occurring limestone patches on the face of the near shore, thus subtly parenthesizing, like one of his signature bowing birch trees, the left side of the composition. If it was the artist's ambition to fashion a warmly somber idyll of "the finest of all the Italian lakes," he commendably achieved this end. In addition, he paved the way for an American counterpart to this scene, *Sunset over the Palisades on the Hudson* (cat. no. 69).

It is unclear whether *Isola Bella in Lago Maggiore* ever was exhibited; it may well have been either the more textured and contrasting oil sketch, or the somewhat larger (now lost) study that was reviewed at the artists' reception at the Century Association in New York in March 1871. The *New-York Times* critic hailed, of all things, "that truthfulness of detail which distinguish[es] this artist's works. The rock and water painting are very fine, and the somewhat gloomy sky above adds largely to the effect of the scene."[4] KJA

1. Weiss 1987, p. 75; letter from Sanford Robinson Gifford to his father, Elihu Gifford, August 24, 1856, in Gifford, European Letters, vol. 1, pp. 91, 94: "On the whole I am disappointed with the Italian lakes. There is a great deal about them to make them charming, but they have been too much praised."

2. Letter from Sanford Robinson Gifford, Bellagio, Lake Como, August 11, 1868, in Gifford, European Letters, vol. 3, pp. 25, 27.

3. For an example see *Looking Down Yosemite Valley* (1865; Birmingham Museum of Art, Birmingham, Alabama), illustrated in Nancy K. Anderson and Linda S. Ferber et al., *Albert Bierstadt: Art and Enterprise,* exhib. cat., The Brooklyn Museum of Art; The Fine Arts Museums of San Francisco; and Washington, D.C., National Gallery of Art (Brooklyn: 1990), p. 201, no. 42.

4. *The New-York Times,* March 12, 1871.

Kauterskill Falls, 1871

Oil on canvas, 14¾ x 12½ in. (37.5 x 31.8 cm)
Inscribed and dated, on the verso: S R Gifford 1871 / Hudson,
N. Y.
MC 577, "Kauterskill Falls. Dated 1871. Size, 13 x 15. Owned by
Augustus E. Bachelder, Boston, Mass."
The Detroit Institute of Arts. Gift of Katherine French
Rockwell

The lofty, two-tiered Kaaterskill Falls, today just off
Route 23A in the town of Haines Falls, New York, in
Kaaterskill Clove, was a required stop for any visitor to
the Catskill Mountain House. Even before the hotel was
built, James Fenimore Cooper had described a visit to
the site through the voice of his fictional scout,
Leatherstocking, in the 1823 novel *The Pioneers*:

*"Why, there's a fall in the hills, where the water of two little
ponds that lie near each other breaks out of their bounds, and
runs over the rocks into the valley. . . . There the water comes
crooking and winding among the rocks, first so slow that a
trout could swim in it, and then starting and running like a
creater that wanted to make a far spring, till it gets to where
the mountain divides, like the cleft hoof of a deer, leaving a
deep hollow for the brook to tumble into. The first pitch is
nigh two hundred feet, and the water looks like flakes of
driven snow, afore it touches the bottom; and there the stream
gathers together again for a new start, and maybe flutters
over fifty feet of flat-rock, before it falls for another hundred,
when it jumps about from shelf to shelf, first turning this-
away and then turning that-away, striving to get out of the
hollow, till it finally comes to the plain."*[1]

When Thomas Cole arrived in the Catskills in 1825,
probably stimulated like others by Cooper's lively
descriptions, he made the falls the subject of paintings
that earned him his earliest renown.[2] Not long before
Cole visited the site, an observation platform had been
erected at the head of the falls; later, the proprietor of
the Laurel House, built near the falls in 1852, dammed

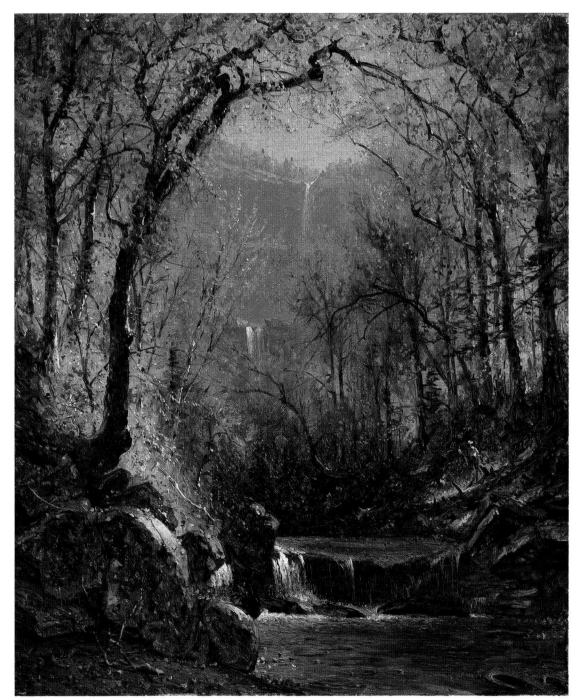

Cat. 52

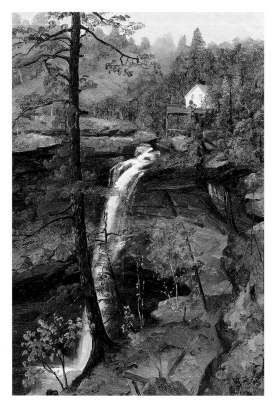

Figure 133. Sanford R. Gifford. *Kauterskill Falls,* 1846. Oil on canvas. Private collection

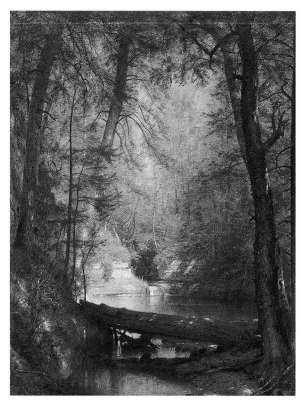

Figure 135. Worthington Whittredge. *The Trout Pool,* 1870. Oil on canvas. The Metropolitan Museum of Art, New York. Gift of Colonel Charles A. Fowler, 1921

Figure 134. Thomas Cole. *Landscape View near the Falls of the Kaaterskill, in the Catskill Mountains,* 1827. Oil on mahogany panel. Private collection

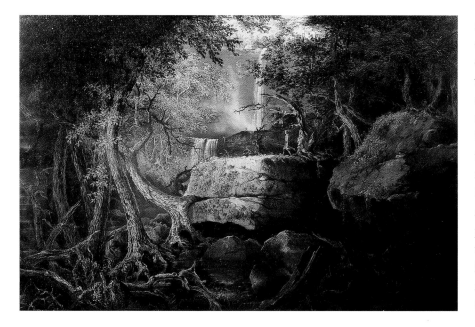

the stream—called Lake Creek—feeding the cascade and charged visitors for the privilege of witnessing the gushing spectacle that he controlled.[3]

The Laurel House was where Gifford stayed with his colleague and friend Jervis McEntee in the autumn of 1871; this excursion resulted in several modest paintings whose subjects, along with a few western and seashore scenes, now formed a minority among the many more foreign subjects that Gifford was painting and submitting for public exhibition.[4] Kaaterskill Falls, in fact, had been one of Gifford's earliest subjects, in a painting dated 1846 (see fig. 133). However, he essayed it only twice thereafter, both times in 1871, and perhaps only as an incident of his stay at the Laurel House that year, where he might have met fellow guests who asked for pictures of it. His own inclinations previously had led him to sites in the eastern Catskills that had been less often interpreted and that he had, indeed, made his own, including the view from South Mountain (see cat. nos. 54, 55), Hunter Mountain (see cat. no. 41), and, of course, the view west through Kaaterskill Clove to Haines Falls (see cat. nos. 21–24, and fig. 85). In 1871, he returned to this last subject yet again in *Autumn in the Catskills* (The Parthenon, Nashville) as he would several more times up until his death in 1880.

Gifford's image of Kaaterskill Falls here may be marked more by artifice than by verisimilitude. He deposits the spectator on lower Lake Creek at the base of Kaaterskill Clove for what seems an impossibly long view of the cascade, as seen through the trees decorously arched over the stream. (However, it is possible that such a prospect was intentionally cleared for tourists in Gifford's time.) The conception may be associated with the vignette-like compositions he had begun in the late 1850s, including *A Sketch on the Huntington River, Vermont* (cat. no. 18), and *Hook Mountain on the Hudson River* (cat. no. 43). Contemporaneously, Gifford also painted *A Catskill Wood-Path, a Sketch* (Whereabouts unknown), which would have lent itself even more readily to comparable treatment.[5] Given its subject, it also may have been informed by a composition of 1826–27 by Cole of Kaaterskill Falls (see fig. 134) and one based on

the site, by John F. Kensett (about 1855–60; The Detroit Institute of Arts), dating from early in that artist's career.[6] The peculiar reddish warmth of Gifford's woodland "naves," as, for example, the present work, is a quality his paintings share with similar ones by his friend McEntee, but especially with some of the signature forest interiors of Worthington Whittredge (see fig. 135), with whom Gifford sketched in the Catskills many times, often as a trio with McEntee. Finally, the composition, along with the bright morning sunlight effect in the forest and on the remote, heavenly cascade, even evokes some of Albert Bierstadt's views of waterfalls at Yosemite as seen through the forest of the valley floor.[7]

In contrast to the techniques of all these artists, Gifford's is marked by a fluid thinness of paint application in the foreground, much of which is little more than red-brown underpainting, skillfully modulated with touches of equally thin umber and discreet impastos of white and pale yellow to indicate rocks, tree trunks, the freshet of lower Lake Creek that links conceptually with the background cascade, and, least conspicuous of all, a figure on the right bank of the falls. The "window" through which that focal motif, along with the escarpment and sky, is espied constitutes the most ethereal but paradoxically the most richly pigmented zone in the picture.

KJA

1. James Fenimore Cooper, *The Pioneers* (1823), in *The Leatherstocking Tales*, vol. 1 (New York: The Library of America, 1985), p. 296.
2. Cole's engagement with Kaaterskill Falls as a subject is perhaps most thoroughly addressed in Myers et al. 1987, pp. 40–46, 117.
3. For the Laurel House and Kaaterskill Falls see Van Zandt 1966, pp. 144–45; Arthur G. Adams, *The Catskills: An Illustrated Historical Guide with Gazeteer* (New York: Fordham University Press, 1990), p. 283.
4. Weiss 1987, pp. 134, 297.
5. *Memorial Catalogue*, no. 562.
6. For an illustration of Kensett's *Waterfall in the Woods, with Indians* see Myers et al. 1987, p. 47, fig. 9, p. 72, fig. 17.
7. Gerald L. Carr, *Albert Bierstadt: An Exhibition of Forty Paintings*, exhib. cat., New York, Alexander Gallery (New York: 1983), no. 10; Nancy K. Anderson and Linda S. Ferber et al., *Albert Bierstadt: Art and Enterprise*, exhib. cat., Brooklyn Museum of Art; The Fine Arts Museums of San Francisco; and Washington, D.C., National Gallery of Art (Brooklyn: 1990), p. 198, no. 40.

53

An October Afternoon, 1871

Oil on canvas, 13½ x 24 in. (34.3 x 61 cm)
Signed and dated, lower right: S R Gifford 1871
MC 573, "An October Afternoon. Dated 1871. Size, 13½ x 24. Owned by Samuel J. Harriot."
Museum of Fine Arts, Boston. Henry H. and Zoe Oliver Sherman Fund, 1988

By late 1870, Gifford had traveled widely, both in the New World and the Old, and he had seen many sites hallowed by the passage of time in England, Italy, Switzerland, Egypt, Syria, and Greece. Perhaps his experiences in those foreign lands made him more acutely aware of the changes that were playing out in his own country, which was moving inexorably from an agrarian-based, rural economy toward an increasingly industrialized urban marketplace. Gifford's own ancestors, whom he traced to early-seventeenth-century New England, had made their living from the land, and he himself may have treasured a comforting belief that

America could always provide for its inhabitants. Yet, surely he knew, when he painted *An October Afternoon*, that the existence of a secure and untroubled Native American settlement like the one he depicted was no longer possible anywhere in the northeastern United States. He had traveled in the West just the year before, and may have seen the realities of life for Native Americans now relocated to reservations. It is difficult, then, to imagine, that such works as *An October Afternoon* were anything other than fundamentally nostalgic, even elegiac, for Gifford.

An October Afternoon thus shares the lineage of *The Wilderness* (cat. no. 12) of a decade earlier.[1] Its closest compositional cognates, *A Lake Twilight* (cat. no. 14) and *The Wilderness* (cat. no. 13), present similar scenes of a wilderness lake set below a prominent, pyramidal mountain, but clearly identify their human occupants as non-Native Americans. Even so, they, too, may be read as paeans to a simpler past, one predating the onslaught of

civilization that had changed irrevocably mankind's relationship with nature.

The Native American settlement in *An October Afternoon* is substantial, consisting of several tepees situated at the edge of the forest at the right, with a number of figures occupying the surrounding area. In a work such as *The Wilderness*, Gifford often included only one or two figures, thus emphasizing their lonely isolation in nature. Here, the size and the suggestion of relative permanence of the settlement give a sense of a continuing community, almost as if European civilization had never reached the New World. Paintings such as this, then, should not be seen simply as attempts to recycle the Hudson River formulas of the 1850s and 1860s but rather as images of memory and loss, of what has been and what never will be again. The warm atmosphere and glowing colors of *An October Afternoon* may initially hint at a mood of peaceful calm, but any possibility of stasis is belied by our knowledge that the tranquil days of an

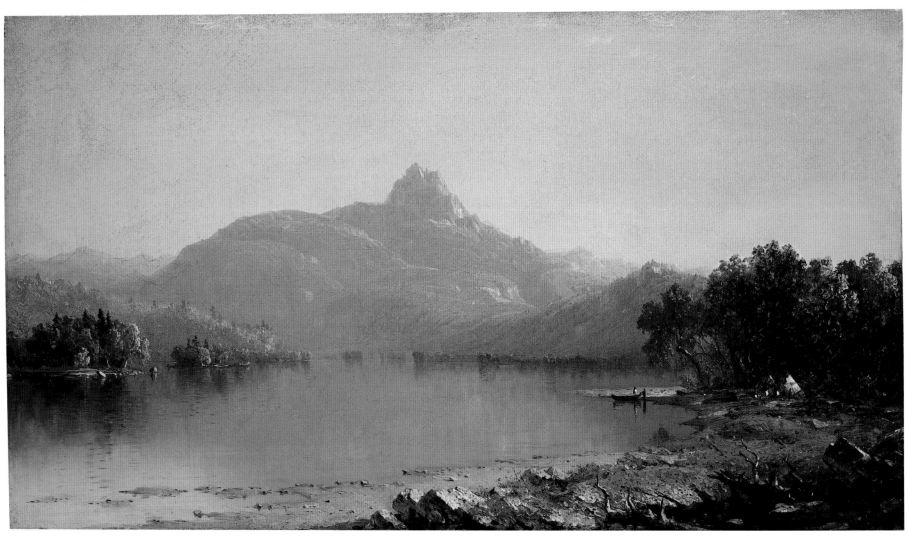

Cat. 53

Indian summer in October inevitably will be followed by the harsh realities of winter. Gifford's vision in these works was thus not that of a pragmatic realist who accepted the ramifications of progress and change but, instead, that of one who mourned what was lost in the process.

Given that the background mountain here resembles Mount Chocorua, which Gifford had by this time seen and painted often, he may have intended his painting to reference the story of "Chocorua's Curse." Thomas Cole had painted a work of that name in 1828 (Whereabouts unknown), and provided a summary of the story:

The name of this mountain is pleasing and I have made some inquiry respecting its origin– It appears that after the

French and Indian war had ceased– A hunter residing in this part of the country cherished (for some cause now unknown) a feeling of revenge against an Indian named Chocorua. he [sic] therefore mustered a party of hunters, his friends and went in pursuit of the unfortunate native of the Wild— They chased him up the high and almost inaccessible mountain now called by his name– and at length found him on the summit– there they gave the poor despairing and defenceless wretch the cruel choice whether he would leap from the dreadful precipice on the top of which he stood or die beneath their rifles. The ill-fated Chocorua refused to destroy himself by that terrific leap. And suffered death– beneath their hands– The country round the foot of Chocorua is inimical to the raising of Cattle such as are taken there

always die by an incurable disease– This, superstition has alledged to a curse which Chocorua is said to have uttered with his dying lips. "That all the Cattle of the Whitemen brought on to his hunting ground. should die".[2]

If viewers of *An October Afternoon* did think of the tragic story of Chocorua, they would have been reminded of the conflicts that the coming of European settlements brought to such peaceful scenes.

F K

54

Study for The View from South Mountain, in the Catskills, 1873

Oil on canvas, 8⅝ x 15½ in. (21.9 x 39.4 cm)
Signed, lower left: S R Gifford
Inscribed, on the verso: South Mountain, Catskills, pinxit 1873
MC 607, "A Study of South Mountain, in the Catskills. Date not known. Size, 8 x 15. Owned by Col. W. C. Squire, Ilion, N.Y."
Exhibited: Possibly Cincinnati Industrial Exposition, 1873, no. 42, as "South Mountain, Catskills"; probably Union League Club, Philadelphia, October 1873, no. 13, as "South Mountain, Catskill"; probably Brooklyn Art Association, December 1873, no. 127 (or 350), both titled "South Mountain, Catskill"; Moore's Art Rooms, New York, about 1874, as "South Mountain, Catskills"; possibly Chicago Industrial Exposition Building, Spring 1876, no. 429, as "South Mountain, Catskill."
Private collection

55

The View from South Mountain in the Catskills, a Sketch, 1865

Oil on canvas, 10 x 18¾ in. (25.4 x 47.6 cm)
Inscribed, lower right: Sept 2[?] 65
MC 398, "The View from South Mountain in the Catskills, a Sketch. Dated September 1865. Size, 10 x 18½. Owned by the Estate."
Private collection

In the Civil War years, almost systematically, Gifford represented the major sites in the vicinity of the Catskill Mountain House—with the exception of Kaaterskill Falls, which Thomas Cole and other fine artists and illustrators (including Gifford himself, earlier and later in his career) had portrayed many times. Among those sites are Kaaterskill Clove (see cat. nos. 21–25, and fig. 85); Hunter Mountain (see cat. no. 41); the Mountain House itself, from North Mountain (see cat. no. 27); and the memorable vista from South Mountain, along the trail from the Mountain House south and west to Sunset

Rock and Kaaterskill Falls. From "the brink of huge cliffs" on South Mountain, as one guidebook of the period noted, the tourist was treated to the double vista of the "[Hudson] river and valley, and the wonderful pass of the Kauterskill, through the mountain chain westward."[1] The popular travel writer Bayard Taylor insisted that "No visitor to Catskill should neglect a visit to the North and South Mountains," from where, "in certain conditions of the atmosphere, the air between you and the lower world seems to become a visible fluid—an ocean of pale, crystaline blue, at the bottom of which the landscape lies. Peering down into its depths, you at last experience a numbness of the senses, a delicious wandering of the imagination, such as follows the fifth pipe of opium. Or, in the words of Walt. Whitman, you 'loaf, and invite your soul'."[2] Taylor's narcotically informed perception seems almost precisely the one sought by Gifford in his 1873 *The View from South*

Catalogue

205

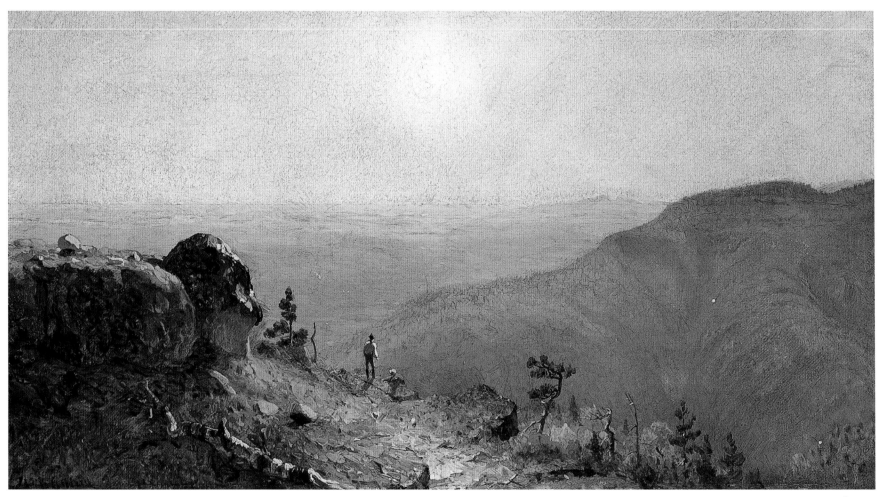

Cat. 54

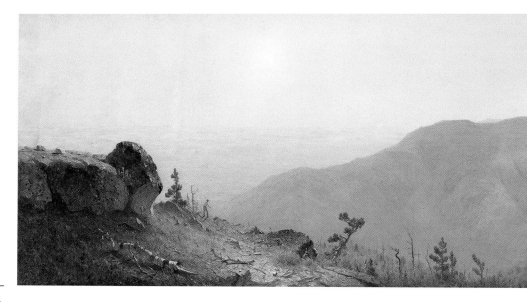

Figure 136. Sanford R. Gifford. *The View from South Mountain, in the Catskills*, 1873. Oil on canvas. Saint Johnsbury Athenaeum, Saint Johnsbury, Vermont

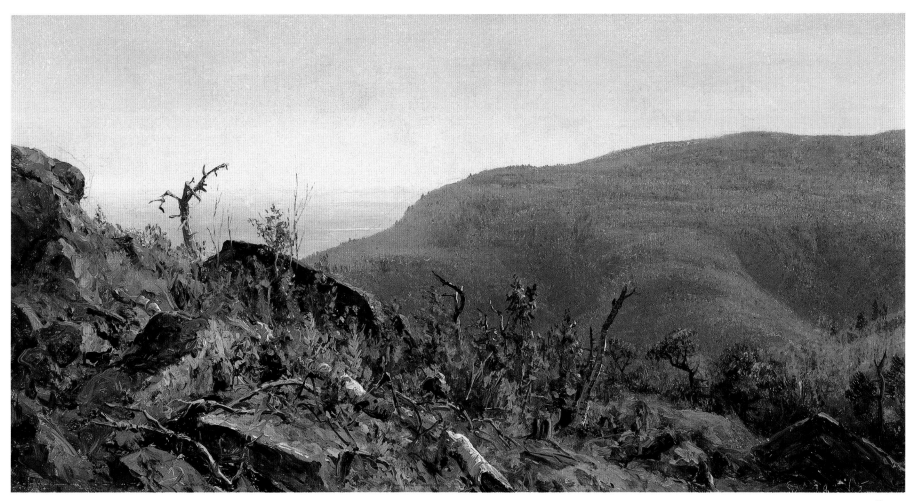

Cat. 55

Figure 137. Sanford R. Gifford. Two compositional studies for *The View from South Mountain, in the Catskills* (from the sketchbook of New Hampshire and New York subjects, 1865–66). Graphite on cream wove paper. The Frances Lehman Loeb Art Center, Vassar College, Poughkeepsie, New York. Gift of Miss Edith Wilkinson, Class of 1889

Mountain, in the Catskills (fig. 136), and in the study (cat. no. 54). Both pictures appear to reprise a now lost major work called *South Mountain, in the Catskills,* which the artist exhibited at the National Academy of Design nearly a decade earlier, in 1864.[3] That picture had garnered relatively little notice compared to the chorus of praise that greeted *A Twilight in the Adirondacks* (1864; Adirondack Museum, Blue Mountain Lake, New York; see cat. nos. 37, 38), which also was in the National Academy exhibition. However, at least one Catskill Mountain devotee admired the "view doubtless well known to many . . . readers":

The far-away horizon, the winding Hudson with its tiny sails, the square dent where lies the lake in the Shawangunk range, the serrated ridges of the lower hills, the smoke from the lowlands outside the Clove, the shadowed, ridgy sides of the Round Top Mountain [sic]*, the stunted pines of the South Mountain, so characteristically represented, the great rock overhanging the cliffs, and* [the] *whortleberry bushes and other low growth clustering about its base—all speak to us unmistakably of that very spot, and tell the story of the place as we scarcely thought it could have been told, yet so simply, so naturally, that the art of the artist is almost forgotten in actual enjoyment of the scene portrayed.*[4]

Nevertheless, the 1864 picture was subjected to the strong dissenting and moralizing voice of the young Ruskinian critic Clarence Cook, the principal spokesman for the small group of American Pre-Raphaelite painters in New York. Cook first of all seemed not to descry any of the detail in the distant valley particularized by the former reviewer, and, given his staunch loyalty to Ruskin's credo of "selecting nothing, rejecting nothing" in the natural scene, would have none of the Taylor-like "wandering of the imagination" that might be induced by Gifford's atmospheric vagaries:

. . . the artist has sought to give the effect of hight [sic]*, by dissolving the mountain side and the valley in vapor; but this is not a means of making us feel the hight* [sic]*; it is, rather, the way to make us unconscious of it. . . . Mr. Gifford has painted high mountains enough to make us suspect that*

he must, at some time, have climbed one. If so, and he be not painting wholly from fancy, he must remember, we think, that the mountain only seemed high when he could see what was at its foot. If all below him were rolled in vapor, and only the river dimly revealed . . . we feel that his only proof that the mountain was high was in his tired legs. Unfortunately, this proof Mr. Gifford cannot communicate to us by a picture. We want better evidence than his statement, which simply gives us nothing, to convince us that we are thousands of feet above the sea.[5]

The 1864 picture had been preceded by at least three sketches or studies in oil from South Mountain, two of them dated the year before.[6] Although Gifford did not return to the subject for a major work for another nine years, as early as 1865 he had made two drawings at the site (see fig. 137) and as many as five oil sketches (see cat. no. 55), which became the raw material of both catalogue number 54 and the large 1873 painting (see fig. 136).[7] At least a few of the drawings and oil sketches date to late September, and are undoubtedly from the same sketching campaign during which Gifford made the only known study for *Hunter Mountain, Twilight* (cat. no. 41). The concept of all of the painted versions was anticipated by the artist's first "chief picture" of native scenery, *Mansfield Mountain* (cat. no. 8), of 1859.

What is fascinating about the 1865 series of drawings and oil sketches is not merely their number but their production over a series of at least four days, from September 23 to 27. The latter date is also that of the second of the two drawings, indicating that Gifford revisited the South Mountain site with his sketchbook even after he executed one or more of the oils. Catalogue number 55, dated "Sept 2[?] 65," probably was painted earlier, for it corresponds closely to the first of the two drawings, especially in the motif of the scraggly remnant of a pitch pine thrust upward at the left. What is inconspicuous in the foreground of the drawings but is beautifully characterized in the oil sketch and increasingly prominent in the study and final version is the fallen birch tree that probably gave rise to the titles ("A Sketch of a Fallen Tree in the Catskills" and "A Study of

a Fallen Tree-Trunk") of four oil sketches listed successively in the *Memorial Catalogue.* Indeed, in both the drawings and this one known oil sketch, what is striking is not the vista of the valley so legible to at least one of the reviewers of the 1864 picture but the lovingly realized litter of rocks and trees in the foreground and the muscular shoulder of Kaaterskill High Peak across the clove. The drawings reveal nothing of the valley, and the oil sketch merely presents a glimpse of its blue reach between the foreground and the terrain in the middle distance. The near focus suggests an almost Pre-Raphaelite accommodation of Cook's criticisms of the 1864 painting, but the 1865 oil sketch barely qualifies as a view from South Mountain. At any rate, Gifford did not embark on another major exploration of the subject; in fact, after *Hunter Mountain, Twilight* (cat. no. 41), and *An October Afternoon* in 1866, he never again exhibited Catskill subject matter at the National Academy.

However we may account for Gifford's obsessive 1865 reprise of the site of his 1864 exhibition picture, when he decided to return to the South Mountain view for a major picture, he also significantly modified the emphasis on the foreground, as seen in the extant 1865 drawings and oil sketches, for an effect that must, in some measure, have approximated that of the 1864 version. He achieved this principally by raising the horizon line from its position in the oil sketch, sinking slightly the level of the immediate foreground and altering the profile of Kaaterskill High Peak to show more of its eastward slope to the valley, thus revealing a larger expanse of the distant plain. The sun hangs impossibly low in the middle of the midday sky, its light absorbing all but a scattering of highlights in the valley, which connote far-off dwellings and the distant Hudson River at the upper left. From oil sketch to study to large picture, the arboreal cover becomes increasingly autumnal and the overall tonality warmer. Perhaps the artist recalled Cook's sarcastic speculation about his mountain climbing when he inserted two figures into the foreground, one bending to help his companion as they scale the final ledge to their vantage point.

Gifford sent two versions of *The View from South Mountain, in the Catskills*—the large one (see fig. 136) and perhaps catalogue number 54—to the Brooklyn Art Association exhibition in December 1873. The admiration for the former picture's "flood of radiance" and for the "vein of poetical feeling . . . expressed in all of Mr. Gifford's works . . . suggested always in the most gorgeous phases of nature," intimates, in the very choice of language (reflecting his familiar subject matter), why the artist's simultaneous offerings to the New York City public were dominated by views of European cities and resorts.[8]

K J A

1. Richards 1861, p. 145.
2. Taylor 1860, p. 43.
3. *Memorial Catalogue*, no. 348, "South Mountain, in the Catskills. Dated 1864. Size, 22 x 42. Owned by Mrs. Charles Gould."
4. *The Continental Monthly*, June 5, 1864, pp. 686–87.
5. Cook 1864b.
6. *Memorial Catalogue*, numbers 317–319.
7. The drawings are in a sketchbook of New Hampshire and New York subjects dated 1865 and 1866 (The Frances Lehman Loeb Art Center, Vassar College, Poughkeepsie, New York; 38.14.4.17,19),

and on microfilm (Archives of American Art, Reel D254, frames 112, 113). The oil sketches, including catalogue number 55, are listed in the *Memorial Catalogue*, numbers 398–402: Of the oil sketches, only catalogue number 55 (no. 398) is known today, and actually alludes to South Mountain in its title. However, its grouping, in the *Memorial Catalogue*, together with all those works whose titles refer to a "Fallen Tree" or "Fallen Tree-trunk"—the feature so conspicuous in the foregrounds of the extant paintings and studies (as in the present pictures and in fig. 136)—strongly suggests that these works were related.
8. *The Brooklyn Daily Eagle*, December 18, 1873.

56

Venetian Sails, a Study, 1873

Oil on canvas, mounted on Masonite, 13 3/8 x 24 in. (34 x 61 cm)
Signed and dated, lower right: S R Gifford 1873
MC 605, "Venetian Sails, a Study. Dated 1873. Size, 13 x 24. Owned by Charles Parsons, St. Louis, Mo."
Exhibited: Possibly Century Association, New York, November 1873, no. 2, as "Sails of Venice."
Washington University Gallery of Art, Saint Louis. Bequest of Charles Parsons, 1905

"I came to Venice to spend four or five days," Gifford wrote to his father in July 1869. "Six weeks have passed and here I am yet—stranded in the lagoons." Later in the same letter he reported that he and the artist George Henry Yewell "have made many excursions on the lagoons to Torcello, Burano, Murano, Molmocco, Chiaggia [*sic*]. I have made a few sketches about Venice, from some of which I may make pictures. The richly colored sails of the Venetian [*sic*] and Chioggian fishing boats have interested me a good deal from the striking contrasts of color they afford with the sky and water. There is also a curious variety of quaint design in them."[1]

Gifford's uncertain intentions for his "few sketches"

turned into at least twenty-five paintings of Venetian subjects, executed throughout the remaining eleven years of his career. The majority of these views were taken from the lagoon, and four of them include some variation on the "Venetian Sails" of the title.[2] To be sure, his second visit to the city proved six times longer than his first, a dozen years earlier; the relative brevity of his 1857 stay coupled with the exotic novelty of Venice, its architecture, and its art, and the more gregarious society he encountered then appear to have deflected any serious observation of the city as a subject (although even in 1857 he did mention those colorful sails).[3] Whatever the reason, no paintings of the "Queen of the Adriatic" are known before 1869.

On the other hand, despite the artist's ambivalence toward his Venetian sketches during his 1869 visit, there seems little mystery about his later productivity. By 1870, paintings of Venice had proliferated to accommodate a burgeoning tide of American travelers who, unlike previous generations, did not limit their explorations to classical Italian sites in Rome, Pompeii, and Herculaneum. Among other publications, John Ruskin's

The Stones of Venice (1851–53), with its revisionist celebration of Italian Gothic architecture, had helped to entice English-speaking tourists. Earlier on, Canaletto and, especially, Turner had immortalized the image of this seemingly weightless metropolis and the variety of vessels plying its lagoon and canals, followed by such artists as the popular Frenchman Félix Ziem and even by a few Americans—John Rollin Tilton, Christopher Cranch, and William Stanley Haseltine—who, by the 1860s, had begun interpreting the Venetian skyline.[4] Ziem's pictures are particularly fascinating in connection with Gifford's work for their common interest in saturated color effects, and, interestingly, Gifford's admiration for Ziem is known from his having recommended that his friend and colleague Jervis McEntee go to see a painting by Ziem on view in New York. Finally, after Gifford exhibited the large *Church of San Giorgio, Venice* (Whereabouts unknown),[5] at the National Academy of Design in New York following his return from Europe, commissions for Venetian subjects escalated. Indeed, by 1875 he was complaining to his friend the painter John Ferguson Weir that the recent orders he was filling for

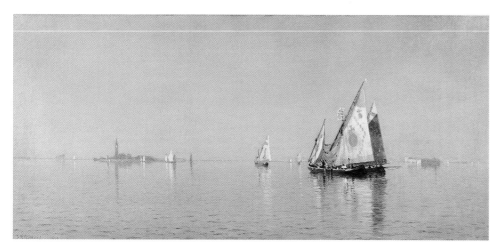

Figure 138. Sanford R. Gifford. *The Lagoons of Venice,* 1869. Oil on canvas. Marsh-Billings-Rockefeller National Historical Park, Woodstock, Vermont

Figure 139. Sanford R. Gifford. *Venetian Fishing Boats,* 1869. Graphite. Private collection

Figure 140. Sanford R. Gifford. *Venetian Fishing Boats,* 1869. Graphite and colored wax pencil. Private collection

paintings of Venice had become so numerous that he had "lately declined to paint them when they have been asked for. One can't stay in Venice forever anymore than one can eat partridge every day."[6] Nonetheless, Venice provided the subject matter of Gifford's four last recorded paintings (all now lost), including his final major work.[7]

The composition of *Venetian Sails, a Study,* began to take shape as early as the months just following Gifford's return from the "Old World," when he executed the wide-angle view entitled *The Lagoons of Venice* (fig. 138). That picture established the artist's preference for making the sailboats the principal motif of the picture, albeit discreetly, while suppressing the profile of Venice itself, stretched across the ruled horizon line about a third of the way up the canvas, with a distant bell tower subtly counterbalancing the verticals of the sails in the foreground. *Venetian Sails, a Study,* is essentially a mirror image of *The Lagoons of Venice,* with the skyline of the city proper dominated by the Campanile overlooking Piazza San Marco on the right replacing the Isola Povillia on the left in the earlier picture. All of these features originated in separate sketchbook drawings of the skyline and of the boats (see fig. 139, 140)—one of which marks an exceptional instance of the artist using colored pencils to record specific tints—and probably in at least one oil sketch dated June 1869 (see fig. 141) showing several clusters of the vessels.[8] As in some of his other scenes with water as their subject, Gifford here deftly establishes a sense of receding space with the inclusion of a few boats of diminishing size in the composition. The artistry of Gifford's Venetian paintings lies in his masterful control of the tonality of the blue sky and water; this sets off the piquant decorative accents of the sails, which suggest butterflies lighting on the picture surface.

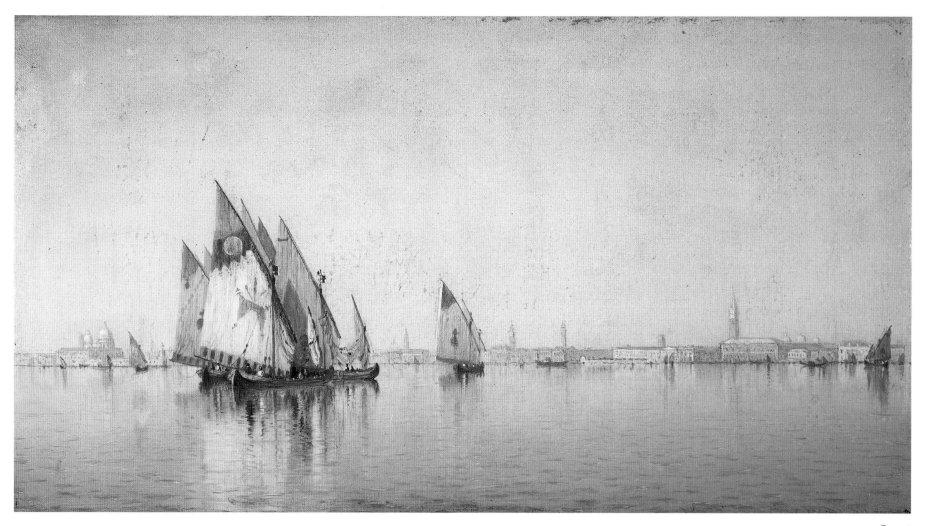

Cat. 56

Figure 141. Sanford R. Gifford.
Venetian Fishing Boats, 1869. Oil
on canvas. Private collection

The present picture probably anticipated the version of *Venetian Sails* (Whereabouts unknown) exactly twice its size that Gifford painted in 1873 for John Jacob Astor, and which he exhibited at the National Academy of Design in 1874.[9] In that work the artist may have heightened the primary hues of the sails, or perhaps they became more conspicuous as a result of their amplification, for the *New York Sun*'s critic questioned their accuracy even as he forgave—and, indeed, hailed—Gifford for his Old Master-like artfulness:

In point of fact, such an atmosphere is as rare as are the brilliant colors in the sails of the barges that float on the placid waters of the lagoon. But there was once, doubtless, a time when the sails were new and brilliant as Gifford has painted them, and once in a year or so such atmospheric effects may occur; and this is enough to justify the artist. Besides, Gifford paints his landscape just as Titian did his flesh, from an ideal point of view; neither, when strictly compared with nature, is like it, and yet both satisfy the imagination and the eye by their feeling, and richness, and fulness [sic] *of color.*[10]

Another reviewer likened Gifford's discriminating rendering of landscape to the fine portraiture in certain *belles-lettres*: "We have often thought with envy of the good times Walter Scott and Dickens must have had, crooning over and adding touch after touch to the characters in their novels; and, in the same way in which we have coveted the happiness of these men, we look upon the poetical imagination of Mr. Gifford, with its remarkable power of purity of expression, as one of the greatest gifts for himself and comforts to the world."[11]

Perhaps the most telling response, with reference both to Gifford's continued success in his last decade and possibly to the power that Venice continued to exert on him personally, is that of the *New York Evening Post* critic, who found his attention fixed "for some time" by the *Venetian Sails*: "The color on the boats in the foreground may be a little too positive; this emphasis, however, does not affect the gradations of tint and of atmosphere by which the eye is led onward to the splendid sweeping line of architecture forming the horizon. A delicate work like this, a true inspiration, keeps alive one's brightest souvenirs of the unrivalled Queen of the Adriatic."[12]

The artist, himself, treasured such mental souvenirs as those that he supplied to his patrons and his public. Worn out from his travels through the Middle East when he arrived in Venice, Gifford had resolved never to go abroad again, yet he resisted the temptation to proceed directly to America, deciding that he "should stay a little longer now, and so get thro' with all I want here, and have finally done with it."[13] When, a month-and-a-half later, he was at last coaxed away by a friend, he was all rueful devotion: "Tomorrow I am to be dragged reluctantly away. . . . I did not know till now, when I am about leaving Venice forever, how strong a hold this dear old, magnificent, dilapidated, poverty-stricken city has taken on my affections. Even in her rags and tatters and old age the 'Bride of the Sea' is the loveliest, the most glorious and the most superb of cities."[14]

KJA

1. Letter from Sanford Robinson Gifford to his father, Elihu Gifford, Venice, July 17, 1869, Gifford, European Letters, vol. 3, pp. 128, 130.
2. *Memorial Catalogue*, numbers 541, 544, 548, 549, 551, 564, 565, 568, 581, 602, 604–606, 633, 640, 642, 653, 654, 686, 687, 714, 728–731. For the various *Venetian Sails* see numbers 604, 605, 653, 654.
3. Letter from Sanford Robinson Gifford to his father, Elihu Gifford, Venice, July 23 (?), 1857, journal entry of July 12, 1857, in Gifford, European Letters, vol. 2, p. 172: "Walked to the Giardino Publico [*sic*]. Sketched one of the curious flags of the fishing boats. The sails of these boats are of all sorts of bright colors, red and orange predominating."
4. Erica E. Hirschler, "'Gondola Days': American Painters in Venice," in Stebbins et al. 1992, pp. 121–22.
5. *San Giorgio, Venice,* is discussed, and an engraving of it is illustrated, in Weiss 1968/1977, pp. 315–16, fig. IX B 2. See also Weiss 1987, pp. 129–30.
6. Letter from Sanford Robinson Gifford to John Ferguson Weir, 51 West 10th Street, May 6, 1875; John F. Weir Papers, Manuscripts and Archives, Yale University Library, New Haven. I am grateful to Ethan Lasser for supplying me with copies of the Gifford-Weir correspondence.
7. *Memorial Catalogue*, numbers 728–731. See also Weiss 1987, p. 158.
8. See Weiss 1987, pp. 280–84; *Lagoons of Venice* is illustrated on page 280.
9. NAD Exhibition Record (1861–1900) 1973, vol. 1, p. 342 (1874), no. 296.
10. *The New York Sun*, April 15, 1874.
11. *Appletons' Journal* 1874, p. 604.
12. *The New York Evening Post*, April 25, 1874.
13. Letter from Sanford Robinson Gifford to his father, Elihu Gifford, Venice, June 7, 1869, journal entry of June 1, 1869, Gifford, European Letters, vol. 3, p. 128.
14. Letter from Sanford Robinson Gifford, July 17, 1869, Gifford, European Letters, vol. 3, p. 129.

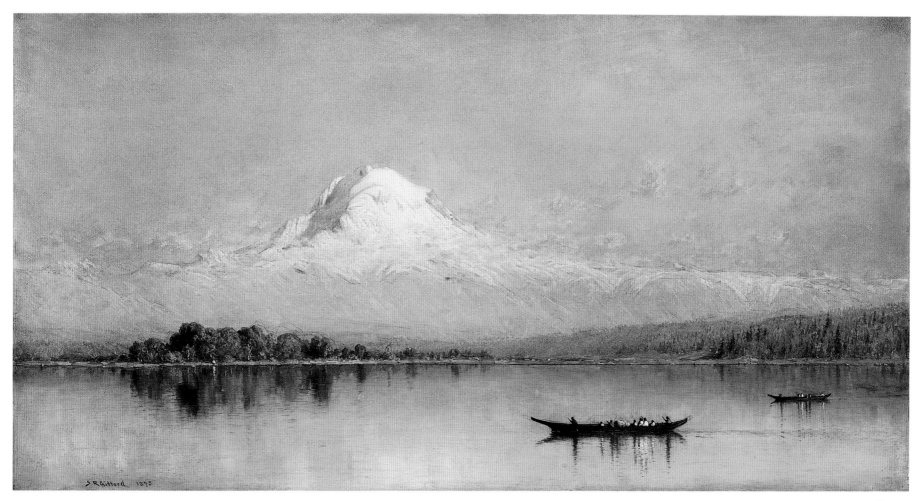

Cat. 57

57

Mount Rainier, Bay of Tacoma—Puget Sound,
1875

Oil on canvas, 21 x 40½ in. (53.3 x 102.9 cm)
Signed and dated, lower left: S R Gifford 1875
MC 636, "Mount Renier, Washington Territory. Size, 21 x 40.
Sold in 1874 [*sic*] to Mr. Fowler, London, Eng."
Exhibited: Century Association, New York, February 1875.
Seattle Art Museum. Partial and promised gift of an anony-
mous donor and 45% fractional interest gift, by exchange, of
Mr. and Mrs. Louis Brechemin, Max R. Schweitzer, Hickman
Price, Jr., in memory of Hickman Price, Eugene Fuller
Memorial Collection, Mr. and Mrs. Norman Hirschl, and the
estate of Louis Raymond Owens

58

Mount Rainier, Washington Territory, 1874

Oil on canvas, 8 x 15½ in. (20.3 x 39.4 cm)
Signed, lower right: S R Gifford
Possibly MC 639, "Mount Renier, Washington Territory.
Dated April 24th, 1875. Size, 8 x 15. Owned by Ira Davenport,
Bath, N. Y."
Private collection

Gifford traveled west for the second time in the summer
of 1874, going as far north as Alaska. He apparently made
only a few sketches on this journey, but on September 1
and 2 he drew detailed studies of Mount Rainier (which

he consistently misspelled "Renier") in what was then the
Washington Territory.[1] According to one report, Gifford
planned to return there in the future: "Now that he
knows the ground, he hopes, on a second visit, to be able
to reproduce some of these almost unknown scenes."[2]
While the second trip never materialized, the 1874 draw-
ings proved sufficient inspiration for several pictures
Gifford later completed in his New York studio.

Rainier, a volcanic peak dominating the landscape of
western Washington, stands nearly three miles higher
than the lowlands to the west and one-and-a-half miles

higher than the neighboring mountains. Gifford likely knew that it was active, for it had erupted as recently as the 1840s. Although extensive glaciation over the centuries had rounded its conical form, the way Rainier towered over its surroundings may have reminded Gifford of Sicily's Mount Etna, which he had sketched in 1868. Etna, in turn, would have recalled to him the work of Thomas Cole, who had painted several images of the volcano in the 1840s (see fig. 142). In Cole's paintings, Etna looms over a vast, fertile countryside, with only a small plume of smoke rising from its crater hinting at its destructive power. Cole's pupil Frederic Church similarly had portrayed the great Andean volcano Cotopaxi early in his career (see fig. 143).[3]

In Gifford's images of Mount Rainier, a still body of water in the foreground establishes a feeling of quiet calm, and the lower flanks of the mountain are softened by the atmosphere, which renders them almost invisible; above floats the snow-clad peak of Rainier, seeming to belong more to ether than to the earth. John F. Weir, after a visit to Gifford's studio in March 1875, marveled at the dissolving evanescence of one of his views of the mountain, describing it as "a miracle of entrapped sunlight, permeating a warm and tremulous atmosphere. Into what vehicle does the artist dip his brush to fix these subtle refinements of light upon the canvas?"[4]

In the smaller painting (cat. no. 58), Gifford included a close view of shoreline and forest, with two Native Americans and their canoe at the right. Two zones of space, one near and the other far distant, are thereby established, as is a contrast between the relative darkness of the foreground and the light-filled space beyond.[5] The painting thus reprises the format of works by the artist depicting eastern scenery, such as *An October Afternoon* (cat. no. 53), but without their nostalgic undertones, because Native Americans were still a very real presence in the Pacific Northwest at the time of Gifford's visit. In the larger painting, he eliminated all traces of foreground land to create three glowing bands that comprise water, earth, and sky. This picture could easily function as a New World pendant to the artist's *Lake Geneva* (fig. 144), a similar dreamy vision juxtapos-

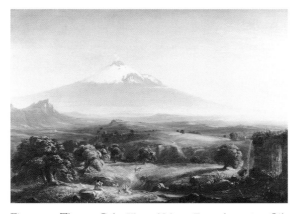

Figure 142. Thomas Cole. *View of Mount Etna*, about 1842. Oil on canvas. Virginia Museum of Fine Arts, Richmond. The Adolph D. and Wilkins C. Williams Fund

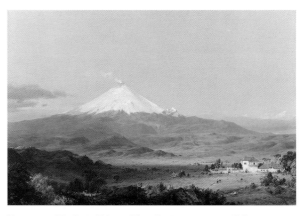

Figure 143. Frederic Edwin Church. *Cotopaxi*, 1855. Oil on canvas. Smithsonian American Art Museum, Washington, D.C. Gift of Mrs. Frank R. McCoy

ing water, earth, and sky. When a version of *Mount Rainier* virtually identical to catalogue number 57 was shown in Paris in 1878, it occasioned an astonished reaction from one French critic, who compared looking at it with staring straight into the sun, but, he added, with "sunglasses one could eventually distinguish a painting."[6]

Catalogue number 57 likely was begun by Gifford soon after his return to New York in October 1874, for it was exhibited at the Century Association in February 1875.[7] The practice of showing works of art at private clubs such as the Century was hardly unusual for Gifford and his fellow painters, but it did become a matter of controversy with the governing council of the National Academy of Design.[8] Early in 1875, the Academy enacted a policy against showing paintings in its annual exhibitions that previously had been publicly displayed. Gifford objected to this, even to the point of tendering a letter of resignation ending his association of more than twenty-five years with the institution. In the end, the council reversed its decision and Gifford's resignation was avoided, although some bitterness may have lingered. The artist could have sent one of his large Mount Rainier paintings or his *Lake Geneva* (fig. 144) to the 1875 Academy exhibition, but he chose to submit

nothing. It was the first time since 1847 that he was not represented; feelings must have cooled by the following year, however, when he once again had paintings on view.

F K

1. For example, see the sketch inscribed "Mount Renier from Tacoma—Sept 1ˢᵗ 1874" (Harvard University Art Museums, Cambridge, Massachusetts), illustrated in Weiss 1987, p. 300.
2. "Art," *The Arcadian* 3, no. 17 (January 7, 187[5]), p. 13.
3. Church would later depict it in a far more dramatic guise in *Cotopaxi* of 1862 (The Detroit Institute of Arts).
4. Weir 1875.
5. See Weiss 1987, p. 301, for an analysis of the composition.
6. Clovis Lamarre and René de La Blanchère, *Les États-Unis et l'Exposition de 1878* (Paris: C. Delagrave, 1878), p. 160; quoted in Weiss 1968/1977, p. 340: "Le Mont Renier de M. Gifford, qui produit d'abord l'effet du soleil vu de face, mais où, avec des lunettes fumée[s], on distingue ensuite un tableau." The painting (Private collection, Seattle) is illustrated in Weiss 1987, p. 299.
7. It is listed as no. 22, "Mt. Renier, Bay of Tacoma, Puget Sound," in the handwritten catalogue of the Century Association; I am grateful to Tom Barwick for sharing his research on the painting with me. According to the *Memorial Catalogue* (no. 636), the painting was sold "in 1874 [*sic*] to Mr. Fowler, London, Eng." The second version, which was acquired by an "R. Dunn," was included on Gifford's list of "chief pictures."
8. See the discussion in Weiss 1987, pp. 142–43.

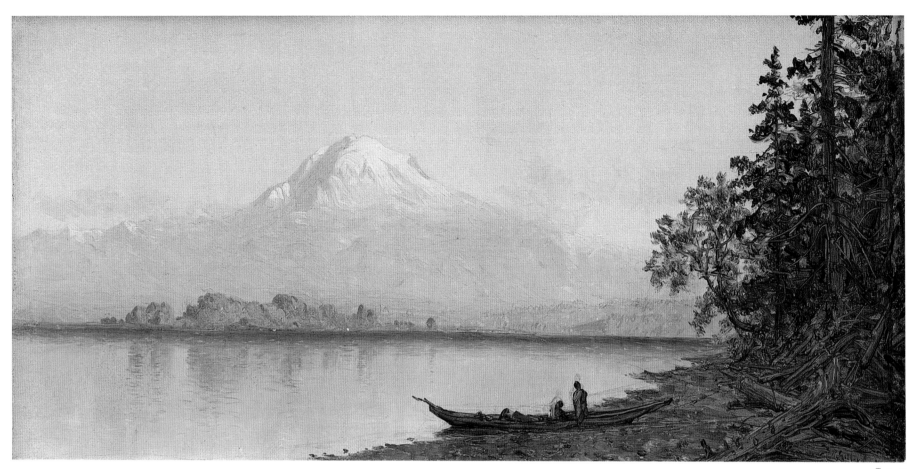

Cat. 58

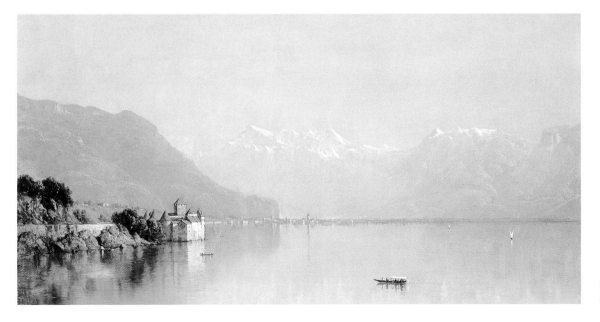

Figure 144. Sanford R. Gifford. *Lake Geneva*, 1875. Oil on canvas. Rhode Island School of Design, Museum of Art, Providence. Anonymous Gift

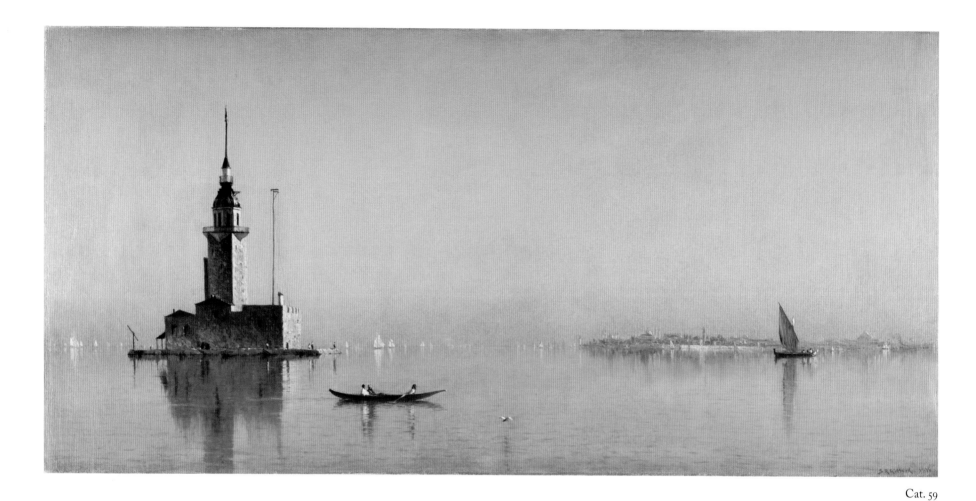

———

Leander's Tower on the Bosphorus, 1876

Oil on canvas, mounted on aluminum, 19¹/₁₆ x 39¹/₈ in. (48.4 x 99.4 cm)
Signed and dated, lower left: S R Gifford 1876
MC 645, "Leander's Tower on the Bosphorus. Dated 1876.
Size, 23 x 42. Owned by William H. Fogg."
Exhibited: National Academy of Design, New York, April 1877, no. 312.
Fogg Art Museum, Harvard University Art Museums, Cambridge, Massachusetts. Bequest of Mrs. William Hayes Fogg

60

———

Constantinople, from the Golden Horn, 1880

Oil on canvas, 8⁷/₈ x 16 in. (22.5 x 40.6 cm)
Signed, lower left: S R Gifford
Inscribed, on the verso: Constantinople / S. R. Gifford pinxit 1880 / From the Horn
MC 727 [22.], "Constantinople, from the Golden Horn. Dated 1880. Size, 9 x 16. Owned by Mrs. S. R. Gifford."
Exhibited: The Metropolitan Museum of Art, New York, "Memorial Exhibition," October 1880–March 1881, no. 22.
Munson-Williams-Proctor Institute, Museum of Art, Utica, New York

Gifford's travels in the Near East took him to Constantinople (now Istanbul) in May 1869. His first view of the city was from aboard ship in the Golden Horn: "It was like a vision of [a] fairy land to see the towers and domes and minarets, glittering and golden in the early sun, appear and disappear in the mysterious air."[1] The horn-shaped estuary was celebrated as one of the finest natural harbors in the world, and for Gifford it was "the heart and soul of Constantinople," a port "more active and busy than any I know except that of London."[2] Late one afternoon he was treated to an especially lovely view of the city: "We floated back down the Golden Horn in a splendid sunset. The boats and costumes on the water and the water on either side were

Hudson River School Visions

216

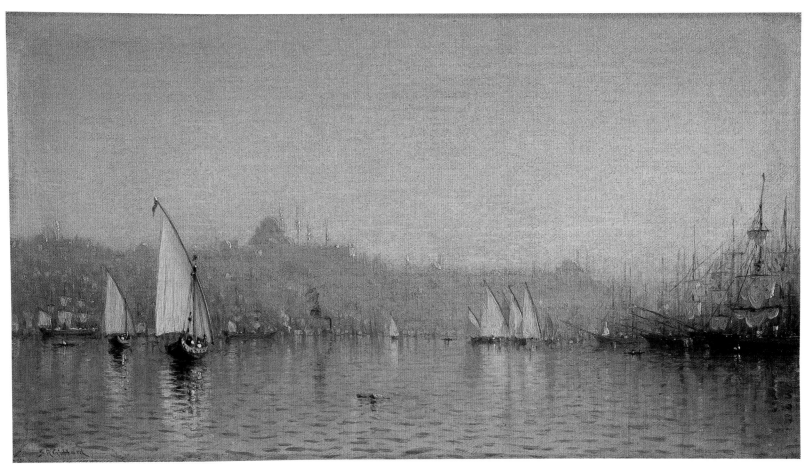

Cat. 60

all aglow with color, while through the purple haze of the distance flashed a thousand little golden lights from the windows of the Seraglio and the mosque of St. Sophia."[3] That experience may have been the inspiration for an oil sketch (Private collection) showing the harbor crowded with ships, with the city, bathed in a glowing golden brown atmosphere, looming beyond.

Gifford completed a larger painting, *The Golden Horn, Constantinople* (Whereabouts unknown), which was included on his list of "chief pictures" and was shown at the National Academy of Design in New York in 1873. One visitor to Gifford's studio in January of that year wrote admiringly of the painting: "There is now on the easel of Sanford R. Gifford, in the Tenth Street

Studio building, a fine picture of the 'Golden Horn,' one of the results of Mr. Gifford's travels in the East some time since. The atmosphere of the picture is a light, warm haze, through which the mosques and minarets of the city loom up with magic effect. On each side of the picture, vast masses of closely-packed shipping are seen."[4] This description suggests that the exhibited picture was similar to the small work dated 1880, in which the flickering highlights on the water, sails, and distant buildings are handled with Gifford's usual brilliance. By the 1870s, that brilliance was widely recognized, even to the point of being considered by some a tiresome mannerism. A critic who saw the large painting at the Centennial Exhibition in Philadelphia in the fall of 1876 observed that "the strong point of this artist is what is denominated 'atmosphere,' and a great deal of it is very pretty," but, the same writer continued, "there is an uniformity in Mr. Gifford's subjects and a persistency in the way in which the same effects of haze, mist, fog and 'atmosphere' recur in all his pieces that makes one suspect a kind of trick by which he gets his picture. We are led to ask why the fog never lifts; whether he can paint nothing else but vapor-laden air, and if so whether he discovers nothing else in the round of nature which is worth his attempting?"[5]

While in Constantinople, Gifford also sketched the famous lighthouse in the strait of Bosporus, variously known as the Maiden's Tower or Leander's Tower. Erected on a small island of rock, the lighthouse served for centuries as a beacon directing sailors to safe harbor. The tower was constructed in the twelfth century (and rebuilt numerous times since), and its several names derive from legends associated with it. In one, the daughter of the emperor Constantine was hidden for safety in the tower after a fortune-teller predicted she would die from the bite of a poisonous snake, but she nevertheless succumbed to the fatal bite of a snake hidden in a basket of grapes that was sent to her.[6] More familiar to westerners and doubtless to Gifford as well was the story of Hero and Leander. Leander, a young man living in the city of Abydos, fell in love with a beautiful priestess named Hero. She was forbidden to

marry, so every night Leander secretly swam across the strait to visit her. Hero lit a torch in the tower where she lived, to guide him, but one night a storm extinguished the torch and Leander lost his way, became exhausted, and drowned. The next morning, after seeing Leander's tattered garments in the sea and realizing his fate, Hero threw herself into the water and also drowned.[7] Although identification of the setting has varied over time, the Hellespont (now the Dardanelles), the strait separating Europe from Asia, is most often cited as the location of this story, interest in which was reawakened after George Gordon, Lord Byron, swam the Hellespont in the early nineteenth century. The American sculptor William Henry Rinehart created marbles of both figures in 1858, and sold many replicas of them in the 1860s and 1870s.

Leander's Tower on the Bosphorus was shown at the National Academy of Design in the spring of 1877.[8] The critic for *The Art Journal* cited it to contrast the truthfulness of the light effects in Gifford's American and European scenes:

In looking at his "Leander's Tower on the Bosphorus" (312), the golden light, that falls on sea and boats and tower, seems poetically true to the sentiment and the associations of the place. Even if no such yellow light ever in truth fell upon mundane things with its supreme glory, it does not, in these remote and half-mythical places, seem wholly improbable; but, in "Sunset on the Hudson" (404) [an earlier version of catalogue number 69], it is impossible for the imagination to accept it. What is a golden glory on the Bosphorus is a dazzling falsehood on the Hudson. In the Bosphorus picture the artist has given to the canvas his best feeling and best skill. It is a poem of light and colour. The picturesque tower in the foreground is bathed in radiant light and washed by waves of molten gold. The sky and atmosphere are luminous, tender, and full of strange beauty, while the distant sails look like birds of glorious wing reflecting the golden splendour of the heavens. Whether one acknowledges the colour as truthful or not, he can be but fascinated with its rare and poetic charm.[9]

The painting inspired another observer to opine about the "analogy of color and music" and the "vibrat-

ing pitch of color and the vibrating pitch of sound"; he continued: "Not more direct than the appeal made by music to our subtlest and deepest emotions is the appeal made by the finest modern landscapes. Some of Mr. Gifford's landscapes, notably his scene on the Bosphorous [*sic*], in the present exhibition, produce precisely the effect of a sonata or a symphony."[10] By this time, equating paintings and music was popularly associated with the works of James A. M. Whistler, who often used the words "symphony" and "nocturne" in the titles of his works.

At first, there may seem to be little in *Leander's Tower on the Bosphorus* that obviously suggests Whistler's work. However, its elegantly reductive composition and tonally unified expanse of water and sky create an effect that recalls the aesthetic of some of Whistler's own seascapes (see fig. 145). Gifford had explored this minimalist compositional scheme in such earlier works as *An Indian Summer's Day on the Hudson—Tappan Zee* (cat. no. 46)— one that he would further develop in the series of pictures of the Palisades on the Hudson, which he began about the same time that he completed *Leander's Tower*.

F K

1. Letter from Sanford Robinson Gifford, Golden Horn, May 1869, in Gifford, European Letters, vol. 3, p. 122.
2. Ibid.
3. Ibid., p. 123.
4. "Fine Arts. In the Studios," *The Arcadian* 1, no. 19 (January 23, 1873), p. 10.
5. Swinnerton 1876.
6. See {http://www.istanbulrooms.com/tourist-information/attractions/landers-tower}, December 6, 2002.
7. See {http://www.geocities.com/crab_wise/Istanbul/bilgi/bilgi1.htm}.
8. A smaller, preliminary version (probably *Memorial Catalogue*, no. 644) was seen by a Boston critic in Gifford's studio in February 1876: "S. R. Gifford has on his easel a study for a larger picture, called 'Leander's Tower.' The tower stands out in the smooth waters as the main object of the picture, with Constantinople in the distance and sailboats between." "Art and Artists," *Boston Evening Transcript*, February 25, 1876, p. 6.
9. "The Academy Exhibition," *The Art Journal* (New York), n.s., 3 (1877), p. 158.
10. *The New York Evening Post*, April 21, 1877.

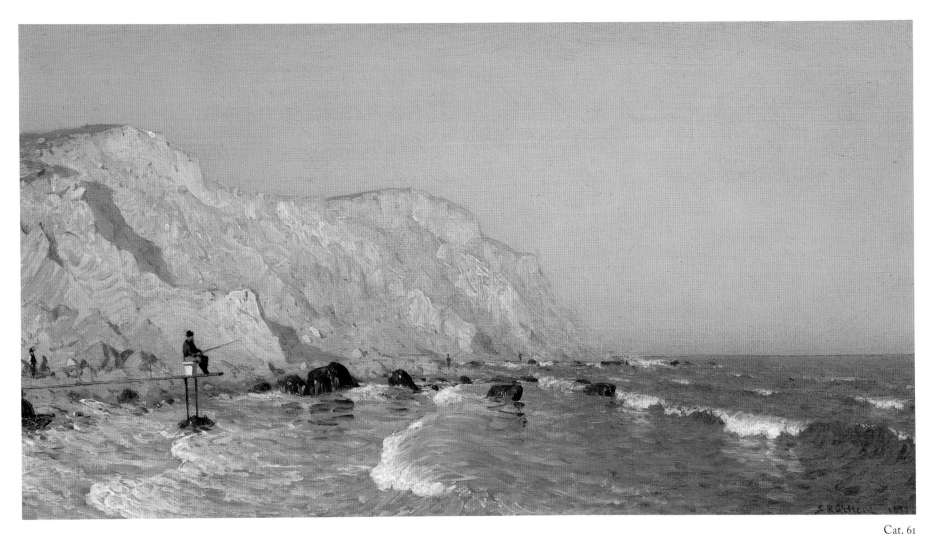

61

A Sketch of Clay Bluffs on No Man's Land, 1877

Oil on canvas, 9¼ x 16 in. (23.5 x 40.6 cm)
Signed and dated, lower right: S R Gifford. 1877.
MC 656, "A Sketch of Clay Bluffs on No Man's Land. Not dated. Size, 9 x 16½. Owned by the Estate."
Private collection

62

Sunset on the Shore of No Man's Land—Bass Fishing, 1878

Oil on canvas, 23 x 42 in. (58.4 x 106.7 cm)
Signed and dated, lower right: 1878 / S R Gifford
MC 672, "Sunset on the Shore of No Man's Land,—Bass Fishing. Dated 1878. Size, 23 x 42. Owned by J. H. Devereux, Cleveland, O."
Collection Deedee and Barrie Wigmore, New York

In October 1877, Gifford visited No Man's Land, a tiny island off the Massachusetts coast. A statement in the *New-York Daily Tribune* suggests that this was an unusual destination for an artist: "Mr. Sandford [*sic*] R. Gifford has found a new haunt on No-Man's Land, a dreary island, inhabited by three families, south of Martha's Vineyard. What he has found there is unknown; hence there will be the greater curiosity to see his next work."[1] Located about two-and-three-quarter miles south of Gay Head, the island was the first land reached by the English explorer Bartholomew Gosnold

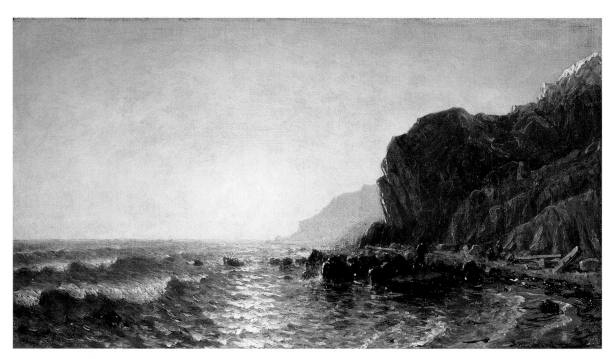

Figure 146. Sanford R. Gifford. *Coastal Scene with Angler* (*Bass-Fishing at No Man's Land*), 1877. Oil on canvas. Private collection

in 1602. What led Gifford there is not certain, although perhaps it was his love of fishing. The island was only accessible in good weather, and accommodations were minimal. The scenery was notable for "huge rocks of unusual formation" and steep cliffs descending to the ocean.[2] Leif Eriksson was believed by some to have landed on the island, as a runic inscription, said to date from 1004 but since proven false, is visible on a boulder near the shore.[3]

Five works depicting No Man's Land, including the present two, are listed in the *Memorial Catalogue. A Sketch of Clay Bluffs on No Man's Land* is freely and expressively painted, suggesting that it may have been developed from a study made on the spot. A figure holding a rod sits at the end of a rudimentary pier, and others are seen fishing in the surf beyond. The full light of

day illuminates the scene, its clarity revealing the warm, mottled colors of the clay cliffs in contrast to the cooler hues of the ocean. *Sunset Off No Man's Land, A Study,* and *Coastal Scene with Angler* (*Bass-Fishing at No Man's Land*) (fig. 146) may have been preliminary to the large painting, *Sunset on the Shore of No Man's Land—Bass Fishing,* which Gifford included on his list of "chief pictures."[4] The last work is one of the artist's most daring formal experiments. The dark cliffs at the right are starkly set off against the strong light of the sun, creating an intensely realized opposition. The small figure of a fisherman on the rocks, casting his line, and two other figures nearby are almost unnoticeable but, once seen, help establish a sense of immense scale. The blazing light of the sun fills the atmosphere and floods across the water, making

the waves seem almost like liquid fire. The result is a work of startling force and power, with an assertive presence that is in marked contrast to the restrained elegance of Gifford's paintings of just a decade earlier, such as *An Indian Summer's Day on the Hudson—Tappan Zee* (cat. no. 46).

F K

1. "Reopening the Studios," *New-York Daily Tribune,* October 13, 1877, p. 2; quoted in Weiss 1968/1977, p. 347.
2. *Massachusetts: A Guide to Its Places and People* (Boston: Houghton Mifflin Company, 1937), p. 558.
3. {http://www.vnlnd.net/author/DE02B35.htm, 1/21/03}.
4. See the *Memorial Catalogue,* number 658: "Sunset Off No Man's Land, a Study. Not dated. Size, 8 x 15. Owned by J. C. Bates, Providence, R. I.," and number 659: "Bass-Fishing at No Man's Land, a Study. Not dated. Size, 8 x 15. Owned by Walter J. Comstock, Providence, R. I." (possibly the picture sold at Sotheby's, New York, December 3, 1987, no. 80).

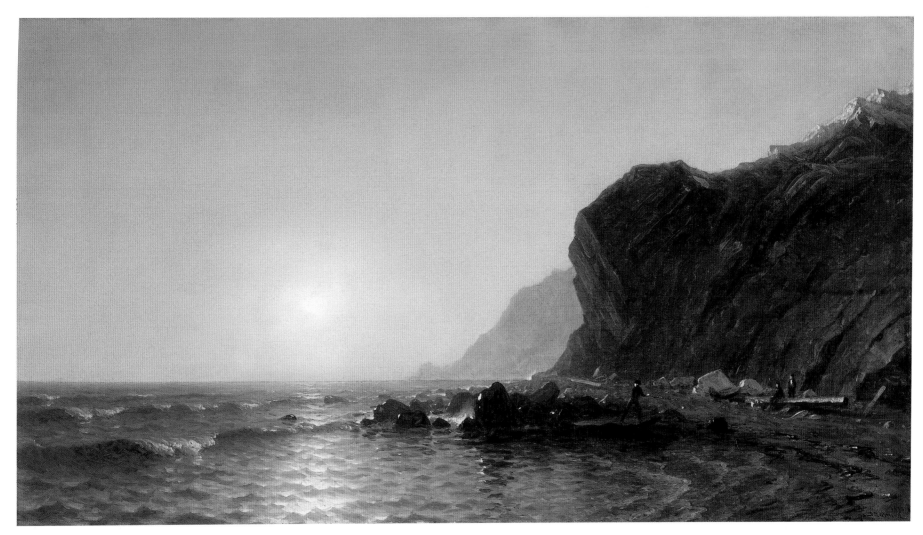

Cat. 62

Fire Island Beach, 1878

Oil on canvas, 13½ x 27½ in. (34.3 x 69.9 cm)
Signed and dated, lower right: S R Gifford 1878
Inscribed, on the wood backing: Fire Island Beach by S R Gifford 1878
MC 689, "Fire Island. Date unknown. Size, 13 x 27. Owned by Horatio Hathaway, New Bedford, Mass."
Exhibited: Possibly National Academy of Design, New York, 1877, no. 577.
Private collection

Figure 147. Sanford R. Gifford. *Studies of Sailboats and Cabanas* (from the sketchbook of New York and Maine subjects, 1873–79), 1875. Graphite on olive-brown wove paper. The Frances Lehman Loeb Art Center, Vassar College, Poughkeepsie, New York. Gift of Miss Edith Wilkinson, Class of 1889

Unlike John Frederick Kensett, Sanford Gifford did not make the Atlantic Coast a signature subject in his oeuvre. The pure light and air of the shoreline did not conform to his primary taste for the atmospheric diffusion of sunlight and the resultant golden tonality that pervade his landscapes. In those—notwithstanding their aesthetic stimulus in the art of Turner—the phenomenon of terrestrial dust suspended in afternoon heat, which Gifford even exaggerated, supplied a plausible premise for the yellow haziness that marks many such works. In his mature career, the artist created an expectation for such effects among his patrons and critics, followed closely by growing reservations about his adopting a single manner. Crepuscular subjects such as *Hunter Mountain, Twilight* (cat. no. 41), were pursued as an alternative to the atmospheric mode.

More than likely, Gifford approached the theme of the seashore as another alternative, especially after he began to frequent Nestledown, the home of his good friends Candace and Tom Wheeler, near the ocean (now Hollis, Queens), probably in the late 1850s.[1] This was also the period in which Kensett commenced his paintings of Newport, Rhode Island, the Shrewsbury River in New Jersey, and other sites along the Atlantic Coast. Those pictures, which proved very lucrative for Kensett, undoubtedly served as inspiration for Gifford. In the 1860s and 1870s, Gifford represented the Atlantic coastline of Maine, Massachusetts, New Jersey, and Long Island—the last, at

least fifteen times from 1863 on.[2] The specific locations range from Coney Island to Montauk, and many are characterized, as in the present picture and in *Long Branch Beach* (cat. no. 45), by plunging one-point perspective up or down the strand that accommodates both land and sea.

Features of *Fire Island Beach* originated as early as September 1875, when Gifford seems to have accompanied his patron and friend Richard Butler to an undetermined seaside locale, possibly to hunt shorebirds or waterfowl. An 1870s sketchbook contains drawings, on successive sheets, of sailboats, two beach cabanas set against an ocean horizon, and five cursory studies of men with rifles or shotguns (see fig. 147, 148). The sketch of the cabanas—one with a pitched roof and a taller one with a peaked roof—are labeled "S. R. Gifford" and "R. Butler," respectively, and the sketch is dated "12 7bre

Figure 148. Sanford R. Gifford. *Studies of Hunters and Sloops* (from the sketchbook of New York and Maine subjects, 1873–79). Graphite on olive-brown wove paper. The Frances Lehman Loeb Art Center, Vassar College, Poughkeepsie, New York. Gift of Miss Edith Wilkinson, Class of 1889

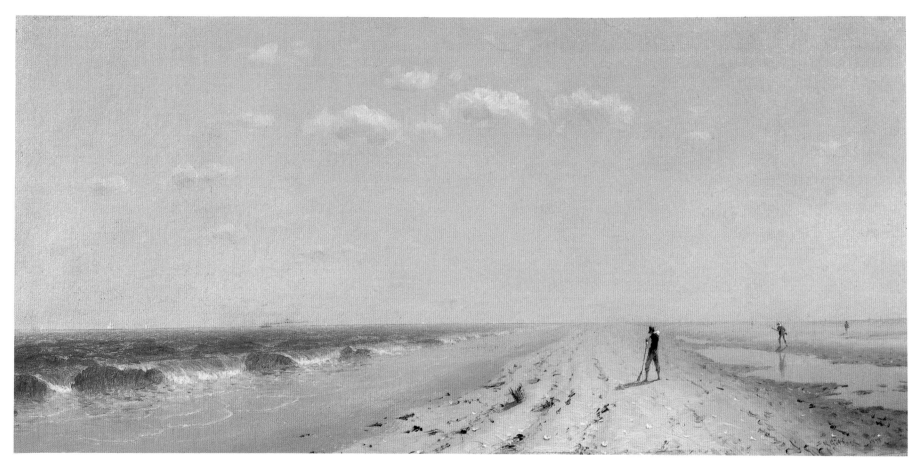

Cat. 63

was offered for sale at the National Academy of Design's annual exhibition, where it was admired, along with the marines of William Trost Richards, precisely for the understated beauty that marks the present picture:

Mr. Gifford's marine is so unfortunately hung that probably two-thirds of the visitors to the Academy have overlooked it. . . . so delicate and sensitive is it that, amid a good deal of surrounding fuss and fury, it seems to be trying to hide its head for the sake of escaping observation; but the profoundly luminous color and light, the warmth and harmony of the tints, the wide and far-reaching perspective, the distant sails gleaming in the sunshine, the hot stretch of sandy beach, and the rolling of the billows, present a view which fascinates the thoughtful spectator. Here is much more than what is ordinarily called marine painting. Scarcely an excellence of a landscape is not in it as well; but there is nothing vulgar, or overwrought, or "loud"—except, indeed, the loudness of the much-resounding sea. . . . [Gifford and Richards] are the only American artists that we know of who seem to feel strong enough to paint an undecorated and unadventurous sea. They will take the simplest scene and make it attractive, first, by brilliancy of technical execution, and, secondly, by an ideal reproduction of the scene through the imagination.[4]

Except for the lack of reference to any figures, the description of the 1877 picture sounds much like the one discussed here. Given that Gifford listed himself as its owner and, according to the critic, that it was hung so inconspicuously, it may be that he preferred to keep the painting, or could not sell it, and then revised and redated it—or else, that the present picture is simply a closely related independent work.

It is tempting to suggest that the inclusion of the figures in the 1878 version of *Fire Island Beach* might have been a response to a picture called *Rail Shooting on the Delaware* by the young Philadelphia painter Thomas Eakins, which was submitted to the 1877 National Academy of Design exhibition. That painting is now believed to be the one called *Pushing for Rail* (fig. 150), presently in the Metropolitan Museum.[5] More concertedly than Gifford in *Fire Island Beach*, Eakins describes a bird hunt being conducted by three pairs of men distrib-

1875." Three of the men on the following sheet—one loading his gun and two waiting to shoot—correspond to the figures in the 7¼ x 14-inch oil study (see fig. 149) for *Fire Island Beach* that probably corresponds to *A Sketch on Fire Island*, number 610 in the *Memorial Catalogue* of Gifford's paintings.[3] (Not included in the study is the hunter firing through the head of another figure in front of him—evidently a burlesque of one of the perennial risks of hunting parties but clearly avoidable under the conditions represented in the paintings, where the figures are spaced widely apart on the beach.)

In the present picture, Gifford altered only slightly the positions of the two hunters in the background (and added one more in the far distance), perhaps to plot the deep spatial recession in more deliberate alignment with

the orthogonal thrust of the breaking surf at the left. In addition, the cool palette of the study—implying full afternoon sunlight—gives way in the painting to a warm buff tonality suggesting late afternoon, an effect that is abetted by the adjustment of the direction of the nearest hunter's shadow. In the present picture, the artist introduced a broken arch of cloud puffs and accented the horizon with sails, a steamboat trailing smoke, and possibly even a skein of flying birds. The presence of a small flock of either sandpipers or plovers is faintly reflected on the wet sand in the middle distance at the left, and an abandoned clam basket lists amid broken clamshells in the immediate foreground, their white impastoed surfaces echoed by the distant sails.

Fire Island Beach reportedly was finished in June 1878. However, the year before, a *Fire Island Beach* by Gifford

uted in a kind of frieze across the comparably flat terrain in the foreground of a canvas of nearly identical dimensions (13 x 30 1/16 inches) to that of Gifford's. The correspondence is, if nothing else, intriguing, as are the contrasts in the treatment of similar subject matter by a landscape painter of an earlier generation and a young, Paris-trained figure painter.

So delicately painted that the ruled pencil line marking the horizon has reappeared through the surface pigments, *Fire Island Beach* exemplifies the artist's traditional style. It contrasts strikingly with the richness of application and effect of *Sunset on the Shore of No Man's Land—Bass Fishing* (cat. no. 62), executed the same year.

K J A

1. Weiss 1987, pp. 84–85.
2. *Memorial Catalogue,* numbers 355–359, 376, 377, 381, 424, 609, 610, and 685 all contain references to Long Island in their titles.
3. *A Sketch on Fire Island* was listed in the *Memorial Catalogue* as undated and measuring 6 1/2 x 14 inches—the approximate size of the oil study in figure 149.
4. *The New York Evening Post,* May 19, 1877.
5. NAD Exhibition Record (1861–1900) 1973, vol. I, p. 255 (1877), no. 150; see also American Paintings in MMA II 1985, pp. 595, 596.

64

A Sunset, Bay of New York, 1878

Oil on canvas, 20 3/4 x 40 3/4 in. (52.7 x 103.5 cm)
Signed and dated, lower right: S R Gifford. 1878
MC 698 [39.], "Sunset over New York Bay. Dated 1878. Size, 23 x 40. Owned by the American Art Gallery."
Exhibited: National Academy of Design, New York, April 1878, no. 468.
Everson Museum of Art, Syracuse, New York

"When one has walked through the galleries of the Academy of Design and has glanced at the seven hundred and odd pictures on exhibition," wrote a visitor to the annual display in 1878, "he will probably be glad to pass by a good many of them without further notice in his future visits."[1] Taking note that "all styles are here, from the regular old conventional academic affair to the latest exposition of the Munich or Paris school by a young American," the writer went on to admit, "I find a good deal to admire and enjoy in the exhibition this year."[2] Among the artists he noted for particular praise were younger men like William Merritt Chase and Winslow Homer—painters who gave the human figure prominence in their works. Hudson River School landscapes (presumably included in the "regular old conventional academic affair") seem to have been few in number and hardly noticed; indeed, by 1878 the school's reputation had waned considerably. Increasingly, critics

were praising painters such as Alexander H. Wyant, who was represented by *Late Afternoon* (Whereabouts unknown), one of his "exquisite transcripts of nature, in which the delicacy of his treatment and his poetic gifts are charmingly indicated," and Arthur Quartley, whose *An Afternoon in August* was cited as the most "attractive view of land or water in the exhibition."[3]

Nevertheless, a select few examples representative of the older school of landscape painting were deemed "attractive pictures," including David Johnson's *Morning at the Harbor Islands, Lake George,* and Worthington Whittredge's *Paradise, Newport, R.I.* (both, Whereabouts unknown), as well as Sanford Gifford's *A Sunset, Bay of New York.* These artists were among those whose openness to emerging styles and willingness to consider new aesthetic possibilities implicit in previous influences managed to keep their work vital long after many of their contemporaries had faded from the scene. In *A Sunset, Bay of New York,* Gifford looked once again to the work of J. M. W. Turner, one of his key formative sources. The painterly freedom displayed in his handling of the orange, red, and gold colors of the sky, which expands across more than two-thirds of the canvas, recalls some of the English master's most extravagant displays—in particular, *Slave Ship* of 1840 (fig. 151). When Gifford first saw that work in England in 1855, he

was challenged by its deviations from the literal truth of nature in what he admitted was a seductively "gorgeous scheme of color, but such a one as I have never seen in nature, and color which I do not think possible when the sun is . . . full half an hour above the horizon—that is, clouds of scarlet and gold."[4] Yet, even at this early stage Gifford recognized the picture's emotional appeal: "Shut your eyes to that want of literal truth, and to the paintiness [*sic*] . . . and it is a splendid vision of a painter." More than two decades later, with vastly more experience as an artist, Gifford must have reevaluated Turner's great work with even deeper understanding when it appeared as a star picture in the 1876 sale of the celebrated collection of New Yorker John Taylor Johnston.[5]

A Sunset, Bay of New York, suggests more than just the influence of Turner's paint handling and color schemes. Its composition, with a thin band of still water, carefully disposed ships, and a glowing expanse of sky receding into a vortex-like distance, recalls such pictures by Turner as *The "Fighting Téméraire," Tugged to Her Last Berth to Be Broken Up, 1838* (1839; National Gallery, London), and *Keelmen Heaving in Coals by Moonlight* (fig. 152).[6] Gifford developed the composition from a small oil study (see fig. 153) in which the horizon is higher, the shoreline less distant, and the ships more tightly grouped closer to the picture plane. His placement

Figure 151. J. M. W. Turner. *Slave Ship (Slavers Throwing Overboard the Dead and Dying, Typhoon Coming On)*, 1840. Oil on canvas. Museum of Fine Arts, Boston. Henry Lillie Pierce Fund

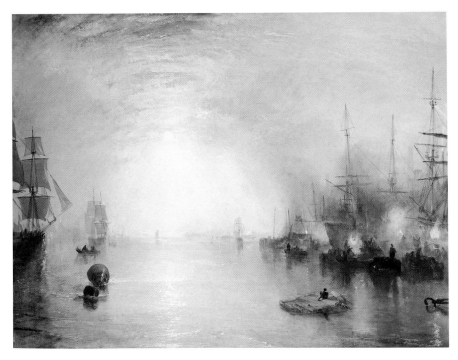

Figure 152. J. M. W. Turner. *Keelmen Heaving in Coals by Moonlight*, 1835. Oil on canvas. National Gallery of Art, Washington D.C. Widener Collection

Figure 153. Sanford R. Gifford. *Sunset Over New York Bay*, about 1878. Oil on canvas. Collection Jo Ann and Julian Ganz, Jr.

of a floating barrel or mooring buoy at the lower center at first may seem a casual addition, but it serves to establish a zigzagging visual rhythm that moves from vessel to vessel through space. Turner also used similar motifs in such paintings as *The "Fighting Téméraire"* and *Keelmen Heaving in Coals by Moonlight*.

Although it may be fairly reckoned Gifford's most complete homage to Turner, *A Sunset, Bay of New York* is also a successful work of great beauty in its own right. Its expressive brushwork not only recalls that of his early

Cat. 64

pictures, among them *Sunset in the Wilderness with Approaching Rain* (cat. no. 3), but it also suggests that Gifford may have been receptive to the more loosely handled styles of such Munich School painters as Chase and even to the work of the emerging French Impressionists.[7] Perhaps, like his friend Whittredge— who, during the 1880s and 1890s, painted landscapes of remarkable freshness and informality—Gifford would have moved toward a similar use of impressionistic (but controlled) handling. We cannot, of course, know what

pictures might have come from his easel had he lived beyond the age of fifty-seven, but his lifetime of aesthetic exploration and innovation makes it certain that he would have continued to evolve as an artist.

F K

1. "Delta," "The Academy Exhibition," *Boston Evening Transcript,* May 6, 1878, p. 4.
2. Ibid.
3. Ibid.
4. Gifford, European Letters, vol. 1, p. 111; Weiss 1987, p. 70.

5. The Johnston sale occasioned considerable attention in the press; see, for example, "The Johnston Collection," *New-York Daily Tribune,* November 5, 1876.
6. Gifford's painting, like Turner's, also juxtaposes the sails of wind-driven ships with the smoking mast of a steam-powered vessel. On the transition from oil sketch to finished picture see Weiss 1987, pp. 315–17.
7. To be sure, one must recall that Sheldon (1877, p. 285) noted that Gifford cared little for painters such as Corot, whose "slovenliness" offended him. Still, it was likely Corot's blurring and softening of natural forms that bothered Gifford and not his brushwork itself.

65

The Marshes of the Hudson, 1878

Oil on canvas, 16½ x 30¼ in. (41.9 x 76.8 cm)
Signed and dated, lower right: S R Gifford 1878
MC 671, "The Marshes of the Hudson. Dated 1878. Size, 16 x 30. Owned by Nelson Hollister, Hartford, Conn."
Exhibited: National Academy of Design, New York, April 1878, no. 369.
Private collection, Courtesy Thomas Colville Fine Art, LLC, New Haven

66

The Marshes of the Hudson, 1876

Oil on artist's board, 7½ x 13¾ in. (19.1 x 34.9 cm)
Signed and dated, lower left: S R Gifford / 1876
MC 652, "The Marshes of the Hudson. Dated 1876. Size, 6 x 13. Owned by J. C. Bates, Providence, R. I."
Private collection

Gifford reprised the simplified compositional scheme he had used for *An Indian Summer's Day on the Hudson— Tappan Zee* (cat. no. 46) and for his 1868 views of Claverack Creek in several paintings set on the marshy banks of the Hudson River near Piermont.[1] Located on the western shore across from Irvington, Piermont was the original eastern terminus of the Erie Railroad.[2] A pier and steamship dock stretched from the town a mile into the Hudson, and although the area declined after the railroad relocated in 1852, there must still have been substantial settlement there when Gifford visited in 1876. One would never know that from his paintings, however, which show only a few figures here and there

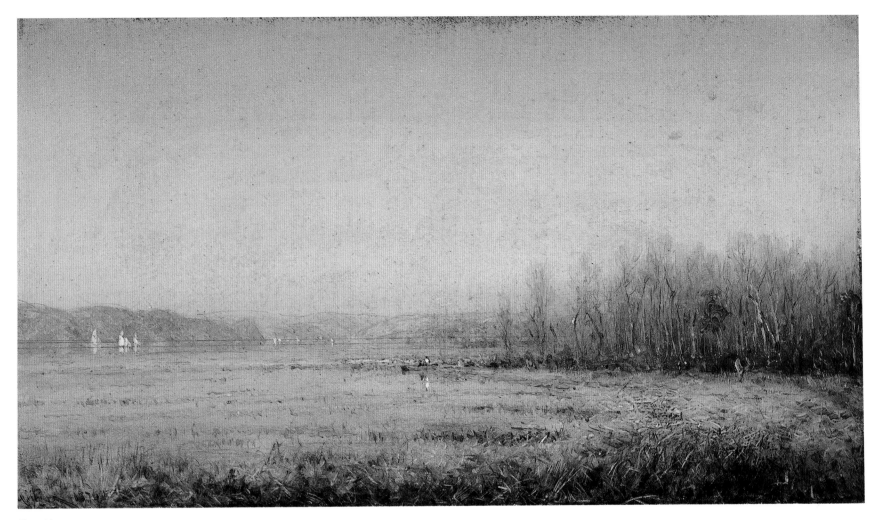

Cat. 66

and scattered boats in the distance sailing the calm waters of the Tappan Zee.

Several undated sketches of Hudson River scenery are listed in the *Memorial Catalogue*, including *A Sketch from Nature on the Hudson River* (Private collection), which depicts the same view as the works catalogued here.[3] In the smaller of the two, Gifford adjusted various elements of the composition—the alternating bands of water and marsh grasses, the distant line of the river, and the background mountains, in particular—to achieve a greater sense of balance and order. A second figure, distinguishable as a woman, occupies the small boat at the point of land entering the scene from the right. Gifford

made further refinements to the large canvas, adding some features (the small pool of water at the lower left, the projecting branch of foliage at the right, and several sailboats), subtracting some (there are fewer bands of grass in the central area of water and more gaps between the trees at the right), and minimizing others (the distant mountains are lower and more obscured by the atmosphere). The two figures are now standing—the man in the boat and the woman on shore—tiny vertical notes in the otherwise largely horizontal composition.[4] Shown at the National Academy in the spring of 1878, and included on the artist's list of "chief pictures," *The Marshes of the Hudson* is one of Gifford's most lyrically

harmonious compositions. It was cited as an example of the work of the "Old Band of American Painters" by the critic for *The New-York Times*: "Here is Sanford R. Gifford . . . who restricts himself to a few, a very, very few subjects. Venice and New York, the Adriatic and the Hudson—he swings placidly between those two places for his marine pictures. Observe, in the East Room, No. 369, 'The Marshes of the Hudson'. . . . He gets much poetry of [a] certain kind into his work. Although some years ago it had already become stereotyped, he remains content with doing fairly well the same things over and over. It is mannerism with him."[5]

In painting his American autumnal scenes, Gifford

Catalogue

Figure 154. Martin Johnson Heade. *Hayfields: A Clear Day*, about 1871–80. Oil on canvas. Collection Jo Ann and Julian Ganz, Jr.

Hudson River School aesthetic. Whatever Gifford may have thought of him and his art, there are affinities between a painting like *The Marshes of the Hudson* and Heade's *Hayfields: A Clear Day* (fig. 154)[6]—obvious similarities in their simplified compositions, freely textured brushwork, and quietly luminous atmosphere. Yet, they also share a certain mood, evoking, from these anonymous and unadorned scenes, a wistful, even poignant sense of reverie. Where others might have seen only boggy ground, low-lying plants, scraggly trees, and dampness, Gifford, like Heade, perceived and then revealed something wonderful and beautiful in its own right.

F K

always preferred to use warm tones of brown, gold, and russet to create a quietly evocative sense of place and season. His pictures are thus very different from the more highly keyed canvases of Jasper Cropsey, his contemporary and the artist most famously associated with the depiction of fall in North America. Cropsey favored brilliant reds, yellows, and oranges for his painted foliage, and at their best his pictures are joyous celebrations of nature in America at its most flamboyant. By the 1870s, however, his work had become increasingly mannered and repetitive, symptomatic, for many critics and observers, of the aesthetic failures of the Hudson River School. By contrast, Gifford's pictures, like those of his friends Worthington Whittredge and Jervis McEntee, were better suited to the growing preference in America for simpler and more subtly suggestive styles of landscape painting as practiced by such Barbizon-inspired artists as George Inness.

Marshes were not an especially common subject for landscape painters of Gifford's generation, but they were a specialty of Martin Johnson Heade, who also worked in the Tenth Street Studio Building. Heade was considered eccentric by many of his fellow painters, a loner and restless traveler whose works never fit comfortably within the

1. Weiss 1987, pp. 148, 307, identifies the site.
2. Arthur G. Adams, *The Hudson: A Guidebook to the River* (Albany, New York: State University of New York Press, 1981), p. 119.
3. See the *Memorial Catalogue*, numbers 471–477, especially no. 475; see also Weiss 1987, pp. 307–9.
4. See the compositional analysis in Weiss 1987, p. 309, who suggests that number 710 in the *Memorial Catalogue* ("The Marshes of the Hudson. Not dated. Size, 8½ x 15½ in.")—now lost—was a "half-size study" for the finished picture, although it may have been a subsequent, reduced version.
5. "The Academy Exhibition. The Old Band of American Painters," *The New-York Times,* April 14, 1878, p. 7.
6. Although it is also tempting to speculate that Gifford might have known some of Thomas Eakins's early landscapes set in the marshes of South Philadelphia, such as *Pushing for Rail* of 1874 (fig. 150), that is probably not the case.

67

The Galleries of the Stelvio—Lake Como, 1878

Oil on canvas, 30½ x 24½ in. (77.5 x 62.2 cm)
Signed and dated, lower right: S R Gifford / 1878
Inscribed in the artist's hand, on the wood backing: The Galleries of the Stelvio-Lake Como / by S. R. Gifford; on the paper card affixed to the back of the frame: The Galleries of the Stelv[io-] / Lake Como— / by S R Gifford / Return to 51 West 10th St New York
MC 691, "The Galleries of the Stelvio, Lago di Como. Dated 1878. Size, 24 x 30. Owned by Mrs. James Watson Williams, Utica, N.Y."
Exhibited: Utica Art Association, New York, March 1878.
Munson-Williams-Proctor Institute, Museum of Art, Utica, New York

The sketches made by Gifford on his second European tour in 1868–69—and, indeed, a few studies dating to his first trip, from 1855 to 1857—supplied source material for the majority of his publicly exhibited paintings, until the end of his career in 1880 (see, for example, cat. no. 70). In 1878, he returned to an oil sketch he had made a decade earlier, on August 6, of the view through the tunnels of the Stelvio Road on the eastern shore of Lake Como.[1] The "galleries," as Gifford termed them, had been blasted through the mountainside by the Austrian army from 1820 to 1825, in order to protect the road from avalanches.[2] Gifford had mentioned the existence of the tunnels and their purpose in his letters from Europe while he was in the vicinity, during his earlier trip.[3] On August 5, 1868, just days after leaving Lake Maggiore and completing the oil study for the present painting, he took a steamboat across Lake Como expressly to walk the half-mile-long stretch of road (and back), which alternated between stark sunlight and deep shade. "Delightfully cool they were," Gifford commented on the tunnels, "like wells, going into them from the hot sun."[4] On facing pages of his sketchbook, he made pairs of drawings—one horizontal and one vertical—looking down the road (see fig. 155). All but one (and perhaps the

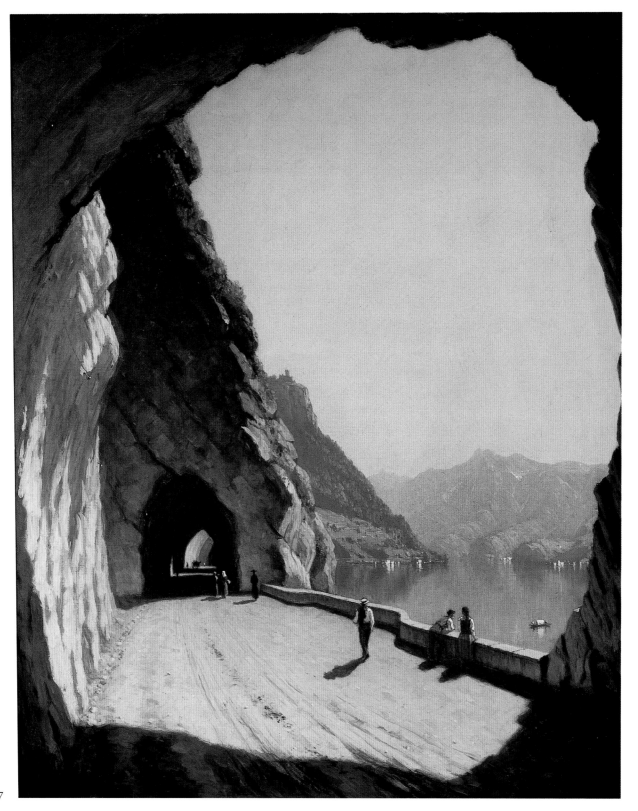

Cat. 67

Figure 155. Sanford R. Gifford. *"Galleries of the Stelvio Road Lake Como—Aug '68"* (from the sketchbook inscribed "Maggiore, Como, Sicily, Rome, Genoa, 1868"). Graphite. The Brooklyn Museum of Art. Gift of Miss Jennie B. Branscomb

earliest) of the drawings incorporate the framing device of the cave walls, seeming to adopt the convention of grotto paintings familiar from the works of Claude Joseph Vernet and Joseph Wright of Derby in the eighteenth century. Surely, the grotto was not unknown in American painting: Both Thomas Cole and Frederic Church had appropriated it, Cole in one of his earliest works, *Kaaterskill Falls* (1825: Whereabouts unknown; 1826 replica: Wadsworth Atheneum, Museum of Art, Hartford), and in the later *Subsiding of the Waters of the Deluge* (1827; National Museum of American Art, Smithsonian Institution, Washington, D.C.); Church in his major painting *The Icebergs* (1861; Dallas Museum of Art). Gifford's composition is distinguished from most of its precedents by its vertical format, which the artist probably arrived at secondarily, to judge from the variations of the view in the pages of his sketchbook, and refined in the fully modeled image drawn at the far left of a double-page spread. For Gifford, the resolution was entirely apt. The vertical composition not only echoed the diminishing perspective of the tall tunnel openings but accorded with the artist's taste for the vignette,[5] which he usually composed with overarching trees (see cat. nos. 43, 52).

The finished drawing became the direct source for the oil study (see fig. 156), measuring almost 10 x 8 inches, which Gifford executed on August 6, the day after his visit to the site, and in which he deepened the shadows to contrast with the stark light of the sun striking the side of the mountain and the road between the tunnels. He included figures from two of the drawings: a couple at the parapet on the right, from one of the horizontal sketches, and the cleric walking along the road in the vertical study, as well as the distant silhouettes of several other figures in the farthest tunnel. He added two colorfully attired women near the cleric, and a little dog skipping toward the couple.

In the large painting, the shade became even more profound, yet it glows warmly on the fringes with the light reflected from the ground. On the right, he simplified the mountains' summits while fashioning volumetric repetitions of the tunnel entrances in the land-

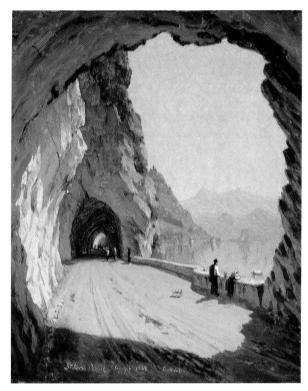

Figure 156. Sanford R. Gifford. *A Sketch on the Stelvio Road by Lago di Como,* 1868. Oil on canvas. Private collection

forms of the distant shore, strengthening the focal highlights of the dwellings. Typically, not only the dimensions but also the scale of the finished painting was altered to reduce the relative size of the figures. Gifford made a significant substitution in the large picture: In place of the dog, a man is seen emerging from the foreground tunnel, his jacket slung over his shoulder in the afternoon heat, his head turned to glance at the lake—a seemingly autobiographical conceit. Strangely, the couple in the oil sketch appear to have been a belated addition to the large canvas: They are painted over the parapet, which now is visible through them, and, in addition, they have traded poses, the woman now standing erect, her head turned toward the passing stranger.

Although a reporter in Gifford's studio in June 1878[6] made mention of the present picture and another Italian subject, *Villa Malta, Rome* (fig. 60), based on an 1857 oil sketch, only the latter painting and two works with

American subjects were exhibited at the National Academy of Design in New York the following year. By then, Gifford may have sold and delivered *The Galleries of the Stelvio—Lake Como,* for the picture is known to have belonged to Mrs. James Watson Williams of Utica, New York, in 1880.[7] A smaller version (Whereabouts unknown), executed in 1870 and measuring 26 x 20 inches, had been exhibited at the Artists' Fund Society in New York in February 1871,[8] and the oil sketch of

August 6, 1868, was shown in the memorial exhibition of Gifford's work at the Metropolitan Museum in 1880–81.[9]

KJA

1. *Memorial Catalogue,* no. 506: "A Sketch on the Stelvio Road by Lago di Como. Dated August 6th, 1868. Size, 9½ x 7½. Owned by the Estate."
2. E[leanor]. Jones, "*Galleries of the Stelvio—Lake Como,*" in Stebbins et al. 1992, p. 300.
3. Letter from Sanford Robinson Gifford to his father, Elihu Gifford, July 28, 1857, in Gifford, European Letters, vol. 2, pp. 177–78.
4. Letter from Sanford Robinson Gifford, Lake Como, August 5, 1868, in Gifford, European Letters, vol. 2, p. 27.
5. Weiss 1987, pp. 314–15; Weiss 1968/1977, pp. 324–25.
6. *New-York Daily Tribune,* June 22, 1878.
7. *Memorial Catalogue,* no. 691.
8. NMAA Index 1986, no. 35400. The painting was number 37 in the exhibition catalogue.
9. "Memorial Exhibition," no. 124.

68

Mount Katahdin from Lake Millinocket, 1879

Oil on composite board, 4½ x 8½ in. (11.4 x 21.6 cm)
Signed, lower left: S R Gifford
Inscribed, on the verso: [Katahdin?] from Lake Millinoket / S. R. Gifford / Sept. 1879
Exhibited: Possibly Brooklyn Art Association, May 1880, no. 121, as "Mount Katahdin, Me."
Private collection

Gifford painted *Mount Katahdin from Lake Millinocket* on or shortly after a trip to northern Maine in September 1879 with his wife, Mary; Frederic Church and his wife, Isabel; and Jervis McEntee and his wife, Gertrude.[1]

The artist had portrayed Mount Katahdin as far back as 1860, in one of his earliest "chief pictures" of American scenery, *The Wilderness* (cat. no. 12). However, the presumed visit to Maine, which resulted in that picture, is poorly documented. The painting accords with many of Gifford's early American subjects not only in its strongly conceptual and idealized character but in its inclusion of Native Americans (whom he had observed in Nova Scotia on a trip there in 1859), which underscores the painting's nostalgic flavor.

In *Mount Katahdin from Lake Millinocket,* the seven figures riding in the canoes are Caucasian, and undoubtedly represent the members of the September 1879 camping party and a guide. In fact, the 1879 excursion was a reprise of an 1877 trip that Gifford made to Lake Millinocket; Church had recently bought property there and had invited Gifford, McEntee, and several others to visit him that September. Gifford dubbed the event "The Katahdin Tea Party" in his sketchbook, which included drawings of the lake, mountain, and camps, most of them executed on this first trip.[2] Some of the 1877 drawings may have informed the 1879 painting—namely, one full-page profile of Katahdin rising above the lake, and two small compositions whose simple schemes recall those of Mount Rainier (see cat. nos. 57, 58) from a few years earlier.[3] This conceptual link is further strengthened in the present picture by the addition of the canoes streaming into the scene from the left, which bring to mind the Indian craft in the Rainier paintings.

At least two studies in the same sketchbook date from the 1879 excursion. The most notable is an elaborate pencil-and-white-gouache portrait (see fig. 157), dated September 19, 1879, of the camp lean-to, including

the three women in the party and at least one of the men. The subject, as well as the exceptional finish of the drawing, seems to capture Gifford's characterization—to John F. Weir—of the "rain which fell half the time, and wind which blew nearly all the other half."[4] The weather affected the men's principal ambition to fish and the party's desire to go canoeing on the lake. Gifford's image of the canoe and its occupants in *Mount Katahdin from Lake Millinocket,* gliding beneath cloudless skies, thus may be largely fanciful. Indeed, the painting appears to have resulted directly from a cursory compositional sketch (see fig. 158), drawn below a study of a canoe, on the inside back cover of the same sketchbook, which might well reflect a combination of memory and imagination, rather than a record of the actual scene. There, Katahdin's profile is considerably altered from its appearance in the 1877 drawings (although it corresponds to the way it looks in the painting), and the flanking summits assume the simplified, conical character (again, as in the painting) of contrived rather than observed mountain peaks. At least one (and possibly a second) canoe in the drawing, on the other hand, seems to reference those obliquely gliding into the scene from

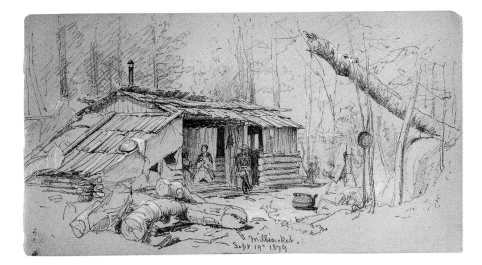

Figure 157. Sanford R. Gifford. *"Millinoket* [sic] *Sept 19th 1879"* (from the sketchbook of New York and Maine subjects, 1873–79). Graphite and white gouache on olive-brown wove paper. The Frances Lehman Loeb Art Center, Vassar College, Poughkeepsie, New York. Gift of Miss Edith Wilkinson, Class of 1889

the right in the drawing for Gifford's earlier *A Sudden Storm, Lake George* (cat. no. 31; fig. 97), which is included on one of the earlier pages in the same sketchbook.

It may well be, then, that the only known painting of Mount Katahdin produced after *The Wilderness,* despite the date on the verso directly linking it to the 1879 trip to Maine, is in its own way as idealized as that picture. Delicately crafted in diminutive scale, the painting offers a gem-like recasting of what Gifford's words suggest was a vacation often dampened by indifferent, even nasty, weather.

Gifford offered a "Mt. Katahdin, Me.," at the May 1880 exhibition of the Brooklyn Art Association for $250. That the painting in question was the present one or a larger version of it is suggested by a *Brooklyn Daily Eagle* reviewer, who termed it a "companion picture" to another by Gifford in the exhibition, *Venice* (Whereabouts unknown). The latter painting probably was one of the two smaller versions of his last major work—known from an old photograph—in which two pairs of sailboats in the right foreground head into the picture toward Santa Maria della Salute and the receding skyline of the "Queen of the Adriatic."[5] The critic was at a loss to cast a vote in favor of one picture or the other. "They are both full of the delicate coloring and dreamy atmospheric effects that render [Gifford's] pictures inimitable. . . . This artist stands about alone in his peculiar field of color, and it is difficult to point out either an American or foreign painter who can rival him in certain effects."[6]

KJA

1. The trip is described in Weiss 1987, pp. 156–57.
2. The 1877 excursion to Maine is discussed in Weiss 1987, pp. 148–49, and Weiss 1968/1977, pp. 345–46; the sketches from that trip are part of a sketchbook, which also includes drawings from 1873 to 1879, in the collection of The Frances Lehman Loeb Art Center, Vassar College, Poughkeepsie, New York (38.14.5), and on microfilm (Archives of American Art, Reel D254, frames 136–145). The 1877 studies (accession numbers 38.14.5.7–19) range in date from September 9 to 20.
3. Weiss 1987, p. 148.
4. Letter from Sanford Robinson Gifford to John F. Weir, October 7, 1879; John F. Weir Papers, Manuscripts and Archives, Yale University Library, New Haven; quoted in Weiss 1987, p. 157.
5. *Venice* appears as the frontispiece of the *Memorial Meeting.*
6. "Art. The Fortieth Reception of the Brooklyn Association. The Attendance at the Academy of Music Last Evening," *Brooklyn Daily Eagle,* May 18, 1880, p. [2]. The version of *Venice* shown at the Brooklyn Art Association may have been the 8 x 15-inch painting, dated 1880 (Whereabouts unknown), listed as number 729 in the *Memorial Catalogue.* The *Mt. Katahdin, Me.,* number 121 in the Brooklyn exhibition, may be either of two undated pictures listed in the *Memorial Catalogue*: no. 668 ("Mount Katahdin, Maine. . . . Size, 8 x 13½.") or no. 669 ("Mount Katahdin from Lake Milnoket, Maine. . . . Size, 9 x 16½."); the latter was number 23 in the "Memorial Exhibition" at The Metropolitan Museum of Art, 1880–81.

Figure 158. Sanford R. Gifford. Compositional study for *Mount Katahdin from Lake Millinocket* (from the sketchbook of New York and Maine subjects, 1873–79). Graphite and white gouache on olive-brown wove paper. The Frances Lehman Loeb Art Center, Vassar College, Poughkeepsie, New York. Gift of Miss Edith Wilkinson, Class of 1889

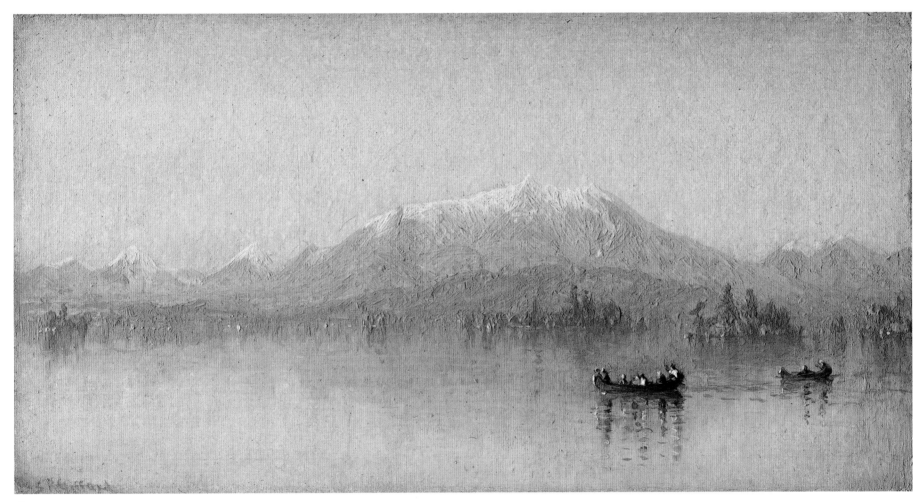

Cat. 68

Sunset Over the Palisades on the Hudson, 1879

Oil on canvas, 18⅛ x 34⅛ in. (46 x 86.7 cm)
Signed and dated, lower right: S R Gifford. 187[9]
MC 708 [111.], "Sunset over the Palisades on the Hudson.
Dated June, 1879. Size, 18 x 34. Presented to the Hudson (N.Y.)
Academy."
Exhibited: The Metropolitan Museum of Art, New York,
"Memorial Exhibition," October 1880–March 1881, no. 111.
Private collection

During the Triassic period, more than two hundred million years ago, immense geological forces shaped the banks of the lower Hudson River.[1] Along the present-day New Jersey shoreline, extending north some fifty miles from below Jersey City to Haverstraw, New York, a single mountain ridge a half-mile to a mile-and-a-half wide took shape. Most of the rock in the New Jersey region is red sandstone, but this ridge is a great columnar dike of basalt that formed slowly and under enormous pressure as molten materials were forced upward.[2] The most distinctive section of this formation is the Palisades—a series of dark, almost perpendicular cliffs of bare rock that run north from Kings Bluff almost as far as Piermont, New York.[3] As one writer observed, about the time that Gifford began painting them, these cliffs form a "rude and rugged but uninterrupted line, to the height of three hundred and even five hundred feet, attaining their greatest magnitude in the enormous and jutting buttress that thrusts itself into the stream nearly opposite Sing Sing."[4] When seen from the eastern shore of the Hudson, this long escarpment resembles nothing so much as a gigantic, wooded and palisaded fortification; thus, the name, the Palisades.[5]

The first evidence of Gifford's interest in the subject of the Palisades dates to 1875, the year given in the *Memorial Catalogue* for an 18 x 34-inch picture entitled *The Palisades* that had been sold to a "Mr. Tinker, London, England" (Whereabouts unknown);[6] six other works of varying size recording the Palisades are listed, and there may well have been more.[7] Two of these pictures were of medium size: *Sunset Over the Palisades, A Study* ("Dated 1876. Size, 13 x 24. Owned by A. B. Stone."), and *A Study of the Palisades* ("13 x 24. Sold in 1876, through the Artists' Fund Society, to Col. W. H. Heusted."), neither of which is known today;[8] two others, including *Sunset on the Hudson* (fig. 159), measured 8 x 15 inches; and yet another, still in the Gifford family at the time of the "Memorial Exhibition" (possibly fig. 160), was slightly smaller.[9] The artist gave the present example to the Hudson Academy, the school he had attended in his youth.

By the late 1870s, Gifford had forged a style that was well known to his contemporaries. "There is a certain atmospheric effect," wrote one, "which we associate with the name of S. R. Gifford. One knows his works afar off by their rich tone and the mellow radiance of his sunlight."[10] Speaking of an example from this series of pictures, the same writer observed: "In 'A Sunset on the Hudson' the view is taken at a point where the Palisades end, the banks fall off and the river widens. The flood of radiance from the setting sun falls upon sky and river,

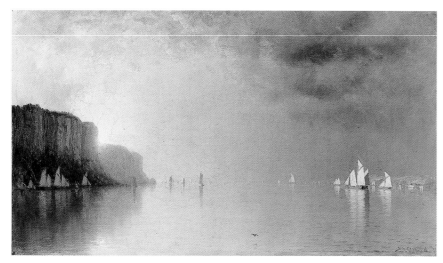

Figure 159. Sanford R. Gifford. *Sunset on the Hudson,* 1876. Oil on canvas. Wadsworth Atheneum, Museum of Art, Hartford. The Ella Gallup Sumner and Mary Catlin Sumner Collection Fund

Figure 160. Sanford R. Gifford. *The Palisades,* 1877. Oil on canvas board. Williams College Museum of Art, Williamstown, Massachusetts. Gift of Mr. and Mrs. Gifford Lloyd

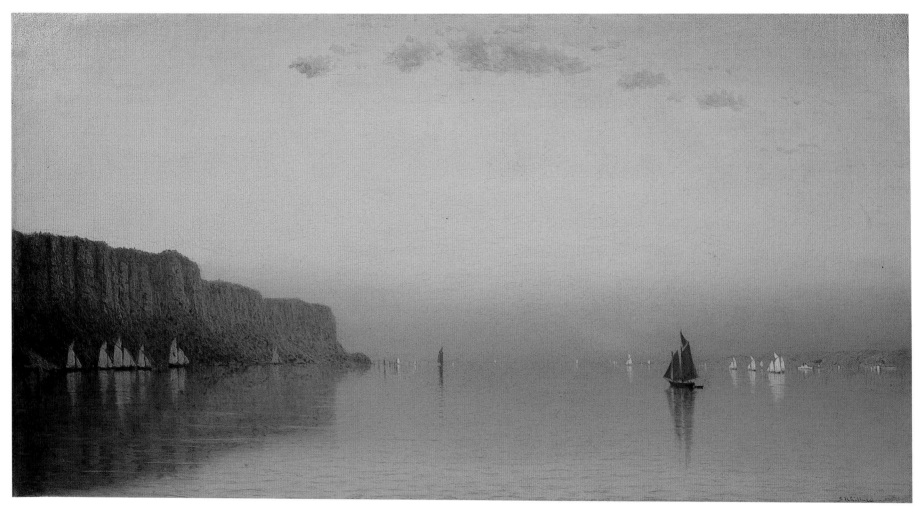

Cat. 69

the clouds glowing with the golden splendor, and the white sails on the placid water are lighted up in the far distance, while under the western bank the Palisades cast the sloops that are hugging the shore into deep shadow. It is a superb picture, and full of the rich, soft harmony of color that Gifford has at his command." Another critic offered an even lengthier discussion:

[Gifford's] works do not depend upon the appreciation of a trained band of disciples. We never heard anybody complain of not being able to understand them; and yet only comparatively few persons see into and around them. Look, for instance, at his "Sunset on the Hudson"—the sun just setting behind the Palisades on the left, the air flooded with light, the pure white sails in the middle distance, the tender gradations of white in the sails in the background, the undefinable, mysterious, dark of the unillumined part of the cliff, the bird in the centre of the nearest foreground, concentrating in itself the deepest light and the deepest shade of the picture, and defining, at the same time, the plane of the water; the vivid contrast of the gilded and the ungilded clouds, the finely-blended tints, the intense glow of the lighting, the vision and the glory. It is not an every-day sunset, to be sure; it is a sunset under exceptionally favorable circumstances. But it is a real sunset, nevertheless. Some of us have seen just such a one. Mr. Gifford saw this one, and he had the impulse and the means to reproduce for others the impression made upon him. Just here is seen an advantage which the painter has over the poet. Each would feel as keenly the effect of such beauty, but words could not reproduce that effect. What is needed is not a master of language, but a master of color.[11]

Most discussions of the group of works to which *Sunset Over the Palisades on the Hudson* belongs have tended to focus on formal analysis. To be sure, it can be revealing to ponder the relationships between the known paintings and to consider how Gifford "explored the aesthetic potential of the view north on the Hudson River: the Palisades a dark weight at the left, answered by sails massed in conjunction with a vague shoreline at the right, against a color-resonant field of sunset light."[12] Yet, if we agree with John F. Weir, who observed that, "his pictures are not the mere collective statement of

facts, they are something more," then we must reflect on what deeper associations Gifford and his audience might have found in the scene he depicted and in the way he chose to depict it.[13]

Part of the answer must lie in the very choice of the Palisades themselves as the subject. Like another singular geological monument Gifford painted, Hunter Mountain (see cat. no. 41), these great rocks also seem to "sleep sphinx-like, holding their meaning within their profound shadows, until thus interpreted to us through the sympathies of a master hand."[14] As the name Palisades suggests, they function literally and symbolically as a barrier, boundary, or border zone. This, at least, was the view of the Mohicans, who believed the Great Spirit had raised the rocks to protect his own favorite abode from mankind.[15] Gifford's contemporaries had similar thoughts, although for them the division was between the urban and the rural: "nothing could present sharper contrasts than do the two regions separated by this natural wall. On its west lies the quietest farming country, with its people leading simple, uneventful, pastoral lives—people to whom the busy towns and the noises of the city seem as far away as if they existed only to be read about and wondered over. But on the eastern side, in the places along the banks of the river, in every kind of dwelling, from great country-seat to smallest suburban cottage, is found a class utterly different."[16] In other words, the Palisades were an emphatic dividing line between New York City, which represented America's densest urban environment, and the pastoral, rural lands that stretched to the west. In these terms, Gifford's paintings of the Palisades might be read as glosses on the cycle of American civilization, which was playing out from east to west. The East, epitomized by New York, was thoroughly civilized and, increasingly, urbanized; the West, by contrast, remained—if only symbolically—a frontier.

Yet, it is also possible that Gifford's deepest interest in this subject derived from far more personal associations. Given his abiding love of late-afternoon scenes, it is hardly surprising that many of his works are organized around stark contrasts of light and shade, but those in

the Palisades series are emphatically so. The radiant sky, doubled by its reflection in the still water, is set off dramatically against the shadowy forms of the rocky cliffs, which are also repeated in reflection. Boats with dark hulls and lighter sails move between the zones of light and dark almost as if in passage from one world to another. From Weir's address at Gifford's memorial service we know that, for the artist, "that placidity of the surface was an indication of the depth of the stream that flowed within, whose floods, and swirls, and eddies often caught him from the light and carried him into cavernous depths of shade."[17] Whatever we may or may not understand about Gifford's innermost workings, it is telling that his friend chose to describe him in terms that were evocative of his paintings. Are pictures like *Sunset Over the Palisades* in some fundamental way about Gifford himself and his thoughts about life? Thomas Cole's famous four-part allegorical series, "The Voyage of Life" (1842; National Gallery of Art, Washington, D.C.), employed a boat borne on the river of life as its central motif, with the transition from childhood and youth to adulthood and old age indicated not only by a changing landscape but also by movement from brightness to ever-increasing darkness. In Gifford's painting, the boats may simply be boats, the river merely his beloved Hudson, and the light and color of the setting sun only an accurate record of the end of day and nothing more. However, if we, like his contemporaries, are to appreciate his achievement as the "exponent of that which is highest, fullest, ripest—most poetic and profound—in landscape,"[18] then perhaps we should also consider the possibility that he was offering us a moving meditation on life itself. F K

1. This entry is based on one by the same author, "Sanford Robinson Gifford (1823–1880): *The Palisades, 1877*," in *American Dreams: American Art to 1950 in the Williams College Museum of Art,* edited by Nancy Mowll Mathews (New York: Hudson Hills Press, 2001), pp. 69–72.
2. *New York: A Guide to the Empire State* (New York: Oxford University Press, 1940), pp. 32–33; Arthur G. Adams, *The Hudson: A Guidebook to the River* (Albany, New York: State University of New York Press, 1981), p. 16.
3. Adams, *The Hudson,* p. 90.

4. E. L. Burlingame, "Highlands and Palisades of the Hudson," in *Picturesque America; or, The Land We Live In*, edited by William Cullen Bryant, vol. 2 (New York: D. Appleton and Company, 1874), p. 21.

5. Adams, *The Hudson*, p. 90.

6. *Memorial Catalogue*, p. 42, no. 643.

7. Although no work preliminary to the 1875 painting is listed in the *Memorial Catalogue*, it is likely, given Gifford's normal working methods, that at least one or more smaller works preceded it.

8. These are, respectively, numbers 646 and 650 in the *Memorial Catalogue*, p. 42.

9. These are *Sunset on the Hudson* of 1876 (*Memorial Catalogue*, no. 651: "Owned by Richard Goodman, Lenox, Mass." [now in the Wadsworth Atheneum, Hartford]); *Sunset on the Hudson, a Study*, of 1877 (*Memorial Catalogue*, no. 664: "Owned by J. W. Harper, Jr."); and *The Palisades* of 1877 (*Memorial Catalogue*, no. 665: "Owned by Mrs. A. J. Gifford, Hudson, N. Y.").

10. "Delta," "The New York Academy," *Boston Evening Transcript*, April 13, 1877, p. 6.

11. *The New York Evening Post*, April 21, 1877.

12. Weiss 1987, p. 305.

13. Weir 1875.

14. Weir 1873, p. 146.

15. *New York: A Guide to the Empire State*, p. 621.

16. Burlingame, "Highlands and Palisades," pp. 21–22.

17. Weir 1880, p. 12.

18. Weir 1873, p. 145.

70

Ruins of the Parthenon, 1880

Oil on canvas, 27⅝ x 53⅜ in. (70.2 x 135.6 cm)

Signed and dated, lower left: S. R. Gifford 1880

MC 726 [27.], "The Ruins of the Parthenon, looking southwest from the Acropolis, over the head of the Saronic Gulf. Dated 1880. Size, 28 x 52. Owned by the Estate."

Exhibited: National Academy of Design, New York, April 1880, no. 261; The Metropolitan Museum of Art, New York, "Memorial Exhibition," October 1880–March 1881, no. 27, as "The Parthenon."

Corcoran Gallery of Art, Washington, D.C. Museum Purchase

Ruins of the Parthenon was Gifford's last important painting, and he personally considered it the crowning achievement of his career. Based on a detailed, two-page sketchbook drawing (see fig. 161) he made on a visit to the Acropolis in May 1869, the painting—according to the artist—was "not a picture of a building but a picture of a day."[1] In the finished work, Gifford adhered generally to the scheme of this drawing, with the east façade of the Parthenon at the left, a field of scattered architectural fragments across the center, and a brick tower of medieval origin at the right. Two figures are situated near a large block of stone at the lower center; the one who

kneels to sketch or take notes possibly is the artist and the other, his Greek guide. At the far right of the composition Gifford added the western end of the Erectheum with its distinctive Porch of the Maidens, whose columns take the form of graceful female figures. Other than the distant water and mountains, the rest of the painting is given over to an expanse of sky, which undergoes the most exquisitely delicate transitions from pale pinks to deep blues. Gifford labored long and hard to get that sky precisely right, even to the extent of repainting it at least once after having publicly exhibited the picture, against the advice of his friend Frederic Church.

Figure 161. Sanford R. Gifford. *"Acropolis. Athens May 5th '69"* (from the 1869 sketchbook). Graphite and chalk. Private collection

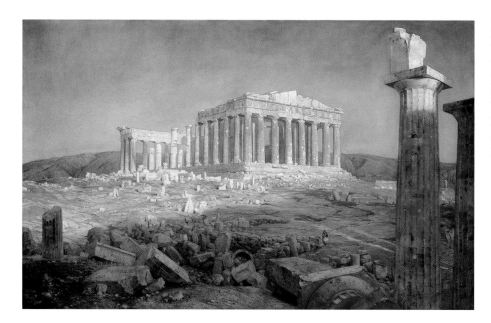

Figure 162. Frederic Edwin Church. *The Parthenon*, 1871. Oil on canvas. The Metropolitan Museum of Art, New York. Bequest of Maria DeWitt Jesup, from the collection of her husband, Morris K. Jesup, 1914

Church's own painting of the Parthenon (see fig. 162) may be compared constructively with Gifford's version. For Church, the building—which he showed in its entirety—was, indeed, the subject of the painting; one can sense its primary role in the way that it is set high in the picture's space, looming powerfully over its surroundings. The landscape is divided diagonally into light and dark halves. The foreground, with its scattered architectural fragments and single figure leaning casually against a stone block, is a world of disorder and dissolution—one that contrasts starkly with the calm quiet of the sunlit building, which represents the highest achievement of the mind and hand of man. Church's vision of history remained in the mold of that of his mentor, Thomas Cole, for whom man was always the central agent in the rise and fall of civilizations. Lessons about the past could be learned from gazing upon a building like the Parthenon, or on a painting of it. Gifford's "portrait of a day" offers no such invitation to ponder the cycles of time in historical depth, but, instead, presents the beauty of an immediate moment—one, of specific conditions of light and atmosphere, that will, like all such moments, prove fleeting.

Gifford hoped that *Ruins of the Parthenon* would be acquired by an American public museum, and made some unsuccessful efforts to bring that about. According to his brother James, the artist "frequently said that no picture of his had cost him so much painstaking labor as this one, being very anxious it should be <u>accurate</u> as well as artistic."[2] James went on to recount Gifford's "remark when at the Corcoran Gallery about a year ago. Reaching the space near Church's 'Niagara,' he said, 'there would be a good place for my "Parthenon".'" Although the painting remained unsold at the time of Gifford's death, his wish was realized when the Corcoran Gallery purchased it at the artist's estate sale in 1881 for $5,100—at the time the highest price ever paid for a work by Gifford. F K

1. *The Art Journal* 1880, p. 319; quoted in Weiss 1987, p. 325.
2. Letter from James Gifford to Jervis McEntee, April 21, 1881 (Corcoran Gallery of Art, Washington, D.C., Archives); I am grateful to Sarah Cash and Marisa Burgoin for bringing this letter to my attention.

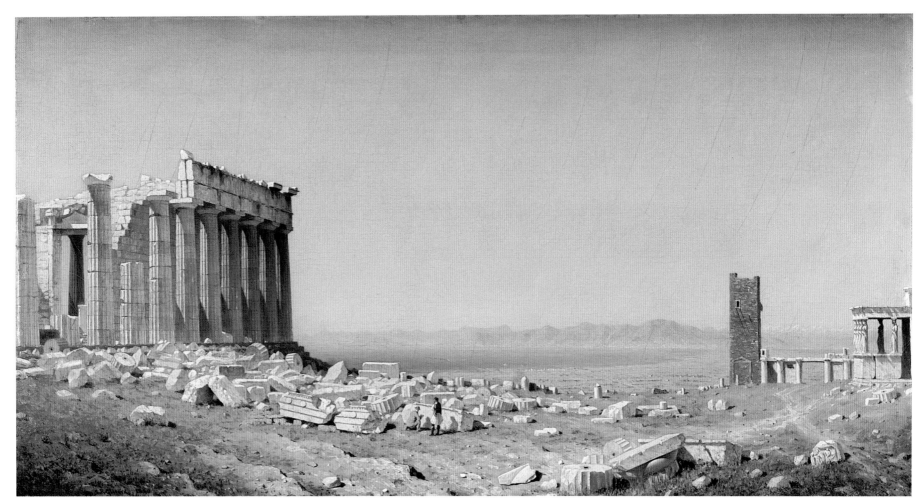

Cat. 70

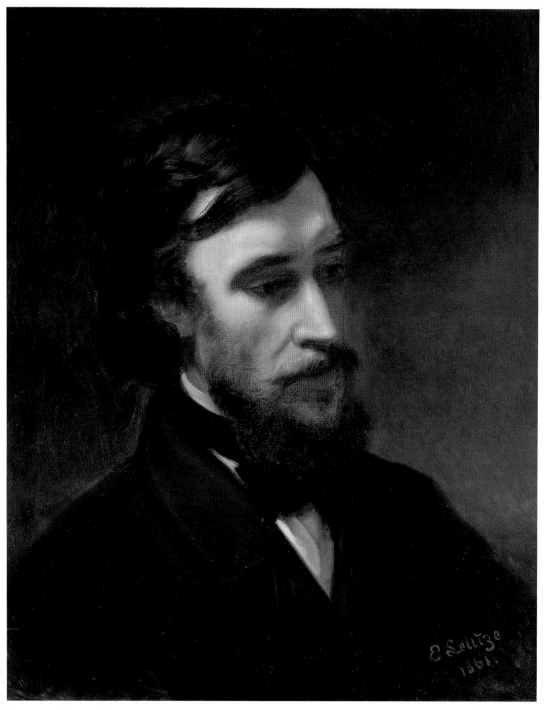

Figure 163. Emanuel Leutze. *Portrait of Sanford Robinson Gifford*, 1861. Oil on canvas. Private collection

CHRONOLOGY

Claire A. Conway and Alicia Ruggiero Bochi

1823

July 10 Sanford Robinson Gifford is born in Greenfield in Saratoga County, New York, the fourth of eleven children (he had five brothers and five sisters) to Elihu and Eliza Starbuck Gifford.

Elihu Gifford enters the iron foundry business; the family moves to Hudson, New York.

James Fenimore Cooper publishes *The Pioneers,* the first of the "Leatherstocking" novels, which describes the eastern Catskill Mountains across the river from Hudson, New York.

1824

Renovations and the expansion of a dormitory overlooking the Hudson River Valley led to the establishment of the Catskill Mountain House, the first successful tourist hotel in the region.

Horatio Gates Spafford publishes the second edition of his *Gazetteer of the State of New-York,* which deals with the new Catskill Mountain House and surrounding area.

Catskill tanneries form the Hunter Turnpike Company to develop the existing road through Kaaterskill Clove.

1825

Thomas Cole (1801–1848), the founder of the Hudson River School, takes his first sketching trip along the Hudson River to the Catskill Mountains to sketch and paint several pictures in the vicinity of the Mountain House and the Hudson River. Exhibited in New York, these works launch Cole's career as a landscape painter and artistic mentor, eventually attracting other aspiring artists to paint landscapes.

The Erie Canal officially opens, positioning New York City as the future economic center of the nation.

1826

Frederic Edwin Church (1826–1900), the leading second generation Hudson River School painter, is born.

The National Academy of Design (formerly The New-York Drawing Association, est. 1825) is founded by Samuel F. B. Morse, Asher B. Durand, Thomas Cole, and others.

James Fenimore Cooper publishes *The Last of the Mohicans,* increasing public interest in upstate New York.

1827

Cole visits the White Mountains of New Hampshire and paints several views of the area.

1828

James Kirke Paulding publishes *The New Mirror for Travelers; and Guide to the Springs,* for tourists in New York State; the book also promotes the purchase of landscape paintings depicting the Catskill region.

1830

Gifford begins formal schooling at the Hudson Academy, which he attends until 1842.

William Cullen Bryant and Asher B. Durand publish *The American Landscape,* a journal dedicated to regional scenery.

Robert Vandewater issues *The Tourist, or Pocket Manual for Travellers on the Hudson River.*

1833

The journal *The Knickerbocker,* which includes art reviews, is founded and continues until 1865.

1834

William Dunlap publishes *A History of the Rise and Progress of the Arts of Design in the United States.*

1836

Ralph Waldo Emerson publishes *Nature,* which summarizes his Transcendentalist views of the relationship of man to the natural world.

Cole's "Essay on American Scenery, " originally a lecture delivered at the New-York Lyceum the previous year, is published in *The American Monthly*.

1837

Asher B. Durand joins Cole on a sketching trip in the eastern Adirondacks and turns from engraving and portraiture to landscape painting.

1839

Elihu Gifford and others found the Farmers' National Bank in Hudson, New York; Elihu accepts the presidency, and retains the post until 1863.

A. T. Goodrich publishes *North American Tourist,* a guidebook that associates the popularity of the Catskill Mountains with the fame of Cole's paintings of the region.

1840

Nathaniel Parker Willis and William Henry Bartlett publish *American Scenery*, a popular gift book devoted to picturesque scenery in the northeastern United States.

1841

The tin paint tube is invented and patented by the artist John Goffe Rand.

1842

Gifford enrolls at Brown University in Providence, which he attends for three semesters.

The Scenery of the Catskill Mountains, edited by David Murdoch, is published and numerous reprints will be issued until 1876.

1843

John Ruskin publishes the first of volume of *Modern Painters.*

1844

October Gifford officially withdraws from Brown University.

Possibly studies art with Henry Ary in Hudson, New York.

Elihu Gifford is appointed a trustee of the new Hudson Iron Company.

The American Art-Union (formerly The Apollo Association for the Promotion of Fine Arts in the United States, est. 1839) becomes an important venue and a market for younger landscape painters at midcentury.

Church commences his two years of study with Cole in the Catskill region.

1845

Gifford moves to New York City and studies drawing, perspective, and anatomy with John Reubens Smith.

Summer Travels (possibly) with "Misters Beard, LeClear and Rev. Starkie" to Montreal and Quebec, through Troy, New York, and Saint John's, Newfoundland, returning via Saint John's; Ticonderoga, New York; Caldwell's (at the head of Lake George); and Saratoga, where he creates his earliest known landscape drawings. Gifford probably also visits the Catskills, since he paints one of his earliest landscape scenes of Kauterskill Lake, which is located in the eastern Catskills, adjacent to the Catskill Mountain House.

Charles L. Beach, a wealthy businessman from the Catskill area who acquired a controlling interest in the Catskill Mountain House in 1839, begins to make extensive improvements and to build additions to the hotel, assuming full ownership the following year.

1846

Summer Gifford visits the Catskills and the Berkshires.

November Registers for the Antique School (where students drew from plaster casts of antique sculptures) at the National Academy of Design in New York.

Bayard Taylor, later a friend of Gifford's, publishes a guidebook of walking tours in Europe, *Views A-Foot*.

Ruskin publishes the second volume of *Modern Painters*

1847

Spring Gifford moves to 66 Cortlandt Street in lower Manhattan and shows his first painting, *Lake Scene, on the Catskills,* in the National Academy of Design annual exhibition.

August Visits the southeastern Catskills (Marbletown, Hurley, and Rondout [Kingston] on the Esopus Creek) and, from the end of the month through early September, travels through the northeastern Catskills (including Saint Lawrence County and Moose Lake).

Autumn Relocates to 182 Prince Street, south of Washington Square Park. Enrolls in life drawing classes at the National Academy school, while probably attending anatomy classes at the Crosby Street Medical College and possibly continuing his studies at the Antique School.

Sends *View on the Kauterskill Creek* to the American Art-Union for exhibition.

Joins the new "New York Sketch Club," modeled after the Artist's Sketch Club and the Old Sketch Club, which recently had become the Century Association.

1848

Spring Gifford submits *The Past, View in Saint Lawrence County,* and *Moose Lake* to the National Academy of Design annual exhibition.

Mid-July–August Visits Lake George, the southeastern Adirondacks, Schroon Lake, and Lake Paradox.

September Visits Kaaterskill and Plattekill cloves in the Catskills; and possibly the artists' colony organized by Durand in Palenville. Continues life classes at the National Academy, and probably attends lectures on anatomy at Crosby Street Medical College. Resides at 502 Broadway.

Submits *View in Saint Lawrence County; Moose Lake; Scene on the Hudson; Lake Scene; Scene on Esopus Creek; Lake George; Autumn;* and *"The Present"* to the American Art-Union for exhibition.

Knoedler opens Goupil, Vibert & Co.'s first gallery in New York; its inaugural exhibition comprises European works. The gallery establishes the International Art Union the following year, which issues engravings of European and American works of art and sponsors a program to send an American artist to Europe to study for two years.

Cole dies, and a memorial retrospective exhibition is held at the American Art-Union.

1849

Spring Gifford exhibits three paintings in the National Academy of Design annual exhibition: two entitled *Sketch from Nature,* and one, *[View] Near Schroon* [?] *Village.*

Summer Sketches with Ary in the Catskills, sketches on Claverack Creek; travels to Shendaken and Schoharie Kill; sketches and goes fishing at West Kill; travels on the Hudson River between Albany and Glens Falls, also stopping at Greenfield, his birthplace.

Late September Tours the western Catskills with Edward H. May until early October.

Resides at 117½ Grand Street in New York until 1852.

Shows *Schroon Lake; Solitude* (cat. no. 1); *Road Scenery near Lake George;* the two works entitled *Sketch from Nature; View near Schroon Village; Creek Scenery, Ulster County, New York; American Lake Scenery;* and *Schoharie Kill* at the American Art-Union.

1850

Spring Gifford exhibits *Deep Hollow, Catskill Mountains; Kauterskill Clove, Catskill Mountains; Sacandaga River;* and *Portrait of a Lady* at the National Academy of Design annual exhibition.

August Goes on a sketching trip to the White Mountains in New Hampshire; stops at the Shawangunk Mountains in New York on his return.

October Travels to Milwaukee with his mother for the wedding of his brother Charles; returns east via Ohio.

Elected an Associate of the National Academy of Design.

Cornelia Gifford, Sanford's sister, dies from tuberculosis.

Presents *On the Delaware at Cochoton; Scene in the Catskills* (cat. no. 2), *Deep Hollow—Catskill Mountains,* and *View on Schoharie Kill* at the American Art-Union.

1851

Spring Gifford exhibits *Mount Merino on the Hudson, Landscape Composition, A Scene from Nature in the Catskills,* and *Echo Lake* at the National Academy's annual exhibition.

Summer Sketches in Plattekill Clove. Goes on a sketching, fishing, and hunting trip (until early September) through the south-central and central Adirondacks with Eliphalet Terry, Richard W. Hubbard, and, later, with his older brother Frederick.

Late September Travels with Terry along the Delaware River and in the southern Catskills in Sullivan County until early October.

Mid-October Spends time in the Hudson, New York, vicinity.

The Hudson Iron Company, the foundry of which Elihu Gifford was a trustee, builds a new plant in South Bay near a new railway line.

The New York and Erie railroads make inaugural runs along the Hudson River.

1852

Spring Gifford submits *Lake Pleasant, Hamilton County; A Wood Path; Landscape; A View on the Hudson;* and *A View on the Schoharie Kill* to the National Academy of Design annual exhibition.

Early July Travels in central and eastern Pennsylvania, along the Juniata and Susquehanna rivers through early September; probably visits Philadelphia.

October Sketches in the Hudson, New York, region.

December Presents *Sacandago River; A Scene in Northern New-York; The Waters of the Delaware; Echo Lake—White Mountains;* and *A Scene from Nature in the Catskills* at the American Art-Union, whose lottery system would be disbanded the following year.

George William Curtis publishes *Lotus-Eating: A Summer Book,* illustrated by John F. Kensett, which discusses his travels to Niagara Falls, Saratoga, Lake George, and Newport, Rhode Island.

The Home Book of the Picturesque, a popular gift book dealing with the Hudson River region and containing engravings of regional scenery, is published.

1853

Spring Gifford exhibits *A View on the Susquehanna; Landscape; Valley of Wyoming; Autumnal Landscape;* and *View Near Hudson* at the National Academy of Design annual exhibition. Resides at 11 Amity Street in Brooklyn and at 105 Bleecker Street in Manhattan.

Summer Possibly travels in the Shawangunk or the Adirondack Mountains through early autumn.

December Moves to 483 Broadway, remaining there until spring 1855.

The "New-York Exhibition of the Industry of All Nations" (America's first World's Fair) opens at the Crystal Palace, in New York.

1854

Spring Gifford shows *The River Bank; The Juniata; Shawangunk Mountains* (fig. 9); and *Morning in the Adirondacks* (fig. 8) at the National Academy's annual exhibition and is elected an academician in May.

June–September Sketches in the Palisades, the Berkshire Hills, and in southern New Jersey. Travels with Richard W. Hubbard, Samuel Colman, and Aaron D. Shattuck to the Saco Valley, near the North Conway, New Hampshire, artists' colony, where he also sketches with Benjamin Champney and Alfred T. Ordway; visits Lake Ossipee and Mount Chocorua.

October Visits Portland, Maine, and Cape Elizabeth. Gifford's younger sister, Elizabeth, dies.

The Kansas-Nebraska Act overturns the antislavery provisions of the 1820 Missouri Compromise.

The dealers Williams, Stevens, and Williams exhibit European and American "modern art" in New York to increase the public's awareness of works and offer subscriptions for engravings.

1855

Spring Gifford submits *Conway Valley* (*with Mount Washington*), *Chocorua Peak,* and *Summer Afternoon* to the National Academy of Design annual exhibition.

Mid-May–July Makes his first trip to Europe via Liverpool, staying in London. Visits the National Gallery, the Royal Academy of Art, the Society of Painters of Water Colors, and other private and public collections. Begins a summer sketching campaign through England, visiting Windsor, Stratford-upon-Avon, Stoke Poges, Warwick, Guy's Cliff, and Kenilworth Castle in the Lake District.

August and September Returns to London; views Rosa Bonheur's *Horse Fair;* travels to Matlock-Bath, Derbyshire, along the Derwent River, to Chatsworth, York, and the town of Gifford, near Dunbar. Arrives in Edinburgh; visits the

Royal Scottish Academy, Holyrood Palace Art Gallery, Dollar, and Stirling. Embarks on a walking tour of Highlands and Callander, traveling to the Trossachs, Loch Katrine and Loch Achray, Ben Venue, Oban, Inveraray, and Loch Awe, eventually reaching Glasgow. Takes a trip to "Land O'Burns," Ayre, and along the Yarrow River; returns to London through the English Lake District: Cumberland, Westmoreland, Loch Awe, and Windermere. Calls on Ruskin in Oxford.

Late October Travels to Paris, where he resides at 14, rue de Navarin, in Montmartre until May 1856. Socializes with Edward May, Dickey Hearne, John Conolly, Horatio Greenough, Christopher P. Cranch, and Theodore Rossiter while there. Attends the Exposition Universelle.

Exhibits *Mount Washington from the Saco* and *The Cabin in the Wilderness* at The Boston Athenaeum.

Leaves of Grass by Walt Whitman and *The Song of Hiawatha* by Henry Wadsworth Longfellow are published.

William J. Stillman and John Durand (Asher B. Durand's son), launch *The Crayon,* a literary and fine arts journal; Asher B. Durand's nine "Letters on Landscape Painting" appear in the early issues (publication ceases in 1861).

1856

Spring Gifford visits Thomas Couture's atelier. Works in Saint-Ouen, the forest of Saint-Germain, Fontainebleau, and Barbizon, and calls on Jean-François Millet. Travels to the Netherlands with college friends, then on to Düsseldorf, where he meets Emanuel Leutze (who makes a crayon portrait of him) and Worthington Whittredge. Goes on a two-week walking tour of Cologne, Mainz, Frankfurt, and Strasbourg. Submits *Landscape* and *Landscape Composition* to the National Academy of Design annual exhibition.

July Enters Switzerland at Basel, traveling to Geneva, the French Alps, Chamonix, Mont Blanc, and Chillon, Saanen, the Lauterbrunnen Valley, Wegernalp, and Grindelwald. Meets Whittredge, Albert Bierstadt, and William Stanley Haseltine in Lucerne and continues on to Zürich.

August and September Continues through southern Switzerland and hikes over the Simplon Pass to Domodossola, in northern Italy. Explores the Mount Mottarone, Lake Maggiore, and Lake Como region mostly by foot; takes the train to Genoa, reaching Florence via La Spezia; crosses the Apennines to Carrara, Pisa, Cascina, Siena, Arezzo, Perugia, Foligno, Spoleto, Terni, Narni, Civita Castellana, and Castelnuovo. Arrives in Rome and takes a studio at 55, Via Sistina, the district near the Spanish Steps popular with American artists, where he remains until May 1857.

October Tours the Roman Campagna with Haseltine, Whittredge, William Beard, and Thomas Buchanan Read.

Exhibits *Mote* [?] *Mountain* at The Pennsylvania Academy of the Fine Arts in Philadelphia.

Ruskin publishes the third and fourth volumes of *Modern Painters*.

1857

Spring Gifford submits *Stratford-upon-Avon* to the National Academy of Design annual exhibition.

May–August Takes a walking tour with Bierstadt through the Abruzzi Mountains to Naples, Capri, and the Amalfi and Calabrian coasts; tours Pompeii, Gaeta, and Ischia, and sketches on Capri. Tours Sorrento and Castellamare, reaching Amalfi and Salerno by foot; also explores Paestum, before going back to Naples. Travels solo to Venice, where he meets Enoch Wood Perry, and north through Verona, visiting Lake Garda and the Stelvio Road. Returns to the Alps region, eventually arriving in Munich, Vienna, Dresden, Berlin, Paris, and London.

Late September Returns to the family home in Hudson, New York.

Autumn Rents quarters in the Tenth Street Studio Building, designed by Richard Morris Hunt, which houses twenty-five studios (open to the public on Saturdays), as well as exhibition space. Other occupants during the next three years include McEntee, George Henry Boughton, James Suydam, Church, Stillman, Whittredge, Launt Thompson, John W. Casilear, Leutze, Shattuck, John F. Weir, and Bierstadt.

December Spends the holidays in Hudson.

The Financial Panic of 1857 occurs.

The Dred Scott case is argued before the Supreme Court, which rules against the fugitive slave's claim to freedom and declares that the federal government has no jurisdiction over slavery issues in the territories.

A board of commissioners is established for what would become Central Park, and it sponsors a competition for the park's design.

Knoedler (after buying out Goupil, Vibert & Co.) and Eugene Gambart organize a large exhibition of contemporary French painting in October at the old American Art-Union building; the same month Gambart mounts a large exhibition of British paintings, which includes the Pre-Raphaelites, at the National Academy of Design.

Church exhibits his painting *Niagara* as a single-picture attraction at the Tenth Street Studio Building in May and at Williams, Stevens, and Williams on Broadway in May and September; he also exhibits *The Andes of Ecuador* at the National Academy of Design in the spring.

T. Addison Richards issues *Appletons' Illustrated Hand-book of American Travel . . .*, which discusses the trails and views around the Catskill region.

1858

January Gifford remains in Hudson through March, painting, ice-skating, and going boating.

Spring Submits *Lake Nemi* (*; cat. no. 6); *Lake Maggiore; Riviera di Ponente, near Genoa; Derwentwater; Loch Awe, with Kilchurn Castle, Highlands of Scotland; A Lake in Cumberland; Ruins of the Claudian Aqueduct;* and *Scene on the Roman Campagna* to the National Academy of Design annual exhibition. Sketches around New York City.

July–September Embarks on sketching campaigns along the Delaware, Chenango, Susquehanna, and Chemung rivers in New York State and in Pennsylvania with Richard W. Hubbard. Visits New England, including Mount Mansfield, the Champlain Valley, and the Huntington River region of Vermont, and the Mount Washington Valley in New Hampshire, as well as the Catskills. Exhibits *Ruins of the Claudian Aqueduct; Loch Awe, with Kilchurn Castle, Highlands of Scotland; Lake Winnipesaukee; Kenilworth;* and *"The Silent Darent," Kent, England,* in New Bedford, Massachusetts. Exhibits *Lake Nemi* at Yale College.

Exhibits *Shawangunk Mountains; Wilderness in Northern New York; Riviera di Ponente, near Genoa; Rydal Water; September Afternoon on the Saco; Lake Winnipesaukee (from Red Hill); West Branch of the Delaware; Ruins of the Claudian Aqueduct;* and *"The Silent Darent" Kent, England,* at the Boston Athenaeum, and *Valley of the Lauterbrunnen, Switzerland,* at the Washington (D.C.) Art Association.

Dodworth's, an artists' studio building, initiates "Artists' Receptions," prompting the inhabitants of the Tenth Street Studio Building to open their studios to friends and visitors on designated evenings during the season.

1859

January–March Gifford participates in two Tenth Street Studio Building exhibitions and one Dodsworth's exhibition, as well as in fund-raising exhibitions for the Yale Art Library and the Young Men's Association of Troy, New York.

February Visited by Charles, his oldest and closest brother, who arrives from his home in Wisconsin to seek treatment for depression and headaches.

Spring Submits *Sunset in the Wilderness; Mansfield Mountain* (*; cat. no. 8); *Camp on Mansfield Mountain; On the Calabrian Coast; Como; Schoharie Kill;* and *Autumn Evening in the White Mountains* to the National Academy of Design annual exhibition.

June Visits his family in Hudson.

July and August Tours Nova Scotia with Boughton, the setting of Longfellow's *Evangeline*. Travels along the Androscoggin River in New Hampshire to Gorham, and King Ravine along the Connecticut River to Lancaster, possibly with Thomas Starr King; also may have continued on to Maine.

September Possibly travels to the Chenango River region of New York State.

December Elected a member of Dodsworth's Artists' Reception Association with Leutze, Eastman Johnson, and Bierstadt.

Joins the Century Association.

Exhibits *The Chenango; Among the Green Mountains; Lago Maggiore;* and *Mansfield Mountain* at the Boston Athenaeum; and *Lake Nemi; La Campagna Romana; Conway Valley;* and *Loch Awe and Kilchurn Castle* at the Young Men's Association, Troy, New York.

The trial and execution of abolitionist John Brown takes place.

Church exhibits the painting *The Heart of the Andes* as a single work at Lyrique Hall, New York City, and at the Tenth Street Studio Building in April and May.

Thomas Starr King publishes the popular tour guide *The White Hills; Their Legends, Landscape and Poetry.*

1860
Winter Gifford participates in two exhibitions at Dodsworth's and in two at the Tenth Street Studio Building, and in the First Annual Sale at National Academy, which continues through the spring.

Spring Submits *The Wilderness* (cat. no. 12); *Rheinstein; Mount Merino on the Hudson; On the Bay of Fundy;* and *Coming Rain* to the National Academy of Design annual exhibition.

July and August Travels to Harper's Ferry, Maryland, and along the Cheat and Monongahela rivers in western Virginia (now West Virginia) with Hubbard and McEntee. Returns to the Catskills; sketches at Schoharie Kill, Kaaterskill Clove, and Kaaterskill Falls with Whittredge and possibly McEntee.

September Together with his siblings Mary and William, travels to Wisconsin to visit their ailing brother, Charles. Returns to Hudson, and goes on a walking tour of the Hudson highlands with McEntee.

Exhibits *The Wilderness* (probably cat. no. 12) and *Near Saint Ouen, Environs of Paris,* at the Boston Athenaeum; and *Valley of the Lauterbrunnen (Switzerland); Lake Nemi; Camp, Mansfield Mountain; The Coming Rain, Hay Making;* and *Windsor Castle* at the Young Men's Association, Troy, New York. Shows *On the Hudson; Mount Merino; Lake Como; Autumn Evening, White Mountains; Green Mountains, Vermont; Autumnal Sunset; Kauterskill Lake; The Riverside;* and *The Susquehanna* at the Artists' Fund Society; *Summer* at the Pittsburgh Art Association; and *Early October in the White Mountains* (cat. no. 11) at the Western Academy of Art, Saint Louis.

Abraham Lincoln is elected the sixteenth president of the United States.

South Carolina secedes from the Union in December.

Ruskin publishes the fifth and final volume of *Modern Painters.*

1861
January Gifford donates *An Autumn Sunset* and *A Lake Scene* to the Artists' Fund Society (founded the previous year to benefit the widows and children of artists).

February Is elected to the "Board of Control" of the Artists' Fund Society with Kensett, Hubbard, Louis Lang, and Régis Gignoux. Exhibits *Autumnal Scene* at the Brooklyn Art Association.

February–July Ten states secede from the Union and join South Carolina in forming the Confederacy. Abraham Lincoln is inaugurated president. Confederate troops seize Fort Sumter (South Carolina) in April, marking the outbreak of the Civil War; Union troops are defeated at the Battle of Bull Run (Virginia).

Spring Submits *A Lake in the Highlands, A Twilight in the Catskills* (*; fig. 12); *Kenilworth,* and *La Marina Grande—Capri* (cat. no. 16) to the National Academy of Design annual exhibition.

April Joins Seventh Regiment of New York State's National Guard. Sails to Washington, D.C., to meet up with the New York City regiment enlisted to defend Washington, quartered in the Hall of Representatives in the Capitol Building; later stationed at Camp Cameron and in Arlington Heights. Remains on duty through June, making casual sketches of military life.

May Learns of the death of his brother Charles from an overdose of chloral hydrate.

June–mid-July Travels to Hudson; visits Candace and Tom Wheeler (whom he had met and befriended at the Tenth Street Studio Building receptions), at Nestledown, their summer house in Hollis, Long Island (now Queens). Spends time in the Palisades with Whittredge, Hubbard, and Fitz Hugh Ludlow.

Late July–September Returns to the Catskills; sketches at Kaaterskill Clove, Catskill Lake, and North Mountain. Takes a walking tour to Stony Clove, Rondout Creek, Balsam Mountain, and Lake Shawangunk with McEntee, Whittredge, and an unspecified companion.

December Sketches on the Bronx River with unidentified companions.

Exhibits *In the Catskills* (cat. no. 20) at The Pennsylvania Academy of the Fine Arts, *Kauterskill Clove* at the Boston Athenaeum, and *Windsor Castle; Mount Merino* [?], *Hudson River; Kenilworth; The Coming Rain; In the Catskills; Sunset* (possibly cat. no. 14); and *The Wilderness* at the Young Men's Association, Troy, New York. Exhibits *The Bivouac; Windsor Castle;* and *Autumnal Sunset* at the Brooklyn Art Association.

Frederic Church exhibits *The Icebergs* at Goupil & Co.

1862

March Gifford exhibits *Torre dei Schiavi—Roman Campagna* (possibily cat. no. 26) and *A Winter Twilight* (possibly cat. no. 28) at the Brooklyn Art Association.

April Submits *Sunday Morning in the Camp of the Seventh Regiment near Washington, D.C.; Bivouac of the Seventh Regiment—Arlington Heights, Virginia* (*); *A Winter Twilight;* and *Torre dei Schiavi—Roman Campagna* to the National Academy of Design annual exhibition.

Early June Visits the Wheelers at Nestledown.

June–August Rejoins his regiment in Maryland and serves as a first corporal; is stationed at Fort Federal Hill and Mount Clare Station in Baltimore.

Autumn Returns to Hudson and sketches at Esopus Creek in Hurley, New York; in the Berkshires (with Thompson and Whittredge); and at Claverack Creek. Visits Kaaterskill Clove with McEntee and Whittredge.

December Exhibits *A Gorge in the Mountains* (cat. no. 21) at an Artists' Studio Reception at the Tenth Street Studio Building, and *Summer* and *From the Berkshire Hills* at the Brooklyn Art Association.

Exhibits *Peak of Green Mountains, Vermont,* at The Pennsylvania Academy of the Fine Arts; and *Torre di Schiavi—Roman Campagna; Autumn;* and *Sunset* at the Boston Athenaeum. Shows *Windsor Castle; Landscape; Camp, Mansfield Mountain; The Coming Rain; Loch Awe and Castle Kilchurn; Mount Merino, Hudson River;* and *A Twilight in the Catskills* at the Young Men's Association, Troy, New York; and *Moonlight on the Meadows, Landscape, Claverack Meadows,* and *Indian Summer* at the Artists' Fund Society.

Lincoln signs the Pacific Railroad Act; construction of the transcontinental railroad commences.

Union forces capture Fort Henry and New Orleans.

Confederate forces win the second Battle of Bull Run and the Battle of Fredericksburg; but are defeated at the Battle of Antietam.

1863

January 1 Lincoln issues the Emancipation Proclamation.

Spring Gifford submits *Baltimore, 1862—Twilight* (*; fig. 32); *Kauterskill Clove* (see the study, fig. 85); *Mansfield Mountain—Sunset;* and *Como* to the National Academy of Design annual exhibition.

May Visits the Long Island shore and probably Nestledown; takes a trip to the Hudson Highlands, possibly with Edith Cook.

July Returns to the Seventh Regiment in Frederick, Maryland, and witnesses the Confederate retreat from Gettysburg; called back to New York to help put down the Draft Riots.

August Sanford's brother Edward, a captain in the Union Army, dies from typhoid fever following his escape from Confederate imprisonment in New Orleans.

September Camps in the Adirondacks with Hubbard and McEntee, stopping at Lake George, Lake Champlain, and Lake Placid.

October Probably visits Kaaterskill Clove and South Mountain in the Catskills.

December Exhibits *Riva—Lago di Garda; Claverack Creek;* and *A Gorge in the Mountains* (cat. no. 21) at the Artists' Fund Society.

Exhibits *The Coming Storm* and *Landscape* at The Pennsylvania Academy of the Fine Arts, and *First Skating of the Season* at the Weehawken Gallery in New Jersey.

Bierstadt exhibits the painting *Rocky Mountains, Lander's Peak.*

Church exhibits *Cotopaxi* to great notice at Goupil & Co.

1864

Late Winter Gifford exhibits *Schoharie Kill, Near Genoa,* and *Mount Washington* at the Brooklyn and Long Island Fair.

Early Spring Exhibits *South Mountain—Catskills* and *A Twilight in the Adirondacks* (*; cat no. 37) at the National Academy of Design annual exhibition; and *View from the Berkshire Hills; A Thunder Storm in the Catskills* (probably *A Coming Storm,* cat. no. 29); *Mansfield Mountain; Lago Maggiore; Kauterskill Clove, from Sunset Rock;* and *Fort Federal Hill, Baltimore 1862* (fig. 32) at the Maryland State Fair.

May Visits Nestledown and the Long Island coast. Exhibits *Thunder Storm* at the Brooklyn Art Association.

June Exhibits *Marine and Landscape; Peak of Green Mountains; Landscape;* and *Camp Cameron* at the Great Central Fair in Philadelphia. Travels to the New Jersey shore.

July–October Travels throughout New England (including Nantucket Island) with his sister Mary; meets McEntee and his wife, Gertrude, in Boston, and they travel to Maine: Mount Desert Island, Bar Harbor, Somes Sound, Green (Cadillac) Mountain, Mount Katahdin, Bangor, Portland, and Fryeburg. With his sister Mary (and possibly the McEntees), tours New Hampshire: North Conway, Pinkham Notch, and Crawford Notch (near Mount Washington), Echo Lake, and Lake Winnipesaukee, as well as the New Hampshire and Massachusetts coasts (including Manchester, Massachusetts; Cape Ann; Cohasset; Plum Island; and then Hampton Beach, New Hampshire). Visits the Shawangunk Mountains and sketches at Hudson.

December Exhibits *Shawangunk Mountains* at the Brooklyn Art Association.

Exhibits *Torre di Schiavi, near Rome* (*) and *In the Catskills* (cat. no. 20), at The Pennsylvania Academy of the Fine Arts; *Mount Mansfield* and *Landscape* (possibly cat. no. 28) at the Boston Athenaeum; and *Sunset* (possibly cat. no. 15); *Manchester Beach, Coast of Massachusetts; Camp of the Seventh Regiment, N.Y.N.G., near Frederick, Maryland, in July 1863* (possibly cat. no. 34); and *Chenango Lake* at the Artists' Fund Society, New York, *Baltimore, 1862—Twilight* (fig. 32) and *Environs of Paris, near Saint-Ouen*, at the Utica, New York, Mechanics' Association; *Early October in the White Mountains* (cat. no. 11) at the Mississippi Valley Sanitary Fair in Saint Louis; and *Pass of the Gonda-Simplon* in the art gallery of the Metropolitan Fair and at the Metropolitan Sanitary Fair, New York.

Abraham Lincoln reelected president.

General William Sherman defeats the Confederate Army at Savannah.

At William Cullen Bryant's seventieth birthday celebration in November, the Century Association presents the author and editor with a portfolio of forty works of art by its artist members, including Gifford, Church, Durand, Kensett, and Bierstadt.

1865

January Gifford's brother Frederick dies.

Spring Exhibits *Manchester Beach* and *Camp [of the] 7th Regiment* (cat. no. 34) at the Brooklyn Art Association; *Coming Storm* (*; cat. no. 29), *Hampton Beach*, and *Shawangunk Mountains* (*; see cat. no. 36) at the National Academy of Design annual exhibition; and *Winter Sunset, Boys on Ice* at the Northwestern Fair in Chicago.

June–September Travels along the Rhode Island and Massachusetts coasts with Whittredge and Suydam. Visits the White Mountains and other New Hampshire sites with Suydam, who becomes ill and dies on September 15; after the funeral, possibly travels to Lake George. Returns to the Catskills, probably with Whittredge and McEntee, to Kaaterskill Clove and South Mountain, and the vicinity of Hunter Mountain.

December Exhibits *Baltimore in 1862* (probably fig. 32) at the Philadelphia Sketch Club and *Green Mountain, Mount Desert* (possibly cat. no. 39), at the Artists' Fund Society. Exhibits *[South Bay] on the Hudson River* (probably cat. no. 35), *Lake on Mount Desert, Indian Summer in the Adirondacks*, and *From the Green Mountains—Mount Desert* at the Boston Athenaeum; *Fort Federal Hill, Baltimore*, at the Buffalo (New York) Fine Arts Academy; and *Mount Mansfield* (cat. no. 10) and *Indian Summer in the Adirondacks* at the Artists' Fund Society.

April After the fall of Richmond, the Confederate States of America formally surrender at Appomattox. Lincoln is assassinated; Andrew Johnson becomes president (1865–69).

1866

Spring Gifford exhibits *Hunter Mountain—Twilight* (*; cat. no. 41) and *An October Afternoon* (*) at the National Academy of Design annual exhibition.

June Goes fishing in Babylon, Long Island, and dines on Fire Island. Exhibits *Baltimore, 1862—Twilight* (*; fig. 32), at the Opera House Art Association, Chicago.

July–September Returns to Hudson; travels in the Catskills and the Adirondacks with his sister Mary and McEntee and wife, Gertrude. Sketches in Hudson.

October Sketches in the vicinity of the Catskill Mountain House with McEntee, Calvert Vaux, and Whittredge. Returns to Hudson.

November Exhibits *Scene in the White Mountains* at the Brooklyn Art Association.

Paints *A Passing Storm in the Adirondacks* (*; cat. no. 44).

Exhibits *The Bay Road* at the Utica (New York) Art Association, and *Morning on the Hudson, Haverstraw Bay* (possibly cat. no. 42), and *Dana's Beach, Cape Ann*, at the Artists' Fund Society.

1867

Late Winter and Spring Gifford exhibits *The Camels Hump, Green Mountains*, at the Artists' Fund Society; *Sunrise on the Seashore* (*) at the Brooklyn Art Association; and *The Bronx River, On Cape Ann*, and *Sunrise on the Seashore* (*) at the National Academy of Design annual exhibition.

Summer Works along the New Jersey shore, in Sandy Hook, Sea Bright, and Long Branch.

September and October Possibly sketches along the Hudson River; joins the McEntees near the Catskill Mountain House.

Exhibits *Hunter Mountain—Twilight* (*; cat. no. 41) and *A Home in the Wilderness* (*; cat. no. 40) in the American Galleries at the Paris Exposition Universelle; *Morning on the Hudson, Haverstraw Bay* (cat. no. 42), at The Pennsylvania Academy of the Fine Arts; *Twilight in the Adirondacks* (*), *Sunrise on the Seashore* (*), *Landscape*, and *Interior of the Woods* at the Yale [College] School of Fine Arts; *First Skating of the Season* at the Derby Gallery, New York; *A Home in the Wilderness* and *Twilight on Mount Hunter* (*; cat. no. 41) at the American Society of Painters in Water Colors; and *The New Jersey Shore* and *Sundown* at the Artists' Fund Society.

Paints *Morning in the Adirondacks* (*; University of Kansas, Lawrence).

1868

March Gifford is elected a member of the Union League Club. Exhibits *An Indian Summer Day* (cat. no. 46) at the Brooklyn Art Association.

Spring Exhibits *Shrewsbury River—Sandy Hook, N.J.* (*); *A Roman Twilight;* and *Indian Summer's Day on the Hudson—Tappan Zee* (cat. no. 46) at the National Academy of Design annual exhibition, and *Landscape, Autumn,* at the Union League Club.

May 27 Sails for England with the McEntees on the second and final European tour.

June Arrives in Liverpool, travels to London through Kenilworth and Stratford-upon-Avon, followed by solo trips to Paris to attend the Salon, and to Geneva.

July–September Travels through the Alps to Val d'Aosta, and the Italian lake district to Milan. Tours Genoa and the Italian Riviera; visits Florence, Perugia, Assisi, and Rome. Travels to Naples, Pompeii, Castellamare, Calabria, Bagnara, and Sicily; then Catania, Taormina, Monte Venere, and Palermo; returns to Rome at the end of September.

October Remains in Rome with his sister Mary, the McEntees, Frederic and Isabel Church, and others; sketches in the Campagna and surrounding regions.

November and December Resides in Rome.

Exhibits *Dana's Beach, Cape Ann,* at The Pennsylvania Academy of the Fine Arts; *New Jersey Shore* and *Hunter Mountain (Catskill)* at the Utica (New York) Art Association; *Shawangunk Mountains* (*; see cat. no. 36), *Kaaterskill C[l]ove* and *Lake of Garda* at the Maryland Historical Society; *Sundown* and *The New Jersey Shore* at the Artists' Fund Society.

1869

January Gifford journeys to Egypt via Naples and Brindisi; visits Alexandria and Cairo.

Late January–mid-March Travels on the Nile. Visits Cairo, Suez, Jaffa, and Port Said with Alfred Craven and others.

Late March–April Travels from Jaffa to Beirut on horseback, in a caravan, through Samaria, Damascus, and Baalbek, taking the side trip to the Dead Sea and Jordan, via Bethlehem.

Late April–mid-May Sails to Athens via Cyprus. Spends several days on the Acropolis. Departs for Constantinople (Istanbul).

Late May Sails to Venice on the Black Sea, travels by train to Bulgaria, sails up the Danube River to Vienna, and stops in Salzburg, Innsbruck, and Verona. Remains in Venice for several weeks.

Late July–mid-August Travels to Paris via the Alps, along the Rhine, and through Belgium.

September Returns to the United States from Le Havre. Visits Catskills, staying at Scribner's with the McEntees and Johnsons.

November At the invitation of the Art Committee of the Union League Club, the artistic and intellectual leaders of New York meet and resolve to establish a Museum of Art. The project is relegated to a "Committee of Fifty" artists, architects, attorneys, editors, and businessman, including Gifford.

December Selected as one of the thirteen subcommittee members, including Frederick Law Olmstead, Calvert Vaux, and J. Q. A. Ward, to organize the new Metropolitan Museum of Art; the primary goal is to submit plans for the institution and to compile a list of nominees for the officers of the new museum, which would be incorporated in April 1870. Exhibits *Scene on the Nile with Ruin and Vessels in the Center* at the Century Association; *Sunset at White Mountains* at the Boston Athenaeum; and *A September Afternoon on the Chenango* and *Mouth of the Shrewsbury River* (*) at the Brooklyn Art Association.

The Central Pacific and Union Pacific railroads meet in Utah, creating the transcontinental railroad.

1870

January Gifford exhibits *Sunset near Cairo* and *Lake Scene* at the Century Association.

February Exhibits *San Giorgio, Venice* (*), at the Union League Club.

March Exhibits *Venice Sunny Day* at the Century Association, and *Assiout in Upper Egypt* (see cat. no. 49) and *Mansfield Mountain, Vermont,* at the Brooklyn Art Association.

April Shows *Lagoons Brilliantly Illuminated, Setting Sun* (possibly, fig. 138), and *Lago Maggiore* at the Century Association, and *San Giorgio (Venice)* (*) and *Tivoli* (*; fig. 53), at the National Academy of Design annual exhibition.

Summer Takes a trip to Colorado and the Rocky Mountains with Whittredge and Kensett.

August–September Explores Wyoming with Ferdinand V. Hayden and the team of the United States Geological and Geographic Survey of the Territories, including photographer William H. Jackson; rejoins Whittredge in Colorado in mid-September.

October Builds a studio "atop of his father's house."

November Exhibits *Near Venice* (possibly fig. 138) and *San Giorgio, Venice* (*), at the Brooklyn Art Association.

Paints *Arch of Nero—Tivoli* (*).

Exhibits *Pallanza, Lago Maggiore* (see fig. 16); *Autumnal Sunset; Fishing Boats of the Adriatic; Hunter Mountain, Twilight* (*; cat. no. 41); and *The Wood Road* at the Yale [College] School of Fine Arts. Shows *Landscape. Mansfield Mountain, Vermont* (*; cat. no. 8), at the Harrison Collection in Philadelphia; and *Riva, Lake*

Garda, and *Twilight in the Adirondack Mountains* at the Jenkins Collection at the Walters Art Gallery, Baltimore.

1871

January Gifford exhibits *The Pyramids; Lake Nemi;* and [*A Foggy Day on the*] *Bronx River* (*) at the Union League Club, New York.

February Exhibits *Galleries of the Stelvio, Lake Como* (cat. no. 67) at the Artists' Fund Society.

March Exhibits *Lago Maggiore, Monte Ferro* (Picker Art Museum, Colgate University; *) at the Century Association.

April Shows *The Column of Saint Mark* (*) and *Fishing Boats of the Adriatic* (*) at the National Academy of Design annual exhibition; and *River Scene on the Nile, River Scene,* and *Lagoon with Vessels in Brilliant Sunshine* (possibly fig. 138) at the Century Association.

May Exhibits *Lake Maggiore Evening Scene* (possibly, cat. no. 51) at the Century Association.

July Exhibits *San Giorgio, Venice* (*), [*The*] *Arch of Nero, Sabine Mountains; Autumnal Sunset; Lago Maggiore Monte Ferro* (*); *Lago Maggiore, Isola Bella* (possibly, cat. no. 51); *The Column of Saint Mark* (*); and *Twilight on Hunter Mountain* (*; cat. no. 41) at the Yale [College] School of Fine Arts.

August Takes a fishing trip to the North Shore of Lake Superior with George Coale and an unidentified Philadelphian.

October Stays at Laurel House, near Kaaterskill Falls, with McEntee. Exhibits *White Mountain Scenery* (possibly cat. no. 11) at the Saint Louis Mercantile Library.

November Exhibits *The Arch of Nero* at the Brooklyn Art Association. Exhibits *Lagoons of Venice* (probably fig. 138) and *Landscape* at the Utica (New York) Art Association.

1872

Late Winter–Early Spring Gifford exhibits *In the Catskills* at the Artists' Fund Society and *Arch of Nero with Figures; Mountain Scenery with Autumn Foliage; Camels; Cataracter* [sic] *Autumn;* and *Egyptian Structure* at the Century Association.

Spring Shows *Santa Maria della Salute, Venice* (*), at the National Academy of Design annual exhibition and *Tivoli* (fig. 53) and *From Monte Pincio, Rome,* and *Derwentwater* (see cat. no. 5) at the Brooklyn Art Association. Gifford, Kensett, Huntington, and McEntee host a luncheon to honor Asher B. Durand.

July Goes on a fishing trip to Dean's Corners in the Catskills with his brother-in-law Robert Wilkinson and McEntee.

August Travels along the Massachusetts coast with McEntee and Whittredge.

Late September Joins the McEntees and the Vauxes at Laurel House in the Catskills.

November Exhibits *Landscape* at the St. Louis Mercantile Library.

December Exhibits *On the Nile* (*; cat. no. 48), *White Mountain,* and *The Statues of Memnon* (fig. 45) at the Brooklyn Art Association. Serves as a pallbearer at the funeral for John F. Kensett (1816–1872).

Exhibits *Twilight on Hunter Mountain, Catskill* (*; cat. no. 41), and *Autumnal Sunset* at the Yale [College] School of Fine Arts.

Yellowstone, the first national park, is established.

Picturesque America, a popular gift book edited by William Cullen Bryant and containing illustrations by Hudson River School artists, is published.

1873

Late Winter–early Spring Weir publishes an article entitled "American Landscape Painters" in the January issue of *The New Englander,* declaring Gifford "our greatest landscape painter." Gifford exhibits *Sunset—Foot of 10th Street, N. Y.,* at the Artists' Fund Society; *Memnon* (probably fig. 45) and *Catskill Mountains* at the Century Association; and *The Golden Horn* [?] and *Rheinstein* (possibly fig. 40) and the Brooklyn Art Association

Spring Submits *Rheinstein* (*; fig. 40) and *The Golden Horn, Constantinople* (*), to the National Academy of Design annual exhibition, and *Venice* and *Study on the Coast—Cape Ann* to the Century Association.

Summer In Hudson; possibly visits Fire Island and Nestledown; goes on a fishing trip to Canada.

September Visits Mount Mansfield and Lake George.

October Visits Laurel House in the Catskills with his sister Mary; Candace Wheeler and her oldest daughter, Cannie; and John Lee Fitch. Exhibits *South Mountain, Catskill* (probably, cat. no. 54) and *Autumn in the Catskills* (cat. no. 20) at the Union League Club.

November Exhibits *Sails of Venice* (possibly cat. no. 56) at the Century Association.

December Exhibits *South Mountain, Catskills* (probably, cat. no. 54), at the Brooklyn Art Association, and *Landscape* at the Century Association.

Exhibits *Arch of Nero—Sabine Mountains* at the Buffalo Academy of Fine Arts. Submits *The Arch of Nero, Castle of Rheinstein* (possibly fig. 40) , and *South Mountain, Catskills* (possibly fig. 54), to the Cincinnati Industrial Exposition; shows *Lake Scene* at the Connecticut School of Design Hartford; and *A Study*

from Nature—Mount Desert (possibly cat. no. 39) at Kensett's memorial exhibition held at the National Academy of Design.

Financial panic erupts in the United States and in Europe.

1874

Late Winter–early Spring Gifford exhibits *South Mountain—Catskills* (see cat. no. 54, fig. 36), *Near Palermo* (possibly cat. no. 17); *The Acropolis,* and *Landscape* at the Century Association.

April Shows *Pallanza, Lago Maggiore* (*; fig. 16), *Venetian Sails* (*; see cat. no. 56), and *Sunset on the Sweet Water, Wyoming,* at the National Academy of Design annual exhibition, and *Near Palermo* and *Woods in Autumn* at the Brooklyn Art Association and the Century Association. With McEntee, Gifford attends Richard A. Proctor's lecture "Other Worlds," which probably was based on the author's 1870 book propounding his theory "that the divine purpose was life itself."

May and June Exhibits *The Wetterhorn; Moonlight on the Coast,* and *Khartoum* [?]—*Upper Egypt* at the Century Association.

Summer Visits Nevada, San Francisco, Oregon, Alaska, Vancouver Island, and Washington, and fishes along the Columbia River.

October Visits Laurel House in the Catskills with his sister Mary and Candace Wheeler (McEntee and Vaux were also in the area at the same time). Exhibits *Torre dei Schiavi* (possibly cat. no. 26) at The Metropolitan Museum of Art.

November Exhibits *San Giorgio, Venice,* at the Brooklyn Art Association.

December Exhibits *Fishing Boats Entering the Harbor of Brindisi* at the Century Association.

Paints *The Grand Canal in Venice* (*).

Exhibits *Tivoli* and *Autumn* at the Cincinnati Industrial Exposition. Shows *Sketch from Nature, Cape Ann; Near Palermo, Sicily* (cat. no. 17)*; Memnon* (possibly fig. 45); *Autumn; Autumn Woods, Autumnal Sunset; Hunter Mountain, Catskill* (*; cat. no. 41); and *Rheinstein* (possibly fig. 40) at the Yale [College] School of Fine Arts, and *Lake View—Sunset* and *South Mountain, Catskills* (cat. no. 54), at Moore's Art Rooms on Union Square in New York.

March Kensett's "Last Summer's Work" is exhibited at The Metropolitan Museum of Art.

1875

January–April Gifford exhibits *San Giorgio—Venice; Mount Rainier, Bay of Tacoma—Puget Sound* (cat. no. 57); *Lake Geneva* (possibly cat. no. 14); *Near Palermo* (possibly cat. no. 17); and *Sketch from Nature—Salt Meadows*

Cape Ann at the Century Association. Joins with his National Academy colleagues in a dispute over the new policy of rejecting previously "publicly exhibited" works of art; attempts to resign from the Academy in protest, but resignation is not accepted; sends no pictures to the spring annual exhibition.

May Exhibits *Memnon* (possibly, fig. 45) at the Brooklyn Art Association. Exhibits *Torre dei Schiavi* (see cat. no. 26) and *Brindisi Harbor* (*) at The Metropolitan Museum of Art.

June Visits Weir in New Haven.

Summer Visits his family in Hudson. Takes a fishing trip to New Brunswick, Canada, with Alfred Craven and Henry Kirke Brown.

October Visits the Shawangunk Mountains.

November and December Exhibits *Venice; From the Interior of a Tomb at Beni Hassan on the Nile;* and *In the Catskills—Autumn Storm Effect* at the Century Association. Makes a loan to his family, whose foundry is in financial difficulty.

Exhibits *Venice,* and *Autumnal Afternoon,* and *Hunter Mountain, Catskill* (cat. no. 41), at the Yale [College] School of Fine Arts; *Mount Mansfield* at the Centennial Loan Exhibition in Hartford; *The Arch of Nero; The Matterhorn at Sunrise; Memnon* (possibly fig. 45); *October Afternoon, San Giorgio, Venice* (*); and *The Wetterhorn* at the Chicago Interstate Industrial Exposition; *Sunrise on the Seashore* (*) at Hoe's Collection in New York; and *A Twilight in the Adirondacks* (possibly cat. no. 37) at the Brooklyn Art Association.

Whittredge is elected president of the National Academy of Design.

1876

January–April Gifford exhibits *S. R. G. on the Plains; Twilight; Lake View; Oriental Scene;* and *The Arch of Nero* at the Century Association; *Santa Maria della Salute, Venice* (*), at the Union League Club; *South Mountain, Catskill* (possibly cat. 54), in the Chicago Industrial Exposition Building. Shows *At Beni-Hassan* and *Near Palermo, Sicily* (cat. 17), in the National Academy of Design annual exhibition; and *A Coming Storm* (possibly cat. no. 29) at the Brooklyn Art Association. Visits Weir in Poughkeepsie.

May At the Centennial Exhibition art gallery in Philadelphia, for which Gifford's friend Whittredge assembles the pictures sent by New York State artists, Gifford shows thirteen paintings, seven of which win the "highest award for eminence in landscape painting": *Bronx River* (*); *Fishing Boats of the Adriatic* (*); *The Golden Horn* (*; see cat. no. 60); *Lake Geneva* (*; fig. 144); *Monte Ferro—Lake Maggiore* (*); *Pallanza, Lago Maggiore* (*; see fig. 16); *On the Nile* (*; cat. no. 48); *San Giorgio, Venice* (*); *Santa Maria della Salute, Venice* (*); *Shrewsbury River, Sandy Hook* (*; see fig. 45); *Sunrise on the Seashore* (*); *Tivoli;* and *Twilight in the Adirondacks* (*). Exhibits *Remembrance of the Mumanchi; Hudson River,* and

Leander's Tomb in the Bosphorus (see cat. no. 59) at the Century Association, and *Shrewsbury River, Sandy Hook* (*; see fig. 45) at the Young Women's Christian Association, New York.

June Exhibits *Lake George* at the Century Association. Goes fishing in the Catskills with McEntee.

Autumn Probably is in New York and vicinity. Exhibits *Autumn Landscape* and *Coast Scene* at the Century Association.

December Exhibits *On the Hudson River* at the Century Association and *The Arch of Nero* and *A Wood Road* at the Brooklyn Art Association.

Exhibits *Hunter Mountain, Catskills* (*; cat. no. 41); *Twilight in the Wilderness; 7th Regiment Camp, near Frederick, Maryland, in July 1863* (*; cat. no. 34); *Lake Garda, Italy* (cat. no. 33); *Kauterskill [Waterloo] Falls* [cat. no. 21]; *Lake Geneva* (*; possibly fig. 144); and *The Column of Saint Mark's, Venice* (*), at the National Academy's Centennial Exhibition. Exhibits *Torre dei Schiavi* (see cat. no. 26), *Mansfield Mountain (Twilight)* (*, see cat. nos. 8–10), and *Fishing Boats Coming into the Harbor of Brindisi* (*) at The Metropolitan Museum of Art's Centennial Exhibition. Exhibits *Rheinstein* (*; fig. 140) at the San Francisco Art Association, and *Siout, The Capital of Upper Egypt* (possibly cat. no. 49), and *View in the White Mountains* at the Chicago Interstate Industrial Exposition

1877
April Gifford exhibits *Leander's Tower on the Bosphorus* (*; cat. no. 59), *A Sunset on the Hudson; Woods in Autumn*, and *Fire Island Beach* (possibly cat. no. 63) at the National Academy of Design annual exhibition, and *A Sunrise* and *A Venetian Twilight* at the Brooklyn Art Association

June Weds Mary Cecilia Canfield in a private ceremony; the couple moves to an apartment on Fourth Avenue in New York.

July Takes a fishing trip to Canada.

August Goes fishing on the Saint Lawrence River, Lake Ontario, and the Elizabeth Islands, Massachusetts.

September With McEntee and others, camps out with the Churches, at Lake Millinocket, Maine; fishes and sketches; possibly visits Lake George.

October Visits No Man's Land, south of Martha's Vineyard, to fish and to sketch.

December Announces his marriage to his family and friends. Exhibits *A Sudden Storm, Lake George* (probably cat. no. 31); *Twilight* at the Brooklyn Art Association; and *Camp of the Seventh Regiment near Frederick Maryland, in July 1863* (cat. no. 34) with R. M. Olyphant's Collection at The National Academy of Design.

1878
March Gifford exhibits *The Galleries of the Stelvio—Lake Como* (cat. no. 67) at the

Utica [New York] Art Association.

April Possibly visits Fire Island and its vicinity to sketch. Exhibits *A Venetian Twilight* (*), *The Marshes of the Hudson* (*; cat. no. 65) and *A Sunset, Bay of New York* (cat. no. 64) at the National Academy of Design annual exhibition and *Leander's Tower on the Bosphorus* (see cat. no. 59) and *An Indian Summer Day on Claverack Creek* (see fig. 126) at the Brooklyn Art Association.

October Visits the Catskills.

December Exhibits *A Sunset, Bay of New York* (possibly cat. no. 64), and *Montauk Point* at the Brooklyn Art Association.

Paints *Sunset on the Shore of No Man's Land–Bass Fishing* (*; cat. no. 62).

Exhibits *Mount Rainier, Washington Territory* (*; see cat. no. 57), and *San Giorgio, Venice* (*) at the Paris International Exposition and *Hunter Mountain* (*; cat. no. 41) at the Exhibition of the Society of Decorative Arts at the National Academy of Design.

June 14 William Cullen Bryant dies.

Autumn A group of chiefly younger artists objects to the hanging practices of the National Academy of Design and forms the Society of American Artists to exhibit their work.

1879
January Gifford joins the "G.B. Club," a dining club whose members include Whittredge, McEntee, and Johnson.

Spring Moves to the Dime Savings Bank Building at 1271 Broadway and 32nd Street. Exhibits *The Seashore, Looking Eastward at Sunset; Villa Malta—Rome* (fig. 60); and *Claverack Creek* (see fig. 126) at the National Academy of Design annual exhibition, and *October in the Catskill Mountains* and *Siout, Upper Egypt* (cat. no. 49), at the Brooklyn Art Association.

June Donates *Sunset on the Hudson* (cat. no. 69) to his alma mater, Hudson Academy. Visits New Brunswick, Canada, on a fishing trip, with Henry Kirke Brown and Ward, remaining through late July or early August.

September With his wife, McEntee, and an unidentified English couple, visits Church's camp on Lake Millinocket

October Briefly visits Montauk, Long Island; visits the Catskills near Kaaterskill Clove.

November Sends four paintings to the Seventh Regiment Fair, all Civil War subjects, including *Baltimore, 1862—Twilight* (*; fig. 32); *Bivouac of the Seventh Regiment—Arlington Heights* (*), *Camp of the Seventh Regiment, near Frederick, Maryland, in July 1863* (see cat. no. 34), and *Sunday Morning in the Camp of the Seventh Regiment near Washington, D.C.* (*).

1880

February Gifford completes a grisaille view of Venice for an engraving for Longfellow's *Poetical Works*.

Spring Exhibits *Sunrise on the Matterhorn* (*) and *Ruins of the Parthenon* (*; cat. no. 70) at the National Academy of Design annual exhibition, and *Venice* and *Mount Katahdin, Maine* (possibly cat. no. 68), at the Brooklyn Art Association.

Paints *Tappan Zee* (*), *October in the Catskills* (*; fig. 34), and *Mountain Gorge* (*; see cat. no. 21 and fig. 85).

July Visits Lake Superior to restore his health; later is diagnosed with malarial fever.

August Returns to New York; his health continues to deteriorate.

August 29 Gifford dies.

August 30 Funeral services take place in Hudson, attended by many artist friends and patrons, including Weir, Whittredge, the McEntees, and the Churches. Gifford is buried on Academy Hill, adjacent to the Hudson Academy.

Mid-October 1880–March 1881 A memorial Exhibition of 160 paintings and oil sketches is held in the new Central Park building of The Metropolitan Museum of Art.

November 19 A memorial meeting honors Gifford at the Century Association, in conjunction with an exhibition of 62 of the artist's paintings.

Coming Rain—Lake George (cat. no. 31) is exhibited at The Pennsylvania Academy of the Fine Arts.

1881

The Metropolitan Museum of Art publishes *A Memorial Catalogue of the Paintings of Sanford Robinson Gifford, N.A.*, which documents 739 paintings in the artist's oeuvre.

April 28 and 29 Thomas E. Kirby & Co. presides over the Gifford estate sale in Chickering Hall, New York.

(*) Gifford designated several of his most important compositions as "chief pictures."

SELECTED BIBLIOGRAPHY

Abbreviated references in the notes may be found in the Bibliography. Articles in the notes for which only the name of the newspaper and the date appear are listed in full in the Bibliography, under the name of the newspaper. Manuscript sources are also fully described below. MC numbers throughout refer to the *Memorial Catalogue*.

AAFA and AA-U Exhibition Record 1953

Mary Bartlett Cowdrey. *American Academy of Fine Arts and American Art-Union.* Vol. 2, *Exhibition Record, 1816–1852.* New York: The New-York Historical Society, 1953.

Alexander Gallery 1986

[Ila Weiss and Steven Weiss]. *Sanford R. Gifford.* Exhib. cat., New York, Alexander Gallery, March 20–April 19, 1986. New York, 1986.

American Paintings in MMA I 1994

John Caldwell and Oswaldo Rodríguez Roque et al. *American Paintings in The Metropolitan Museum of Art.* Vol. 1, *A Catalogue of Works by Artists Born by 1815.* Edited by Kathleen Luhrs. New York: The Metropolitan Museum of Art, 1994.

American Paintings in MMA II 1985

Natalie Spassky et al. *American Paintings in The Metropolitan Museum of Art.* Vol. 2, *A Catalogue of Works by Artists Born between 1816 and 1845.* Edited by Kathleen Luhrs. New York: The Metropolitan Museum of Art, 1985.

American Paintings in NYHS 1982

Richard J. Koke et al. *American Landscape and Genre Painting in The New-York Historical Society: A Catalog of the Collection, Including Historical, Narrative, and Marine Art.* 3 vols. New York: The New-York Historical Society; Boston: G. K. Hall and Co., 1982.

American Paintings in Wadsworth Atheneum 1996

Elizabeth Mankin Kornhauser et al. *American Paintings Before 1945 in the Wadsworth Atheneum.* 2 vols. New Haven and London: Yale University Press, 1996.

ANB 1999

John A. Garraty and Mark C. Carnes. *American National Biography.* 24 vols. New York and Oxford: Oxford University Press, 1999.

Appletons' Journal 1874

"Art. Some Landscapes at the Academy." *Appletons' Journal* 11, no. 268 (May 9, 1874), pp. 603–4.

Armstrong 1920

[David] Maitland Armstrong. *Day Before Yesterday, Reminiscences of a Varied Life.* New York: Charles Scribner's Sons, 1920.

Arnold 1864

George Arnold. "The Academy Exhibition. First Article." *The New York Leader,* April 23, 1864, p. 1.

The Art-Journal 1867

"Paris International Exhibition. No. VI. National Schools of Painting." *The Art-Journal* (London), n.s., 5 (November 1867), pp. 245–49.

The Art Journal 1880

"Sanford R. Gifford." *The Art Journal* (New York), n.s., 6 (October 1880), pp. 319–20.

AWS Exhibition Catalogues 1867–

National Academy of Design. *Catalogue of the . . . Winter Exhibition of the National Academy of Design, including the . . . Annual Collection of the American Society of Painters in Water Colors.* New York: Sackett and Mackay, 1867– . Title, venue, and publisher vary.

Baur, ed. 1942

John I. H. Baur, ed. "The Autobiography of Worthington Whittredge, 1820–1910." *Brooklyn Museum Journal,* 1942, pp. 3–68.

Benjamin 1879

S. G. W. Benjamin. "Our American Artists. V.—Sandford [*sic*] R. Gifford." *Wide Awake* 8, no. 5 (May 1879), pp. 306–9.

Benson 1861

"Proteus" [Eugene Benson]. "Our Artists. II." *New-York Commercial Advertiser,* October 17, 1861, p. 1.

Benson 1862

"Proteus" [Eugene Benson]. "Art. Concerning Two Great and Representative Works." *New-York Commercial Advertiser,* December 27, 1862, p. 1.

Benson 1865

"Sordello" [Eugene Benson]. "National Academy of Design. Fortieth Annual Exhibition. Third Article." *The New York Evening Post,* May 22, 1865, p. 1.

Benson 1866a

"Sordello" [Eugene Benson]. "American Landscape Painters—I. George Inness and S. R. Gifford." *The New York Evening Post,* March 30, 1866. p. 1.

Benson 1866b

"Sordello" [Eugene Benson]. "National Academy of Design. Forty-first Annual Exhibition. Second Article." *The New York Evening Post,* May 11, 1866, p. 1.

***Boston Evening Transcript,* August 1, 1859**

"Art Matters." *Boston Evening Transcript,* August 1, 1859, p. [2].

Brettell 1999

Richard R. Brettell. *Modern Art, 1851–1929: Capitalism and Representation.* Oxford and New York: Oxford University Press, 1999.

Brooklyn Art Association Exhibition Index 1970

Clark S. Marlor, ed. *A History of the Brooklyn Art Association with an Index of Exhibitions.* New York: James F. Carr, 1970.

***The Brooklyn Daily Eagle,* December 18, 1873**

"Brooklyn Art. Notes on the Present Exhibition." *The Brooklyn Daily Eagle,* December 18, 1873, p. [2].

***The Brooklyn Daily Eagle,* December 1, 1875**

"The Association Exhibition. A Glance at Some of the Paintings." *The Brooklyn Daily Eagle,* December 1, 1875, p. 3.

***The Brooklyn Daily Eagle,* April 25, 1876**

"Fine Arts. The Thirty-second Reception of the Brooklyn Art Association." *The Brooklyn Daily Eagle,* April 25, 1876, p. [4].

***The Brooklyn Daily Eagle,* December 2, 1877**

"Pictures. The Exhibition of To-morrow Night. A Preliminary Look at Some of the More Notable Works." *The Brooklyn Daily Eagle,* December 2, 1877, p. [4].

Burroughs 1915a

[Bryson Burroughs]. "Bequest of Mrs. Morris K. Jesup." *The Metropolitan Museum of Art Bulletin* 10, no. 2 (February 1915), pp. 22–23.

Burroughs 1915b

B[ryson]. B[urroughs]. "The Jesup Collection." *The Metropolitan Museum of Art Bulletin* 10, no. 4 (April 1915), pp. 64–69.

Burrows and Wallace 1999

Edwin G. Burrows and Mike Wallace. *Gotham: A History of New York City to 1898.* New York and Oxford: Oxford University Press, 1999.

Butlin and Joll 1984

Martin Butlin and Evelyn Joll. *The Paintings of J. M. W. Turner.* 1977. Rev. ed. 2 vols. New Haven and London: Yale University Press, 1984.

Callow 1967

James T. Callow. *Kindred Spirits: Knickerbocker Writers and American Artists, 1807–1855.* Chapel Hill: The University of North Carolina Press, 1967.

Carmer 1968

Carl Carmer. *The Hudson.* 1939. Rev. ed. New York: Grosset & Dunlap, 1968.

Carr 2003

Gerald L. Carr. "Sanford Robinson Gifford's *Gorge in the Mountains* Revived." *The Metropolitan Museum of Art Journal* 38 (2003), forthcoming.

***Centennial Loan Exhibition* 1876**

Catalogue of the New York Centennial Loan Exhibition of Paintings, Selected from the Private Art Galleries. New York: National Academy of Design and The Metropolitan Museum of Art, 1876.

Cikovsky 1970

Nicolai Cikovsky, Jr. *Sanford Robinson Gifford [1823–1880].* Exhib. cat., Austin, University of Texas Art Museum, October 25–December 13, 1970; New York, Albany Institute of History and Art, December 28, 1970–January 31, 1971; New York, Hirschl & Adler Galleries, February 8–27, 1971. [Austin, 1970].

Cikovsky and Kelly et al. 1995

Nicolai Cikovsky, Jr., and Franklin Kelly, with Judith Walsh and Charles Brock. *Winslow Homer.* Exhib. cat., Washington, D.C., National Gallery of Art, October 15, 1995–January 28, 1996; Boston, Museum of Fine Arts, February 21–May 26, 1996; New York, The Metropolitan Museum of Art, June 20–September 22, 1996. Washington, D.C., 1995.

Cikovsky and Quick 1985

Nicolai Cikovsky, Jr., and Michael Quick. *George Inness.* Exhib. cat., New York, The Metropolitan Museum of Art, April 1–June 9, 1985; The Cleveland Museum of Art, August 21–October 6, 1985; The Minneapolis Institute of Arts, November 10, 1985–January 12, 1986; Los Angeles County Museum of Art, February 20–May 11, 1986; Washington, D.C., National Gallery of Art, June 22–September 7, 1986. Los Angeles, 1985.

***The Continental Monthly,* June 1864**

"An Hour in the Gallery of the National Academy of Design. Thirty-ninth Annual Exhibition." *The Continental Monthly* 5, no. 6 (June 1864), pp. 684–89.

Cook 1861

[Clarence Cook]. "National Academy Exhibition." *New-York Daily Tribune,* March 27, 1861, p. 8.

Cook 1864a

[Clarence Cook]. "Exhibition of Pictures at the Sanitary Fair." *New-York Daily Tribune,* April 16, 1864, p. 12.

Cook 1864b

[Clarence Cook]. "National Academy of Design. The Thirty-ninth Exhibition. (Second Article)." *New-York Daily Tribune,* April 30, 1864, p. 3.

Cook 1866

[Clarence Cook]. "The National Academy of Design. Forty-first Annual Exhibition." *New-York Daily Tribune,* July 4, 1866, p. 5.

Cook 1877

C[larence]. C[ook]. "Academy Criticism. Comments on 'C.C.'s' Letters Answered. Number of the Seceding Party—Success of Their Exhibitions—Portraits and Their Merits as Pictures—The Academy Mercenary." *New-York Daily Tribune,* June 9, 1877, p. 4.

***The Crayon* 1857**

F. "Foreign Correspondence, Items, etc. To the Crayon, Rome, May 6, 1857." *The Crayon* 4, no. 7 (July 1857), p. 219.

The Crayon 1858

"Sketchings. Exhibition of the National Academy of Design." *The Crayon* 5, no. 5 (May 1858), pp. 146–48.

Cummings 1865

Tho[ma]s S. Cummings. *Historic Annals of the National Academy of Design . . .* Philadelphia: George W. Childs, Publisher, 1865.

Denvir 1993

Bernard Denvir. *The Chronicle of Impressionism.* Boston: Bulfinch Press; Little, Brown and Company, 1993.

Driscoll and Howat et al. 1985

John Paul Driscoll and John K. Howat, with Dianne Dwyer and Oswaldo Rodríguez Roque. *John Frederick Kensett: An American Master.* Exhib. cat., Massachusetts, Worcester Art Museum, March 24–June 9, 1985; Los Angeles County Museum of Art, July 11–September 8, 1985; New York, The Metropolitan Museum of Art, October 29, 1985–January 19, 1986. New York and London: Worcester Art Museum, in association with W. W. Norton and Company, 1985.

Eldredge 1987

Charles C. Eldredge. "Torre dei Schiavi, Monument and Metaphor." *Smithsonian Studies in American Art* 1, no. 2 (Fall 1987), pp. 14–33.

Ellis 1878

Franklin Ellis. *History of Columbia County, New York, with Illustrations and Biographical Sketches of Some of Its Prominent Men and Pioneers.* Philadelphia: Everts and Ensign, 1878. Reprint, Old Chatham, New York: Sachem Press, 1974.

Evers 1972

Alf Evers. *The Catskills: From Wilderness to Woodstock.* Garden City, New York: Doubleday & Company, 1972.

Ferber and Gerdts 1985

Linda S. Ferber and William H. Gerdts. *The New Path: Ruskin and the American Pre-Raphaelites.* Exhib. cat., The Brooklyn Museum, March 29–June 10, 1985; Boston, Museum of Fine Arts, July 3–September 8, 1985. Brooklyn, 1985.

Gifford 1855

[Sanford R.] G[ifford]. "Correspondence. Exhibition of Fine Arts in Paris." *The Crayon* 2, no. 19 (November 7, 1855), p. 295.

Gifford 1869

S[anford]. R. Gifford. "American Artists in Europe. Letter from Gifford." *The New York Evening Post,* April 26, 1869, p. 1.

Gifford, European Letters

Sanford R. Gifford. "European Letters." Typescript bound in 3 volumes. Vol. 1: May 1855–February 1856; Vol. 2: March 1856–August 1857; Vol. 3: June 1868–August 1869. Smithsonian Institution, Archives of American Art, Washington, D.C., reproduced on microfilm reel D21.

Gifford Family Records and Letters

"Gifford Family Records and Letters." Typescript of unlocated original letters, transcribed by Alice Carter Gifford and bound in 3 volumes edited by Robert Wilkinson, Edith Wilkinson, and Eleanor Peckham. Collection Sanford Gifford, M.D., Cambridge, Massachusetts.

Gifford, Frothingham Letter

Letter from Sanford R. Gifford to O[ctavius]. B[rooks]. Frothingham with "A List of Some of My Chief Pictures" appended, November 6, 1874; Collection Sanford Gifford, M.D., Cambridge, Massachusetts. Another version of the letter lacking the list of chief pictures is in the Smithsonian Institution, Archives of American Art, Washington, D.C., reproduced on microfilm reel D10. Typescript including "A List of Some of My Chief Pictures" in Vol. 3 of Gifford Family Records and Letters. An annotated version of the list was prepared by Ila Weiss: see Weiss 1987, Appendix B, pp. 327–30.

Greenhalgh 2001

Adam Greenhalgh. "'Darkness Visible': *A Twilight in the Catskills* by Sanford Robinson Gifford." *The American Art Journal* 32, nos. 1–2 (2001), pp. 45–75.

Groseclose 2000

Barbara Groseclose. *Nineteenth-Century American Art.* Oxford and New York: Oxford University Press, 2000.

Grun 1982

Bernard Grun. *The Timetables of History: A Horizontal Linkage of People and Events, Based on Werner Stein's Kulturfahrplan.* 1975. New ed. New York: Simon and Schuster, 1982.

Harper's Weekly, **May 8, 1858**

"The Lounger. Pictures Again." *Harper's Weekly* 2, no. 71 (May 8, 1858), p. 291.

Harvey 1998

Eleanor Jones Harvey. *The Painted Sketch: American Impressions from Nature, 1830–1880.* Exhib. cat., Dallas Museum of Art, June 21–September 20, 1998; Washington, D.C., Corcoran Gallery of Art, October 11, 1998–January 10, 1999; Williamstown, Massachusetts, Sterling and Francine Clark Art Institute, February 6–May 9, 1999. Dallas, 1998.

The Home Journal, **March 24, 1860**

"Fine Arts. Gifford's Pictures." *The Home Journal,* March 24, 1860, p. 5.

Howat 1972

John K. Howat. *The Hudson River and Its Painters.* New York: The Viking Press, 1972. Reprint, New York: American Legacy Press, 1983.

Howat et al. 1987

John K. Howat et al. *American Paradise: The World of the Hudson River School.* Exhib. cat., New York, The Metropolitan Museum of Art, October 4, 1987–January 3, 1988. New York, 1987.

Huntington 1960

David Carew Huntington. "Frederic Edwin Church, 1826–1900: Painter of the Adamic New World Myth." Ph.D. diss., Yale University, 1960.

Janson 1989

Anthony F. Janson. *Worthington Whittredge.* Cambridge and New York: Cambridge University Press, 1989.

Jenkins 1997

Philip Jenkins. *A History of the United States.* Houndmills, Basingstoke, Hampshire: Macmillan Press, 1997.

Johnson 1997

Paul Johnson. *A History of the American People.* London: Weidenfeld & Nicolson, 1997.

Kelly 1988

Franklin Kelly. *Frederic Edwin Church and the National Landscape.* Washington, D.C., and London: Smithsonian Institution Press, 1988.

Kelly et al. 1989

Franklin Kelly, with Stephen Jay Gould, James Anthony Ryan, and Debora Rindge. *Frederic Edwin Church.* Exhib. cat., Washington, D.C.: National Gallery of Art, October 8, 1989–January 28, 1990. Washington, D.C., 1989.

Lassiter 1978

Barbara Babcock Lassiter. *American Wilderness: The Hudson River School of Painting.* Garden City, New York: Doubleday & Company, 1978.

***The Literary World*, May 8, 1852**

"The Fine Arts. Exhibition of the National Academy of Design.—No. III." *The Literary World* (New York) 10, no. 275 (May 8, 1852), pp. 331–34.

Lossing 1866

Benson J. Lossing. *The Hudson, from the Wilderness to the Sea.* New York: Virtue and Yorston, 1866.

Mandel 1990

Patricia C. F. Mandel. *Fair Wilderness: American Paintings in the Collection of the Adirondack Museum.* Exhib. cat., Blue Mountain Lake, New York, Adirondack Museum. Blue Mountain Lake, New York, 1990.

McEntee Diaries

Jervis McEntee. "Diaries." Ms., 6 vols. 1851; 1 vol., Adirondack Museum, Blue Lake Mountain, New York, reproduced on microfilm, Archives of American Art, reel D9. 1872–91; 5 vols., Smithsonian Institution, Archives of American Art, Washington, D.C., reproduced on microfilm reel D180.

Memorial Catalogue

[Waldo S. Pratt]. *A Memorial Catalogue of the Paintings of Sanford Robinson Gifford, N. A., with a Biographical and Critical Essay by Prof. John F. Weir, of the Yale School of Fine Arts.* New York: The Metropolitan Museum of Art, 1881.

"Memorial Exhibition"

Loan Collection of Paintings, in the West and East Galleries (October 1880 to March 1881). Handbook No. 6. *The Memorial Collection of the Works of the Late Sanford R. Gifford.* Introduction by John F. Weir. Exhib. cat., New York, The Metropolitan Museum of Art. New York [1880].

Memorial Meeting

Gifford Memorial Meeting of The Century, Friday Evening, November 19th, 1880, Century Rooms. New York: The Century Association, 1880.

Miller 1993

Angela Miller. *The Empire of the Eye: Landscape Representation and American Cultural Politics, 1825–1875.* Ithaca and London: Cornell University Press, 1993.

Minick 1950

Rachel Minick. "Henry Ary, an Unknown Painter of the Hudson River School." *The Brooklyn Museum Bulletin* 11, no. 4 (Summer 1950), pp. 14–24.

Montgomery, ed. 1889

Walter Montgomery, ed. *American Art and American Art Collections.* 2 vols. Boston: E. W. Walker and Co., 1889. Reprint, New York and London: Garland Publishing, 1978.

Moure 1973

Nancy Dustin Wall Moure. "Five Eastern Artists Out West." *The American Art Journal* 5, no. 2 (November 1973), pp. 15–31.

Myers et al. 1987

Kenneth Myers et al. *The Catskills: Painters, Writers, and Tourists in the Mountains, 1820–1895.* Exhib. cat., Yonkers, New York, The Hudson River Museum, February 28–June 19, 1988; Rochester, New York, The Margaret Woodbury Strong Museum, July 15–October 16, 1988; Albany Institute of History and Art, New York, November 20, 1988–February 12, 1989; Syracuse, New York, Everson Museum of Art, February 26–April 23, 1989. Yonkers, New York, 1987.

NAD Exhibition Record (1826–1860) 1943

[Bartlett Cowdrey]. *National Academy of Design Exhibition Record, 1826–1860.* 2 vols. New York: The New-York Historical Society, 1943.

NAD Exhibition Record (1861–1900) 1973

Maria Naylor. *The National Academy of Design Exhibition Record, 1861–1900.* 2 vols. New York: Kennedy Galleries, 1973.

***The Nation*, June 2, 1870**

"Fine Arts. Forty-fifth Exhibition of the National Academy of Design. (Second Notice)." *The Nation* 10 (June 2, 1870), p. 357.

***The Nation*, September 9, 1880**

"Notes [obituary]." *The Nation* 31 (September 9, 1880), p. 187.

***New-York Daily Tribune*, June 22, 1878**

"Brush and Pencil. Notes from the Studios. An Exodus to the Country—The Results of the Winter in New Pictures." *New-York Daily Tribune*, June 22, 1878, p. 5.

***The New York Evening Post*, April 17, 1862**

"The Academy of Design. Second Notice. The Large Room." *The New York Evening Post*, April 17, 1862, p. 1.

***The New York Evening Post*, February 5, 1863**

"Fine Arts. The Studio Pictures." *The New York Evening Post*, February 5, 1863, p. 2.

***The New York Evening Post*, May 16, 1863**

"The National Academy of Design. Its Thirty-eighth Annual Exhibition. Second Article." *The New York Evening Post*, May 16, 1863, p. 1.

***The New York Evening Post*, December 1, 1863**

"Fine Arts. A New Picture by Gifford." *The New York Evening Post*, December 1, 1863, p. 2.

The New York Evening Post, May 21, 1864
"The National Academy of Design. Thirty-ninth Annual Exhibition." *The New York Evening Post*, May 21, 1864, p. 1.

The New York Evening Post, February 27, 1866
"Our New York Painters. Works Now on Their Easels. Second Article." *The New York Evening Post*, February 27, 1866, p. 1.

The New York Evening Post, March 3, 1870
"Mr. Gifford's New Picture." *The New York Evening Post*, March 3, 1870, p. [2].

The New York Evening Post, April 25, 1874
"National Academy of Design." *The New York Evening Post*, April 25, 1874, p. 1.

The New York Evening Post, June 19, 1876
"The National Academy of Design. The New York Centennial Loan Exhibition. The Names of the Contributors—Some of the Paintings &c." *The New York Evening Post*, June 19, 1876, p. [4].

The New York Evening Post, April 21, 1877
"The Academy of Design. Some Landscapes in the Fifty-second Annual Exhibition. Second Paper." *The New York Evening Post*, April 21, 1877, p. 1.

The New York Evening Post, May 19, 1877
"The Academy of Design. Animal Paintings, Marine Paintings and Other Paintings in the Fifty-second Annual Exhibition. Sixth Paper." *The New York Evening Post*, May 19, 1877, p. 1.

The New York Evening Post, September 1, 1880
"Sanford Gifford's Funeral." *The New York Evening Post*, September 1, 1880, p. [4].

The New York Sun, April 15, 1874
"Fine Arts. The Exhibition of the Academy of Design." *The New York Sun*, April 15, 1874, p. 2.

The New-York Times, April 21, 1861
"The National Academy Exhibition. The Landscapes of the Present Year." *The New-York Times*, April 21, 1861, p. 3.

The New-York Times, April 24, 1862
"The National Academy of Design. Paintings in the First Gallery." *The New-York Times*, April 24, 1862, p. 2.

The New-York Times, April 27, 1862
"The National Academy of Design. A Second Visit to the Gallery." *The New-York Times*, April 27, 1862, p. 5.

The New-York Times, March 12, 1871
"Fine Arts. Art Receptions at the Century and Union League Clubs—New Pictures—Picture Sales—Notes." *The New-York Times*, March 12, 1871, p. 5.

The New-York Times, August 30, 1880
"A New-York Artist Dead: Sanford R. Gifford Taken Off by Pneumonia. An Early Attack of Malaria—His Life Abroad, On the Battle-field, and in His Studio—His Works." *The New-York Times*, August 30, 1880, p. 5.

The New-York Times, August 31, 1880
"Died.–Gifford." *The New-York Times*, August 31, 1880, p. 5.

The New-York Times, January 4, 1899
"The Clarke Picture Sale." *The New-York Times*, January 4, 1899, p. 7.

NMAA Index 1986
James L. Yarnell and William H. Gerdts, eds. *The National Museum of American Art's Index to American Art Exhibition Catalogues from the Beginning Through the 1876 Centennial Year.* 6 vols. Boston: G. K. Hall and Co., 1986.

PAFA Exhibition Record 1988–89
Peter Hastings Falk, ed. *The Annual Exhibition Record of the Pennsylvania Academy of the Fine Arts, 1807–1870.* 3 vols. Madison, Connecticut: Sound View Press, 1988–89.

Parry 1988
Ellwood C. Parry III. *The Art of Thomas Cole: Ambition and Imagination.* Newark, Delaware: University of Delaware Press, 1988.

Pychowska 1864
L[ucia]. D. P[ychowska]. "Sketches of American Life and Scenery. II.—The Catskill Mountains." *The Continental Monthly* 5, no. 3 (March 1864), pp. 270–73.

Richards 1861
T. Addison Richards. *Appletons' Illustrated Hand-book of American Travel . . .* New York: D. Appleton & Co., 1861.

Rockwell 1867
Charles Rockwell. *The Catskill Mountains and the Region Around . . .* New York: Taintor Brothers and Co., 1867.

Rosenblum and Janson 1984
Robert Rosenblum and H. W. Janson. *19th-Century Art.* New York: Harry N. Abrams, 1984.

The Round Table, April 30, 1864
"Art. Exhibition of the National Academy of Design. II." *The Round Table* 1, no. 20 (April 30, 1864), p. 312.

The Round Table, May 9, 1866
E. B. [Eugene Benson?]. "Art. About Landscapes at the Academy." *The Round Table* 3, no. 37 (May 9, 1866), p. 311.

Sheldon 1876
[George William Sheldon]. "American Painters.—Sanford R. Gifford, N. A." *The Art Journal* (New York), n.s., 2 (1876), pp. 203–4.

Sheldon 1877
[George William Sheldon]. "How One Landscape-Painter Paints." *The Art Journal* (New York), n.s., 3 (September 1877), pp. 284–85.

Sheldon 1879
G[eorge]. W[illiam]. Sheldon. *American Painters, with Eighty-three Examples of Their Work Engraved on Wood.* New York: D. Appleton and Company, 1879.

Sheldon 1881
G[eorge]. W[illiam]. Sheldon. *American Painters, with One Hundred and Four Examples of Their Work Engraved on Wood.* New York: D. Appleton and Company, 1881. Reprint, New York: Benjamin Blom, 1972.

Sheldon and Weir 1880

[George William Sheldon]. "Sanford R. Gifford [obituary]," with J. F. W. "A Tribute to the Dead Artist's Memory, and an Analysis of his Art, by his Friend, Professor John F. Weir" appended. *The New York Evening Post*, August 30, 1880, p. [3].

Simpson et al. 1988

Marc Simpson et al. *Winslow Homer: Paintings of the Civil War.* Exhib. cat., The Fine Arts Museums of San Francisco, M. H. de Young Memorial Museum, July 2–September 18, 1988; Portland, Oregon, Portland Museum of Art, October 8–December 18, 1988; Fort Worth, Amon Carter Museum, January 7–March 12, 1989. San Francisco, 1988.

Skalet 1980

Linda Henefield Skalet. "The Market for American Painting in New York, 1870–1915." Ph.D. diss., Johns Hopkins University, 1980.

Stebbins et al. 1992

Theodore E. Stebbins, Jr., et al. *The Lure of Italy: American Artists and the Italian Experience, 1760–1914.* Exhib. cat., Boston, Museum of Fine Arts, September 16–December 13, 1992; The Cleveland Museum of Art, February 3–April 11, 1993; Houston, Museum of Fine Arts, May 23–August 8, 1993. Boston, 1992.

Sweeney 1997

J. Gray Sweeney. *Jervis McEntee and Company.* Exhib. cat., New York, Beacon Hill Fine Art, November 25, 1997–January 17, 1998. New York, 1997.

Swinnerton 1876

Henry U. Swinnerton. "Centennial Letters. Pictures and Statuary." *Newark Daily Advertiser,* November 13, 1876.

Taylor 1860

Bayard Taylor. "Travels at Home. From the *New-York Daily Tribune* of July 12, 1860." In *The Scenery of the Catskill Mountains as Described by Irving, Cooper, Bryant, Willis Gaylord Clark, N. P. Willis, Miss Martineau, Tyrone Power, Park Benjamin, Thomas Cole, Bayard Taylor, and Other Eminent Writers* [compiled by Rev. David Murdoch], pp. 40–46. New York: D. Fanshaw Publisher [1860?].

Truettner and Wallach, eds. 1994

William H. Truettner and Alan Wallach, eds. *Thomas Cole: Landscape into History.* Exhib. cat., Washington, D.C., National Museum of American Art, March 18–August 7, 1994; Hartford, Wadsworth Atheneum, September 11–December 4, 1994; The New-York Historical Society, January 8–March 25, 1995. Washington, D.C., 1994.

Tuckerman 1966

Henry T. Tuckerman. *Book of the Artists: American Artist Life, Comprising*

Biographical and Critical Sketches of American Artists, Preceded by an Historical Account of the Rise and Progress of Art in America. 1867. 2nd ed., 5th printing. New York: G. P. Putnam and Son, 1870. Reprint, New York: James F. Carr, 1966.

Van Loan 1881

[Walton Van Loan]. *Van Loan's Catskill Mountain Guide, with Bird's-eye View, Maps, and Choice Illustrations.* New York: The Aldine Publishing Company, 1881.

Van Zandt 1966

Roland Van Zandt. *The Catskill Mountain House.* New Brunswick, New Jersey: Rutgers University Press [1966].

Voorsanger and Howat, eds. 2000

Catherine Hoover Voorsanger and John K. Howat, eds. *Art and the Empire City: New York, 1825–1861.* Exhib. cat., New York, The Metropolitan Museum of Art, September 19, 2000–January 7, 2001. New York, 2000.

Weir 1873

[John F. Weir]. "American Landscape Painters." *The New Englander* 32 (January 1873), pp. 140–51.

Weir 1875

J[ohn]. F. W[eir]. "A Visit to the Studio of Mr. Sanford R. Gifford." *The New York Evening Post,* March 18, 1875, p. 1.

Weir 1880

John F. Weir. "Sanford R. Gifford, His Life and Character as an Artist and Man." In *Memorial Meeting,* pp. 11–31.

Weiss 1968/1977

Ila Weiss. "Sanford Robinson Gifford (1823–1880)." Ph.D. diss., Columbia University, 1968. Published with a new preface in Outstanding Dissertations in the Fine Arts. New York and London: Garland Publishing, 1977.

Weiss 1977

Ila Weiss. "Sanford R. Gifford in Europe: A Sketchbook of 1868." *The American Art Journal* 9, no. 2 (November 1977), pp. 83–103.

Weiss 1987

Ila Weiss. *Poetic Landscape: The Art and Experience of Sanford R. Gifford.* Newark, Delaware: University of Delaware Press, 1987.

Wilmerding 1999

John Wilmerding. *Compass and Clock: Defining Moments in American Culture, 1800, 1850, 1900.* New York: Harry N. Abrams, 1999.

Wilton 1979

Andrew Wilton. *J. M. W. Turner, His Art and Life.* New York: Rizzoli International Publications, 1979.

INDEX

PHOTOGRAPH CREDITS

Photographs were supplied by the lending institutions and individuals, with the exception of the following. Additional photograph and reproduction credits are also listed below. All rights reserved for photographs provided by private collections and for photographs not included on this list.

Boston, Vose Galleries, fig. 134; Burlington, Vermont, Zak Demers, fig. 56; Cambridge, Massachusetts, Fogg Art Museum, Harvard University Art Museums: Allan Macintyre, figs., 26, 27, 78, 79, 80, 105, 106, 108; London, Christie's Images Ltd., figs. 104, 124, 132; New Haven, Thomas Colville Fine Art, LLC., fig. 115; New York: Alexander Gallery, fig. 98; Art Resource, figs. 11, 96; Godel & Co., Inc., Fine Art, fig. 149; Hirschl & Adler Galleries, Inc., figs. 133, 139, 140, 161; Kennedy Galleries, fig. 141; The New York Public Library, Astor, Lenox and Tilden Foundations, Milstein Division of United States History, Local History & Genealogy, fig. 18; Phillips, de Pury & Luxembourg, figs. 127, 156; Sotheby's, Inc., figs. 35, 41, 85; Spanierman Gallery, LLC, fig. 146; Providence, Museum of Art, Rhode Island School of Design: Cathy Carver, fig. 144; Tuscon, The James C. Gifford Family: Carol A. Gifford, Sharon Katharine Gifford, and James Sanford Gifford, fig. 163; Washington, D.C., Library of Congress, Prints and Photographs Division, fig. 46.